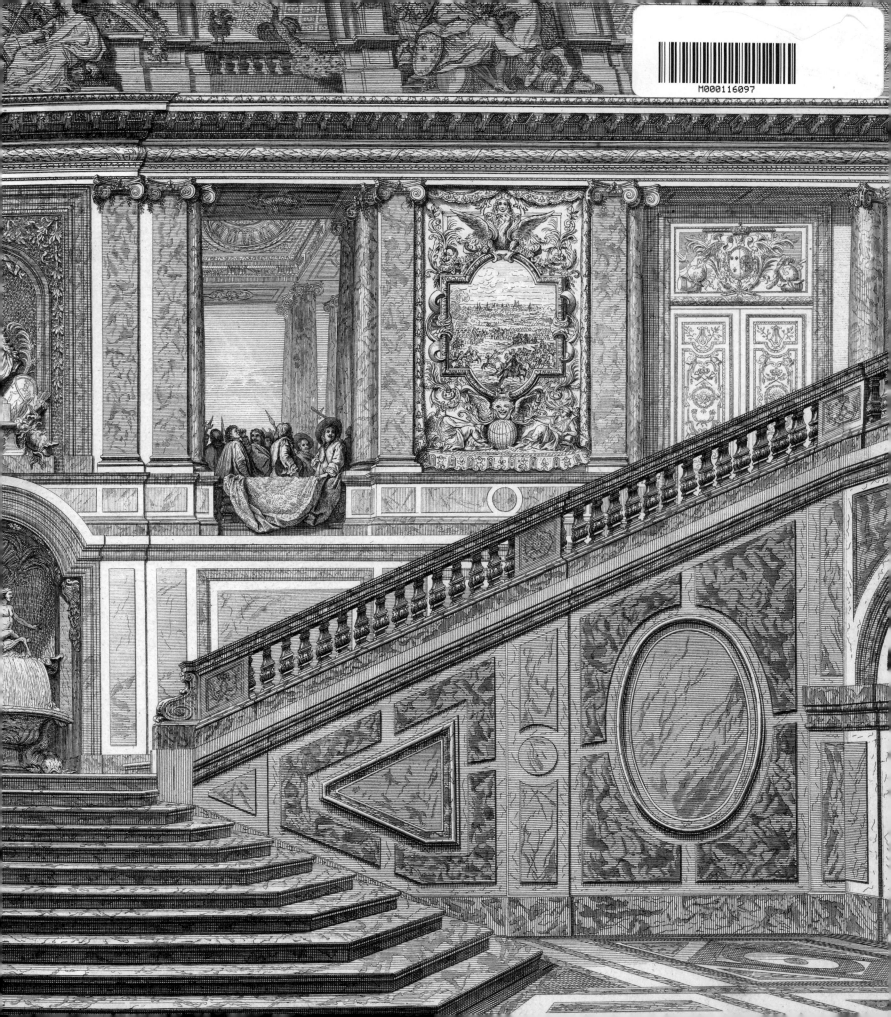

VISITORS TO
VERSAILLES

VISITORS TO
VERSA

ILLES

From Louis XIV to the French Revolution

Edited by Daniëlle Kisluk-Grosheide
and Bertrand Rondot

THE
MET

THE METROPOLITAN MUSEUM OF ART, NEW YORK
DISTRIBUTED BY YALE UNIVERSITY PRESS, NEW HAVEN AND LONDON

CONTENTS

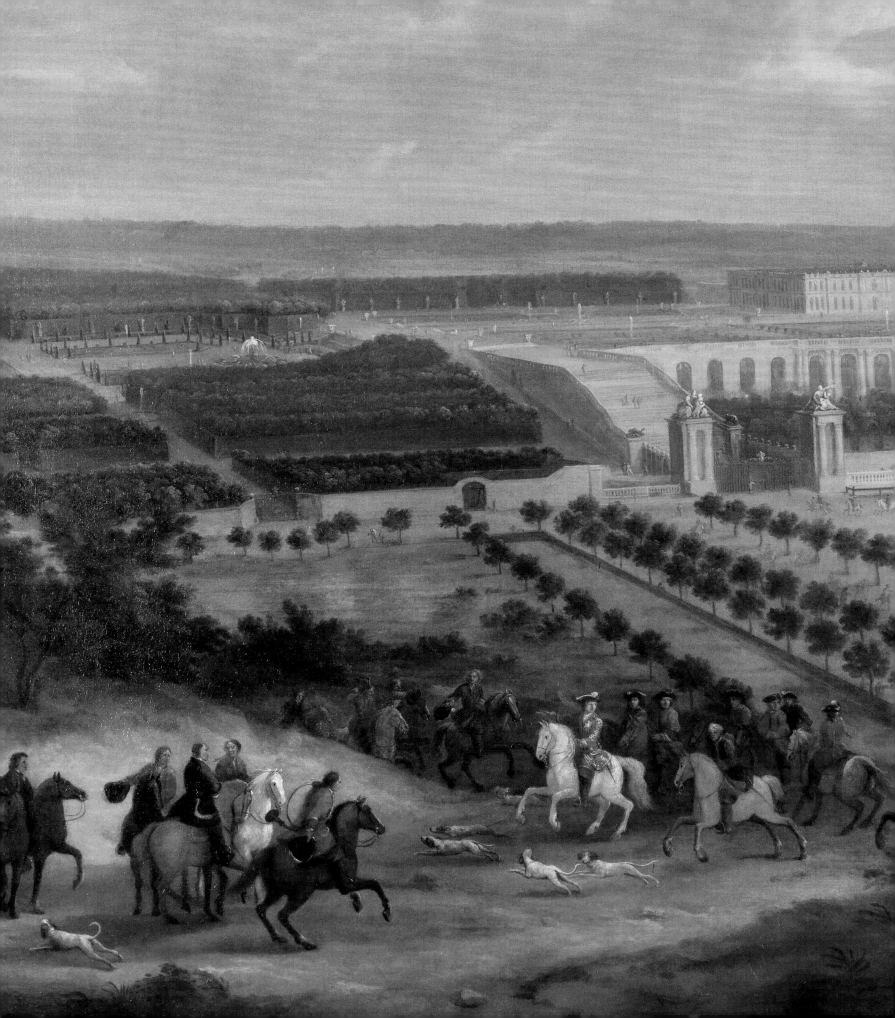

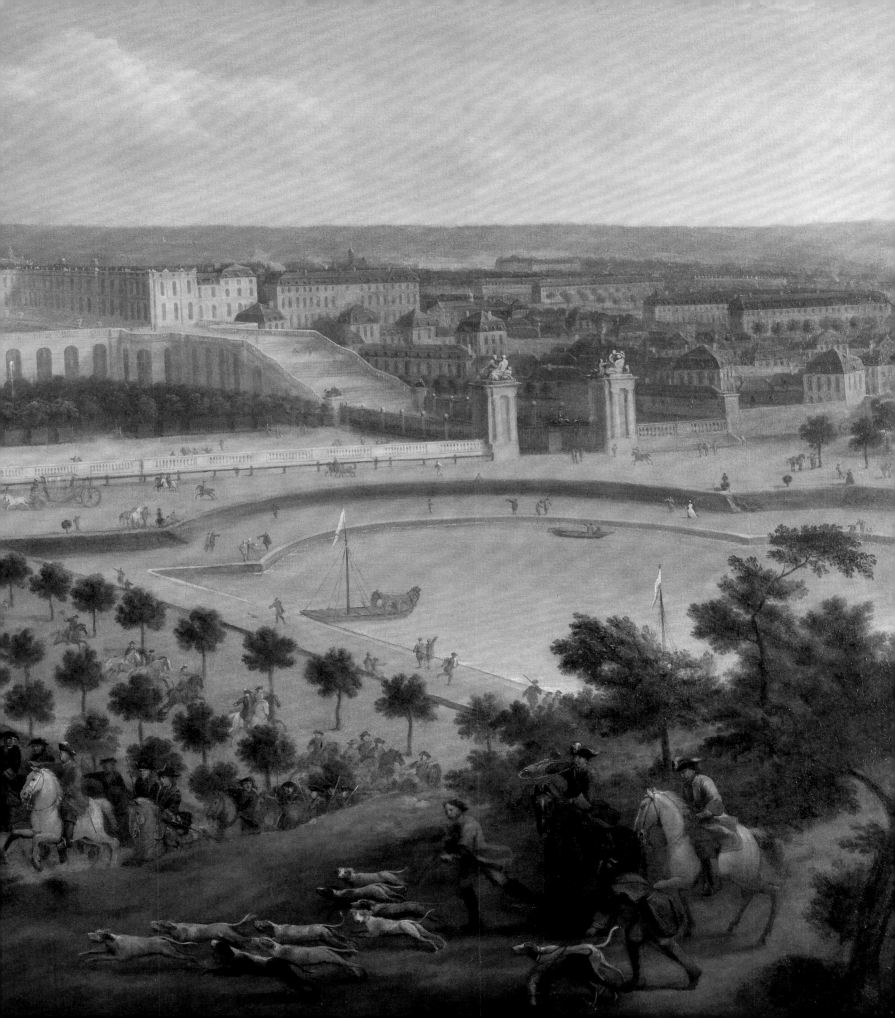

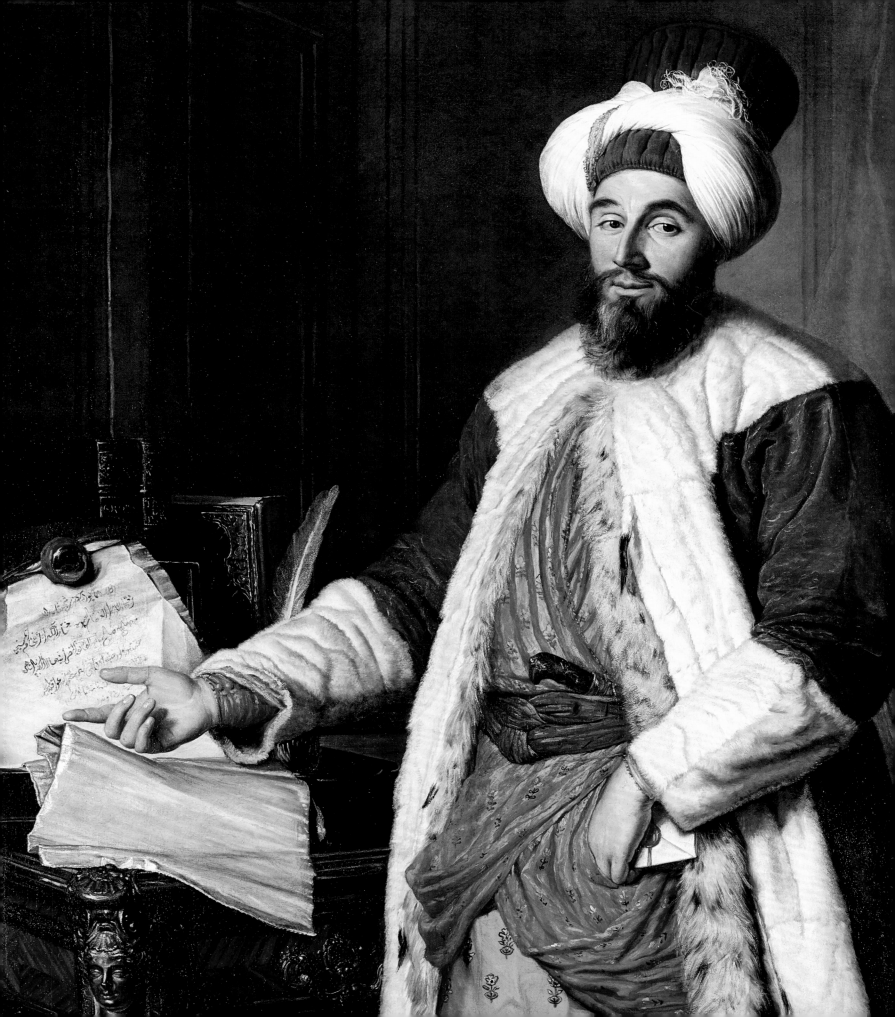

FOREWORD

Versailles, the celebrated royal residence built by Louis XIV, has long dazzled visitors and continues to enchant millions of tourists each year. Intended to awe and impress, the château was a center of power at a time when France was the dominant force in European politics. At the same time, Versailles was also one of the most public palaces in the world, accessible to anyone who was properly dressed.

Visitors to Versailles offers a novel approach to this well-known and much-studied subject, allowing us to see the palace through the eyes of the international travelers, tourists, diplomats, artists, philosophers, musicians, and foreign royalty who sauntered through its famous gardens or strolled in the Hall of Mirrors when Versailles was the seat of the Bourbon kings. Many of those visitors recorded their experiences in correspondence, diaries, and travel journals, an important source of research and inspiration for the present exhibition. Although the impressions that Versailles made on visitors varied widely and opinions changed substantially over time, especially with the approach of the French Revolution, one view remained nearly constant until the end of the ancien régime and continues to hold true today: Versailles is a magnificent place of spectacle and astonishment.

Visitors to Versailles would not have been possible without the support and cooperation of many institutions and collectors around the world. I extend special thanks to our colleagues at the Château de Versailles, with whom this exhibition—the first major collaboration of its kind between our two institutions—was jointly organized. At the Château de Versailles we are particularly grateful to Catherine Pégard, President; Béatrix Saule and Laurent Salomé, former and current Directors, respectively; and

Thierry Gausseron, Executive Officer. The exhibition was conceived and organized by Daniëlle Kisluk-Grosheide, Henry R. Kravis Curator in the Department of European Sculpture and Decorative Arts at The Metropolitan Museum of Art, and Bertrand Rondot, Senior Curator at the Château de Versailles. They are also responsible for the accompanying publication, which is the fruit of years of dedicated research. Special appreciation also goes to Elizabeth Benjamin, Research Associate in the Department of European Sculpture and Decorative Arts, for her exemplary assistance with all aspects of the project.

Bringing together nearly 190 works of art from eleven different countries, *Visitors to Versailles* would not have been possible without the numerous institutional and private lenders to the exhibition, to whom we are much indebted. We also extend heartfelt thanks to The Met's International Council, which helped us turn this ambitious concept into reality. Additional support is provided by the William Randolph Hearst Foundation, Beatrice Stern, the Diane W. and James E. Burke Fund, the Gail and Parker Gilbert Fund, The Florence Gould Foundation, The Danny Kaye and Sylvia Fine Kaye Foundation/French Heritage Society, The Al Thani Collection, Sally Spooner and Edward Stroz, as well as Atout France, the Paris Region Tourist Board and Lafayette Travel, and the Toile de Jouy International Foundation/Ruth Stanton Foundation. Finally, we are grateful for the Diane W. and James E. Burke Fund and The Andrew W. Mellon Foundation, whose generosity made this important catalogue possible.

Daniel H. Weiss
President and CEO
The Metropolitan Museum of Art

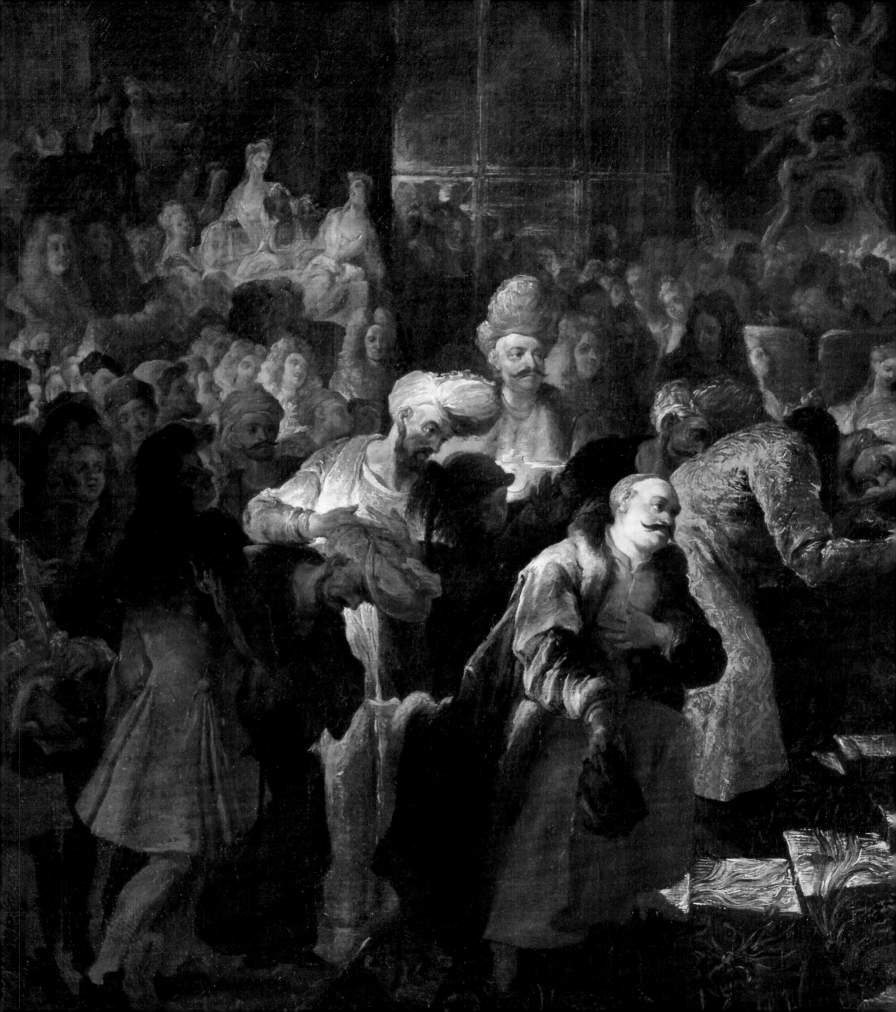

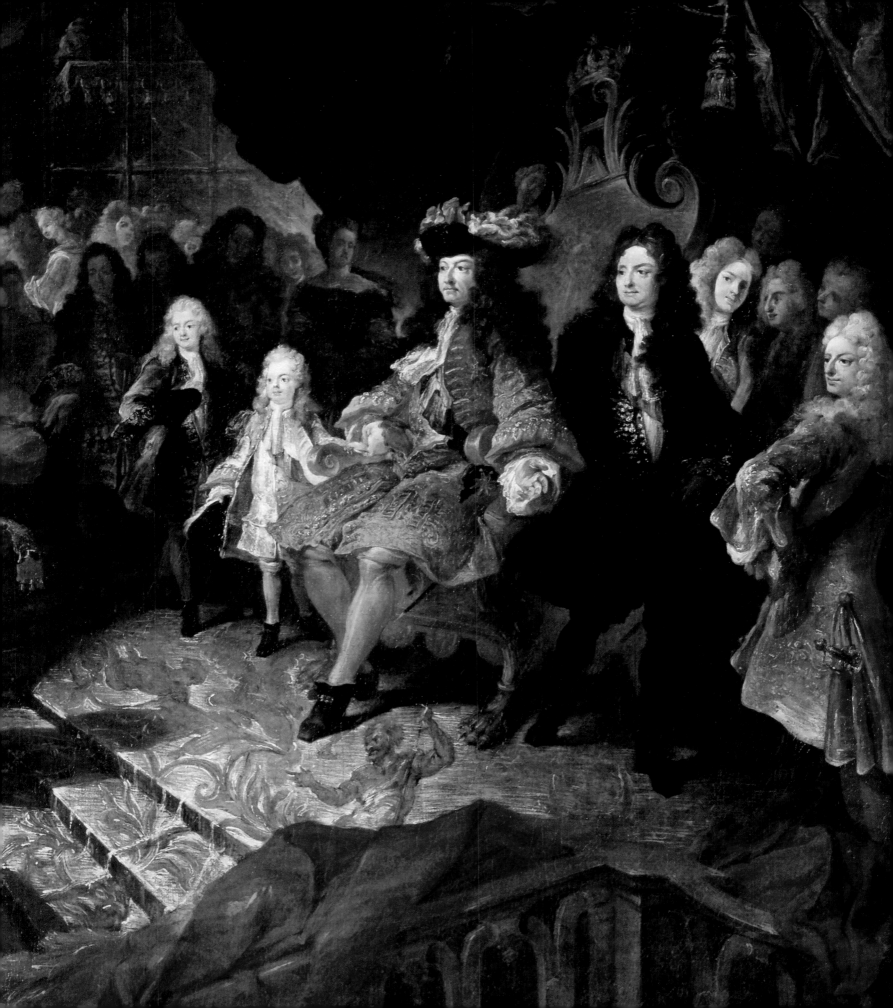

ACKNOWLEDGMENTS

Visitors to Versailles represents a landmark collaboration between The Metropolitan Museum of Art and the Musée National des Châteaux de Versailles et de Trianon. We thank the Presidents of both institutions, Catherine Pégard at Versailles and Daniel H. Weiss in New York, as well as the former and current Directors, respectively, of the Château de Versailles, Béatrix Saule and Laurent Salomé. We are also grateful to Thierry Gausseron, Executive Officer of Versailles, and Thomas P. Campbell, former Director of The Met, for their enthusiastic support of the project in its earliest stages. For his bold suggestion to turn what was initially an idea for a book into this magnificent exhibition and catalogue, credit and gratitude must be given to Luke Syson, Iris and B. Gerald Cantor Chairman of the Department of European Sculpture and Decorative Arts. We are also much indebted to Elizabeth Benjamin, Research Associate in the Department of European Sculpture and Decorative Arts, for her invaluable contributions at every level, and to Janice Barnard, Vincent Bastien, and Marie-Laure Buku Pongo for their assistance in myriad ways. Special thanks also go to our unsurpassed editorial team, Margaret Donovan, Dale Tucker, and Jayne Kuchna. Throughout this long endeavor we enjoyed the love, support, and hospitality of many friends and family, especially Eugene J. Kisluk, whose stimulating discussions at the dinner table were a welcome source of inspiration and strength.

Numerous colleagues at Versailles and at The Met shared with us their expertise and advice, and we are profoundly grateful to them all.

At Versailles: Natacha Akin, Jean-Manuel Alliot, Lionel Arsac, Pierre Aziza, Valérie Bajou, Nathalie Bastière, Marie-Alice Béziaud, Jérémie Benoît, Romain Beretti, Elisabeth Berger, Louis-Samuel Berger, Morgane Bertho, Géraldine Bidault, Céline Blondel-Henquez, Luciana Bocca, Claire Bonnotte, Cécile Bouchayer, Mathilde Brunel, Marion Buxtorf, Florence Cailliéret, Alice Camus, Yves Carlier, Chloé Carré, Matilde Cassandro-Malphettes, Elisabeth Caude, Florence Cailleret, Stéphane Ceccaldi, Paul Chaine, Charlotte Chastel-Rousseau, Laure Chedal-Anglay, Cornelia Cione, Hélène Dalifard, Mathieu Da Vinha, Olivier Delahaye, Frank Desclos De La Fonchais, Christine Desgrez, Mathilde Dillmann, Delphine Dubois, Laura Dubosc, Clémence Duquesnoy-Micheron, Virginie Estève, Handy Fernandez, Luis Fernandez, Gwenola Firmin, Danilo Forléo, Sébastien Forst, Christophe Fouin, Thomas Garnier, Serena Gavazzi, Aurélie Gevrey-Dubois, Jacqueline Goncalves, Florence Gravereau, Agnès Grelier, Pierre-Xavier Hans, Jean-Philippe Harriague, Marie-Armelle Hoyau, Catherine Huisse, Laurent Jannin, Olivier Jauneau, Olivier Josse, Antoine Jouanneaux, Jean-Philippe Julien, Alexandra Kurkdjian, Maïté Labat, Frédéric Lacaille, Marie-Laëtitia Lachèvre, Thierry Lamouroux, Camille Lanciaux, Marie-Ange Laudet-Kraft, Jérôme Lebouc, Mathias Le Galic, Jérémie Le Guillou, Olivier Legrain, Marie Leimbacher, Anne-Laïs Lemarchand, Thibaud Lemoine, Pierre-Yves Le Nir, Ariane de Lestrange, Carine Lopez, Elisabeth Maisonnier, Karine McGrath, Eric Manoncourt, Alexandre Maral, Aline Martelot, Elsa Martin, Stéphanie Martin, Raphaël Masson, Marylène Mercier, Eric de Meyer, Christian Milet, Sylvain Molfessis, Florence Muzellec, Emilie Neau, Constance Nemitz, Isabelle Noël, Valérie Noiville, Marc Nolibé, Agnès Ollier, Aurianne Ortiz, Damien Peron, Benjamin Ringot, Mélanie Rivault, Gérard Robaut, Silvia Roman, Florence Renouf, Marie-Laure de Rochebrune,

Chloé Sarrazin, Béatrice Sarrazin, Didier Saulnier, Cesar Scalassara, Christelle Schaal, Mélissa Schitt, Romain Siegenfuhr, Violaine Solari, Christophe Thomet, Delphine Valmalle, Denis Verdier-Magneau, Alexandre Verjus, Valentine Vila y Vicens, Thierry Webley, Souad Zerrim, and Sébastien Zimmermann.

At The Met, we received assistance from nearly every department in the Museum. The American Wing: Sylvia Yount, Lawrence A. Fleischman Curator in Charge, Elaine Bradson, Alice Cooney Frelinghuysen, Anthony W. and Lulu C. Wang Curator of American Decorative Arts, Elizabeth Mankin Kornhauser, Alice Pratt Brown Curator of American Paintings and Sculpture, Catherine MacKay, Leela Outcalt, Lauren Ritz, and Thayer Tolles, Marica F. Vilcek Curator of American Paintings and Sculpture. The Antonio Ratti Textile Center: Melinda Watt and Eva L. Labson. Arms and Armor: Pierre Terjanian, Arthur Ochs Sulzberger Curator in Charge, Sean P. Belair, Stephen J. Bluto, John Byck, Edward A. Hunter, Donald J. La Rocca, Stuart W. Pyhrr, and Lindsay Rabkin. Arts of Africa, Oceania, and the Americas: Alisa LaGamma, Ceil and Michael E. Pulitzer Curator in Charge; Yaëlle Biro, and Christine Giuntini. Asian Art: John Guy, Florence and Herbert Irving Curator of the Arts of South and Southeast Asia. Communications and Marketing: Kenneth Weine, Mary Arendt, Ann M. Bailis, Kimberly Drew, Mary Flanagan, and Egle Žygas. Construction and Facilities: Tom Scally, Marcel Abbensetts, Ray Abbensetts, Raouf Ameerally, Solomon Azaraev, Lionel Carre, Saul Cohen, Vadim Danilov, Michael Doscher, William Foley, Pietro Giordano, Gordon Hairston, Chi-Wei Hue, Lawrence Kellermueller, Rameshwar Kissoon, Matthew Lytle, Taylor Miller, Miroslaw Mackiewicz, Maria Nicolino, Luis A. Nunez, Daniel Olson, Todd Rivera, Oneil Robinson, Crayton Sohan, Jaami Sowerby, Sean Thomas, Salvatore Vaina, Derrick Williams, and Thomas G. Zimmerman. The Costume Institute: Andrew Bolton, Elizabeth D. Arenaro, Lauren Bierly, Michael Downer, Joyce Fung, Cassandra Gero, Regan Lin Grusy, Marina Hays, Bethany L. Matia, Christopher Mazza, Marci K. Morimoto, Glenn O. Petersen, Jessica Regan, and Sarah Scaturro. Office of the Secretary and General Counsel: Sharon H. Cott, Amy Desmond Lamberti, Nicole Sussmane, and Janet N. Yoon. Design: Emile Molin, Brian Oliver Butterfield, Maanik Singh Chauhan, Clint Ross Coller, Christopher DiPietro, Patrick Herron, Aubrey L. Knox, Daniel Koppich, Jaime Johnsen Krone, Michael Langley, Richard Lichte, Frank Mondragon, Amy Nelson, Joshua C. Nusbaum, Sarah M. Parke, Tal Pritzker, Ria Roberts, Jennifer Spoley, Alejandro Stein, David Stith, Katharina Weistroffer, and Andrew Zarou. Digital: Loic Tallon, Farhan Ali, Melissa Bell, Dan Brennan, Kaelan Burkett, Paul Caro, Jennie Choi, Skyla Choi, Michael Cirigliano II, Marco Castro Cosio, Nina Diamond, Claire C. Dienes, Kate Farrell, Dia Felix, William Fenstermaker, Austin Fisher, Ashley J. Hall, Lauren Nemroff, Pac Pobric, Stephanie J. Post, Lisa Rifkind, Robin Schwalb, Neal Stimler, Jessica Colleen Williams, and Julie Zeftel. Drawings and Prints: Nadine M. Orenstein, Drue Heinz Curator in Charge, David del Gaizo, Ricky Luna, Jillian Pfifferling, Femke Speelberg, Perrin Stein, and Elizabeth Zanis. Education: Sandra Jackson-Dumont, Frederick P. and Sandra P. Rose Chairman of Education, Emily Blumenthal, Mary Ann Bonet, Marie Clapot, Erin Flannery, Kathryn Calley Galitz,

Anastasiya Gutnik, Rebecca McGinnis, Jennifer Mock, Darcy-Tell Morales, Maricelle Robles, Julie Marie Seibert, Marianna Siciliano, Limor Tomer, and Maya Valladares. European Paintings: Keith Christiansen, John Pope-Hennessy Chairman, Katharine Baetjer, Rebecca Ben-Atar, Lisa Cain, Theresa King-Dickinson, John McKanna, and Rachel Robinson. European Sculpture and Decorative Arts: Luke Syson, Iris and B. Gerald Cantor Chairman, Ellenor M. Alcorn, Denise Allen, Elizabeth Cleland, Ana Matisse Donefer-Hickie, Marva Harvey-Walcott, Kristen Hudson, Wolfram Koeppe, Marina Kellen French Curator, Nicholas Merkelson, Iris Moon, Jeffrey Munger, Elyse Nelson, Erin E. Pick, Elizabeth St. George, Julia Siemon, Juan Stacey, Denny Stone, Melinda Watt, and Sam Winks. Executive Offices: Daniel H. Weiss, Quincy Houghton, Carrie Rebora Barratt, Martha Deese, Rachel Ferrante, Elizabeth Katherine Fitzgerald, Gillian Fruh, Sophie Golub, Christine D. McDermott, Christopher Noey, Jennifer Russell, and Linda Sylling. Imaging: Barbara J. Bridgers, Einar J. Brendalen, Joseph Coscia, Jr., Dahee Han, Christopher Heins, Heather L. Johnson, Anna-Marie Kellen, Thomas Ling, Mark Morosse, Wilson Santiago, Hyla Skopitz, and Bruce J. Schwarz. Institutional Advancement: Clyde B. Jones III, Daphne B. Birdsey, Elizabeth A. Burke, Evelin M. Chabot, Katharine Dobie, Heather A. Gallagher, Jason Herrick, Sarah Higby, Bronwyn Keenan, Hanah Lee, Kristin MacDonald, Leah Moliterno, Olivia Ouyang, Amy O'Reilly Rizzi, Jessica M. Sewell, and John L. Wielk. Islamic Art: Sheila Canby, Patti Cadby Birch Curator in Charge, Deniz Beyazit, Maryam Ekhtiar, and Navina Najat Haidar. Mail Services: Joel Chatfield, Nazmoon Jahoor, and Damaris Rosario. Member and Visitor Services: Lisa S. Krassner, Margaret Choo, Nicholas DeVogel, Jeffrey Gardner, and Allison E. Sokaris. Merchandising and Retail: Rich Pedott, Kathy Mucciolo, Chiara Ponticelli, Elizabeth Stoneman, and Erin Thompson. Objects Conservation: Lisa Pilosi, Sherman Fairchild Conservator in Charge, Mechthild Baumeister, Warren L. Bennett, Linda Borsch, Nancy C. Britton, Matthew Cumbie, Jacob D. Goble, Anne Grady, Jean-François de Lapérouse, Sara Levin, Marijn Manuels, Shoji Miyazawa, Pascale Patris, Frederick J. Sager, Karen Stamm, Jack Soultanian, Jr., and Wendy Walker. Paintings Conservation: Michael Gallagher, Sherman Fairchild Conservator in Charge, Shawn Digney-Peer, Charlotte Hale, and Cynthia Moyer. Paper Conservation: Marjorie Shelley, Sherman Fairchild Conservator in Charge, Marina Ruiz-Molina, and Rachel Mustalish. Photographs: Jeff L. Rosenheim, Joyce Frank Menschel Curator in Charge. Publications and Editorial: Mark Polizzotti, Peter Antony, Jennifer Bantz, Anne Rebecca Blood, Elizabeth De Mase, Crystal Dombrow, Margaret Donovan, Lauren Knighton, Jayne Kuchna, Cheryl Lemmens, Laura Lindgren, Jessica Palinski, Briana Parker, Josephine Rodriguez-Massop, Gwen Roginsky, Fronia Simpson, Richard Slovak, Michael Sittenfeld, and Dale Tucker. Registrar's Office: Aileen Chuk, Charles Agro, Allison E. Barone, Meryl Cohen, Caitlin Corrigan, Benjamin Dillon, Tim Dowse, Reagan Duplisea, Robert Kuszek, John Laughner, Fatima Mahdi, Mary McNamara, Wayne Morales, Jorge Roldán, and Hector Serna. Scientific Research: Marco Leona, David H. Koch Scientist in Charge; Eric Breitung, and Nobuko Shibayama. Security: Jose Rivero. Textile Conservation: Janina Poskrobko, Cristina B. Carr, Giulia Chiostrini, and Olha Yarema-Wynar. Thomas J. Watson Library: Kenneth Soehner, Arthur K. Watson Chief Librarian, William Blueher, Mindell Dubansky, Robyn Fleming, Dana Hart, Sophia A. Kramer, Dan Lipcan, Andrea Puccio, Patrick J. Raftery, Jessica Ranne, and Fredy Rivera.

We extend our profound thanks to all the institutions and private lenders to the exhibition. The Al Thani Collection: HH Sheikh Hamad bin Abdullah Al Thani, Amin Jaffer, and Laura Stuart.

American Philosophical Society Museum: Merrill Mason and Mary Grace Wahl. Bibliothèque Municipale de Versailles: Sophie Danis, Pierre-Emmanuel Biot, and Christophe Thomet. Bibliothèque Nationale de France: Laurence Engel, Mathilde Avisseau-Broustet, Cyril Chazal, Chiara Pagliettini, Brigitte Robin-Loiseau, and Inès Villela-Petit. Cité de la Céramique–Sèvres et Limoges: Romane Sarfati, Coralie Dusserre, and Sandrine Fritz. Buccleuch Living Heritage Trust and The Buccleuch Collection: The Duke of Buccleuch & Queensberry, Sandra Howat, and Crispin Powell. The Fan Museum: Hélène Alexander, Marta Cipolla, Imogen Clarke, Camilla Hiscock, and Jacob Moss. Fashion Museum Bath: Rosemary Harden and Eleanor Summers. The Fine Arts Department, Thailand, The National Museum, Bangkok, and Somdet Phra Narai National Museum: Ananda Chuchoti, Amara Srisuchat, Phuthorn Bhumadhon, Sahabhum Bhumtitterat, Phnombootra Chandrajoti, Rakchanok Kojaranont, Disapong Netlomwong, Patcharin Sukpramool, Chudamas Supar-Klang, Jaruk Wilaikew, and Khum Wiparat. Herzog Anton Ulrich Museum: Jochen Luckhardt and Silke Gatenbröcker. Hillwood Estate, Museum & Gardens: Kate Markert, MJ Meredith Hagan, the late Liana Paredes, and Wilfried Zeisler. The Hunterian, University of Glasgow: David Gaimster, Malcolm Chapman, and Graham Nisbet. Institut de France, Abbaye Royale de Chaalis: Jean-Pierre Babelon, and Hélène Couot Echiffre. Aline Josserand-Conan. Kunsthistorisches Museum, Vienna, Gemäldegalerie: Sabine Haag, Anne Campman, Francesca Del Torre, Guido Messling, Katja Schmitz-von Ledebur, and Paulus Rainer. The Kyoto Costume Institute: Norikata Tsukamoto, Rie Nii, and Tamami Suoh. Laing Art Gallery: Julie Milne, Amy Barker, Ana Flynn, and Lucinda Willis. Library of Congress: Carla Hayden, Simonette dela Torre, and Rachel Waldron. MAK—Austrian Museum of Applied Arts / Contemporary Art: Christoph Thun-Hohenstein, Martina Dax, Johanna Enzersdorfer-Konrad, Barbara Karl, Edith Oberhumer, and Susanne Schneeweiss. Monsieur and Madame Dominique Mégret. Mobilier National: Hervé Barbaret, Thomas Bohl, Hélène Cavalié, Sylvie Desrondaux, Nathalie Machetot, Laurence Montlouis, Muriel Morizet, and Christiane Naffah-Bayle. Morgan Library & Museum: Colin B. Bailey, John Alexander, Sheelagh Bevan, John Bidwell, John T. McQuillen, Maria Molestina-Kurlat, Lindsay Stavros, and Sophie Worley. Musée Carnavalet—Histoire de Paris: Valérie Guillaume, José De Los-Llanos, Marie-Laure Deschamps, Christiane Dole, Valérie Fours, Charlotte Lacour, Maïté Metz, David Simonneau, and Anne Zazzo. Musée de l'Armée: General Christian Baptiste, Dominique Prévôt, Emilie Prud'hom, Olivier Renaudeau, and Emilie Robbe. Musée des Beaux-Arts de Quimper: Guillaume Ambroise and Catherine Le Guen. Musée des Beaux-Arts, Rennes: Anne Dary and Anne-Laure Le Guen. Musée du Louvre: Jean-Luc Martinez, Sébastien Allard, Djamella Berri, Michèle Bimbenet-Privat, Stéphanie Brivois, Valérie Corvino, Laurent Creuzet, Frédéric Dassas, Martine Depagniat, Blaise Ducos, Jannic Durand, Eva Duret, Catherine Gougeon, Frederick Hadley, Sophie Jugie, Olivier Laville, Philippe Malgouyres, Florian Meunier, Fanny Meurisse, Nicolas Milovanovic, Marlène de Quelen, Anne-Solène Rolland, Marie-Pierre Sale, Xavier Salmon, Guilhem Scherf, Carole Treton, Juliette Trey, and Christel Winling. Musée du Quai Branly: Stéphane Martin, André Delpuech, Laurence Dubaut, Catherine Duruel, Valérie Eyéné, Yves Le Fur, Sarah Ligner, Hélène Maigret-Philippe, Paz Nunez-Regueiro, and Sarah Puech. Musée Lambinet: the late Françoise Roussel-Leriche, Virginie Bergeret, and Alice Gamblin. Museum of Fine Arts, Boston: Matthew Teitelbaum, Ronni Baer, Janet Moore, and Marietta Cambareri. National Portrait Gallery: Nicholas Cullinan, Richard Dark, and David

McNeff. National Portrait Gallery, Smithsonian Institution: Kim Sajet, Brandon B. Fortune, Molly Grimsley, Beth Isaacson, and Claire Kelly. Nationalmuseum, Stockholm: Berndt Arell, Anders Bengtsson, Merit Laine, Audrey Lebioda, Wolfgang Nittnaus, Magnus Olausson, Martin Olin, Carl Johan Olsson, and Karin Sandstedt. Nordiska Museet: Sanne Houby-Nielsen, Sandra Åberg, Ulf Berger, Susanna Janfalk, Helena Lindroth, Chiara Romano, Kajsa Stavebring, Anders Svensson, and Leif Wallin. Patek Philippe Museum: Peter Friess and Sylvie Dricourt. Petit Palais, Musée des Beaux-Arts de la Ville de Paris: Christophe Leribault, Hubert Cavaniol, and Patrick Lemasson. Philadelphia Museum of Art: Timothy Rub, Nancy Ash, Dilys Blum, Conna Clark, Stephanie Feaster, Nancy Leeman, and Sara Reiter. Philip Mould & Company: Philip Mould, Laura Edmundson, and Lawrence Hendra. Powis Castle, The Clive Collection (The National Trust): Dame Helen Ghosh, Ben Dale, Holly Lopez, Isabelle Marty, Christopher Rowell, and Fernanda Torrente. Princeton University Art Museum: James Steward, Elizabeth Aldred, Karl Kusserow, Betsy Rosasco, and Carol Rossi. Rijksmuseum: Taco Dibbits, Reinier Baarsen, Joosje van Bennekom, Dirk Jan Biemond, Wendela Brouwer, Femke Diercks, Sara van Dijk, Gijs van der Ham, Wobke Hooites, Erwin Kriger, Robert van Langh, Janneke Martens, Eveline Sint Nicolaas, and Frans Pegt. Royal Armoury, Stockholm: Malin Grundberg, Sofia Nestor, Ann-Cathrin Rothlind, and Monica Sargren. The Royal Artillery Museum: Major-General N. H. Eeles, Lieutenant Colonel John Le Feuvre, Jackie Dryden, Siân Mogridge, Mark Smith, Joanne Clare Thomson, and Simon Wright. The Royal Collections Sweden: HM King Carl XVI Gustaf, Margareta Nisser-Dalman, Maria Fritz, Kerstin Hagsgård, Alexander Holm, and Lars Ljungström. Royal Ontario Museum: Josh Basseches, Nur Bahal, Karla Livingston, Alexandra Palmer, Chris Paulocik, and Tricia Walker. National Museum of American History, Smithsonian Institution: John Gray, Richard Barden, Nancy Ellen Davis, Sunae Park Evans, Joshua M. Gorman, Margaret Grandine, and William H. Yeingst. Société des Missions Etrangères de Paris: Fr. Georges Colomb, Eric Henry, Fr. Bernard Jacquel, and Fr. Vincent Sénéchal. St. John's College, Cambridge: Christopher M. Dobson and the Fellows of St. John's College, Mark Nicholls, and Kathryn McKee. Swiss National Museum: Andreas Spillmann, Jürg Burlet, Erika Hebeisen, Maya Jucker, and Elke Mürau. United States Naval Academy Museum: Lieutenant Commander Claude Berube, James Cheevers, Jenna Scholz, John Swift, and Grant Walker. Vartanian & Sons: Paul Vartanian, Nishan P. Vartanian, and Katie Kerr. Victoria and Albert Museum: Tristram Hunt, the late Martin Roth, Juliet Ceresole, Judith Crouch, Helen Dawson, Richard Edgcumbe, Reino Liefkes, Tessa Murdoch, Susan North, Sophie Parry, Christina Ritschel, Anna Sheppard, Suzanne Smith, Holly (Marjorie) Trusted, and Rebecca Wallis.

We are also grateful to the following: Katinka Ahlbom, Kathy Alliou, Kathy Amey, Elin Andersson, Sergueï Androsov, Agnès Angrand Letizia Arbeteta Mira, Stephen Astley, Jean-Dominique Augarde, Leticia Azcue Brea, Natalia Bakhareva, Françoise Banat-Berger, Pierre Baptiste, Ilsebill Barta, Katrin Bäsig, Valery Bataille, Christian Baulez, Eric Beaussant, Marie Bégué, Michele Beiny, Lucien Bély, Anne-Marie Benson, Virginie Bergeret, Marie-Ange Bernieri, Silvana Bessone, Raphael Beuing, Rufus Bird, Maria Ana Bobone, Sylvie Bourrat, Ryan Brown, Sylvia Brown, Emmanuelle Brugerolles, Denis Bruna, Jean-Marc Bustamante, Pierre Caessa, David Caméo, Vera F. Carasso, Philippe de Carbonnières, Maureen Cassidy-Geiger, Stéphane Castelluccio, Martin Chapman, Dorothée Charles, Yannick Chastang, Alix and Amaury de Chaumont Quitry, Gérard Chouin, Grace Chuang, Katerina Cichrova, Luis Fernandez Cifuentes, Jeffrey Collins, Pierre Colliot, Stanislas

Colodiet, Coralie Coscino, comte and comtesse Édouard de Cossé-Brissac, Didier Cramoisan, Sandrine Cure, Léon Dalva, Serge Davoudian, Pierre-François Dayot, Hélène Demagny, Vera A. Dement'eva, Franck Devedjian, Jet Pijzel-Domisse, Hartmut Dorgerloh, Eliza Douglas, Bernard Dragesco, Vincent Droguet, Emmanuel Ducamp, Romain Dugast, Agathe Dupont, Maximilien Durand, Theodore Eisenman, François Farges, Rupert Featherstone, Christina Ferando, Hervé Ferrage, Fabian Forni, Anne Forray-Carlier, Cyrille Froissart, Perrine Fuchs, Peter Fuhring, Olivier Gabet, Tiana Gamez, Marie-Noël de Gary, Bertrand Gautier, Laurent Gaveau, Mary Gaylord, Christine Germain-Donnat, Alden Gordon, François-Joseph Graf, Gilles Grandjean, David M. Gray, J. H. Grosheide, Virginie Guffroy, David Guillet, Aleksei N. Guzanov, Vincent Haegele, Astrid Hall, Brian Hall, Katharina Hantschmann, Richard Hart, Jennifer Herlein, Nadine Hingot, Leonhard Horowski, Elfriede Iby, John Peters Irelan, Atelier Jault, Emmanuel Joyerot, Pierre Jugie, Rachel Kalnicki, Olga Kamakova, Eva-Lena Karlsson, Dena Kaye, Denis de Kergorlay, Martha J. King, Marina Kliger, Tim Knox, Marcus Köhler, Caroline zum Kolk, Gabriela Lamy, Jill Lasersohn, Mathilde Lejeune-Faust, Alfred van Lelyveld, Bertrand Le Masson, Sylvie Le Ray-Burimi, Ulrich Leben, Pierre-Yves Lefèvre, Tatiana Lekhovich, Séverine Lepape, Isabelle Levêque, Anne Lhuillier, Ben David Liot, Bénédicte Macedo, Markus Maier, Emilie Maisonneuve, Olivier de La Malène, Giulio Manieri Elia, Philip Mansel, General

Jean-Pierre Martin, Stéphane Martin, Christine Martinez, Maud Mary, Catherine Maunoury, Brian McLaughlin, Olga Medvedkova, Eve Menei, Erika Smeenk-Metz, Colombe de Meurin, Marine de Meurin, Thomas Michelon, Robin Miller, Yves Monin, Bénédicte de Montlaur, Sophie Motsch, Riha Moumni, Anna Nikiforova, Jonas Nordin, Sonia O'Connor, Anita Oger-Laurent, John O'Halloran, Yotam Ottolenghi, Hans Ottomeyer, Anastasia Ozoline, Susan Palmer, Joseph Panetta, Dimitri Papalexis, Cinzia Pasquali, Joséphine Pellas, Pierre-Hippolyte Pénet, Jean-Jacques Petit, Alain Peyrot, Maria-Anne Privat Savigny, Andrea Puccio, Christian Quaeitzsch, Julia Ream, Gilles Reithinger, Nicolas Rimaud, Emilie Robbe, Alicia Robinson, Sofia Rodriguez Bernis, Verena Roedern, Fionnuala Rogers, Bernard Roosens, Olivier Saillard, Jean Salomon, Jean-Pierre Samoyault, Mireille Schneider, Selma Schwartz, Linda Seckelson, Vanessa Selbach, Charlotte Servat, Caroline Shaw, Pippa Shirley, Kristel Smentek, Sally Spooner and Edward Stroz, Per Stålebro, Emmanuel Starcky, Beatrice Stern, Elizabeth Stribling, Patrick Strzoda, Dirk Syndram, Bertrand Talabardon, Nina Tarasova, Natalia Torija-Nieto, Catherine Tran, Julie Travis, Olivier Trebosc, Anne-Laure Tuncer, Emma Vignon, George V. Vilinbakhov, Hubert de Vinols, Aymar de Virieu, Aurélie Voltz, Sylvia Vriz, the late Giles Waterfield, Robert Wellington, Stefan Weppelmann, John Whitehead, Zoé Wittock, Samuel Wittwer, Angkanit Yingprayoon, Hilary Young, and Hendrik Ziegler.

DK-G and BR

NOTE TO THE READER

Quotations from manuscripts, correspondence, travel journals, and diaries reflect the original spellings used by the authors. Of the French currencies and denominations cited in the catalogue, one écu equaled about three livres tournois ("livres"); one livre equaled twenty sols; and one sol equaled twelve deniers. For context, during the reign of Louis XIV an unskilled worker earned an annual income of about 220 livres, while a specialized craftsman might receive approximately 500 livres per year. Life dates are included in the index.

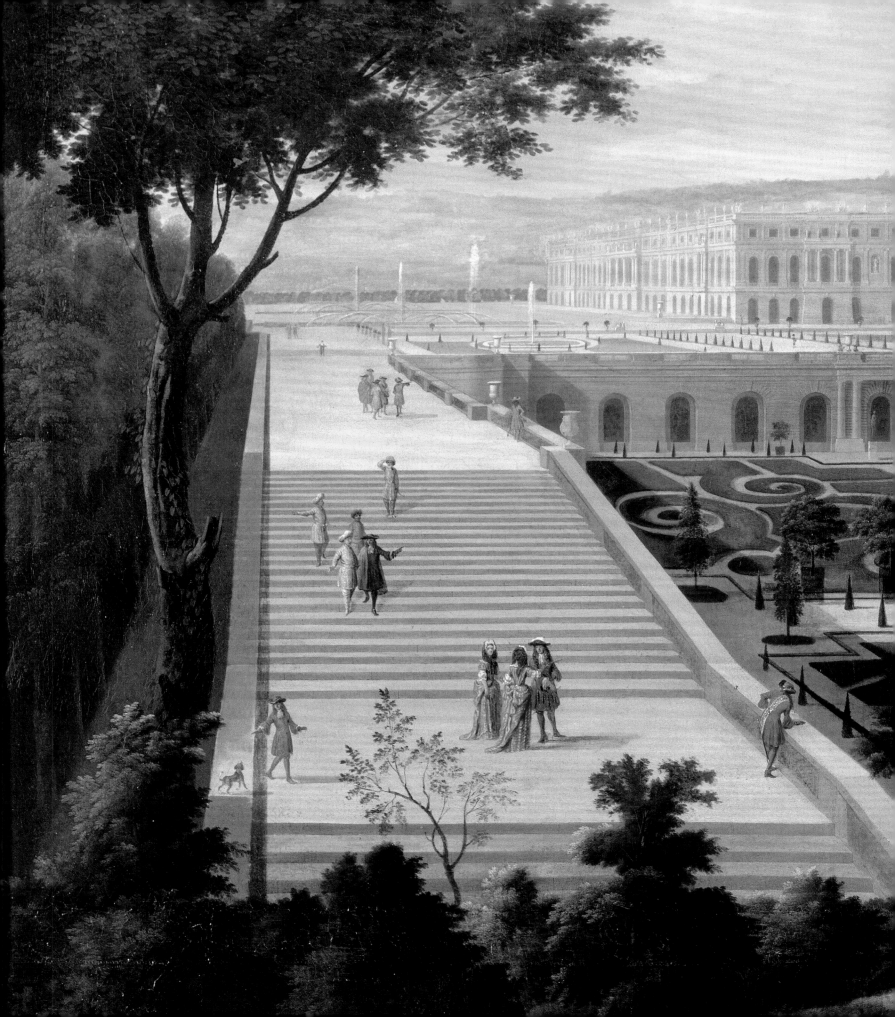

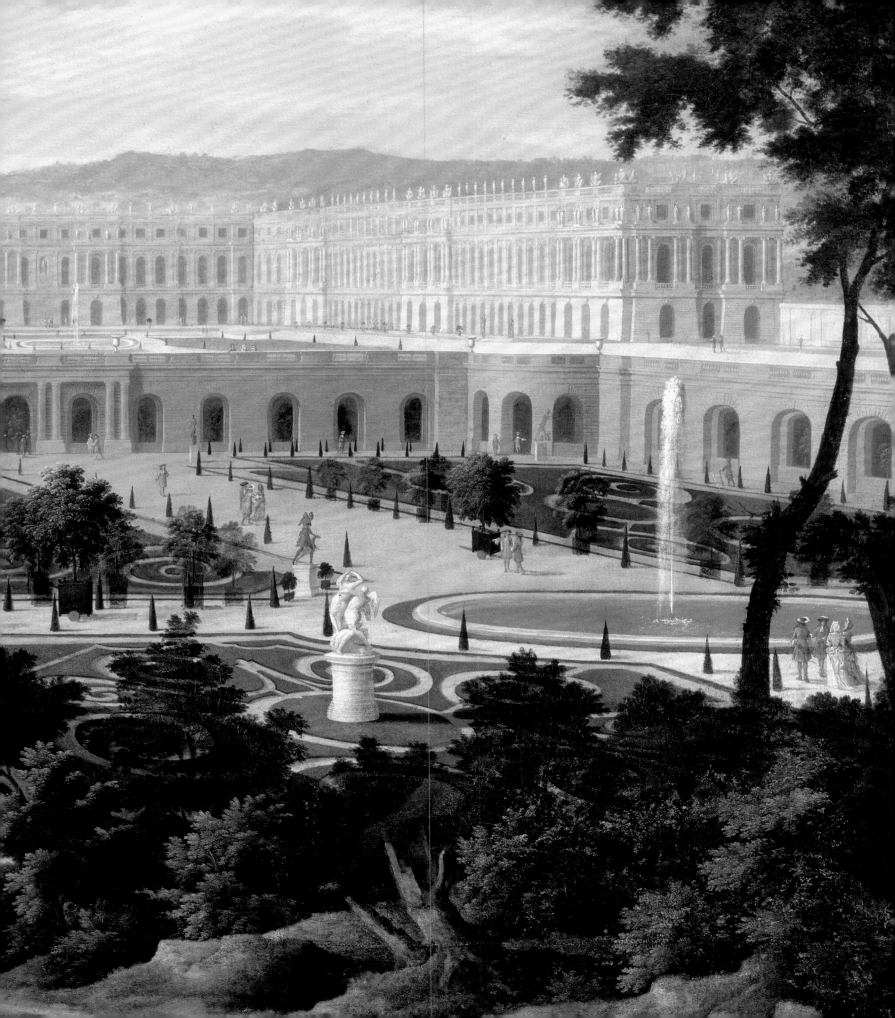

LENDERS TO THE EXHIBITION

Austria
Vienna, Kunsthistoriches Museum, Gemäldegalerie, 93
Vienna, MAK—Austrian Museum of Applied Arts / Contemporary Art, 96, 97A–D

Canada
Toronto, Royal Ontario Museum, 28

France
Fontaine-Chaalis, Institut de France, Abbaye Royale de Chaalis, 62, 72
Paris, Bibliothèque Nationale de France, Département des Monnaies, Médailles, et Antiques, 60, 70
Paris, Mobilier National, 1, 74
Paris, Musée de l'Armée, 38, 76, 77
Paris, Musée Carnavalet, 7–10, 29, 87, 126A–C, 150
Paris, Musée du Louvre
 Département des Arts Graphiques, 61
 Département des Objets d'Art, 49, 55, 66, 105, 157
 Département des Peintures, 139–141
 Département des Sculptures, 81, 82
Paris, Musée du Quai Branly, 78
Paris, Petit Palais, Musée des Beaux-Arts de la Ville de Paris, 143
Paris, Société des Missions Etrangères, 80
Quimper, Musée des Beaux-Arts, 79, 98
Rennes, Musée des Beaux-Arts, 68
Sèvres, Cité de la Céramique—Sèvres et Limoges, 83
Versailles, Bibliothèque Municipale, 166
Versailles, Musée Lambinet, 30, 34, 128, 155, 158, 159
Versailles, Musée National des Châteaux de Versailles et de Trianon, 2, 4–6, 31, 35, 36, 40, 41A–B, 45, 56, 59, 71, 75, 88, 94, 101–103, 114A–C, 115 117, 121, 122, 125, 127, 129, 130, 133, 134, 136–138, 144–146, 148, 160, 161

Germany
Braunschweig, Herzog Anton Ulrich Museum, 51

Japan
Kyoto, The Kyoto Costume Institute, 26

The Netherlands
Amsterdam, Rijksmuseum, 52–54, 112

Sweden
Stockholm, Nationalmuseum, 89, 106–109, 111, 135, 147
Stockholm, Nordiska Museet, 17
Stockholm, The Royal Armoury, 91
Stockholm, HM King Carl XVI Gustaf, The Royal Collections Sweden, 92, 110
Stockholm, The Swedish National Portrait Gallery, 90

Switzerland
Geneva, Patek Philippe Museum, 58
Zurich, Swiss National Museum, 39

Thailand
Bangkok, National Museum of Thailand, 63
Lopburi, Somdet Phra Narai National Museum, 64

United Kingdom
Bath, Fashion Museum, 27
Cambridge, St. John's College, 47
Glasgow, The Hunterian Museum and Art Gallery, University of Glasgow, 57
Larkhill, The Royal Artillery Museum, 65
London, The Fan Museum, 131
London, The National Portrait Gallery, 152, 153
London, Victoria and Albert Museum, 22, 84, 85, 149
Newcastle upon Tyne, Laing Art Gallery, 120
Powys County, Powis Castle, The Clive Collection, 86

United States
Annapolis, United States Naval Academy Museum, 171, 172
Boston, Museum of Fine Arts, 15, 173
New York, The Metropolitan Museum of Art, 3, 11–14, 16, 18, 19–21, 23–25, 37, 42–44, 46, 48, 67, 99, 100, 104, 113, 123, 124, 142, 162, 167, 170, 175, 176
New York, The Morgan Library & Museum, 50
Philadelphia, American Philosophical Society Museum, 164
Philadelphia, The Philadelphia Museum of Art, 154
Princeton, Princeton University Art Museum, 168
Washington, D.C., Hillwood Estate, Museum & Gardens, 165
Washington, D.C., Library of Congress, 174
Washington, D.C., Smithsonian Institution, National Museum of American History, 163
Washington, D.C., Smithsonian Institution, National Portrait Gallery, 169

Private Collections
Hélène Alexander, London, 132, 156
The Al Thani Collection, 69A–B, 118A–B, 119
The Duke of Buccleuch & Queensberry, 151
Aline Josserand-Conan, Paris, 33
Monsieur and Madame Dominique Mégret, Paris, 32
Philip Mould & Company, London, 73
Vartanian & Sons, New York, 95

CONTRIBUTORS TO THE CATALOGUE

Lionel Arsac (LA)
Curator, Department of Sculpture, Musée National des Châteaux
de Versailles et de Trianon

Pascale Gorguet Ballesteros
Senior Curator, Palais Galliera, Musée de la Mode de la Ville de Paris
Associate Lecturer, UFR Art et Archéologie de Paris IV
Paris-Sorbonne

Volker Barth
Assistant Professor of Modern History, Department of History,
University of Cologne

Vincent Bastien (VB)
Independent art historian

Elizabeth Benjamin
Research Associate, Department of European Sculpture and
Decorative Arts, The Metropolitan Museum of Art, New York

Jean Boutier
Professor, Ecole des Hautes Etudes en Sciences Sociales,
Paris-Marseille

John Byck (JB)
Assistant Curator, Department of Arms and Armor,
The Metropolitan Museum of Art, New York

Yves Carlier (YC)
Chief Curator and Head of Collection Management,
Musée National des Châteaux de Versailles et de Trianon

Mathieu Da Vinha (MDV)
Scientific Director, Centre de Recherche du Château de Versailles

Gwenola Firmin (GF)
Curator of Eighteenth-Century Paintings, Musée National des
Châteaux de Versailles et de Trianon

John Guy (JG)
Florence and Herbert Irving Curator of the Arts of South and
Southeast Asia, Department of Asian Art, The Metropolitan Museum
of Art, New York

Helen Jacobsen
Senior Curator and Curator of French Eighteenth-Century
Decorative Arts, The Wallace Collection, London

Daniëlle Kisluk-Grosheide (DK-G)
Henry R. Kravis Curator, Department of European Sculpture and
Decorative Arts, The Metropolitan Museum of Art, New York

Antoine Leduc (AL)
Former Curator, Musée de l'Armée, Paris

Elisabeth Maisonnier (EM)
Curator of Prints and Drawings, Musée National des Châteaux de
Versailles et de Trianon

Alexandre Maral (AM)
Chief Curator and Head of the Department of Sculpture, Director of
the Centre de Recherche, Musée National des Châteaux de Versailles
et de Trianon

Meredith Martin
Associate Professor of Art History, New York University

Jessica Regan (JR)
Assistant Curator, The Costume Institute, The Metropolitan
Museum of Art, New York

Bertrand Rondot (BR)
Senior Curator, Decorative Arts, Musée National des Châteaux de
Versailles et de Trianon

Béatrice Sarrazin (BS)
Chief Curator and Head of the Department of Paintings, Prints, and
Drawings, Musée National des Châteaux de Versailles et de Trianon

Paul Staiti
Alumnae Foundation Professor of Fine Arts, Mount Holyoke
College, Massachusetts

Corinne Thépaut-Cabasset
Research Associate, Musée National des Châteaux de Versailles et
de Trianon

INTRODUCTION

THE INCOMPARABLE VERSAILLES

DANIËLLE KISLUK-GROSHEIDE AND BERTRAND RONDOT

Having seen Versailles there remains nothing worth y^e seeing in France.
—Richard Ferrier, *Journal of Major Richard Ferrier*, 1687[1]

"Magnificent" was the word for Versailles. The residence that Louis XIV built was frequently described as such in the journals, diaries, and letters of French and foreign travelers drawn to the palace during the late seventeenth and eighteenth centuries. Many came to conduct business—especially after May 6, 1682, when the Sun King moved his court and government ministries from Paris to Versailles—but most wanted just to see the sights: to wander through the splendid palace, marvel at its riches, and stroll in the formal gardens, with their shaded walks, groves of trees, spectacular fountains, and marble sculptures. Most of all, however, visitors to Versailles hoped to catch a glimpse of the king.

Versailles was probably the most public palace in Europe, accessible to anyone who was decently dressed.[2] This gesture of openness reflected a long French tradition of granting the king's subjects access to their sovereign. It was also a careful political calculation, since the palace, constructed at astronomical expense, served as tangible evidence of both the power and the wealth of the French State. Versailles functioned as a magnificent stage on which its principal actor, Louis XIV, could be seen. The king chose Apollo, the Sun God, as his emblem, implying that his reign cast light over the entire world. The royal motto, *Nec Pluribus Impar* (literally, "not unequal to many," but implying "par to none"), was made manifest at Versailles, whose sheer size, sumptuous interiors, and expansive gardens were designed to impress and awe.

Versailles was, in effect, the ultimate expression of the king's absolute rule. Heroic images of the

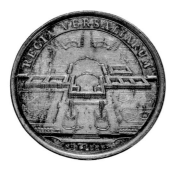 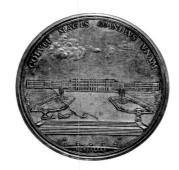 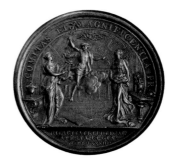

Fig. 1. Medal, 1680. Silver, Diam. 1⅝ in. (4.1 cm). Inscribed (on reverse): *REGIA VERSALIARUM / M.DC.LXXX* (The Palace of Versailles 1680). Bibliothèque Nationale de France, Paris, Cabinet des Médailles (Série Uniforme, no. 341)

Fig. 2. Medal, 1687. Silver, Diam. 2¾ in. (7.1 cm). Inscribed (on reverse): *COLVIT . MAGIS . OMNIBVS . VNAM / VERSALIAE . / . 1687* (He Prefers It to All the Others Versailles . . 1687). Bibliothèque Nationale de France, Paris, Cabinet des Médailles (Série Royale, no. 956)

Fig. 3. Jean Mauger, medal, 1683. Bronze, Diam. 1⅝ in. (4.1 cm). Inscribed (on reverse): *COMITAS ET MAGNIFICENTIA PR. / HILARITATI PUBLICAE APERTA REGIA. M.DC.LXXXIII* (The King's Palace Open to His Subjects' Pleasures). American Numismatic Society, New York (1981.57.20)

monarch—from Antoine Coysevox's large marble relief in the War Salon, which shows Louis XIV trampling his enemies, to the depictions of his military victories painted by Charles Le Brun on the ceiling of the Grande Galerie (later known as the Hall of Mirrors)—boldly proclaimed his power and fame. This lavish program of aggrandizement was lost on no one, of course, even on those who experienced Versailles well after the Sun King's rule, as was the case with the German painter and architect Johann Christian von Mannlich. Writing in the 1760s, Mannlich proclaimed that "the Hall of Mirrors, the Hercules Room, the rich collection of paintings and antique sculptures offer an idea of the taste, the luxury, the greatness and power of the ruler who took up residency here."[3]

As the personification of the French State, the king lived in full view of his subjects and was surrounded at all times by courtiers. When the court, and with it the four government ministries—the Maison du Roi (the king's household), War, Navy, and Foreign Affairs—moved from Paris to Versailles, the palace effectively became the capital of the realm. Except for a seven-year interlude during the Régence—following the death of Louis XIV, in 1715, when Philippe II d'Orléans, regent for the young Louis XV, moved

the court back to Paris—Versailles's position as the center of French society and governance remained unchanged until 1789. All political business was conducted there, and the palace was the source of all government news and information.[4] Versailles was where military support, loans, and passports were obtained, contracts were signed, petitions delivered, offices awarded, and royal favors bestowed. The reception of foreign diplomats also took place at the palace, as did the presentation of distinguished visitors to the king or queen. If Versailles was a stage for the monarch, then it also functioned in many respects like a theater for its visitors, who could on any given day witness the arrival of an overseas embassy, the formal audience of an ambassador, or the royal family dining in public.

The Palace Transformed

When Louis XIV transferred the seat of the French government and the court to Versailles in 1682, the château was still a construction site. As the marquis de Sourches recalled, "On May 6, the king left Saint-Cloud to come settle at Versailles, where he had long wished to be—even though it was still filled with masons."[5] The king's determination to move to Versailles was reflected

in a number of medals, including one struck by the Royal Mint in 1680 with an image of what the enormous palace would look like once finished (fig. 1). The completion of the residence would be the culmination of Louis XIV's long-desired transformation of what had been his father's hunting lodge into a vast, official palace that would be unique in Europe. The striking of a medal in 1687 with the legend COLVIT MAGIS OMNIBVS VNAM (He Prefers It to All the Others) unambiguously confirmed that fact (fig. 2). An earlier medal, struck in 1683, praises the king's "affability and magnificence" and evokes the lavish receptions (or *jours d'appartement*) held there three times a week (fig. 3).

The inscription on the 1683 medal, HILARITATI PUBLICAE APERTA REGIA (The King's Palace Open to His Subjects' Pleasures), would seem to suggest that Versailles was open to all visitors, but soirées were restricted to the court and distinguished guests. The château was originally not intended, in fact, to be either the public venue or the tourist attraction that it became beginning in the late seventeenth century. That role was supposedly reserved for the Palais du Louvre, seat of the French monarchy since medieval times. According to the ideas of the young Louis XIV, the hunting lodge he had inherited from his father should have remained a secluded place where he could escape the crowds that, according to French royal tradition, had access to all the king's residences, but especially the official ones: the Louvre, Fontainebleau, and Saint-Germain-en-Laye.

The first of Louis XIV's alterations to Versailles began in 1662, and the planned exclusivity of the king's retreat was attested to by the king's cousin, Anne Marie Louise d'Orléans, duchesse de Montpensier: "We often go to Versailles; no one could follow the king there without his order. That sort of distinction intrigued the entire court, and everyone wanted to have it."[6] Certain distinguished visitors were nonetheless welcomed; in 1665 Paul Fréart de Chantelou, who was accompanying the sculptor Gian Lorenzo Bernini during his stay in France, "had not dared propose to take [Bernini] there, not knowing whether the king would be agreeable." The king, on his part, seems to have been apprehensive as well, believing "the Cavalier [Bernini] to be a man prepared from the outset to find nothing well done in France." The visit, postponed several times, finally took place on September 13. "Having arrived at Versailles, we found M. Le Nôtre"—André Le Nôtre, the landscape architect responsible for the formal gardens of Versailles—"who first took us into the garden; from there, he [Bernini] considered the palace at leisure, and I noticed that, with measured words, he sought to praise it as follows: 'It's charming, anything that is proportionate is beautiful; this palace is well proportioned.'" Having met the king in the palace courtyard, Bernini is said to have exclaimed, "Sire, up to now, I thought Your Majesty was great in great things—now I recognize that He is wondrously great even in the little things."[7] That same year the British architect Christopher Wren visited Versailles twice but was evidently underwhelmed, commenting that "the Mixtures of Brick, Stone, blue Tile [slate] and Gold make it look like a rich Livery."[8]

In its early days Versailles was, in fact, more renowned for its gardens than its interiors. The constantly changing designs of the groves (*bosquets*) and, above all, the celebrated attractions contained therein— the Menagerie, the Grotto of Thetis, the Labyrinth—were celebrated in special publications (see "Visitors' Guidebooks and Engravings" by Elisabeth Maisonnier in this volume). The grounds were also the setting for fêtes in 1664, 1668, and 1674—elaborate entertainments, arranged over several days, consisting of pageants, games, ballets, dances, music, plays, suppers, illuminations, and fireworks—for which the palace served as a theatrical backdrop.

The next step in Louis XIV's ambitious transformation of Versailles was begun in 1668 with the construction of three new wings on the garden side: the so-called Envelope that would effectively

encase the former hunting lodge within a completely new structure. It would be architect Louis Le Vau's final project for the king. Developed around the theme of Apollo, the distribution of space was the antithesis of the plans for the Louvre, in which Le Vau had actively participated. Instead of a public palace, in the Envelope the King's and Queen's Apartments, each named for a Roman god or goddess and associated with one of the planets, would occupy the entire main floor but not communicate directly with one another. The only common space—the central salon located between the private rooms in the old hunting lodge—would not be accessible to the public. The true nature of the new Versailles was reflected by the famous terrace facing the gardens: an unpassable barrier meant to keep mobs of visitors away from the palace.

These major extensions were completed about 1672, but a subsequent alteration of the palace's iconographic program reveals that Versailles would increasingly be seen less as a private retreat and more as an official, and thus public, residence.[9] Two projects emblematic of Louis XIV's new ambitions, the Ambassadors' Staircase and the Hall of Mirrors, marked this transition as Versailles emerged as a true *regia*, or seat of ruling authority. Planning for the Ambassadors' Staircase, conceived by Le Vau as the grand entrance to the King's Apartment, began in 1669, and the work was done in 1674. The decoration by Le Brun, executed between 1676 and 1680, followed a new iconographic program incorporating allegories of the Four Parts of the World on the vault and representations of crowds of foreign visitors on the walls. "These double galleries," wrote Claude III Nivelon, Le Brun's biographer, "seem to be filled with figures that represent all sorts of nations from the two Indies, East and West, Persians, Greeks, Armenians, Muscovites, Germans, Italians, Dutchmen, Africans; in short all those who are known. . . . And it can be said that when the great king descends by that staircase amidst and followed by all the princes and princesses,

it creates such a great and superb spectacle that one would think all these people are thronging to this place to honor his passing and to see the most beautiful court in the world" (cats. 40, 41).[10]

The Hall of Mirrors, which replaced the terrace facing the garden, was constructed between 1678 and 1684. This spectacular new gallery provided the king's residence with an unrivaled representational space, one that was clearly designed for public consumption and was no longer restricted to the court.[11] The Hall of Mirrors perfectly illustrates how the original iconographic program for Versailles, centered on Louis XIV's identification with Apollo, had been abandoned in favor of one that would extol the king's earthly achievements. Events from Louis's reign up to 1678 were recorded on its barrel-vaulted ceiling in an explicitly heroic mode and described in cartouches below each scene. Originally composed in Latin, these explanatory texts were later rendered in French. "Most of the courtiers and foreigners," noted the *Mercure galant*, the court gazette, "not having command of the Latin language, agreed that it was a great pleasure accorded them to facilitate their understanding of these paintings and to be able to learn by heart the praise given our great monarch."[12] Booklets explaining Le Brun's paintings were even made available in the gallery itself.

Numerous visiting dignitaries are included in the decoration of the vault, but here, in contrast to the Ambassadors' Staircase, they are not the main subject, which is the king himself. One of the medallions, *Embassies Sent from the Ends of the Earth*, shows the ambassadors of the King of Arda in Guinea, who came to France in the year 1670.[13] The same medallion also contains an allusion to the audiences of the envoys of the Russian czar in 1668, the Ottoman sultan in 1669, and the sultan of Morocco in 1682 (fig. 4).[14] A nearby trophy of Asian weapons, most received as diplomatic gifts, includes a samurai suit of armor given to Louis XIII by Shogun Tokugawa Ieyasu.[15] Other exotic offerings are rendered below the panel *The*

Fig. 4. Jean-Baptiste Massé, "Embassies Sent from the Ends of the Earth," from *La grande galerie de Versailles, et les deux salons qui l'accompagnent* (pl. 15). Paris: Imprimerie Royale, 1752. H. of book, 26 in. (66 cm). Thomas J. Watson Library, The Metropolitan Museum of Art (196.5V61 L49 F)

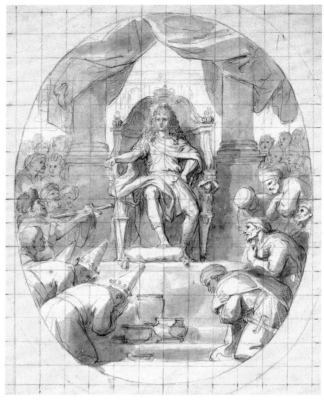

Fig. 5. Charles Le Brun, *Louis XIV Granting Audience to Ambassadors of Distant Nations*, before 1690. Black chalk and gray wash, 15¼ × 11⅞ in. (38.7 × 30 cm). Musée du Louvre, Paris, Département des Arts Graphiques (29758, recto)

King Armed on Land and at Sea, foreshadowing gifts brought by the embassies of Siam, Persia, and the Ottoman Empire that would later be received in the Hall of Mirrors. In its decoration, Versailles thus incorporated diplomatic audiences long after they had taken place and belatedly welcomed these visitors, as it were, in the Hall of Mirrors, where they would have been received if this grand reception space had existed at the time of their embassy. The Peace Salon, located at the end of the Hall of Mirrors (opposite the War Salon), was intended to be similarly embellished with a large overmantel composition, *Louis XIV Granting Audience to Ambassadors of Distant Nations*, although it remained unfinished at Le Brun's death. According to Nivelon, the artist had depicted "His Majesty on a superb throne, painted in the same place [the Hall of Mirrors] where he had been observed receiving the Siamese ambassadors . . . and those of all the nations of the world who visited that prince" (fig. 5).[16]

The change in the scale and floor plan of the palace was made permanent and especially noticeable on the facade facing town. Composed of a series of successive, increasingly narrow courtyards leading, as of 1701, to the King's Bedchamber at the center of the original building,

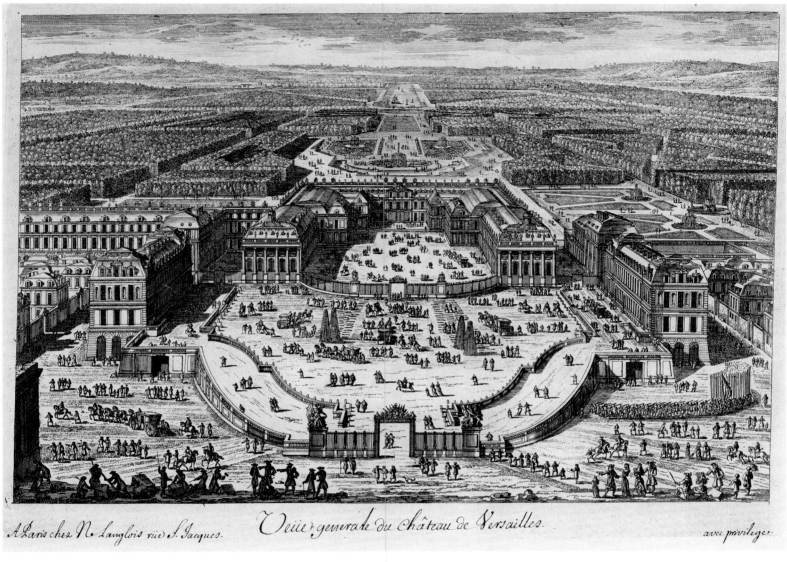

A Paris chez N. Langlois riie S. Jacques. Veüe generale du château de Versailles. avec privilege.

Fig. 6. "General View of the Château de Versailles," plate 117 from *Veües des plus beaux lieux de France et d'Italie*, by Gabriel Perelle, Israël Silvestre, Jacobus van Merlen, Adam Perelle, and Nicolas Pérells. Paris: N. Langlois, 1688(?). Engraving, 12¼ × 16½ in. (31 × 42 cm). Princeton University Library, Department of Rare Books and Special Collections, Gift of Susan Dwight Bliss (NC1130.U35f)

this facade was in effect a gradual extension of Louis XIII's hunting lodge. Although praised in the official guidebooks, the spatial tension created by the architecture of the successive recesses, which guided the eye (and the visitor) toward the political heart of the monarchy, could not mask what the comte d'Hézecques, a page at the court of Louis XVI, called "one of the principal faults to be found with the castle of Versailles is that there is no entrance worthy of the edifice" (fig. 6).[17]

Once the original core of the palace had been remodeled, the lofty symmetry of the two main apartments, designed in 1668, was abandoned after the king decamped from the north apartment and moved his living quarters to the center of the old hunting lodge. The king's former apartment was

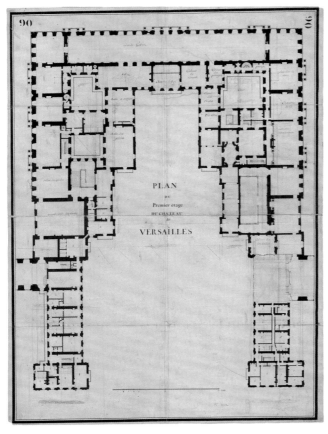

Fig. 7. Plan of the second floor (*premier étage*) of the palace, ca. 1715. Archives Nationales, Paris (VA XXVII 2)

subsequently transformed into the so-called Grand Appartement, a series of salons used to accommodate court receptions and whose splendid interiors visitors could admire daily (fig. 7). This new arrangement respected the French tradition that the king should receive visitors in his apartment, whether in the antechamber, the bedchamber, or the private cabinet. (The term "Grand Appartement" adopted for these reception salons, which continued to be furnished with a bed until 1745, is a clear illustration of this concept.)[18] The lack of suitable antechambers large enough to receive the crowds of spectators stood in marked contrast to the palace floor plans of other monarchies of the period and was always keenly felt at Versailles.[19]

The comte d'Hézecques described the somewhat unusual route that now led to the heart of the

palace, which remained unchanged until the end of the eighteenth century: "The real entrance to the apartments," he commented, "was by the splendid marble staircase [the Queen's Staircase]; but it is at the side, and reached by three narrow arcades, and only leads to the King's ante-chambers, and the way into the gallery is only by a door in the middle; so that the King's rooms are reached without enjoying the beauty of the grand rooms."[20] The Ambassadors' Staircase (torn down in 1752) was used only on special occasions, such as the public audience of overseas embassies; in most other situations the masses followed the route described by d'Hézecques. This reconfiguration of the original hunting lodge required that some ceremonies, such as the reception of ambassadors, take place partly outdoors. On those occasions, a procession of coaches formed at the entrance of the Avenue de Paris and then proceeded "at a stately pace, circling the courtyard" to the Salle de Descente (Ambassadors' Salon), a room on the south side of the royal courtyard, where ambassadors relaxed before their audiences with the king.[21] The ceremonial arrival could thus be admired by the residents of the palace, including the sovereign, who watched discreetly from his apartment (cat. 33).

The duchesse de Bourgogne, having arrived too late at the window of Madame de Maintenon's bedroom to witness the entrance of the ambassador of the dey of Algiers in 1699, asked the baron de Breteuil, the Introducer of Ambassadors, "to have that sort of masquerade walking in front of our coaches and having reached already the end of the second courtyard, to circle round again." The baron complied: "I had them come back, and we circled a second time to satisfy the princess's curiosity."[22] Having waited in the salon, an ambassador was then invited to go back out into the courtyard toward the Queen's Staircase, if the audience was to be held in the King's Bedchamber. If it was to take place in the Grand Appartement, however, the diplomat had to cross the courtyard toward the Ambassadors' Staircase on the other side (cat. 40).

The Ambassadors' Salon itself was rather small, and occasionally adjacent spaces, such as the apartment of the colonel of the French Guard, had to be commandeered to accommodate certain special guests. "That apartment was reserved for the Persian [delegation]," recalled the baron de Breteuil, "because the ambassadors' room is so small that one can say it is very unworthy of the immensity of the Château de Versailles and even more of the monarch residing in it, and because, that day [Tuesday], it was filled with all the ambassadors and envoys from Europe."[23] Similarly, the luncheons offered to an ambassador on the days of his first and final audiences took place in the neighboring salon, the Privy Council chamber,[24] which normally served as an office for the Council of State and whose decor bestowed little of the luster expected of such meals.[25]

The completion of the north wing in 1689 marked the maximum extension of the palace's footprint, which, although vast, continued to be insufficient for many of the festivities hosted at Versailles owing to the sheer number of visitors. Certain improvements were later envisioned: in 1752, for instance, the Ambassadors' Staircase was torn down to make space for a new staircase that would be built in front of the Hercules Salon (completed in 1736) and link it to the Grand Appartement, thus creating a coherent route for ceremonies and official visits. Its construction was repeatedly delayed, however, and the space reserved for the staircase was ultimately turned into a private theater. The need for a clearer path through the palace had not abated, but by that time the prevailing concern governing the allocation of official spaces within the palace was the comfort of the monarch and royal family.

The assignment of apartments to the different members of the royal family—legitimized children, princes of the blood (cousins of the king), and main court officers—was a constant headache for the governor of the palace, and almost no space was available to accommodate distinguished guests. Each visit from a foreign prince prompted a decision as to which occupant had to be temporarily evicted from his or her quarters. That lot generally fell to the princes of the blood, who lived in Paris most of the time anyway. Ferdinando Carlo III Gonzaga, Duke of Mantua, traveling incognito as the marquis de San Salvador, was housed in the apartment of the comte de Toulouse upon his arrival at Versailles on May 12, 1704, "entering directly by a door that opens onto the garden."[26] Breteuil revealed the distinctive feature of these rooms: "This apartment is beneath the Grand Appartement of His Majesty, with which it communicates by a hidden staircase."[27] While the same apartment was made available to the Ottoman ambassador in 1721, the Persian envoy received the rooms of the colonel of the French Guard, at the time the duc de Guiche, "in which a carpet and cushions had been placed for him to sit on."[28] Certain guests even requested renovations of the rooms allocated to them. Charles Henri de Vaudémont, a natural son of Charles IV, duc de Lorraine, a regular visitor to Versailles, was offered the apartment of the maréchal de Tessé, located in the Ministers' North Wing in 1707, but "not having found all the amenities needed both for himself and for his people, [he] was obliged to put the laborers of the king's household to work to make additions and changes."[29]

Beginning in the 1740s, when Louis XV's daughters gradually moved to the ground floor of the central part of the palace, it was no longer possible to offer apartments there to important guests. An exception was made for the visits of Madame Louise Elisabeth of France after her 1739 marriage to Philip, Infante of Spain. The apartment of the captain of the guards, located in the northwest corner of the Marble Court, was given to her so that she could be near her sisters. To accommodate visiting princes, the royal household had to choose between apartments in the wings on the ground floor. The one closest to the central core on the south side, originally the apartment of

the prince de Condé, was prepared for the Swedish king Gustav III, who in 1784 traveled incognito as the comte de Haga (see "Incognito in Versailles" by Volker Barth in this volume). The apartment on the north side, originally the duc du Maine's, was made available to Paul I and Maria Feodorovna, the grand duke and grand duchess of Russia, who in 1782 were likewise traveling incognito as the comte and comtesse du Nord.[30] The Marble (or Grand) Trianon in the gardens, once used as the king's private retreat, was also occasionally used to accommodate guests, the last being the Mysore ambassadors in 1788.

To See the Palace

Visitors to Versailles traveled there via one of three tree-lined avenues leading, respectively, from Sceaux, Paris, and Saint-Cloud to the Place d'Armes (Parade Grounds), in front of the royal residence (see "Going to Versailles" by Mathieu Da Vinha in this volume). En route they passed between the two imposing royal stables opposite the château: immense horseshoe-shaped buildings that housed up to two thousand horses in addition to the royal coaches. The stables were so large that some visitors mistook them for palaces in their own right.[31] Among them was the British physician Ellis Veryard, who in 1701 noted that he "could not but admire that so much Money should be spent in beautifying a Bogg, for such is the Ground all round it, which was formerly very unhealthy, 'till the Waters were in some measure drain'd, and the Air purified."[32]

Although Versailles was far from coherent as a structure—the Swiss physiologist and writer Albrecht von Haller described it as "put together of many pieces"[33]—it seldom failed to impress. Many visitors preferred the garden facade (fig. 8), an opinion echoed by the British traveler Harry Peckham, who called it "wonderfully magnificent, adorned with trophies, busts, statues, and all the ornaments which sculpture could devise."[34] The interiors, meanwhile, often had an overwhelming

effect. "Nothing in the world can be more beautiful, more magnificent, or more surprising," wrote Pierre Michon Bourdelot, who attended festivities organized during carnival in 1683. "The Vestibule, the Hall, the rooms, the Gallery, and the Cabinet in the back are infinite in length," continued Bourdelot, a physician who worked for the Condés. "Imagine the brilliance of a hundred thousand candles in that large suite of apartments. I thought everything was ablaze, for a big sun in the month of July glows less. Moreover, the gold and silver furnishings had their special brilliance, as did the gilding and the marble. All the decorations there were rich and sumptuous, one saw tapestries, statues, paintings, table silver, vases, flowers, braziers, chandeliers, candelabras, portières, carpets, all different and rare."[35] In 1719 Richard Barrett, a tourist from England, summed up the magnificence of Versailles to his brother Joseph, a London goldsmith: "Pictures, Statues, Precious Stones & Tapistry are there dispos'd in such a Manner that it is almost with Pain that the Eye can bear to look upon 'em."[36]

All visitors to Versailles were granted access to the Grands Appartements and the Hall of Mirrors. "The King was formerly approached by the marble staircase, through the guard-room, the ante-chamber, the Oeil de Boeuf [Bull's Eye], and, lastly, the waiting-room," wrote the comte d'Hézecques. "But those who had not the right to remain in the King's apartments, passed at once into the gallery—one of the finest in Europe."[37] Early on, many visitors to the palace were dazzled by the ostentatious display of the solid-silver furnishings,[38] as was Prince Karol Stanisław Radziwiłł, who visited Versailles on his Grand Tour in 1685. In a letter to his uncle, John III Sobieski, king of Poland, he described the massive silver throne in the audience chamber, the twenty-four silver vases in the Hall of Mirrors, and other objects made of the precious metal.[39] Nicodemus Tessin the Younger, the Swedish architect, went so far as to count the number of silver pieces in the State

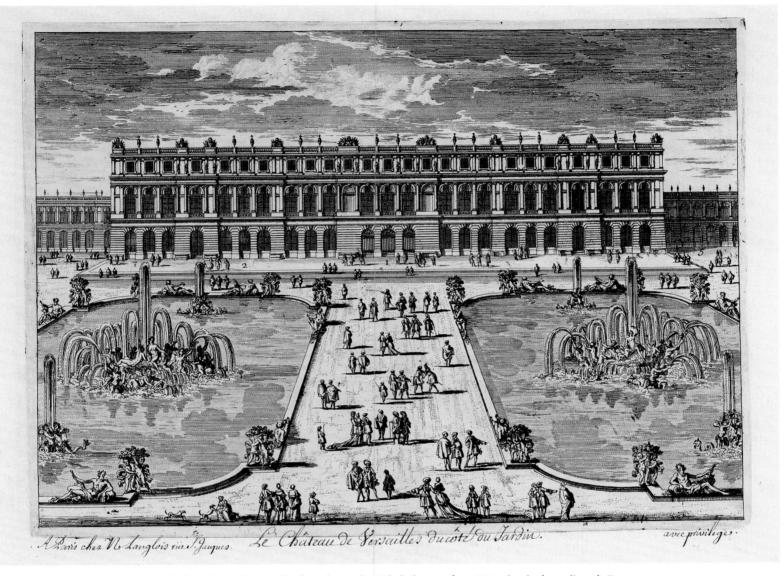

A Paris chez N. Langlois ria S.ᵗ Jacques. Le Château de Versailles du côté du Jardin. avec privilege.

Fig. 8. "The Château de Versailles from the Garden Side," plate 120 from *Veües des plus beaux lieux de France et d'Italie*, by Gabriel Perelle, Israël Silvestre, Jacobus van Merlen, Adam Perelle, and Nicolas Pérells. Paris: N. Langlois, 1688(?). Engraving, 12¼ × 16½ in. (31 × 42 cm). Princeton University Library, Department of Rare Books and Special Collections, Gift of Susan Dwight Bliss (NC1130.U35f)

Apartment: 167 in all.[40] Indeed, the reputation of the king's silver lived on long after 1689, when it was sent to the Mint and melted down to finance yet another of Louis XIV's military campaigns. In 1741 Friedrich Karl von Hardenberg, head of the Royal Gardens and Buildings Department for the British King George II (and Prince Elector of Hanover), recalled in his travel diary that the Grande Galerie and adjacent salons were once furnished with "an infinite number of basins, baskets, tables, benches, stools, pedestals, torchères, gueridons, perfume burners, ewers, tubs, braziers, [and] candelabra of solid silver, goldsmithwork made by [Claude] Ballin."[41]

The spectacular mirrors reflecting the arched windows on the opposite side of the Grande Galerie

were a testament to the skills of the Manufacture Royale des Glaces in the Faubourg Saint-Antoine.[42] The use of mirrored glass on this scale was both unprecedented and much praised,[43] no doubt because visitors could admire their own full likeness, many for the first time. James Upjohn, a clockmaker from Devon, observed in 1768 that one side of the gallery "was marble and the other side all looking-glass, so that all those who walked could see themselves at full length" (cat. 136).[44] The parquet floors were also exceptional. "Laid in Squares and Parallelograms, of different Sizes," the floors were "exceeding[ly] slippery, from being much rubb'd with Wax," according to Robert Poole, who witnessed a gentleman in the Hall of Mirrors "stooping down to pick up a Lady's Fan, slipp'd up with his Feet, as though he had been upon Ice."[45]

Charles Le Brun's celebrated paintings on the vault seldom escaped the attention of visitors. Noticing the scenes illustrating Louis XIV's victorious episodes from the Dutch War of 1672–78, the Leiden cloth merchant Pieter de la Court wrote wistfully in 1700 wishing for a different outcome for the Dutch Republic.[46] Many years later, Le Brun's *Crossing of the Rhine* provoked a more visceral reaction from the American lawyer John Wickham, who confessed to his diary in 1784 that this artist's works "disgusted me by their nauseous flattery."[47] The red velvet wall hangings in the throne room, known as the Apollo Salon—which were trimmed in gold and framed by gold-embroidered pilasters—so impressed the physician Bourdelot that, according to his own account from 1683, he could not stop looking at them and thus ignored such masterpieces of Italian painting as Paolo Veronese's *Feast in the House of Simon the Pharisee*, hanging directly in front of him.[48] Wandering through the Hercules Salon in 1734, the British painter Joseph Highmore encountered fellow artist François Le Moyne on scaffolding beneath the ceiling at work on his depiction of the Apotheosis of Hercules.[49]

In the King's Bedchamber, where many official rituals took place—from his daily ceremonial

awakening (*lever*) and going-to-bed (*coucher*) (discussed in greater detail below) to his audiences with European ambassadors—the wall hangings were changed twice a year, as remembered by Bostonian Katherine Greene Amory in her 1776 travel diary: "The King's Apartments are as Magnificent as can be conceved, his winter bed Chamber is crimson velvet almost covered with gold—his summer one blue velvet [actually a *gros de Tour*] with gold Embroider'd."[50] The king's bed was a potent symbol of power, in fact, more so than the throne, and was accorded great respect even when the monarch was not present. Upon entering the royal bedchamber, for example, one was expected to remove one's hat and bow, but not everyone respected the rule. With a bold lack of deference, the Italian writer Alessandro Verri, for one, refused to doff his hat "for the walls and the straw mattress where His Majesty sleeps."[51]

Touring the palace was considerably easier when the royal family was absent, as Horace Walpole, the noted British writer and politician, observed in a letter of 1765: "The court goes to Fontainbleau the last week in September, or the first in October, and therefore it is the season in the world for seeing *all* Versailles quietly and at one's ease."[52] While the king was in residence at Versailles, one had to wait until he had left his rooms, and only then, according to the *Traveller's Companion* (1753), may you "see his Apartments, by applying to any of the Gentlemen of the Houshold . . . who will . . . shew you them, and all the other Apartments very complaisantly."[53]

With special permission, certain guests could also access the king's private or inner apartment (*appartement intérieur*), a series of smaller rooms where Louis XIV displayed much of the royal collection of paintings and precious works of art; his heir, Louis the Grand Dauphin, kept a similar collection in his own rooms (cat. 147).[54] Visitors to these inner sanctums were requested to don special slippers to protect the exquisite marquetry floors.[55] If one believes the comte d'Hézecques, during

the reign of Louis XVI this inner apartment, too, was open to the public in the king's absence.[56] He recalled that a near-sighted visitor broke a porcelain vase, having hit its protective glass case with his forehead. Rather than being condemned to some fortress, as the poor man feared he would be, the king had him consoled and reassured, even though the damage was more than a thousand écus.[57]

Weary of royal protocol and notoriously shy, Louis XV greatly expanded his inner apartment by adding libraries and workshops, game rooms, and dining rooms arranged over several floors, where he could live a relatively private life. In 1769 he allowed his mistress, Madame Du Barry, to move into part of his private apartment. The British travel writer Henry Swinburne managed to visit her there with John Frederick, the 3rd Duke of Dorset, in April 1774. Swinburne described climbing a dark, winding staircase to a low mezzanine, where he "found the favourite sultana in her morning gown, her capuchin on, and her hair undressed; she was very gracious, and chatted a good deal" (cats. 120, 121).[58]

Louis XVI left the decoration of his grandfather's private apartment basically intact but added spaces to pursue his interests in science and geography.[59] "The King's favourite walk was on the roof of the castle, because he could go there alone and without fear of interruption," wrote the comte d'Hézecques, and enjoy "the fine air, the beautiful view, and the entertainment of seeing all arrivals at Versailles with a telescope." The king's preferred time to do so was in the morning, apparently, after breakfast. The attic library, located above the council chamber, was his usual observation post, along with his private library on the second floor. Having placed a small desk in front of the window, Louis XVI amused himself while he worked by watching people crossing the courtyards.[60] Until recent renovations replaced the windows of the attic library, one could still see a hole in the window pane through which the king put his telescope.

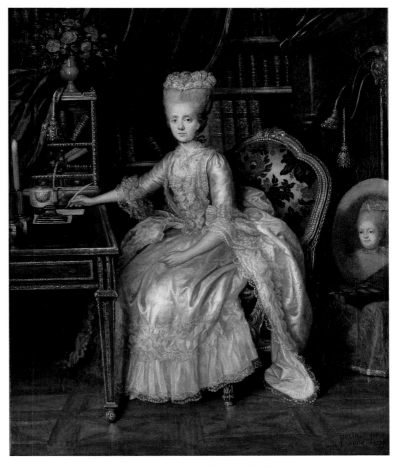

Fig. 9. Louis Lié Périn-Salbreux, *Marie-Adélaïde (called Madame Adélaïde) at Her Writing Table in Her Apartment at Versailles*, 1776. Oil on canvas, 23⅛ × 19⅛ in. (60 × 49 cm). Musée National des Châteaux de Versailles et de Trianon (MV 9085)

Louis XVI had just left his inner apartment when Arthur Young visited in 1787. Young, a British agriculturist and writer, described seeing "those slight traits of disorder that shewed he *lived* in it."[61] In 1789 a manufacturer of stockings from Avignon took the liberty of touching the suit that had been prepared for the king upon his return from the hunt, possibly an act of devotion from a French subject toward his sovereign (as one would worship the relic of a saint), or maybe a simple matter of professional curiosity.[62] The same year the American diplomat Gouverneur Morris was less fortunate; he was denied entrance to the apartment of the queen because she was in

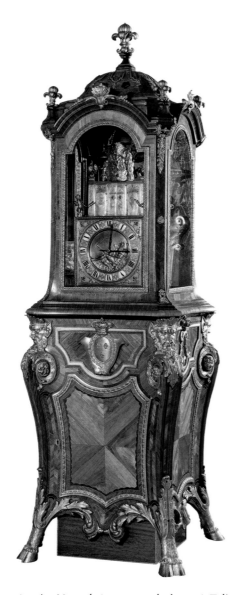

Fig. 10. Antoine Morand, Automaton clock, 1706. Tulipwood and amaranth marquetry, gilded bronze, H. 8 ft. 10¼ in. (270 cm), W. 33⅞ in. (86 cm), D. 34⅛ in. (88 cm). Musée National des Châteaux de Versailles et de Trianon (VMB 977)

Fig. 11. Manuscript of Louis XIV's "Manière de montrer les jardins de Versailles," 1689–1705. Bibliothèque Nationale de France, Paris, Département des Estampes et de la Photographie (RESERVE FOL-VE-1318, fol. 2)

residence (see "The Americans" by Paul Staiti in this volume).[63] Another American, the artist John Trumbull, managed to see the rooms belonging to one of Louis XV's daughters in 1786: "The apartments of Madame Adelaide are simple and elegant; her workshop, in which she is alternately joiner, carver, turner, engraver, &c., is curious and complete" (fig. 9).[64]

While the interior decoration of Versailles seldom failed to make an immense impression on the average visitor, sometimes individual works of art caught the eye of more discerning guests. Several accounts mention a *pietre dure* (hardstone) table decorated with "a curious map of France" (cat. 137).[65] Intended no doubt to boast of the great size of the French realm, the map also conveyed the power of its ruler. Noticeable, too, was an elaborate 1706 musical timepiece by Antoine Morand that once stood in the Mercury Salon (fig. 10). Decades later, the British clockmaker James Upjohn, who had traveled to France on business, noted in his journal that "at 12 at noon we heard a clock was to strike, but before it struck, a cock crowed . . . then opened two folding doors . . . and out came the king, and over him, out of the clouds, came an angel [actually the personification of Fame]; then the clock played a tune, after which it struck the hour."[66]

The Gardens

Before the expansion of Versailles, the formal gardens, planned and laid out by André Le Nôtre during the 1660s, were the château's primary attraction for visitors. Tours of the gardens

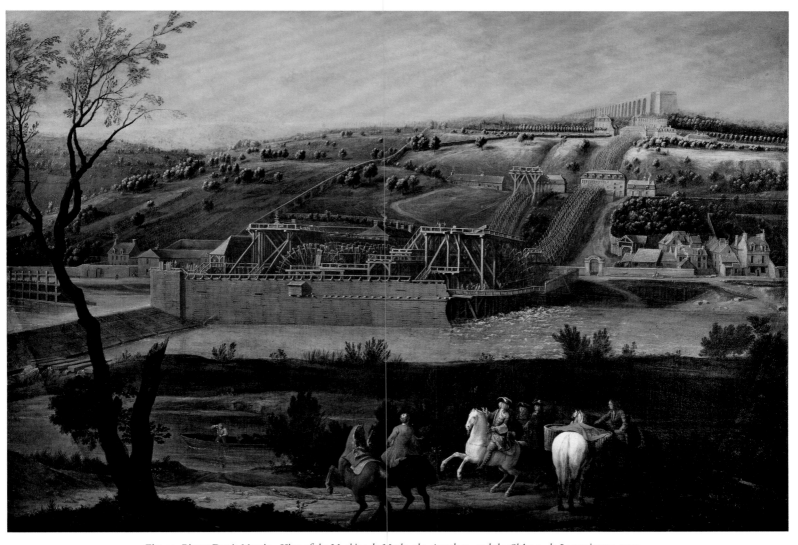

Fig. 12. Pierre Denis Martin, *View of the Machine de Marly, the Aqueduct, and the Château de Louveciennes*, 1722. Oil on canvas, 36¼ × 50⅜ in. (92 × 128 cm). Musée National des Châteaux de Versailles et de Trianon (MV 778)

eventually included four itineraries devised by Louis XIV himself ("Manière de montrer les jardins de Versailles") to show off the grounds to best possible effect (fig. 11).[67] The first of the king's itineraries was written on the occasion of a visit from the exiled queen of England, Mary of Modena, wife of James II, who arrived from Saint-Germain-en-Laye on July 19, 1689.[68] The next two versions, completed between 1691 and 1695, followed the route taken by the Siamese ambassadors during their embassy of 1686.[69] Even toward

the end of his life, Louis XIV still took pleasure in escorting guests about the gardens: "After dinner the king enjoyed showing a part of his gardens to the marquis de Bedmar," wrote Breteuil, "and nothing could be added to the distinction and consideration with which His Majesty treated him."[70]

Not to be missed were the famous fountains, which were activated either on special occasions or in honor of high-ranking visitors. The dates of these displays were announced in almanacs such as Luc Vincent Thiéry de Sainte-Colombe's

Almanach du voyageur à Paris.[71] The philosopher
John Locke, who in 1677 had the good fortune
of seeing the fountains as the king "walked
about with Madam Montespan from one to an
other," was deeply impressed with the ingenious
hydraulic system that pumped water from the
Seine (fig. 12).[72] As Locke discovered, seeing
the fountains at their full glory required both
persistence and not a little luck. In 1723 it took the
architect Balthasar Neumann several visits to see
the waterworks in action,[73] but Thomas Greene,
who traveled to Versailles with the portraitist
George Romney on September 11, 1764, had his
hopes dashed. Having learned that the papal nun-
cio would be at Versailles, Greene and Romney
"immediately after dinner set out in a coach," but
before reaching their destination they encountered
the nuncio on his return and so "were disappointed
as to the waters."[74] The British botanist James
Edward Smith had better luck in 1786 but was
somewhat grudging in his appraisal, noting that
"the water-works surprise by their magnificence
and absurdity, and tire with their noise and fre-
quency; yet, when they are not playing, Versailles
is the most melancholy spot upon earth."[75]

The gardens of Versailles were freely accessible
except, as the marquis de Dangeau wrote in his
journal, for the short periods when "the King, no
longer able to stroll in his gardens without being
crushed by the multitude of people who come from
all directions and especially from Paris, ordered
the guards to grant entrance only to the people
of the court and those whom they bring with
them; the riffraff who promenade there have much
ruined the statues and vases."[76] For tourists such
as Sacheverell Stevens, the open access was aston-
ishing: "This liberty we are denied in England in
the royal gardens at Kensington, unless when his
majesty is gone to visit his German dominions."[77]
Stevens recommended visiting Versailles in the
spring, when "it is perfect rapture to wander
through the labyrinths and shady groves, to hear
the melody of the birds, and distant murmuring of

the falling waters from the fountains and cascades."
The Orangerie, he mused, was well worth a visit
for its elegant architecture and for the fragrant
orange trees that "agreeably entertain the smell."[78]

In addition to buying a guidebook, it was often
helpful to have someone on the "inside" take
you around the gardens. In 1754 William Lucas
recommended in his popular *Five Weeks Tour to
Paris, Versailles, Marli, &c.* to "bespeak one of
the Gardeners, whom you'll see in waiting with
the Keys . . . to shew you every Thing there."[79]
A decade later, Thomas Greene reported that he
and Romney had "met with a person who had
keys of those places which were not public, and
he conducted us through them all."[80] Although
Greene did not identify the man, he may have been
one of the Swiss Guards, part of the security force
on duty outside the palace who regularly served as
guides, especially for German-speaking visitors.[81]
He could also have been referring to the so-called
gardes bosquets: sentinels who, for most of the eigh-
teenth century, were charged with the daily sur-
veillance of the gardens and protection of its works
of art, fountains, and groves. Often doubling as
tour guides, these special guards carried the keys
to the gates of the groves (or *bosquets*, hence their
name), which were locked to keep vandalism at
bay (cats. 114, 115, 117).[82]

One of the most admired diversions in the gar-
dens was the Menagerie, which captivated visitors
until the end of the ancien régime.[83] Built by Louis
Le Vau in 1662 in the shape of an octagonal plea-
sure pavilion, the Menagerie offered amusement
but also served scientific inquiry, as its denizens
were studied and their carcasses later dissected by
anatomists (fig. 13).[84] From the balcony of the two-
story structure, visitors could observe the animals
in seven enclosures below. Most were birds, some
roaming free and others locked inside an aviary,
but caged mammals were present as well,[85] and
their domestication was seen as a symbol of the
king's dominion over the natural world.[86] To
stock the Menagerie, exotic species were procured

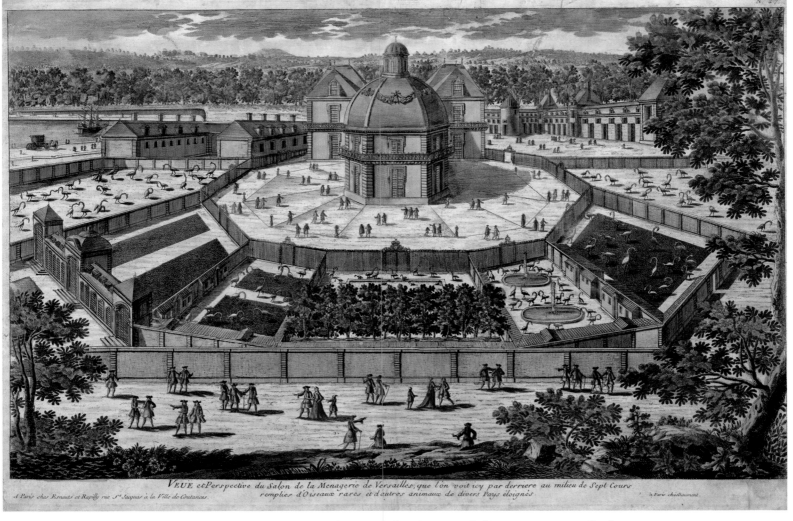

VEUE et Perspective du Salon de la Menagerie de Versailles, que l'on voit icy par derriere au milieu de Sept Cours remplies d'Oiseaux rares et d'autres animaux de divers Pays éloignés.

A Paris chez Esnauts et Rapilly rue St Jacques à la Ville de Coutances.

à Paris chez Daumont.

Fig. 13. Jean François Daumont, *View and Perspective from the Courtyard of the Menagerie at Versailles*, late 17th or early 18th century. Engraving with watercolor, 14⅛ × 21 in. (35.8 × 53.3 cm). Musée National des Châteaux de Versailles et de Trianon (INV.GRAV 4147)

from across the globe by traders such as Mosnier Gassion, who traveled annually to the Levant during the reign of Louis XIV.[87] Other animals entered the royal collection as gifts. A young Syrian visitor, Hanna Dyâb, brought a pair of desert rats, or jerboas (*gerboises*), for Louis XIV in 1708.[88] In 1777 Süleyman Aga, envoy from Tunis, traveled with a pair of lion cubs.[89]

One of the most celebrated residents of the Menagerie was a rhinoceros acquired for Louis XV by the governor of Chandannagar, a French settlement in Bengal, India. It arrived at Versailles in 1770 after a long and hazardous journey and remained in the Menagerie until the Revolution.[90] Among its many visitors was the famed naturalist Georges Louis Leclerc, comte de Buffon, who observed the rhinoceros several times, noting that it ate sixty livres' worth of food each day.[91] Although little remains of the Menagerie today, the masterful studies painted by the Flemish artist Pieter Boel between 1669 and 1671 immortalized some of its original inhabitants (cats. 139–141).[92]

Fig. 14. Jacques I Bailly and Sébastien Leclerc the Elder, "Battle of the Animals (Fountain XII)," from *Labyrinte de Versailles*, by Charles Perrault and Isaac de Benserade, ca. 1677 (plate from cat. 143). Vellum, gouache, ink, gold, and red morocco leather binding, H. 7⅛ in. (18.2 cm), W. 5⅜ in. (13.8 cm). Petit Palais, Musée des Beaux-Arts de la Ville de Paris, Collection Dutuit (LDUT00724)

Another favorite with sightseers was the Labyrinth, located within one of the groves. Designed by Le Nôtre in 1665 as a network of meandering paths hidden between trees and tall arbors, the maze was enriched with a series of thirty-nine fountains between 1671 and 1674 (fig. 14; cats. 142, 143).[93] Created by Jean-Baptiste Tuby, Pierre Legros, Benoît Massou, and other sculptors, the animal figures for the fountains were based on Aesop's *Fables*, which had recently been rendered in verse by Jean de La Fontaine and were hugely popular in France. Made of brightly painted lead, the sculptures spurted jets of water that animated the fountains and created a sense of interaction among the animals (cats. 144–146).[94] The anonymous author of an epistolary travel book of 1771 had "the pleasure of observing a child of four years old explain the figures which were perfectly adapted to his age and understanding."[95] Owing to the high maintenance costs, the Labyrinth suffered neglect over time and was demolished in 1775.

Access to the Petit Trianon—the small château in the gardens presented by Louis XVI to Marie Antoinette in 1774 as a sanctuary from the strict etiquette of the court—was more carefully controlled,[96] and the queen herself drafted the regulations granting access to her domain. A few privileged visitors were nonetheless permitted to tour the new Anglo-Chinese garden laid out for her by Richard Mique.[97] The Baroness d'Oberkirch, who accompanied the Grand Duke and Grand Duchess of Russia on their incognito visit of 1782, discovered the Petit Trianon on a beautiful spring day. Enchanted, she described the "delicious gardens" and remembered the "groves perfumed by lilacs, populated by nightingales . . . and butterflies showing their golden wings in the early sunshine."[98] Arthur Young managed a visit to the Trianon "to view the Queen's *Jardin Anglois*" on October 23, 1787, noting that "I had a letter to Mons. Richard, which procured admittance."[99]

To See the King

The remarkable gardens notwithstanding, the "best part of Versailles," wrote Adam Ebert, a Grand Tourist from Frankfurt, in 1724, "was the king himself."[100] This sentiment proved true as much for foreign visitors as it did for the king's own subjects, whose fascination with their monarch was seemingly boundless. The French "flock to Versailles every Sunday, behold [the king] with unsated curiosity, and gaze on him with as much satisfaction the twentieth time as the

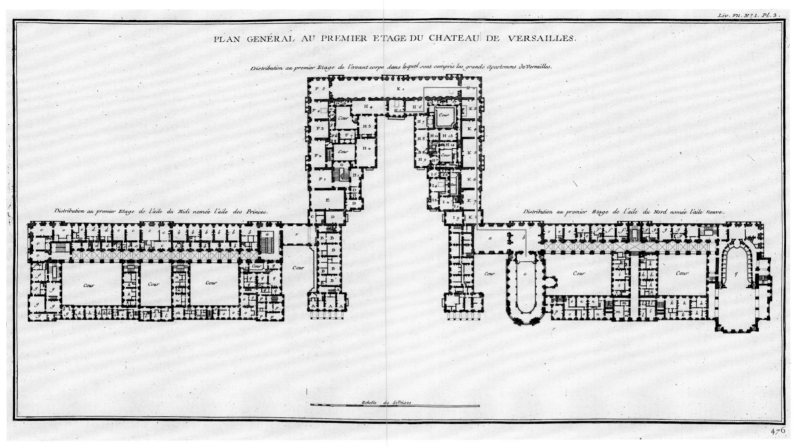

PLAN GENERAL AU PREMIER ETAGE DU CHATEAU DE VERSAILLES.

Distribution au premier Etage de l'avant corps dans lequel sont compris les grands apartemens de Versailles.

Distribution au premier Etage de l'aile du Midi nomée l'aile des Princes.

Distribution au premier Etage de l'aile du Nord nomée l'aile Neuve.

Echelle de 50 Toises

476

Fig. 15. Plan of Versailles showing the daily path taken by the king from his bedroom to the chapel, from Jacques François Blondel, *Architecture françoise* (book 7, no. 1, pl. 3). Paris: Pierre Charles Jombert, 1752–56. The Metropolitan Museum of Art, New York, Gift of Mrs. Alexander McMillan Welch, 1946 (46.52.3[1–4])

first," declared the Scottish physician and writer John Moore in 1779.[101] The king made himself available to his subjects most readily through a routine of daily ceremonies.[102] As the duc de Saint-Simon famously noted in 1715, "With an almanac and a watch, even at a distance of three hundred leagues, you would still precisely know what he [Louis XIV] was doing."[103] Some of these ceremonies, including the *lever* and *coucher*, dated back to the Valois kings, in particular the reign of Henri III, in the late sixteenth century, while others were adopted from the Spanish Court. However, Louis XIV was much more visible than any of the monarchs in Spain, England, or Austria.[104] Elaborated, codified, and brought to their absolute

apogee during the reign of the Sun King, the daily ceremonies of Versailles were largely retained by his successors but over time lost their meaning and by the late eighteenth century were little more than antiquated protocols.[105]

Each day began with the king's public awakening, or *lever*, which unfolded in several stages. It was during this ceremony that the British diplomat James Harris, 1st Earl of Malmesbury, was presented to Louis XV in 1768: "At eleven, the King's *levée* began, and as soon as he had dressed himself, which he did before us all, and said his prayers, the master of the ceremonies presented me to him, and His Majesty honoured me with a look, more than which he never does anybody."[106] In May

1778 the American diplomat John Adams fared even better during his presentation to Louis XVI, who did the future president a great honor by addressing him directly. Not speaking French, Adams confided in his diary that the king talked to him "with such rapidity that I could not distinguish one Syllable nor understand one word."[107]

Although access to the *lever* was restricted, all visitors could see the monarch when he passed through the Hall of Mirrors on his way to attend a daily mass (fig. 15).[108] Awaiting him was a crowd of courtiers and ladies dressed in magnificent court attire (cat. 27), who escorted the monarch and members of his family to the palace chapel (see "Exchanging Looks" by Pascale Gorguet Ballesteros in this volume). Preceded by uniformed pages, equerries, and officers of the guard, this colorful procession was a sight to be seen, and most visitors made sure not to miss it.[109]

The king and the royal family attended the services from the tribune (or gallery), located on the upper level of the Royal Chapel, directly opposite the high altar. Much to the annoyance of the baron de Breteuil, mass with the king in attendance became something of a spectacle: "The lackeys and grooms mingle willy-nilly with the greatest lords, and the most abject common people likewise enter and hear the mass there. It is only at Versailles that such confusion has been introduced and that it is maintained in all its excess."[110] According to *The Traveller's Companion*, "The Music at the High Mass is very grand, and well worth hearing, if it was not for the extraordinary Satisfaction you will have of seeing the Royal Family."[111] Even Madame Du Barry could be seen during worship. Horace Walpole, whose purpose on a visit to Versailles in 1769 was to espy the royal mistress, spotted her in the chapel, noting that she wore no makeup.[112] This was in contrast with most ladies at court, who were described by Samuel Romilly, a British lawyer, as "glowing with rouge."[113] Many attendees ignored the priest altogether, in fact, and all present in the chapel

enjoyed watching Louis XVI as the latter "laughed and spied" at the ladies. The royal family, for their part, seems to have been just as curious about the gawking crowd. In 1787 Marie Antoinette was observed looking intently around the chapel through a lorgnette incorporated in her fan.[114]

Shortly before the mass concluded, most spectators rushed back to the Hall of Mirrors to glimpse the royal family as they passed by on their return from the chapel.[115] Lady Holland, wife of the politician Henry Fox, 1st Baron Holland, was waiting there in 1763 when "the Queen and the Dauphin stopp'd to speak to me very graciously which was very *polie*, as we English ladies are not presented. But the Dauphin said so much to me that in the meantime the King passed by . . . and I lost the opportunity of seeing him near, which I regret, for at a distance he appears to me the handsomest man I ever saw."[116] Some visitors sought to speak to the king or to hand him a personal request. Such was the case with a Moroccan merchant in 1772 whose ship had been confiscated by the French navy. According to the German traveler Heinrich Gottfried von Bretschneider, who witnessed this event, the trader, wearing his national garb, wanted to present a petition to Louis XV for the return of his property. Having waited in the Hall of Mirrors for a long time, the turbaned merchant grew tired, had a carpet unfurled for him, and sat down right in the middle of the gallery desiring to smoke, causing a considerable stir.[117]

The receptions known as *jours d'appartement*, initiated in 1682 under Louis XIV, gave courtiers as well as distinguished guests an opportunity to mingle with the royal family in an informal manner in the Grand Appartement, especially at the gaming tables. Although these receptions took place less frequently during the reign of Louis XVI, the Reverend Dr. Jeans, chaplain to the British Embassy in Paris, attended one in 1775 and was duly impressed: "We (I speak of the foreigners) were admitted into the area

of the great gallery, with the Court, which was exceedingly brilliant and numerous, to be present at the card-playing. . . . All the accounts which I had formerly read in the 'Thousand and One Nights' of the palaces of the genii under the sea fell short in their descriptions to the reality which here presented itself to my view."[118]

A highlight of any visit to Versailles was the opportunity to witness a Grand Couvert, when the sovereign dined in public together with members of his family (cat. 131).[119] For these formal meals, a throng of courtiers, guests, and visitors gathered in the king's antechamber awaiting the arrival of the royal family. The Grand Couvert could be so crowded, in fact, that people were frequently turned away and one had to be careful not to get pickpocketed.[120] Strict etiquette dictated that all those who watched remained standing in the presence of the monarch with the exception of princesses and duchesses entitled to sit on stools (*tabourets*). Despite the large number of attendees, the event could be an intimate experience, as Giustiniana Wynne, a visitor from Venice, learned in 1758. The king and queen, she recalled, sat with their backs to the fireplace in a "rather small, not very well lit, and rather unremarkable" room. "There were so many people we were not directly in the king's view; yet he saw us and observed us attentively. . . . He has very beautiful eyes, and he fixes them on one so intently that one cannot sustain his gaze for long."[121]

Michael Alphonsus Shen Fuzong (known at the time as Chin Fo Cum, or Mikhel Xin), a young Chinese convert to Christianity, attended the king's dinner in 1684 accompanied by Father Philippe Couplet. The *Mercure galant* described him "in his Indian clothes, dressed in a rich jacket of gold brocade on a blue ground with dragon figures. . . . Over it he had a kind of tunic in green silk" (fig. 16). Louis XIV, the account continues, bid Shen Fuzong to say his prayers in "the Chinese language" and then "had a plate served to him on the table, to see how neatly

Fig. 16. *Chin Fo Cum (Michael Alphonsus Shen Fuzong)*, ca. 1684. Engraving, 15¾ × 10⅝ in. (40 × 27 cm). Bibliothèque Nationale de France, Paris, Département des Estampes et de la Photographie (Oe 48)

and with what dexterity the Chinese eat with two small sticks . . . which they hold in the right hand, between two fingers."[122] Hoping for royal patronage, the young Wolfgang Amadeus Mozart charmed the court when he played the organ in the chapel of Versailles on New Year's Day 1764 (cat. 150). Later the same day the famous child prodigy stood next to Marie Leszczyńska, the queen consort, during the Grand Couvert.[123] The queen apparently fed Mozart morsels of food and conversed with him in German before translating everything into French for her husband.[124]

Not wanting to leave Versailles without having attended a public dinner, the painter Johann

Christian von Mannlich, traveling in the retinue of Christian IV, Duke of Pfalz-Zweibrücken, talked his way into the antechamber, which was already filled with beautiful women. At one point the queen's cat jumped onto a chair next to the artist and started to purr loudly. When the queen became aware of her pet, she also began to notice Mannlich, who, perhaps much to his astonishment, then attracted the attention of everyone else in the room.[125]

Of the meal itself, the Welsh naturalist and traveler Thomas Pennant observed in 1765 that "His Majesty had an excellent stomach, Her Majesty seemed thirsty; the rest of the Company only piddled."[126] The courses were served from a gold service, as noted by various visitors.[127] In order to attend a Grand Couvert, the Swedish physician Martin Roland and his companions had their wigs specially tidied, probably by a wigmaker operating one of the small shops or booths placed against the wrought iron gates of the palace forecourt or elsewhere in its vicinity.[128] Nicely coiffed for the occasion, the Nordic travelers were disappointed to be told that the king would not dine in public that day.[129]

Watching a Grand Couvert in 1773 inspired a moment of reflection for Teofila Konstancja Morawska (née Radziwiłł), whose grandfather had visited Versailles on his Grand Tour in 1685: "Looking during this dinner at the persons who were serving and their eagerness to serve I had to think about what a chance of birth plays in life. The beginning of us all is the same. . . . But here in this world by what right the position of some is so elevated that some seem unworthy of serving others."[130] Her observations are somewhat ironic given that she was a member of one of Poland's highest-ranking aristocratic families. Even Marie Antoinette's brother, Joseph II, attended the public ceremonies at Versailles, which he described to his brother Leopold in Vienna in a letter written during his incognito visit of 1777: "Yesterday I saw the celebration of a Sunday at Versailles in

public: the lever, the mass, the grand souper. I was among the crowd to observe everything."[131]

It was an advantage, the German novelist Sophie von La Roche observed in 1785, that visitors did not have to bow but simply avert their eyes when the king looked at them, because this gave them a chance to observe him well.[132] Many letters and travel journals from the period contain frank accounts of members of the royal family, not only describing their physical traits and dress but also offering assessments of their character. The appearances of members of the royal family were generally known from formal portraits, flattering busts, and heroic equestrian statues; prints offered an even more widely circulated representation of the family, as did coins and medals.[133] But the kings and queens of France did not always resemble these familiar, idealized likenesses.[134] In 1700 Pieter de la Court wrote to his wife that the posture of Louis XIV, who was sixty-two at the time, reminded him of one of their relatives "but a bit more stomach." The king's hollow cheeks, owing to the loss of teeth, would no doubt have detracted further from the perception of his once handsome visage.[135]

Special Events

Religious holidays and other special ceremonies as celebrated at Versailles—from the procession held on Whitsunday to the foot washing on Maundy Thursday—were spectacular occasions.[136] A ceremony performed at Easter and on other holy days in which the king touched those suffering from the skin disease scrofula (*les écrouelles*) in order to cure them attracted large crowds of both the afflicted and the curious.[137] Four times a year the reception of the chivalric Order of the Holy Spirit took place at Versailles, permitting visitors to gaze in wonder at the stately procession of the king and his fellow knights, dressed in black velvet mantles embroidered with gold flames and wearing the cross of the order (fig. 17).[138] John Adams, writing to his wife on May 15, 1780, described such a scene: "I went Yesterday, Pentecost, to Versailles, and

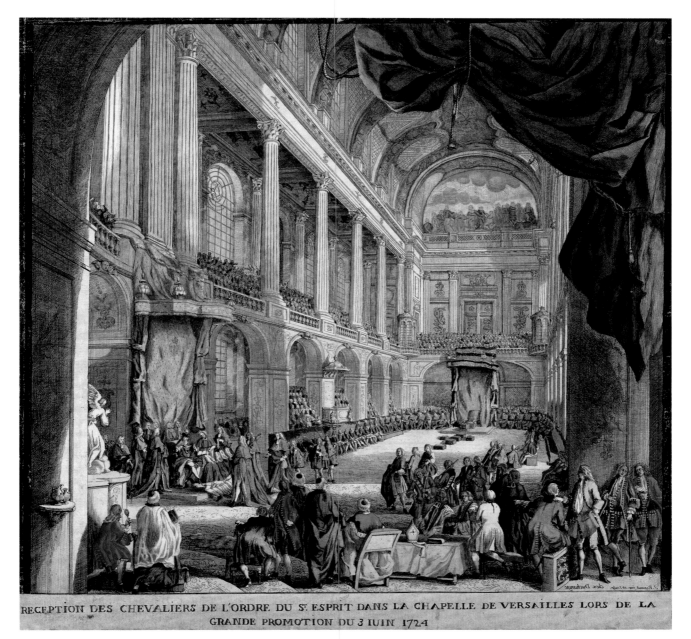

RECEPTION DES CHEVALIERS DE L'ORDRE DU S.T ESPRIT DANS LA CHAPELLE DE VERSAILLES LORS DE LA
GRANDE PROMOTION DU 3 IUIN 1724

Fig. 17. Jacques Rigaud, *Reception of the Chevaliers of the Order of the Holy Spirit in the Chapel at Versailles,
June 3, 1724*, 1724. Colored engraving, 11¾ × 16⅛ in. (29.8 × 41 cm). Bibliothèque Municipale de Versailles
(Sites et M.G. H66)

saw the Nights of the order of St. Esprit. There was magnificence enough."[139] Jacob Muhl, an Amsterdam merchant, attended festivities for the *fête Dieu* (Corpus Christi), the most lavish of the religious feasts, on June 18, 1778. Anxious about being crushed by the masses, Muhl regretted that he would have been better able to see the palace if he had not visited on a holiday.[140]

Breathtaking entertainments such as illuminations and fireworks celebrating royal births or marriages likewise brought throngs of people to Versailles. The fireworks organized on August 26, 1739, for instance, for the wedding of Madame Louise Elisabeth of France, Louis XV's eldest daughter, and Philip, Infante of Spain, attracted nearly a hundred thousand spectators (fig. 18).[141]

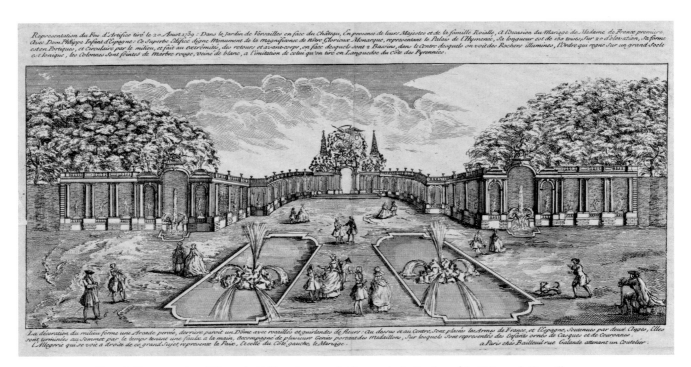

Fig. 18. *Representation of Fireworks Held on August 20 [sic], 1739 in the Gardens of the Château de Versailles, on the Occasion of the Marriage of Louise Elisabeth of France and Philip, Infante of Spain*, after 1739. Engraving. Bibliothèque Nationale de France, Paris, Département des Estampes et de la Photographie (Coll. Hennin, vol. 95, no. 8305)

Abraham Joseph Bénard Fleury, an actor with the Comédie-Française, enthused over the fêtes organized for the nuptials of the future Louis XVI and Marie Antoinette in 1770: "No description can convey any adequate idea of their splendor; they attracted an immense concourse of people from different parts of the kingdom and even from foreign countries. The luxury of dress, the splendor of equipages, the beauty of the *parures* [sets of jewelry] worn by the ladies of the court, all resplendent with diamonds, and the magnificence of the *grand couvert*, presented all together a perfect scene of enchantment. The gardens of the palace were illuminated by several thousand varicolored crystal lamps."[142] Also popular were the aeronautical experiments of 1783 and 1784, when hot-air balloons ascended from the Ministers' Courtyard.[143] The first flight took off from Versailles on September 19, 1783, carrying a sheep, a cock, and a duck. A subsequent flight of the balloon

dubbed *Marie Antoinette* on June 23, 1784, carried the aeronauts Jean François Pilâtre de Rozier and Joseph Proust as part of an entertainment for the visiting king of Sweden (fig. 74).

Occasionally the hordes of spectators could cause trouble, as they did on August 6, 1682, following the birth of the duc de Bourgogne, Louis XIV's first grandson. So great was the exultation that "the riffraff, not wanting to display less joy than the gentle folk, in a kind of fury broke all the windowpanes of the superintendent's house, where Madame la Dauphine was lying."[144] Upon the death of Queen Marie Leszczyńska, on June 24, 1768, emotions were no less intense: "At five o'clock in the afternoon, as the princes were crossing through their apartments to go to Marly, the Swiss Guards pushed back the common people swarming up the Princes' Staircase to see the queen, with so much force and violence that . . . two sections . . . of the stone balustrade

of that staircase fell off, injuring several people" (fig. 19).[145] The large number of curious onlookers present during the public audiences of overseas diplomats was often similarly disruptive, as was the case in 1715 with the reception of the Persian ambassador when, according to baron de Breteuil, the disorderly crowd debased what should have been a magnificent spectacle.[146]

Of the special embassies from overseas, the royal family was sometimes no less curious than the regular visitors to the palace. In 1788, on the occasion of the embassy of Tipu Sultan, ruler of Mysore, Madame Victoire, one of the daughters of Louis XV, asked her librarian for two books, *Affaires de l'Inde* (*Affairs of India*)[147] and a biography of Tipu's father,[148] so that she would not be embarrassed before the Indian delegation. Marie Antoinette commissioned wax figures of the ambassadors. "The Queen had their effigies constructed in wax," remembered the comte d'Hézecques, "and made a group of them, with the interpreter and a slave smoking their pipes in one of the huts in the Trianon. The likeness was perfect."[149]

Tourism and Travelers' Accounts

Many young gentlemen from European noble and aristocratic families visited Versailles on their Grand Tours. Often traveling with a tutor, they sought to further their education by studying for-eign languages, cultural life, and social behavior, and by polishing their manners. As a highlight of their journey through France, those carrying letters of introduction would be presented to the king (see "Grand Tourists" by Jean Boutier in this volume).[150] The court also attracted philosophers, naturalists, gardeners, agronomists, medical doctors, tradesmen, artists, and architects, all with their respective professional interests in mind.

The architects—notable visitors included Christoph Pitzler, Nicodemus Tessin the Younger, Balthasar Neumann, William Chambers, Robert Adam, and John Soane—examined the buildings,

Fig. 19. Note from Charles Lécuyer, Superintendent of the Bâtiments du Roi, on the accident on the Princes' Staircase, June 26, 1768. Archives Nationales, Paris (O¹ 1071, no. 135)

interiors, and surrounding gardens to familiarize themselves with the latest French fashions. Pitzler, who visited in 1686 at the behest of his patron, Johann Adolf I, Duke of Sachsen-Weissenfels, and the Swedish architect Tessin, who visited in 1687–88, took notes and made drawings during their visits (cat. 147).[151] It is possible that in doing so they had to work from memory, if we are to believe Leonhard Christoph Sturm, a mathema-tician and architect who visited Paris in 1699 and later lamented that, while excellent engravings of the palace were available, no floor plans or elevations drawn to scale existed and, moreover,

Fig. 20. Friedrich Karl von Hardenberg's diary and sketches of the gardens at Versailles, 1741. Hardenberg Archiv, Lietzen (1486, fols. 15v–16r).

that it was strictly forbidden to make sketches or take notes and measurements.[152] In 1741 Friedrich Karl von Hardenberg toured the gardens with the French architect Jacques François Blondel. As head of the British royal gardens, Hardenberg was especially interested in the horticultural techniques and equipment and in the design of trelliswork, arbors, and planters for orange trees, which he recorded in his diary (fig. 20).[153] Most people, however, came out of a sheer desire to see the palace, as did Henry Swinburne, who reported in 1774, "having nothing but mere curiosity to gratify, with no fear of disappointment, I made a tolerable day of it."[154]

A 1687 advertisement in the *London Gazette* notified the paper's readers that a large-scale model "of the most magnificent and royal palace of Versailles, made in Copper, Gilt over with Silver and Gold, and of all the Gardens and Water-works" was available for viewing daily at the Exeter Change, the famous emporium on the Strand.[155] No doubt this model stimulated many to visit Versailles, whose fame as "the crown of all

the pleasure seats in Europe which for good reason could be called the eighth wonder of the world" and desirability as a travel destination were also disseminated by guidebooks (see "Visitors' Guidebooks and Engravings" by Elisabeth Maisonnier in this volume).[156] The Danish writer Ludvig Holberg remarked in 1714 that, notwithstanding all he had heard and read about Versailles, the palace still surpassed his expectations.[157] Several Native American chiefs received by the king in October 1725 were so overwhelmed by their surroundings that they asked whether "the Grande Galerie had been created by men."[158] The comparisons made by many travelers generally tilted in the palace's favor. Ellis Veryard reported in 1701, for instance, that the waterworks at Versailles far exceeded those of Frascati and Tivoli in Italy.[159] The British actor and playwright David Garrick, who visited in 1751, opined in his diary that there was no "Cascade so large as that at Chatsworth, nor any Jet d'Eau that equals that I have seen there," overlooking the fact that the water features of that stately home, among England's finest, were modeled after those at Versailles.[160]

Visitorship to Versailles increased markedly during the second half of the eighteenth century, a direct result of the growing numbers of travelers, especially British, who made the journey following the conclusion of the Seven Years' War, a period of extended peace in Europe. By that point some thought it redundant to write down their own observations: "The palace of Versailes," complained British tourist Philip Thicknesse, "has been so often described, that I find it as unnecessary, as it is difficult, to speak of such an amazing pile of building; which, however, seems to me to have been built with more expence, than real judgment."[161] Or, as the London author Samuel Ireland wrote: "To enter into a description of the magnificence of the palace of Versailles, . . . to enumerate the various attitudes in which the grand Monarque is here represented in every apartment, 'The hero of each tale,' would be filling a volume on a subject

so often and so elaborately treated that even if I had time and inclination, would be superfluous."[162]

These descriptions as well as letters and diaries, never intended for publication, are frequently candid and often rich with amusing incidents, and some of the more elaborate examples were written by women. The British diarist Hester Thrale, for instance, offered a detailed narrative of her 1775 trip to Paris, unlike her travel companion Samuel Johnson, who confined himself to terse remarks (cat. 153).[163] Whereas the famous lexicographer curtly mentioned the theater at Versailles, Thrale recounted in detail how they walked upon its stage and chatted about which play they would like to perform there, with Dr. Johnson suggesting Shakespeare's *Henry V*.[164]

By contrast, visitors on official business, such as foreign diplomats, left behind few descriptions of the palace and gardens or even of their experience at Versailles (see "Magnificent Display" by Helen Jacobsen in this volume). Their reports tend to focus instead on the preparations for their official entry into Paris and on issues of protocol related to their public audiences with the king. The letters of ambassador Cornelis Hop to the Dutch States General, however, occasionally contain trivial if fascinating information about life at the court: for instance, that in January 1723 Louis XV enjoyed himself by watching skaters on Versailles's Grand Canal, or that in February 1725 the king's recent sickness was blamed on his large consumption of chocolate (cats. 52, 53).[165] Count Conrad Detlev von Dehn, *envoyé extraordinaire* of Augustus William, Duke of Braunschweig-Wolfenbüttel (cat. 51), visited the palace before his official audience with Louis XV to examine the rooms where he would be received on August 14, 1723. In doing so he caught sight of the young fiancée of Louis XV, Mariana Victoria, Infanta of Spain, zestfully eating in the presence of her governess, Madame de Ventadour.[166] Another notable exception was Yirmisekiz Çelebi Mehmed Efendi (better known as Mehmed Efendi), the Ottoman ambassa-

dor, who documented his 1721 journey to France in great detail (see "Special Embassies and Overseas Visitors" by Meredith Martin in this volume; see also cat. 73). Although received by Louis XV in Paris, where the court was then residing, the distinguished guest made an excursion to Versailles and memorably rode through the gardens in the king's own wheeled chair (*chaise à deux roues*).[167]

Disappointment and Neglect
Versailles sometimes failed to live up to the high expectations of its visitors, especially in the waning years of the monarchy. As early as 1739, however, Horace Walpole's hopes had far exceeded what he viewed as Versailles's disappointing reality. He derided the front of the palace as "a lumber of littleness, composed of black brick, stuck full of bad old busts, and fringed with gold rails. The rooms," Walpole continued, "are all small, except the great gallery, which is noble, but totally wainscoted with looking-glass. The garden is littered with statues and fountains."[168] In 1787 Arthur Young concluded that the palace was "not in the least striking: I view it without emotion: the impression it makes is nothing."[169] Even the special events at the court could occasionally disappoint, as did the fireworks celebrating the birth of Louis, duc de Bourgogne, on December 30, 1751. Henry Lyte, tutor and traveling companion to Lord John Brudenell Montagu, wrote that they "were short and miserably executed, confusion let the finale off first." The king, he added, was "highly displeased and ordered two of the engineers to be imprisoned."[170]

Lack of cleanliness had long been a problem at Versailles. When the court returned from Paris in 1722, some four thousand people were listed as living within the palace and its enclosures, including many courtiers and their servants,[171] but there were only a few public latrines.[172] The duchesse d'Orléans, sister-in-law to Louis XIV, grumbled in 1702 that it was "impossible to leave one's apartment without seeing somebody pissing."[173] Chamber pots were regularly emptied

through the windows of the palace, leading the Reverend William Cole from Cambridgeshire to complain that right "under the Windows of the Royal Apartments, people were suffered to lay their Nastiness in such Quantities, that it was equally offensive to the Sight & Smell," contributing to what he deemed the "dirty magnificence of Versailles."[174] Sacheverell Stevens observed in 1756 that the furniture in the Grand Gallery was very soiled,[175] and much to Harry Peckham's indignation in 1772 the marble staircase leading up to the apartments not only was as filthy "as an alehouse kitchen" but also housed on its landing several stalls of merchants selling snuffboxes and other knickknacks.[176] Four years later, Thomas Bentley, the business partner of the famed ceramist Josiah Wedgwood, lamented how Le Brun's celebrated paintings on the vaulted ceiling of the Hall of Mirrors were either "faded or covered with dirt."[177] Similarly, according to Jacob Muhl, the Dutch merchant, by 1778 the garden facade had lost much of its beauty and distinction owing to blackened stone.[178] Reacting to such criticism, Marc Marie, marquis de Bombelles, questioned how the lack of cleanliness and neglect of the palace could possibly be remedied considering that it housed thousands of people. Certainly, ventured the French diplomat, one could not expect it "to be as neat and tidy as a pretty woman's boudoir."[179]

This state of decline and neglect reflected the obvious reality that Louis XIV's Versailles was extremely expensive to maintain, especially in a time of mounting state debt. Tastes had also shifted by the mid-eighteenth century away from formal public rooms to the comfort of smaller ones. Nearly unaltered out of respect for the Sun King, the King's Apartment was "very dirty, & extremely out of repair," wrote Lady Mary Coke in 1774. By contrast, she praised the apartments belonging to Louis XV's daughters as "so clean, so finely furnish'd, & so agreeably situated, all to the Garden upon the ground floor, that I almost envied them" (see fig. 9).[180]

The formal gardens laid out by Le Nôtre were also considered old-fashioned by mid-eighteenth-century standards and, like the rest of the palace, were by then in dire need of maintenance. Already in 1727 Albrecht Haller saw mutilated statues in the groves, and in 1741 Hardenberg noticed that the gravel walks were badly kept, as was the king's kitchen garden.[181] The waterworks at the Menagerie were "now much ruinated," according to Poole in 1750, while Mannlich commented on the repulsive odors emitted by the water in the Grand Canal and basins.[182] A pair of paintings by Hubert Robert records this natural deterioration, including the removal of old and dying trees in order to replace them (cats. 5, 6).[183] In 1775 Robert Wharton likened the once resplendent gardens to the shop of a wood merchant, with trees cut into pieces and large trunks lying among the statues.[184]

The Last Visitors

The Enlightenment, which emphasized the virtues of reason, individualism, and political and religious tolerance, influenced the views and beliefs of many eighteenth-century travelers to France, especially during the reign of Louis XVI.[185] At a time when the divine right of kings was openly challenged and the authority of the absolute monarchy opposed, the need for the strict etiquette and traditional ceremonies of Versailles, long the lifeblood of the monarchy, was subject to question. In 1775 the German physician and author Johann Friedrich Karl Grimm could not understand, for example, why the French king did not terminate the custom of dining in public, since surely, Grimm thought, it was an unbearable burden to eat among a "crowd of hot and perspiring spectators."[186]

Others were more pointed in their condemnation of the stark divide between the extravagant lifestyle of the court and the prevailing poverty among the French populace, illustrated nowhere more poignantly than by the beggars waiting outside the palace gates.[187] In 1766 the Reverend Garland wrote in his travel diary that Versailles was built

"in the midst of a very Bloody & Expensive War which he [Louis XIV] carried on against the principal Powers off Europe at the Expence of the Blood and Treasure of his Subjects who were reduced to the very dernire [last] resort."[188] Built as a symbol of French power and the glory of its monarch, Versailles was ridiculed on the eve of the French Revolution by the American diplomat Gouverneur Morris as "an immense monument [to] the vanity and folly of Louis Fourteenth" (cat. 175).[189]

Facing a growing financial crisis stemming from mounting State debt (exacerbated by French support for the American Revolutionary War), Louis XVI summoned the Estates General to Versailles on May 5, 1789, for the first meeting of that nominal legislative body since 1614. This would prove to be the final occasion—the last of the French monarchy—for which grandiose ceremonies were organized for all to see and with all the ostentation that had characterized life at Versailles for more than a century. Although rising tensions in Paris led to the storming of the Bastille on July 14, life in the palace was not immediately affected. With more serious trouble clearly ahead, however, regiments were recalled from the provinces to take the place of the French Guards, who were too closely linked to the ferment in Paris.

One of the last receptions at Versailles was a banquet given on October 1 for the officers of the Flanders regiment, who arrived in Versailles in late September.[190] The banquet took place at the Royal Opera, where the fête for the wedding of the Dauphin and Marie Antoinette had been held (cat. 7). Four days later, on October 5, a crowd of women, enraged over the lack of bread, marched on Versailles (cat. 8). After a restless night of waiting, in the early morning of October 6 the rioters invaded the palace and killed two guards as they tried to get to the queen, who fled to the king's quarters (cat. 9). During the morning hours the royal family, escorted by a crowd of more than thirty thousand, was forced to return to Paris and move into the Tuileries Palace, where they lived as virtual prisoners (cat. 10). Witnessing these early events of the French Revolution, Friedrich Schulz, a novelist from Magdeburg, stated bluntly that Versailles was a child of despotism and, as such, must die with it.[191]

With the court departed, the number of sightseers to the palace dwindled, but it did not end altogether. The dramatic events of October 1789 may even have heightened the curiosity of some visitors, perhaps an early instance of what today would be derisively termed "disaster tourism." The British novelist Helen Maria Williams, who supported the ideals of the French Revolution, visited the former royal residence in the summer of 1790. She was shown the passages through which the queen had escaped during the night of the attack as well as the balcony on which Louis XVI and Marie Antoinette appeared before the mob the next day. Williams confessed that she "could not help fancying I saw, in the back ground of that magnificent abode of a despot, the gloomy dungeons of the Bastile, which . . . prevented my being much dazzled by the splendor of this superb palace."[192] Although some of the palace furnishings were removed and sent to the Tuileries soon after the king and queen were forced to take up residence there, much of it remained in place until the Revolutionary sales held at Versailles in 1793–94 (cats. 11, 12).[193] The Russian writer Nikolai Karamzin, who in June 1790 visited the abandoned palace as well as the once bustling but now desolate town, poetically compared Versailles without a court to a body without a soul.[194] Touring the state apartments, he admired Morand's clock (fig. 10). Each time the hour struck, the cock crowed and Louis XIV was crowned by Fame, as if nothing had changed. In the Apollo Salon the throne still stood under a richly embellished canopy, symbol of the once all-powerful Bourbon kings. Upon returning to Paris, the Russian traveler and future historian threw himself exhausted onto his bed and wrote: "I have never seen anything more magnificent than the palace of Versailles."[195]

1 *The Palace of Versailles and the Month of April*

Gobelins Manufactory, Paris, ca. 1673–77

This tapestry is part of a series of twelve representing the months and the royal residences. Designed by Charles Le Brun, they were eventually hung in the Grands Appartements at Versailles.[1] Each hanging celebrates Louis XIV's power and wealth by illustrating a Crown property. Seen here in the distance, the palace of Versailles pays homage to his father, Louis XIII, whose hunting lodge was transformed into a splendid residence. Garlands suspended between double columns surround a central cartouche with a Taurus, the zodiac sign of April. In addition to showing a royal promenade in the park of Versailles, the tapestry refers to the sumptuous furnishings commissioned for the palace at the Gobelins manufactory. Of the two precious-metal vases filled with flowers on the balustrade, the larger resembles those described as a pair of silver vessels with Medusa-head decoration created by Guillaume Loir in 1666.[2] Perched on the railing are a peacock and a parrot, the latter based on Pieter Boel's studies of birds in the Menagerie.[3] DK-G

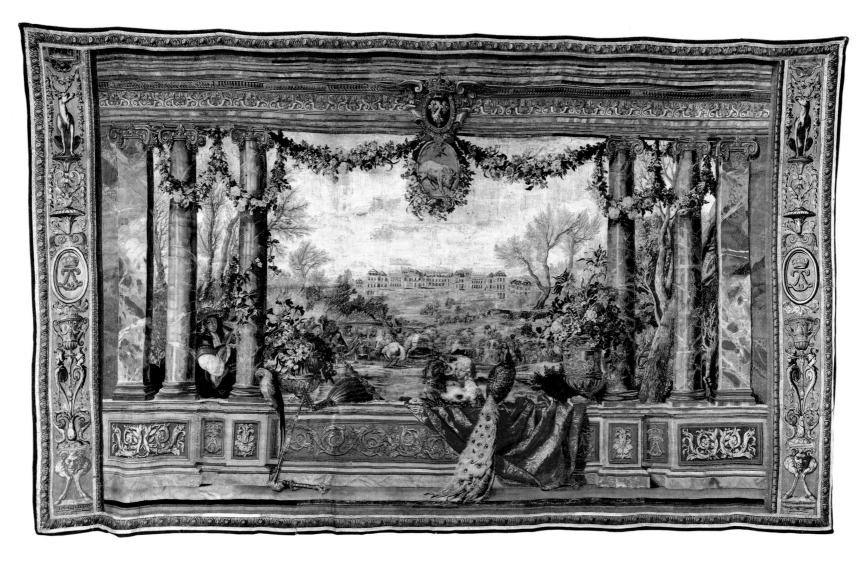

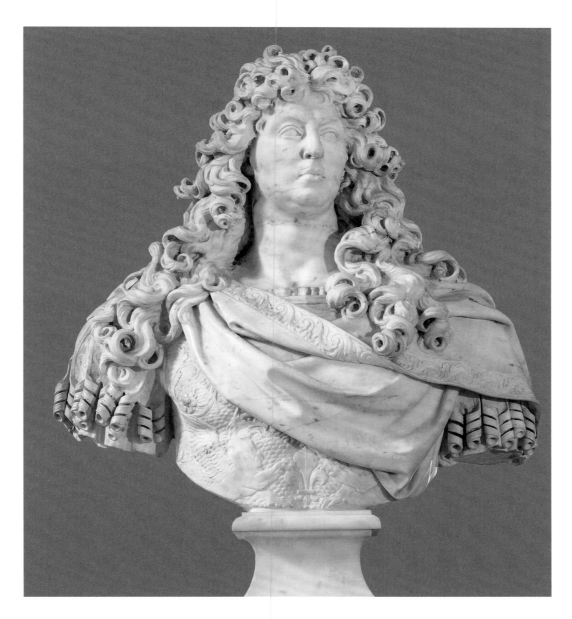

2 *Louis XIV*

Antoine Coysevox, 1678–81

In 1681 Coysevox, who worked at Versailles and Marly, represented Louis XIV in the classical style, wearing armor, but with a large wig.[1] The king's serene and impassive features convey the majesty of an official portrait. Some time before 1693, this work had replaced Jean Warin's 1665 bust of Louis displayed in a niche on the north wall of the Ambassadors' Staircase, the center of an allegorical composition celebrating the glory of the monarch. Placed opposite the coats of arms of France and Navarre—which were framed by the palm fronds of Victory and Fame—the bust was flanked by shields, helmets, arrows, and quivers and crowned by the king's motto.[2] Coysevox's masterpiece remained in this prestigious setting until the destruction of the staircase in 1752. LA

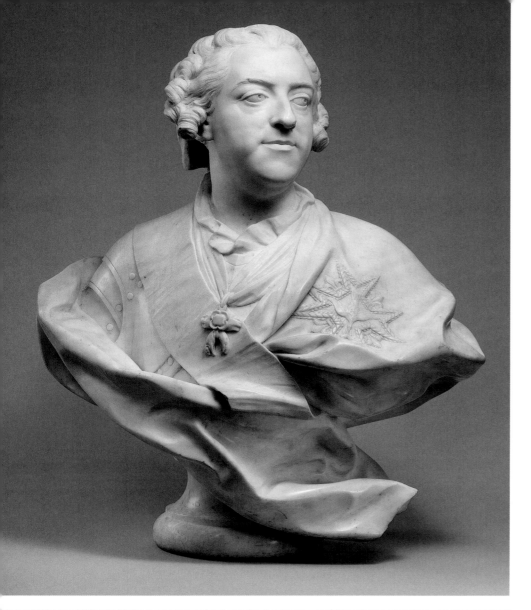

3 *Louis XV*

Jean-Baptiste Lemoyne, 1757

Lemoyne took numerous trips to Versailles and in 1745 stayed there for several months to work on a marble bust of Louis XV. As official portraitist, the artist rendered the king multiple times, in both marble and bronze.[1] This work shows the forty-seven-year-old sovereign dressed in armor, with his left shoulder covered by a flowing mantle and wearing both the Orders of the Holy Spirit and the Golden Fleece. Visitors would have rarely seen Louis attired for battle, but they would have recognized his face. Lemoyne's faithful rendition of the large eyes, prominent nose, and softening flesh speaks to a close observation of the sitter. While expressing grandeur, the marble also exudes the king's appetite for the pleasures of life, flourishingly described by the British captain Philip Thicknesse: Louis XV "is extremely fond of women; nor has any man been more indulged that way. He is also fonder of wine than is the present fashion of France. He finds the saddle the seat of health, and spends more time of the day on it than off."[2] Shown at the Salon of 1757, the bust belonged to Madame de Pompadour. After she died, in 1764, Louis bought the portrait and presented it to Charles François de Lavery, Controller General of Finances.[3] DK-G

4 *Louis XVI*

Louis Simon Boizot, 1777

Wishing to commemorate the 1777 visit of her brother, Emperor Joseph II of Austria, Marie Antoinette commissioned Boizot to carve busts of him and of her husband, Louis XVI. "Executed at the direct order of the Queen,"[1] but paid for by the king's household, these portraits were displayed on column-shaped wood pedestals in the antechamber of the Petit Trianon, a placement that explains their informal appearance. Departing from official, idealized portraits, Boizot ably expressed the king's good nature. In addition to the chain of the Golden Fleece, Louis wears a sash and the badge of the Order of the Holy Spirit, the primary order of the French monarchy, of which he was the grand master. These prestigious insignia, emphasized by the ample drapery on which the bust rests, endow the likeness with an air of great majesty. LA

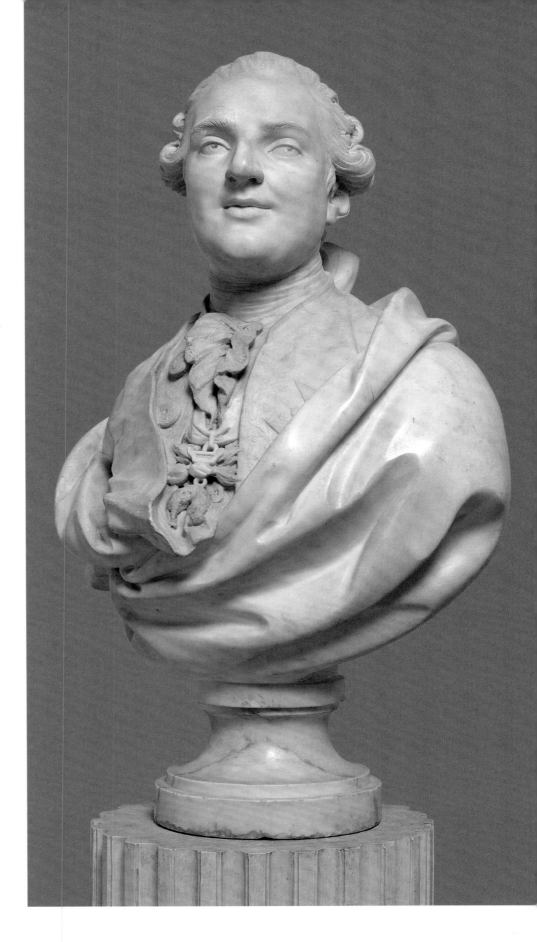

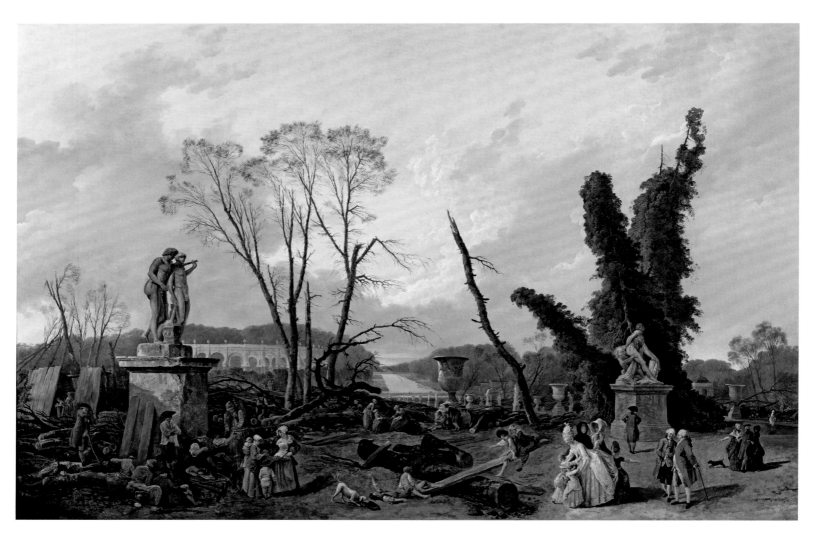

5 *The Entrance to the Lawn*

6 *The Grove of the Baths of Apollo*

Hubert Robert, 1777

In 1775 Robert Wharton, a traveler from Durham, wrote "the Gardens of the Palace . . . are in a sad Condition. Some one has persuaded the King to Cut down all the Trees."[1] Robert's paintings, combining grandeur and desolation, document the neglect that necessitated such changes in 1775. In the first, the woodcutters and their families appear on the left, courtiers on the right. Marie Antoinette, in a light-colored dress, bends toward two children, while the king, in a red coat, talks with the comte d'Angiviller, director of the Bâtiments du Roi. A visitor, absorbed in the *Milo of Crotona*, turns his back on the king and queen (the site and circumstances allowing for a relaxation

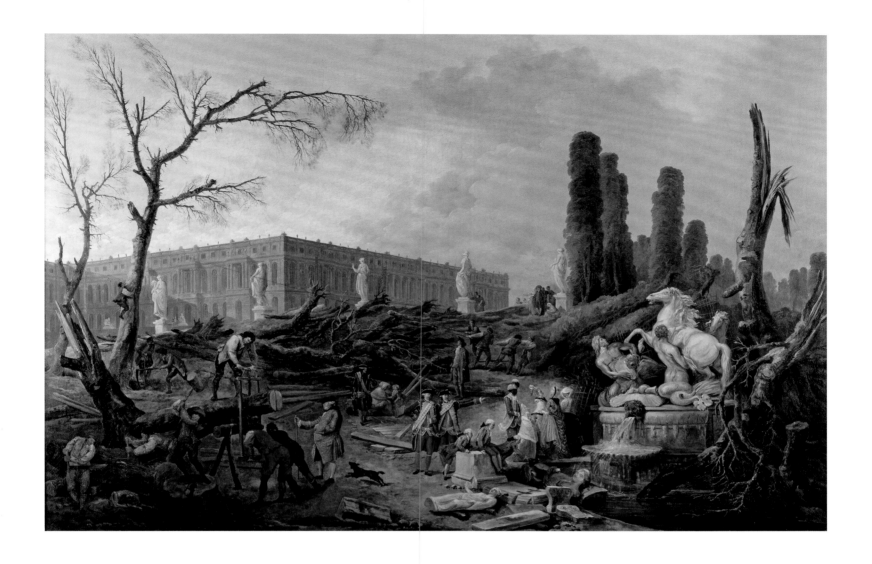

of etiquette). In its pendant, the woodcutters in the left foreground work under the watchful eye of their foreman; on the right fashionable ladies are shown along with their servant, three young pages in royal livery (cat. 45), French Guards, and, in the background, visitors marveling at the destruction of the Baths of Apollo. Even so, the emptiness of the park opened up broad vistas and allowed statues like Gaspard and Balthasar Marsy's *Tritons Grooming Two Horses of the Sun* to stand out against the trees. As the duc de Croÿ remarked, "A superb ensemble was left uncovered."[2] GF

Jean Louis Prieur the Younger, 1789

In a series of sixty-nine drawings, Prieur, who was involved in Revolutionary politics and was guillotined in 1795, documented with great narrative detail the momentous events that unfolded between June 1789 and September 1792. Nearly all his illustrations were subsequently engraved by Pierre Gabriel Berthault for the so-called *Tableaux historiques,* which were available by subscription in sets of two prints each with commentary. These four drawings illustrate the dramatic developments in the fall of 1789 that led to the forced return of the king to Paris.

On October 1, a magnificent banquet was held in Versailles's Opera House by the king's Gardes du Corps to honor the officers of the Flanders Regiment, part of which had been called in to protect the palace and the royal family following recent riots in Paris. Prieur brilliantly depicts the festivities in their splendid setting, in stark contrast with the cries for bread in Paris. Reports of this banquet further aggravated the discontented Parisian populace and culminated four days later in the march to Versailles of armed women (and men) in search of the king. The peaceful hilly landscape is strikingly juxtaposed here with the ominous crowd in the foreground. Prieur has taken some liberties by leaving out the driving rain and by including the National Guard, which actually left Paris several hours after the angry crowd.

The next drawing shows the palace and its crowded forecourts early on the morning of October 6, while the National Guard tries to reestablish order. Having waited all night for concessions by the king, a group of rebels—the last, unwelcome visitors to Versailles—forced their way into the Queen's Apartment. Marie Antoinette fled to the King's Apartment as two of her guards were killed. After a brief calm, the crowd assembled in the courtyards and demanded the return of the king to Paris. Prieur masterfully depicts the troops enveloped by the smoke of an artillery salvo, set against the seemingly peaceful backdrop of the palace. Hours later that same day, the king consented to return to the capital, a long journey slowed by the jubilant hordes accompanying his carriage. Reaching Paris, the disorderly procession is rendered here passing in front of the church of the Convent of the Bonshommes. The palace of Versailles would never again be the seat of the French monarchy. DK-G

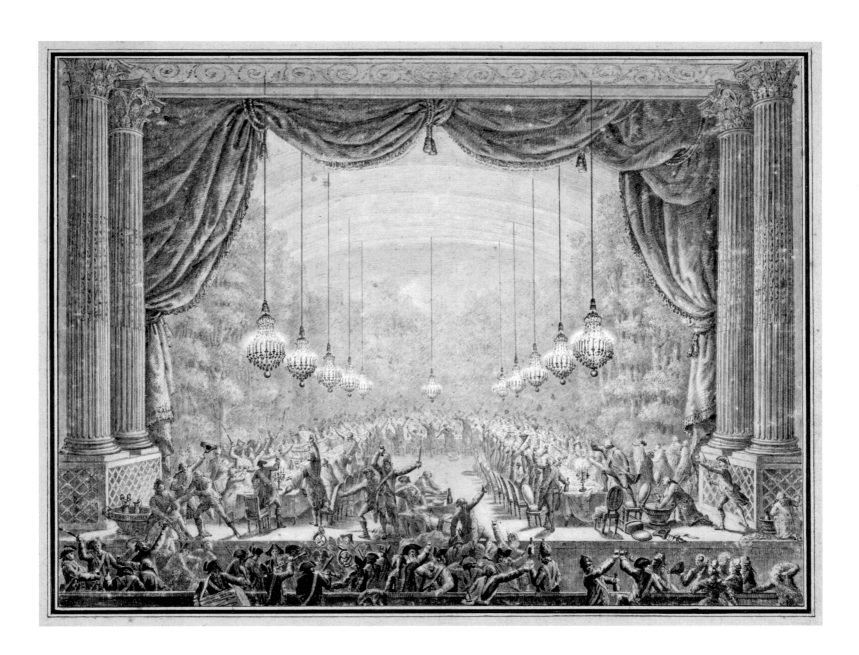

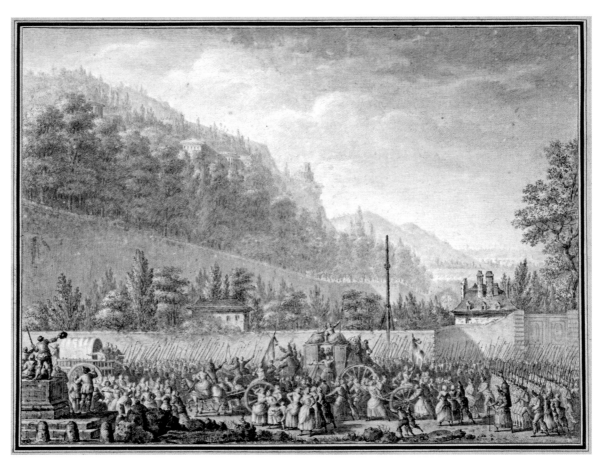

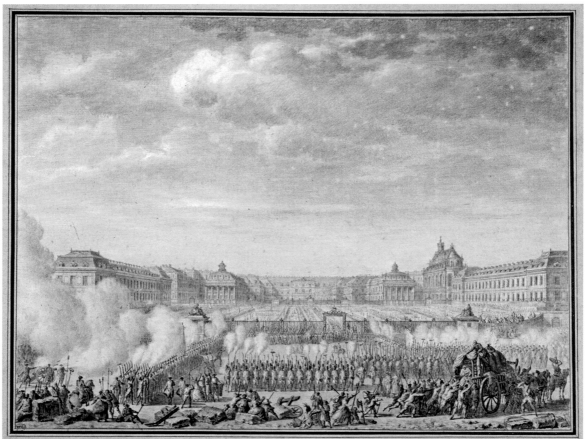

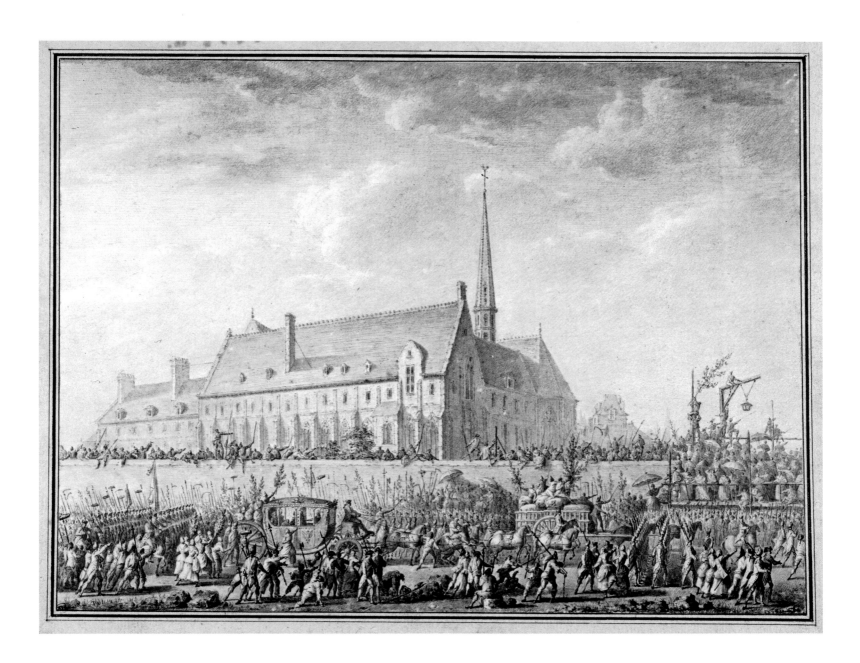

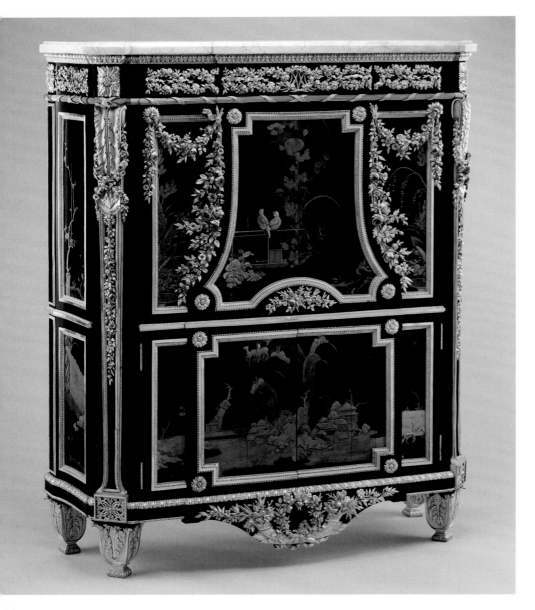

11 Drop-Front Secretary
12 Commode

Jean Henri Riesener, 1783

This splendid secretary and commode were commissioned together with an *encoignure* (corner cabinet), now lost, for Marie Antoinette's Grand Cabinet Intérieur at Versailles. Riesener, the queen's favorite cabinetmaker, reused as a veneer fragments of seventeenth-century Japanese lacquer, whose glossy surface forms a striking background for the exceptional gilt-bronze mounts incorporating the queen's initials. The history of these pieces is well documented. Sent to the summer palace of Saint-Cloud in 1787, they were confiscated during the Revolution and subsequently offered as payment to Abraham Alcan, a military contractor.[1] Other works of art from the royal collections were sold in the Revolutionary sales of 1793–94, and many left the country. During the nineteenth century, the commode and secretary formed part of the celebrated British collections of George Watson Taylor at Erlestoke Park, and later of the dukes of Hamilton, before being acquired at the Hamilton Palace sale of 1882 for Alva Vanderbilt, one of the reigning hostesses of New York society.[2] DK-G

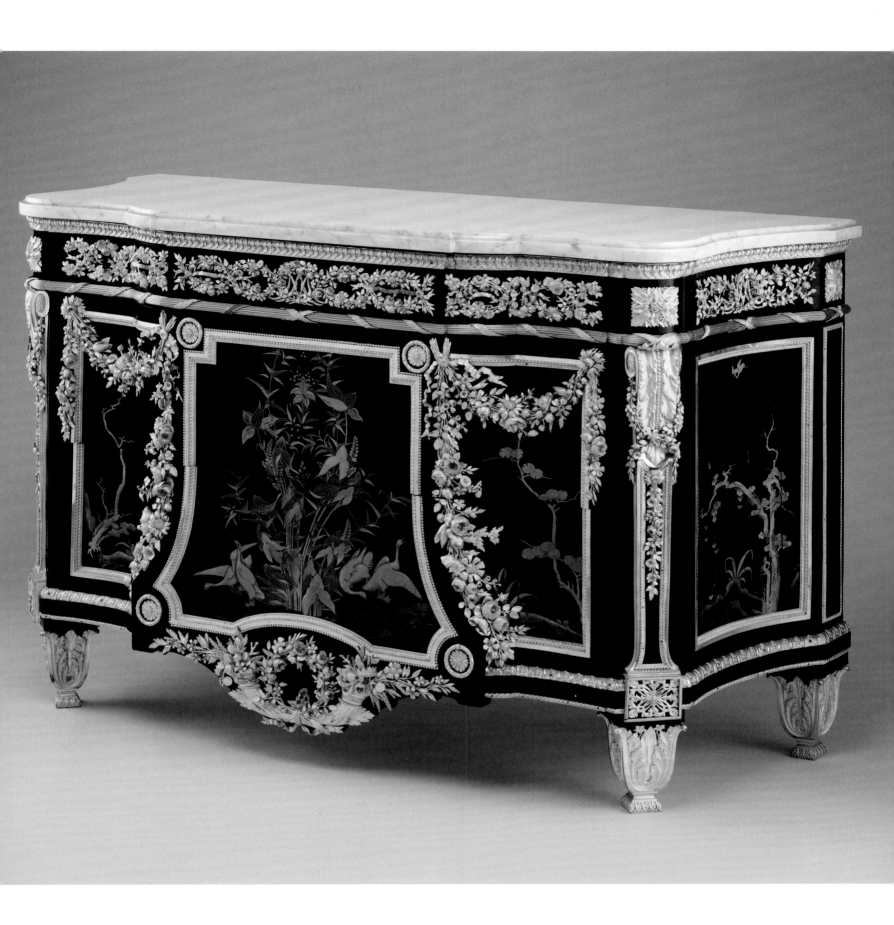

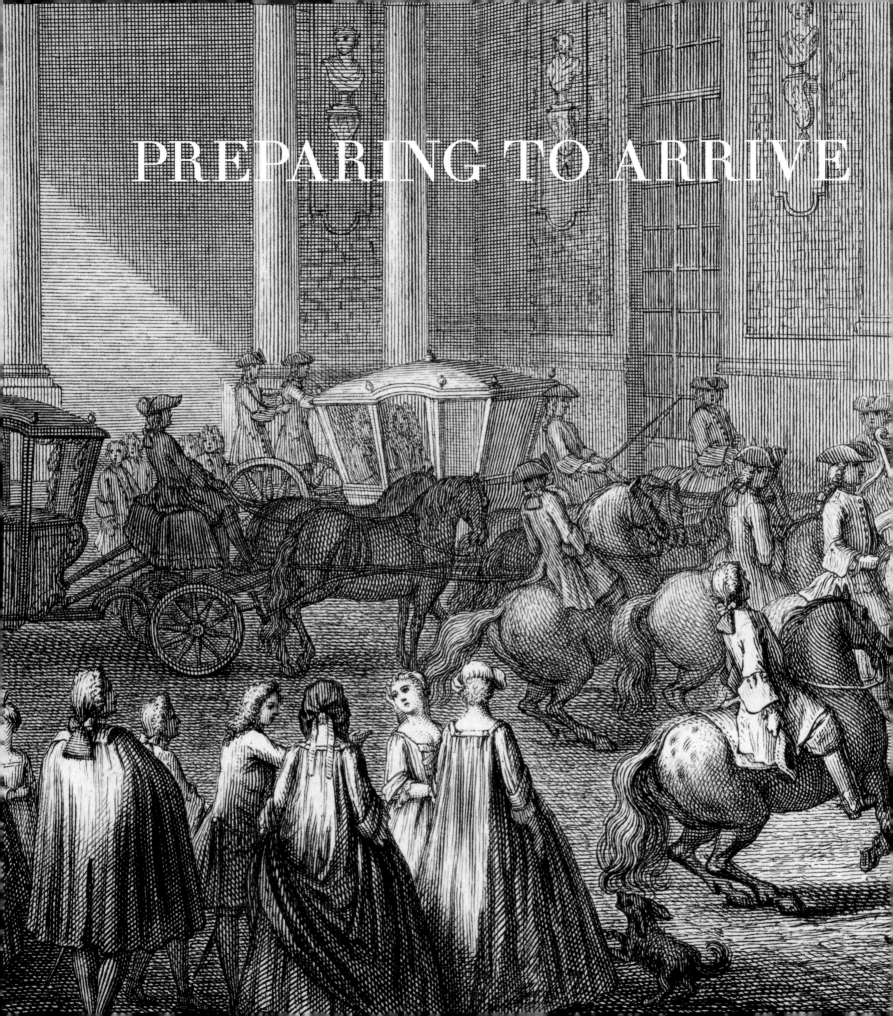

PREPARING TO ARRIVE

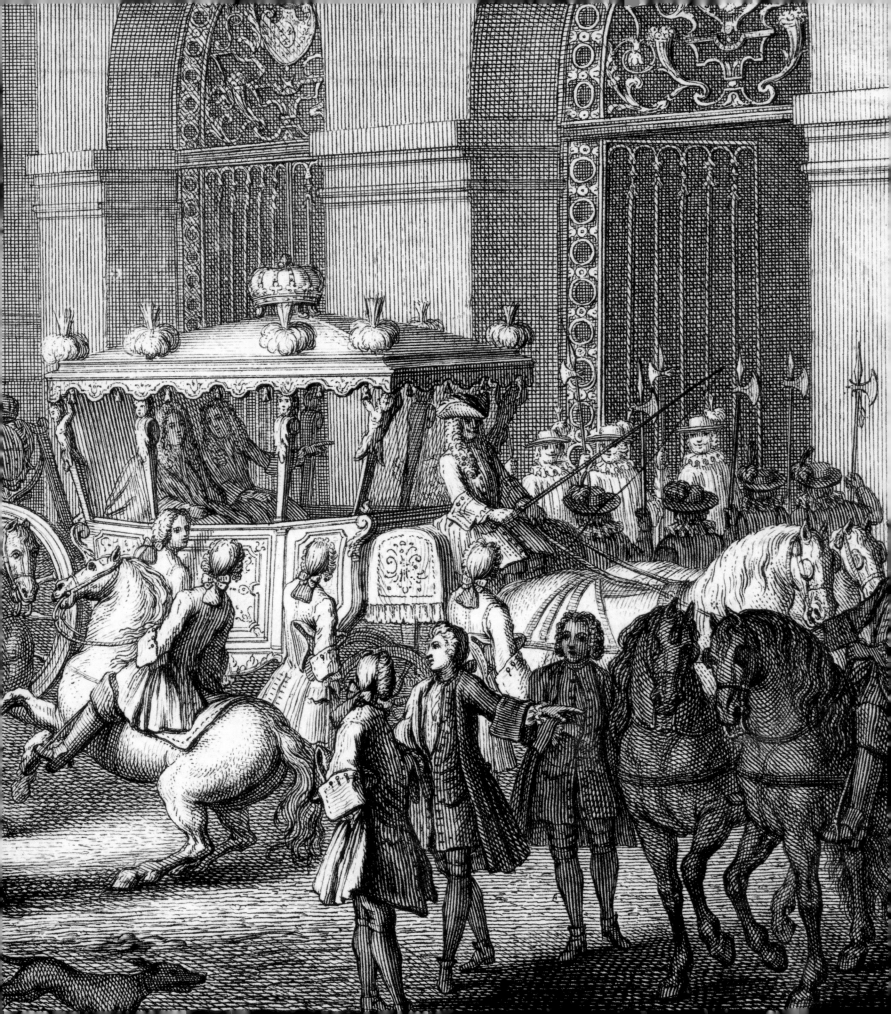

GOING TO VERSAILLES

MATHIEU DA VINHA

In May 1682, Louis XIV made Versailles his main residence. With the expansion of his father's former hunting lodge, the king turned a pleasure palace into a highly symbolic site that concentrated the court and the government in a single place. As Versailles became a strategic hub for visitors of all kinds, both French and foreign, the village and its surroundings were forced to develop in order to keep up with the crowds that converged on the royal city (fig. 21). Dozens of guidebooks offered their services to help these travelers not only navigate around the city but also visit the palace (see "Visitors' Guidebooks and Engravings" by Elisabeth Maisonnier in this volume) (fig. 22).[1] Infrastructures, rules, and customs were gradually devised for going to Versailles,[2] finding accommodations, and gaining access to the palace, if not to the king.

Traveling to Versailles

Versailles lies four leagues (approximately twelve miles) to the west of Paris, and in the late seventeenth century it took at least two hours to reach the palace by means of the fastest conveyance. While access to Versailles was never a problem for the royal family (fig. 23), the high nobility, or persons of wealth,[3] for those individuals who did not have their own carriages it was more difficult.

For this class of visitor, there were substitutes displaying varying degrees of technical sophistication depending, above all, on the clients' budgets.[4]

Most of these travelers had to settle for a public transportation service operating out of Paris. In May 1657, a certain Monsieur de Givry had been granted the privilege of renting coaches, carriages, and public carts "in the city and suburbs of Paris, as well as 4 & 5 leagues in the environs, either for excursions or for private individuals to go to their country houses."[5] In order to cover his costs, Givry lost no time in sharing his privilege with the Francini brothers, famous fountain designers and hydraulic engineers; then, to meet the continually rising demand, he went into partnership with Monsieur and Mademoiselle de Sautour, who had been previously granted a competing privilege.[6]

The privilege held by Monsieur de Givry and his associates was seriously jeopardized in the early 1660s by the "establishment of carriages for the court's retinue," since "carriages used to be the most difficult thing to provide for on the occasion of the travels of our kings; their large courts, and the inseparable retinue, could not be adequately provided for without extraordinary means being resorted to."[7] This privilege, granted on July 21, 1662, to Madame de Beauvais, Anne of Austria's

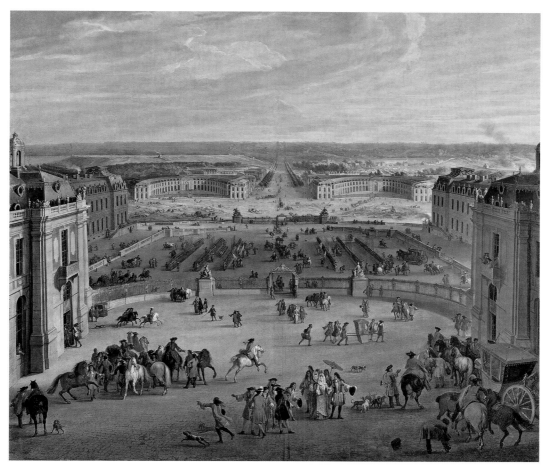

Fig. 21. Jean-Baptiste Martin, *View of the Forecourts of the Palace of Versailles and the Stables* (detail of fig. 43), 1688.
Oil on canvas, 92⅜ × 73⅜ in. (234.5 × 186.5 cm). Musée National des Châteaux de Versailles et de Trianon (MV 748)

first lady-in-waiting, covered the operation of carriages, coaches, calèches, and carts of two or four seats to transport all kinds of passengers going wherever the royal family and ministers went, be it Saint-Germain, Fontainebleau, or Versailles. It was subsequently transferred to her son, Louis de Beauvais, then to Elie Du Fresnoy, first assistant to the marquis de Louvois.[8]

It was only at the end of the 1660s, in response to the increasingly frequent stays of the court in Versailles and Louis XIV's desire to see the town prosper, that a special freight service was created between Paris (whence artists and laborers came to work on the construction sites) and Versailles

as well as between the latter and Saint-Germain (where the court often resided at the time). A patent dated March 18, 1669, stated, "His Majesty . . . ordered and orders . . . that an ordinary freight service of one coach, one carriage, and one cart, a set of wagons and horses of burden be established to come and go each day of every week from the city of Paris to said village of Versailles and from said Versailles to Saint-Germain-en-Laye, and for the return trip from said Saint-Germain-en-Laye to said Versailles and from said Versailles to said city of Paris. Which carriage, coach, and cart will each be pulled by four horses and said carts by one, two, or three, and able to carry and bring back all

Fig. 22. Title page from volume 2 of *Les Curiositez de Paris, de Versailles, de Marly, de Vincennes, de Saint Cloud, et des environs . . .*, by M. L. R. Paris: Saugrain, 1742. 6¾ × 4 in. (17 × 10 cm). Thomas J. Watson Library, The Metropolitan Museum of Art, New York (911.6 L561)

goods transported. Its establishment was ratified by the Parliament only two years later by letters demanding that the owners register this state of affairs (fig. 24). Edmond Léry points out that a deed of adjudication was later filed on May 15, 1682, on behalf of Jérôme Gambon, who, for an annual fee of 6,600 livres, became the operator for three years of the freight services that connected the cities of Paris, Saint-Germain-en-Laye, and Versailles. The prices were set as follows: forty sols for a seat in a carriage during the king's stay in Versailles, and thirty during his absence; thirty sols in a carriage during the stay of the court, and twenty during its absence; twenty sols in the cart during the court's stay, and only fifteen during its absence. The king also wished to benefit the inhabitants of Versailles, who were required to pay only the lowest fee whether Louis XIV was in town or not. In addition to these fees, one had to pay six deniers for every pound of merchandise.[10]

The comfort of these vehicles was rudimentary, and only the coaches equipped with a suspension system afforded a modicum of convenience. The fees in use were mentioned by the Swedish traveler Mårten Törnhielm in his account of his travels to Versailles in 1687: "On the morning of Tuesday, September the 20th we took a carriage to Versailles, four leagues away from Paris; there are in fact three ways of traveling the distance between the two places: either in a coach in which there is room for sixteen persons, at 25 sous per person, or in a carriage with 8 seats for which each pays 30 sous, which is worth half a rixdale, or in a rented carriage with four seats, which generally costs one rixdale or 16 sous per person."[11]

After 1683, the offices of the freight service, located in the Rue des Coches (today's Rue Saint-Simon),[12] were merged with the "carriages for the court's retinue." Indeed, on July 19, 1685, the king revoked the privilege that he had granted to Messrs de Beauvais and Du Fresnoy. The offended concessionaires claimed their rights so insistently that Louis soon made amends, restoring

manner of persons, loads, and packages." The patent also stipulated that those who run said freight service would set up offices in Paris, Versailles, and Saint-Germain.[9]

The freight service was modeled after, and applied the same rules as, those already in existence in French cities, the most notable regulation being that the concessionaires were liable for the

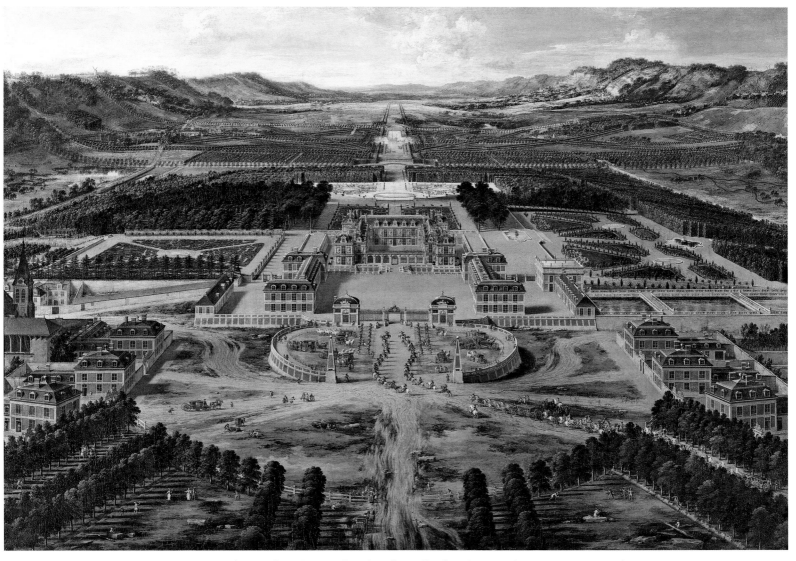

Fig. 23. Pierre Patel, *View of the Château and Gardens of Versailles, from the Avenue de Paris in 1668*, 1668. Oil on canvas, 45¼ × 63⅜ in. (115 × 161 cm). Musée National des Châteaux de Versailles et de Trianon (MV 765)

their privilege by letters patent in the form of an edict in August 1685. The two regained their former monopoly and much more, as the king declared: "In accordance with the decree of our State Council of said July 26th last, . . . said Sirs de Beauvais & Dufresnoy, their Heirs and Assignees, will be made to establish & maintain always the number of Carriages, Coaches, Carts, Wagons & Horses of burden necessary for the Freight Service from Versailles to Paris, & from Versailles to

Saint-Germain-en-Laye & back." The king continued that this privilege would continue "whether we are staying at said Versailles and Saint-Germain, or we choose some other place; which Carriages, Coaches, Carts, Wagons & Horses of burden, they or their Operators will make to leave daily in sufficient numbers at the times that have been or will be set by our Bailiff of Versailles."[13]

Thus, commoners who did not lodge in Versailles or were not wealthy enough to have

Fig. 24. *Lettres de cachet* to the Parliament registering letters patent for the establishment of a coach and other vehicles in Versailles, issued at Fontainebleau on August 19, 1671. Archives Nationales, Paris (O¹ 15, fols. 360v–361r)

their own carriages could use this regularly scheduled public transportation. For those better off, once in Versailles, there was a sedan chair service (cat. 35), which was also subject to royal privilege. The system of portable chairs was an old one, going back to the late sixteenth century.[14] A change was introduced with a patent of October 30, 1667, that established in Versailles a company of sedan chairs—called *chaises bleues* because of the color of the liveries of their porters—which distinguished them from private ones.[15] This concession was granted to the comte de Nogent and the chevalier de Forbin, who "took the initiative of asking the King for the right to have *chaises bleues* in which anyone could enter the Louvre and be carried within the precincts of the King for a fee."[16] The fee was twelve sols for a trip within the town. For the sake of convenience, the chairs were obliged to park on the Place d'Armes, the Place Dauphine, and the Place Saint-Julien. There was no *carosse de remise* (hackney coach) and no fiacre, according to Leopold Mozart, who visited Versailles with his family in 1764, only sedan chairs, he complained, and "for every drive one has to pay twelve sous."[17]

The privilege of the sedan chair owners was threatened almost immediately by chairs with two wheels, a technical innovation from the end of Louis XIII's reign. The concessionaires were able to maintain their monopoly only until 1670, at which time such two-wheeled chairs, called *brouettes* or *vinaigrettes,* were authorized.[18] These chairs were easier to maneuver and less tiring for the porters (who now became "pullers") (fig. 25).

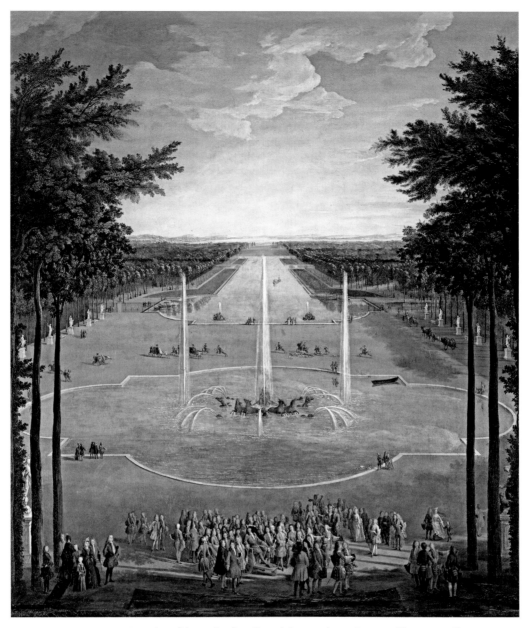

Fig. 25. Pierre Denis Martin, *View of the Basin of Apollo and the Grand Canal at Versailles*, 1713. Oil on canvas, 92⅛ × 74 in. (234 × 188 cm). Musée National des Châteaux de Versailles et de Trianon (MV 757)

The introduction of these new chairs led to the construction of ramps in the center of the stairs, flanked by steps on either side. On November 25, 1701, the king ordered Jules Hardouin-Mansart to "build ramps of low incline to permit his cart to go to the front steps of said Trianon Palace, both on the sides of the courtyard and the garden."[19] The marquis de Dangeau made several allusions to these chairs being used by Louis XIV (fig. 26), especially after he had undergone the "great operation" for a fistula. On January 12, 1687, for example, the diarist wrote that the king "took a carriage and went for a ride to Trianon. He called for a new chair in which he could be pulled conveniently; he tried it and found it quite gentle and quite comfortable."[20]

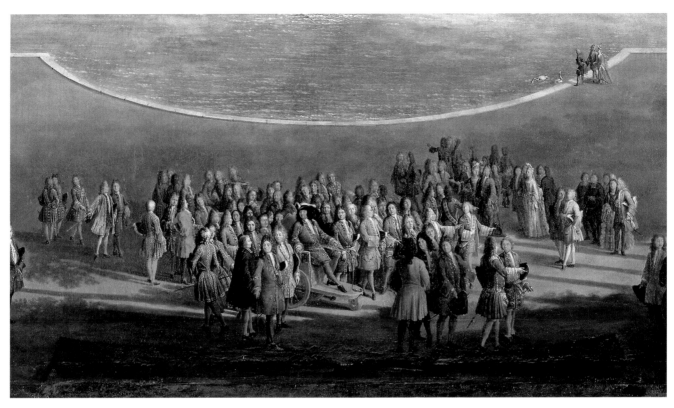

Fig. 26. Detail of fig. 25

In addition to these somewhat traditional vehicles, there were also less conventional, but probably more pleasant, means of transportation. The British author Sacheverell Stevens mentions travel by boat in his accounts: "But, in my opinion, the most agreeable passage is in the galliot, or small barge, which sets out every morning about eight o'clock from Pont-Royal [see cat. 29]; the expence whereof is but six sols, which is but a mere trifle. Here you take water, and are landed at a place call Seve [Sèvres], being exactly half way. A stranger cannot but be agreeably amused in this passage, by the odd mixture, or groupe of persons, with whom this galliot is sometimes crowded."[21] This type of transportation was not only the most pleasant but also the least expensive, according to the Irish travel writer Thomas Nugent: "From Paris you may go to Versailles for five and twenty sols with the Coche, which sets out twice a day from the Rue Saint Nicaise. You may likewise go with the carosse or stage-coach

that holds but four, for a French crown each; or with a post-chaise. Another way is by water for five sols as far as Seve [Sèvres]. . . . From Seve there is a great causeway, that carries you by the heights of Virofle [Viroflay] to the great avenue of Versailles."[22]

"Honors of the Louvre" and Lodging in Versailles

Upon arrival in Versailles, only certain visitors were allowed to enter the palace enclosure with their carriages or sedan chairs (cat. 33). These were said to have "passed the Louvre," the "Louvre" by extension referring here to the entry gates of any royal palace. They were also said to enjoy what was known as the "honors of the Louvre," in the sense that the "Louvre" represented any palace in which the king resided.[23] Aside from the immediate royal family (king and queen, dauphin and dauphine, and their children) and the palace corps, there were four distinct

categories of these individuals. First were all the royal princes and princesses (sons, daughters, and grandchildren of France, princes of the blood, and bastards or those legitimized), foreign sovereigns or princes and their wives, and cardinals, as princes of the Church. Then came the extraordinary and ordinary ambassadors of the crowned heads of Europe (and their wives) or of the pope, followed by the dukes and duchesses of France as well as the three ecclesiastical counts and peers (the bishops of Châlons, Beauvais, and Noyon). Last were the "Officers of the Crown. The Lord Chancellor. The Keeper of the Seals. The Marshals of France. The Grand-Master of Artillery, and others," the "First Officers of the Queens and of Madame la Dauphine," and the "First Officers of the Children of France."[24]

Those granted this privilege were nevertheless bound by a very strict hierarchy.[25] Entry was possible only when the king and queen had awakened, and the conveyances had to leave the court before the couple retired for the night. Moreover, these various visitors could not enter the palace however they wished: "All the carriages that come to the residence of their Majesties, are to park as closely as possible to the bottom of the stairs, according to the rank that the Masters and Mistresses to whom they belong hold in France."[26] The choreography must have been quite elaborate, for as soon as someone of higher title arrived, the carriage already in line had to leave immediately to make room. Depending on the number of visitors, there could be several rows of carriages parked all around the courtyard in a more or less orderly arrangement.

Although visitors were permitted entry, they were not necessarily lodged. For all its size, the palace of Versailles and its outbuildings could accommodate only the king, his family, and those who worked in their service. If they did not have relatives lodged at the court, visitors—whether from the region, the provinces, or abroad—had to seek quarters of their own from among a number

of inns or taverns of varying quality (cat. 34).[27] During the construction of the hunting lodge by Louis XIII in 1623–24, there was only one hotel, which displayed the sign of the "Ecu" (later changed to "Ecu Royal" in honor of the king's regular presence in the town). The number of inns increased during the 1630s and even more during the expansion under Louis XIV, with workers arriving in droves. The construction also drew the curiosity of visitors, who took lodgings in the various inns near the palace, including the Lion d'Or, Image Notre-Dame, and Pélican, which were heavily frequented by workers and servants at the palace. After 1672, more inns were built in the new quarter (near the marketplace and the future Place Dauphine), with such evocative names as the Branche d'Or, Pavillon Royal, Fleur de Lys Couronnée, and Trois Couronnes. These establishments were often the scene of brawls, usually between the workers and servants but, judging by reports of the provost-marshal, sometimes between travelers as well.[28]

The growth of the royal complex greatly increased the demand for accommodations in town, and it became in effect Europe's largest inn during the eighteenth century. According to the census of June 1722, Versailles had a population of twenty-five thousand residents, about a thousand of whom lived in furnished quarters, in addition to all the rooms in the inns, taverns, and various hotels.[29] By the end of the ancien régime the population had reached eighty thousand, and the palace had become a must for foreign visitors.

Reaching the Castle

In his *Mémoires* of 1662, Louis XIV pointed out that the French monarchy had traditionally been open and accessible to all its subjects.[30] The king, who wanted to maintain this custom, extended the accessibility beyond his own subjects, especially at his main residence. And so every day an extremely diverse crowd of people made its way to the palace of Versailles. Various members of

the royal family stayed there, as did courtiers with the good fortune of having lodgings (together with their many servants). Also passing through were nobles who wanted to further their interests, various suppliers, workers from the seemingly never-ending construction site, the curious and other tourists, and those who hoped to glimpse the master of the house, if only from afar. According to the Italian courtier Primi Visconti, the Sun King shone in the midst of his court: "It is a fine spectacle to see him coming out of the palace with his escort of guards, the carriages, the horses, the courtiers, the valets, and a crowd of people in utter confusion, milling noisily about him. This . . . recalls queen bees when they go out into the fields with their swarm."[31] The sovereign's accessibility was a source of surprise to foreigners, Primi Visconti noting that "in Spain the princes can be approached only by the jesters, but in France they can be approached by anyone."[32]

This unusual, specifically French, openness of the royal residence and sovereign continued to make an impression at the close of the following century. On May 27, 1787, the British traveler Arthur Young wrote: "The whole palace, except the chapel, seems to be open to all the world; we pushed through an amazing croud of all sorts of people to see the procession, many of them not very well dressed, whence it appears, that no questions are asked. But the officers at the door of the apartment in which the King dined, made a distinction, and would not permit all to enter promiscuously."[33] On September 23 of the same year, Young noted:

> Again to Versailles. In viewing the King's apartment, which he had not left a quarter of an hour, with those slight traits of disorder that shewed he *lived* in it, it was amusing to see the blackguard figures that were walking uncontrouled about the palace, and even in his bed-chamber; men whose rags betrayed them to be in the last stage of poverty, and I was

> the only person that stared and wondered how they got thither. It is impossible not to like this careless indifference and freedom from suspicion. One loves the master of the house, who would not be hurt or offended at seeing his apartment thus occupied, if he returned suddenly; for if there were danger of this, the intrusion would be prevented. This is certainly a feature of that *good temper* which appears to me so visible every where in France.[34]

Young's remarks are at variance with the traditional image of the palace's accessibility. The popular legend has it that anyone who was well dressed could enter Versailles,[35] and this information has been readily accepted in every study since the nineteenth century. Nevertheless, it is difficult to find precise written rules for the right of entry into the palace. Although we read over and over again that male visitors had to have a hat and a sword, this is not clearly mentioned in contemporary texts. The reports of foreigners are therefore very useful in order to understand the attitudes and behavior necessary for entering the palace grounds. The German traveler Joachim Christoph Nemeitz, writing in his *Séjour de Paris* in 1727, recorded that there were more restrictions than it appeared at first,[36] and he made no secret of the "pains" to be taken to gain access to the palace on the occasion of high ceremonies. It was absolutely essential to know someone among the guards, the Introducer of Ambassadors, or an influential dinner companion. Geographic origins did not always suffice for doors to be opened, as Nemeitz noted: "For it is not always useful to say that one is a foreigner, nor to start speaking *German* to the *Swiss*, who usually stood guard at the entrance of the apartments, reminding them of their place of birth. It depended on the mood of these people, the honest and the brutes are mixed pell-mell."[37]

In addition, these guards appeared incorrupt-ible, and it therefore seemed better to wait for

the passage of some princely retinue and join it surreptitiously in order to enter the apartments. Short of that, it was always possible to wander around in the Grande Galerie (Hall of Mirrors) or various antechambers.[38] To foil the vigilance of the guards, Nemeitz advised visitors to wear a coat "with braid and trimming," which always makes an impression and, he added, "looks a bit more like a uniform, & usually impresses the Guards, making them think you are an officer, for entry is rarely denied to such people, & besides it is impossible for them to know all the Officers in the Army."[39]

Being well dressed was unquestionably an advantage in gaining entry to Versailles. One British visitor, the clergyman Richard Valpy, pointed this out in 1788, writing that such people "are admitted to the Chapel-Royal, and to the state dinner."[40] The Swiss Guards, if they knew the visitor or had been persuaded to help, naturally proposed their services as guides inside the palace. The same British visitor noted, "We ranged some time, under the direction of one of the Swiss guards, through the maze of public apartments which compose this wonderful edifice."[41]

Seeing the King

Entering the palace was one thing, but coming face to face with the king was quite another. For visitors to Versailles, this seems to have been the ultimate goal. Despite the relative accessibility noted by Primi Visconti, security remained a concern, and there were many guards making the rounds. They were divided into the guards "from outside the Louvre" and the guards "within the Louvre" (the king's quarters began only after one had passed the gates of the "Louvre"). Without going into the complex responsibilities of each division, the regiments of Swiss (fig. 27) and French Guards (fig. 28) basically oversaw the security of the outer perimeter, while the others—including the Gardes de la Porte, de la Prévôté de l'Hôtel, and du Corps—were generally entrusted

with internal security. The Gardes du Corps and the Cent-Suisses (consisting of 100 Swiss mercenaries), charged with the king's personal security, flanked him whenever he left his chambers, both within the palace and in the gardens. From six in the morning to six in the evening, the protection of the residence was entrusted to the Gardes de la Porte, who were posted at the various entrances to the apartments, and to the bowmen of the provost, who patrolled the grounds and watched for suspicious behavior. At night, the Gardes du Corps relieved the Gardes de la Porte at the various entrances, while others, including the guards of the Cent-Suisses, slept in the king's guardroom and still others stood watch throughout the palace.

According to Jacques Levron, a chronicler of daily life at Versailles, the large number of guards and the specificity of their tasks sometimes hampered their effectiveness, for each corps clung to its function and intervened only in keeping with its jurisdiction.[42] This is the reason why the much-touted French security was jeopardized a number of times. Princess Ekaterina Romanovna Dashkova, lady-in-waiting to Empress Catherine II of Russia, gave a flagrant example of this in 1770. The princess very much wanted to go to Versailles before her retinue left Paris for Aix-en-Provence. In spite of her companions' attempts to deter her— they claimed that "no stranger, however modest, can take a step in Paris without his comings and goings being watched"—she transgressed the rules and attended a royal meal, as she reported in her memoirs:

> It was one of those days when the King and royal family dined in public. We mingled in the crowd, which was certainly anything but the beau monde, and entered along with it into a very dirty, [and] tattered room, where presently afterwards Louis the Fifteenth, the dauphin and dauphiness, and the two other daughters, Mesdames Adelaide and Victoire, appeared. . . .

Fig. 27. Jacques Antoine Delaistre, "Swiss Guards," plate 50 from *Infanterie et gardes françaises*, ca. 1721 (vol. 1). Print, watercolor, gouache, and ink on paper, 16½ × 21⅛ in. (41.7 × 54.8 cm). Musée de l'Armée, Paris (A1J7; 10849)

Fig. 28. Jacques Antoine Delaistre, "Dress of a Soldier in the Regiment of the Gardes Françaises," plate 6 from *Infanterie et gardes françaises*, ca. 1721 (vol. 1). Print, watercolor, gouache, and ink on paper, 16½ × 21⅛ in. (41.7 × 54.8 cm). Musée de l'Armée, Paris (A1J7; 10849)

When the royal repast was at an end, we hurried into our carriage, and arrived at Paris without any one knowing that we had for the moment left it, very much amused at the notion of having eluded the boasted vigilance of the French police.[43]

Richard Valpy, the clergyman who visited in 1788, had more in mind than just visiting Versailles: he wanted to witness the *souper au Grand Couvert*. His descriptions are the most specific that we have of the attire to be worn in the presence of the monarch. In October 1788, when he visited, the court was in mourning, and etiquette therefore forbade colorful clothing. For this reason, the court ushers had already denied entry to some of the traveler's compatriots. Fortunately for our visitor, he happened to be in mourning as well and so wore black clothing. Nevertheless, an official still tried to send him away. The account of this foreign memoirist surely contains the most detailed information on the norms and customs of the court in appearing before the king of France:

> "Sir," said he, "you are in black, it is true, but you are not dressed; you have neither sword nor bag [wig]." — "I am an English clergyman, Sir, and you have surely too great a sense of propriety to wish me to wear either." — "That indeed alters the case," said he, "but you are *en gilet* [in an unadorned waistcoat]." — I buttoned my coat. — "Even that, sir, will not do; you have a round hat." [—] My hat was immediately cocked and placed under my arm. — "Sir," said he, "you are so ingenious at metamorphosing your dress, that I shall make no more objections."[44]

The unwritten but generally accepted dress code therefore required proper clothes, a hat, and a sword. According to tradition, those who lacked these items could rent them from the concierge of Versailles at the entranceway to the palace. While this clever source of further income was fully in keeping with the secondary profits so characteristic of the ancien régime, we have so far found no official trace of it.

Like Princess Dashkova, foreigners were often surprised and disappointed by the simplicity in which French kings lived in the late eighteenth century, and like Valpy, they often encountered unforeseen difficulties. Nevertheless, the spectacle was worth seeing, and foreign visitors would not have missed it for the world.

EXCHANGING LOOKS
Codes of Dress at Versailles

PASCALE GORGUET BALLESTEROS

At Versailles, residents and outsiders continually crossed paths, meeting at the palace in a series of carefully staged entrances and exits. The visitor was thus both actor in and witness to the courtly practices associated with modes of dress.

Unfortunately, sources do not always note the presence of outsiders when describing dress. We must therefore consider these practices without being absolutely certain that they were subject to an external gaze, while at the same time taking into account a rigorous system of courtly etiquette in which every gesture took on a "prestige value"[1] in the unfolding of the ceremonial. Hence, the sociologist Norbert Elias points out that the ritual of the *lever du roi*, characterized by successive entries, reveals the hierarchy among the king's children, the princes of the blood, the officers, courtiers, and all those favored by the king. The changing of the king's shirt during that ritual was entrusted to the Grand Chamberlain if no prince was present. The honor associated with this "ceremonial gesture" fell to "the person charged with bringing the shirt."[2] The shirt became a metaphor for the royal authority that needed to be witnessed: to see and to be seen were thus the two aims of the action, which placed sartorial appearances in the service of the visual display of power.

Indeed, it was essential that the court be "magnificently dressed" for the prestigious receptions welcoming ambassadors. At the audience for the Persian ambassador in the Hall of Mirrors in February 1715, two observers, the marquis de Dangeau and the baron de Breteuil, emphasized the importance of the courtiers' clothing, the luxury of which, dictated by the king, attested to the wealth of the French court. "The gallery was filled with very richly dressed courtiers and with many outsiders," Dangeau writes. The baron de Breteuil adds that all the courtiers were "magnificently dressed with . . . costumes made especially for that ceremony."[3] A major role was allotted to the ladies positioned on risers installed for the occasion (fig. 52). Once the ambassador of Persia and his retinue had entered, "the king came into the gallery, where there were four rows of risers from one end to the other, but on one side only. These risers were filled with more than four hundred magnificently attired ladies; the ladies of the court were on the risers closest to the throne, with the ladies from Paris extending back to the far end of the gallery."[4]

Richly dressed, these ladies flaunted themselves under the eyes of visiting diplomats, who had a real fondness for the splendors of the French court. Their interests were reciprocal. For the ladies, it was to validate royal power, and in turn their presence underscored the status and favor they enjoyed at the court.

At the formal ball (*bal paré*) held in the Hercules Salon for the wedding of Madame Première (Princess Louise Elisabeth) in 1739, the ladies' position on the risers proved to be a veritable political issue, mocked by the satirist Louis Charles Fougeret de Monbron:

> As soon as a pretty woman made her appearance, she was sure to secure a place. Unfortunately, such a large number came that the risers were almost all filled by the time the court arrived. I leave it to the reader to imagine the indignation that inflamed the duchesses, marquises, countesses, and all the women who have the privilege of sweeping the apartments of the Louvre with their comet tails. . . . There was no indication that these great ladies would have the patience to stand around in their high heels, while that colony of plebeian women, seated in great comfort, rubbed it in their faces . . . with a judicious use of their fans. . . . It was immediately decreed that these women would clear out and return to Paris by whatever means they had come.[5]

To their misfortune, the plebeian women of Paris were not allowed to wear court dress, the *grand habit* with its "comet tail" train, which was reserved for ladies related to the king and the royal family or for those officially introduced to them, because of their ancient lineage and royal favor.

Indeed, the *grand habit* was the quintessence of court dress for women (cat. 27). It was an ensemble composed of a very low-cut whalebone bodice with cap sleeves; a skirt placed over a pannier, whose circumference would continue to increase

from the late seventeenth to the late eighteenth century; and a detachable train, sometimes several yards long. The *grand habit* was completed by a collection of accessories in the form of lingerie, lace, and trimmings. Elisabeth Charlotte, the duchesse d'Orléans (called Madame) and sister-in-law to Louis XIV, wrote in 1702, "When one is at Versailles, which is considered the royal residence, all who appear before the king or before us are in *grand habit*."[6] Baroness d'Oberkirch indicated how large the *grand habit* had become by the 1780s, referring to the one she ordered for her introduction at court: "I had the *grand habit* made for me with an enormous pannier, as etiquette requires, and with a *bas de robe,* that is, a train that can be detached. . . . The fabric is gold brocade with naturalistic, admirably beautiful flowers; I received a thousand compliments on it. It required no fewer than twenty-three aunes [ells] of fabric; it was an enormous weight."[7] The baroness also pointed out the physical effort required to wear this outfit, noting that in preparation for the day of her introduction she had to train herself to walk backward while maneuvering her train.[8]

The *grand habit* encapsulates what a costume in the service of power must be: visible above all. It made its presence known by its bulk and the physicality it required and put on display the greatest luxury, both in its fabrics and in its decoration. In the second half of the eighteenth century, the pannier of a *grand habit* could have a width of six and a half to nearly ten feet, and its detachable train could be more than thirteen feet long. Yet it was the trains of women's mantles and mourning cloaks that set records for length. The trains on these cloaks, for which no known illustrations or precise descriptions survive, could exceed twenty-six feet. The one that Madame wore for the formal service held in 1683 at the abbey church of Saint-Denis for the interment of the queen mother, Maria Theresa of Spain, had a cloak "with a train trailing a length of seven aunes" and was borne by three noblemen.[9] The volume of the

Fig. 29. Buttons worn by Joseph de Villeneuve Bargemon on the occasion of his presentation to the court (February 16, 1788), ca. 1788. Paste mounted in silvered copper, Diam. 1⅛ in. (3 cm). Private collection

costumes, then, demonstrated to all eyes the latent symbolism at stake in the representation of power.

Men, paradoxically, did not need a particular court costume. Having been presented to the sovereign at the end of the *lever*, they obtained the favor of following the king on a hunt, mounted on a horse from the royal stables. At most, they would wear a gray and red costume, according to the account of the young François René de Chateaubriand, introduced to court in February 1787.[10] A lavishly adorned suit was indeed necessary, however, to show due respect for the morning ceremony or, at the end of the day, for an invitation to the king's supper (fig. 29).

Another characteristic of court dress was the richness and luxury of its fabrics and decoration, which are described repeatedly in the periodical *Mercure galant* (fig. 30). For Louis XIV's audience with the Siamese ambassadors in September 1686, the king's costume "was completely covered with embroidery. On top, there was several millions' worth of gemstones, which in many places formed the ornamentation of the embroidery. All of the princes' costumes were either embroidered or made of gold brocade covered with gemstones. That of Monsieur [Philippe I, duc d'Orléans, the king's brother] was black, the prince being in mourning dress, and, because that color gave a greater sparkle to the diamonds with which it was embellished, there was nothing more brilliant."[11]

The duchesse d'Orléans in her turn remembered that, for the marriage of the duc de Bourgogne in December 1697:

the crowd was so large that one had to wait a quarter of an hour at every door before being able to enter, and I had a gown and an underskirt so horribly heavy that I could barely stay on my feet. My costume was of gold frisé with black chenille forming a flower pattern, and my set of jewelry [*parure*] pearls and diamonds. Monsieur had a black velvet suit embroidered with gold and all his large diamonds. . . . The king had a suit of gold cloth lightly embroidered at the waist in a blond color [*couleur cheveux*]; . . . the groom was in a black mantle embroidered with gold and a white doublet embroidered with gold and bearing diamond buttons. . . . The bride had a gown and underskirt of silver cloth, with ribbons of the same material, and trimmed with rubies and diamonds. The diamonds she wore in her hair and everywhere were those of the Crown.[12]

The brilliance of precious stones was so indispensable to the representation of power that, for the audience of the Persian ambassador on February 19, 1715, the king did not hesitate to lend his jewels to those in his intimate circle. Louis XIV "chose an outfit in a gold and black fabric embroidered with diamonds; they were worth 12,500,000 livres, and the outfit was so heavy that the king changed his clothes immediately after his dinner. In addition to the gemstones he had on his person, he had lent a set of diamonds and pearls to M. le duc du Maine and a set of colored gemstones to M. le comte de Toulouse."[13]

The glory and magnificence of power were thus expressed through an ostentatious, voluminous, and sparkling costume designed to catch the eye. But some clothing and accessories played an even more precise visual role in court rituals. Such was the case for the king's shirts and the queen's chemises, metaphors for the status of the people who dressed them in these garments. This was also true for the king's hat. With foreign ambassadors and envoys, the king used this accessory not only as a sign of the prestige of the French monarchy and his own political authority but also as a mark of respect for his visitors, according to their family connections and the power of their countries on the world stage. The key importance of the royal hat was manifest at audiences of Muslim ambassadors, who never removed their turbans and whose heads were therefore considered to be uncovered in the king's presence. That determination would give rise to many discussions regarding the king's behavior and that of his intimate circle at the audiences for the Persian ambassador in 1715 and especially for the Turkish ambassador in 1742, among others. In the end, Louis XV removed his hat several times during the Turkish ambassador's reverences at the first audience; at the farewell audience, however, he uncovered his head only at the first bow.[14] Also, when the visitor was incognito, the baron de Breteuil wrote, the king did not wear his hat during the audience, "because incognito is better marked . . . when the head is not covered."[15]

Costumes and accessories, proclamations of the grandeur of the absolute monarchy, performed one final role before the outsider's gaze: they legitimized the monarchy by visually recalling its historical roots. In the eighteenth century, some ceremonial costumes were deliberately archaic, adopting forms that had been in fashion in the late

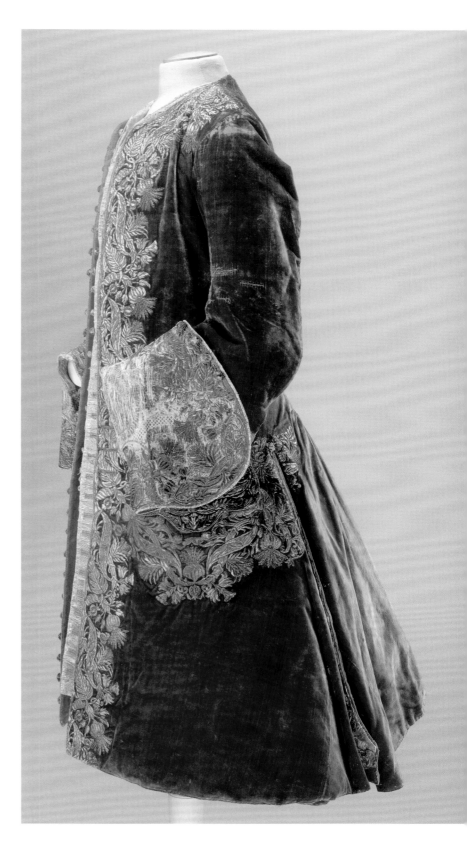

Fig. 30. Frock coat, ca. 1730–40. Brown silk velvet, brocaded lampas, glazed cream linen, silk, satin stitch embroidery, gilded silver thread, and wooden buttons covered with foil and gilded silver thread, H. 45¼ in. (115 cm). Palais Galliera, Musée de la Mode de la Ville de Paris (GAL 1995.104.Xa)

sixteenth century and thus evoking the grandeur of the courts of Henri III, the initiator of French court ceremonial, and especially Henri IV, from whom the Bourbons were descended. Among the guards of the king's Maison Militaire, one company distinguished itself by its old-fashioned ceremonial costumes. The Cent-Suisses, "faithful to their manners and customs," still wore "on days of ceremony . . . the ancient dress of the liberators of Switzerland; the large slashed breeches, the doublet, starched ruff, and plumed cap" (cat. 39).[16] Another example of an archaic costume that combined a doublet and trunk hose was the novice's costume for the Order of the Holy Spirit, which future knights wore under their mantles.

Outdated costume was also worn for betrothals or weddings at court in the early eighteenth century. As the baron de Breteuil notes, this practice was dropped for the marriage of the duc de Berry in 1710:

> The ordinary costume in which one is married and betrothed at the king's palace, both princes of the royal family and courtiers, is a full suit of clothes with mantle, doublet, and trunk hose. But the duc de Beauvillier, First Gentleman of the Chamber and Grandmaster of the Wardrobe for that prince, whose governor he had been, told us that Monseigneur le duc de Berry's weight prevented him from having a doublet made for him, and furthermore that, for the last few years, the king has worn for his greater comfort a *justaucorps* under his cloak on the feast days of the Order of the Holy Spirit, and the dukes have for a short time worn a similar costume at Parliament.[17]

In the eighteenth century, in fact, the practice of wearing that cumbersome and archaic ceremonial costume gradually fell away. Among the men, fitted coats (*justaucorps*) and breeches took the place of doublets and trunk hose. The *grand habit* for women, as seen in a painting of Marie Leszczyńska (fig. 31), was gradually replaced for use in less formal circumstances by the *robe de chambre,* a voluminous gown with pleats in the front and back, from the neck down to the hem, worn over whalebone stays and a pannier. An anecdote reported by the duc de Luynes for March 5, 1749, highlights this shift in clothing styles. Marie Leszczyńska asked the king to allow her, in his absence, to attend mass in a *robe de chambre* and not a *grand habit,* on the pretext that she sat at such times in the gallery instead of on the ground floor in the Royal Chapel. The king having agreed, the duke added that, on March 6, the queen did indeed attend mass in the gallery "without being in full dress."[18]

Court dress thus became part of a cycle of tensions and oscillations between formal costumes and the fashionable clothing worn in town. Town clothes were more comfortable, displayed current tastes, and were more modern than those produced by the machinery employed for court garments. They thus became increasingly prevalent in the everyday life of the court, evidence of a gradual relaxation of the rules of etiquette. For example, the Swedish Madame de Linange and her sister, Madame la comtesse d'Hamilton (the wives, respectively, of a German and a Scotsman in the service of the king of Sweden), wore *robes de chambre*[19] when they were received by Marie Leszczyńska at an audience, albeit private, in September 1749.

The gradual replacement of the *grand habit* by the *robe de chambre* for less formal circumstances was particularly noteworthy when the Versailles court traveled to the other palaces, as the duc de Luynes regularly indicates in his memoirs. On September 29, 1749, for example, he wrote, "The practice, as everyone knows and as I have noted, is to allow, on the occasion of journeys by the court, the women who have the honor of following

Fig. 31. After Louis Tocqué, *Marie Leszczyńska, Queen of France,* 1740. Oil on canvas, 88 × 60⅞ in. (223.5 × 154.5 cm). Musée National des Châteaux de Versailles et de Trianon (MV 4390)

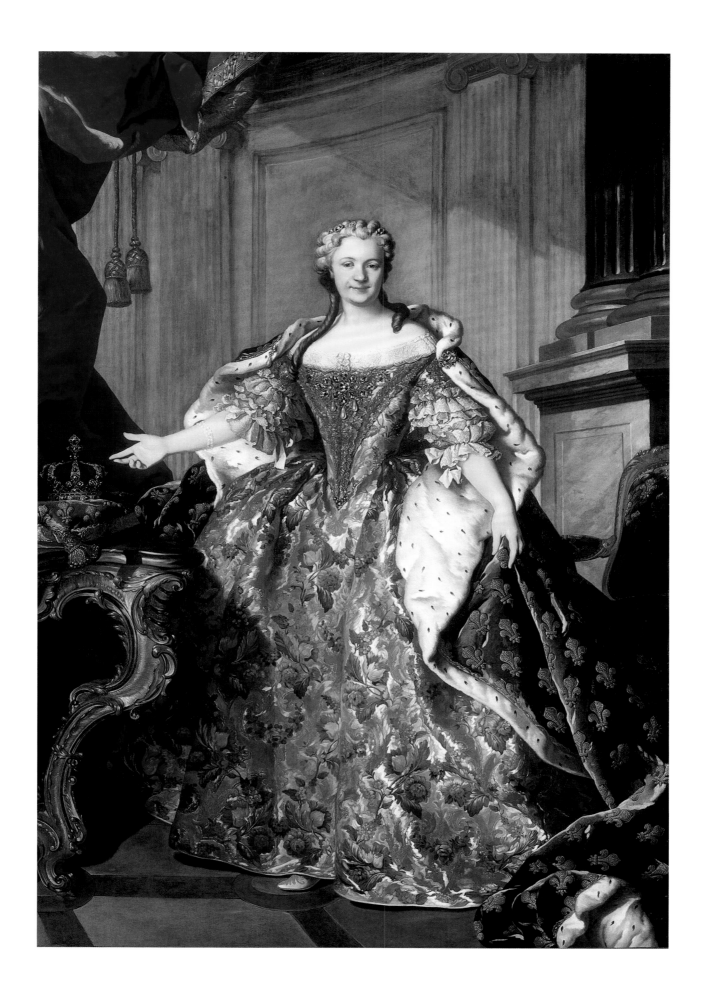

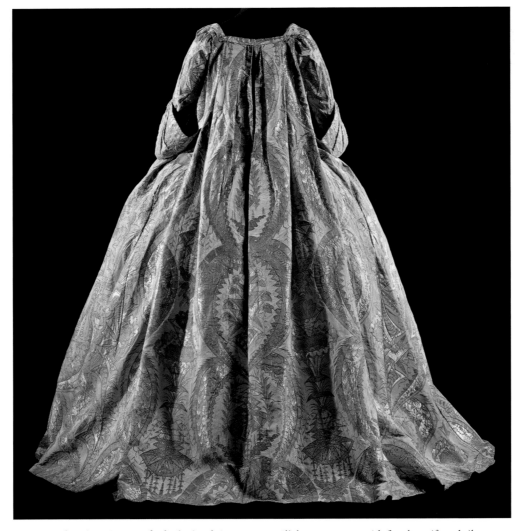

Fig. 32. *Robe volante* (a type of *robe de chambre*), 1720–30. Silk lampas woven with floral motifs and silver thread, H. 78¾ in. (200 cm), D. 59 in. (150 cm), W. 70⅞ in. (180 cm). Palais Galliera, Musée de la Mode de la Ville de Paris (GAL 2016.281a)

Their Majesties to don *robes de chambre* the day before departure, or even two days before. Since Mesdames [the king's daughters] are leaving the day after tomorrow, the king allowed them, and therefore the ladies who have the honor of following them, to be in *robes de chambre* as of today" (fig. 32).[20] In 1753, writing about Louis XV's visit to the newlywed Madame la princesse de Condé, who received the king in *grand habit*, the duke explained that this "ancient practice" "was almost no longer in use, because the current fashion is to do away with all things ceremonial, even the most commendable, for the sake of convenience."[21]

In the second half of the eighteenth century, the attire worn at court became more and more simple: the *grand habit*, cloaks, mantles, and the uniforms of the various orders were increasingly confined to official ceremonies. Town fashions now dominated at Versailles, with their slimmer silhouettes, fabrics light in weight and color, and subtle patterns. Henceforth, it was these fashions that memoirists and travelers most often described in their writings. During the particularly hot summer of 1778, Marie Antoinette, pregnant at the time with her first child, and the princesses would regularly cool off in the gardens while

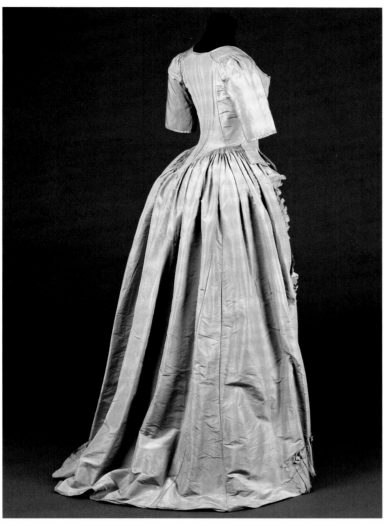

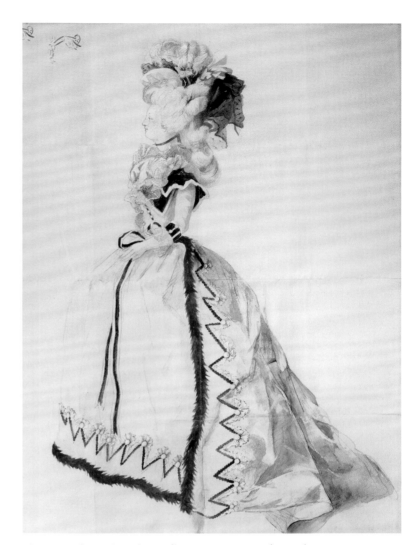

Fig. 33. *Robe à l'anglaise*, ca. 1785. Shot silk tabby or taffeta, ribbon, silk satin, H. 59⅞ in. (152 cm). Palais Galliera, Musée de la Mode de la Ville de Paris, Gift of Mrs. Aucoc (GAL 1960.64.1)

Fig. 34. *Marie Antoinette in a Redingote*, ca. 1780. Graphite and watercolor on paper, 23⅝ × 18⅛ in. (60 × 46 cm). Östergötlands Museum, Linköping, Sweden (ÖM.ÖML.001983)

listening to musicians set up on risers. As Madame Campan reported, "It is true that all the residents of Versailles wanted to enjoy these serenades, and that there was soon a crowd from eleven o'clock at night until two or three o'clock in the morning." The queen, Madame, and Madame la comtesse d'Artois were dressed "in white percale gowns with large straw hats and muslin veils (a costume universally adopted by women)."[22]

Sophie von La Roche also observed this taste for elegant simplicity at a party given by the queen on June 27, 1785. A privileged spectator—she was admitted into the large tent set up in one of the groves—she noted the good-sized meadow reserved for the townspeople and the *danses champêtres* held in the queen's garden, open to "high-ranking persons." The queen was "simply and lightly dressed in a mauve taffeta gown, a white underskirt and bodice with a pink belt, a large muslin collar, and a simple straw hat."[23] Madame was in a "pale blue satiny gown," the comtesse d'Artois in white silk crepe, the young royal princess in white linen, the duchesse de Guiche in "lightweight brown moiré taffeta," and the ladies of the court in white bodices and skirts "with a pinked edge and no trim at all" (figs. 33, 34).[24]

Fig. 35. Joseph Siffred Duplessis, *Benjamin Franklin*, 1783. Pastel, 28¼ × 23½ in. (73 × 59.7 cm). New York Public Library, Astor, Lenox, and Tilden Foundation

This taste for simplicity, promoted by the fashion of the time, was shared by Louis XVI, but in his case no doubt out of natural modesty. The king confined himself to solid colors, gray or brown cloth, except on Sundays and days of ceremony, when "the most beautiful fabrics, the most precious embroidery, in silk, gold, or sequins," embellished his clothing.[25] Thomas Bentley, business partner of the famous British ceramist Josiah Wedgwood, confirmed the economy of dress during his visit to Versailles in 1776, noting that "the dresses at court were not magnificent. His Majesty was in a dark chocolate-coloured silk stuff, with large yellow buttons. . . . The

gentlemen in general were in plain or figured silk coats."[26]

The sartorial restraint in the everyday life of the royals seems to have resonated with Benjamin Franklin, who, according to Madame Campan, was introduced to the court in the late 1770s "in the costume of an American farmer: his flat and unpowdered hair, his round hat, and his brown cloth suit contrasted with the sequined, embroidered suits and the powdered and perfumed coiffures of the courtiers at Versailles."[27] Although he dressed simply, in the British fashion (cat. 13), Franklin ensured that his wardrobe was augmented while he was in Paris, particularly after he was named minister plenipotentiary in 1779. Between February and October 1779 he purchased four complete suits in the French style, cut from elegant and refined fabrics: vicuña wool, blue- and purple-tinged royal gray cloth, and "plum-colored" silk (fig. 35; cat. 163).[28] In the following years, he continued to expand his wardrobe, demonstrating a taste for velvet and fine Louviers cloth.[29]

It was the custom, in fact, for illustrious visitors to dress up when going to the court and to adopt French clothing out of deference. As the duc de Luynes notes regarding the ambassadors from the Republic of Venice who arrived at court on April 23, 1748, "The customs of the ambassadors of Venice are different from those of the other ambassadors. They stay here for only three years; the first year, they are as good as incognito. At the first audience, they are dressed in their Venetian court robes; at their farewell audience, they are dressed as Frenchmen."[30] The type of visit influenced the code of dress. A man invited to participate in the royal family's activities would wear a beautiful French suit, adorned more or

Fig. 36. Jean-Baptiste Bonnart, "Madame," fol. 15 from *Collection des estampes illuminées, représentant le siècle et la cour de Louis le Grand*, 1695. Engraving, 12⅞ × 8¼ in. (32.6 × 21.2 cm). Musée National des Châteaux de Versailles et de Trianon (GR 213)

I.B.F. Chez N. Bonnart, ruë S.t Iacques à l'Aigle auec priuil. du Roy

Madame

Sans les rares Vertu, qui brillent dans son âme Dans le deüil de la Cour couuert d'obscurité,
Et qui sçauent si bien marquer sa qualité; On ne connoitroit pas quelle seroit Madame.

Fig. 37. Embroidered suit panel, ca. 1780–85. Silk satin, silk embroidery, 50 × 22½ in. (127 × 57 cm). Palais Galliera, Musée de la Mode de la Ville de Paris (GAL 13535 D 32A)

less richly to fit the occasion (cat. 17), while a woman, depending on the circumstances, would have on a *grand habit*, a *robe à la française* (cat. 25), or a lighter, fashionable gown. To attend royal activities, one simply had to be nicely dressed, not *in full dress*.

In his guide for travelers to Paris, published in 1727, Joachim Christoph Nemeitz drew attention to the need to order a coat decorated with braid and trimming, so that the officers of the royal guard would usher one into the palace, since "one must sometimes appear at court on formal occasions, which are not to be missed by the curious traveler."[31] Braid on one's coat was a clever way to pass for an officer. Furthermore, because Versailles was often in mourning, it was necessary to arrange for mourning clothes, which allowed one to enter under such circumstances (fig. 36).[32] In that regard, Paris offered all the commercial amenities to outsiders, particularly the men, who could easily buy what were known as garments "in pieces," composed of lengths of preembroidered cloth, which their tailor would assemble for them (figs. 37, 38; cat. 14). Women, especially if they had to have a *grand habit* tailor-made and decorated, were more at the mercy of suppliers, especially *marchandes de mode* (fashion merchants), who were not always available. Baroness d'Oberkirch notes, for example, that she was obliged to settle for the *marchand* Beaulard because the famous Marie Jeanne "Rose" Bertin was too busy.[33] In 1785 La Roche confirmed that anyone could go to the Hall of Mirrors, "provided one is properly dressed." "Everyone here can see the king, his family, and the court on their way to church, as they pass through that gallery and the six adjoining rooms."[34] On June 7, the author borrowed a black gown to go to court, which was in mourning at the time, explaining that she could not in all propriety visit if she did not conform to the rules of etiquette currently in force.[35]

The idea that one had to be properly attired is, however, contradicted by Bentley, who

remarked on commoners wearing sabots at the royal residence. "Many very ordinary people admitted to the pleasure of being at court, and walking in these fine apartments. Several women in *sabots,* the heeled slippers that almost all the lower and middling kind of people wear from Calais to Versailles, and I suppose through all the kingdom."[36] This observation tallies with that of Arthur Young, who was moved by the presence, even in the king's bedchamber, in 1787, of "men whose rags betrayed them to be in the last stage of poverty."[37] Some twenty years earlier, the Reverend William Cole noted that, when he was visiting Versailles, the court had retired to Fontainebleau.[38] The king's presence or absence, as well as the desire to witness his public activities, created different conditions for visiting the royal residence. That no doubt explains the apparent contradictions in travelers' accounts.

Although Versailles was largely open to outsiders, the costumes sported by them depended on their rank, their position, and the objective of their visit. Caught up in interpersonal role-playing, visitors were indeed both actors and spectators: they had to react to a theatricalization of dress, whether governed by the assertion of absolute power or by the display of a controlled casualness, even as they too, with their own attire, had a part in the play. These exchanges of looks highlight a constant in the way dress has been considered since the sixteenth century. Clothes can deceive—the vestment makes or unmakes the monk, as the humanist François Rabelais put it— hence the importance and essential role of costume in the representation of nations and royal power. Travelers to Europe had no illusions on that score and dressed by turns as Frenchmen, Englishmen, or Dutchmen depending on the country they were visiting. Dress is truly a language, and it was not unintentionally that Laurence Sterne had the unschooled hero of *A Sentimental Journey* refer to tailored clothing when reflecting on the difficulties of communication across cultures. The

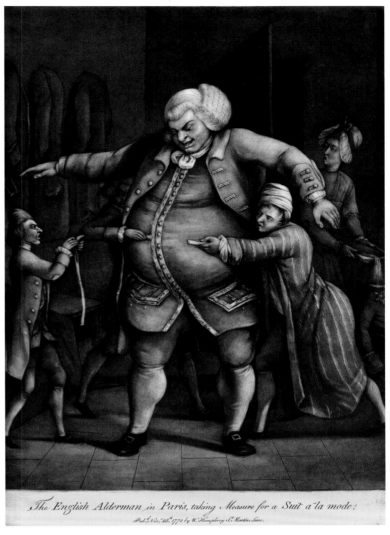

Fig. 38. Unknown artist, *The English Alderman in Paris, Taking Measure for a Suit à la Mode!*, 1772. Mezzotint, 14 × 9⅞ in. (35.5 × 25 cm). British Museum, London (2010,7081.353)

hero, seeking to submit a petition to the duc de Choiseul, and knowing that his self-presentation was important, notes, "Then nothing would serve me, when I got within sight of Versailles, but putting words and sentences together, and conceiving attitudes and tones to wreath myself into Monsieur le Duc de C—'s good graces.—'This will do,' said I.—'Just as well,' retorted I again, 'as a coat carried up to him by an adventurous tailor, without taking his measure.'"[39]

13 Suit

British, 1755–65

This suit of unadorned wool broadcloth reflects the British preference for simple, informal menswear and practical but fine-quality fabrics. This mode of dress, the product of a society less centered on the royal court, would become influential in the last quarter of the eighteenth century in France, where it was associated with political values such as liberty and egalitarianism. In the 1760s, a British gentleman traveling to France may have worn such a suit, only to leave it off in favor of a more lavishly trimmed style in the French taste. A British naval officer touring France advised that his countrymen should, on arrival, dress "*a la mode de France*," with silk stockings, lace cuffs, and powdered hair, to assure themselves a greater level of respect while visiting the country.[1] JR

14 Embroidered Panels for a Man's Suit

French, 1780s

John Adams, the American minister plenipotentiary to France, wrote in his diary in 1782, "The first Thing to be done, in Paris, is always send for a Taylor, Peruke maker and Shoemaker, for this nation has established such a domination over the Fashion, that neither Cloaths, Wigs nor Shoes made in any other Place will do in Paris."[1] Consisting of multiple pieces, comprising the cuffs, collar, and front panels for the waistcoat (including pocket flaps, vents, and buttons in two sizes) as well as knee bands for the breeches, this suit was ready to be cut and sewn to the client's specific measurements. Such *habits à la disposition* allowed visitors to dress themselves quickly according to the latest French taste. The colorful floral embroidery, combined with white netting, against a purple figured-silk ground not only guaranteed that the wearer would cut a dashing figure but also testifies to the high quality of French needlework. DK-G

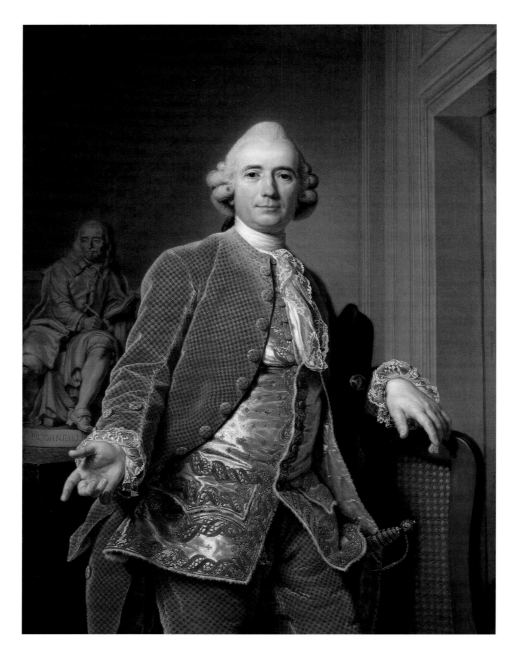

15 *Jean Jacques Caffiéri*

Adolf Ulrik Wertmüller, 1784

Wertmüller submitted this portrait in 1784 as a *morceau de réception* to gain admission to the Académie Royale.[1] A visual record of one of the esteemed institution's members, the formal depiction shows the sculptor Caffiéri dressed in a *habit à la française* of luxuriant red velvet lined with lustrous, slightly puckering white satin and a ditto satin waistcoat trimmed with gold braid and embroidery.

Lace embellishes the cuffs of his shirt and jabot. Wertmüller has rendered the various materials with admirable verisimilitude. Wearing a powdered wig, the sitter is attired as a gentleman, with a tricorne under his arm and a dress sword at his side, as if ready to visit Versailles. Only the background sculpture of Pierre Corneille, one of Caffiéri's most famous works, refers to his profession. DK-G

16 Suit (*habit à la française*)

French, 1780s

Composed of a matching coat and breeches of
voided silk velvet with black stripes against a red
ground, this suit is enlivened with silk embroidery
in a pattern of daisy sprays and completed with
a coordinating waistcoat of embroidered silk
satin. The splendor of the formal French suit,
or *habit à la française*, featuring richly patterned
and ornamented fabrics, exemplifies the skill of
French textile designers, weavers, and embroi-
derers and speaks to France's dominance in
fashion. By the 1760s, the *habit à la française* was
adopted as the court dress throughout Europe.
Although the identity of the original wearer of
this suit is not known, stitch lines at the left breast
of the coat suggest he was the recipient of a
chivalric honor. JR

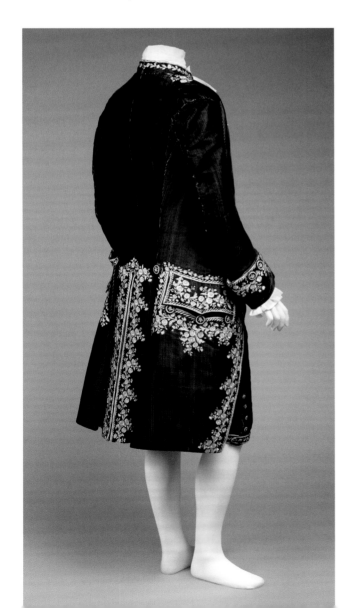

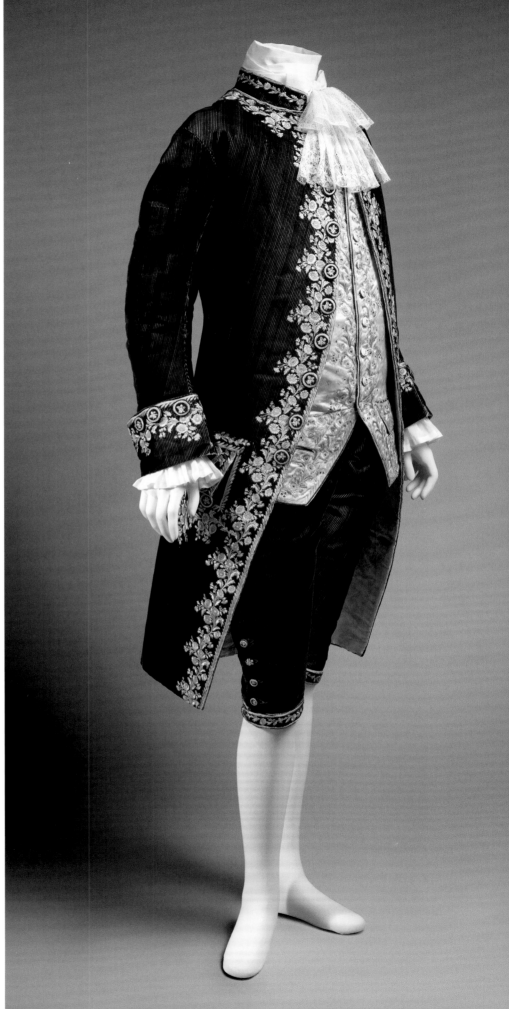

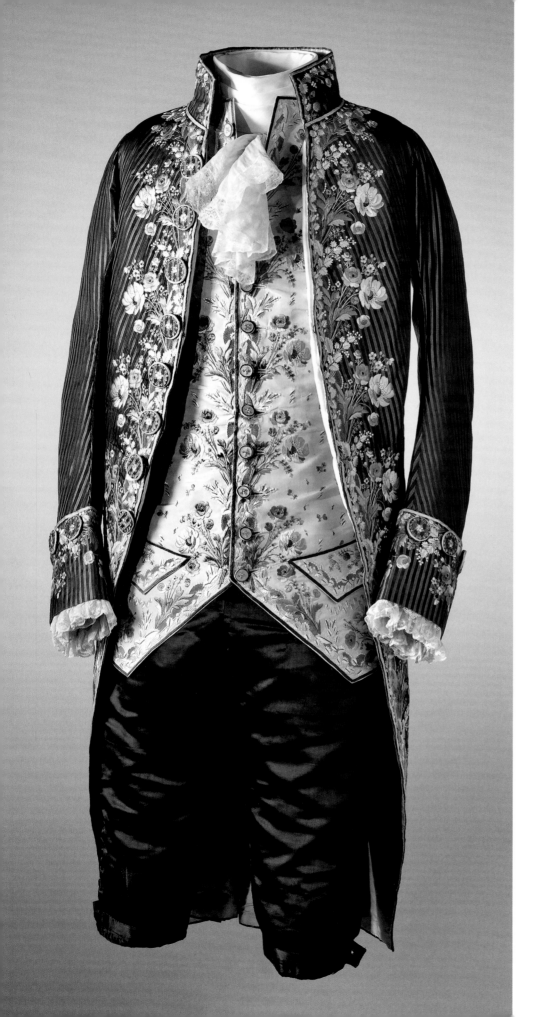

17 Suit (*habit à la française*)

French, 1780s (modern breeches)

Consisting of a gray striped-silk coat with floral embroidery along the edges and a waistcoat of plain white silk but with matching needlework decoration, this French suit belonged to Count Axel Fersen the Younger. Tall and handsome, Fersen was a member of an influential Swedish aristocratic family and served as a diplomat and a soldier. He visited France on his Grand Tour in 1773–74, when he first met Marie Antoinette.[1] He was presented at court in 1778[2] and later distinguished himself during the War of American Independence. During Gustav III's 1784 incognito visit, Fersen returned to Versailles in the king's retinue and may well have worn this exquisite suit, which originally had matching breeches, while at court.[3] Developing an intimate friendship with the queen, the Swede corresponded regularly with her. In 1791 he helped organize the royal family's unsuccessful escape from the Tuileries Palace. DK-G

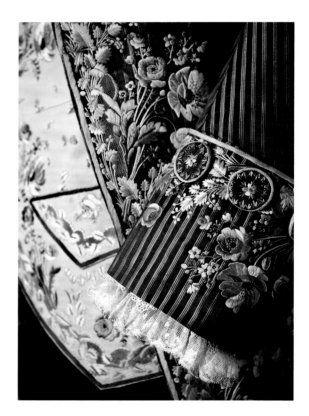

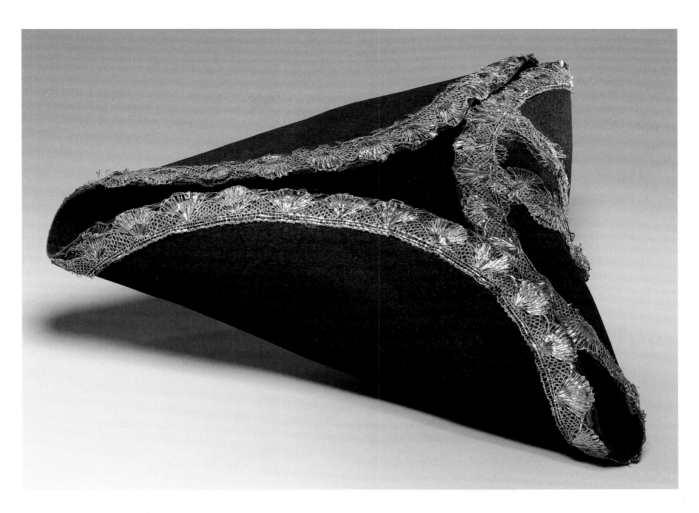

18 Tricorne

Italian, mid-18th century

During the reign of Louis XIV, a three-cornered hat such as this example of black felt trimmed with silver lace became an indispensable accessory for the man of fashion. As wigs grew increasingly elaborate in the early eighteenth century, these hats were worn under the arm, so as not to disrupt the coiffure. Carried in this manner, they were a test of elegant deportment and a required feature of French court dress. So essential were these accessories for appearances at court that the marquise de La Tour du Pin noted in her memoirs that her cousin, returning to France in 1779 with news of a military victory over the British, was not permitted to appear before the king in military uniform, but had to quickly borrow a court suit, sword, and *chapeau bras.*[1] JR

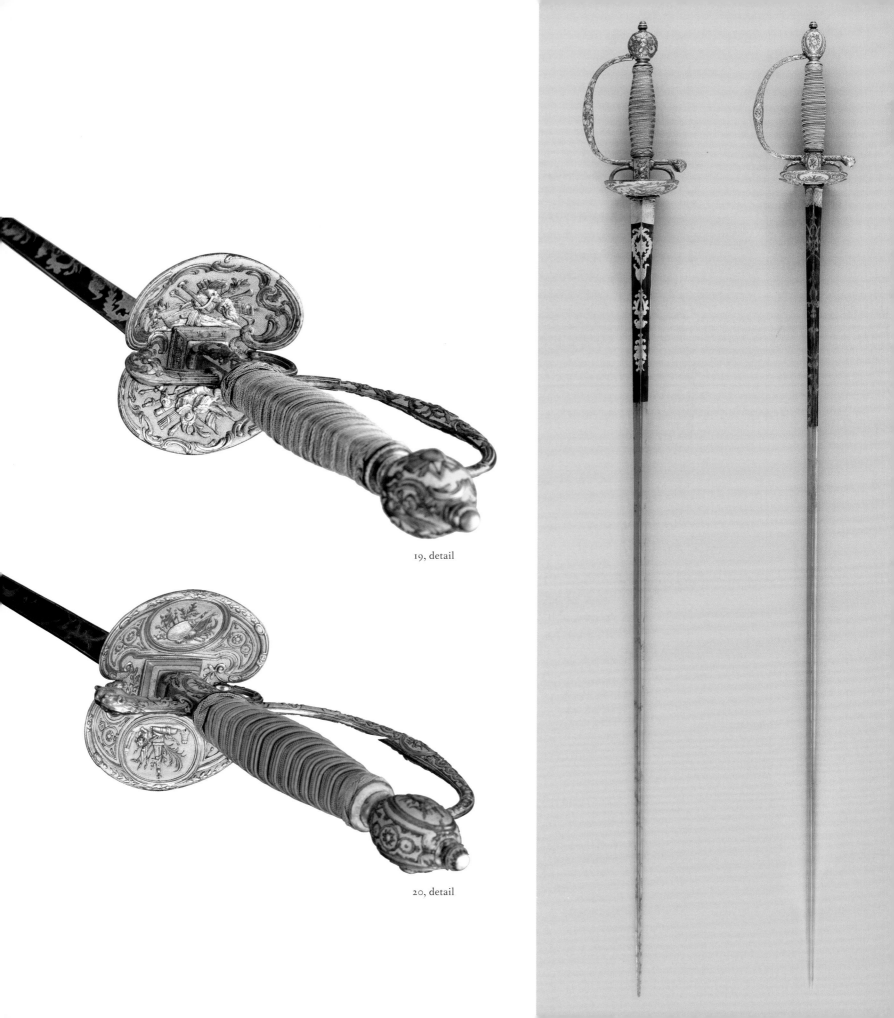

19, detail

20, detail

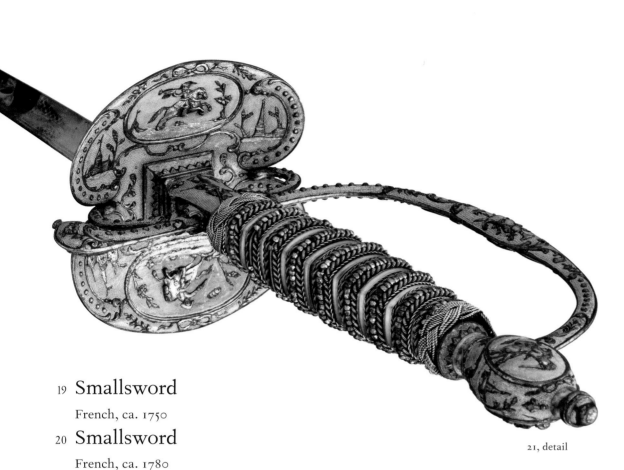

19 Smallsword

French, ca. 1750

20 Smallsword

French, ca. 1780

21 Smallsword with Scabbard

French, ca. 1780

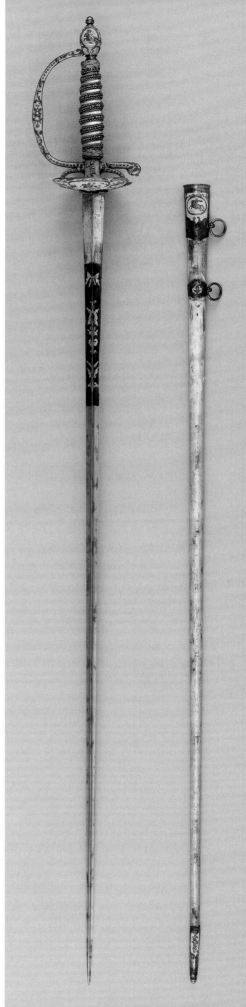

21, detail

For more than one hundred years, from the last quarter of the seventeenth century on, smallswords were the most stylish edged sidearm in western Europe. Carried by civilians and the military alike, they were light and ideal for thrusting, with fully developed French examples typically featuring thin, tapering blades of triangular section. Smallswords were an essential component of the dress code for gentlemen visitors to Versailles, and the finest displayed exquisite, jewel-like decoration. The polished steel hilts of these three are elaborately chiseled in relief, with gold foil set in the recesses and punched to yield a contrasting matte finish. Their rococo flourishes and cartouches with military imagery reflect fashionable decorative themes of the period.

One exceptionally preserved sword (cat. 21) brilliantly captures the level of finish the most talented *fourbisseurs* (sword-cutlers) could achieve. On its shell the gold foil has been expertly worked to yield varied textures—a smooth, flat matte for the sky within the cartouches, a grainy sparkle for the slivers of ground beneath the horsemen. Delicately chiseled buildings as well as strings of nailhead ornament, ribbons, and leaves, all set against precisely dotted foil, fill out the miniature landscapes. C. Liger, who signed the blade of this sword, produced some of the most lavish smallswords in late eighteenth-century Paris, including presentation examples commissioned by the United States Congress. JB

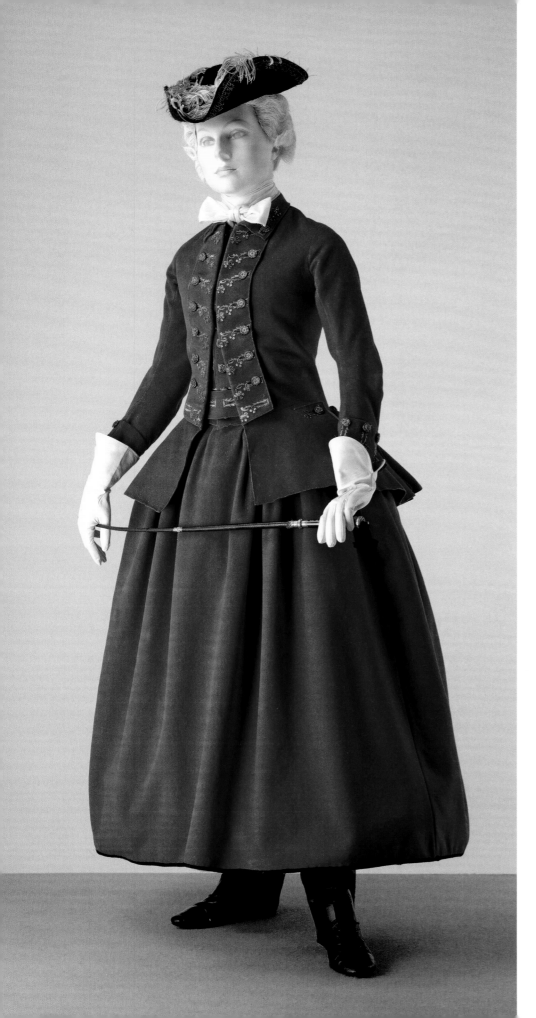

22 Riding Habit

British, early 1770s

A woman's riding habit consisted of a fitted jacket tailored similar to a man's, complete with cuffs, pockets, trim, and buttons, but combined with a pleated, flared skirt rather than breeches. The shorter skirt, leaving the wearer's feet uncovered, allowed for greater freedom of movement and made the outfit suitable for traveling and horseback riding. Frances Anne Hawes, Viscountess Vane, described in her memoirs how the French "complimented me on my person, and seemed to admire my dress, which was altogether new to them, being a blue English riding habit, trimmed with gold, and a hat with a feather."[1] This type of informal British dress influenced eighteenth-century hunting costumes in France. DK-G

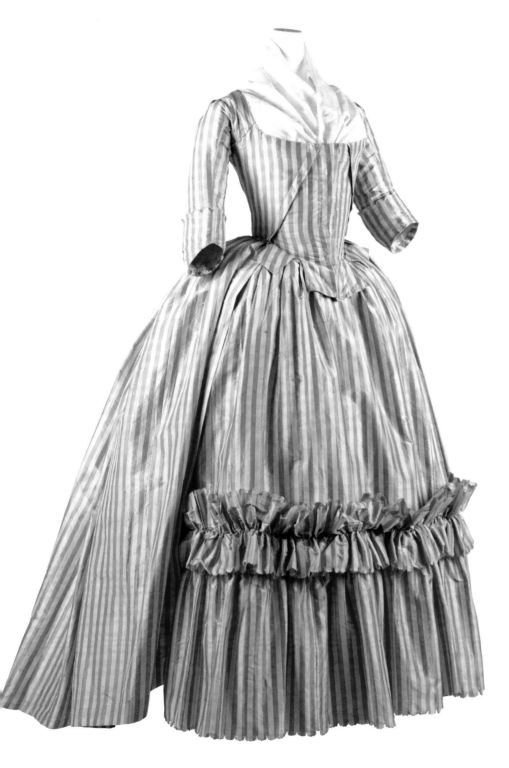

23 Dress (*robe à l'anglaise*)

French, 1785–87

24 Pair of Shoes

British, 1780s

The refined simplicity and neat tailoring typical of informal British dress grew increasingly influential in France during the latter half of the eighteenth century. By the 1770s, French fashion magazines regularly featured British-inspired styles such as the *robe à l'anglaise*, which dispensed with the loose back pleats of the *robe à la française* in favor of a tightly fitted bodice. The *Magasin des modes nouvelles* noted the ubiquity of this style in its June 20, 1787, issue, which also praised its modest charm.[1] This *robe à l'anglaise* of striped silk taffeta is cut *en fourreau*, that is, with back panels that extend from bodice to skirt without a waist seam, and is discreetly ornamented with a pinked self-fabric ruffle. Worn over hip pads rather than hoops and with a shorter skirt suitable for walking, the gown would have been appropriate for a stroll in the gardens of Versailles and might have been combined with an elegant straw hat and heeled shoes such as this pair of silk satin. JR

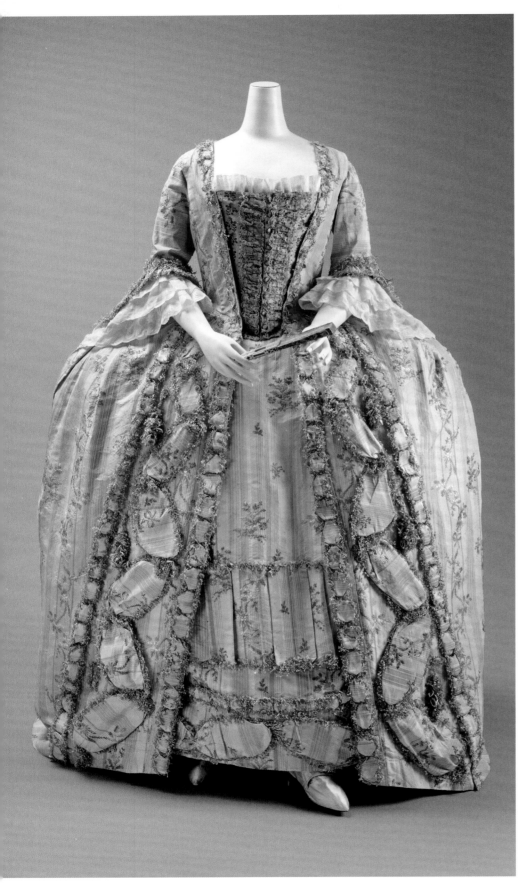

25 Dress (*robe à la française*)

French, ca. 1770–75

The *robe à la française*, or "sack" in English, was characterized by freely flowing back pleats that extended from shoulder to hem. To support its full skirt, it was worn over a wide pannier, or hoop, which by the 1770s was largely abandoned except at court. A woman at court displayed her status and good breeding not only through the rich textiles and lavish trimmings of her garments, but also through her elegant negotiation of the cumbersome hoop, a learned skill intended to give the impression of natural grace. It is not known who wore this splendid example made of silk faille brocaded with floral garlands and bouquets and adorned with serpentine self-fabric ruchings and fly fringe. Formed by knotting and clipping the threads of silk floss that branched from a core of silk cord, the fly fringe here is perfectly coordinated to the color of the dress silk, a sophisticated pairing probably made by a *marchande de mode* (fashion merchant). JR

26 Dress (*grande robe à la française*)

French, 1775–85

This dress is believed to have been worn by one of the wives of Christophe Philippe Oberkampf, a successful cotton-printing entrepreneur, for a visit with Marie Antoinette. The silk brocade, woven in Lyon, shows a complex weave structure with a fanciful pattern of multicolored bouquets combined with a meandering motif of fur tufts. Featuring a tight, funnel-shaped bodice and a petticoat worn over a pannier, the gown has tight sleeves with double flounces at the elbow and a pleated back ending in a modest train. Oberkampf, whose factory was in Jouy-en-Josas, near Versailles, married Marie Louise Petiteau in 1774 and, following her death, Anne Michelle Elisabeth Massieu in 1785. The dress could have belonged to either of his wives and remained with descendants of the family. Although no account of a visit to court appears to have been preserved, Pierre Philippon, teacher of the Oberkampf children, remembered that Marie Antoinette wished to meet the manufacturer.[1] DK-G

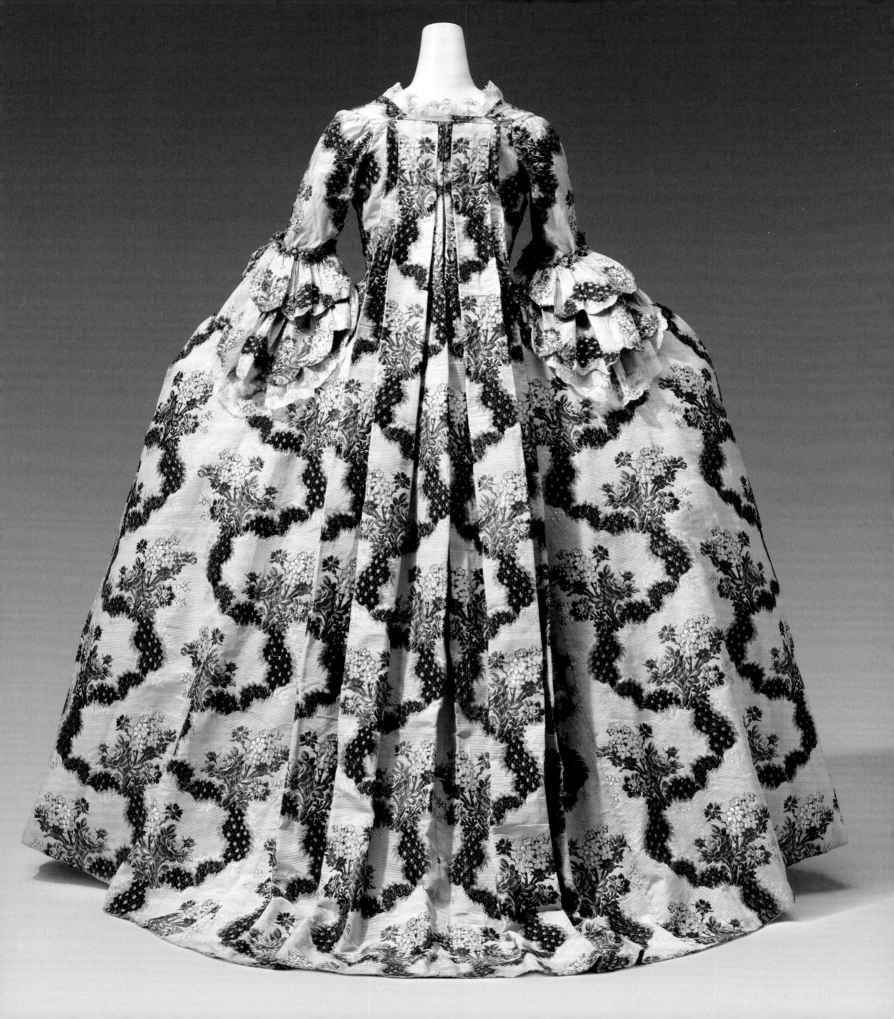

27 Doll's Court Gown (*grand habit de poupée*)

French, ca. 1769–75

For presentation to the king and other ceremonial occasions at Versailles, women were required to wear a *grand habit*, or formal court gown, which could not be used more than once without substantial alterations. Consisting of a low-cut bodice leaving the shoulders bare, a petticoat worn over an enormous pannier, and a long train, the *grand habit* certainly did not reflect the latest fashion trends and, in fact, was rather antiquated by the mid-eighteenth century. Adding considerably to the overall cost was the exquisite trimming of the expanse of silk with metal lace, spangles, artificial flowers, or jewels, as is beautifully demonstrated by this miniature court dress. It is thought that *marchandes de mode* such as Rose Bertin used these so-called fashion dolls as precursors of modern mannequins to show off their abilities. DK-G

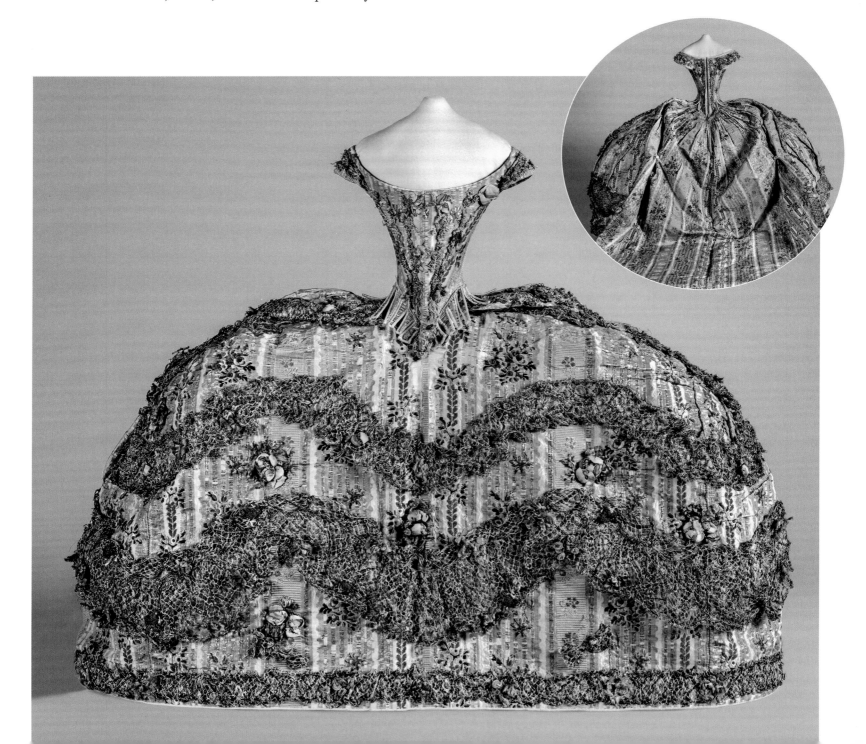

28 Formal Ball Gown (*robe parée*)

Attributed to Marie Jeanne "Rose" Bertin, 1780s

A luxury very few could afford, richly embellished ball gowns such as this show the refinement of French eighteenth-century court dress. The metallic threads, sequins, and glass stones must have sparkled by candlelight. The petticoat, originally worn over a large pannier (but altered in this example), increased the volume and weight of the dress and, in combination with the train, made it difficult for the wearer to dance freely.[1] Although it is not known who commissioned this

rare surviving example embroidered with peacock and pheasant feathers, naturalistic flowers, ribbon festoons, and bows, it may have been the work of Rose Bertin, the most famous of the *marchandes de mode* who dressed Marie Antoinette. Bertin is documented in 1791 as having sold the queen a court gown similarly decorated with ribbon and feather motifs, but it is impossible to tell if she was responsible for this earlier one as well. DK-G

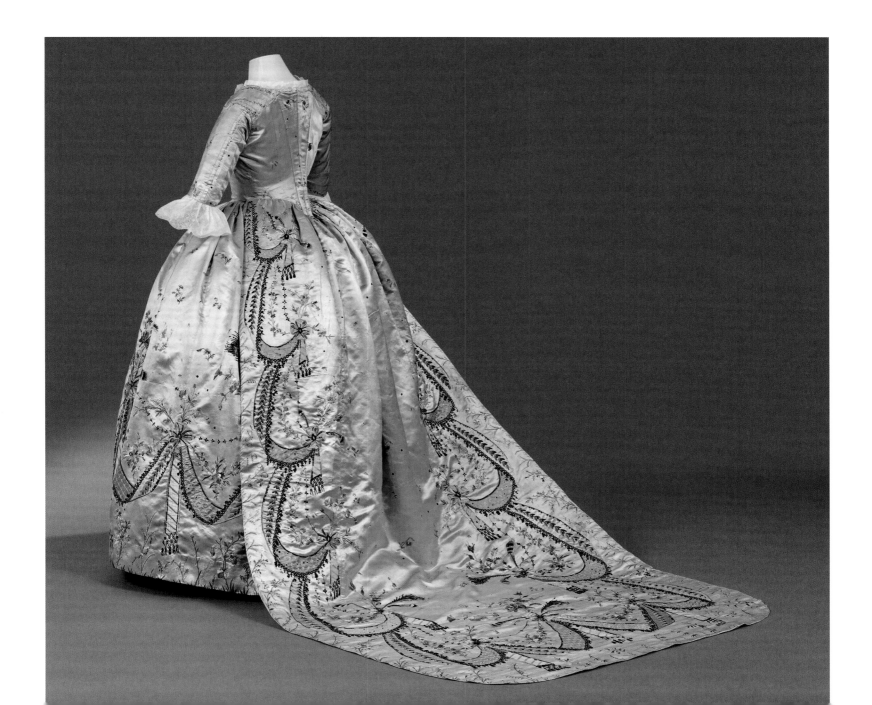

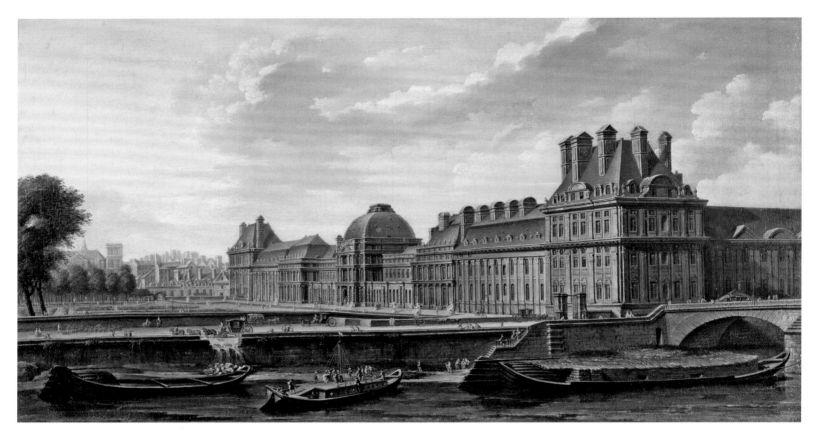

29 *The Tuileries Palace Seen from the Seine*

Nicolas Jean-Baptiste Raguenet, 1757

Specializing in views of Paris, Raguenet included the Seine frequently in his compositions, which rendered the traffic on the water as well as on the quays in great detail. In this painting, various vessels are seen near the arched Pont Royal, the bridge crossing the river at the Tuileries Palace. It was there, at eight o'clock in the morning, that visitors could board a small barge, known as a galliot, that would take them to Saint-Cloud or Sèvres, from where it was a "most delightful walk to Versailles," according to the British travel writer Sacheverell Stevens.[1] Charging only four sols per passenger in 1716 (and six in 1756), the journey by water was the least expensive way to travel to Versailles.[2] DK-G

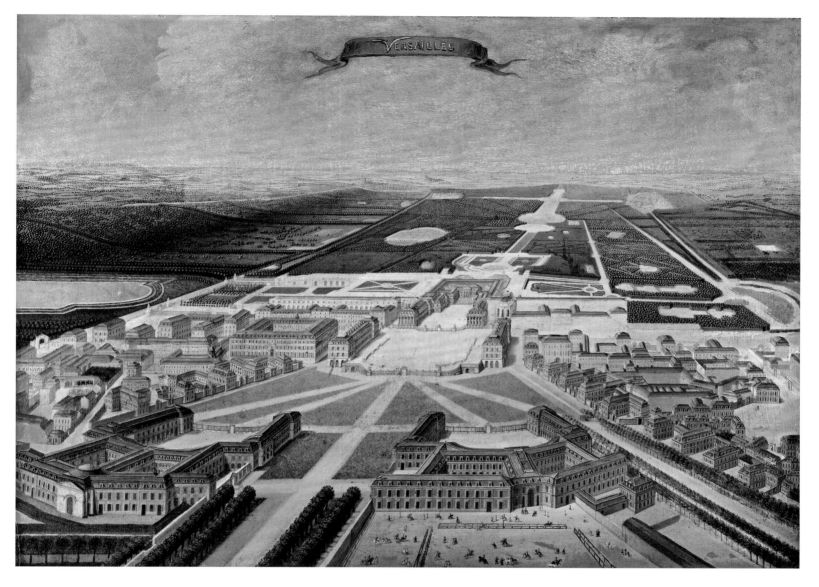

30 *Panoramic View of Versailles*

French, early 18th century

This bird's-eye view of the town, palace, and park of Versailles shows the three avenues leading respectively from Sceaux, Paris, and Saint-Cloud to the Place d'Armes in front of the royal residence. Many visitors would have used one of these roads, traveling in a carriage (their own or a hired one) or by the stagecoach that left Paris twice a day from the Rue Saint-Nicaise.[1] The crescent-shaped Small and Large Stables, constructed by the architect Jules Hardouin-Mansart between 1679 and 1682, are depicted in the foreground; the visiting British physician Ellis Veryard mistook the stables for palaces in their own right.[2] The town's Saint-Louis neighborhood stretches to the left and the Notre-Dame neighborhood, named for the parish church, to the right, while the Swiss Lake, a large pond in the gardens of Versailles, is clearly visible on the left-hand side and the Grand Canal in the distance. DK-G

31 *View of the Château de Versailles from the Place d'Armes*

Pierre Denis Martin the Younger, 1722

After the death of his great-grandfather Louis XIV, on September 1, 1715, the five-year-old Louis XV was placed under the tutelage of the regent, Philippe II d'Orléans, who moved the court back to Paris. On June 15, 1722, the young monarch reestablished the court at Versailles. Well acquainted with the topography of the site, Martin represented the hustle and bustle of the royal residence at the time of the court's return. The palace is shown from the east with its three courtyards, each closed by metal gates, and, at its heart, the King's Bedchamber. Stone carvers are at work in the foreground, while the carriage of the prince de Conti as well as wagons and horses wend their way between them. Beyond the first gate, in the Ministers' Courtyard, stands an honor guard composed of the regiment of the Swiss Guards in red coats and blue breeches on the right and that of the French Guards in blue coats and red breeches on the left. GF

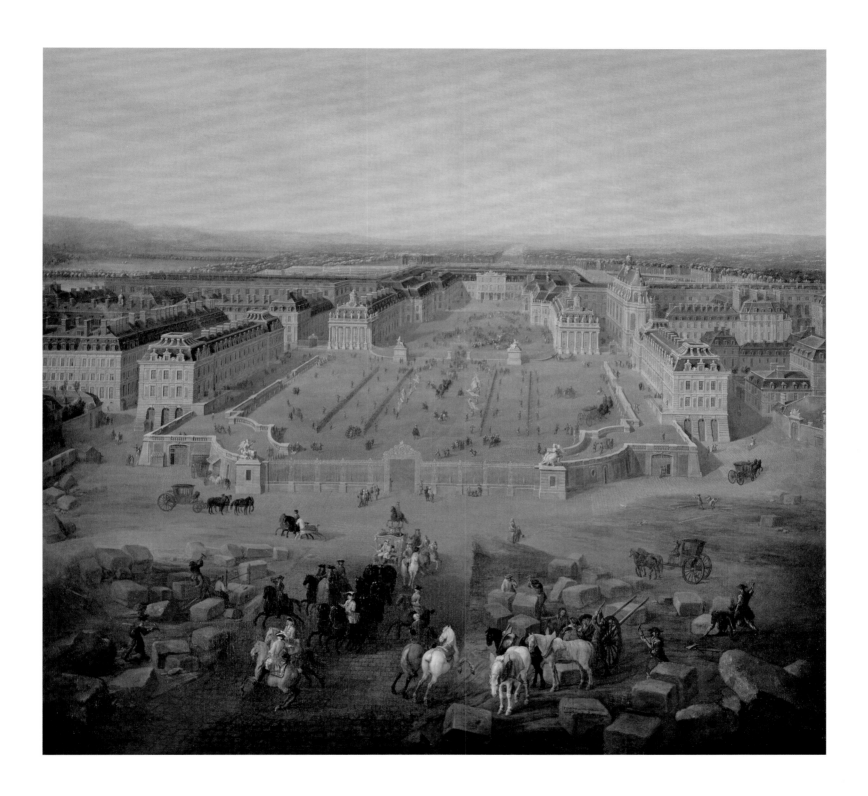

32 Folding Screen

Charles Cozette, ca. 1768–70

Their forecourts bustling with life, the palaces of
Versailles (right) and Fontainebleau (left) appear
on this folding screen, whose trompe l'oeil curtains
on either side create a sense of theater. Could these
depictions be the ones commissioned from Cozette
and Louis Nicolas Van Blarenberghe in 1769 for
the audience chamber of the French ambassador's
residence in The Hague?[1] Depicting royal palaces,
these *toiles peintes* clearly had a representational
function and would have corresponded with the
Dutch fashion for painted hangings in vogue from
the late seventeenth century until around 1800.[2]
Since the scenes are incomplete, it is conceivable
that they were rescued from the fire that damaged
the embassy in 1782 and were later joined to
decorate a screen (a smaller view of the château
of Choisy appears on the back). Whatever the
case may be, this is exactly the magnificent view
of Versailles that would rise up before visitors
once they reached the Place d'Armes in front of
the palace. DK-G

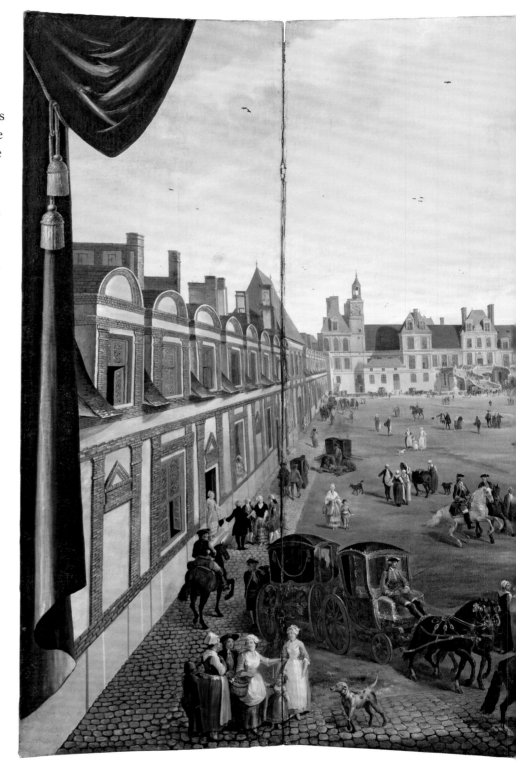

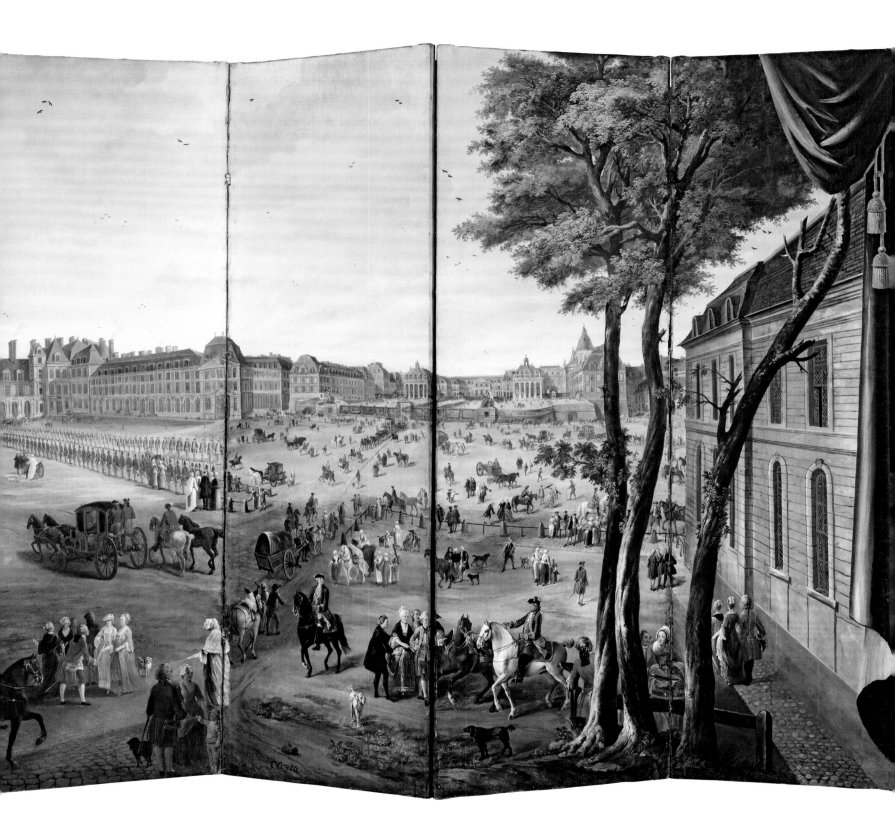

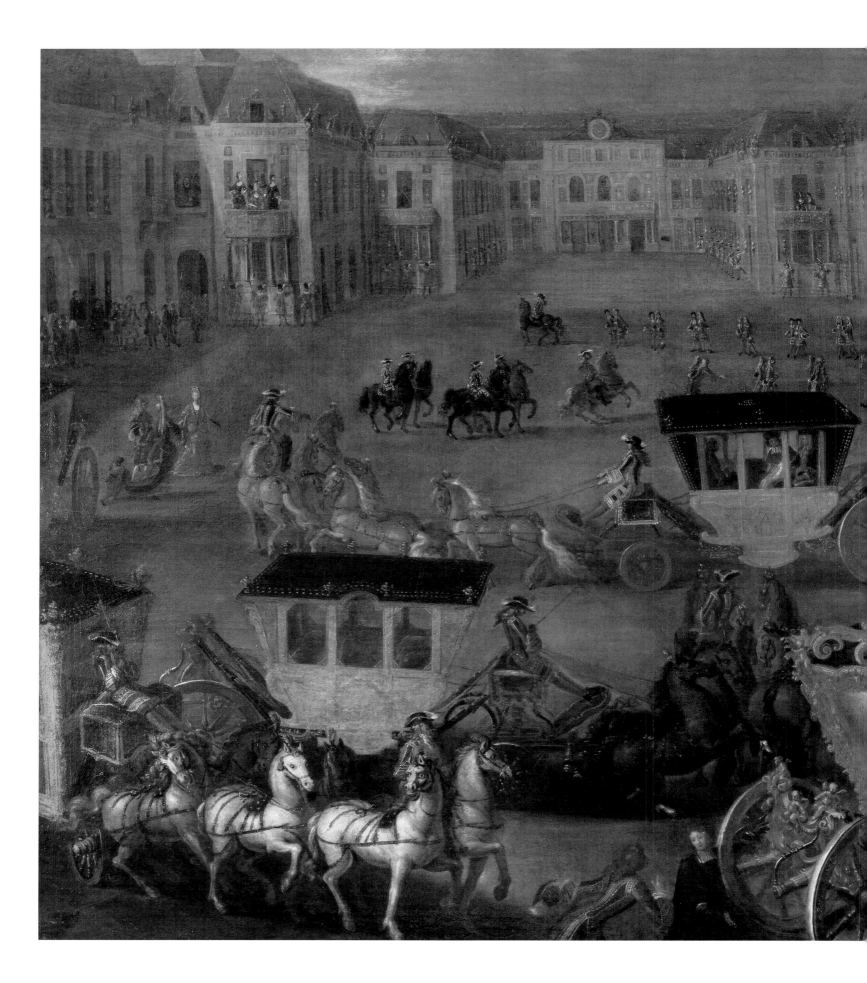

33 *The Arrival of the Papal Nuncio*

French School, after 1692

A long cortege—probably that of the papal nuncio, Giovanni Giacomo Cavallerini—winds through the royal court. This envoy, who facilitated the reconciliation between Pope Innocent XII and Louis XIV, arrived for his ceremonial audience at Versailles on November 18, 1692.[1] The Cent-Suisses, dressed in ceremonial uniform *à l'antique* (cat. 39), are stationed at left outside the Queen's Staircase. In the Marble Court at center are the Gardes de la Porte, armed with rifles, while outside the Ambassadors' Staircase at far right stand four Gardes de la Prévôté de l'Hôtel. Courtiers and some of the king's bodyguards watch from above; Madame de Maintenon is seated on her balcony at far left.[2] Recognizable by his cassock, the nuncio is seated in a carriage emblazoned with the king's cipher next to the comte de Brionne and opposite the Introducer of Ambassadors.[3] Empty carriages, including the comte's glazed one as well as those of the nuncio and the king's and the Dauphine's households follow.[4] The Secretary for the Conduct of the Ambassadors and the Master of Ceremonies await the visitors at far left, in front of the Ambassadors' Salon.[5] BR

34 Tavern Sign

French, second half 18th century

This rare surviving sign for the tavern or coffeehouse A la Gaité, believed to have been established in the town of Versailles in 1760, shows three merry drinkers. Sprawled against a tree, the principal figure rests his left arm on a barrel while holding a bottle and lifting a glass with his right hand. A la Gaité was one of many establishments near the palace that catered to the crowds of travelers in need of refreshment after their journey to Versailles or simply looking for a place to touch up their wigs, as did Martin Roland, a doctor from Sweden, in September 1754.[1] DK-G

35 Sedan Chair

French, ca. 1785

To travel within the town of Versailles, visitors made use of sedan chairs. The so-called *chaises bleues* (blue chairs) were named for the color of the livery of the porters who carried the poles. They were used outside and inside the palace, but only on the ground floor. This particular sedan chair, characterized by its elegant, restrained Neoclassical outline, is embellished with the coat of arms of France and Navarre encircled by the chain of the Order of the Holy Spirit.[1] It would have carried courtiers or members of the royal family. In 1766 Philip Thicknesse noted, "The Queen [Marie Leszczyńska] is a little cheerful looking woman, and though she was but just recovered from a dangerous fit of illness, she condescended to walk through the apartments (her sedan chair following her) that those who had not seen her, might have an opportunity; and that those who knew her, might rejoice, and congratulate her upon her recovery."[2] DK-G

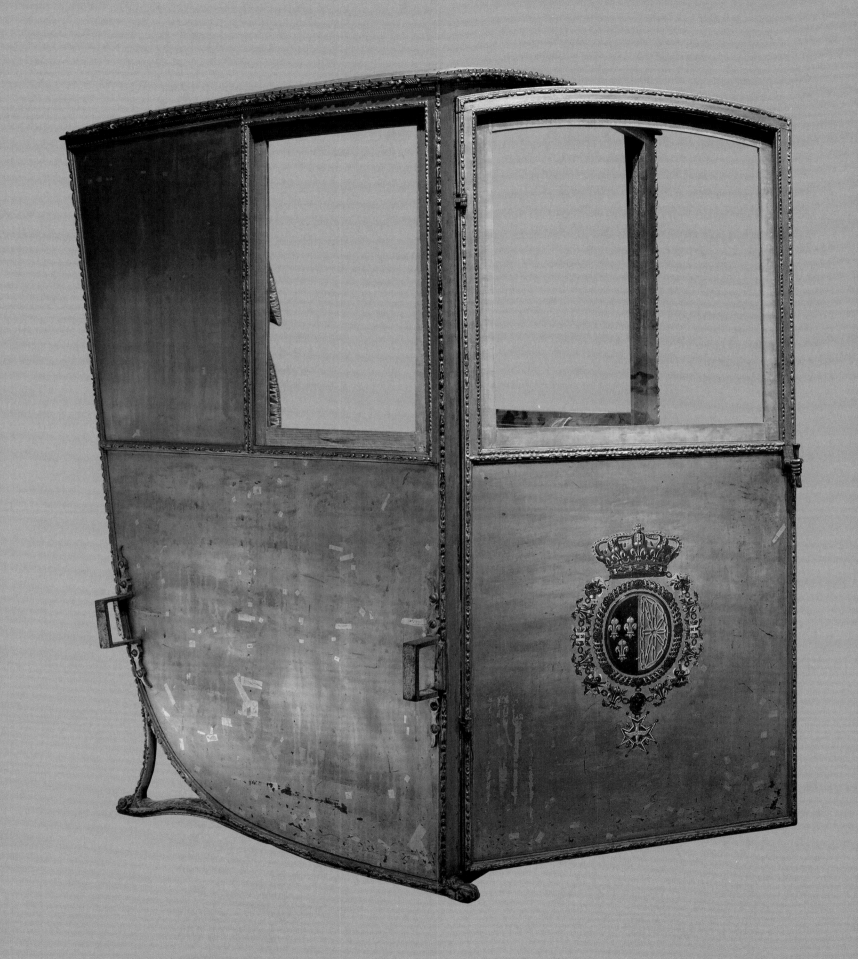

OFFICIAL VISITORS AND GIFTS

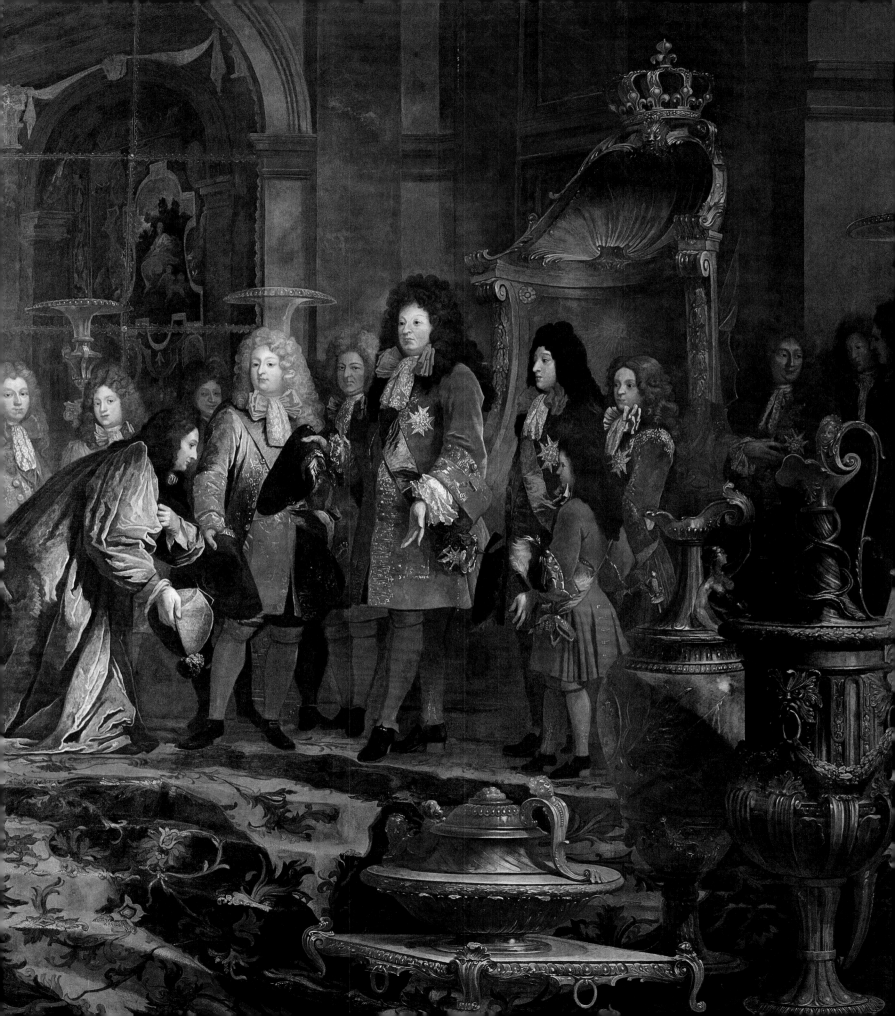

MAGNIFICENT DISPLAY
European Ambassadorial Visitors

HELEN JACOBSEN

By virtue of their position as the personal repre-
sentative of a foreign monarch, ambassadors expe-
rienced Versailles in a different manner
from other visitors. Although
often of noble birth, once in
receipt of their formal letters
of introduction to the French
king (their "credentials")
(fig. 39), they were accorded
a temporary status and
standing in court circles that
ranked them even higher,
alongside princes of the
blood. They were actors in the
theater of diplomacy, and their
ambassadorial duties were bound
up with ceremonies that confirmed
the social hierarchy and reflected the dignity of
monarchs. Louis XIV's reception of ambassadors,
an important element of his foreign policy, was
a highly visual affirmation of his political power.
Disputes over precedence were endless, and
geopolitical struggles were reflected in strategic
nuances of etiquette and social positioning that
were clearly comprehensible to a court society. It
was not surprising that Versailles was remodeled
to enable it to fulfill its role in this performance,
with grand reception spaces and lavish artistic
displays that underlined the king's personal mag-
nificence: the *Gloire* of France and the Bourbon
dynasty. Designed to awe and impress visiting

ambassadors, the art and architecture and the
ritualized ceremony of performative diplomacy
sent clear messages to fellow sovereigns,
whether allies or enemies.

Audiences at Versailles
The first official occasion on
which an ambassador went
to Versailles was on the day
of his "public" audience
with the king, a few days
after his formal entry into
Paris. Both were magnificent
occasions, demanding a display
of coaches, horses, dignitaries,
and liveried servants worthy of the
visiting nation, and the carriages used
were often spectacular creations (cat. 52). With
lavish upholstery, sculpture, and decorative paint-
ing, no expense was spared in their construction,
and many, such as that of the Count of Ribeira
Grande, were built in Paris using the most fash-
ionable techniques and materials (fig. 40). Waiting
for a coach to be delivered could take some time;
the Earl of Manchester waited three months for
a calèche (a type of two-wheeled horse-drawn
carriage) to be built for his ambassadorial entry. "I
like it," he wrote to his secretary, Matthew Prior,
"tho' I assure you the Coaches I brought from
England do exceed it in gilding, painting, and
carving."[1] But this was nothing compared to the

Fig. 39. Letter from Queen Anne to Louis XIV, September 13, 1712. Archives du Ministère des Affaires Etrangères, Paris-La Courneuve, France (8/CP/239, fol. 296)

and gold thread, and drawn by matching teams of eight horses. The grooms, footmen, and pages wore liveries of blue, orange, gold, and silver with cockades and feathers in their hats, while the pages and equerries rode horses with bridles of solid silver.[2] Clearly the advice to a previous ambassador that "the beauty of one's coaches and the *bel air* of one's liveries are things essential to a man's reputation in France" had not gone unheeded.[3]

For the ceremonial audience at Versailles, the French king sent one of his own carriages to transport the ambassador to the palace, with the ambassador's coaches and more of the king's coaches forming the rest of the cavalcade. A French prince and the Introducer of Ambassadors, a royal office-holder in charge of all diplomatic ceremonial, were his escorts. Nothing was left to chance in these highly choreographed occasions, and records of past embassies were studied to provide patterns of behavior for new ones. One particularly splendid arrival was that of the Earl of Portland (fig. 42) in 1698, who, as the representative of the victor of the War of the League of Augsburg, was determined to underscore England's superpower status and, accordingly, took with him sixty liveried footmen, two equerries, twelve pages, twelve grooms, and six of his own carriages filled with British noblemen. Portland's audience followed the prescribed ceremonial: Nicolas II de Sainctot, the Introducer (cat. 36), met him in Paris at the Hôtel des Ambassadeurs in the early morning, whence they drove the two hours to Versailles and joined the rest of the entourage in the Place d'Armes. At 8:30 A.M. precisely they entered the Cour d'Honneur, the first courtyard of the palace, where two ranks of foot guards were lined up on either side: the French on the left, in their blue coats, and the Swiss on the right in red, both flying regimental colors (fig. 43). The men presented arms, the officers doffed their hats, and drums beat the approach. Portland's coaches drew up to the gates of the second, inner

experience of Prince Joseph Wenzel von Liechtenstein, who arrived in Paris in December 1737 as ambassador from Emperor Charles VI and waited a year for five new coaches, designed by Nicolas Pineau, to be built (fig. 41). For his embassy of compliment for Louis XV's coronation, the Earl of Stair was accompanied by five coaches, all elaborately carved in gilded and silvered wood, upholstered with crimson and green velvet inside and out, with fringes, tassels, and trimmings of silver

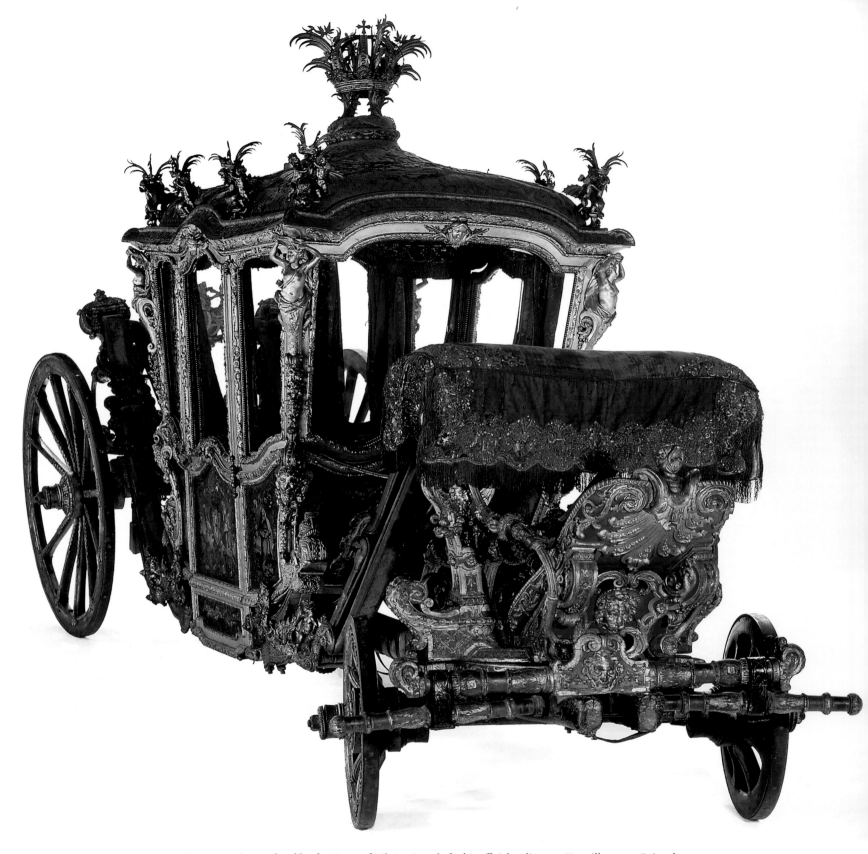

Fig. 40. Carriage ordered by the Count of Ribeira Grande for his official audience at Versailles, 1715. Painted and gilded wood, metal, textiles, tortoiseshell, and brass, H. 7 ft. 10 in. (240 cm), W. 12 ft. 1⅛ in. (370 cm), L. 24 ft. 3¼ in. (740 cm). Museu Nacional dos Coches, Lisbon (V 0007)

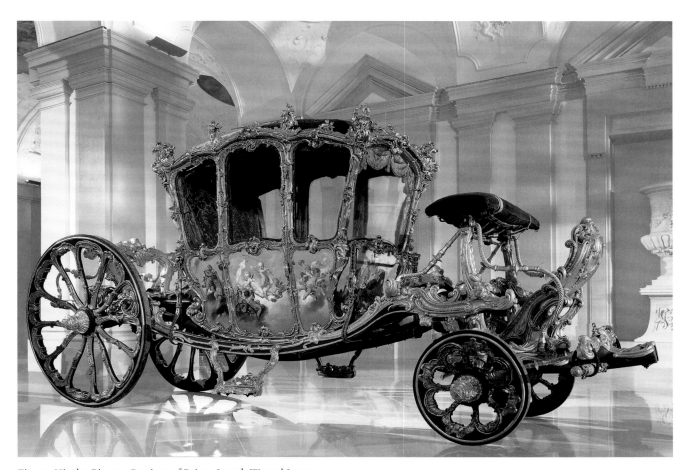

Fig. 41. Nicolas Pineau, Carriage of Prince Joseph Wenzel I von Liechtenstein, 1738. Painted and gilded wood, steel, gilt bronze, leather, crystal, velvet with gold embroidery, and brocade, H. 7 ft. (213 cm), W. 10 ft. 5⅛ in. (319 cm), L. 20 ft. (610 cm). Liechtenstein Museum, Vienna (SK1)

courtyard, the Cour Royale, where the entrance was barred by gilded railings surmounted by the arms of France.[4] Only members of the royal family, princes of the blood, and certain officers of state were allowed to drive through, as these railings, directly in front of the King's Apartment, marked the limits of his personal space and only those granted the "honors of the Louvre" could get past the Gardes de la Porte on duty (fig. 44).[5] Ambassadors, however, were granted this privilege for their formal audiences, and Portland was waved through.

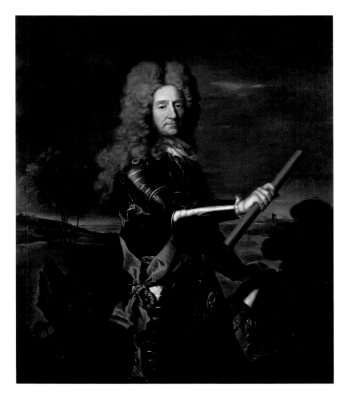

Fig. 42. Studio of Hyacinthe Rigaud, *William Bentinck, 1st Earl of Portland*, 1698–99. Oil on canvas, 55 × 46¼ in. (139.7 × 117.4 cm). National Portrait Gallery, London (NPG 1968)

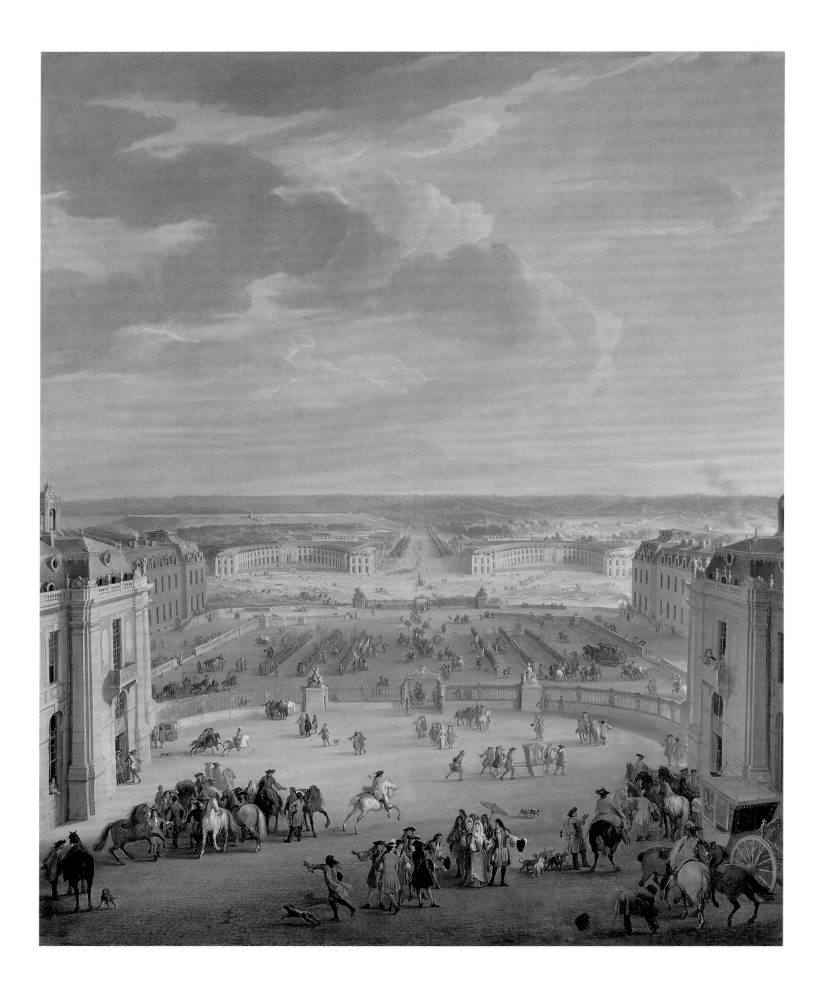

Another set of foot guards, the Gardes de la Prévôté de l'Hôtel, awaited the ambassador in the next courtyard outside the Ambassadors' Salon: a room in the Old Wing, on the south side of the royal courtyard, where ambassadors waited while the king was notified of their arrival. European ambassadors were received in the King's Bedroom on the first floor, and once the Introducer announced that the king was ready for the audience, the double doors of the Ambassadors' Salon were thrown open and the embassy procession made its way to the bottom of the Queen's Staircase: first the Introducer's lackeys; then the ambassador's footmen, equerries, and pages, two by two; then the foreign nobility and gentlemen; and, finally, the ambassador flanked by the prince and the Introducer, with his secretary carrying the credentials at the rear. At the top of the staircase, lined from top to bottom with guards of the Cent-Suisses regiment, the captain of the king's bodyguard greeted Portland and led him through the guardroom and the two anterooms preceding the bedroom. At each threshold double doors were opened (cat. 48), a further mark of respect shown to ambassadors but not to lesser envoys, and various ranks of the procession stayed behind as the rules of etiquette prohibited their venturing further into the palace: first the footmen, then the pages and equerries. Access to certain spaces depended on status, as it did inside the bedchamber: the king sat in an armchair behind the balustrade that marked off

Fig. 44. Jacques Antoine Delaistre, "Gardes de la Porte," plate 68 from *Infanterie et gardes françaises*, ca. 1721 (vol. 3). Print, watercolor, gouache, and ink on paper, 16½ × 21⅝ in. (41.7 × 54.8 cm). Musée de l'Armée, Paris (A1J7; 10851)

Fig. 43. Jean-Baptiste Martin, *View of the Forecourts of the Palace of Versailles and the Stables*, 1688. Oil on canvas, 92½ × 73⅛ in. (234.5 × 186.5 cm). Musée National des Châteaux de Versailles et de Trianon (MV 748)

his bed from the rest of the room, accompanied only by royal princes and, behind him, important officers of the royal household. The protective covers and curtains of the bed were drawn back to reveal the sumptuousness of the silk brocade (fig. 45). During Portland's audience, the British noblemen tried to line the route to the bed, "but the crowd was so thick that it was impossible, and it was with the greatest difficulty that my Lord got to the Balustrade." Everyone in the room except the king was bareheaded; following the prescribed liturgy, Portland made a deep bow as he approached, and Louis stood up and took off his hat, acknowledging two more deep reverences with an inclination of his body. In another mark of respect to the representative of a foreign monarch, the ambassador was received inside the balustrade, where both men put their hats back on and Portland delivered his formal address to the king.[6]

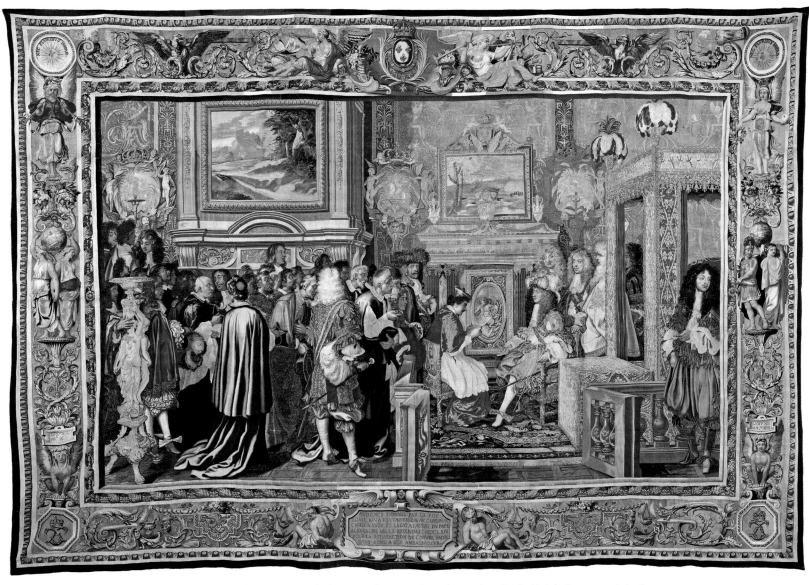

Fig. 45. After Charles Le Brun, Gobelins Manufactory, *The Audience of Cardinal Chigi (July 29, 1664), in the King's Bedroom at Fontainebleau*, from the series L'Histoire du Roi, 1665–72. Wool, silk, and silver and gilt thread, 16 ft. 9 in. × 23 ft. 5½ in. (510 × 715 cm). Mobilier National, Paris (GMTT 95/1)

Non-European embassies were subject to the same ceremonial, but it took place in another part of the palace (see "Special Embassies and Overseas Visitors" by Meredith Martin in this volume). After 1678, the suite of rooms forming the Grands Appartements was used to stage events of particular significance, including the reception of ambassadors from far-flung countries, for whom the symbolic effect of a throne was believed to be more powerful than that of a bedroom, and where the full effect of the richly decorated state rooms was employed to underscore French wealth and the king's magnificence.[7]

One of the earliest of these receptions was the visit of the ambassadors from the Grand Duke of Muscovy in 1681.[8] On the day of their audience at Versailles, they were escorted by the Introducer from the Ambassadors' Salon but, unlike European ambassadors, they were taken across the Ministers' Courtyard to the newly built Grand

Staircase (later referred to as the Ambassadors' Staircase) on the north side of the palace. This was the ceremonial route leading to the Grand Appartement, and on this occasion it was lined with Cent-Suisses, whose red uniforms lent even more color to Charles Le Brun's painted interior (cats. 40, 41A, B). The ambassadors brought up the rear of the procession, behind a phalanx of Russian servants and Cent-Suisses carrying the fine rich furs and Persian gold silk brought as gifts for Louis XIV. They passed through the different rooms of the apartment, lined with the king's bodyguard and thronged with courtiers, past increasingly grand furniture: candelabra, mirrors, urns, tables, bowls, torchères, and other works of silver and gold. Entering the Apollo Salon (the throne room), they caught their first glimpse of the king, seated on a silver throne decorated with solid-silver figures of Apollo, Justice, and Strength and upholstered with gold-embroidered green velvet.[9] Two massive silver torchères, each weighing 350 kilograms (more than 770 pounds), flanked the dais, with more candlestands, a table, a chandelier, firedogs, and a mirror—all of silver—furnishing the room. Everything was stage-managed for full effect, including the brightness of the silver highlighting the king, "whose grandeur came from his own radiance."[10] Instead of the customary lavish costume, Louis was wearing a simple brown suit, its only decoration some gold braid and a plume of white feathers in his hat, in stark contrast to the Dauphin and Monsieur, his brother, who were wearing magnificent outfits glittering with precious stones. The ambassadors acquitted themselves of the usual ceremonial, but the impression instilled in them by the Grands Appartements, the vast crowds of richly dressed courtiers, and the king seated in majesty was overwhelming. When they met Louis a few days later, they prostrated themselves and trembled in his presence, unable to look him in the face, remarking that only Solomon and the king of France had ever appeared in such

grandeur, and that King David had not even approached it.[11]

Two more embassies from Muscovy were received by Louis XIV in the Apollo Salon, but only one European embassy was received in the Grands Appartements: the ritualized humiliation of Genoa in 1685. The Doge himself was forced to leave Genoa, against the city's laws, to visit Versailles and apologize to Louis for having supplied galleys to Spain. Crowds thronged the streets and the palace courtyards to get a glimpse of him, and all foreign ambassadors were invited, expressly to witness Genoa's formal submission. Ordered to dress in his red velvet ceremonial robe and bonnet and accompanied by four senators in black robes, the Doge was led up the Grand Staircase lined with Cent-Suisses and through the crowded rooms, past the magnificent furnishings and silver furniture. In an important change from the itinerary of the Russian ambassadors, the Doge was conducted further into the Apartment, through the War Salon and into the Hall of Mirrors beyond, signifying the emergence of Genoa from the horror of the French naval bombardment into the light cast by Louis's benevolence. The king sat on his silver throne at the far end of the gallery, on the side of the Peace Salon (fig. 46). Struggling to find a passage through the crowds, the Doge walked the length of the gallery, took off his hat, and approached the throne, making two deep reverences; the king stood up and responded by lifting his hat and then beckoned the Doge onto the first step of the dais. As he mounted he made his third reverence and, while everyone else remained bareheaded, he and the king put on their hats. The Doge then delivered a grandiloquent speech in Italian glorifying Louis, the senators made their compliments, and the king graciously responded. When it was all over, the Genoans made three more deep bows and were escorted out through the Apartment to a grand dinner. The *Mercure galant* declared the Doge was "charmed by all

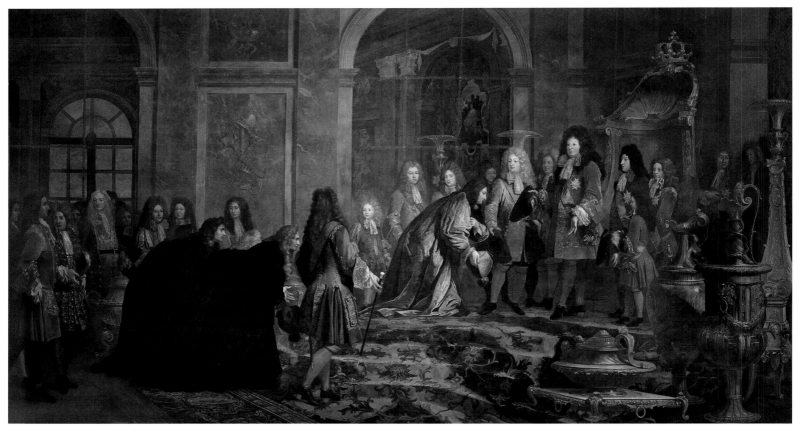

Fig. 46. Claude Guy Hallé, cartoon for *Reparation Made to Louis XIV by the Doge of Genoa, May 15, 1685*, 1715. Oil on canvas, 11 ft. 3 in. × 19 ft. 9⅛ in. (343 × 603 cm). Musée National des Châteaux de Versailles et de Trianon (MV 2107)

that he had seen that was noble and attractive in His Majesty."[12]

The pomp and circumstance surrounding these audiences, and the similar *audience de congé* (farewell audience) that marked the end of an embassy, were only the beginning of a long day for an ambassador. After he had been presented to the king, formal visits to other important members of the royal family followed one by one; Portland was presented to the Dauphin and each of his three sons; to Monsieur, his wife, and his two children; and, after a lavish dinner in his honor, to the duchesse de Bourgogne, the Dauphin's daughter-in-law. The Earl of Manchester was not alone in finding these ambassadorial visits tedious: "I take it to be the worst part of the

Embassy here, tho' it is what must be done."[13] Meetings with the royal family took place in their apartments in Versailles, thus introducing an ambassador to a wide array of the palace's interiors. The Doge was certainly impressed. Two days after his audience with Louis he was back at the palace, mesmerized by the Dauphin's new apartments, with their profusion of mirrors, precious stones, marquetry, and gilded decoration. On leaving, and alluding to the French bombardment of Genoa, he remarked that "a year ago we were in hell, and now we are leaving Paradise."[14]

Ezekiel Spanheim, the envoy from Frederick III, Elector of Brandenburg, wrote of the "superb furnishings . . . in silver, beds, tapestries, paintings and portraits, gems and stones,

and other jewels and curiosities of value" that he saw at Versailles, highlighting their cost.[15] Others, like Sir William Trumbull, were concerned only with the size of the expenditure, and not all were impressed with the architecture; the Spanish ambassador, for example, was overheard comparing the front of the château to "a little doublet with big sleeves."[16] Matthew Prior, secretary to Portland's embassy and later the British representative in his own right (cat. 47), was even more prosaic in his description of Louis's interiors: "His house at Versailles is something the foollishest in the world; he is strutting in every panel and galloping over one's head in every ceiling, and if he turns to spit he must see himself in person or his Viceregent the Sun with *sufficit orbi*, or *nec pluribus impar*. I verily believe that there are of him statues, busts, bas-reliefs and pictures above two hundred in the house and gardens."[17] Despite his apparent disparagement, however, Prior's personal library contained several books with descriptions and engravings of the palace of Versailles, while Portland was particularly keen to get hold of the architectural plans for Versailles, Marly, and the Trianon.[18]

In the weeks or months before their public audiences, or if they wished to raise some particular issue with the king, ambassadors could request a private audience. These were held in the king's *cabinet*, where he conducted business on a daily basis, and, although such audiences took place in the presence of various officials, they were more spontaneous affairs at which neither the king nor the ambassador had to stick to a prescribed text. An ambassador had limited exposure to the king and was never alone with him; even "secret" meetings were held in the presence of the Minister of Foreign Affairs and are unlikely ever to have been kept much of a secret in the corridors of Versailles.[19] Additionally, ambassadors regularly attended the daily *toilette* of members of the royal family, the king's *lever*, and, on rare occasions, his *coucher*, although they were generally not entitled to participate in either the first or second wave

of spectators.[20] Portland received the greatest accolade of all: being allowed to hold Louis XIV's candlestick during his *coucher*, although it is not clear that the ambassador fully appreciated the import of this gesture.[21]

Diplomats were invited to state events, such as the ten days of festivities held to celebrate the duc de Bourgogne's wedding in December 1697, during which Protestant ambassadors who could not attend the mass waited in the Grand Appartement to see the royal procession pass by. About eighty diplomats were invited to the ball four days later, but only the papal nuncio and the Portuguese ambassador were singled out for invitations to the first performance of a new opera at the Trianon.[22] Louis threw a ball in the Hall of Mirrors for the Doge to experience French dances; it lasted until midnight, and a large number of courtiers attended as well as the king and the Dauphine.[23] Diplomats also attended the evening "apartments": parties introduced by Louis XIV and held in the Grand Appartement on certain weekdays. This parade of rooms, with its rich tapestries, silks, and marbles, was transformed into spaces for eating, drinking, gaming, billiards, and music-making, providing an opportunity for ambassadors to observe more closely the activities of the court (fig. 47). Ambassadors were invited to more private events, such as the party attended by Prior in Madame de Maintenon's apartment, followed after supper by a masque in the Dauphin's apartment.[24] The Swedish ambassador, the Count of Creutz, regularly played cards with Marie Antoinette.[25] These events helped shape diplomats' impressions of the royal family. Spanheim first met Louis XIV in 1680; he described the king's appearance favorably but also noted his vanity, sentiments echoed by Prior eighteen years later: "The king has good health for a man of sixty, and more vanity than a girl of sixteen."[26] The Earl of Hertford, British ambassador after the Seven Years' War (1756–63), was likewise favorably impressed with Louis XV. He had spent half an hour with the king in his study

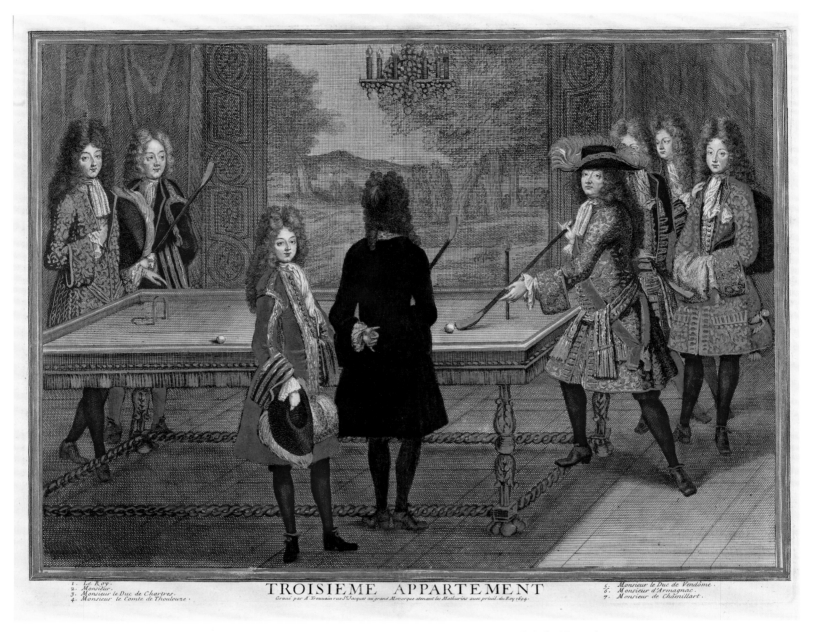

Fig. 47. Antoine Trouvain, "Third Apartment," in *Appartements ou amusements de la famille royale à Versailles*, 1694–98. Engraving and etching, 18 × 24 in. (45.5 × 60.5 cm). The Getty Research Institute, Los Angeles (2011.PR.20)

at Versailles and reported that he talked "to me with ease, which is the greatest compliment he can pay," and appeared "one of the best-natured men in the world."[27]

By the second half of the eighteenth century, however, the power of parties at Versailles to attract both foreigners and French courtiers had dwindled. The "apartments" happened only

infrequently, and Creutz noted not the art nor the architecture of the palace but the sumptuousness of the dress of the partygoers. "Yesterday's apartment was the most brilliant that I have yet seen at Versailles," he wrote. "The richness and taste of the dress was carried to a degree of refinement that is imitated in vain in other countries."[28] Correct attire was always a matter of some concern for

diplomats, most of whom visited tailors and mercers before making their appearances at court. The Duke of Bedford, for example, found time in between negotiating clauses of the Treaty of Paris to run up tailors' bills of nearly ten thousand livres, while Creutz regularly provided up-to-date information on fashions to Gustav III, including samples and swatches.[29] Both ambassadors bought from the fashionable mercers De La Roux and De La Salle, and both acquired dress swords for wearing at Versailles, where "one needed an epée of plain gold garnished with diamonds" (cats. 19–21).[30] The Duchess of Bedford, like Count Giandemaria, the envoy from Parma, bought a doll "dressed as a Court Lady of France," complete with an elaborate dress, silk stockings, linen chemise and diamond earrings, and a spare pair of shoes and stockings (cat. 27).[31] Her own *habit de cour* was made by a couturier called Ortolan (see "Exchanging Looks" by Pascale Gorguet Ballesteros in this volume).[32]

The Role of the Ambassadress

Women played an important role in the daily ritual of court life at Versailles, and ambassadors' wives had independent status. They were expected to entertain and to be entertained and were conduits for information. Several of them received formal gifts from the king when they left France, just as their husbands did, such as the Sèvres porcelain dinner services given to the Duchesses of Bedford and Manchester and Mrs. William Eden or the miniature portrait of Louis XIV framed in diamonds (probably a bejewelled wrist ornament; see cat. 58) that the king presented to the wife of the Russian ambassador to Holland. Although she and her husband were merely visiting Versailles and not acting in any formal diplomatic capacity, the marquis de Dangeau recorded that "she is very handsome, and has a great deal of wit" (fig. 48).[33]

An ambassadress did, however, have a formal identity, and her official visits to Versailles

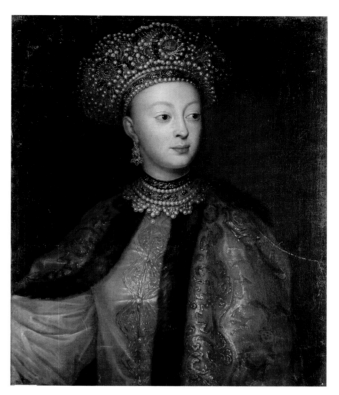

Fig. 48. Studio of Matthieu des Angles, *The Wife of Andrei Matvieiev, Russian Ambassador*, ca. 1702. Oil on canvas, 31⅞ × 25 in. (81 × 64 cm). Musée National des Châteaux de Versailles et de Trianon (MV 3633)

mirrored those of her husband. Far from being a silent appendage, wives were expected to undertake a similarly grueling schedule of ceremonial visits to royal women. The Introducer escorted them from Paris in one of the queen's coaches, and they too were shown the "honors of the Louvre" and driven into the inner courtyard of the palace. During the meeting with the queen, reverences were made, speeches delivered, and the ambassadress received a kiss. She was also allowed to sit, a signal honor reserved for only the highest-ranking women at court. The king was later ushered in, and he too kissed the ambassadress, after which a perfunctory conversation followed. After several such meetings, a grand dinner was served in honor of the ambassadress, mirroring that served to her husband after his public audience.[34]

The social demands placed on these foreign women were considerable. Madame Heemskerk, wife of the Dutch ambassador, upset protocol in 1700 by taking her daughter with her for an audience with the duchesse de Bourgogne and was severely embarrassed when the duchess did not kiss her daughter.[35] Maria Franziska von Salm-Salm, married to the Austrian ambassador, Georg Adam, Prince of Starhemberg, claimed to have been so terrified by the experience of her formal audience that she was unable to speak to Louis XV when he came into the room.[36] Despite having French lessons to prepare her, the Countess of Hertford (cat. 57) was very anxious about the ordeal she faced and her husband was sympathetic: "I must pity her, it is a dreadful one." He considered, however, that the queen was "a good old woman that will fatigue no person with too many questions" and that "the worst part of the whole [is] from the gravity which attends it. . . . The Mesdames seem the stiffest part of the whole, but as they are not the most considerable, it is of less consequence." Believing it might help Lady Hertford's shyness, the queen darkened her rooms for the audience, but this exacerbated the countess's agitation.[37] Hertford's house guest, Horace Walpole, may have captured something of what Lady Hertford experienced when he described his own presentation at Versailles: "The four Mesdames, who are clumsy plump old wenches, with a bad likeness to their father, stand in a bedchamber in a row, with black cloaks and knotting-bags, looking good-humoured, not knowing what to say, and wiggling as if they wanted to make water."[38] The Countess of Rochford's audiences "must have proved very fatiguing to the ambassadress, by the severity of the weather, and the great distance of the several apartments of the royal family from each other," but at the dinner afterward the table was "illuminated with upwards of sixty wax lights, and the desart was inconceivably magnificent."[39]

Amusements at Versailles

On Lady Rochford's birthday, her husband, the British ambassador, took her to visit the gardens at the king's house at Marly, a tradition started by Louis XIV, who delighted in showing his gardens and who penned his own guide to the best route to be taken around the palace grounds.[40] In contrast to some of the less flattering accounts of the architecture, the reaction to André Le Nôtre's perspectives, *bosquets* (groves), and parterres at Versailles was universally one of admiration, and diplomats and tourists alike enjoyed walks through the gardens. Ambassadors were often paid the compliment of a guided tour. A full visit took a whole afternoon and covered several miles, such as the one taken by the Venetian ambassadors in 1703. Their guide was the Introducer's secretary, and they invited "three women from Paris" to accompany them;[41] starting inside at the Ambassadors' Salon, they were given a tour of the King's Apartment and the Dauphin's before getting into wheeled chairs propelled by Swiss Guards for a tour of the garden (fig. 25).[42] After seeing the Orangery and the *bosquets*, they embarked on little boats and gondolas and floated down the Grand Canal to look at the exotic animals in the Menagerie and at the Trianon before returning via more parterres and fountains.[43]

As with the privileges of the *lever* and *coucher*, Louis XIV meted out similarly graduated favors with respect to the gardens, sometimes having the fountains turned on and sometimes even escorting ambassadors around the park himself. Portland, one of the most graciously received ambassadors of Louis's reign, had both the fountains playing and the king as his guide, although Prior cynically saw this as an opportunity for Louis to brag about his own involvement with the garden design (see fig. 11).[44] Portland's subsequent correspondence with Le Nôtre and export of three thousand fruit trees suggest that the gardens made a significant impact on him.[45] He was also shown the huge waterworks at Marly, another special gesture from

Louis to representatives of important powers or would-be allies. Count Knyphausen, the envoy from Groningen, one of the United Provinces, was similarly entertained: "The house was open, Chocolat and Wine for his followers and the same profusion of respect and Tulipps as the last year for my Lord Portland."[46] The technological feat of pumping so much water from the Seine via the *machine de Marly* (see fig. 12) and a series of reservoirs and pipes to Versailles was extraordinary, but it was not always successful, as the Swedish envoy, Nils Lilierot, and his friend Nicodemus Tessin found when they went to Versailles to see the fountains play for the Danish ambassador. A problem with the hydraulics meant that they would not work, and the visit had to be repeated two weeks later.[47]

Gardens, paintings, architecture, parties, fireworks, and spectacles were all on display to visiting diplomats, but essentially Versailles remained for them a place of work. Here the foreign ministers mingled with officers of state in the corridors of power or gossiped in the Hall of Mirrors.[48] Tuesdays were set aside for regular ambassadorial duties and appointments with the Minister for Foreign Affairs, whose vast apartment in the Ministers' Wing had anterooms for business on the ground floor and large reception rooms above. On that day he kept open table for ambassadors, served from his private basement kitchens, and the duc de Choiseul's dinners were famous: "One dined at 2pm precisely, and all the foreigners being present, all the courtiers were also admitted. The main table had 35 covers, and there was another ready . . . the vast amount of plate was magnificent, all worked in silver, which made a dazzling effect."[49] Sometimes ambassadors would stay in Versailles overnight on Mondays to avoid an early morning start the next day;

lodging in the town was always at a premium, so some, like the Duke of Bedford, rented their own house.[50] The duchesse de Praslin, wife of the Minister for Foreign Affairs, hosted Monday night suppers, followed by card parties until 3 A.M. for the diehards.[51]

Regular royal entertainments, however, became increasingly rare in the later eighteenth century, with Creutz noting only one during the autumn of 1781.[52] The myriad attractions of life in Paris—shopping, theatergoing, card parties, art collecting—appealed more to European ambassadors, and it was there they made their home. "The Paris way of living is extremely magnificent," wrote Lord Hertford.[53] "The corps diplomatique are here upon a very great footing and live away—the suppers are very frequent, the dinners less so & the eating is excellent & much studied," wrote his son, while Count Ekeblad believed the Swedish ambassador must be mistaken for a millionaire from the lavishness of his house and his entertaining.[54] By contrast, Versailles became less and less attractive in tandem with the increasing dissatisfaction of courtiers themselves with life at the palace. Even the fabric of the building seemed to be suffering from years of neglect, with Creutz reporting in 1781 that it was "falling down on all sides."[55] Tourists continued to flock to see the attractions, but standards had slipped and rules for access had loosened.[56] The dazzling effects intended by Louis XIV no longer inspired diplomatic awe and, despite the magnificence of the expenditure, of the art and architecture, and of the furnishings and garden design, the glory days of the palace were over. Its position at the heart of French foreign policy had shifted; no longer the spectacular representation of Louis XIV's political power, it had become a rigid and decaying metaphor for the struggling regime that it housed.

SPECIAL EMBASSIES AND OVERSEAS VISITORS

MEREDITH MARTIN

Ambassadors who traveled from faraway lands or who crossed oceans to visit Versailles during the late seventeenth and eighteenth centuries tended to attract far more attention than their European counterparts. Whereas European diplomats maintained permanent residences in Paris and were a frequent fixture at court, embassies from Asia, Africa, and other parts of the world were relatively uncommon and indulged a French taste for the foreign and exotic. Scores of men and women flocked to catch a glimpse of these foreign envoys from the moment they set foot in France, and they continued to draw large crowds wherever they went, from parks and entertainment venues in Paris to royal audiences with the king at Versailles (cats. 74, 83). For those unable to see these dignitaries in the flesh, the monarchy and the court gazette, *Mercure galant*, published detailed accounts of their itineraries, while Parisian printmakers produced images offering highly sought after, if not always accurate, information about their clothing, habits, and appearance (figs. 49, 50).[1] In addition, the Crown publicly displayed gifts that Asian and African emissaries brought with them, including textiles and objects made from

porcelain and lacquer. These presents fueled global imports, spurred European imitations—among them striped "Siamoise" fabrics inspired by the 1686 Siamese (Thai) embassy to Versailles—and transformed France's economy along with its manufacture and consumption of fashion and luxury goods.[2] The visual and textual record associated with such "exotic" embassies provides multiple opportunities for assessing the varied reactions they elicited in France, from intense curiosity and admiration to extreme boredom and even hostility. But what about the impressions that France, and the court of Versailles in particular, made on these foreign visitors? That response is more difficult to gauge. Few African or Asian dignitaries left behind firsthand accounts of their experiences, and those that do survive—for example, a *Sefâretnâme*, or "embassy book," written by the Ottoman ambassador Yirmisekiz Çelebi Mehmed Efendi on the occasion of his visit to Paris from 1720 to 1721—were designed to be read by rulers and administrators back home and, therefore, are typically cautious, coded, or impersonal in their commentary.[3] Although this filtering is true of many French reports of foreign

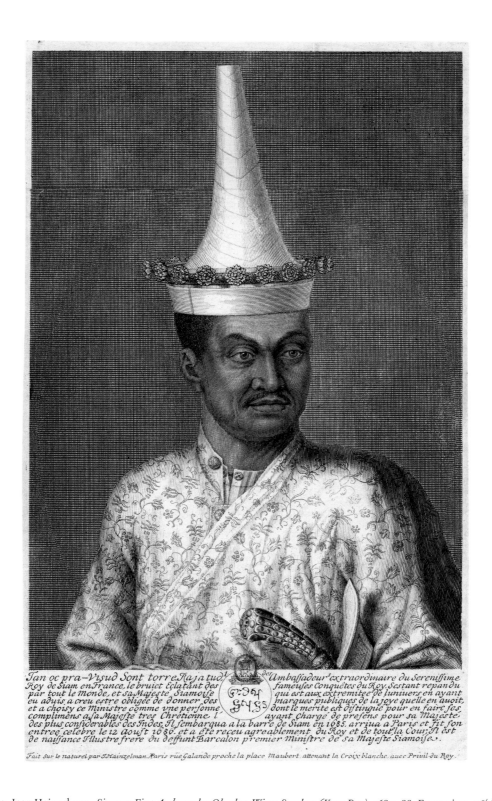

Fig. 49. Jean Hainzelman, *Siamese First Ambassador Ok-phra Wisut Sunthon (Kosa Pan)*, 1687–88. Engraving, 11⅞ × 6⅞ in. (30 × 17.5 cm). Bibliothèque Nationale de France, Paris, Département des Estampes et de la Photographie (Coll. Hennin, vol. 63, no. 5500)

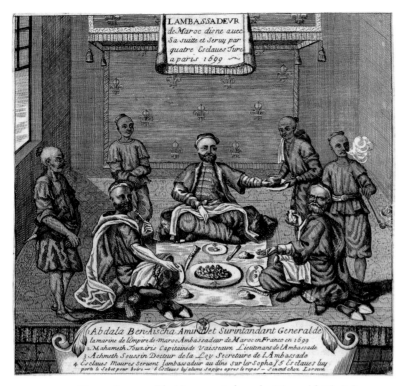

Fig. 50. Leroux, *The Moroccan Ambassador Dines with His Suite, Served by Four Turkish Slaves* (detail), 1699. Etching and engraving. Bibliothèque Nationale de France, Paris, Département des Estampes et de la Photographie, Histoire de France (Qb1)

of diplomatic and courtly protocol; the display of French art, technology, and culture; and the encounter with French women.

Royal "Gloire" Reflected around the World

On the walls of the Ambassadors' Staircase, completed in 1679 and destroyed in 1752, mural paintings designed by Charles Le Brun portrayed emissaries from around the globe marveling at the palace's magnificence (cats. 41A, B). Embodying the ideal foreign visitor, these fictive dignitaries hinted at how their real-life counterparts, who upon entering Versailles would ascend the grand staircase on their way to meet the king, should react to and behave in this space.[5] In organizing diplomatic receptions, the French monarchy aimed to maximize the potential to display royal glory (*Gloire*) to both foreign and domestic audiences.[6] This was notably the case for spectacular receptions orchestrated for embassies sent from Siam (1686), Persia (1715), and the Ottoman Empire (1742), which, aside from an audience given to the Doge of Genoa in 1685, were the only such ceremonies to be staged in the Hall of Mirrors during the ancien régime. (Most other ambassadorial audiences took place in the King's Bedroom.)[7] Their privileged status implies the Crown's desire to forge political and commercial links with these foreign powers, but it also indicates an awareness of the propaganda value of such encounters beyond whatever actual business (if any) the two parties hoped to conduct.[8]

embassies as well, such descriptions can often be weighed against other forms of documentation that are generally lacking on the other side. Conversely, texts authored by French diplomatic officials, translators, and propagandists claim to record truthfully the statements and impressions of overseas dignitaries, but readers must consider the biases of these sources as well as their potential for embellishment or censorship.[4] Still, even with such challenges, it is possible to trace some common themes and impressions that marked these special embassies to France, not only by reading between the lines but also by using images and objects to supplement texts. In exploring some of the ways that Asian, African, and Native American emissaries responded to Versailles, we will focus on four main topics associated with their visits: the assertion of French royal power; the exercise

During Louis XIV's reception of the Siamese embassy on September 1, 1686, as illustrated in several large French royal almanac prints published soon after the event, the ambassadors arrived at Versailles in the late morning dressed in ceremonial attire, including elaborate conical hats wrapped in white muslin and encircled by a gold crown at their base (figs. 49, 51; cats. 60–62, 64).[9] The emissaries brought with them an official letter from their king, Phra Narai, to Louis XIV that they had reverentially transported all the way from

Siam in an ornate gilded structure called a *busabok*, which was dubbed "*la machine*" by the French press (cat. 63). The trove of gifts accompanying their embassy—comprising hundreds of pieces of porcelain, lacquered furniture, precious-metal items, hardstone vases, and other wares—had preceded their arrival and were displayed in the War Salon, adjacent to the Hall of Mirrors, rather than at the base of Louis XIV's throne, as one of the almanac prints suggests.[10]

Entering the palace, flanked by two rows of Cent-Suisses and accompanied by the sound of trumpets and drums, the Siamese ambassadors were led up the marble stairs of the Ambassadors' Staircase, through the Grand Appartement, and into the Hall of Mirrors, where approximately 1,500 spectators, who stood in neat rows on either side of the room so as not to block the ambassadors' view of the king, waited to witness their audience with Louis XIV. At the far end of the long gallery, the Sun King sat perched on his silver throne covered by an elaborate canopy and raised nine steps above his guests. Paying homage to the opulent courtly costumes of Phra Narai and other Asian rulers whose dignitaries he hoped to impress, Louis had donned an extravagant golden silk suit studded with diamonds that was reportedly worth two million livres.[11] Several years later, in 1715, Louis XIV wore a similar suit to receive a delegation from Persia during a ceremony that echoed the Siamese royal audience in several respects, including the time of day; the orderly arrangement of spectators (now standing on risers specially erected for the occasion); and the elevated throne, in this instance made of gilded wood instead of solid silver (fig. 52; cat. 71).[12] For the Persian reception, Louis also asked the ladies of the court to wear shining jewels in their hair, which, combined with the king's own bejeweled costume and sunlight streaming in through the gallery windows and reflected in the large mirrors, must have created a sparkling, almost hallucinatory effect.

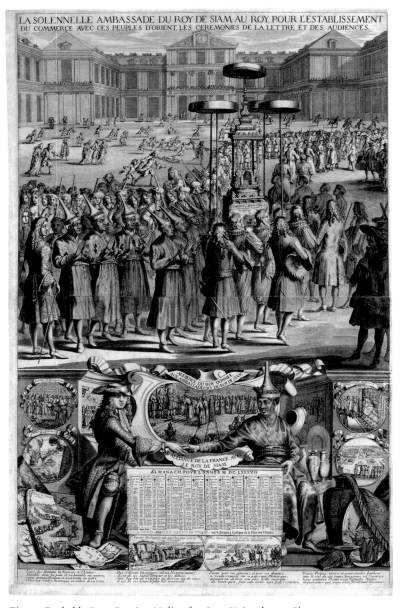

Fig. 51. Probably Jean-Baptiste Nolin after Jean Hainzelman, *Siamese Mission at Versailles Palace Parading King Narai's Golden Letter to Be Presented by Ambassador Kosa Pan to Louis XIV, September 1, 1686*, ca. 1687 (v. 63, no. 5548). Engraving, 34½ × 21¾ in. (87.5 × 55 cm). Bibliothèque Nationale de France, Paris, Département des Estampes et de la Photographie, Coll. Hennin (RESERVE QB-201(63)-FOL)

Such splendid ambassadorial ceremonies and related events—among them tours of the Versailles gardens, a feature of diplomatic visits that was instituted during Louis XIV's reign—were clearly designed to inspire awe and proclaim the

Fig. 52. Floorplan of the Hall of Mirrors as arranged for the reception of the Persian Embassy in 1715 and revised for the Ottoman Embassy in 1742. China ink, wash, and watercolor, 15 × 71⅛ in. (38 × 182 cm). Archives Nationales, Paris-Pierrefille (CP/o/1/1772/2/4)

monarchy's global reach.[13] But did they actually hit their mark? Most official sources maintain that they did. After the Tunisian ambassador Süleyman Aga had an audience with Louis XVI at Versailles in 1777, for instance, his French interpreter, Pierre Ruffin, translated a letter in which the ambassador described the moment he "viewed the glory of [Louis XVI's] imperial throne" as "the most beautiful moment of my life."[14] Süleyman Aga's hyperbolic praise echoes that of an Algerian envoy, Hajji Ja'far Aga, who had visited Versailles nearly a century before (in 1684), and who, after sailing along the Grand Canal, had purportedly said that "the sea of Versailles was the sea of the Emperor of the World."[15] His remark appeared in the *Mercure galant*, whose editor, Jean Donneau de Visé, devoted thousands of pages to recounting diplomatic visits during the Sun King's reign. Although the *Mercure* may have quoted Hajji Ja'far Aga accurately, the fact that Donneau de Visé's embassy descriptions served mainly to promote the many splendors of Versailles, coupled with the Crown's desire to use the Algerian embassy (and other diplomatic encounters with North Africa) to assert France's dominance over Muslim "infidels" in the region, make the statement suspect. In tone,

it accords well with one of the few surviving visual documents of the 1684 encounter: a French commemorative medal depicting a "suppliant Africa" in the form of the Algerian envoy kneeling humbly before Louis XIV, who is dressed as a Roman conqueror (fig. 53). Maritime motifs appear in the foreground and background, above an inscription celebrating France's victory in the Mediterranean "pirate wars."[16]

This is not to suggest that North African emissaries or other foreign dignitaries were not impressed by what they saw at Versailles—many of them were. Upon returning home from his 1699 embassy to France, the Moroccan ambassador Abdallah ben Aisha, who is depicted dining with his retinue in a French almanac print from that same year (see fig. 50), wrote in a letter to the French trader Jean Jourdan that he had repeatedly spoken to his king about the "Sultan Louis, his court, his reign, his fame, his

Fig. 53. Jean Mauger, *Commemoration of Peace with Algiers* (reverse), 1684. Silver, diam. 1⅛ in. (4 cm). British Museum, London (G3,FrM.608)

gracious manners and honor," and "his kindness to all people."[17] The ambassador's glowing reports prompted the king of Morocco, Mulay Ismail ibn Sharif, to attempt to build a palace modeled after Versailles, for which ben Aisha asked Jourdan to send French engineers to Morocco to erect fountains and aqueducts, as well as to propose marriage between himself and one of Louis XIV's natural daughters, the princesse de Conti.[18] Many other foreign envoys also professed admiration, in either words or deeds. After his 1728 visit to Versailles, the Tunisian ambassador Yusuf Khujah claimed to have been so overwhelmed by its grandeur that he feared he would not be able to describe it adequately, entreating French officials to send him engravings of the palace to show his ruler and other members of the government.[19] Although a fear of forgetting the wonders of Versailles was a trope of the embassy literature, it could also be sincere, and upon returning home several emissaries attempted to keep and showcase mementos of their journey. For example, during a trip to Siam in 1690, the German naturalist Engelbert Kaempfer visited the home of Kosa Pan, the lead Siamese ambassador to Versailles (fig. 49), and described how the ambassador not

only spoke fondly of his time in France but also hung pictures of the French royal family along with European maps in the main hallway of his residence, "the rest of his furniture being nothing but dust and cobwebs."[20]

Diplomatic Protocol and Cultural Distinctions

The 1686 Siamese embassy was almost universally viewed, from the standpoint of spectacle at least, as a success in France, one that continued to be invoked as a model to emulate more than a century later. During planning discussions related to an embassy that Tipu Sultan of Mysore sent to France in 1788, one French official based in India urged his colleagues to receive Tipu's ambassadors with the same degree of pomp that had been accorded to "the envoys of Siam under the reign of Louis XIV," so as not to risk losing face with Louis XVI's chief ally on the subcontinent.[21] Special embassies represented an important promotional opportunity for the French Crown, but they had the potential to fail spectacularly as well, particularly if cultural misunderstandings occurred or if violations of all-important diplomatic protocol took place.

Whereas the European diplomatic community adhered to a strict hierarchical system of protocol known as precedence (*préseance*), ambassadors from outside Europe were not part of the system and sometimes tried to circumvent it to uphold their sovereign's prestige. When the Persian ambassador Muhammad Reza Beg visited Paris in 1715, for example, he refused to adhere to certain rituals, such as standing when high-ranking Frenchmen entered the room or waiting for the king to address him first during his audience with Louis XIV at Versailles.[22] Although the painting showing Muhammad Reza Beg's reception in the Hall of Mirrors gives no indication of his perceived slight—in fact, both the ambassador and his retinue appear duly deferential (cat. 71)—the duc de Saint-Simon commented on the offense in his memoirs, accusing the Persian visitor of being an

impostor and claiming that his behavior during the ceremony "was as disgraceful as his wretched suite and miserable presents."[23]

Other foreign dignitaries seemed more conciliatory or willing to assimilate. In 1688 a group of Dominican missionaries brought a fifteen-year-old African emissary named Aniaba, the purported son and heir of the king of Issiny (an early modern kingdom on the Ivory Coast), to France.[24] Louis XIV took a special interest in the young African prince and was officially designated his "godfather" after Aniaba converted to Christianity and was baptized in Paris in 1691. Aniaba spent more than a decade in France, where he served both as a symbol of the monarchy's political authority in West Africa and as confirmation of Louis XIV's commitment to spreading Catholicism around the globe, particularly after his controversial decision (in 1685) to revoke the Edict of Nantes. For his part, Aniaba may have been hoping to shore up a powerful European ally who could support his claim to the throne of Issiny against local rivals. After learning of the death of his father, in 1700, Aniaba returned to Issiny, but not before asking Louis XIV to help him found a new chivalric order. In an engraving by Nicolas Bonnart, he is shown pointing to the necklace of that order while wearing a mixture of classical armor, an ermine-trimmed robe, and an exotic headdress (fig. 54). Derived from the tradition of Baroque state portraiture, Bonnart's print anticipates other images of non-European emissaries to Versailles, notably those depicting similarly young or impressionable sitters, such as the Ottoman ambassador Mehmed Said Efendi or the Prince of Cochinchina, who were thought to blend well into French society and thus to embody the potential for merger or "collaboration" (whether political or colonial) between France and the territories they represented (cats. 75, 80). Aniaba's portrait may also suggest his skill at adopting or mimicking French royal conventions, a talent that he emphasized in two paintings celebrating his conversion

that he is said to have commissioned and dedicated to Parisian churches in emulation of French monarchs.[25] One of these paintings formerly hung in the Cathedral of Notre-Dame, but both are now lost.

Prior to Aniaba's departure, the French Crown presented him with a gold medal depicting Louis XIV on one side and the king's male heirs on the other: the so-called *famille royale* medal (cat. 70).[26] While the exchange of presents was a standard part of diplomatic procedure, this particular gift may have had special meaning: in addition to commemorating the strong, intimate bond Aniaba had forged with Louis XIV, the medal was perhaps intended to portend the French-based Catholic dynasty that the young prince was supposed to establish in Issiny.[27] (This development, however, never came to pass, and not long after his return Aniaba disappeared from the historical record.) Similar "royal family" medals were presented or sent to foreigners with whom the Crown wished to forge alliances, most notably Native American chiefs and warriors who helped the French fight off rival British settlers in their North American colony of Nouvelle France. In 1706 the Montreal-born military officer Jacques Testard de Montigny brought an Abenaki chief named Nescambiouit to Versailles, where Louis XIV presented him with a medal in recognition of his support for France. Although very little information survives about Nescambiouit's visit, we do know that French royal medals were highly valued in the eighteenth century by their Native American recipients, who viewed them as markers of distinction and military prowess.[28]

Although the Siamese dignitaries were less obliging than Aniaba in certain respects—despite the Sun King's best efforts, neither Phra Narai nor his ambassadors converted to

Fig. 54. Nicolas Bonnart, *Le Roy d'Eissinie*, fol. 185, 17th century. Engraving, 16¼ × 11 in. (41.3 × 28 cm). Musée du Louvre, Paris, Département des Arts Graphiques, Collection Edmond de Rothschild (L 88 LR/184 Recto)

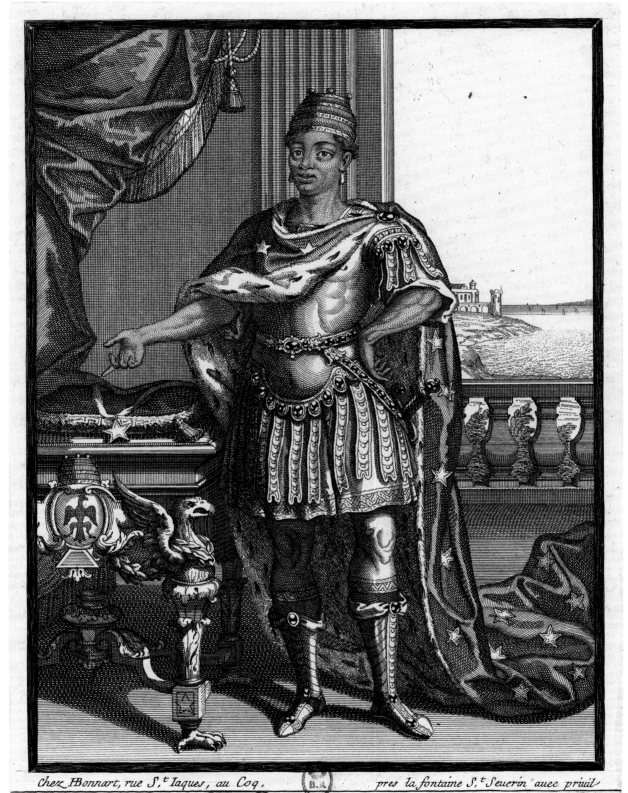

Chez IBonnart, rue S.ᵗ Iaques, au Coq. pres la fontaine S.ᵗ Seuerin auec priuil

Le Roy d'Eissinie.

Louis Aniaba Prince d'Eissinie, royaume de la Coste d'or en Affrique, apres auoir esté
eleué en france, dans le culte de la vraye Religion par les soins du Roy Louis le Grand, qui
luy a fait apprendre tous les exercices conuenables à un Prince, à esté rappellé par ses
sujets en l'année 1700. pour estre eleué sur le throsne, Auant que de Sortir de France,
il a institué l'ordre de l'Etoile, et à consacré un tableau, pour monument de sa piete,
deuant l'Autel de la Vierge dans l'Eglise Cathedrale de Paris.

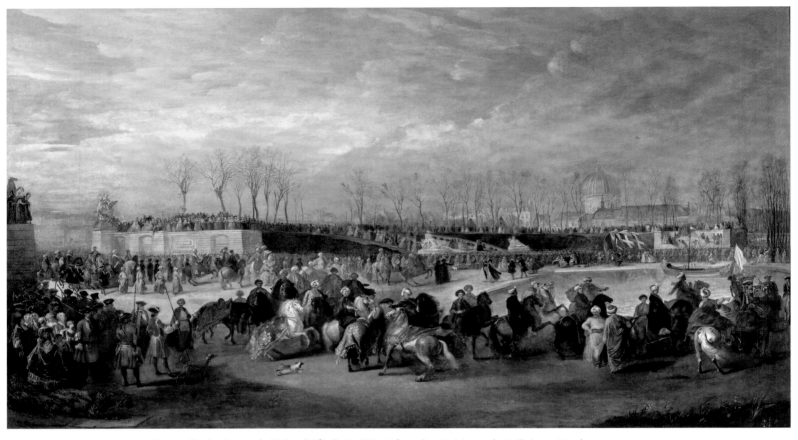

Fig. 55. Charles Parrocel, *Mehmed Efendi, Turkish Ambassador, Arriving at the Tuileries on March 21, 1721*, 1723. Oil on canvas, 73⅛ × 10 ft. 11 in. (187 × 333 cm). Musée National des Châteaux de Versailles et de Trianon (MV 177)

Catholicism—the members of the 1686 embassy were praised for their impeccable adherence to diplomatic and courtly protocol, perhaps a result of the extensive preparation they received from French royal officials during their six-month voyage from Bangkok to the French port of Brest.[29] Kosa Pan and his colleagues also willingly indulged the throngs of people who gathered to see them throughout their time in France. In a fragment from a lengthy journal he kept of his visit, which was unfortunately almost entirely destroyed during the eighteenth century, Kosa Pan expressed a mutual fascination to a group of French ladies whom he encountered in Brest: "You would like to see me; it is exactly the same as I would like to see you."[30]

Less eager to entertain crowds was the Ottoman ambassador Mehmed Efendi, who had an audience with the eleven-year-old Louis XV at the Tuileries Palace during the Ottoman embassy of 1720–21. In his written account, Mehmed Efendi complained of being constantly trailed by curious onlookers, several of whom can be seen pushing against iron railings or scrambling up trees to get a better view of the ambassador and his retinue in a painting by Charles Parrocel that depicts them arriving at the Tuileries (fig. 55). Mehmed Efendi was especially offended at having to tolerate French men and women watching him eat—observing Muslim and other exotic dining rituals being a favorite "spectator sport" for overseas embassies to France (see fig. 50)—but he acknowledged that this was a common (if bizarre) tradition in his host country, where the king would not only dine but would even "rise and get dressed in the morning" in public.[31]

French Art, Technology, and Culture

After two crushing defeats against European powers in 1699 and 1718, Ottoman rulers felt both an intensified need to establish political alliances with the West and a greater interest in learning about Western technology (especially military technology), science, and culture. Prior to his departure, Mehmed Efendi's superiors had instructed him "to visit fortresses and factories [in France], and to make a thorough study of means of civilization and education, and report on those suitable for application in the Ottoman Empire."[32] Fortunately for him, it was standard practice for foreign dignitaries to tour military arsenals and production facilities like the Saint-Gobain mirror manufactory and the Gobelins tapestry works, where, French officials hoped, consumer appetites might be whetted. Ambassadors were also taken regularly to royal palaces, gardens, theaters, the Paris observatory, and the Jardin du Roi, where they witnessed a variety of French cultural and scientific achievements. Their lodgings were outfitted with French furnishings and objets d'art that took into account Western views of their customs and habits—such as comfortable sofas for Ottoman dignitaries, or an avoidance of figural imagery for followers of Islam—and they, along with their sovereigns, were offered gifts that attempted to showcase French art and technology in addition to stimulating trade. For example, when Tipu Sultan's ambassadors visited Versailles in 1788, they were given more than two hundred pieces of Sèvres porcelain dinnerware in a range of colors and patterns to take back to Tipu, along with custom-made Sèvres hookah pipes, rosewater sprinklers, and other "Indian" wares (cats. 84–86; see also fig. 66).[33]

Foreign emissaries thus had ample opportunities to study, admire, and consume French products, and many eagerly complied. After visiting the Saint-Gobain manufactory in 1686, the Siamese ambassadors ordered more than four thousand pieces of French mirrored glass to ornament the palaces and buildings of their king.[34] Mirrors were already being used in Siamese palace decoration and had a strong cultural and symbolic resonance in Siam, and indeed it was often the case that foreign emissaries responded more favorably to objects (or pastimes) with which they were readily familiar. For example, although Mehmed Efendi seemed unimpressed by the easel paintings he was shown during his visit, he took a keen interest in tapestries from the Gobelins, which he described as a "workhouse for *kilim* weavers."[35] More than fifty years later, the Tunisian ambassador Süleyman Aga echoed Mehmed Efendi's curiosity regarding Gobelins tapestries while also conveying his enthusiasm for Ottoman gifts presented to Louis XV, among them a bejeweled horn-shaped powder flask and other hunting implements (cats. 76, 77). According to Ruffin, his interpreter, while in France the Tunisian ambassador also enjoyed taking a steam bath à la turque and watching a "bloody" animal combat in Paris, an activity that befit his "natural sensibility" as a man of war.[36]

Even more than tapestries, however, Mehmed Efendi was fascinated by the architecture and landscape of Versailles and other palaces such as Marly, which he dubbed "the paradise of the infidels."[37] In the embassy book he presented to the Ottoman sultan, he professed admiration for the symmetry and uniformity of French gardens, where tall trees were "planted with such calculation that all have the same proportion and do not differ from one another."[38] The Topkapı Museum Library contains twelve French engravings of Versailles that Mehmed Efendi took back to Constantinople, which seem to be annotated in his own hand. They may have served as inspiration for Sa'dabad, an Ottoman summer palace built for Sultan Ahmed III between 1721 and 1722. Sa'dabad featured a canal and gardens that resembled those of Versailles, but it was no mere pastiche; the design also responded to developments within Ottoman architecture and court society that made this new type of imperial residence desirable at this moment.[39]

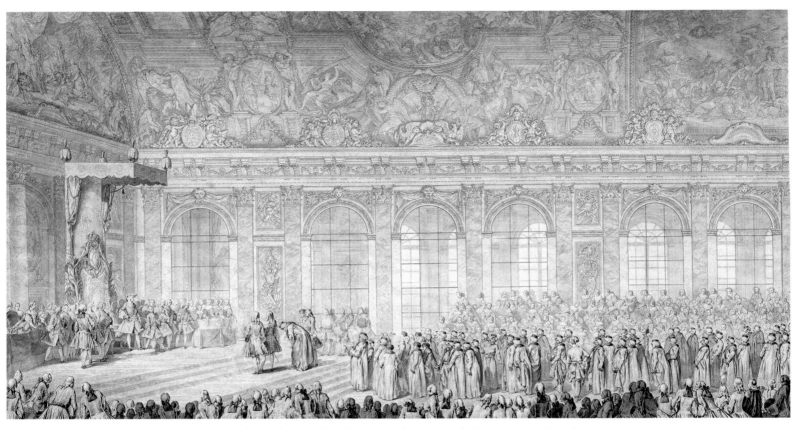

Fig. 56. Charles Nicolas Cochin, *Public Audience Given by Louis XV for the Ottoman Ambassador*, 1742. Gray wash on vellum, 17½ × 28⅞ in. (44.5 × 73.5 cm). Musée du Louvre, Paris (RF 41257)

Mehmed Efendi's son, Mehmed Said Efendi, was an even greater admirer of French culture. At the age of twenty-five, he traveled with his father to France, where he served as secretary for the 1720–21 embassy. Said Efendi was a huge hit with the French court and enjoyed a variety of artistic and cultural pursuits, from studying the delicate art of ivory-turning with Louis XV's teacher to spending two days and nights drinking and wandering around lost in the Versailles Labyrinth with three noblewomen.[40] Upon his return to Constantinople, he continued to seek out the company of French women and men, became fluent in the French language, and assisted in the founding of an Ottoman printing press on the French model in 1726. He also helped start a fad at the Ottoman court for drinking French wine and champagne, which he and his father had sampled privately in Paris.

Promoted to the rank of ambassador, in 1742 Said Efendi led a second Ottoman embassy to France. He was welcomed back with open arms by Louis XV, who staged an extravagant audience ceremony in the Hall of Mirrors that resembled the Sun King's Siamese and Persian embassies (figs. 52, 56). Said Efendi was also granted the rare privilege of attending the weekly Tuesday gatherings that Louis XV hosted for resident ambassadors, and he toured numerous cultural establishments and workshops, where he placed orders for the latest scientific instruments and other products.[41] He even found time to have his portrait painted by Jacques André Joseph Aved, which was exhibited to great acclaim at the Paris Salon of 1742 (cat. 75). Acquired by Louis XV and hung in the royal château at Choisy, Aved's portrait seamlessly blends Turkish and European motifs to depict Said Efendi as the supremely

OFFICIAL VISITORS AND GIFTS

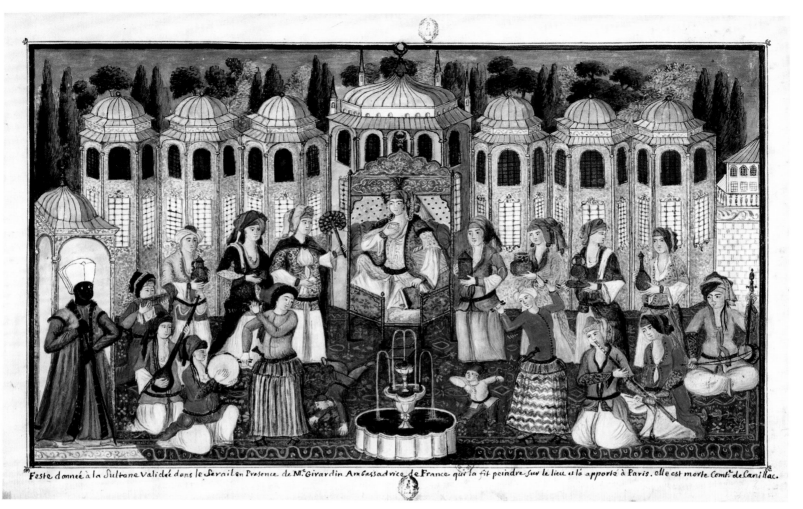

Feste donnée à la Sultane Validé dans le Serail en Presence de M.ᶜ Girardin Ambassadrice de France qui la fit peindre sur le lieu et la apporta à Paris, elle est morte Comtᵉ de Caniliac.

Fig. 57. Unknown Ottoman artist, *Feast Held for the Sultana Validé in the Palace in the Presence of Mᵉ Girardin, Ambassadress of France*, late 1680s. Gouache on paper(?), 12⅛ × 15¾ in. (32 × 40 cm). Bibliothèque Nationale de France, Paris, Département des Estampes et de la Photographie (OD-1 [1]-FOL, M03299)

"enlightened" diplomat that Voltaire, among others, claimed he was. (Of course, this view of the Ottoman dignitary as enlightened was predicated on the obvious esteem he held for France.)[42] By showcasing Turkish fashions in a French interior, together with the copious papers and books that seem to spill over the side of the desk onto the ground, the image perhaps also hints at the abundant commercial benefits presaged by the newly signed Franco-Ottoman trade agreement.[43] Certainly the painting brought considerable commercial gain to Aved himself, who became one of the leading artists of fashionable turquerie portraits.[44]

"Le Paradis des femmes"

If the royal retreat of Marly was "the paradise of the infidels," then France itself, according to Mehmed Efendi, was "the paradise of women" (*le paradis des femmes*). There, the Ottoman ambassador wrote, "Women can do what they want and go where they desire."[45] He expanded on this observation in a private oral report he gave to the sultan and the grand vizier, recounting a visit he made to observe military maneuvers in Sablons, where he observed a group of French ladies riding on horseback while dressed as Amazons.[46] Mehmed Efendi was also struck by the leading role Frenchwomen played as social and diplomatic agents, among

them the marquise de Girardin, wife of the former French ambassador to Constantinople, who threw a dinner party in his honor at which she donned Turkish dress and served food in the Ottoman style. Madame de Girardin may have wanted to recall or reciprocate a banquet (albeit one attended only by women) that the sultan's mother had hosted for her years earlier in the harem quarters of Topkapı, as depicted in a painting that was likely made by an Ottoman artist during the late 1680s (fig. 57).[47]

Frenchwomen, and not just the ones with whom he cavorted in the Versailles Labyrinth, made a strong impression on Mehmed Efendi's son as well. When he returned home after the first Ottoman embassy, Said Efendi tried to take back with him two portraits of French noblewomen, which the sultan confiscated.[48] During his second trip to Paris, he spent a great deal of time with actresses and other ladies and acquired a French mistress named Mademoiselle Pichard. The French playwright Germain François Poullain de Saint-Foix, who dedicated a one-act comedy to the ambassador entitled *Les Veuves turques*, reported that his Ottoman friend jovially thanked him with a gift of Baume de la Mecque, an infamous aphrodisiac.[49] With this gift, was Said Efendi attempting to play into European stereotypes about Oriental lasciviousness, or Turkish views of France as a land of erotic intrigue, or both?

Either way, many foreign emissaries viewed France, as travelers continue to do today, as a place to pursue *l'amour*. Muslim visitors in particular (and not only diplomats) commented on the ubiquity and accessibility of European women, especially compared with their female counterparts at home. While residing in Paris during his 1699 visit, the Moroccan ambassador Abdallah ben Aisha befriended the wife of his host, Jean Jourdan, and fell in love with a woman named Charlotte Le Camus Melson, with whom he was able to converse in English. After returning to Morocco, he sent gifts of fine shawls to Madame Le Camus, Madame Jourdan, and other ladies whom he had encountered and fondly remembered.[50] The Persian ambassador Muhammad Reza Beg, who was considered something of a heartthrob by his Parisian hosts, may not have put up with official diplomatic protocol, but he enthusiastically embraced more pleasurable aspects of French culture such as theater, music, and dancing. After a visit to the Paris Opera, he reportedly invited two female dancers back to his ambassadorial lodgings and treated each of them to a sable fur.[51]

Tipu Sultan's envoys followed in the Persian ambassador's footsteps during their 1788 embassy, according to private ministerial reports submitted by their interpreter, Pierre Ruffin, who had also served the Tunisian diplomat Süleyman Aga in 1777. Ruffin grumbled about the "rudeness" and lack of interest shown by the lead ambassador from Mysore, Muhammad Dervish Khan, and his fellow emissary Akbar 'Ali Khan, while maintaining that the third ambassador, Muhammad Osman Khan, was much more "polite" and "honest."[52] Much to Ruffin's annoyance, Tipu's ambassadors had apparently refused to leave Paris until their hosts could procure French manufacturers of porcelain, glassware, and other products, workers whom Tipu had asked to be sent to Mysore. According to Ruffin's reports, however, Osman Khan told him that the *real* reason his colleagues would not depart France was because of their romantic liaisons with women, a fact that the ambassador found particularly embarrassing given that his "nearly octogenarian" colleague, Akbar 'Ali Khan, had taken up with the much younger daughter of a Swiss Guard.[53] Finally, Ruffin claims, he persuaded them to leave, although he describes their trip from Paris to Brest (from where they would sail back to Mysore) as onerous after Dervish Khan's constant complaints about being sick, swollen, and unable to sit comfortably or "suffer the movement" of their carriage owing to the "tasteless" pleasures he had enjoyed in Paris.[54]

Not all of the Mysore ambassadors' encounters with women were sexual in nature. Marie Antoinette's favorite portraitist, Elisabeth Vigée Le Brun, painted both Dervish Khan and Osman Khan, and their portraits were prominently exhibited at the Salon of 1789, although the latter has been lost.[55] In her memoirs, Vigée Le Brun recounts seeing Tipu's ambassadors at the Opera and finding them so "picturesque" that she set about obtaining permission to paint them, and she vividly recalls how, after she was finished, she snuck into their Parisian hotel and took the paintings so that the ambassadors could not take them back to Mysore, thereby incurring Dervish Khan's murderous wrath.[56] Her imposing, full-length portrait of Dervish Khan likewise contains a stereotypical trace of "Oriental" violence, though the artist lavishes much more attention on depicting the ambassador's exquisite white muslin robe, floral overcoat, and golden sash (fig. 58). In so doing, she not only underscores one of the embassy's chief raisons d'être—the commercial trade in Indian textiles—but also invokes one of the principal ways that Frenchwomen were associated with foreign embassies, as arbiters and consumers of Asian fashions and luxury goods.

The magnetic force of Vigée Le Brun's portrait implies that the French female artist and her male Muslim subject—two equally strong-willed, confident individuals—were cautiously drawn to each other as mutually exotic presences. It is unfortunate that we are missing Dervish Khan's own description of this encounter, along with the personal perspectives of so many non-European emissaries who visited Versailles during the late seventeenth and eighteenth centuries. Yet despite this regrettable absence, ambassadorial portraits, diplomatic gifts, and other art objects can help us at least speculate on the reactions and motivations of those foreign visitors to Versailles whose voices have been lost or interpreted by others. In so doing, they offer a window onto an early modern French court culture that was far more international than we have previously acknowledged.

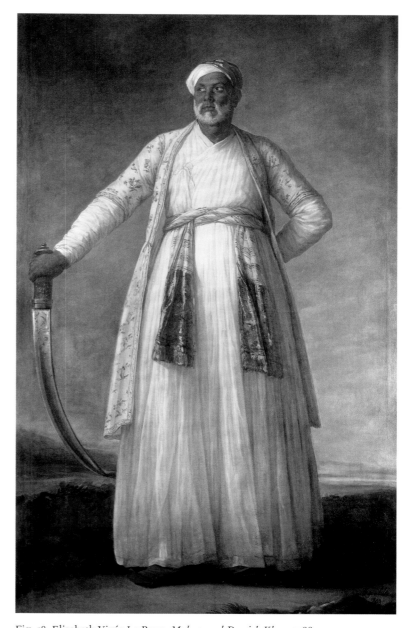

Fig. 58. Elisabeth Vigée Le Brun, *Muhammad Dervish Khan*, 1788. Oil on canvas, 96½ × 63⅜ in. (245 × 161 cm). Private collection

"PRÉSENTS DU ROY"
Official Gifts from the French Court

CORINNE THÉPAUT-CABASSET

Avoid as much as possible doing favors to those who offer money to get them. Give fittingly and liberally, and do not accept gifts, unless they be trifles. However, if you cannot avoid getting some, then make even bigger gifts to those who gave them to you, after letting a few days pass.

—Louis XIV to his grandson, cited by Voltaire
in *Le siècle de Louis XIV*, chap. XXVIII

One can easily imagine the impression that this extraordinary magnificence made on Europe.
—Voltaire, *Le siècle de Louis XIV*, chap. XXV

Beginning with the reign of Louis XIV and continuing up until the Revolution, gifts offered by the kings of France were systematically entered into ledgers called "Les présents du Roy," which also served to document the many official and unofficial visits made to Versailles during the period when it served as the seat of the French court.[1] A gift offered in the name of the king was intended as a public expression of the monarch's esteem. Among those presented by Louis XIV, most were of a type of gemstone jewelry called *pierreries*,[2] small masterpieces of French goldsmithing that, like most of the presents, were designed in part to demonstrate technical innovations in the production of French luxury items. Such gifts were also objects of royal propaganda,[3] since many of them bore the monarch's image or cipher. They thereby attested to the symbolic presence of the king—illustrating his military exploits, for example, or commemorating his reign—but, because they were decorated with his symbol, they also could be said to have represented the monarch's literal presence as well.

Through their monetary value and symbolic nature, royal gifts—from *boîtes à portrait* (pendants with the king's portrait in miniature), medals, and snuffboxes (cats. 49, 50, 54, 55) to tapestries and leather-bound volumes of engravings with the French royal coat of arms on the cover—were intimately bound up with the domestic and foreign policy of the monarchy. The luxurious gifts exchanged

between rulers were no doubt intended to impress rivals, perhaps expressing the good relations between kingdoms or, sometimes, the desire for rapprochement.[4] Gifts were also presented by the king to ambassadors, envoys, resident ambassadors, military officers, and wives of foreign ministers; to princes, bishops, queens, and the sons and daughters of the king; and to historians, scholars, and artists. In a portrait of Charles Le Brun, First Painter to the King, by Nicolas de Largillière, for example, the sitter is shown wearing a medallion given to him by Louis XIV (fig. 59).

As a currency of esteem, royal gifts often represented the terms of a negotiation, since the gift was a quantified, regulated reward matched to the rank of its recipient or to the value of a contract, mission accomplished, or services rendered. Royal gifts also typically served as compensation or reward for a diplomat's

Fig. 59. Nicolas de Largillière, *Charles Le Brun*, ca. 1684. Oil on canvas, 31½ × 25⅛ in. (80 × 65 cm). Galleria degli Uffizi, Florence (1880, no. 1858)

term of service, rather than having the Crown reimburse those expenses. According to Abraham de Wicquefort, a Dutch diplomat at the court of Louis XIII and author of the 1680–81 manual *L'ambassadeur et ses fonctions*, when an ambassador left his official post he was "treated according to the esteem we have for his merit, or according to the consideration that we have for the prince, his master. And sometimes also according to the importance of the matter that was the

object of his embassy."[5] In 1698 Ambassador Ezekiel Spanheim reported to his sovereign, Frederick III, Elector of Brandenburg, that the gift offered by Louis XIV, "namely a *boîte à portrait* with the portrait of the king on the back," to the ambassador extraordinary of England, the Earl of Portland, "is valued by experts at ten thousand écus" and "exceeds considerably and almost by half those that we are in the habit of giving to ambassadors of crowned heads."[6]

Questions of Protocol

The presentation of gifts was considered customary in France to the extent that one could not "refuse the king's gift without incivility."[7] It bears noting that the word "present," in the sense of a gift, derives from the Latin *de praesentia*, meaning that it had to be given to someone who was present.[8] According to Wicquefort, in order to prevent fraud or theft where the king's gifts were involved, "trusted persons [were] used on these occasions . . . either the masters of ceremonies or the introducers of ambassadors, who received the gift either personally from the king, or from one of the officers of his house, the Superintendent of Finance, or the Secretary of State in charge of the department of foreign affairs."[9] Spanheim related that "Mssrs. Bonneuil and Giraut, introducer and under-introducer of ambassadors, came . . . to bring on behalf of the king the standard gift for taking leave" presented to him upon his departure from the French court.[10]

Because royal gifts represented a market value, they were regularly returned or exchanged for money, although this practice was considered less honorable than accepting them.[11] A minister could also turn down this type of cash "present" or "pension" to avoid being put in a compromising situation and opt instead for a "courtesy gift," such as a piece of jewelry, for his wife.[12] In the case of diamond jewelry, the quality of the gems was of paramount concern. Some recipients preferred several diamonds over a single one, since they were considered to be more valuable. In the choice of presents offered to the Swedish minister Nicodemus Tessin the Younger, Daniel Cronström, a Swedish envoy to the French court, noted that Tessin "did well to prefer the portrait to the ring," explaining that "a single stone, however fine, never goes beyond four to five thousand livres, and thirty or forty stones must be of pretty poor quality if they are not worth more."[13]

In 1689, when Spanheim received his gift from the king upon the conclusion of his embassy, he did not think that he was in a rightful position to turn it down, writing to Frederick III that royal gifts had "no consequences, thank God, [and] are a customary formality . . . practiced indiscriminately upon the dismissal of public ministers."[14] Describing his *audience de congé* (the farewell audience marking the end of his embassy), Spanheim indicated that he had "not yet relinquished" the *boîte à portrait* given to him as an official gift, as many other public ministers often did, even if they "had less cause and particular arrears to meet upon such a departure," making it clear that he would have much preferred to receive instead the four thousand livres of the gift's value.[15]

Wicquefort saw nothing untoward in these practices: "I do not see how an ambassador can be corrupted by the gift that is offered to him when he is no longer in a position to negotiate, or to betray the interests of his prince, even if he wanted to; and by a gift that could not serve as reward, I do not say for some disloyalty and treason, but even for a service of little importance."[16] When a gift was offered publicly, moreover, it was considered legitimate: "In receiving the gift, the ambassador must have as much regard for his master's interest and for the satisfaction that he brings back from his embassy as for the one he leaves behind for his conduct at the court at which he has served."[17]

Some observers, however, detected a whiff of corruption. Antoine Pecquet, for one, was suspicious, observing in his 1738 treatise *De l'art de négocier avec les souverains* that the practice "legitimized the favors of a foreign prince when the natural sovereign allows them to be accepted."[18] It bears noting that an ordinary gift (*présent ordinaire*) from the crown had to be *reciprocated* in the future, whereas a payment was seen as compensation for legitimate and formal services.[19] It was reciprocated by services that were supposed to be made public as opposed to rewards given for public services, such as embassies rendered for the commonwealth.[20] The courtesy gifts made to

kings and queens, ministers and courtiers, were considered permissible, but when a gift was kept secret—a subtle but significant distinction—then corruption was thought to come into play. As the *Dictionnaire universel* (1701) put it, the "liberalities of Caesar" were "corruptions to buy the votes of the people, or rewards to pay those who had served him."[21]

Categories and Types of Gifts
During the reign of the Sun King, a *boîte à portrait* was the customary gift to foreign diplomats upon their departure from the French court.[22] Although they contained a miniature portrait, those presented by Louis XIV were pendants rather than actual boxes. Richly embellished with faceted diamonds, they were essentially fine jewels offered in protective cases, from which the term *boîte* (box) may derive.[23] Largillière's 1724 portrait of the envoy Conrad Detlev, Count von Dehn, from Braunschweig shows such a precious gift resting in its leather case (cat. 51). Most bore an enameled portrait of the monarch on one side and the royal monogram of two intertwined *L*'s on the other,[24] although a 1650 reference to this type of portrait medallion describes a likeness of the king on one side and of the queen on the reverse.[25] The goldsmiths Laurent and Pierre Le Tessier de Montarsy used silver leaf underneath the stones to enhance their brilliance.[26] Germain Brice, in his famous guide to the city of Paris, *Description nouvelle de ce qu'il y a de plus remarquable dans la ville de Paris* (1687), recommended a visit to the Rue de l'Université studio of the artist Jean Petitot the Elder, considered the most skillful enameler in Europe, who executed many miniature portraits of Louis XIV: "It is he who makes these fine enamel portraits that are set in diamond mounts and that are given as gifts to ambassadors. . . . No one has a better idea of this type of work than he, nor has captured the likeness as well."[27]

Of the more than four hundred *boîtes à portrait* recorded during Louis XIV's reign, only three are known to have been preserved: one given to the count of Malvasia, an Italian poet, in 1681;[28] one, now missing its gems, given to the Dutch statesman Anthonie Heinsius in 1683;[29] and a third, undocumented example now at the Musée du Louvre, Paris (cat. 49).[30] Some of the miniature portraits also survived after being remounted on elaborate gold snuffboxes,[31] which over the course of the eighteenth century eventually supplanted the *boîte à portrait*. Of these, the most famous examples were made by the goldsmith Daniel Govaers, who flourished until the end of the ancien régime (cat. 55).

The *table de bracelet*, a jewel worn on the wrist, was typically presented to the spouses of ambassadors and foreign ministers but also to female members of the royal family (cat. 58).[32] Containing a likeness of the king or queen, these miniature portraits were usually "not much bigger than a fifteen sous coin and often much smaller," richly mounted with diamonds, and set into a ribbon or pearl bracelet.[33] These types of jewels can be seen in various portraits, including one, after Jean Marc Nattier, of Mademoiselle de Sens (fig. 60).

A court sword, or *espée*, was a ceremonial weapon given to princes of other European kingdoms; its value depended on the rank of the recipient's nation.[34] Embodying the spirit of chivalry, the *espée* was a symbol of bravery but also skill in combat or equestrian games, and for that reason it was also offered as a *prix de carrousel* (award to the winner of a tilting match or jousting tournament).[35] It was often accompanied by an embroidered baldric or belt buckle with inset gemstones.[36] Although none of Louis XIV's presentation swords is known today,[37] a reference to one given to the prince of Tuscany can be found in Spanheim's account: "Last Tuesday the marquis de Torcy brought to Versailles a fine sword to the envoy from Florence as a present from the King to the prince of Tuscany, who was here recently. The hilt is adorned front and back with diamonds,

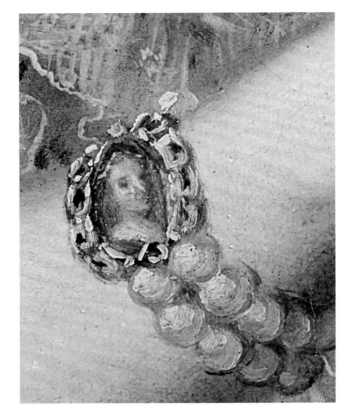

Fig. 60. After Jean Marc Nattier, *Elisabeth Alexandrine de Bourbon-Condé, Mademoiselle de Sens*, second half of 18th century. Oil on canvas, 32 × 25⅝ in. (81.5 × 65 cm). Musée National des Châteaux de Versailles et de Trianon (MV 3762)

Detail, fig. 60

some of which are large and beautiful. It is said that it costs the King fifty thousand livres."[38] An engraving by Gabriel Huquier illustrates Juste Aurèle Meissonnier's designs for the gold-hilted swords given on the occasion of Louis XV's wedding, in 1725 (fig. 61).

Silver services represented an especially high monetary value for a gift since they could be easily melted down or converted into cash. Those given by Louis XIV varied in value between three and four thousand livres. A receipt registered in 1667 to the accounts of the Menus Plaisirs (the operations of the royal household in charge of events and festivities) itemizes the pieces of a silver service given to the resident ambassador of Denmark that had cost 3,936 livres and 19 sols. The service consisted of "six trays and twenty-four

plates, weighing altogether ninety-five marks, seven ounces, two gros at twenty-nine livres, ten sols per mark, and 1,107 livres, fourteen sols, four deniers for two oval bowls, two ewers, four candlesticks and one salt cellar, weighing altogether thirty-six marks, two ounces, six gros at thirty livres, ten sols per mark."[39] These services enabled French goldsmiths to advertise their wares abroad, sometimes leading to further commissions passed on through foreign ambassadors in Paris. Since most of the silver in France was later melted down, this high-quality work is known almost exclusively through the extant pieces ordered by foreign clients from talented silversmiths in Paris.[40]

Gold chains and medals were given to interpreters and secretaries of ambassadors, artists, writers, scholars, and valorous seamen. On the

OFFICIAL VISITORS AND GIFTS

Fig. 61. Gabriel Huquier, "Design by Juste Aurèle Meissonnier for Smallswords Given as Gifts at the Wedding of Louis XV in 1725," in *Huitieme livre des oeuvres de Mr. Messonnier*, ca. 1745. Etching and engraving, 7½ × 8½ in. (19 × 21.6 cm). Victoria and Albert Museum, London (E.188-1967)

occasion of the Persian embassy in 1715, for instance, the baron de Breteuil (fig. 62) relates that "the secretary to the *Conducteur of Ambassadeurs* brought four gold chains to Chaillot, on each hung a medal of the king; each of these chains had a weight of five hundred écus. They were [intended] for the chief servants of the ambassador and for the interpreter Padery."[41] Considered "tokens of esteem," medals bearing the royal portrait were registered in the ledgers of the king's gifts and accounted for in official statements and inventories.[42] The gold supplied for the chains and medals was controlled and evaluated according to a unit called the mark (equivalent to about eight ounces), and a statement recorded the orders of payments to be made to the goldsmiths who supplied these objects. The goldsmith Montarsy, for example, is recorded as a supplier of the gold chains during the reign of Louis XIV; a certain "de Launay" is noted as the maker of the medals. Sets of medals presented during the reign of Louis XIV[43] and decorated with the history of the king (cat. 54) were emblematic gifts in the sense that they combined historiography, propaganda, and the propagation of the king's *Gloire*.[44]

Tapestries, textiles, and other luxury goods from royal manufactories were also given as gifts. In 1682 four ministers of the king of Denmark were given carpets and wall hangings made at the Savonnerie manufactory, with a total value of 50,034 livres.[45] The following year, the Margravine of Brandenburg received two Gobelins tapestries from the series The Months of the Year worth 60,000 livres.[46] Such costly and luxurious presents from the royal Savonnerie and Gobelins manufactories continued to be given during the eighteenth century. In addition, table services and decorative wares such as vases as well as biscuit porcelain groups and busts made at the Sèvres porcelain manufactory were offered to diplomats and to important incognito visitors of Versailles (see "Incognito in Versailles" by Volker Barth in this volume).[47]

Gifts of collections of prints from the Cabinet du Roi, the royal administration that published them, were much sought after in Europe and, beginning in 1684, were recorded by the Keeper of the King's Prints in a register still extant today.[48] Such albums were tokens of special favor and not available for sale. In 1695 Cronström noted that albums of prints were "given upon request by ambassadors to esteemed persons at foreign courts."[49] These collections were bound in sumptuous red morocco leather stamped with the royal coat of arms, which considerably enhanced the value of the prints. As Cronström wrote to Tessin, these were "gifts [ranging] from six to seven hundred écus between connoisseurs and the curious."[50]

The ambitious volume *Médailles sur les principaux événements du règne de Louis le Grand* (1702) was illustrated with etchings of all the medals created to date by Louis XIV in France (cat. 50). Captions at the bottom of the plates gave a concise explanation of each one. This comprehensive *histoire métallique* "incarnated the glorious body of the king . . . and was above all the instrument for a much wider distribution."[51] An enlarged edition issued in 1723, after Louis's death, celebrated the late king's rule. Attesting to the skill of the

LOVIS N. BARON. DEBRETEVIL
ET DE PREVILLY PREMIER BARON
DE TOVRAINE. INTROD. DES AMB.^{rs}
ET DES PRINCES ESTRANGERS
AVPRES DV ROY . 1701

engravers, these volumes were much-appreciated gifts and were sometimes depicted in the portraits of diplomats, such as that of Conrad Detlev, Count von Dehn, by Largillière or Jacques André Joseph Aved's portrait of Mehmed Said Efendi, the Ottoman representative, from 1742 (cats. 51, 75). Both sitters chose to have themselves represented with objects that manifested the French king's friendship for them and for their respective rulers, including these albums, which received a prominent place among the other rarefied works. In 1703 Jean François Félibien des Avaux, the historiographer of the Bâtiments du Roi, believed the engravings made for the king's collection would long be treasured, for it was "through them that posterity [would] see in the light of pleasant figures the story of the great deeds of this august monarch, and already today, the most far-off peoples will enjoy, as we do, the new discoveries that are made in the academies that His Majesty established for the arts and sciences." He considered that it was "still by means of these prints that all the nations admire the splendid buildings that the King is raising on all sides, and the rich ornaments with which they are decorated."[52]

Gifts or Tribute?

As Wicquefort observed, the gifts of tapestries, fabrics, rifles, telescopes, clocks, and watches offered to Eastern sovereigns—listed in the royal inventory of the presents made to the Ottoman embassy in 1721 (fig. 63)—were considered "merchandise" designed to stimulate orders for these technically advanced and innovative objects. They also helped establish new foreign markets for French luxury goods. In 1715 Breteuil, then the Introducer of Ambassadors, recorded that "the king's gifts" to Muhammad Reza Beg, the Persian ambassador, "consisted of a very large

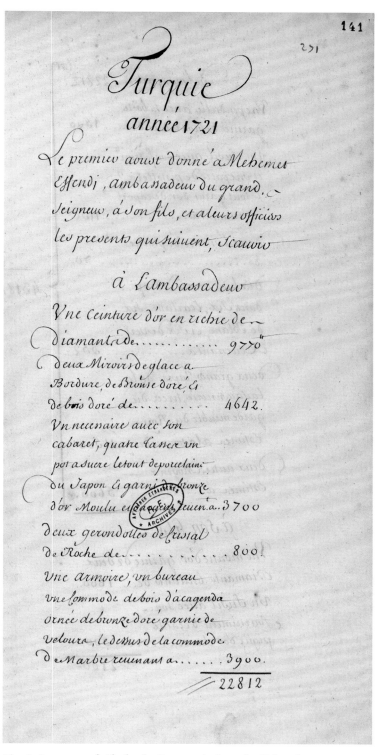

Fig. 62. After Hyacinthe Rigaud, *Baron Louis Nicolas Le Tonnelier de Breteuil, Introducer of Ambassadors*, 1701. Oil on canvas, 39¼ × 32 in. (99.8 × 81.3 cm). Musée des Beaux-Arts, Orléans (558)

Fig. 63. Inventory of gifts for the Ottoman Ambassador Mehmed Efendi, in *Recueil des présents fait par le roy*, 1721. Archives du Ministère des Affaires Etrangères, Paris-La Courneuve, France (Mémoires et Documents, vol. 2037, fol. 271)

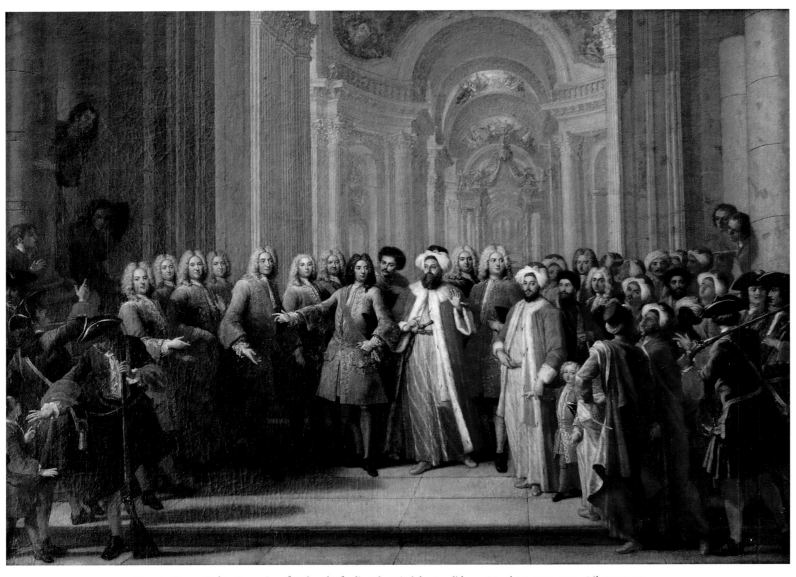

Fig. 64. Pierre Dulin, *Reception of Mehmed Efendi at the Hôtel des Invalides on March 25, 1721*, 1721. Oil on canvas, 47¼ × 63 in. (120 × 160 cm). Private collection

and magnificent Savonnerie carpet, six pieces of gold and silver fabric, eighty ells of the finest wool cloth made in France, of which twenty ells scarlet, twenty ells blue, twenty ells purple, and twenty ells yellow; two gold watches, one with a repeater; two very beautiful clocks; a brooch with the finest emeralds that could be found, and some diamonds mixed in with the emeralds, for the Persians value colored stones more than diamonds."[53]

Textiles created at French manufactories were intended to show off the country's latest innovations in weaving and, at the same time, preserve recipients' memories of their visit to the Gobelins, part of a grand "tour" of royal workshops and public buildings organized for extraordinary embassies. The Ottoman ambassador Yirmisekiz Çelebi Mehmed Efendi, for example, visited the Gobelins, and was also shown the Hôtel des

OFFICIAL VISITORS AND GIFTS

Fig. 65. Paul Androuet Du Cerceau, "Design for Mirror to Be Given to the Siamese Ambassadors," in *Ornemens d'orfevrerie propres pour flenquer et emailler*, 1686. Etching, 10¾ × 6¾ in. (27.3 × 17 cm). Victoria and Albert Museum, London (E.1392-1925)

Fig. 66. *Spittoon Made to Please the Indians Ordered by Monsieur Régnier on July 14, 1788* ("857bis"), 1788. Ink on paper, 6⅛ × 7⅞ in. (15.5 × 20 cm). Cité de la Céramique, Sèvres, France (2011.3.128)

Invalides (fig. 64).[54] The designs of the jewelry and other objects with precious stones were sometimes adapted to the taste of the recipient, as illustrated in engravings of mirrors designed as gifts for the Siamese ambassadors (fig. 65). This was also the case in the eighteenth century with porcelain wares made at Sèvres, where some works were specifically designed with the local customs and religious concerns of the beneficiaries in mind. In 1788, for instance, a special cuspidor (spittoon) was designed for the ambassadors of Mysore (fig. 66) along with porcelain cups decorated with floral motifs out of respect for the traditional Islamic opposition to figural representation (cat. 86).

The printed books and engraved illustrations of the *Vues des maisons royales* were among the most highly esteemed royal gifts and were solicited by the representatives of countries that did not have printing presses. These volumes helped to spread and preserve the deep impressions Versailles and Marly made on foreign visitors well beyond the borders of France. Gifts of watches and clocks reveal more complex exchanges and relationships. Much sought after in the Middle East, these mechanical timepieces offered different ways to measure time from the more traditional sundials or elaborate water clocks.[55]

Referring to the reception of the Moroccan embassy of envoy Abdallah ben Aisha, Breteuil noted in his memoirs that "nothing is written regarding the ambassadors extraordinary from Muscovy, Turkey, and others to whom the king wants to show his grandeur."[56] Interestingly, the first volume of the *Présents du Roy* registers includes a chapter titled "Traitements particuliers" (Special Treatments), which gives information about the various presents and compensations for travel and sojourns to foreign embassies considered atypical or exceptional. This record was no doubt intended to establish "typical" cases that could be referred to on future occasions when no established protocol existed for these extraordinary visits to Versailles.

36 *Nicolas II de Sainctot*

French, 17th century

Sainctot, seigneur de Vemars, served the French court in various capacities—including as Master of Ceremonies of France, as he is portrayed here (with the baton denoting that office)—before becoming Introducer of Ambassadors in 1691. He acquired the office from Michel de Chabenat de Bonneuil, who held this position from 1680 until he sold it in 1691 for the sum of 246,000 livres. Although the Introducer took his oath before the Grandmaster of France, he received his orders only from the king.[1] The title itself dates from the reign of Louis XIV, but the function existed long before that. One of two officials who performed the role (alternating biannually), the Introducer was in charge of all diplomatic ceremonial duties. He arranged an ambassador's formal entry into Paris, public audience with the king, and farewell audience at the end of his tenure. He also conducted ambassadors to the king's *lever* and was on hand each Tuesday when ambassadors were received at court.[2] In his memoirs, Sainctot detailed the protocol to be observed during the audiences with the king and other members of the royal family.[3] BS

37 Smallsword

French, 1769

The inscription on the blade indicates that this smallsword belonged to a member of the Gardes du Corps, the premier cavalry unit charged with the protection of the king and his household. Drawn from the aristocracy and distinguished by their courtly comportment, members of this unit would have been a common sight for visitors to Versailles. The pierced-silver hilt, adorned with royal-sun-in-splendor emblems framed by laurel leaves, was created in Paris by an unidentified *fourbisseur* (sword-cutler) and then mounted with a blade in Versailles by the *fourbisseur* Guilmin, known to have made a number of swords for the Gardes du Corps. The use of precious metal suggests that the sword was intended for an officer. JB

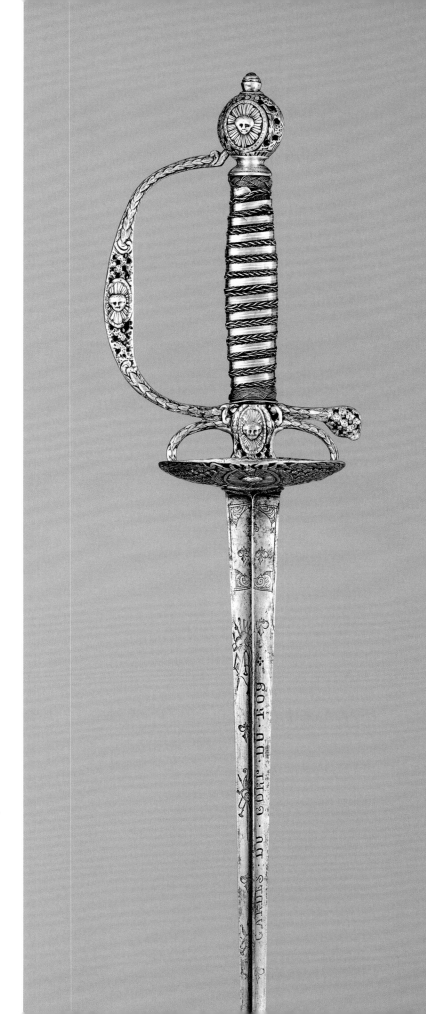

38 Musket

Royal Manufactory of Saint-Etienne, ca. 1730–40

Made for a member of the Maison Militaire du Roi—the king's military household—this musket bears an inscription identifying it as having belonged to one of the Swiss soldiers at court, known as the Swiss Guard, who along with a French infantry regiment shared the duty of protecting the gates, entrances, and perimeter of the palace.[1] The two units were easily distinguished because the French always stood on the right side of the palace and the Swiss Guard on the left, and while the French wore blue coats with red facing, the Swiss had red coats with blue trim.[2] The town of Saint-Etienne, where the musket was made, was long a center for the production of knives and swords, but during the eighteenth century its armorers also crafted firearms for the French military. DK-G

39 Ceremonial Uniform of the Cent-Suisses

French, 18th century

The Swiss provided mercenary services to foreign powers, including the French Crown. Among the members of the king's military household was a group of one hundred Swiss Guards known as the "Cent-Suisses." Armed with a halberd displaying the royal arms, these guards were charged with protecting the king inside the palace. During the king's public audiences with foreign ambassadors and on other special occasions, they wore gala uniforms whose elaborate design—including a starched and pleated ruff, a doublet and trunk hose richly decorated with braid, and a plumed hat—dated back to the sixteenth century. Although some eighteenth-century observers might have agreed with the German literary critic Johann Friedrich Karl Grimm that the uniform was "somewhat ridiculous," the Cent-Suisses certainly stood out among the crowds at Versailles and contributed to an atmosphere of pomp and splendor.[1] DK-G

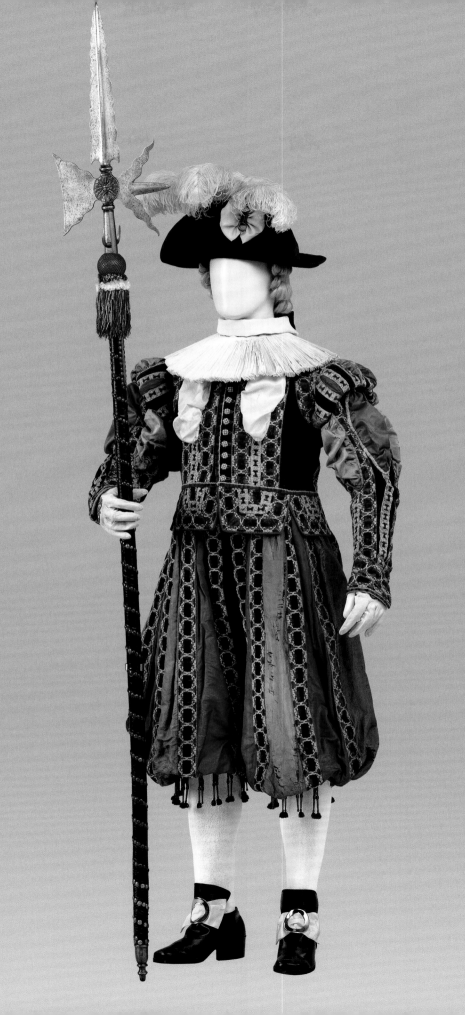

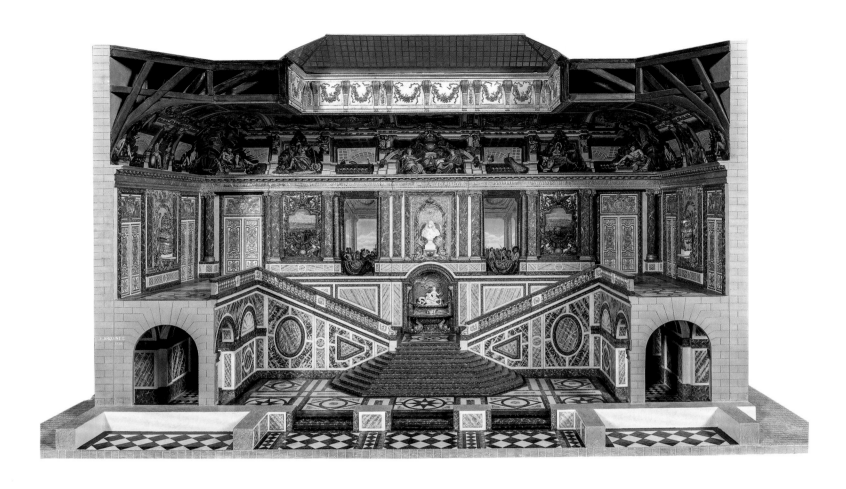

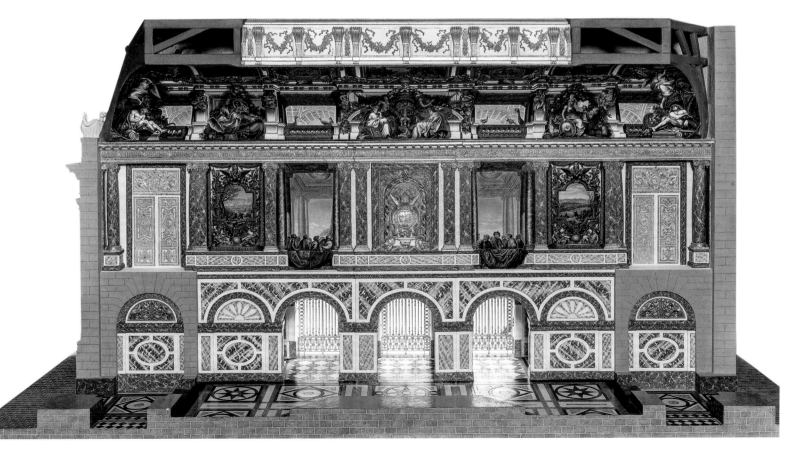

40 Model of the Ambassadors' Staircase

Charles Arquinet, 1958

41A *The Nations of Europe*

41B *The Nations of Asia*

After Charles Le Brun, after 1678

The Ambassadors' Staircase was a major component of the formal plan for Versailles initiated by Louis XIV. Known formally as the Grand Degré du Roi, the monumental staircase was designed in 1671 by the architect Louis Le Vau and decorated between 1674 and 1679 with an elaborate program of sculptures and paintings after designs by Charles Le Brun. It was destroyed in 1752. Located in the right wing of the palace, facing the Cour d'Honneur,[1] the staircase provided access to the King's State Apartment. A first flight of stairs ascended to a landing where it split into two flights, each leading up to a pair of doors that opened onto the Salons of Venus and Diana, respectively.

In this dramatic space, illuminated by a skylight, visitors of note—particularly representatives of diplomatic embassies—were meant to climb the steps and be amazed by the spectacle of Le Brun's decorative vision, which seemingly unfolded between heaven and earth, reality and illusion. At the bottom of the staircase were polychrome marbles; on the first level, trompe l'oeil paintings of loggias with envoys of the four continents (Europe, Asia, Africa, and America) and imitation tapestries celebrated the great achievements of the king's reign. The vaults were embellished with allegorical and mythological motifs alternating with historical subjects. BS

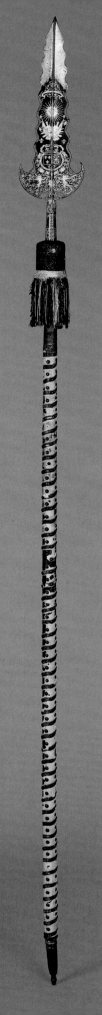

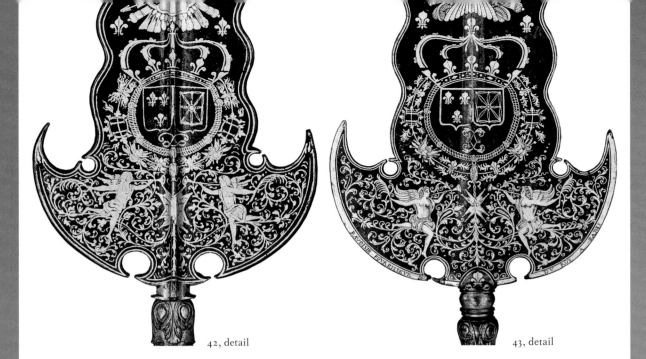

42, detail

43, detail

42 Partisan

French, ca. 1658–1715

43 Partisan

Attributed to Bonaventure Ravoisié, ca. 1678–1709

44 Partisan

Jean Bérain the Elder, designer, ca. 1679

These three grand partisans (shafted weapons with trident-like blades) were carried by Louis XIV's bodyguards, the Gardes de la Manche (Guards of the Sleeve), an elite unit whose name conveyed their close proximity to the monarch. The splendor of these tall, richly detailed weapons would have been apparent to onlookers even from afar. The two flamboyant, blued blades (cats. 42, 43) are similar in form and decoration; both are emblazoned with gilt suns in splendor, the royal motto above the arms of France and Navarre, and winged personifications of Fame.[1] Slight differences in size and quality of execution indicate that they were made by different *fourbisseurs* (sword-cutlers), possibly at different times. The most opulent of the group, the pierced partisan (cat. 44), depicts Louis as Mars driving a chariot over a lion and an eagle, signifying the king's triumph over England and Austria, respectively. Overhead, Fame crowns him with a laurel wreath, and his motto frames a sun in splendor. Significantly, these motifs depart from the Herculean imagery that had served as the insignia of the Gardes de la Manche since the reign of Henri IV and had decorated similar chiseled royal partisans. The new design was considered so exceptional that it was published in the *Mercure galant* in 1679, complete with a print of the blade's design and a commentary on its iconography.[2] The periodical also revealed that the royal designer Jean Bérain had devised the weapons specifically for the marriage ceremonies of Louis XIV's niece Marie Louise d'Orléans to Charles II of Spain. Only four other examples of this partisan are known.[3] JB

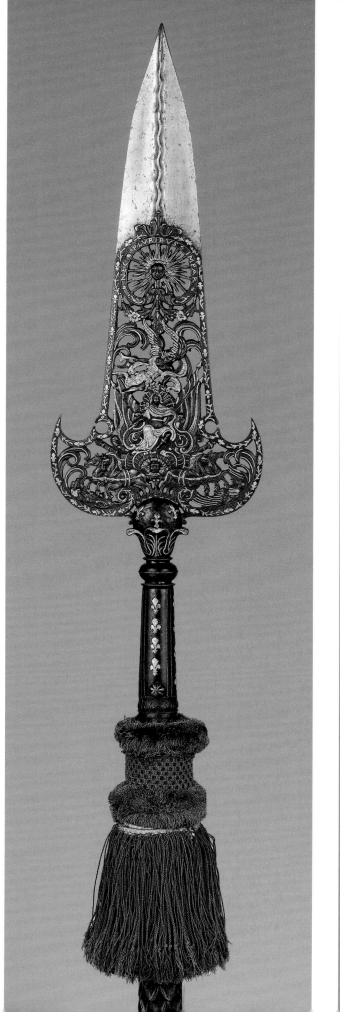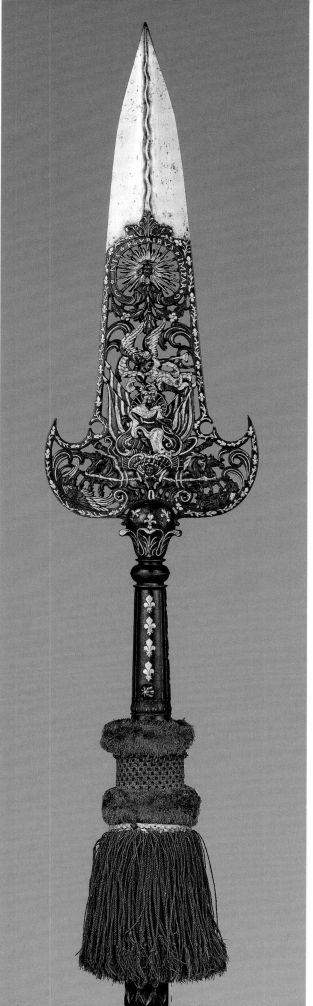

44, details of
front and back

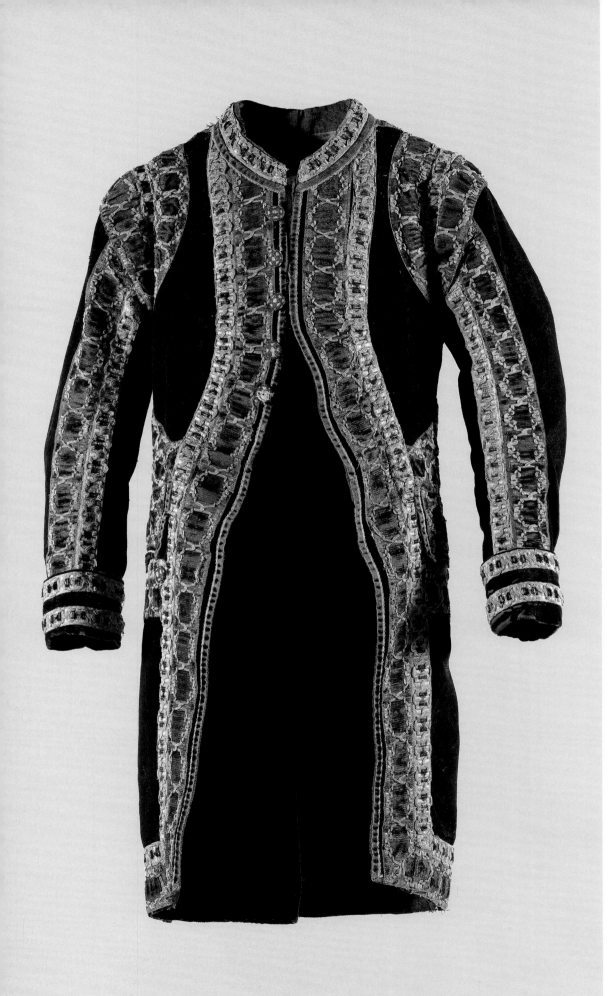

45 *Justaucorps* from the Grand Livery of the Royal Household

French, 1770–80

Upon arriving in Versailles, many visitors were immediately struck by the regal red, white, and blue uniforms of the *gens de livrée*, or members of the royal household. Each livery consisted of a *justaucorps* (knee-length coat) of blue wool lined with red-dyed serge or raz (silk) worn over a waistcoat and breeches. The colors of the braids on the coat and the matching buttons defined the wearer's rank in the household.[1] Although it is difficult to establish the exact number, the men who wore the livery included pages, lackeys, coachmen, grooms, and footmen for the stables; sweepers, floor-waxers, and others attached to the management of the royal residences; and minor officers of the King's Chamber.[2] MDV

46 Armchair

French, ca. 1700

This stately armchair (*fauteuil*) is richly embellished with symbols of the French monarchy that strongly suggest a royal origin. Interlaced *L*'s alternating with fleurs-de-lis motifs are carved on the lambrequin-shaped seat rails, while a medallion with the double *L* monogram surmounted by a crown decorates the crest rail. The chair has been identified with one listed in an inventory drawn up after Louis XIV's death.[1] The king sat on his throne only on special occasions, such as the reception of overseas embassies, which took place in the Apollo Salon or, exceptionally, in the Hall of Mirrors (see cats. 60, 71). At other times, including for the public audiences of foreign diplomats (held in either the royal bedchamber or the Cabinet du Conseil), he was seated on an armchair, and it is possible that this formal example was used as such during an official visit of some kind. DK-G

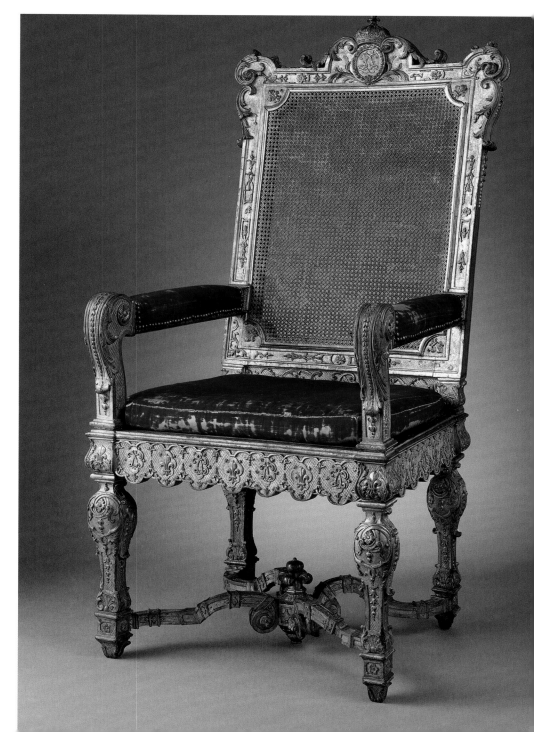

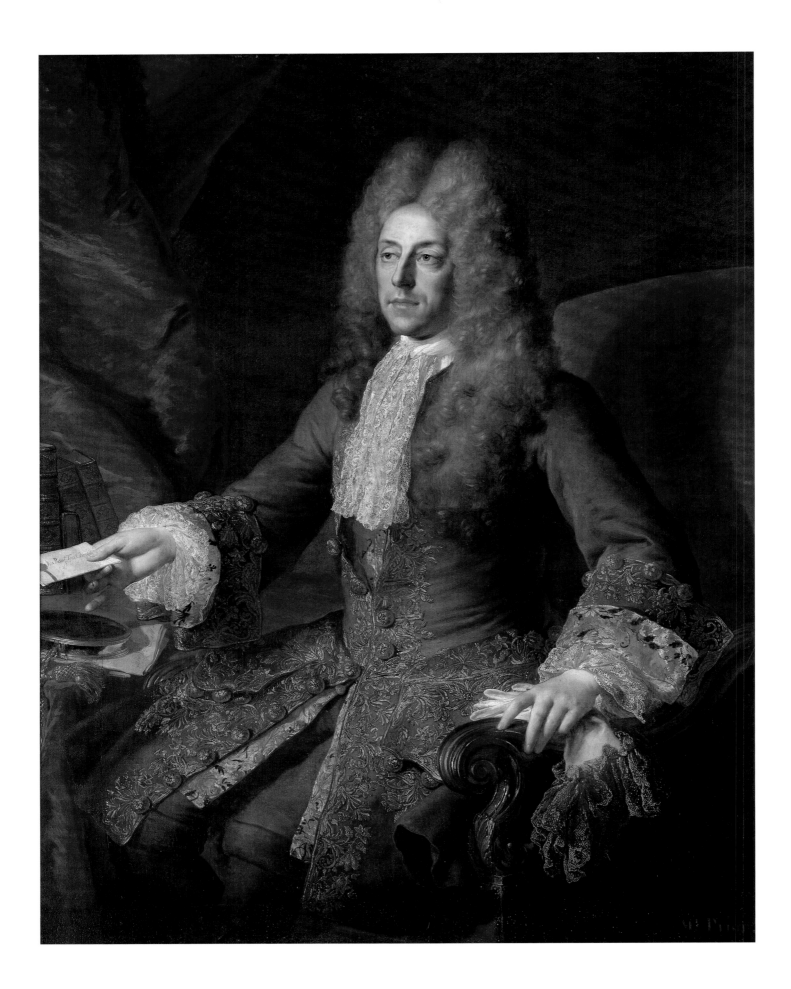

47 *Matthew Prior*

Alexis Simon Belle, 1713–14

Belle portrayed Matthew Prior when he served as British minister plenipotentiary to France. Prior was charged with improving relations between the two countries, which had fought on opposite sides during the War of the Spanish Succession. Belle, who was painter to the exiled Jacobite court in France, depicted the diplomat seated and wearing a long powdered wig and formal French dress. The sealed letter in Prior's right hand is addressed "Au Roi très Chrétien" (To His Most Christian King), a reference to the diplomatic credentials he presented to Louis XIV (fig. 39).[1] On the table next to him lies a second document, with an inscription identifying the sitter. A silver skippet (box) for the safekeeping of a wax seal is attached to this folded paper by a tasseled cord. Prior, described by the duc de Saint-Simon as capable, clever, and extremely witty, was also a man of letters, a distinction to which the books in the painting allude.[2] DK-G

48 Double Doors

French, ca. 1710

These doors are closely related to similar sets at Versailles. Although their provenance remains unknown, they bear sunflowers, symbols of the Sun King, incorporated in the design. They would have been placed beneath a carved or painted overdoor to increase the illusion of height. In diplomatic circles and at court, it was of the utmost importance that individuals of rank be accorded the proper respect. In 1723, on the day of his public audience with the king, Conrad Detlev, Count von Dehn, *envoyé extraordinaire* from the Duke of Braunschweig-Wolfenbüttel, was escorted via the "ordinary" stairs because the grand Ambassadors' Staircase (see cat. 40) was used only on exceptional occasions or for non-European visitors.[1] The diplomat and his retinue then proceeded through several crowded rooms to the Cabinet du Conseil, but each time through a single open door, since opening both leaves was a distinction reserved for ambassadors. As the doors remained closed until the envoy approached, his view down the enfilade would have unfolded only gradually. DK-G

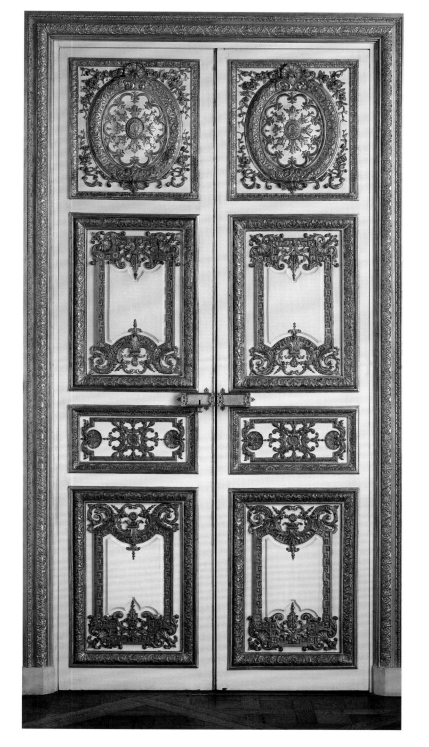

49 *Boîte à portrait* of Louis XIV

Miniature portrait by Jean Petitot the Elder; setting by Laurent Le Tessier de Montarsy or his son Pierre, ca. 1668

50 *Médailles sur les principaux événements du règne de Louis le Grand*

Engraved by Charles Simonneau; binding attributed to Luc-Antoine Boyet, 1702

51 *Conrad Detlev, Count von Dehn*

Nicolas de Largillière, 1724

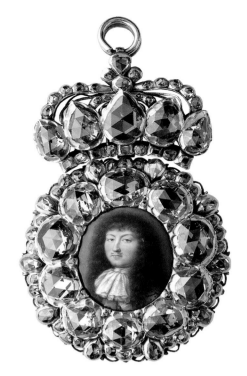

In 1723 Duke Augustus William von Braunschweig-Wolfenbüttel sent Conrad Detlev von Dehn to France as his *envoyé extraordinaire* to congratulate Louis XV on his ascension to the throne. On August 24, Dehn's public audience with the king took place at Versailles in the king's study.[1] While in Paris, Dehn commissioned this portrait, in which he wears a long wig, a sumptuous coat of orange-red and silver brocade, and a fine lace cravat. The tricorne hat under his left arm would have played an important role in court ceremonial.

The portrait must have been painted after Dehn's farewell audience at Versailles on November 30, 1723, since it shows the gifts he subsequently received from Louis.[2] These included a bejeweled *boîte à portrait*, with a miniature of the king, enclosed within a protective leather case.[3] Although Louis XIV had presented hundreds of such jewels, only three are known to have survived; in most cases the precious stones were sold and the miniature recycled. It is not known to whom the present example was originally offered. During the eighteenth century *boîtes à portrait* were largely replaced by more fashionable snuff-boxes (cats. 55, 170).

Among the books shown in the portrait is an illustrated volume of medals depicting the principal events of Louis XIV's reign, first published in 1702 and enlarged in 1723. Given that Dehn visited the

same year, he probably received the revised edition. The *Perspective de Versailles*, also depicted, was one of the sumptuously bound collections of engraved views of the palace routinely presented as royal gifts.[4] A letter addressed "a mon Cousin le Duc de Wolfenbutel Prince du St. Empire" is placed on the table between the gifts. The portrait itself, for which the sitter paid three thousand livres, served as a brilliant souvenir of Dehn's visits to Versailles, which were surely among the highlights of his diplomatic career. DK-G

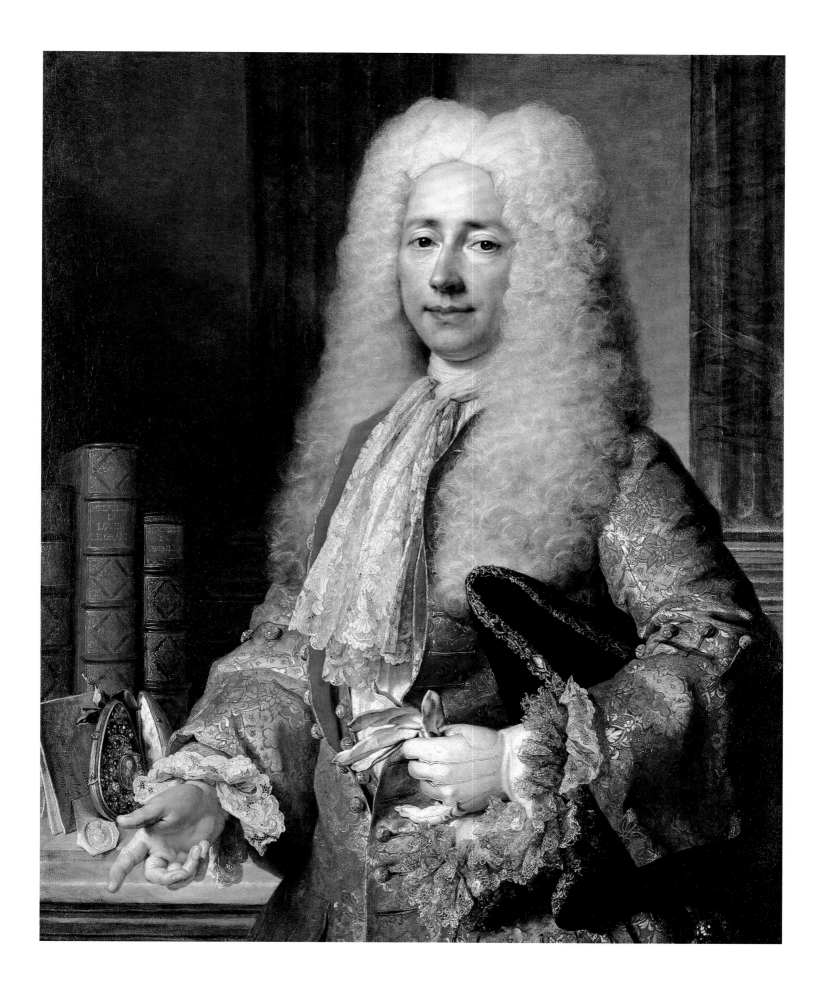

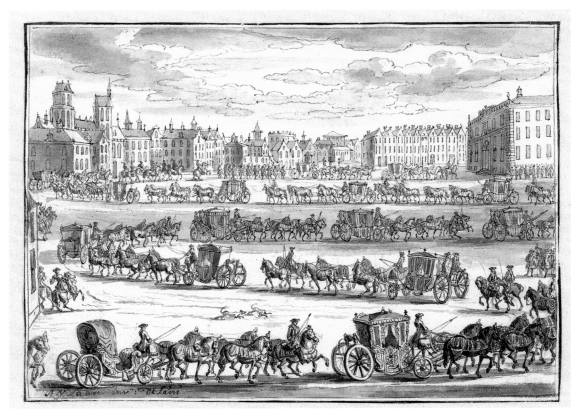

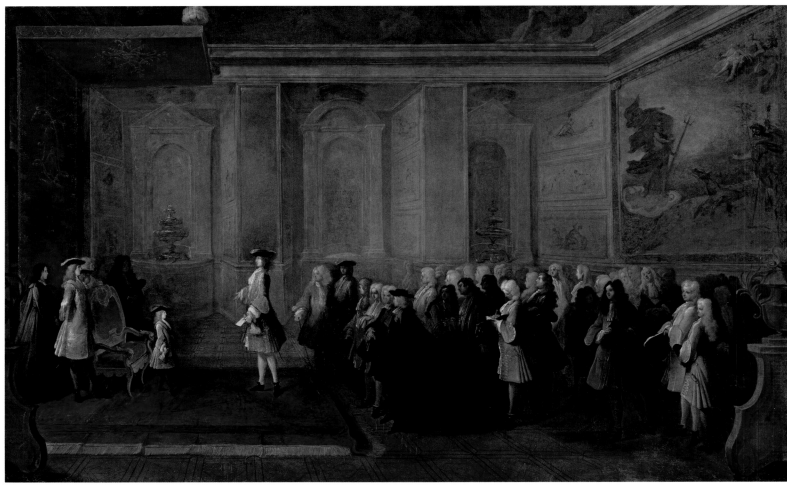

52 *The Formal Entry of Cornelis Hop into Paris*

Adolf van der Laan, ca. 1719–20

53 *The Formal Audience of Cornelis Hop at the Court of Louis XV*

Louis Michel Dumesnil, ca. 1720–29

54 Box for the Storage of Medals

French, ca. 1700

55 Snuffbox with Miniature Portraits of Louis XV and Marie Leszczyńska

Box by Daniel Govaers; miniature portraits attributed to Jean-Baptiste Massé, 1725–26

Appointed in 1718, Hop was the first Dutch resident ambassador to France to be received with the same honors as the representative from the Venetian Republic.[1] Although he arrived months earlier, his formal entry into Paris did not take place until July 23, 1719, when the equipage for the ceremony was ready.[2] Following Hop's account, Van der Laan shows his carriage preceded by two equestrian Swiss Guards and drawn by eight black horses, although the diplomat himself rode with the Introducer of Ambassadors in the third (royal) carriage.[3] His public audience with the king two days later at the Louvre was recorded in Dumesnil's painting, one of the few representations of such an official event.[4] With his letter of credence still in his hand, Hop is shown delivering his formal harangue to the child king.[5] The man dressed in light blue and attentively taking notes might be Dumesnil himself.[6]

Hop visited Versailles for the first time in September 1719 at the invitation of the Regent;[7] once the court had returned to Versailles in 1722, he went to the palace regularly. In November 1725, he took his leave of Louis XV in a private audience at Fontainebleau during which the king, as usual, was silent.[8] Several months later, Hop received a collection of commemorative gold medals stored in two *medaillers* that were perhaps similar to the leather-covered box shown here bearing the royal coat of arms.[9] He was also presented with Govaer's diamond-mounted snuffbox with miniature portraits of Louis XV and Marie Leszczyńska inside the lid.[10] Attributed to Jean-Baptiste Massé, these miniatures are based on engravings by Nicolas IV de Larmessin after paintings by Jean-Baptiste Vanloo. DK-G

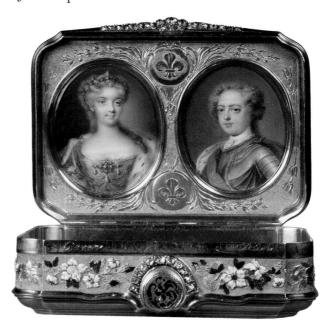

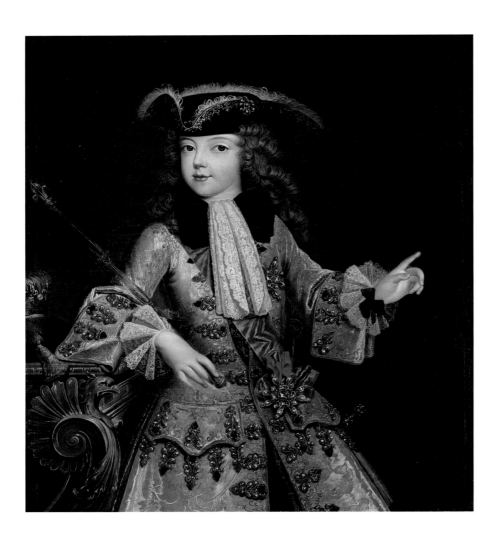

56 *Louis XV*

Augustin Oudart Justina, ca. 1717

Although a member of the Paris Academy of Saint Luke (and not of the Royal Academy of Painting and Sculpture), Justina was granted in 1716 the honor of painting the then six-year-old Louis XV. Holding the fleur-de-lis scepter, the young king majestically rests his arm on a console table bearing the bejeweled crown. His costume of silver brocade trimmed with gold is striking in its luxury. Sapphires, diamonds, and garnets belonging to the Crown jewels sparkle on its cuffs, pocket flaps, and buttonholes. The suit is also decorated with the sash of the Order of the Holy Spirit as well as the red knot and diamond cross of the Order of Saint Louis. A diamond brooch embellishes the tricorne hat. The monarch appeared so richly adorned only when receiving overseas embassies. At the public audience of the Ottoman ambassadors on March 21, 1721, for instance, Louis added the diamond called the Regent to his costume.[1] GF

57 *Isabella, Countess of Hertford*

Alexander Roslin, 1765

Working in Paris, the Swedish painter Roslin counted many diplomats among his clients, including in 1765 the Countess of Hertford, the wife of the British ambassador. The sitter's *grand habit* was most likely the formal French gown specially commissioned for her presentation at Versailles, which took place on November 20, 1763. The difficulty of moving gracefully in a court dress, with its tight bodice, billowing hooped skirt, and long train, may well have added to the anxiety the ambassadress experienced.[1] In addition to the silk, lavishly brocaded with metallic thread, her diamond jewelry was reputedly valued at sixty thousand pounds. Her husband reported that Lady Hertford was magnificently prepared for the ceremony, her dress beautiful, and the retinue of pages, officers, and servants in livery were all dressed for the occasion, which was "nobly done."[2] DK-G

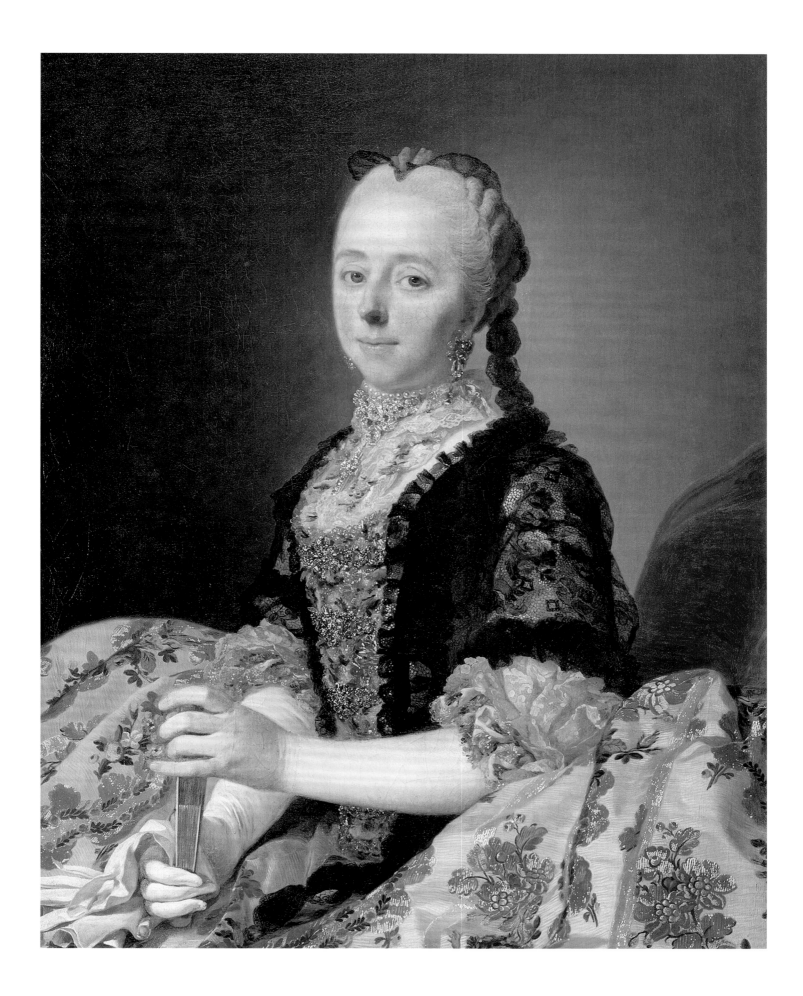

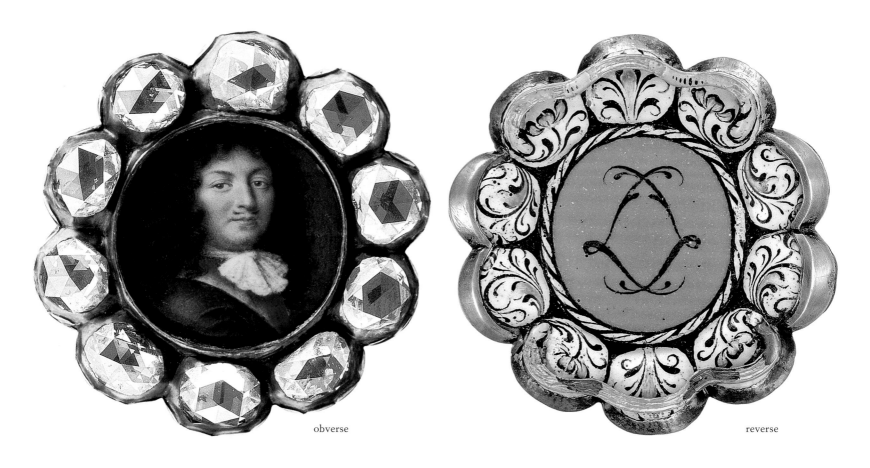

obverse

reverse

58 Bracelet Element with Miniature Portrait of Louis XIV

Jean Petitot the Elder, ca. 1670

"The King has made a present of his portrait, enriched with diamonds, to the wife of the Russian ambassador," noted the marquis de Dangeau in his diary on October 8, 1706.[1] Unlike the bejeweled *boîte à portrait* (see cat. 49), which could be worn as a pendant, the miniature royal portrait referred to by Dangeau served as a wrist ornament, as is seen in paintings (see fig. 60).[2] The diamond-studded medallion here is painted with great finesse by Jean Petitot, celebrated as the Raphael of enamelers.[3]

Depicted in three-quarter view, the armor-clad Louis XIV wears a white lace jabot and the blue sash of the Order of the Holy Spirit. The luxuriant curls of the long wig beautifully frame the king's face. The Swiss Petitot worked first at the court of Charles I in England and later in Paris, where he enjoyed the patronage of the Sun King, creating enameled portraits of the monarch, members of his family, and courtiers. DK-G

59 *The Moroccan Ambassador, Muhammad Temin, and His Retinue at the Comédie-Italienne*

Antoine Coypel, ca. 1682

During his stay in France from October 1681 to February 1682, Muhammad Temin, the Moroccan ambassador, attended the first performance of the Comédie-Italienne in Paris. An article in the *Mercure galant* noted, "He understands the language, and it would have been difficult for the excellent actors . . . not to give him a great deal of pleasure. A very able friend of mine . . . did me the favor of giving me their portraits."[1] Coypel, the painter mentioned, was barely twenty at the time and already a promising talent. In this small format, he enlivened the scene with a play of gestures and glances. In the foreground, both fascinated by the performance, are the ambassador, dressed in white, with 'Ali Maanino El Hajj, the governor of Salé, next to him. Behind them sit two secretaries and advisers (Ahmed Ben Marraki and Abdelkader Al-Hajj), a third unidentified figure, and to the left of the ambassador, Monsieur de Raymondis, who oversaw the embassy and acted as interpreter. BS

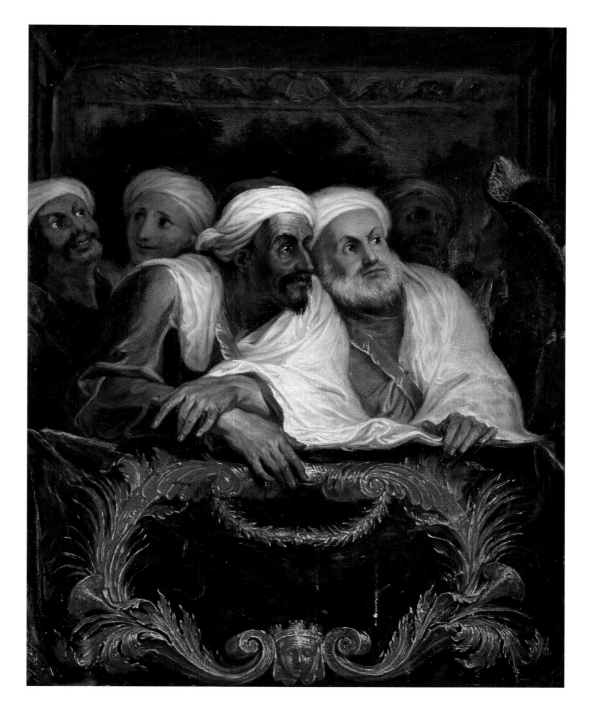

60 *Louis XIV Receiving the Siamese Ambassadors*

Jean Mauger, ca. 1687–89

Visual representations of the 1686 Siamese audience, unlike those of later embassies, circulated only in print form and in this commemorative medal, which shows the three ambassadors approaching Louis XIV.[1] The elevation of the throne, which is deliberately raised on a dais equal to the height of that used by the Siamese king for his reception of the French ambassador in 1685, marks the two rulers as diplomatic equals. Each of the ambassadors received medals from the king in early 1687, possibly including this one. Importantly, the medals' monetary values correlated to each man's rank: gold on a chain for Kosa Pan, the lead ambassador, silver for the second ambassador, and bronze for the third.[2] An engraving of this medal was also included in the *Médailles sur les principaux événements du règne de Louis le Grand*, a compendium of medals depicting major events from Louis XIV's reign (cat. 50). EB

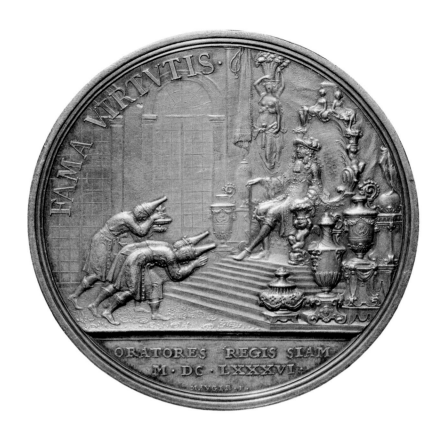

61 *The Royal Reception of Ambassadors from the King of Siam by His Majesty*

Attributed to Pierre Paul Sevin; published by François Jollain, ca. 1687

Broadsheets and royal almanac prints such as this were used, together with written accounts in the *Mercure galant,* to widely publicize the Siamese embassy of 1686. Cartouches bordering the central audience scene illustrate related episodes from this diplomatic visit, including the dinner hosted for the embassy at Versailles and the introduction of their elephants to the Menagerie. Visible at right is the miniature processional throne on which Phra Narai's letter was carried, known as a *busabok* (cat. 63), while a collection of gifts, all metal, including a pair of silver inlaid cannons (cat. 65), is laid out in the foreground. Inventories indicate that the Siamese also brought fifteen hundred pieces of Chinese porcelain and dozens of Japanese lacquered objects.[1] Nevertheless, the French were most interested in pieces made from Siam's natural resources. These precious and semiprecious metals not only showcased artistic craft, they also had intrinsic monetary value. EB

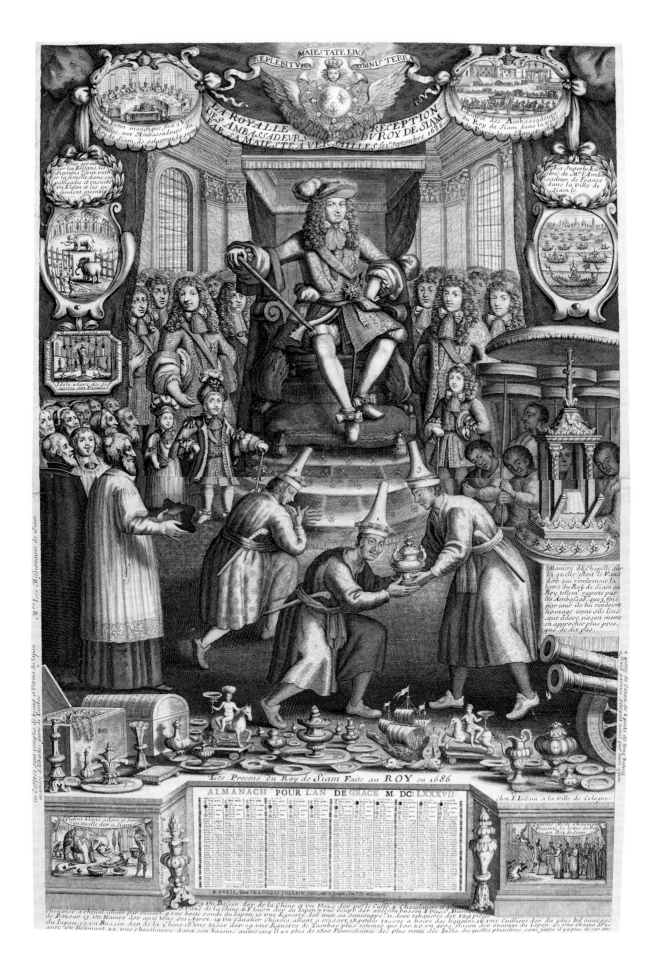

MAIESTATE EIVS
REPLEBITVR OMNIS TERRA

LA ROYALLE RECEPTION DV ROY DE SIAM
DES AMBASSADEURS PAR SA MAIESTÉ A VERSAILLES le 1.er septembre 1686.

Les Presens du Roy de Siam Faits au ROY en 1686.

ALMANACH POUR L'AN DE GRACE M. DC. LXXXVII.

chez F Iollain a la ville de Cologne.

A PARIS, Chez FRANÇOIS IOLLAIN

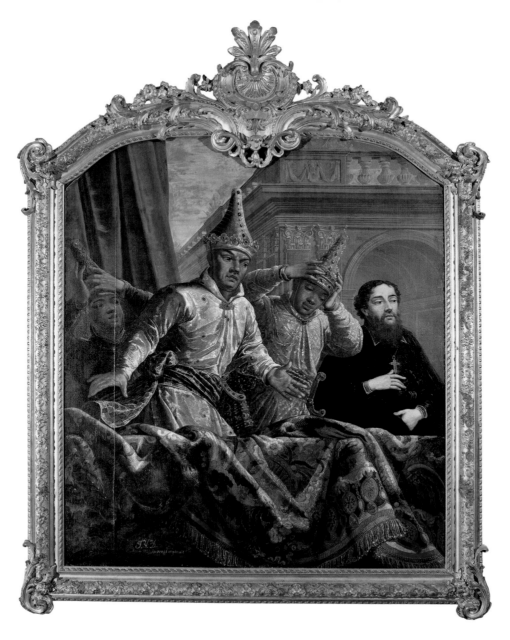

62 *The Siamese Ambassadors and Their Interpreter, the Abbé de Lionne*

Jacques Vigoureux-Duplessis, ca. 1715

The Siamese embassy of 1686 was so influential culturally that it continued to have visual currency thirty years later, when Vigoureux-Duplessis drew upon it for a pendant to his overdoor painting of the 1715 Persian visit (cat. 72). Little is known of Vigoureux except that he was a set painter for the Paris Opera in the 1710s and that he later designed seat covers and screens for the Beauvais tapestry works.[1] In this decorative painting, Vigoureux shows the Siamese ambassadors donning the tapered conical hats of rank for which they were known at the time of their visit (cat. 64). The presence of their interpreter, Abbé Artus de Lionne, highlights the central role of the Church in Franco-Asian diplomacy. While Louis XIV was interested above all in trade relations,[2] the priests of the Missions Etrangères, who had shepherded the relationship, ardently hoped the Siamese king would convert to Christianity, although this was never Phra Narai's intention.[3] EB

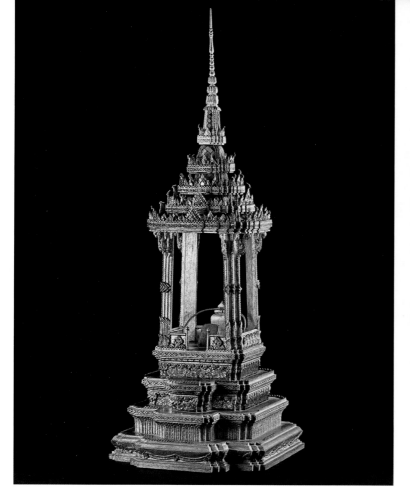

63 Processional Miniature Throne (*Busabok*)

Thailand, late 18th–early 19th century

Portable miniature thrones were used to house small-scale regalia and royal insignia or religious relics and images. This example houses a miniature throne-chair, directly resembling a Siamese coronation throne. Serving to sanctify the object they conveyed, *busabok* were deployed in state and religious processions. The personal message sent by the Siamese monarch, Phra Narai, to Louis XIV was engraved on gold sheet shaped to resemble palm-leaf folios, the traditional book form of Siam. On September 1, 1686, this precious document was placed in a miniature shrinelike throne such as this and carried on a palanquin to the Hall of Mirrors, where Ambassador Kosa Pan presented it before the French monarch (see fig. 51).[1] According to the king's wishes, some fifteen hundred members of the French court, arranged strictly according to rank, were in attendance. Among the other gifts presented by King Narai were gold and silver vessels, Chinese porcelain, and Japanese inlaid and lacquered chests (cat. 66).[2] JG

64 Siamese Hat of Rank and Case (*Lompok*)

Thailand, late 18th–early 19th century

When the Siamese king Phra Narai's delegation, led by Ambassador Kosa Pan, was received by Louis XIV at Versailles on September 1, 1686, members of the French court were delighted by the pageantry that accompanied the delegation.[1] Kosa Pan's audience and departure speeches, called "harangues," clearly impressed the king, who ordered that they be published by the Royal Printer (issued in 1687).[2] Siamese court protocol and strict sumptuary laws dictated codes of dress and the display of emblems of rank.[3] The ambassadors wore this type of conical hat, known in Thai as *lompok* (literally, "piled up and layered-wrapped head cover"), which was restricted to members of the nobility (*khunnang*) (fig. 49). Kosa Pan's hat was described as having a thick gold band with golden flowers set with rubies that shimmered as he moved. The hat and crossover jacket were both recent adaptations of Safavid Persian dress at the Siamese court of King Narai.[4] JG

65 Cannon

Siamese, before 1686

Among the gifts presented to Louis XIV by the embassy of Phra Narai in 1686 were two pieces of Siamese artillery of exceptional quality. These cast-iron cannons were embellished with hammered and engraved silver foil in a stylized flame motif, typical of Siamese artillery, textiles, and decorative arts.[1] The gun carriages (now lost) were similarly decorated.[2] The cannons, long believed to be lost as well, were originally stored at the Royal Furniture Repository (Garde-Meuble de la Couronne) in Paris. During the onset of the Revolution they were seized by the mob, which

may have used them during the storming of the Bastille. They were among the trophies displayed along the Seine near the Hôtel de Ville. Returned to the weapons collection of the Furniture Repository, they were transferred to the Arsenal on October 14, 1794, and were subsequently part of the Artillery Museum set up in the Eglise Saint-Thomas d'Aquin before being taken as spoils by the Prussian and British coalition forces in July 1815. The cannon shown here was recently identified in Great Britain; the second was probably sent to Berlin, but its whereabouts are unknown.[3] AL

OFFICIAL VISITORS AND GIFTS

66 Lacquer Cabinet

Japanese, 17th century

Louis XIV distributed many of the hundreds of Siamese presents from the 1686 embassy to members of the royal family.[1] This precious Japanese-made cabinet and its pair were possibly among them, as records show that they were given by the king to the Grand Dauphin, who kept them at the Château de Meudon.[2] These gifts were only occasionally products of Siam, but instead reflected the kingdom's well-established trade networks with India, Persia, Japan, and China. Because Japan had been closed to trade since 1640, all lacquerware for the international market—rare and thus highly prized in Europe—had to pass through the Dutch or Chinese at the port of Nagasaki. With the 1686 embassy, the French and Siamese hoped to establish their own (ultimately short-lived) trade alliance.[3] EB

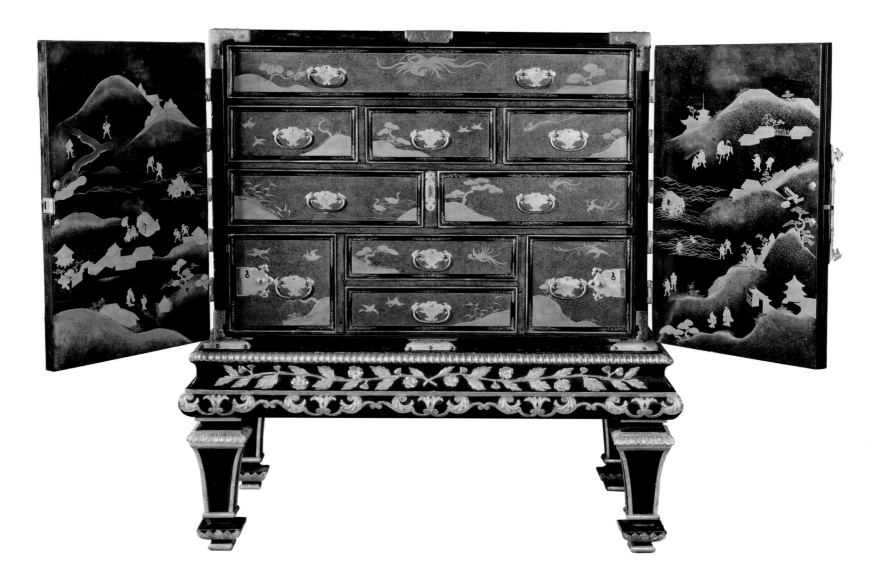

67 *Music*

Savonnerie Manufactory, Paris,
ca. 1685–97

Phra Narai was very interested in
products from the French royal
manufactories. He decorated his
palace at Ayutthaya, known to
British tourists as the "Siamese
Versailles," with four hundred
French-made mirrors.[1] He was
especially enamored of Savonnerie
carpets. This particular design,
representing Music, was part of a
series of ninety-three originally
intended for (but never used in)
the Grande Galerie of the Louvre.
Instead, Louis XIV distributed
individual carpets from the series as
diplomatic gifts, including a version
of this one sent to the Siamese
king in 1685. The present example
was copied sometime after 1685
in order to recomplete the Louvre
series, while other duplicates were
set aside for later gifts (another
carpet of this design was given to
the Persian ambassador in 1715).[2]
Although Phra Narai himself
was overthrown and his palace
destroyed in 1688, nine carpets
from the 1685 French gift remained
in the Thai national collections as
late as 1910, when the Savonnerie
factory received a request from the
Thai for repairs.[3] EB

68 *Brittany Offers Louis XIV the Model of His Equestrian Statue*

Antoine Coysevox, 1692–93

This relief by Coysevox is one of a pair that decorated the pedestal of an equestrian statue of Louis XIV. Commissioned by the States General of Brittany in 1686 for the city of Nantes, the monument was not erected until 1726, in Rennes. Only the reliefs have survived. Here, the personification of Brittany, assisted by the sculptor and the architect Jules Hardouin-Mansart, presents the design of the statue to Louis amid a crowd of spectators. Coysevox included the Siamese ambassadors, recognizable by their conical hats,

who, having arrived in Brest, traveled through Brittany to pay their respects to the king. Their audience took place in the Hall of Mirrors on September 1, 1686, with the throne raised on a stepped dais just as Coysevox has rendered it. The silver vessels in the foreground furnished the gallery until they were melted down in 1689. A representation of the marriage of Louis XII and Anne, duchesse de Bretagne, unifying France and Brittany in 1499, hangs on one of the arched mirrors. DK-G

69A, B Pair of Vases

Italian, early 18th century

A series of porphyry vases, alternating with others of alabaster, decorated the Hall of Mirrors. Showing great variety in their ornamentation, most of the porphyry vessels were specially commissioned for the king from stone carvers in Rome, who skillfully worked the very hard and much sought-after purplish Egyptian stone traditionally associated with imperial power.[1] The Leiden cloth merchant Pieter de la Court mentioned seeing forty-four vases of "all sorts of marbles and sizes" in the Hall of Mirrors at Versailles in 1700.[2] Although the original provenance of this lidded pair, each with a spirally fluted and gadrooned body embellished with a female mask, is not known, it is possible that they were acquired by a Grand Tourist during his stay in Rome, where antique columns of porphyry were reworked. More recently, they were in the possession of the Chilean collector Arturo López Willshaw at the Hôtel Rodocanachi in Neuilly-sur-Seine, where the French artist Alexandre Serebriakoff depicted them in a 1946 watercolor of the Grande Chambre.[3] DK-G

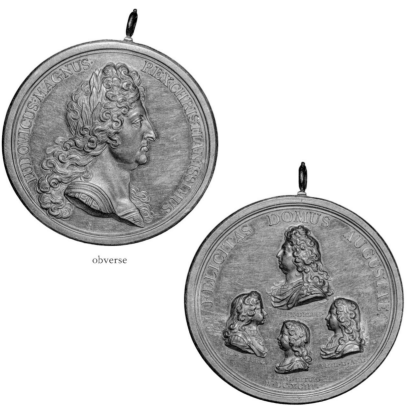

obverse

reverse

70 *Famille Royale*

Roettiers family, possibly Jacques, 1693 or later

The "royal family" medal, so called for its portraits of Louis XIV and his heirs, was first struck in 1693 to commemorate the birth of the Dauphin's third son. Such medals were also used as diplomatic gifts and awards, often presented for their monetary value rather than their iconographic relevance to the recipient. Originally offered to two Abenaki chiefs on March 21, 1693, in recognition of their feats in fighting the British, medals with this and other designs were sent overseas to various chiefs over the next two decades.[1] These "Indian peace medals" carried great symbolic value for Native and Indigenous Americans, who wore them suspended on ribbons and were even buried with them.[2] Other foreign rulers also received them. According to the *Présents du Roy*, a gold version was intended for the Ivory Coast prince Louis Aniaba (see fig. 54).[3] The Persian shah received a medal of this design and many others, which he chose to regift.[4] EB

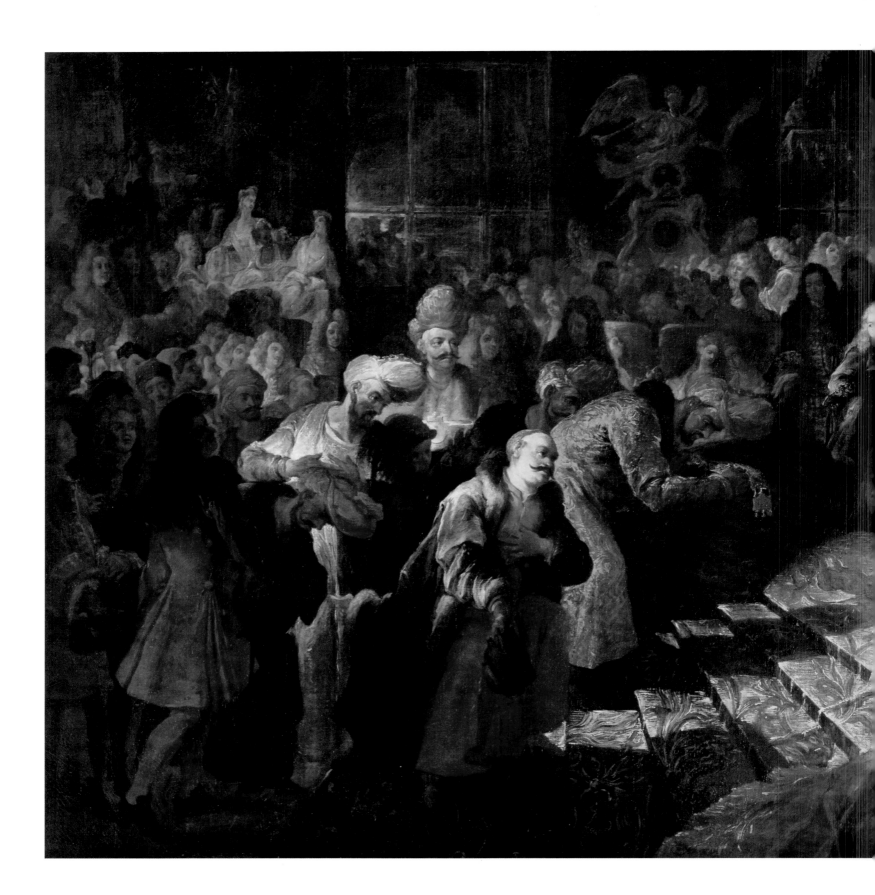

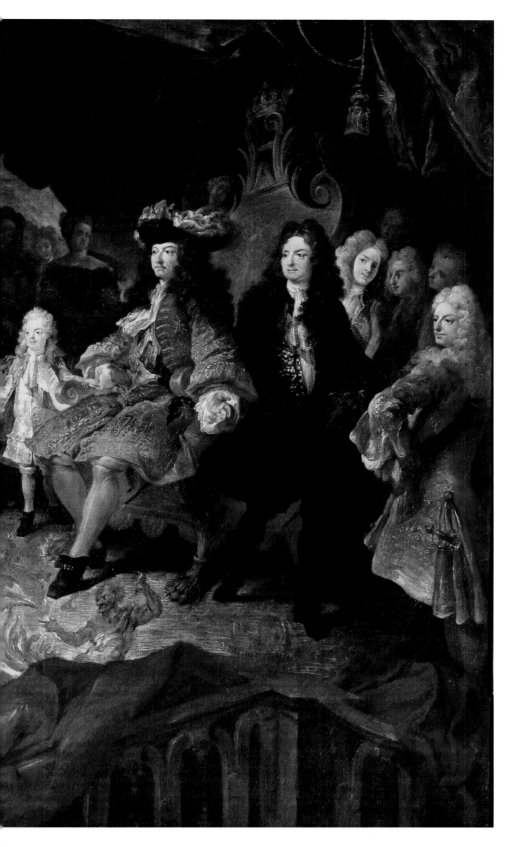

71 *Louis XIV Receiving the Persian Ambassador Muhammad Reza Beg*

Attributed to Nicolas Largillière, after 1715

The reception at Versailles of the Persian ambassador, Muhammad Reza Beg, on February 19, 1715, was among the most famous events toward the end of Louis XIV's reign. The ceremony took place in the Hall of Mirrors, on one side of which stood the throne on a raised platform surmounted by a canopy. The *Mercure galant* reported on the assembled nobles, who crowded around the ambassador's retinue, which was quite small.[1] The memoirist Saint-Simon remarked on the contrast between the splendor of the royal family's attire and jewels and the simplicity of the embassy, which seemed "all in all rather wretched, and the supposed ambassador quite embarrassed and very poorly dressed; the gifts worth next to nothing."[2] He was also skeptical about Reza Beg's status as ambassador, claiming that this lowly merchant had been enlisted by the comte de Pontchartrain to fool the king. The audience remained famous nevertheless, and the authenticity of the embassy has since been verified. BS

72 *A Persian Ambassador*

Jacques Vigoureux-Duplessis, 1721

Louis XIV's 1715 reception of the Persian ambassador Muhammad Reza Beg, held in the Hall of Mirrors, was modeled on the great embassy of Siam. Both receptions were depicted by Vigoureux-Duplessis in fanciful scenes painted on pendant overdoors (cat. 62). Here, Reza Beg stands at a carpet-draped balcony flanked by members of his entourage. Held on February 19, the audience was widely attended,[1] but courtiers were disappointed with the ambassador, whom they thought provincial and found obstinate in matters of protocol.[2] Much of the problem was cultural, as when his soothsayer disputed the appointed dates of his entrance into Paris and his Versailles audience.[3] Following Persian custom, Reza Beg traveled on horseback for his entry into Paris. The French, affronted, convinced him to ride in the king's carriage on the day of his public audience, but he smoked during the drive.[4] Nevertheless, the Western preoccupation with exoticism made Reza Beg an irresistible subject for the sensationalizing Orientalist novel *Amanzolide* of the following year.[5] EB

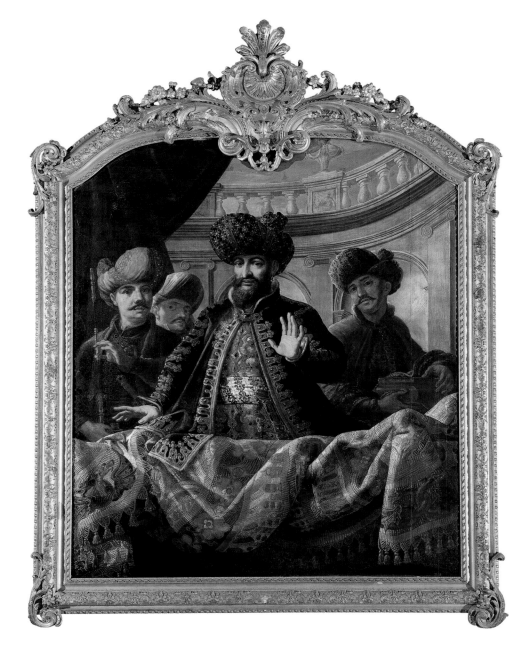

73 *Yirmisekiz Çelebi Mehmed Efendi*

Attributed to Pierre Gobert, 1724

In 1726 Louis XV paid Gobert six hundred livres for a portrait of Mehmed Efendi, most probably this one, which shows the Ottoman ambassador dressed in the fur-lined caftan, green cap, and white turban tied with a gold band befitting his rank.[1] Although Mehmed Efendi traveled to France during the Régence and was therefore officially received in Paris, he made a point of visiting Versailles. In his *Sefâretnâme,* or official travel account, he wrote extensively about the fountains and their sprays of water, recounted riding in the king's wheeled chair through the Labyrinth, and admired the stables.[2] Of the palace, he remarked on its "infinite number of apartments leading one into the other," and noted that it and the gardens were unrivaled in Europe.[3] EB

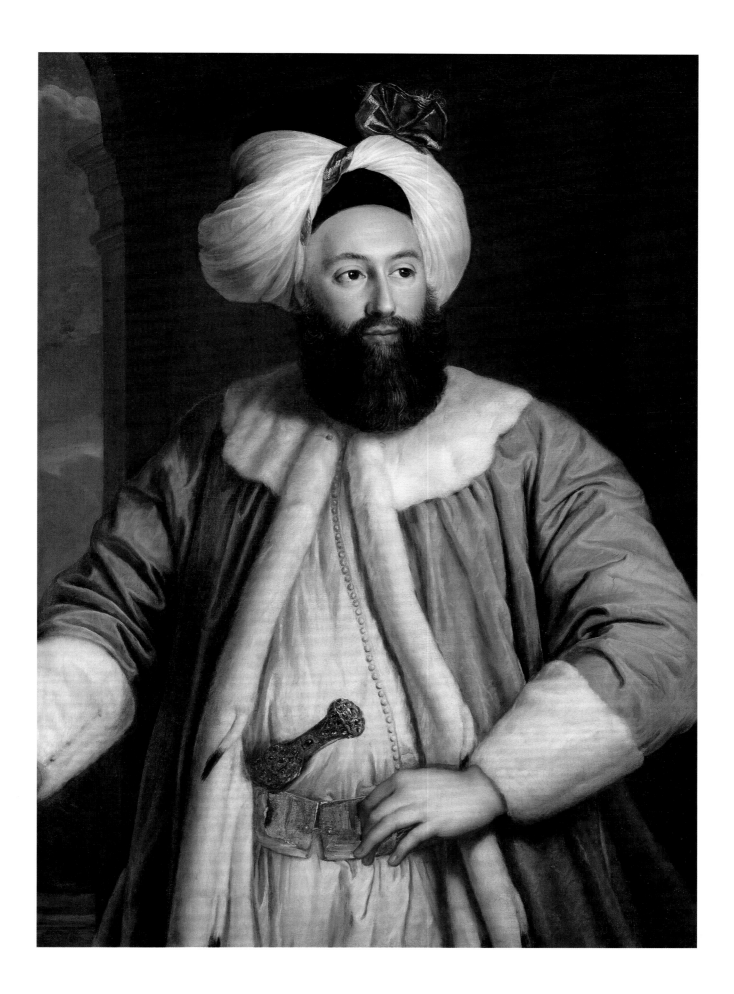

74 *The Departure of the Ottoman Embassy from the Tuileries*

Gobelins Manufactory, Paris, 1734–1736/37

Charles Parrocel painted pendant scenes of the 1721 Ottoman embassy's arrival at and departure from the Tuileries Palace that were later woven into tapestries by the Gobelins. In this tapestry showing the departure, crowds have turned out to watch Yirmisekiz Çelebi Mehmed Efendi leaving the Tuileries gardens by the Port Tournant. Their presence indicates the extent to which the Ottoman visit was a cultural event for the French as much as a diplomatic success for the Crown. During his stay in Paris, Mehmed Efendi went to the Gobelins factory, where nearly one hundred tapestries were put on view for him. In his official travel account, he marveled at their expense and the skill of the craftsmen. He saw weavers working from painted models like Parrocel's and commented that the lifelikeness and emotion of their woven human figures surpassed the work of even the best Ottoman miniaturists.[1] EB

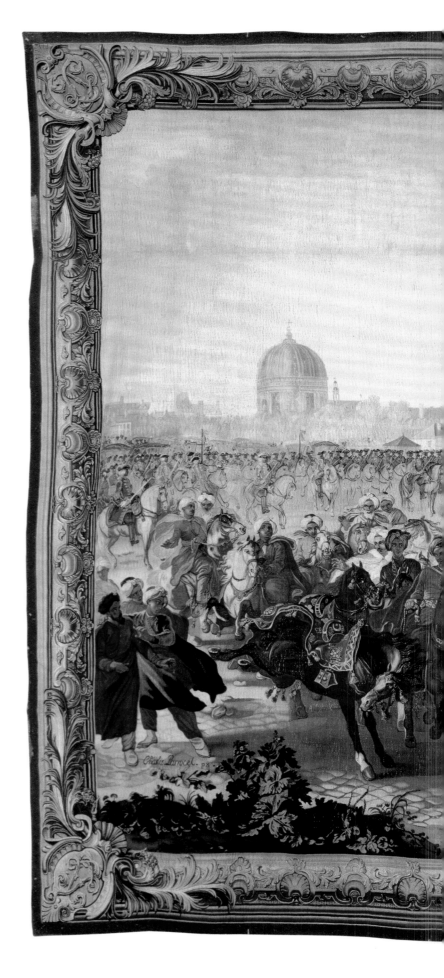

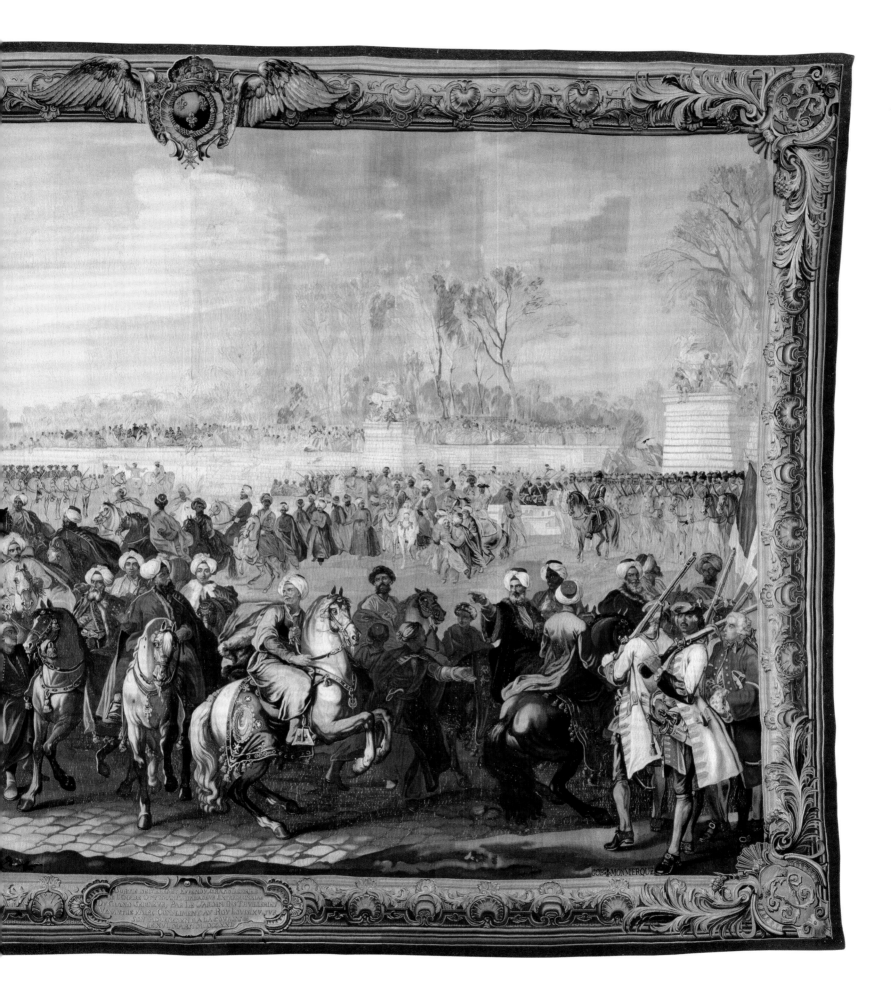

GOB·MONMERQUE

75 *Mehmed Said Efendi, Ambassador of the Sublime Porte*

Jacques André Joseph Aved, 1742

Following the Treaty of Belgrade (1739), which established the Austrian-Turkish border at the Save River, the Ottoman sultan Mahmud I sent an extraordinary embassy to France to thank Louis XV for his intervention in the negotiations. Mehmed Said Efendi, who had already accompanied his father to France in the spring of 1721, was received in the Hall of Mirrors at Versailles on January 10, 1742. During the ambassador's stay in Paris, Aved, a painter renowned for his truthful renditions, executed this lifesize portrait. Dressed in a sable-lined caftan and wearing under his turban the headwear of the men of law, Said Efendi is surrounded by symbols of his learning: on the desk a book by the Dutch jurist Hugo Grotius, as well as his letter of credence, written in Ottoman court language (a combination of Arabic and Persian words and script) and bearing the seal of the Empire.[1] In the background, a view of Paris includes the solemn procession of Said Efendi's entry through the Porte Saint-Antoine. GF

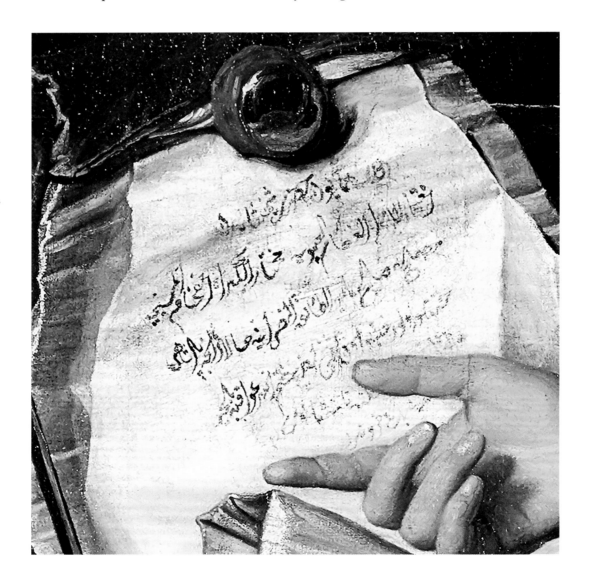

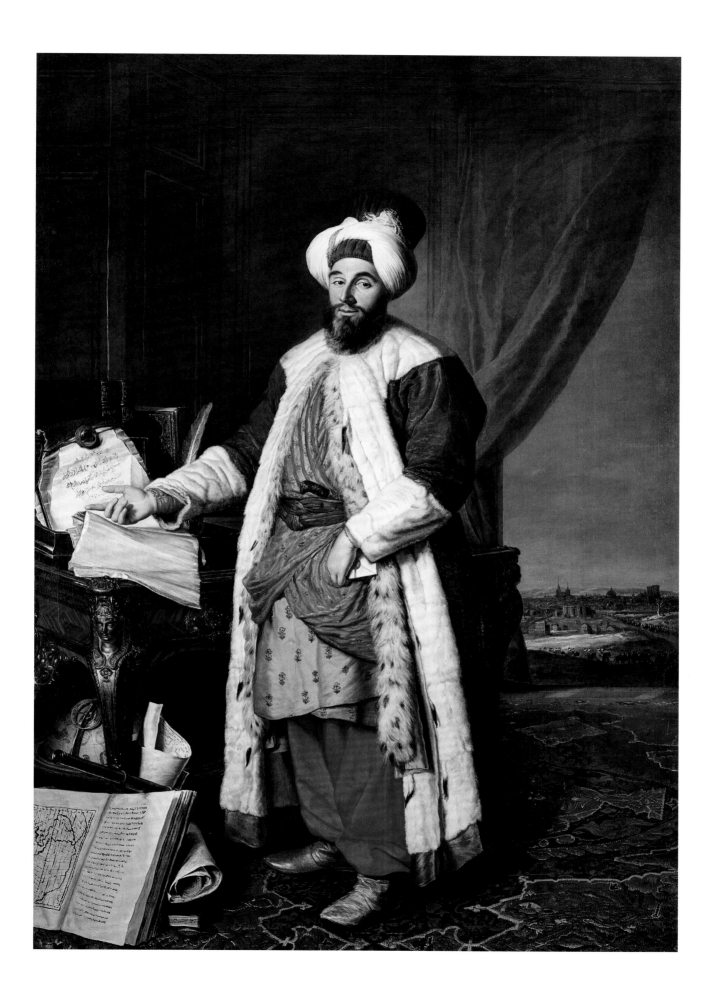

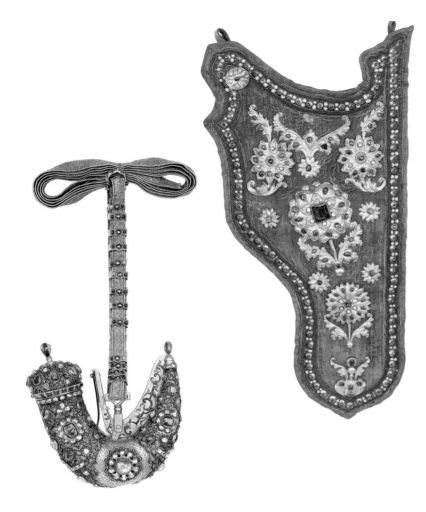

76 Powder Flask

77 Quiver

Ottoman, before 1742

At the conclusion of his 1742 audience with
Louis XV, the ambassador Mehmed Said Efendi
presented the king with sumptuous arms and
armor reflective of Ottoman imperial pride in
the military arts.[1] These included the present
emerald-studded powder flask (worth eighteen
thousand livres) and velvet quiver (worth twelve
thousand livres), as well as a bejeweled saddle,
harness, and set of gold stirrups. Most imposing
perhaps was a multiroom Persian gold cloth tent
with inlaid turtleshell and mother-of-pearl pillars.
At roughly thirty-two by twenty-one feet, it was
too large to be displayed inside the palace and so
was temporarily erected outside, where the duc de
Luynes toured it.[2] Although the tent was afterward
kept in storage, the gem-encrusted arms—the
quiver and powder flask most likely among
them—were displayed in the Treasury together
with the gifts from the Mysore and Tunisian
ambassadors. Many of these precious objects were
sold after the Revolution. EB

78 Horned Headdress

Eastern Plains or Western Great Lakes,
ca. 1700–1750

Thought to have been given to the king of France
after 1750, this headdress was among the objects
at the Jardin du Roi that were transferred to the
Muséum des Antiques at the Bibliothèque Natio-
nale de France after the Revolution.[1] Its design of a
rawhide cap fitted with split buffalo horns, porcu-
pine quills, and dyed deer hair indicates that it was
likely part of warrior ceremonial dress. The deco-
rative glass beads that line the headband suggest its
maker had contact with European settlers. A fitting
object for the king's cabinet of curiosities, it was
perhaps collected and sent to France by the marquis
de la Galissonnière, commandant general of New
France, a naval officer and scientific enthusiast. EB

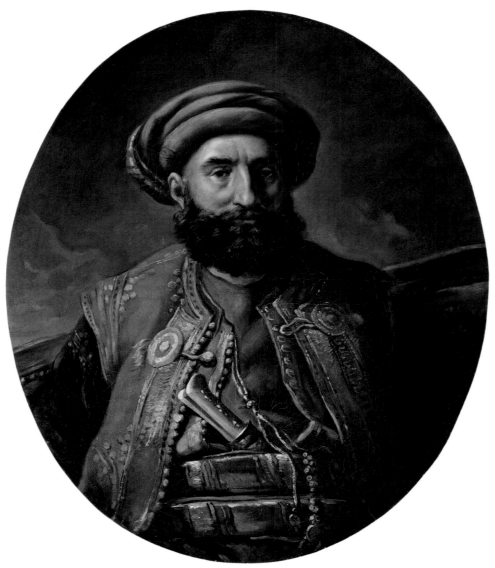

79 *Süleyman Aga*

Jean Bernard Restout, 1777

With a retinue of fourteen including ministers and a chef, Süleyman Aga landed in France on January 18, 1777, to represent the bey of Tunis's interests in France. According to an official journal kept by the French translator Pierre Ruffin, they were brought by Louis XVI's frigate *Aurore* from Tunis to Toulon, where they were quarantined for fear of *la peste* before being driven to Paris.[1] Selected for diplomatic experience and physical hardiness, Süleyman appeared recalcitrant to his hosts when it came to matters of protocol.[2] Restout rendered his tempestuous disposition in this portrait painted at Süleyman's request.[3] Although overseas visitors were encouraged to wear indigenous costume for their audience, small weapons such as the dagger tucked into his sash here were not permitted in the king's presence;[4] the official account indicates that the ambassador kept warm with an ermine-lined red velvet cloak with gold frogging purchased in Paris.[5] Süleyman's audience at Versailles took place on March 10.[6] The official record mentions "cartloads" (*charrettes*) of gifts from the bey, comprising horses, a gold-and silver-embroidered saddle, and sabers; two lion cubs for the Menagerie; and seven slaves, among them six Corsicans, whom the king "clothed decently and sent back to their country."[7] In exchange, Louis presented Süleyman with a gold medal on a gold chain and sent the bey sumptuous gifts of jewelry, clocks, and textiles.[8] EB

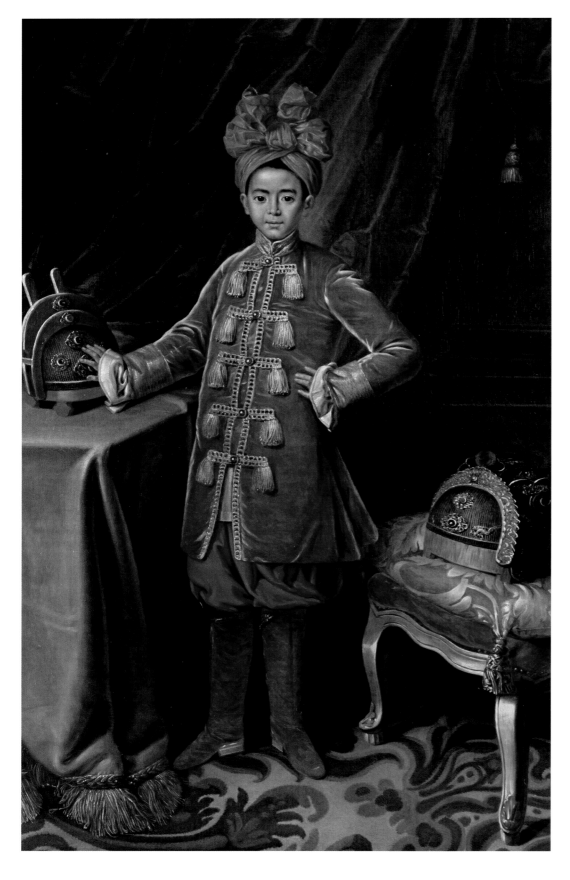

80 *Nguyễn Phúc Cảnh*

Maupérin, 1787

Rebellion in Cochinchina (modern Vietnam) forced the crown prince, Nguyễn Phúc Cảnh, to seek French aid. Arriving in 1787 at nearly the same moment as the Mysore embassy (cats. 81, 82), he received a more intimate reception at Versailles. The seven-year-old prince played with the royal children but also met with dignitaries such as Thomas Jefferson.[1] Maupérin portrays the prince in a stunning, fanciful costume that conflates a Western silhouette (red coat with gold frogging, ruffled sleeves, puffed breeches, and tall boots) with Eastern influences, including an intricately tied turban that inspired a fashion craze.[2] The mandarin's hats on the table and chair were perhaps gifts he brought with him.[3] Although his chaperone, Bishop Pierre Pigneau de Béhaine, secured support of his bid for trade relations and military aid, the Revolution thwarted these plans. At their departure, the prince received a pendant miniature (*médaillon de col*) of Louis XVI by Louis Marie Sicardi framed with twenty-nine diamonds valued at 8,560 livres. Pigneau was given a gold snuffbox.[4] EB

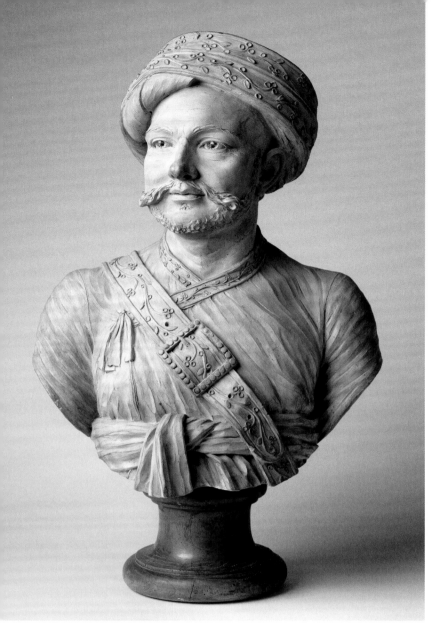

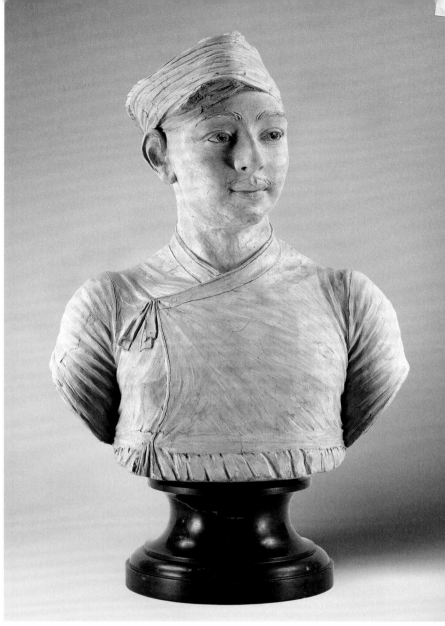

81 *Muhammad Osman Khan*

82 *Nephew of Muhammad Osman Khan*

Claude André Deseine, 1788

In his portraits of the Mysore ambassador Muhammad Osman Khan and his nephew, Deseine lends the figures autonomy and dignity. Deseine, who signed his works "deaf and mute," faithfully recorded the delicate folds of Osman Khan's fine muslin *jama* (robe), complete with decorative tie closures, asymmetrical neckline, and sash. The stylized chain of flowers encircling his turban, neckline, and sword belt recalls the painter Elisabeth Vigée Le Brun's account of the ambassadors' gold-embroidered robes.[1] Osman Khan's nephew, whom he brought to France as part of his suite, is dressed more simply. Without any needlework decoration, a sword belt, or full beard (only the hint of a mustache), his is a youthful portrait compared with his uncle's. EB

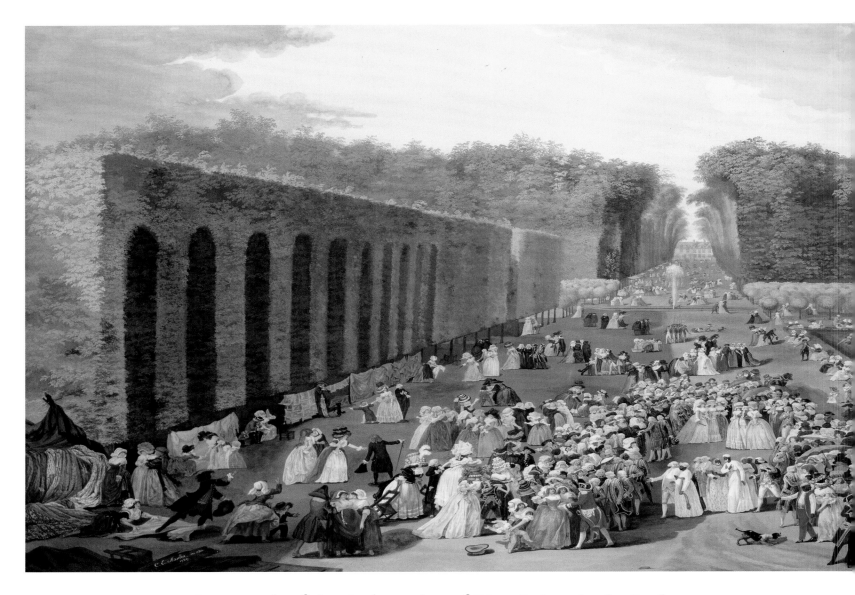

83 *Promenade of the Ambassadors of Tipu Sultan in the Park of Saint-Cloud*

Charles Eloi Asselin, 1788

Contemporary accounts of the Mysore embassy often remarked on the crowds that mobbed the ambassadors wherever they went.[1] Here, aiming for political commentary as much as reportage, Asselin renders the fashionable Parisians turned out to see the visitors touring Saint-Cloud. The figures who stroll past textile merchants displaying cotton muslins are dressed in British-style—not French—muslin, a pointed nod to the embassy's informal mission to negotiate direct trade with France. Made on the eve of the French Revolution, however, this and Tipu Sultan's official proposal for aid to remove the British from Mysore were ill-timed. Ultimately neither military nor trade agreements between the two powers was feasible.[2] EB

OFFICIAL VISITORS AND GIFTS

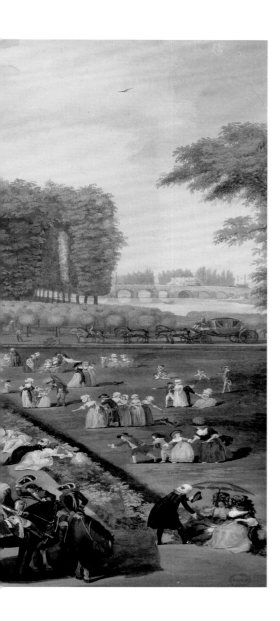

84 *Louis XVI*

85 *Marie Antoinette*

Sèvres Manufactory, Louis Simon Boizot, 1788

Although Tipu Sultan's presents were rumored to include "casks of diamonds," in reality both kingdoms exchanged luxury wares, not treasure.[1] The French presented the embassy with Lyon silks, Savonnerie carpets, and Sèvres porcelain, including hookahs and spittoons (see fig. 66).[2] Each ambassador also received ceramic busts of his hosts. This biscuit porcelain bust of Louis XVI, modeled by Boizot, the director of Sèvres, was based on the artist's marble original exhibited at the 1785 Salon. The sculptor created this commemorative version that same year along with a companion bust of Marie Antoinette.[3] Many of the French gifts, including this pair, were seized in 1799 when Tipu Sultan was overthrown and killed by the British and his palace at Seringapatam ransacked. EB

86 Set of Twelve Cups and Saucers (*tasses litrons*)

Sèvres Manufactory, 1776–88

In hopes of establishing a trade relationship with France, the Mysore embassy visited Sèvres in 1788 and received dozens of custom pieces as gifts. Certain designs, including porcelain spittoons and hookahs, do not survive, but among those that did is this composite set of twelve specially ordered cups and saucers, each painted in a distinct floral pattern. The manufactory made certain that its decoration was culturally sensitive: notes in Sèvres's archives stipulate that the sultan be given wares "with flowers, without either human or animal figures" in keeping with the Islamic prohibition against human images.[1] The set did not remain in Mysore long; following the plundering of Tipu Sultan's palace in 1799, it was acquired by Lord and Lady Clive and taken by them to Powis Castle in Wales.[2] EB

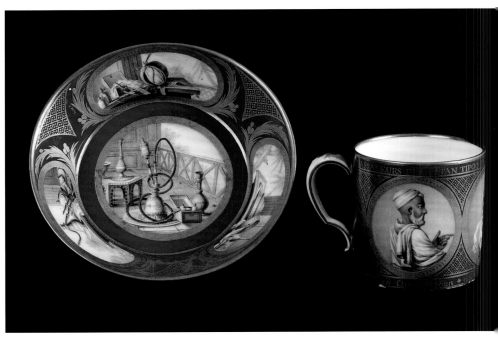

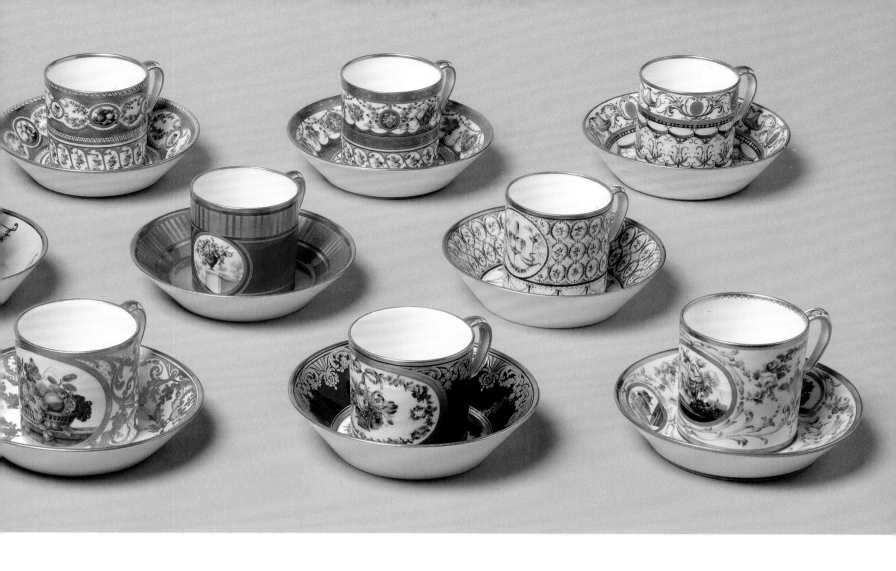

87 Cup and Saucer (*tasse litron*)

Sèvres Manufactory, decorated by Nicolas Pierre Pithou the
Younger and Jean-Baptiste Etienne Nicolas Noualhier *fils*, 1788

Not subject to the same religious proscription against
figurative images that it had observed in gifts made to Tipu
Sultan (cat. 86), the French luxury market abounded with
commemorative portraits of Tipu Sultan's ambassadors.
Their likenesses were captured in media such as paintings,
waxworks, and even buttons.[1] For this demand, Sèvres
produced a cup showing cameos of the three ambassadors
based on a gouache by Charles Eloi Asselin (cat. 83) and

paired with a saucer decorated with hookahs and turbans.[2]
At least four versions of these were produced, three of which
were acquired by members of the court: Monsieur, the king's
brother, purchased one at the Versailles porcelain exposition
in late 1788, while Monseigneur the duc de Penthièvre and
the comtesse d'Artois received delivery of their versions in
early 1789 for the price of 288 livres.[3] EB

INCOGNITO
TRAVELERS

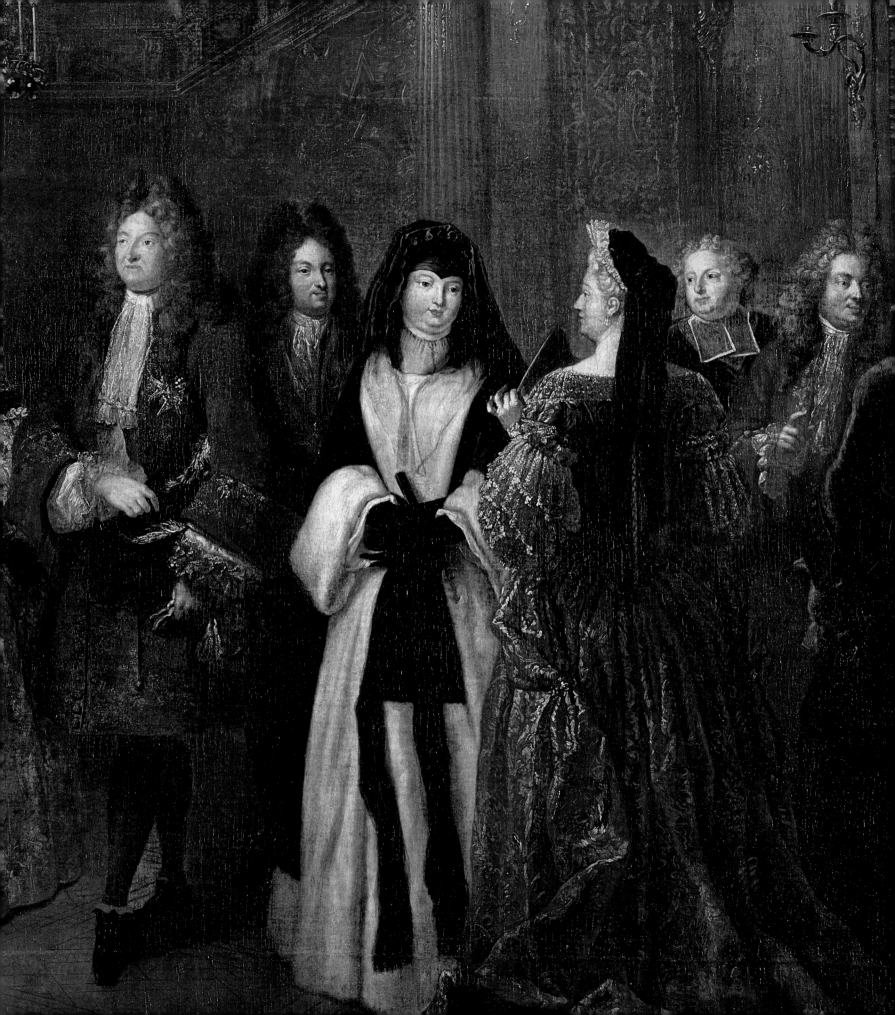

INCOGNITO IN VERSAILLES
Or, How Not to Travel as a King

VOLKER BARTH

In the summer of 1784, the Swedish king Gustav III traveled to France. During his seven-week stay, he visited the French capital and spent a considerable amount of time at the Palace of Versailles, repeatedly meeting with Louis XVI and Marie Antoinette, dining with them, and accompanying them on outings. Yet he did not do so in his official status as king, but under the assumed identity of a certain comte de Haga. During his entire stay, Gustav remained incognito, adopting a form of travel that had a long tradition at Versailles and many other European courts.

The Ceremony of Incognito

In courtly protocol, the term "incognito" refers to a temporary change of identity, primarily adopted by ruling monarchs and high officials, for a specific, often political purpose. An open secret, ceremonial incognito required that everyone involved be aware of who the disguised person actually was and accept the person's assumed identity. To ensure that the false identity was integrated into an existing social order, a lower rank had to be feigned that in no way challenged existing hierarchies.[1] This willingness to temporarily renounce one's position of power was a calculated political act.[2]

Rulers used incognito outside of their own courts and, except for inspection tours conducted by monarchs of enlightened absolutism in the second half of the eighteenth century, outside their own territories. After they negotiated the specific details with their host, an official invitation would be issued, and the incognito traveler would chose a fictitious title. Appended to this was the name of an actual place in the traveler's realm, the pseudonym thus playfully alluding to the true identity.

The adoption of incognito and the selected pseudonym were made public before departure. Considerable care went into the selection of the incognito's dress, attendants, and carriages, all of which had to accord with the assumed lesser social status. Upon arrival, the visitor would call on his or her host and be received in a manner appropriate to the fictitious identity. During the visit, the guest, in agreement with the host, might occasionally set aside the incognito, and the switch between the true identity and that of the incognito would be reflected both in court ceremony and in the behavior of the public.

One of the primary functions of incognito was to provide a greater range of freedom and privacy for the traveler. The assumed lower rank

180

dramatically reduced the need for ceremony, which meant that he or she might travel far more cheaply, with no need for pompous self-display, elaborate receptions, and or the presentation of lavish gifts. This appealed particularly to nobles of lesser rank and rulers of smaller territories. From a political standpoint, it permitted activities and public appearances that were otherwise neither acceptable nor practicable. In times of crisis, incognito allowed rulers or high-ranking ambassadors to meet in person without having to deal with the extremely delicate question of precedence.

Because of its flexibility and adaptability, incognito developed many different modes over the course of its history. In addition to its multiple advantages for the traveler, it permitted anonymous visits in advance of arranged marriages, the enjoyment of costume parties, and seemingly chance encounters of high-ranking diplomats. It engaged the imagination of the public as it attempted to flesh out the character and history of the invented personage, and the resulting narratives influenced future uses of incognito. Various forms of fictionalization were thus essential to the development of ceremonial incognito.

The Origins of Incognito

From the high Middle Ages to the beginning of the modern era, there are many historical and literary precedents for what crystallized in the sixteenth and seventeenth centuries as the ceremony of incognito. Tournaments, official visits, and numerous types of costumed banquets, all influencing and being influenced by a variety of literary genres, feature temporary identity changes as social and political conventions.[3] Beginning in the second half of the seventeenth century, the term "incognito" appears with increasing frequency in texts in French, the dominant language of diplomacy as well as aristocratic and courtly life. Claude Desgranges Favre de Vaugelas, a founding member of the Académie Française, commented on the word in 1647 in his *Remarques sur la langue*

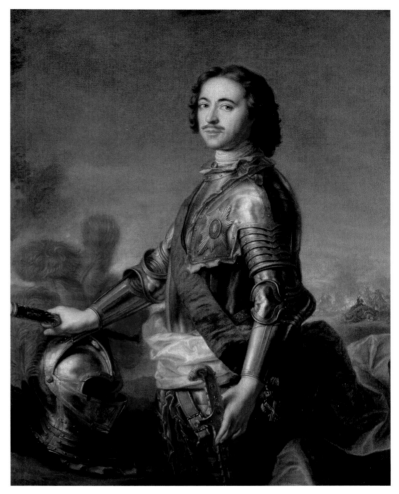

Fig. 67. Jean Marc Nattier, *Peter I of Russia*, 1717. Oil on canvas, 56⅛ × 43¼ in. (142.5 × 110 cm). The State Hermitage Museum, Saint Petersburg (ERZH-1856)

françoise: "In the last few years we have taken this word from the Italians to express something that they were wise enough to introduce, so as to avoid the ceremonies to which the great are subject when they make themselves known. . . . Today, all nations make use of so convenient an invention, borrowing from the Italians both the thing and the word at once. We say, *he has come incognito, he will come incognito*, not because one is not in fact known, but because one does not want to be."[4]

The Grand Embassy of Peter I of Russia (fig. 67), in which the czar traveled incognito from March 1697 to August 1698 to several European

courts, established the practice at the highest diplomatic level and served in many respects as the ideal type of incognito travel as defined in the ceremonial literature of the eighteenth century.[5] Although Peter demonstratively avoided Versailles, the French court was well acquainted with incognito travelers.

In April 1704, Ferdinando Carlo III Gonzaga, the last Duke of Mantua, went to Versailles to arrange his marriage to Suzanne Henriette de Lorraine, for which he needed the approval of Louis XIV. In order not to burden the upcoming negotiations with the ceremonial demands of an official visit, he traveled incognito under the pseudonym marquis de San Salvador.[6] The baron de Breteuil, the Introducer of Ambassadors, made the necessary arrangements. For the correct protocol, Breteuil followed the precedent of the incognito visit by the Danish Crown Prince Frederick IV in 1693. Appropriately, given his assumed identity, when Ferdinando visited Versailles he had himself transported across the palace courtyard in a sedan chair rather than a coach. There were no members of the royal guard to receive him, there were no public tributes, and at table he was not served by the king's officers. During the entire visit, the French court treated the duke as the marquis de San Salvador.[7]

The French court could fall back on such experiences when Czar Peter I visited on his second incognito journey through Europe in 1717. While in Holland, Peter commissioned the French ambassador to inquire whether an incognito visit would be welcome. Philippe II of Orléans, regent for the seven-year-old Louis XV, gave his consent and dispatched M. de Liboy, a Gentleman of the King's Household, to Dunkirk to receive the czar. Scrupulously following detailed instructions by the Master of Ceremonies, Michel II Ancel Desgranges, Liboy was to find out what protocol had been followed in Holland and ask Prince Kurakin, the Russian ambassador to The Hague, accompanying Peter, what the czar's wishes might

be.[8] He even managed to quietly offer Kurakin money, so that the French court, despite the incognito, could assume its guest's travel expenses. Liboy's assignment read, "not to neglect anything that would show [the czar] due respect, but leave him entirely free regarding all things."[9]

Peter traveled incognito partly because it had been such a success in 1697–98. The freedom from elaborate official ceremony that this sort of visit offered allowed him to pursue unhampered his goal of improving diplomatic ties between Russia and France. In the 1680s, France had expelled the Russian ambassador, but after the Peace of Utrecht (1713) and the formation of the Triple Alliance (January 1717), the czar hoped to negotiate a treaty of friendship with the *grande nation*, one that would give him a free hand in the ongoing Great Northern War (1700–1721).[10]

The French regent was equally reluctant to see the sensitive diplomatic mission endangered by ceremonial conflicts. Philippe sent to Dunkirk the two-wheeled carriages the czar requested instead of the heavy Berlins that had been readied, and he commissioned the comte de Tessé, a marshal of France and experienced diplomat, to extend Louis XV's official welcome at Beaumont, the last stop before Paris.[11] He also gave his guest a choice of lodgings: in addition to royal chambers in the Louvre, he had the Hôtel de Lesdiguières prepared and newly furnished. True to his incognito, the czar chose the latter.[12]

On the day after his arrival, Peter received a visit from Philippe, the course of which had been regulated in detail by the Conseil de Régence. On May 10, 1717, Louis XV visited the czar; breaking through the carefully worked out protocol, Peter took the child king in his arms and kissed him repeatedly.[13] With this "perhaps somewhat intentional brusqueness," the czar demonstrated the special affection he felt for the French ruler.[14]

Peter followed an extensive program of sightseeing in Paris, during which, thanks to his incognito, he moved about freely. The same was

true of his visits to Versailles. Although the palace and garden had been brought to a high polish for the special guest, Peter enjoyed himself in ostentatious modesty, especially in his dress: "[He] was dressed quite simply in a rather rough *bouracan* greatcoat, entirely black, with a vest made of gray woollen material that had diamond buttons, without a neckcloth, and without cuffs or lace at the wrists of his shirt, with a brown, unpowdered wig *à l'espagnole*, the back of which he had cut off because he found it too long."[15]

In other ways, however, the czar abandoned his humble demeanor. Jean Buvat, the Ecrivain de la Bibliothèque du Roi, records repeated alcohol excesses and visits to prostitutes, which presented delicate challenges for the French staff.[16] The czar also took the liberty of summoning musicians to Versailles, who he sent back to Paris in the early hours of the morning without paying.[17] Sometimes he spent the night in the rooms of Madame de Maintenon, prepared for him in the Trianon; other times he preferred sleeping in more modest connecting rooms.[18]

On June 17, 1717, the eve of his departure, the czar finally took part in a major military parade on the Champs-Elysées, temporarily setting his incognito aside. Although the political discussions that he had led in the previous weeks had ended without concrete results, both states resumed diplomatic relations in the following months.[19] Before he left, the czar made a last incognito visit to the young French king that Louis, likewise incognito, returned the following day.[20]

Incognito in the Second Half of the Eighteenth Century

The court at Versailles received most of its incognito visitors during the second half of the eighteenth century. One visit especially, that of Emperor Joseph II, attracted considerable attention on the part of contemporaries (fig. 68).[21] The Habsburg ruler traveled incognito in 1777 as the comte de Falkenstein, the pseudonym he used on

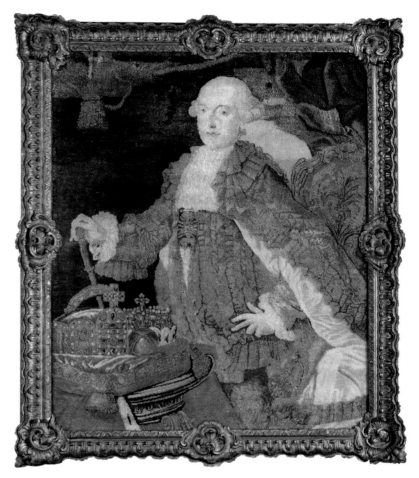

Fig. 68. Savonnerie Manufactory, Paris, *Tapestry Portrait of Joseph II, Emperor of the Holy Roman Empire*, ca. 1777. Wool, 47 × 39 in. (119.4 × 99.1 cm). The Metropolitan Museum of Art, New York, Gift of J. Pierpont Morgan, 1906 (07.225.469)

nearly all his journeys. Joseph had various reasons for visiting France. He wanted to discuss current foreign policy issues with Louis XVI, see his sister Marie Antoinette again, and take in the sights of the French capital. In its organization, schedule, and reception, this stay serves as the archetypal incognito journey of an absolutist ruler in the Age of Enlightenment. It became the pattern and point of reference for the organization of several subsequent incognito visits to Versailles.

Among these was the tour of Grand Duke Paul of Russia, later Czar Paul I, and his consort, Maria Feodorovna (figs. 69a,b; cats. 98, 99). The couple visited Europe incognito in 1781–82,

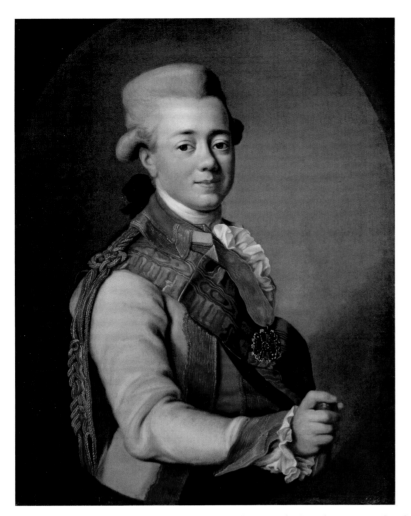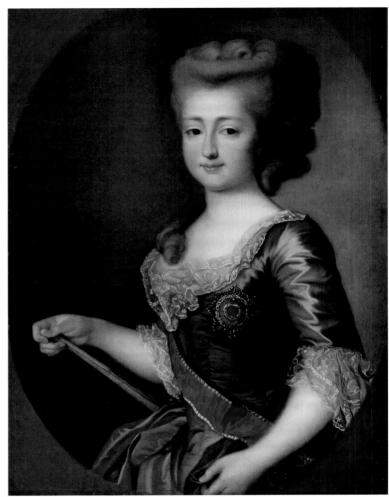

Fig. 69a, b. Gavril Ivanovich Skorodumov, *Grand Duke Paul Petrovich with the Order of Saint Vladimir* (left), and *Maria Feodorovna* (right), ca. 1782. Oil on canvas, 34½ × 25¾ in. (87.5 × 65.5 cm) each. Imperial Palace, Pavlovsk, Saint Petersburg (CCh-1991-III and CCh-1992-III)

staying primarily in Italy, but between May 18 and June 19 they were in Paris and Versailles. For their carefully planned journey, they chose the pseudonyms comte and comtesse du Nord. In Paris, Paul and Maria lodged at the Russian Embassy in the Rue de Gramont.[22] They usually maintained their incognito, both on semiofficial visits, to the Académie Française, for example, and on private shopping expeditions, but sometimes a certain vacillation was apparent, both in their behavior and in that of the public. At the Académie Royale des Inscriptions et Belles-Lettres and the Académie des Sciences, they insisted on being seated on simple side chairs rather than on

the armchairs that had been prepared for them as a sign of respect;[23] at Notre-Dame, however, they accepted the canons' compliments.[24]

At Versailles, where the travelers spent seven nights, they were greeted on their arrival by the prince de Poix, the Intendant and Governor of the Palace, and Louis XVI placed at their disposal the apartment of the prince de Condé; their subsequent activities were meticulously recorded.[25] The distinguished visitors were treated to twelve parties (organized following the pattern of the receptions held for the comte de Falkenstein in 1777)[26] as well as three operas and Jean Racine's tragedy *Athalie*.[27] The grand

INCOGNITO TRAVELERS

ball held on June 8 later
served as the pattern for one
during the incognito visit by
Gustav III; an outing to the
palace in Sceaux was reprised
during the incognito journey
of Archduke Ferdinand of
Austria and his wife, Maria
Beatrice d'Este, as the comte
and comtesse de Nellenburg in
1786 (figs. 70a, b).[28]

The incognito of the
Russian couple was reflected
in the protocol observed
at Versailles. The duc de
Villequier, the First Gentle-
man of the King's Chamber,
presented the compliments of
the king and gave instructions
to the servants placed at the
visitors' disposal. Of the
two sedan chair carriers who

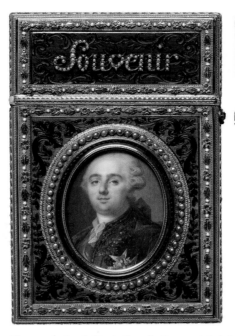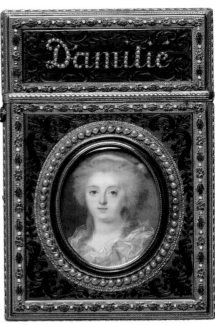

Fig. 70a, b. Louis Marie Sicardi, *Carnets de bals* (souvenirs) given to Archduke Ferdinand of
Austria, with portraits of Louis XVI (left) and Marie Antoinette (right), ca. 1786. Gold, enamel,
miniature portraits, pearls, ivory, 3½ × 2¼ in. (8.8 × 5.8 cm) each. Kunsthistorisches Museum,
Vienna, Kunstkammer (KK 8269)

accompanied their every move in the palace,
the count demonstratively made no use.[29] Like
Joseph II before him, Paul wore no orders and
strictly adhered to his incognito status in title and
precedence.[30] This allowed him and his wife to
visit the royal family several times, sometimes
unannounced, and to dine tête-à-tête with the
king and queen. Louis XVI even delayed his *lever*
so that Marie Antoinette might accompany them
on an outing.[31]

Admittedly, the incognito did not solve all the
problems resulting from the rules of precedence at
the French court. These were so strict and detailed
that the memoirist Baroness d'Oberkirch goes
so far as to describe incognito as the only option
if foreign rulers wished to stay in the palace of
Versailles. For with it they ranked below members
of the royal house and especially the so-called
princes du sang (princes of the blood).[32] This
was in fact the reason why Peter I had abstained
from visits to the princes back in 1717.[33] Even

the anonymous author of the "Nottes [*sic*] sur le
voyage de M. le comte et de M[me] la comtesse du
Nord en France au mois de may 1782," concerned
to present a harmonious narrative, recorded that a
meeting between Paul and the princesse de Lam-
balle had been possible only because "the queen
was good enough to arrange things in such a way
that everything took place without ranks being
compromised."[34] To avoid such problems, dinners
with the royal family were served at round tables,
for in that way no hierarchy was indicated by the
seating arrangement.[35]

Outside the palace walls, the royal couple's
visit roused great public interest. Alexandre
du Coudray, who had already devoted a book
to Joseph II's journey, published *Le comte et la
comtesse du Nord; Anecdote russe*, which he was
permitted to present to the count and countess
personally at Versailles. His flattering hymn of
praise for the travelers was based on information
obtained from the Paris press and a "person at the

Court instructed in the ceremonial."[36] Du Coudray reports on the crowds of people who accompanied the visitors in Paris and the huge demand for tickets to the parties given for them at Versailles. For the latter, a special information office had been set up in Paris.[37]

Comte de Haga

The previously mentioned journey of Gustav III, in June and July 1784, illustrates the procedures involved in an incognito reception at Versailles during the waning years of the ancien régime. The emphatically Francophile king of Sweden had been raised by Count Carl Gustaf Tessin, who had long sojourned at the court of Louis XIV in Versailles before being named Sweden's ambassador in Paris in 1739.[38] Gustav, who spoke and wrote almost fluent French, shared the admiration of many enlightened northern European rulers for the *grande nation*, and he deliberately sought to imitate its culture after his accession to the throne.[39]

Gustav's first trip to France, in 1771 (see cats. 89–92), when he traveled incognito as the comte de Gothland to make the acquaintance of several French philosophers and to discuss French-Swedish relations with Louis XV, was cut short by the sudden death of his father, Adolf Frederick.[40] On August 19, 1772, in a bloodless coup d'état, Gustav seized power from the government, effectively making Sweden an absolutist monarchy.[41] His plans for a second trip to France began taking shape by 1780 at the latest. This one, following the pattern of the Grand Tour, was also to take him to Italy for an extended stay.[42]

The Swedish king undertook the trip, which lasted more than a year, under different identities at the various stops along the way. In Italy he first assumed the comte de Gothland pseudonym, but once he arrived in Florence, he became the comte de Haga—the name of a royal palace near Stockholm—and this was the incognito he maintained until his return to Sweden.[43] Despite his incognito, prominent personages courted Gustav's favor, just as he courted that of other rulers traveling incognito at the time, such as Russia's Grand Duke Paul, visiting Italy as the comte du Nord, and Emperor Joseph II, there as the comte de Falkenstein.[44]

Gustav arrived in the French capital on June 9, 1784 (fig. 71). His visit had been preceded by extensive correspondence with Charles Gravier, comte de Vergennes, the French foreign minister and former French ambassador in Stockholm, which culminated in Marie Antoinette's inviting Gustav to her court.[45] The Swedish ruler only occasionally made use of the expensively renovated Versailles apartment of the duchesse de Bourbon (cats. 100–103), which had been prepared for him, preferring to stay in the Swedish Embassy on the Rue du Bac in Paris;[46] financial considerations also affected that decision.[47] Gustav did a great deal of sightseeing, making visits to famous buildings, prominent art collections, various academies, and scholarly circles as well as the Gobelins and Savonnerie tapestry manufactories and the porcelain manufactory at Sèvres.[48] On most of these, the illustrious incognito guest was presented with valuable gifts (fig. 72; cats. 104–107).

As the comte de Haga, Gustav could move about in public without ceremony and with the smallest possible entourage. On June 14 he wrote to Count Gustaf Philip von Creutz, the former Swedish ambassador in Paris, "I am applauded everywhere I go, entering and leaving the theater, and in the corridors."[49] The comte de Haga was especially honored on his many visits to the Opera,[50] where, notwithstanding his incognito, he was allowed to share the royal couple's loge. When he arrived too late for one performance, the orchestra began the concert again from the beginning at the express wish of the public. In his public

Fig. 71. Niclas Lafrensen, *King Gustav III of Sweden*, 1792. Gouache on paper, 15¼ × 12⅝ in. (40 × 32 cm). Nationalmuseum, Stockholm (NMB 77)

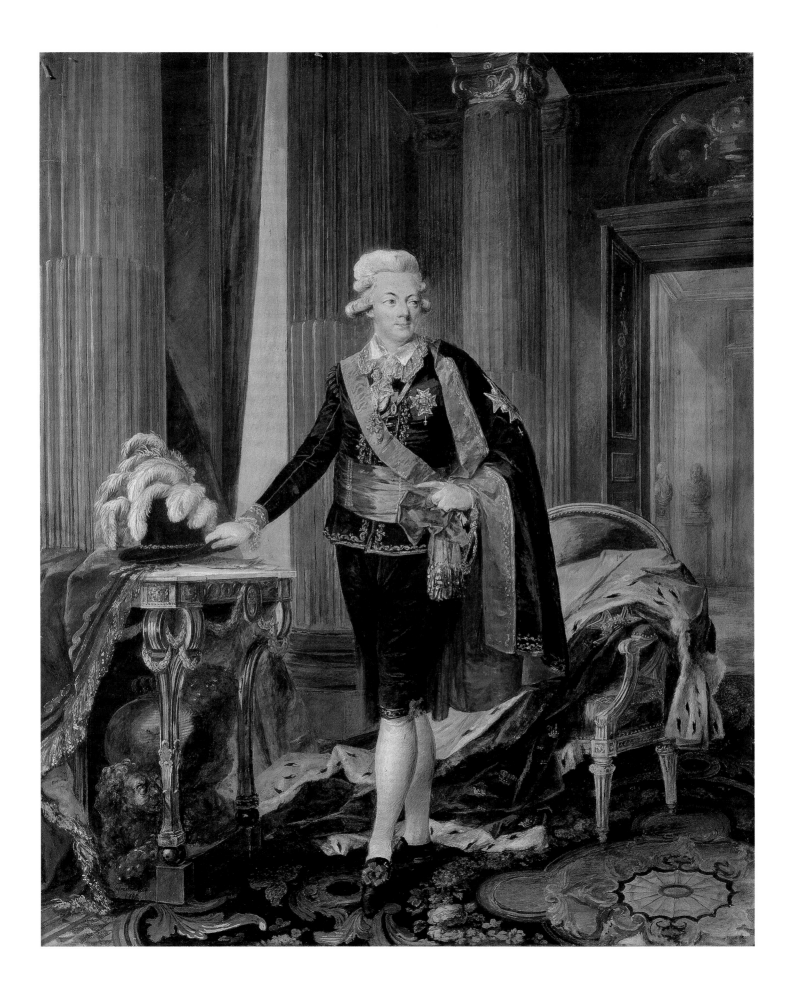

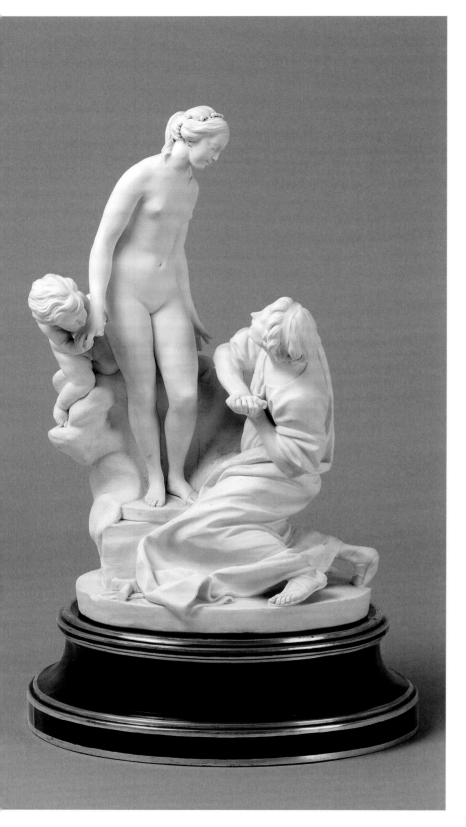

Fig. 73. Carte de visite of Gustav III, dated June 29, 1784. Archives Nationales, Paris-Pierrefitte (K/161/A, no. 27)

appearances, Gustav regularly called attention to himself and demonstratively greeted politically important personages. All this activity was extensively documented in the contemporary press, so that Gustav's incognito journey became in effect a carefully staged public relations campaign.[51]

Precisely because he was under constant public scrutiny, Gustav placed great importance on the ceremonial observance of his incognito. He deliberately dressed modestly, so that it was possible for him to "wander in the city in the daytime like the least of burghers."[52] He had special calling cards printed with his pseudonym (fig. 73) and, referring to his incognito, repeatedly dismissed the duc de Fleury, whom Louis XVI had assigned to be his personal escort.[53] Despite his incognito, the French king provided him with every conceivable amenity. Gustav reported, "I was received with the greatest friendship and cordiality by the entire royal family."[54] These privileges are attested to by Louis's diary, in which he meticulously registered the numerous visits of his fellow blueblood.[55] The court staff at Versailles also documented

Fig. 72. *Pygmalion Group* with matching base, 1770s, after a 1763 model by Etienne Falconet. Group: biscuit porcelain, H. 13¼ in. (35 cm), W. 8¼ in. (21 cm), D. 6¼ in. (17 cm). The Royal Collections Sweden (HGK 1168)

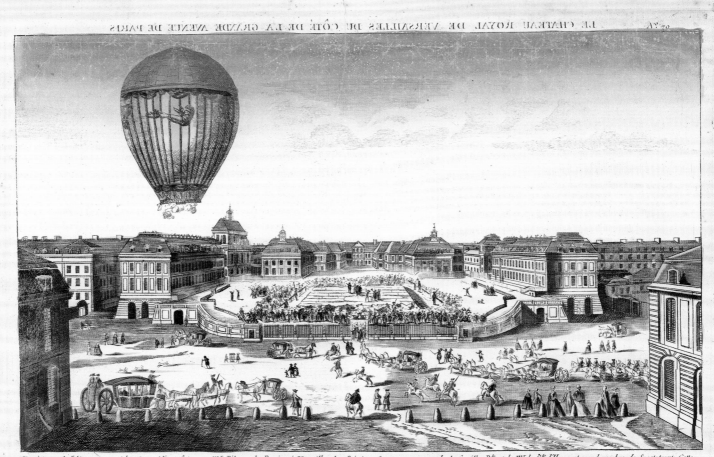

Fig. 74. Jacques Chereau, *The Royal Palace at Versailles from the Side of the Grande Avenue de Paris, June 23, 1784*. Colored engraving, 16¼ × 20½ in. (42.5 × 52.1 cm). National Air and Space Museum, Washington, D.C. (A20000707000)

Gustav's sojourn, and the court records illustrate how incognito protocol was respected and implemented on the part of the French.[56]

On the very evening he arrived, Gustav proceeded to Versailles, and he was a frequent guest in the following weeks. Despite his incognito, he spent the night in the palace several times and also, without formal invitation, visited the royal residence in Rambouillet. He even took the liberty of seeking out Louis XVI and Marie Antoinette unannounced in their private rooms, although he did not always find them there. Throughout his stay, Gustav moved about the palace unimpeded, behaved toward the French ruling couple like a close, private friend, and took unaccompanied walks in the palace park with Louis.[57] These liberties were not altogether approved, however. The marquis de Bombelles, most intimately conversant with Versailles court society, haughtily reports in his diary how the

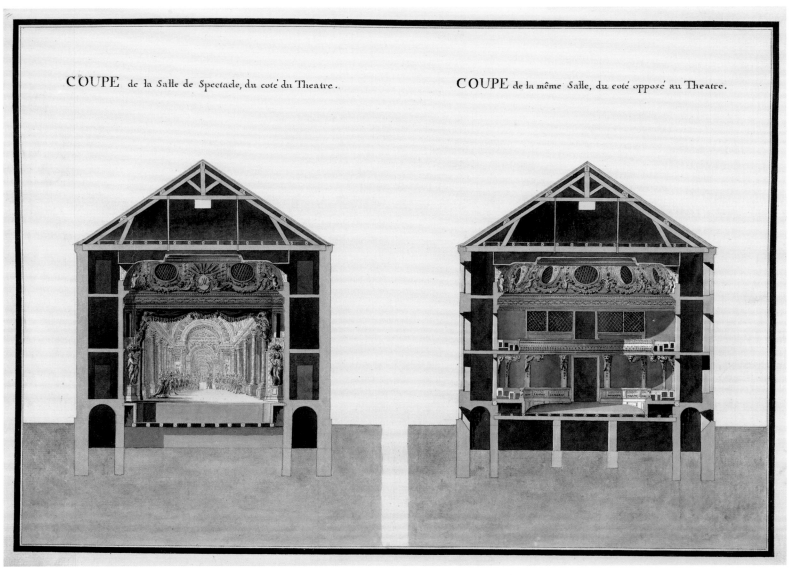

COUPE de la Salle de Spectacle, du coté du Theatre. COUPE de la même Salle, du coté opposé au Theatre.

Fig. 75. Richard Mique and Claude Louis Châtelet, "Sections of the Theater at the Petit Trianon," from *Souvenir Album of the Petit Trianon*, 1781 (cat. 95). Watercolor, pen and ink, 19½ × 15⅛ in. (49.5 × 39 cm). Vartanian & Sons, New York

comte de Haga bored the royal couple with his long-winded conversation.[58]

On June 21 the queen arranged for a major evening reception in the guest's honor in the garden of the Petit Trianon. She had invited numerous foreign guests, all of whom appeared dressed in white, and so, according to Gustav, "they were a sight to see on the Champs-Elysées."[59] Two days later, a montgolfier named for Marie Antoinette and carrying Louis's and Gustav's initials was launched from the palace's Ministers' Courtyard; as a special tribute, a white ribbon (a symbolic reference to Gustav's successful coup d'état in 1772) was affixed to the hot-air balloon (fig. 74).[60]

Even with all the parties, receptions, plays, and other amusements in Paris as well as at the Petit Trianon, Gustav did not forget the political goals that had brought him to France (fig. 75). In this he was helped by his incognito status, which made many informal meetings possible with the French

king, his ministers, and other personages. On the one hand, Gustav wanted to ensure French support for Sweden's policies in Scandinavia, and on the other he hoped to expand Sweden's position outside Europe. He managed to sign a contract with the French king on July 1, 1784, that was followed by further negotiations.[61] Because of his incognito, Gustav could make spontaneous visits to the home of the comte de Vergennes,[62] where in privacy the two could identify problems and openly discuss possible solutions. In his official capacity as king, on July 19, 1784, Gustav finally signed a binding agreement with France. It amounted to a secret alliance in the event of war, gave France the right to use the harbor at Göteborg, and sold the French Caribbean islands Saint-Barthélemy and Saint-Martin to Sweden.[63]

Gustav departed on the day the agreement was signed. Incognito had not only made his diplomatic mission a success, but it had also given the French public a positive image of Sweden and its monarch. This is evident from the detailed newspaper reports, some of which Gustav forwarded to Sweden and had published there to convince his subjects of his accomplishments.[64]

In its literary record, Gustav's journey is a perfect example of the use of incognito at the end of the eighteenth century. Du Coudray, who virtually specialized in the description of illustrious incognito visitors, devoted a book to the journey that in its elaborate praise emphasizes the Swedish monarch's amiable personality and personal charm. The comte de Haga is described as a simply dressed, modestly behaved monarch who, thanks to his incognito, enters into contact with the populace.[65] Anecdotes relate how strangers failed to recognize him, and how with visible delight Gustav left them in doubt as to his identity until on their own they declared him worthy of being a genuine king. With their obviously romanticized descriptions of his public profile and especially noble nature, such reports helped to legitimize Gustav's rule.[66]

These narratives also covered Gustav's return to Sweden, accompanied solely by his courtier Count Axel Fersen, a physician, and a valet. In Sweden he commissioned the French painter and architect Louis Jean Desprez to decorate the Swedish Opera, and on May 18, 1785, had Augustin Caron de Beaumarchais's *La folle journée ou Le mariage de Figaro*—the first performance of which he had attended at the Comédie-Française—presented in Sweden's Drottningholm Palace.[67] In 1786 Gustav reestablished the Swedish Academy, founded by his mother, and had it reorganized after the French model.[68] On March 29, 1792, at a masked ball at the Stockholm Opera, he was assassinated.[69] Just as on his incognito journey to Versailles, the Swedish king's temporary change of identity had not kept him from being recognized.

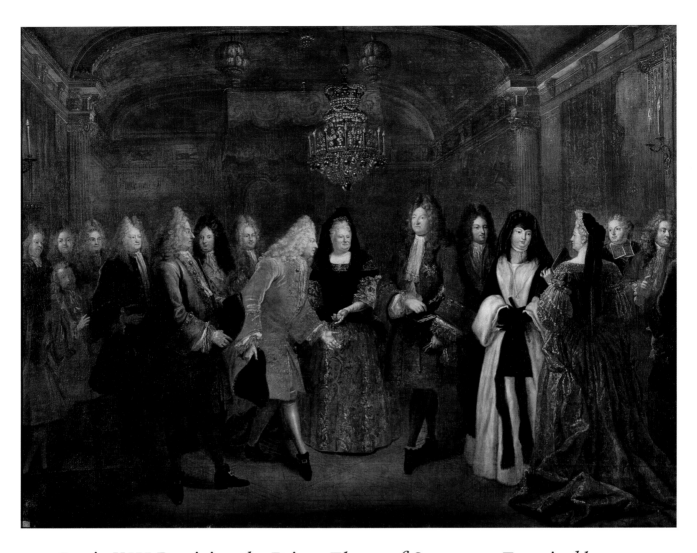

88 *Louis XIV Receiving the Prince Elector of Saxony at Fontainebleau*

Louis de Silvestre, 1715

From late August 1714 until early June 1715, Frederick Augustus, the Prince Elector of Saxony and future Augustus III of Poland, completed his education in France under the assumed name comte de Lusace. On September 27, 1714, Elisabeth Charlotte of Bavaria, called Madame, second wife of the king's late brother, introduced the prince to Louis XIV. Although this took place at Fontainebleau, many similar presentations occurred at Versailles that, unfortunately, have not been depicted. On the king's left-hand side stand the duc d'Orléans; Louise Elisabeth d'Orléans, widow of the duc de Berry, grandson of Louis XIV; a woman who is perhaps the duchesse de Brancas, Madame's lady-in-waiting; the Cardinal de Rohan; and an unidentified courtier. Frederick is accompanied by the comte Joseph Cos, his governor; Baron Hagen, his father's personal adviser; and Montargon, a Gentleman of the King's Chamber. This painting, an autograph replica of one that was in Dresden, was part of a cycle of twenty commissioned by the prince's father, Augustus II, on the model of the tapestry series L'Histoire du Roi. Silvestre reconstructed the scene, which he had not attended, by consulting existing accounts and portraits. BS

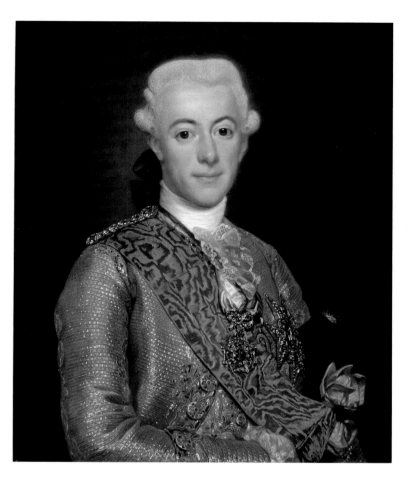 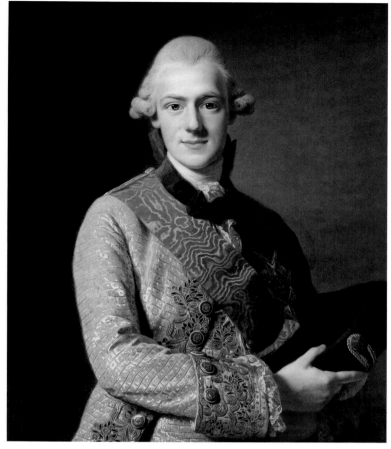

89 *Gustav III*

Alexander Roslin, 1775

90 *Frederick Adolf*

Alexander Roslin, 1771

During his visit to Paris in February 1771, the future Gustav III of Sweden and his younger brother Frederick Adolf sat for Roslin on several occasions. The Crown Prince's sessions were cut short when he received word, at the opera, of his father's death. Gustav's immediate departure left Roslin with numerous portrait commissions from the new king but only facial sketches from which to fulfill them. The artist subsequently adapted Gustav's high brow and large eyes into this canvas, a full-length portrait, and even a group scene of the king with his brothers. Frederick Adolf, by contrast, remained longer in Paris and continued to sit for Roslin, which perhaps accounts for his portrait's more successful composition. EB

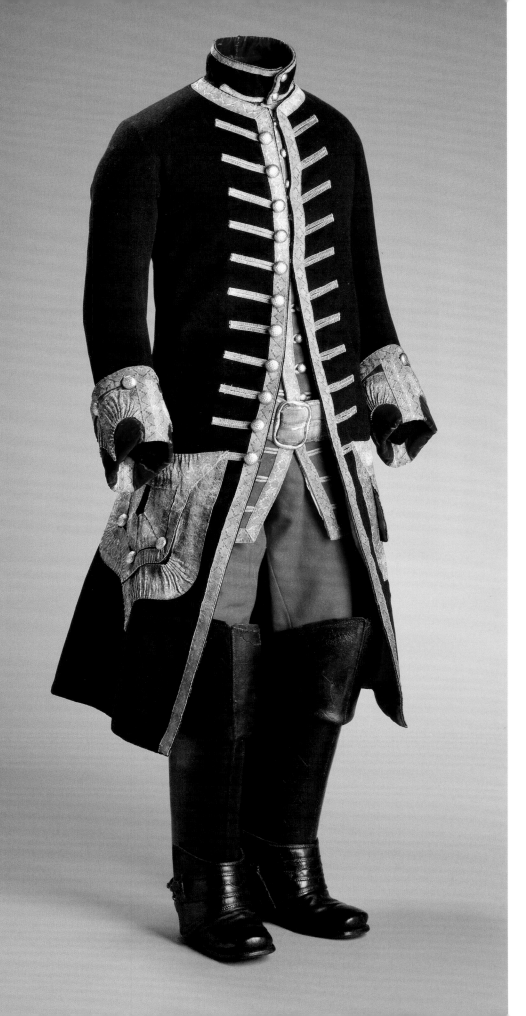

91 Hunting Costume

Le Duc, recorded 1771

The purpose of Gustav's trip to France in 1771, as Crown Prince, was to see Europe and to build political friendships. Using the incognito comte de Gothland during this first visit, he was received by Louis XV with "all the markers of friendship and consideration possible."[1] Among his entertainments at Versailles were two hunting excursions with the king, on February 16 and 23, for which he received a fashionable French hunting costume. This costume, similar to one presented to Christian VII of Denmark in 1768, so impressed Gustav that he immediately wrote about it in a letter to his mother.[2] EB

92 Tureen and Stand (*terrine et plateau*)

Sèvres Manufactory, 1771

At Versailles in 1771, the future Gustav III and Frederick Adolf received gifts customary for royal visitors. Although not as generous as what Gustav would receive on his second visit once he was king, these lavish presents included nearly six hundred pieces from two similarly decorated Sèvres dinner services alone, not to mention a suite of tapestries and panels for folding screens. (Even though the various dishes served at the public Swedish royal meal on January 1, 1779, numbered as many as thirty-two, this was still an extraordinary amount of porcelain.)[1] The present tureen, used for soup, was a stunning presentation piece that would have remained on the table throughout the meal. Decorated with finely rendered, brightly colored birds surrounded by gilded acorn garlands against a turquoise ground, it matched the other pieces in the two composite services, among which were 264 plates, 32 assorted fruit dishes (*compotiers*), dozens of platters and wine buckets, and punch bowls. EB

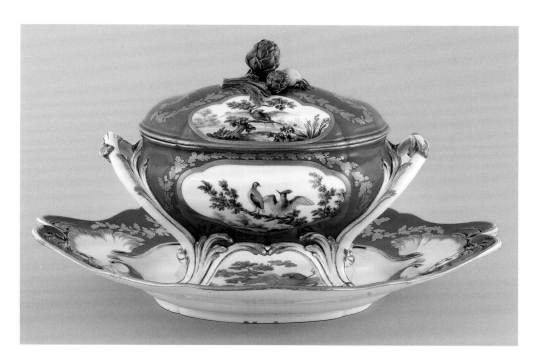

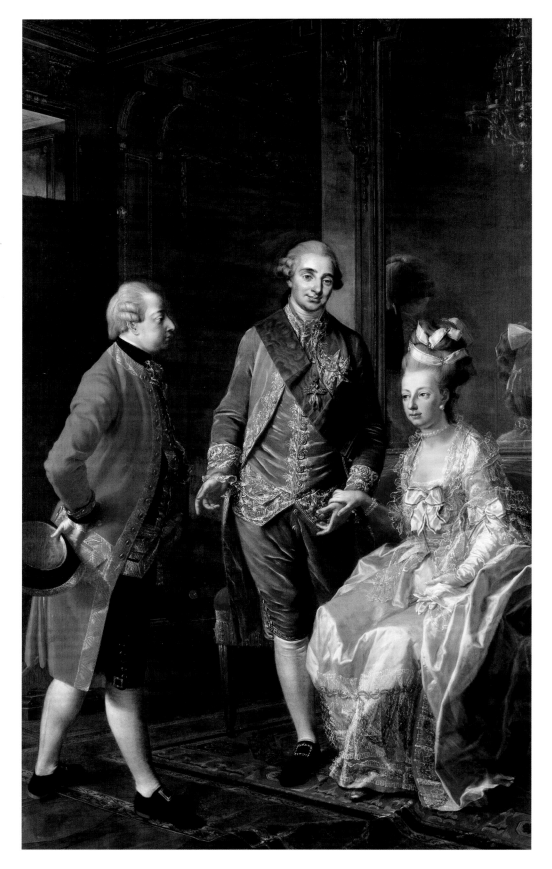

93 Marie Antoinette, Louis XVI, and the Archduke Maximilian

Josef Hauzinger, 1778

Hauzinger painted this intimate portrait commemorating the 1775 visit of Archduke Maximilian with his sister Marie Antoinette and her husband to augment his series portraying Maria Theresa's children, which was installed in the Familienzimmer (family room) in Schloss Hof. Rare for its depiction of a private meeting of the queen with her family, this work was painted several years after the visit (indeed an early sketch shows the three figures in different poses and settings).[1] Although he was received warmly by the king and queen, Maximilian did not win friends in France outside the immediate royal family, largely because he expected to be treated like an archduke while he traveled incognito as the lower-ranked comte de Burgau.[2] EB

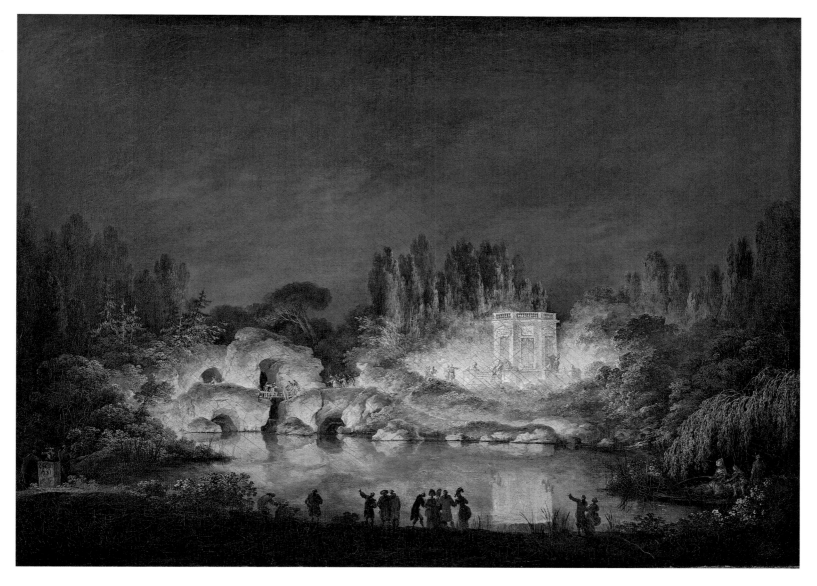

94 *The Rock and Belvedere at the Petit Trianon*

Claude Louis Châtelet, 1781

Renowned for his views of the castles and parks in the Île-de-France region, Châtelet
was commissioned by Marie Antoinette to make watercolor scenes and floor plans
of the Petit Trianon (*Vues et plans du Petit Trianon*), which she offered in albums to
some of her private visitors (cats. 95, 99). The artist also created a number of paint-
ings of the queen's favorite retreat. One of them, seen here, records the illumination
of the gardens on August 3, 1781, organized in honor of the second visit of Marie
Antoinette's brother Emperor Joseph II. Set within the deep blue of the night, at the
heart of the garden designed in 1777 by the architect Richard Mique, the Belvedere
Pavilion and the Rock appear within a halo of light in an enchanting scene reflected
on the mirrorlike surface of the lake. GF

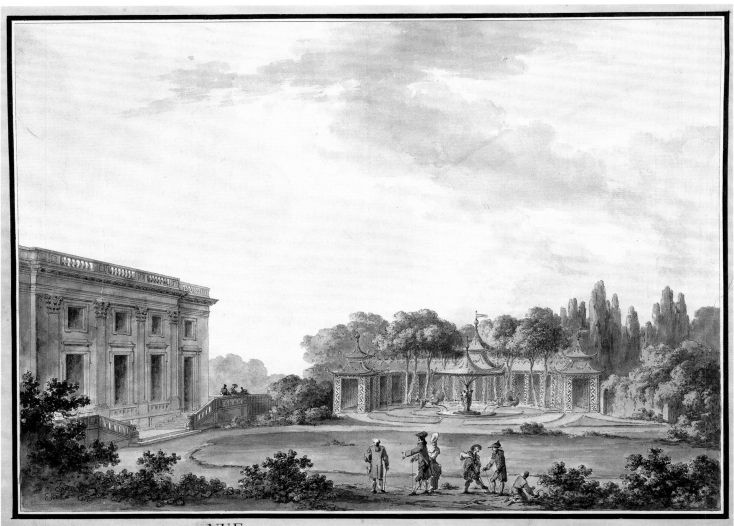

VUE du Jeu de Bague, de Sa Gallerie, & d'une des Façades du Chateau.

95 *Souvenir Album of the Petit Trianon*

Richard Mique and Claude Louis Châtelet, 1781

Between 1776 and 1783, Mique renovated the Petit Trianon and relandscaped its gardens for Marie Antoinette. This private retreat was depicted by Châtelet between 1779 and possibly 1786 in souvenir albums intended for the queen's royal guests. Five of these, all different, are extant. The present copy is believed to have been given to the queen's brother Emperor Joseph II in 1781. Three of the known albums went, respectively, to another brother of the queen, the Archduke Ferdinand; to the Swedish king Gustav III; and to the comte and comtesse du Nord (Grand Duke and Grand Duchess Paul and Maria Feodorovna of Russia; cat. 99), while the queen kept a personal copy.[1] Châtelet's brilliant watercolors, interspersed with Mique's architectural plans, reminded recipients of the places where they were entertained, from the Chinese-style merry-go-round, the Grotto, and the Temple of Love to the "gem"-like Theater, where ballets and operas were performed.[2] EB

96 Fire Screen Panel

Savonnerie Manufactory, Paris, before 1777 (design, late 1720s)

Savonnerie fire screen panels decorated with figures from the commedia dell'arte were never meant to match other furniture en suite or folding screens.[1] To ensure exclusivity, the manufactory kept limited stock. This one, given to Joseph II in 1777, was part of the small supply that Louis XVI exhausted through presents to the comte and comtesse du Nord and to the comte de Haga (Gustav III), who received two each. This left the manufactory scrambling to adapt a larger folding screen panel into one suitable for a fire screen when the king later wanted to offer the same design to Prince Henry of Prussia.[2] EB

97A–D **Four Folding Screen Panels**

Savonnerie Manufactory, Paris, before 1777 (designs, 1739)

A. *The Rooster and the Pearl*
B. *The Fox and the Crow*
C. *The Fox and the Grapes*
D. *The Stag at the Pool*

Chamber screen panels such as these, part of a set of six representing Aesop's Fables, were produced at the Savonnerie manufactory throughout the eighteenth century. The manufactory's tightly controlled distribution reserved such screens principally for French royal use, although records do indicate that on rare occasions they were lent to visiting ambassadors such as the Ottoman Mehmed Said Efendi.[1] Almost never available for sale, such screen panels made exclusive gifts for foreign royalty.[2] The recipients were responsible for mounting the panels; the present examples, never used for a screen, were woven from designs dating to 1739. They were given in 1777 to the queen's brother Joseph II, who visited under the name comte de Falkenstein to encourage his sister and brother-in-law to consummate their marriage. As was the case with all incognito travelers, Joseph's true identity was an open secret that was acknowledged through these and other lavish gifts delivered to him at the Austrian ambassador's residence.[3] EB

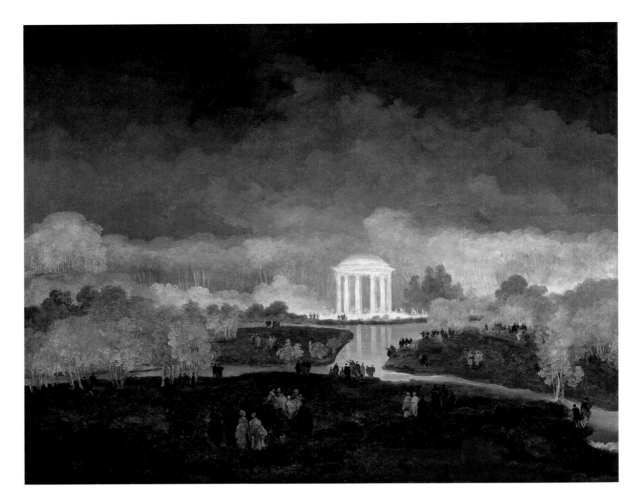

98 *Nighttime Festivities with Fireworks in the Gardens of the Petit Trianon*

Hubert Robert, 1782–83

Many of the entertainments that the royal family provided for their private visitors, including fireworks, ballets, and suppers, were held at the Petit Trianon. Robert's painting, perhaps made to decorate the queen's apartments there, shows crowds of people assembled around the Temple of Love to observe a fireworks display staged for the comte and comtesse du Nord in 1782. Other types of nocturnal illuminations, such as those for Joseph II in 1781 (cat. 94) and for Gustav III in 1784, involved lighting fires in earthenware pots and placing them around the buildings, an effect that Gustav described as a "perfect enchantment."[1] EB

99 *Design for a Frontispiece*

Claude Louis Châtelet, 1782

Baroness d'Oberkirch, a childhood friend of the comtesse du Nord, remarked that traveling under an assumed identity was a means to avoid mingling with lower-ranking courtiers.[1] Such visits were hardly secret: the duc de Croÿ described the couple's sojourn as "an incognito published and arranged" (they brought with them thirty carriages and a household of ninety).[2] Given an apartment to use at Versailles in the north wing, next to the chapel, the couple enjoyed ballets such as *Zémire and Azore* and *La Française au Sérail*, followed by supper.[3] The queen also bestowed gifts, including a copy of Châtelet's watercolor album (cat. 95); this frontispiece, although it does not bear the mark of Paul I, was originally part of the album given to them in 1782.[4] EB

RECUEIL
Contenant le Plan general &
diverses Vües du Jardin de la
Reine au petit Trianon.

Par le Sr. Mique Chevalier de
L'ordre de St. Michel, Premier
Architecte honoraire Intend.
General des Batimens du
Roy & de ceux de la Reine.
1782

100 Mechanical Table

Jean Henri Riesener, 1781

The inventory number 3066 painted on the underside identifies this small mechanical table as the one supplied by Riesener in January 1781 for Marie Antoinette's Grand Cabinet Intérieur at Versailles. The allegorical trophy on the top, surmounted by a large Gallic cock and the motto *Numine afflatur* (Inspired by divine light), appears to express pride in French achievements in science, commerce, and learning. As early as April 1784, the cabinetmaker was asked to restore the piece and to regild its mounts "as promptly as possible."[1] The reason for this urgent work was the second incognito visit of Gustav III in June and July of that year. An apartment at the palace was readied for the Swedish king, and both this piece and another of the queen's mechanical tables were among its furnishings (cats. 101–103).[2] How often the distinguished visitor used either table is not clear, because most nights he returned to Paris.[3] DK-G

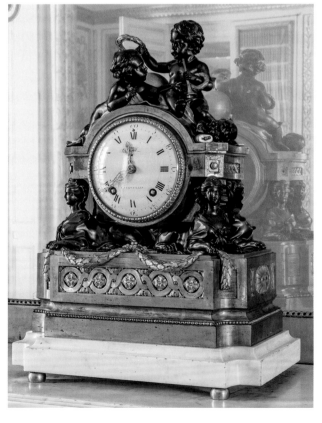

101 Mantel Clock

Movement by Joseph Juhel; case by François Caranda, 1784

Caranda, established in Versailles in 1778, supplied "four altered clocks" for the apartment of Gustav III at the palace.[1] He reused movements from earlier timepieces stored at the Royal Furniture Repository and fitted them in modern cases. Was this a measure of thrift by the royal administration faced with the necessity of furnishing an apartment for the Swedish king in a short time? The present clock, intended for Gustav's cabinet, was decorated with "patinated bronze figures symbolizing the Union of the Arts, . . . which was represented by two children surrounded by attributes of the various arts."[2] BR

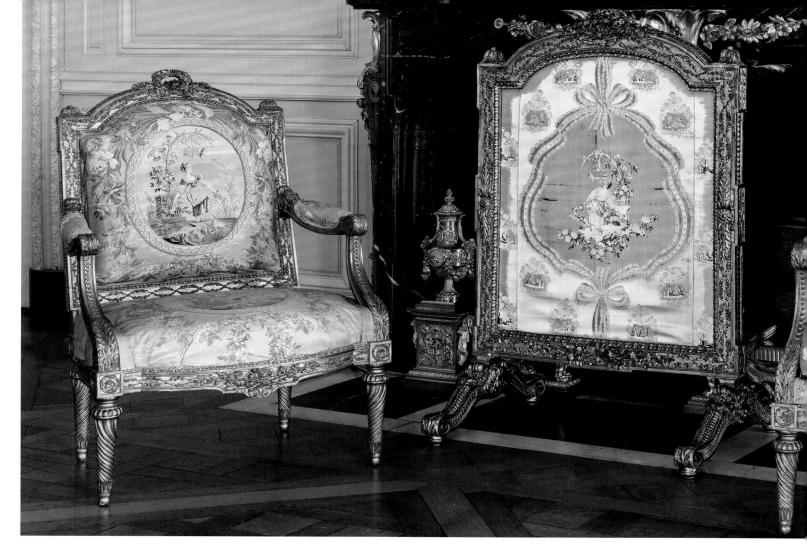

102 Armchair (*fauteil à la reine*)

103 Fire Screen

Jean-Baptiste II Tilliard, 1777–78

The spacious apartment arranged for Gustav III on the ground floor of the Midi Wing was normally reserved for the duchesse de Bourbon. After some architectural alterations were made, it comprised an antechamber, a dining room, a corridor, a reception room, a bedchamber, and a cabinet. According to the arrangements summarized by Marc Antoine Thierry de Ville d'Avray on April 22, 1784, its furniture included pieces from the Royal Furniture Repository, of which he was the intendant, as well as others specially commissioned, including the bed, four armchairs, and eight folding stools required by etiquette for the

bedchamber. An extremely rich set was purchased "secondhand" in Paris to furnish the cabinet; this had been created in 1777–78 by Tilliard under the direction of the *marchand mercier* François Charles Darnault. The settee, two bergères, six armchairs, and a fire screen were already upholstered with one of Philippe de Lasalle's best-known fabrics, "a gros de Tour brocade on satin ground with medallions and figures."[1] In order to make the interior decoration even "more luxurious," Thierry de Ville d'Avray suggested embellishing the mantelpiece and commode with Sèvres porcelain vases and figures.[2] BR

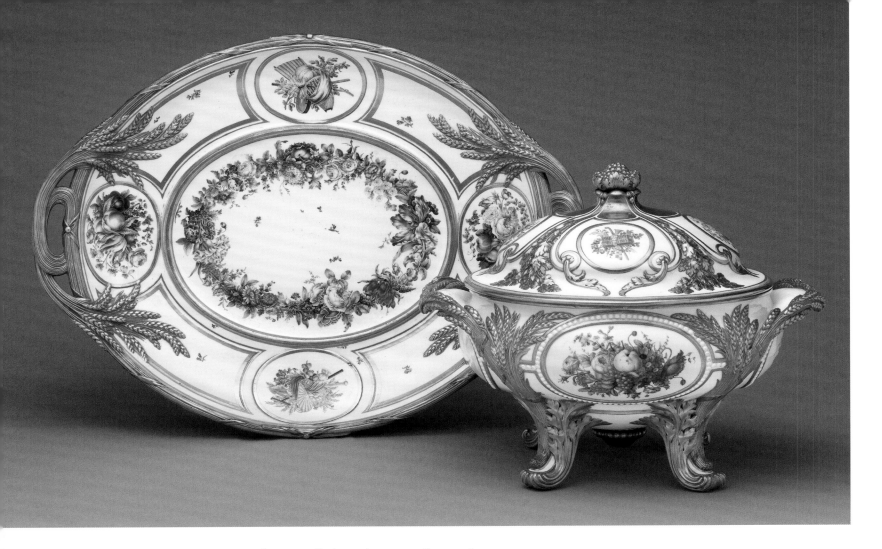

104 Tureen and Stand (*terrine et plateau*)

Sèvres Manufactory, ca. 1777

As part of his gift in 1784, Gustav III received two oval tureens and matching stands in the pattern known as *épis de blé*, which featured painted flowers encircled by stalks of gilded wheat in low relief. A sales register described the pair as "richly painted and gilded" and valued them at 900 livres, the most expensive available at the time.[1] While some tureens, like the one Gustav received in 1771 (cat. 92), were decorated to match a complete

service, *épis de blé* tureens were developed as stand-alone dinner pieces. Earlier versions, including a pair of round tureens (*pots à oilles*) and another oval pair, were presented to Joseph II in 1777, while Louis XVI himself ordered four for his own use.[2] This particular serving dish was perhaps taken out of Sweden by Gustav's son, who was exiled to Germany in 1809 and reputedly sold some of his family's porcelain.[3] EB

105 Tureen and Stand (*pot à oille et plateau*)

Sèvres Manufactory, 1784

When Gustav III arrived at Versailles on June 7, 1784, earlier than expected, Louis XVI rushed back from the hunt to receive him.[1] The royal manufactories, also caught off guard, had to improvise some of their stock. On June 19, as was common for visiting royalty, Gustav toured the Sèvres manufactory, where he had his pick of dinner and dessert services and biscuit-porcelain figures.[2] Three days later, he received dozens of pieces from the queen's own "Colorful Frieze" service, including this round *pot à oille* tureen, used for stews.[3] Still more pieces, probably including the tray paired with this tureen, were ordered for Gustav in early September. The whole gift of porcelain—valued at 38,434 livres on June 23—was put on private view before it was delivered to Gustav.[4] In her diary, the British tourist Anna Francesca Cradock recounted that she was especially impressed with the "gilded and excellently painted" service that she and her husband saw on June 24.[5] EB

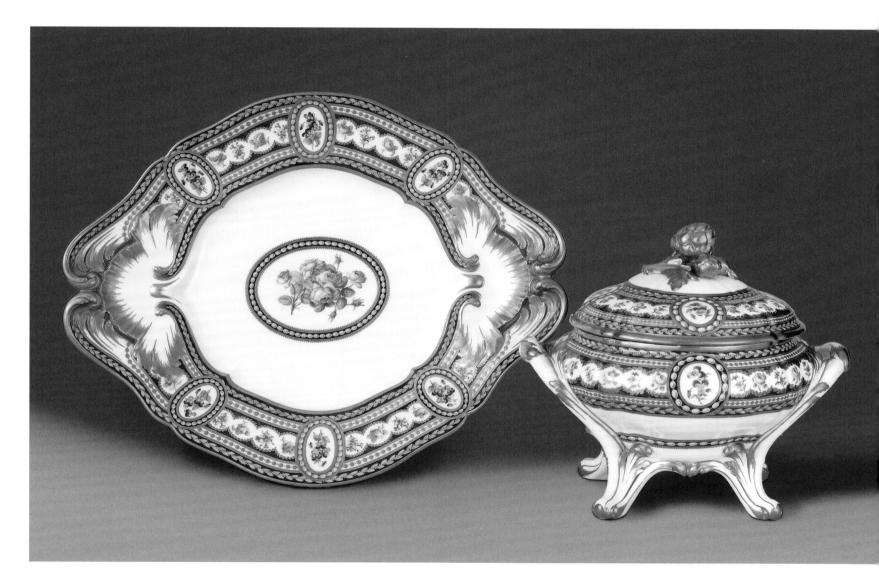

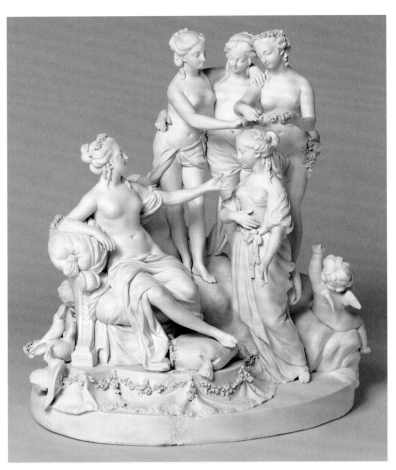

106 *Beauty Crowned by the Graces*

Sèvres Manufactory, after 1775

107 *The Birth of Bacchus*

Sèvres Manufactory, after 1783

Biscuit-porcelain figure groups—always white and usually unglazed—typically decorated the dessert table and were often arranged there on a mirrored centerpiece. The two mythological groups seen here were given to Gustav III in 1784 together with other biscuit figures of celebrated men, busts of the king and queen (cats. 84, 85), and glazed blue bases (see fig. 72).[1] These were likely shown at the same private viewing of the gifts to the Swedish king as the "splendid" dinner and dessert services admired by the tourists Mr. and Mrs. Cradock (see cat. 105). The figures, Mrs. Cradock marveled, had such lively features "one could almost read their thoughts."[2] Having been to see the gifts after breakfast on the morning of June 24, she and her husband "returned enthused."[3] EB

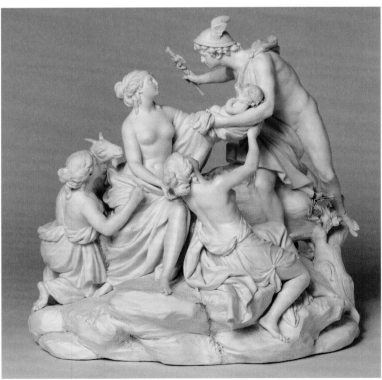

INCOGNITO TRAVELERS

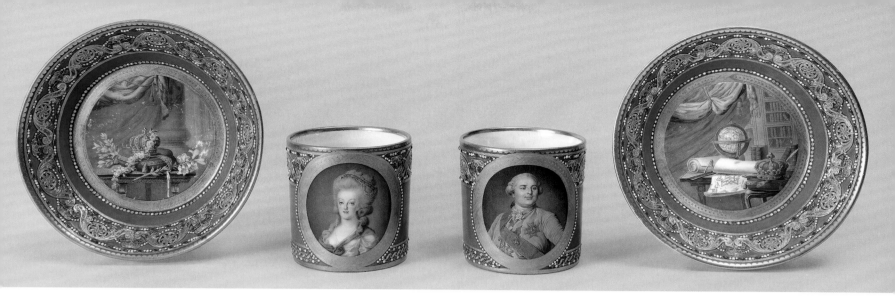

108 Cup and Saucer (*tasse litron*) with Portrait of Marie Antoinette

109 Cup and Saucer (*tasse litron*) with Portrait of Louis XVI

Sèvres Manufactory, 1782

During the 1780s, the craftsmen at the Sèvres manufactory produced cups with miniature portraits that were embellished with translucent and opaque enamels raised on gold foil, so-called jeweled porcelain. In May and June 1782, the Sèvres workshops made pieces intended for the comte and comtesse du Nord. The enamel was applied by Philippe Parpette and the Pithou brothers were responsible for the painting.[1] In the fall, the younger Pithou painted two more cups—those exhibited here—with a turquoise (*bleu céleste*) ground and the portraits of the king and queen; they were fired on December 28, 1782.[2] These cups most likely are the ones valued at 288 livres that were given in 1784 to Gustav III of Sweden during his visit.[3] Produced only during the reign of Louis XVI, these luxurious cups attest to the care that Marie Antoinette put into the gifts she commissioned. VB

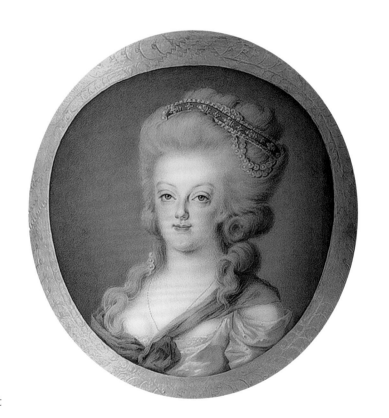

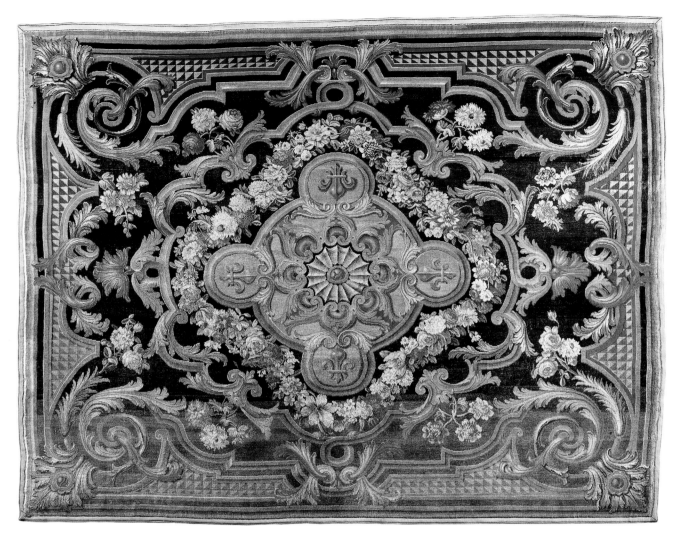

110 Carpet

Savonnerie Manufactory, Paris, 1780–81

Established in an abandoned soap factory outside Paris (hence the name), the Savonnerie manufactory was granted a monopoly by Louis XIII in 1627 to supply high-quality knotted-pile carpets to vie with those formerly imported from Persia. Until the Revolution, two-thirds of its carpet production furnished the French royal houses, while the remaining stock was reserved for private gifts.[1] This carpet was among more than half a dozen presented to Gustav III during his 1784 visit to France. A royal inventory of carpets shows that earlier versions of this design were delivered to Choisy and Fontainebleau.[2] So much did Gustav treasure his floor carpets—he may well have picked them out himself—that the artist Niclas Lafrensen portrayed him standing on this particular one (see fig. 71).[3] EB

111 Tableau

Sèvres Manufactory, early 1780s(?)

Jacques François Micaud began his career at Sèvres in 1757, and by the time he painted this tableau, in the early 1780s, he was one of the best flower painters at the factory. He was paid handsomely for his expertise: in two decades, his wages more than tripled, and by the 1780s he was earning 100 livres a month.[1] In this exquisite floral still life, presented to Gustav III in 1784, highly naturalistic flowers dotted with dewdrops spill over the top of a vase. Micaud's effortless handling belies the high degree of technical achievement required to successfully fire such a piece, which was executed on a flat plane intended to be framed. Referred to in factory records as a *tableau* (the same term used to describe an oil painting), this form was distinct from so-called *plaques*, which were for mounting on furniture. EB

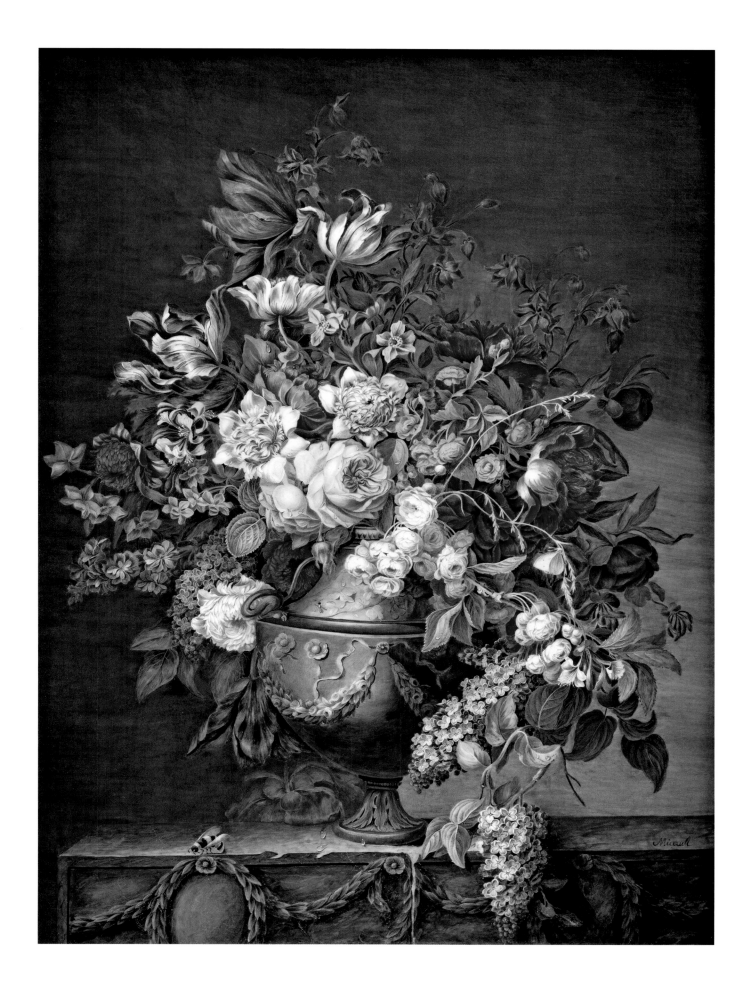

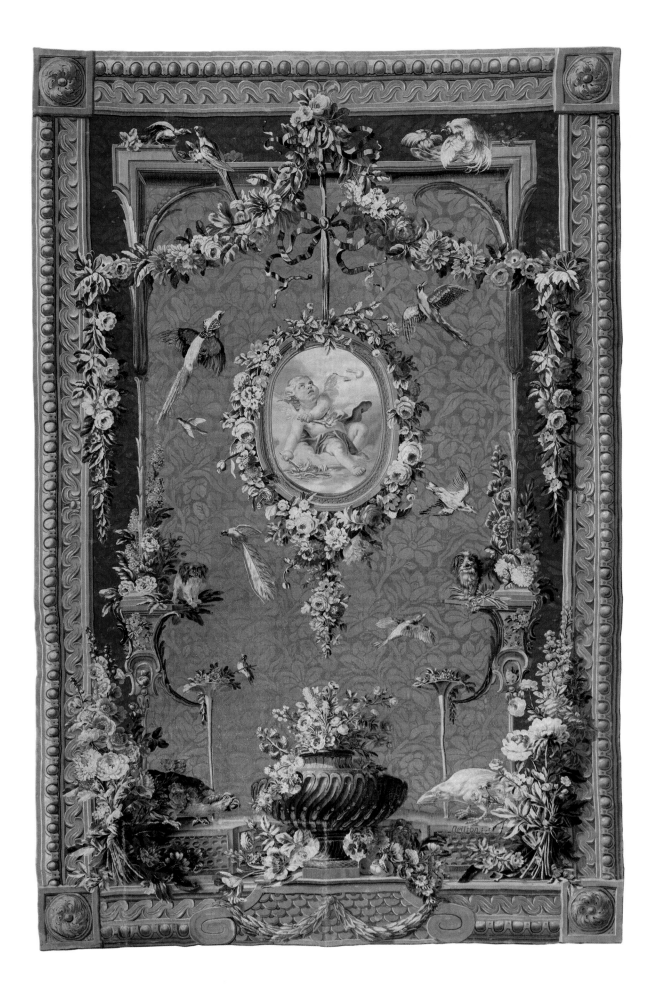

112 *Cupid in a Medallion*

Gobelins Manufactory, Paris, ca. 1776–83

This tapestry was part of a larger series known as the Tentures de Boucher, whose design dates to 1758. Louis XVI presented this hanging and its pair, along with matching upholstery for seat furniture, to Prince Henry of Prussia on his 1784 visit to Versailles. Other notable foreign royal recipients of the same series included the comte and comtesse du Nord and Emperor Joseph II. For his part, Henry was so taken with this gift that he hung the tapestries in the bedroom of his Berlin palace, a display that received specific mention in a 1786 Berlin guidebook.[1] EB

113 Plate

Sèvres Manufactory, 1784

Shortly after Prince Henry of Prussia, traveling incognito as the comte d'Oels, arrived in Paris on August 17, 1784, preparations were made to present him with an impressive group of Sèvres porcelain on the occasion of his visit to Versailles.[1] The largest component of this royal gift, valued at 25,462 livres and 16 sols overall, consisted of a green-ground dessert service, of which this plate was part.[2] Decorated with polychrome flowers and fruits by several Sèvres painters, the pieces bear the date letters for either 1782 or 1784, underscoring the haste with which the 124-part service was assembled.[3] Henry, the younger brother of Frederick the Great, also received biscuit figures and groups, ditto busts of Louis XVI and Marie Antoinette (cats. 84, 85), and other porcelains. The set was sold after Henry's death in 1802, and a number of plates from the dessert service entered the Metropolitan's collection in 1937 with the bequest of Emma T. Gary. DK-G

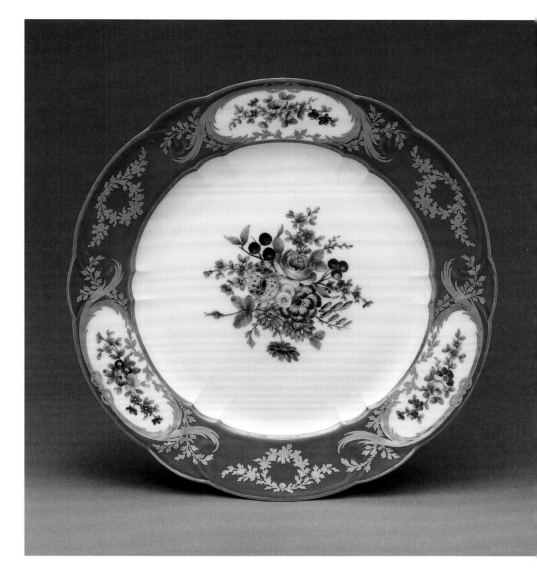

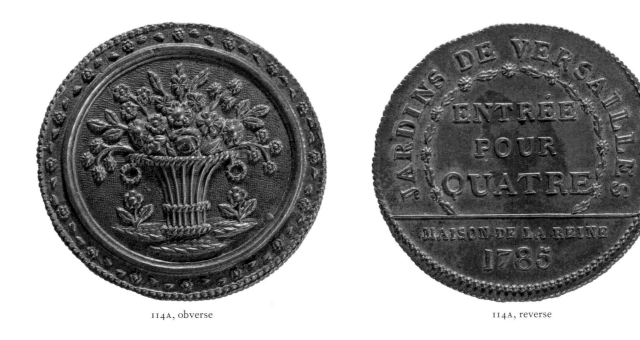

114A, obverse 114A, reverse

114A–C Tokens

French, 1785

115 Master Key (*passe-partout*)

French, ca. 1760–74

It is not known how these tokens, each granting access to four persons to the gardens of Versailles, were distributed or if they were issued for a particular event in 1785. The inscription on the reverse, mentioning the queen's household, is somewhat puzzling because the expected reference would be to the gardens of the Petit Trianon, Marie Antoinette's domain, which required special permission to visit.

By contrast, the gardens of Versailles, belonging to the Crown, were freely accessible except for the fenced-in groves, which were locked for protection against vandalism. Keys were needed to gain entrance to them, as the British traveler Thomas Greene reported in 1764, "We met with a person who had keys of those places which were not public, and he conducted us through them all."[1] YC and DK-G

French, after 1774

Of the many rules established for the guards at Versailles, these were intended for the sentinels at the entrance to the apartment of Marie Antoinette:

> The sentinel for the Queen's apartment will not let any unknown priest or monk enter without a pass from the Captain; even with a pass from the Captain, he will not let them enter during the Grand Couvert without express order.
>
> He will not let pass any stranger or person with unhealthy complexion or with fresh smallpox scars.
>
> In the apartment, no sedan chairs will be left other than those of the royal family and of the princes and princesses of blood.
>
> He will not suffer any valet to stay.
>
> The valets of princes and princesses of blood, the knight of honor, the ladies-in-waiting and ladies of the bedchamber, or the Grand Chaplain of the Queen will pass into the antechamber.
>
> He will give admittance to only one servant of a cardinal and minister.

The prohibition of entry to unknown persons, in particular clergymen, was a security measure prompted by the memory of the assassination of Henri III by the monk Jacques Clément on August 1, 1589. Also addressed was the danger of infection by such diseases as smallpox, which claimed the lives of many members of the royal family, including Louis XV in 1774 (Louis XVI and his brothers were inoculated against it that year). The rules were also intended to control the passage of dignitaries' servants and give due consideration to rank. This document is incomplete, and there were probably more rules to be obeyed. EM

117 *The Marais Grove*

French, early 18th century

This somewhat naively rendered painting provides a precise depiction of the Marais Grove as it was between 1685, when it was enclosed with gates for protection against vandalism, and 1704, when André Le Nôtre's original design was remodeled by Jules Hardouin-Mansart.[1] Working from an idea that had probably come from Madame de Montespan, Le Nôtre and the hydraulics engineer Francine designed, between 1670 and 1674, a rectangular area bordered by a trellis fence and a

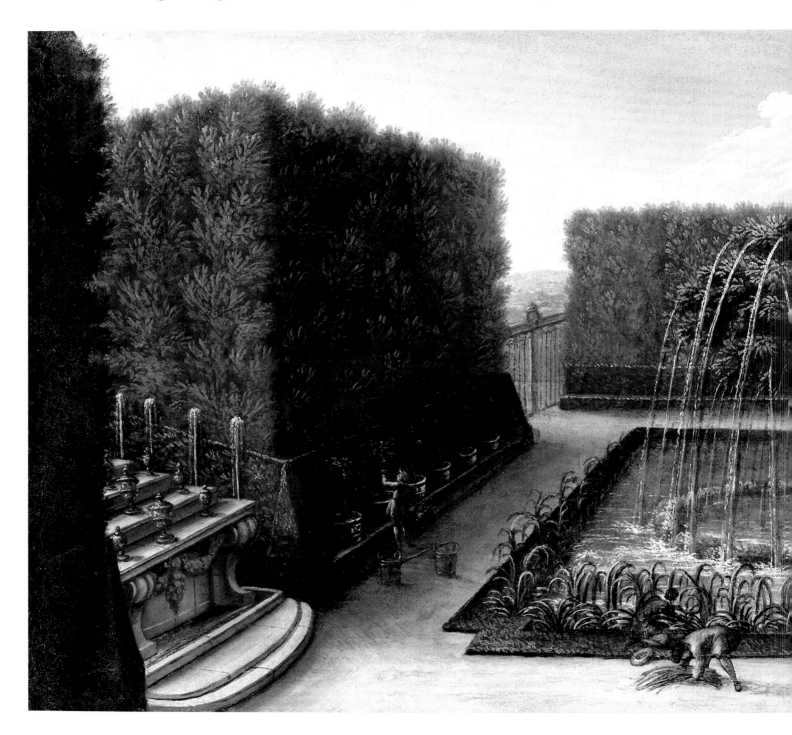

stepped lawn with yew trees. On the sides, there were two red-and-white marble buffets topped with vases and water jets. At the center, a green oak made of bronze, its branches spraying water, was placed in the middle of a pool decorated with reeds concealing additional spouts of water. The visitors here, in Persian costume, enjoy the tranquility of the place while the gardeners are busy working. BS

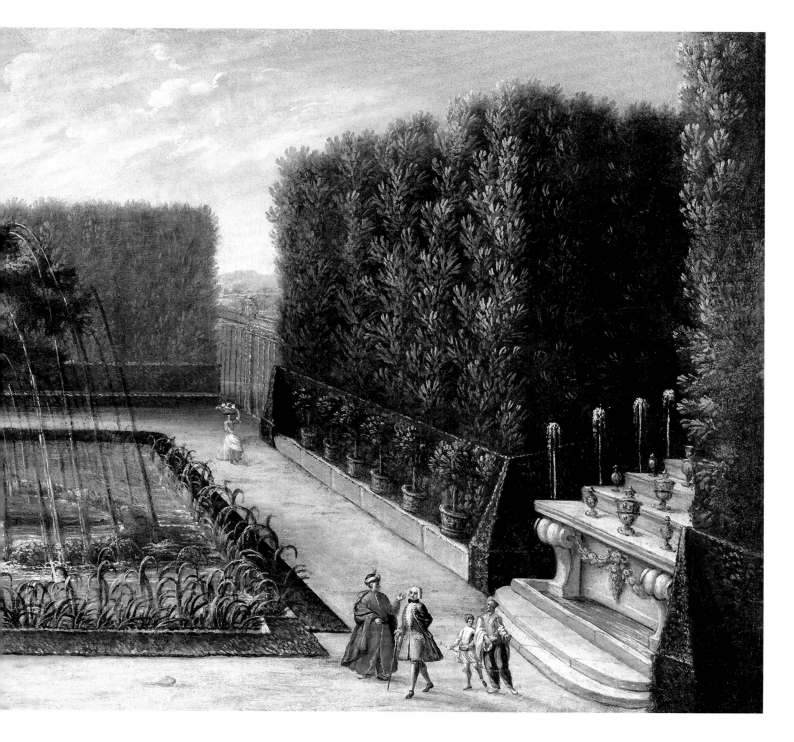

118A, B Pair of Pedestals

André Charles Boulle, ca. 1684

This pair is believed to have been among the nine pedestals Boulle delivered in 1684 to Louis, Grand Dauphin of France, for display in his Cabinet des Glaces (Mirror Cabinet) at Versailles.[1] The stands are decorated with marquetry of tortoisehell, brass, and pewter, for which the cabinetmaker was renowned, and are embellished with gilt-bronze masks. Son and heir of Louis XIV, the Grand Dauphin was a passionate collector of paintings and porcelains, as well as hard stone and rock-crystal objects, which he arranged in several rooms at the palace. Overlooking the gardens, the most precious of these cabinets had mirror glass lining the ceiling compartments, doors, and window recesses.[2] The walls and floor were paneled with marquetry of various woods and metal inlay, also done by Boulle. In his guide to Versailles, Jean Aimar Piganiol de La Force called this room the cabinetmaker's "chef d'oeuvre," while visitors, asked to wear slippers to protect the floor, marveled at the richness of its interior and the splendor of the Grand Dauphin's collections.[3] DK-G

119 Fall-Front Secretary on Stand

Attributed to Adam Weisweiler, 1784

On January 11, 1784, the *marchand mercier* Dominique Daguerre delivered this fall-front secretary on stand to Versailles for the use of Louis XVI. Attributed to Weisweiler, the piece is listed in a 1787 inventory as being in the king's Cabinet Intérieur, to which few visitors would have gained access.[1] The Japanese-lacquer panels with shaped pictorial cartouches decorating the front are about 150 years older than the secretary itself. Cut from the surface of a close stool (chamber pot) dating to about 1640, they testify to the continued appreciation of Japanese lacquer in Europe. The sacrificed close stool, produced for export, may have been in the French royal collections before being made available to Daguerre, who in turn supplied the lacquer panels to the cabinetmaker. The interlaced stretchers and bulbous, downward-tapering legs are characteristic of Weisweiler, and the gilt-bronze mounts on the frieze appear on other pieces by this talented *ébéniste*, who settled in Paris in the late 1770s. DK-G

120 *Henry Swinburne*

Pompeo Batoni, 1779

An inveterate traveler, Swinburne shared his experiences in letters and books. While in France, in April 1774, he went to Versailles, and during the *lever* was presented to Louis XV not long before the latter's death. Having paid his compliments to other members of the royal family that same day, he visited Madame Du Barry in her rooms under the roof of the palace. Although Swinburne found the king's mistress gracious, he did not "think her a pleasing figure now, whatever she may have been."[1] He later toured Spain and Italy, where Batoni painted this beautifully modeled portrait in 1779. Known for his full-length depictions of British aristocrats on the Grand Tour, the artist rendered Swinburne more modestly in a half-length oval composition against a plain background. DK-G

121 *Jeanne Bécu, Comtesse Du Barry, Being Offered a Cup of Coffee by Zamor*

Jean-Baptiste André Gautier Dagoty, ca. 1770

This intimate scene shows Madame Du Barry at her toilette stirring the coffee that Zamor, a young liveried page, has just brought her on a lacquered tray. Seated at her dressing table, the royal mistress is *en déshabillé*, her powdered curls resting on her shoulders. Henry Swinburne saw Madame Du Barry in a similar state when he visited her in her apartment at Versailles on April 30, 1774. He reported climbing "up a dark winding staircase, which I should have suspected would have led to an apartment of the Bastile, rather than to the temple of love and elegance. In a low entresol we found the favourite sultana in her morning gown . . . and her hair undressed."[1] DK-G

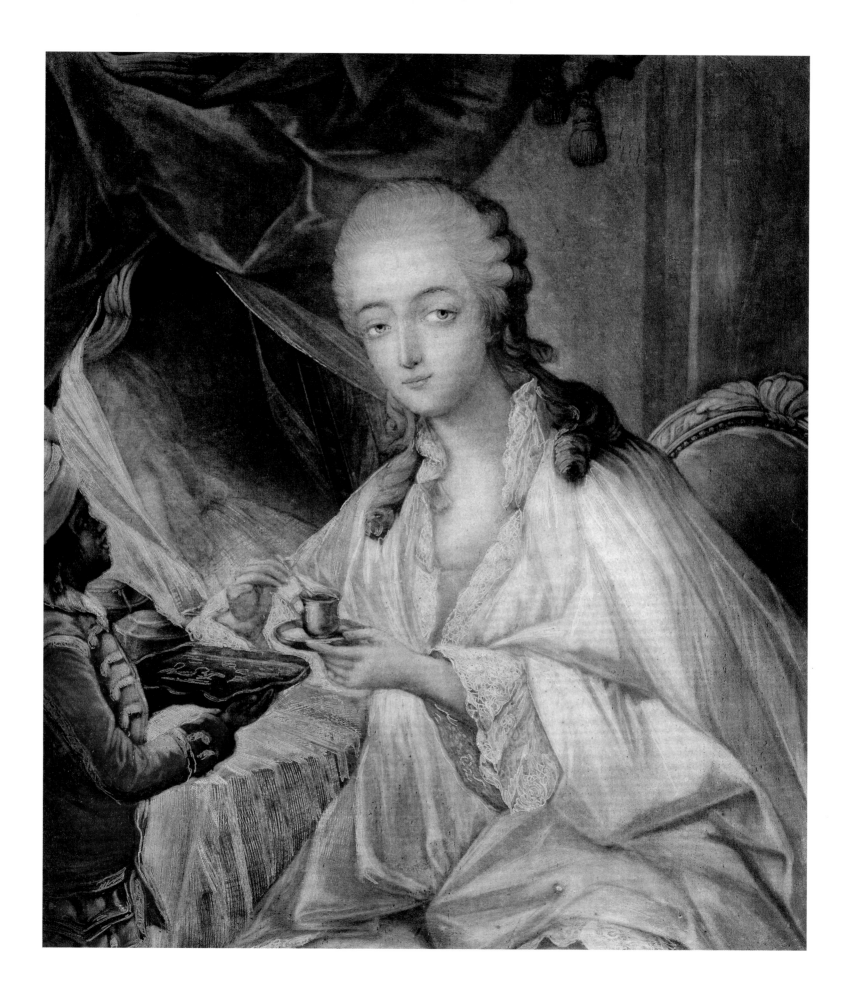

122 Side Chair (*chaise à châssis*)
Louis Delanois, 1769

123 Barometer and Thermometer
Works by Claude Siméon Passement, 1769

124 Writing Desk (*bonheur-du-jour*)
Attributed to Martin Carlin, 1768

On May 16, 1770, the Duchess of Northumberland noted in her diary that Madame Du Barry "is lodged in parts of the Kings apartment in the Attic."[1] The previous year, the royal mistress had moved into these rooms, which were largely furnished with richly carved pieces commissioned from Delanois. Much of this furniture was of a *"nouvelle composition,"* according to the bills submitted by the *menuisier* (joiner).[2] The innovative design of the seat furniture in the Salon de Compagnie, for instance, featured a medallion-shaped back that was to become a quintessential characteristic of Neoclassical chairs.

A discerning patron of the arts, the king's favorite also had a penchant for porcelain-mounted furniture supplied by the *marchand mercier* Simon Philippe Poirier, including in 1768 this small stepped writing desk (*bonheur-du-jour*). A desk recorded as being in her cabinet at Versailles may well have been this one, given the date of its porcelain.[3] The scenes painted on the Sèvres plaques of the barometer and thermometer, from the same room, were inspired by a rare astronomical event. On June 3, 1769, at the Château de Saint-Hubert, the court observed the transit of Venus across the sun, and, in a public display of favor, Louis XV himself explained the phenomenon to Madame Du Barry. Later that same year, she bought this instrument as a souvenir of her triumph. Henry Swinburne (cat. 120) may have seen these luxurious furnishings on April 30, 1774, when he visited Madame Du Barry in her rooms at Versailles, where she remained until just days before the king's death, on May 10. DK-G

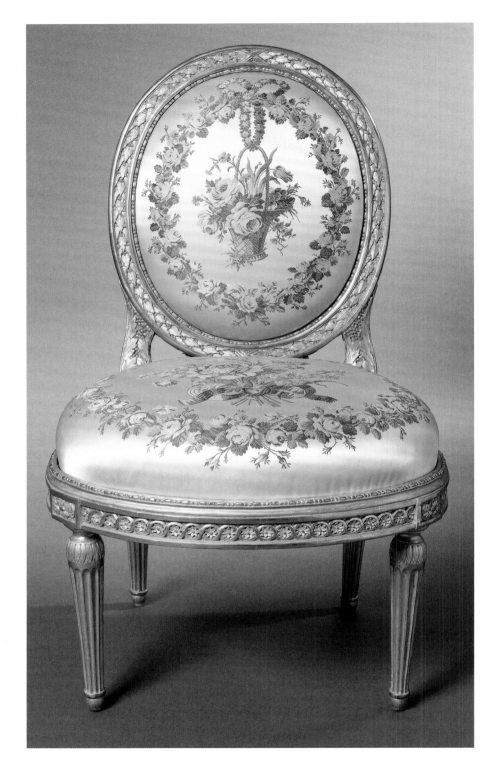

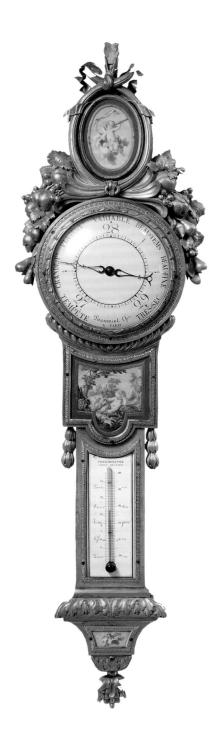

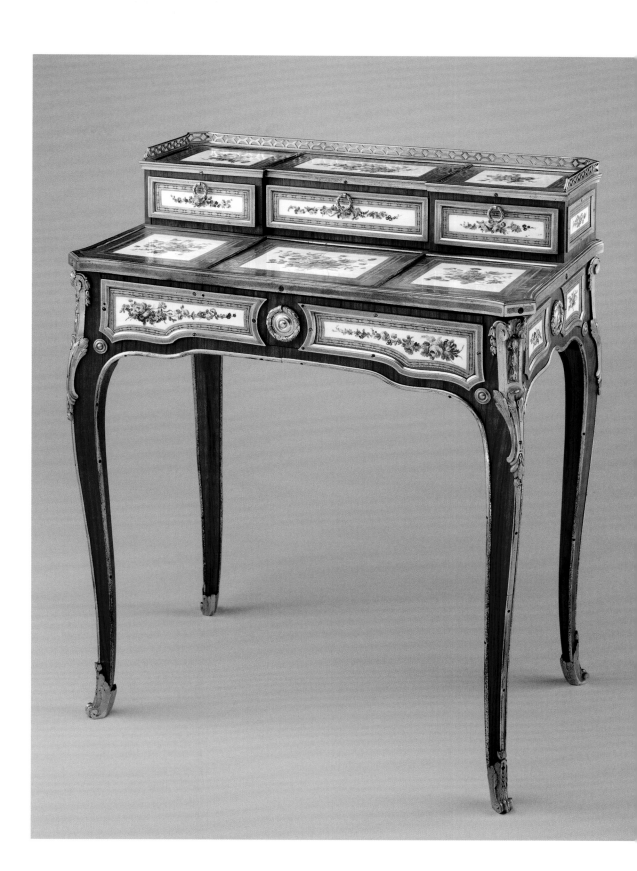

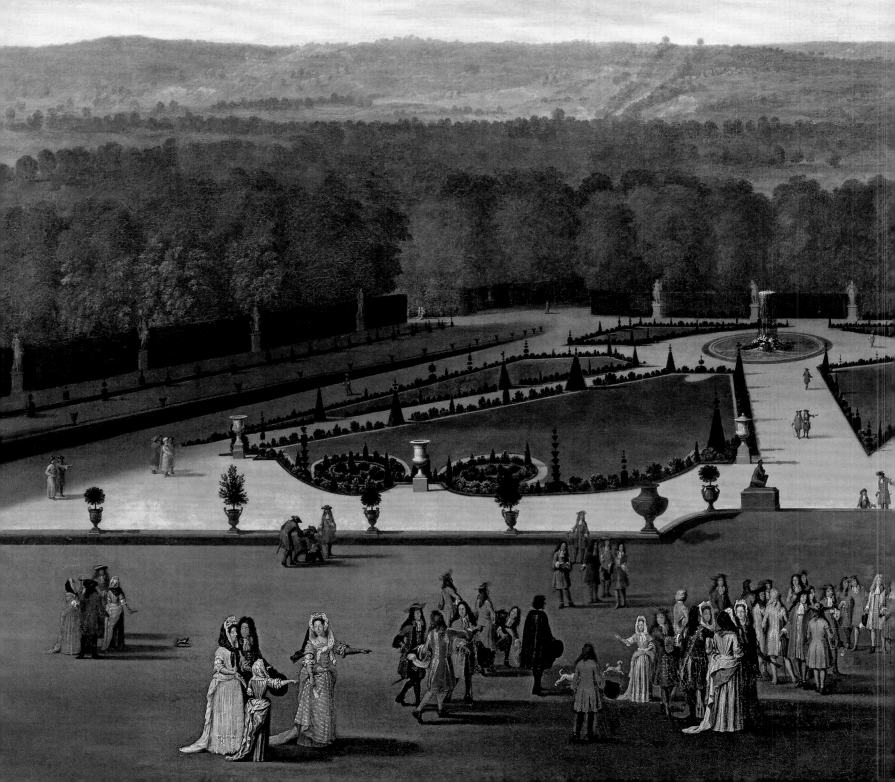

TOURISTS, SOUVENIRS, AND GUIDEBOOKS

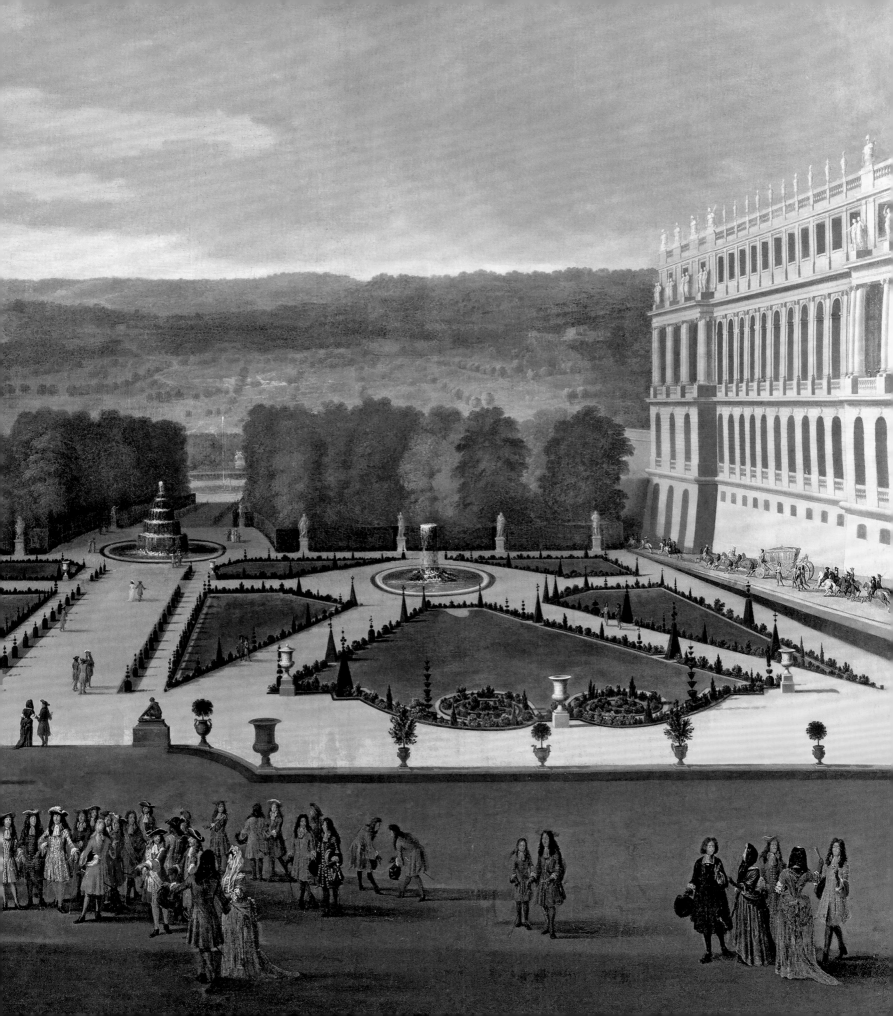

GRAND TOURISTS
Noble Visitors to the Court of the French Kings

JEAN BOUTIER

Even before 1682, when Louis XIV made Versailles his permanent residence, the palace, its gardens, Orangerie, Menagerie, and park attracted visitors in droves, from French subjects coming to seek favors, to Parisians on Sunday outings with their families, to travelers from every part of Europe. Among the latter were young nobles completing their education with a "tour of the courts of Europe,"[1] the famous Grand Tour, of which Versailles was a choice destination. Only a few of these visitors expected to be received by the king, but even fewer passed up the opportunity to be close to one of the most powerful monarchs of Europe.

Crowds of Curiosity Seekers

According to a popular guidebook of 1716, Versailles "is the worthiest object of your curiosity. All the splendors of Nature & Art shine there on all sides."[2] Curiosity, which the writer Antoine Furetière called "the passion to see and learn new, secret, rare, & curious things," could be piqued by the reading of guidebooks and travel accounts.[3] Like many others before him, the British physician John Moore described this "passion" in 1779 as uncontrollable: the French "flock to Versailles every Sunday, behold [the king] with unsated curiosity, and gaze on him with as much satisfaction the twentieth time as the first."[4] This frenzy was manifest as soon as one left Paris, as vehicles on the road to the palace jockeyed to pass each other and arrive there first. The German novelist Sophie von La Roche noted on Sunday, May 17, 1785, "Today, more than a thousand Parisians went to Versailles."[5] She was amazed at the crowds, which did not diminish on weekdays. Joachim Christoph Nemeitz, a German gentleman who accompanied many young noblemen from his country as Hofmeister (tutor) during their *Kavalierstour*, wrote of the road between Paris and Versailles, "I always found many people on this road, either on horseback or in some conveyance, every time I went or came back from there, and this both day and night."[6] (See "Going to Versailles" by Mathieu Da Vinha in this volume.)

For their first visit, travelers usually followed an itinerary that was well described in the travel literature. It was on the Avenue de Paris that they caught their first glimpse of the palace in the distance. Upon reaching the Place d'Armes, they would stop briefly at an inn and then continue

Fig. 76. Louis Nicolas de Lespinasse, called the Chevalier de Lespinasse, *The Château de Versailles Seen from the Gardens*, 1779. Pen and black ink, watercolor heightened with white gouache over traces of graphite, 8⅛ × 11⅞ in. (20.4 × 30.4 cm). The Metropolitan Museum of Art, New York, Bequest of Susan Dwight Bliss, 1966 (67.55.20)

toward the gilded wrought-iron gates. According to the Irish travel writer Thomas Nugent, the tour could begin with the chapel, "an exceeding fine piece of architecture," which was finished about 1710. After visitors crossed the last courtyard, paved in black-and-white marble, they came to the Grand Appartement with its "large triple row of rooms, all very magnificent," which led to the War Salon through a series of rooms full of antiquities, gems, medals, and paintings by French and Italian masters (see figs. 7, 15).[7] There, they discovered the Hall of Mirrors, which, according to La Roche, was filled on Sundays with the "hum of hundreds of people speaking in low voices."[8] Next came the queen's chambers, then those of the king, the crown

prince, and the rest of the royal family, described by Nugent as a series of "chambers, cabinets, halls, &c. laid out with a great deal of art to render them more commodious."[9] Afterward visitors could discover the gardens and park, which spread out as far as the eye could see: "The gardens here facing you are not to be paralleled in Europe, all the beautiful models that Italy or the world affords having been considered in order to render them the most perfect in their kind" (fig. 76).[10] Nemeitz declared that it required more than a day to "consider all that is rare and beautiful in this Park."[11]

Travelers were surprised to discover that they could move around freely. Versailles was open to everyone because the French monarchy granted

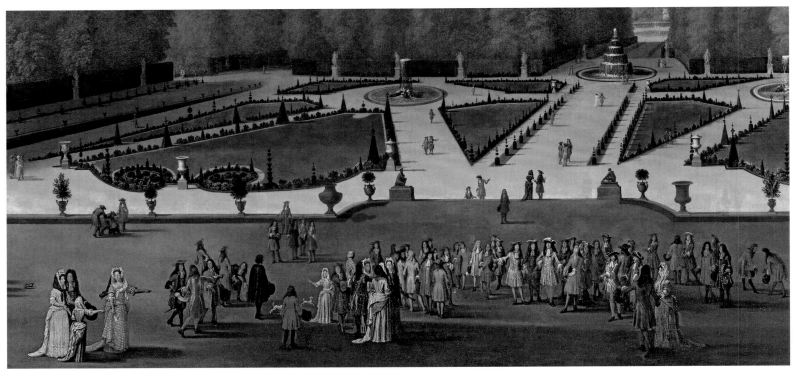

Fig. 77. Etienne Allegrain, *Promenade of Louis XIV in Front of the North Parterre* (detail of cat. 127), ca. 1688. Oil on canvas, 92⅛ × 9 ft. 8½ in. (234 × 296.5 cm). Musée National des Châteaux de Versailles et de Trianon (MV 752)

its subjects free access to their sovereign and his residence. As the duc de Luynes noted:

> During the trip to Marly, we were all astonished to see in the château a nobleman who was unknown to us; it was a lord from the land of Holstein who, having come to see Marly, walked into the gardens, thinking that he could do this without further ado and as freely as at Versailles. He came up to the château and was about to enter the salon, when the Swiss Guards [les Suisses] stopped him. . . . Since he was a person of good will and had trespassed only because he had not been forewarned, we allowed him to stay in the salon during the King's supper, and after the supper to stay in one of the smaller salons to glimpse the large one.[12]

Indeed, as Nemeitz pointed out, at Versailles the gardens and park were open to everyone day and night, "when and as much as one wants," and this without "consideration of sex, age, or condition," unless "the king was taking a stroll, and only his retinue was allowed to enter" (fig. 77; cat. 127).[13]

Once inside the palace, visitors could gain access to the Hall of Mirrors and adjacent rooms, but only if, as La Roche noted, they were "properly dressed." In those areas "everyone [can] see the king, his family, and the court on their way to church."[14] On the occasion of major ceremonies, such as the August 1739 wedding of Louise Elisabeth, Louis XV's eldest daughter, the king could even decide to show the Hall of Mirrors and apartments illuminated in the evening: "Everyone but commoners was allowed to enter. The Swiss Guards stationed in the apartments had the task of letting people in and out."[15]

Despite these liberties, visitors did not have complete freedom of movement at Versailles. Access to the palace was regulated: the gates to the courtyard were closed in the evening and

reopened in the morning. The Swiss Guards blocked access whenever a visitor wished to go where the king conducted his everyday life and affairs. For that, the young nobleman had to make use of his connections. He could turn to the First Gentleman of the King's Chamber, to the First Master of Ceremonies, to the Introducer of Ambassadors, to an officer of the guard, or even to one of the chaplains: these were the people who could get him a good place at an official ceremony.[16] A Grand Tourist never traveled without letters of recommendation, which he could use to convince an important courtier to present him to the king or to a member of the royal house. Otherwise, the visitor would have to resort to some daring. Nemeitz suggested, for instance, "staying in the Galerie or some Antechamber until one of the Princes or some other Lord came by. These persons are usually followed by a large retinue, and so one can sneak into this party and gain entry with them in this way." The Hofmeister added some practical advice to ensure success: "One just has to pass boldly with the retinue, without worrying about a thing. And if by chance one were recognized by the Guard, and he knows that one does not belong to the retinue, then there is enough time to say that one is a foreigner and that one would like to be among the spectators of the solemnity, in which case it can happen that one of the Cavaliers there takes your side and defense against an uncouth Guard."[17]

A Stage of the Grand Tour

How could a young nobleman on his Grand Tour agree to be among those "frivolous, futile people, who make at least three parts in four of mankind, [who] only desire to see and hear what their frivolous and futile precursors have seen and heard: as . . . Notre Dame, Versailles, the French King, and the French Comedy, in France"?[18] For Philip Dormer Stanhope, 4th Earl of Chesterfield (fig. 78), the author of this comment, someone who traveled through Europe to complete his education

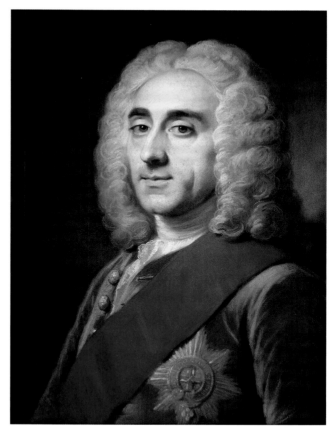

Fig. 78. William Hoare, *Philip Dormer Stanhope, the 4th Earl of Chesterfield*, ca. 1730–73. Pastel, 24 × 18 in. (60.9 × 45.7 cm). Victoria and Albert Museum, London, Presented by The National Art Collections Fund (P.11-1943)

with a view to a career in the higher spheres of politics or diplomacy could not be satisfied with such simple tourism from court to court. As Nugent recalled, "that noble and ancient custom of travelling" must above all serve to "enrich the mind with knowledge, to rectify the judgment, to compose the outward manners, and to form the complete gentleman."[19] In order to educate himself, therefore, the Grand Tourist owed it to himself to experience the everyday life of the court as a means of acquiring the science of government and the art of conducting oneself.[20]

Versailles was the ideal place for this kind of apprenticeship. As Antonio Farnese, brother of the Duke of Parma, noted during his European tour of 1697–1701, "The court is Europe's leading one,

not only because of the great numbers of princes and lords, but because of its magnificence, its affluence, and its license."[21] Living at such a court implied being able to master the strict rules of French etiquette. In progressing from one court to another, the Grand Tour made a gradual initiation possible. Upon leaving Tuscany in October 1695, Lorenzo Strozzi, a young nobleman from Florence, was advised to begin with the German courts, such as Munich, Dresden, Leipzig, and Berlin, "which are less fine, and where everywhere they seek to imitate, if not French conduct, at least French fashion." Vienna was seen as a first test, before taking on the court of the "most civilized and most beautiful country."[22] Versailles therefore marked the culmination of the educational trip that would transform the young nobleman into a "complete gentleman."

At the peak of his notable political career, Lord Chesterfield, who had been personally introduced to Louis XV in 1741,[23] meticulously planned the Grand Tour of his son Philip, from the summer of 1746 to early 1753.[24] He regarded courts as a central concern, for it was there that one learned "politeness and manners," where "clashing views, jarring opinions, and cordial hatreds, are softened and kept within decent bounds." Writing from London, Chesterfield never stopped insisting, "Frequent, observe, and learn courts." After visiting Dresden, Berlin, Vienna, Rome, and Naples, Philip was finally prepared for the French court. Once in Paris, where he stayed from December 1750 until May 1752, his father badgered him: "Are you often at Versailles? . . . The good breeding *de la ville et de la cour* are different; but without deciding which is intrinsically the best, that of the court is, without doubt, the most necessary for you, who are to live, to grow, and to rise in courts."[25] A few weeks later, he urged his son further, "Go and stay sometimes at Versailles for three or four days, where you will [feel at home] in the best families. . . . Go to the King's and the Dauphin's levees, and distinguish yourself from the rest of your countrymen, who, I

dare say, never go there when they can help it."[26] In another letter, Chesterfield noted, "I am very glad you are going to . . . Versailles also, often. It is that interior domestic familiarity with people of fashion, that alone can give you *l'usage du monde, et les manières aisées*."[27] Thus, "an hour at Versailles, Compiègne, or St. Cloud, is now worth more to you, than three hours in your closet with the best books that ever were written."[28]

Chesterfield and Nemeitz both agreed that one had to return to Versailles several times, for very few visitors were lodged at the palace or in the hotels in town. The vast majority resided in Paris. During the five weeks of his stay in the capital (October–November 1723) at the beginning of his Grand Tour, Edward Southwell, son of the Principal Secretary of State of Ireland, went to Versailles three times. Although he was not introduced to the king, he nevertheless met the former regent, Philippe II, duc d'Orléans, and dined with the Secretary of State for Foreign Affairs and the Lord Chancellor.[29]

During their tour of Europe in 1752–55, the young Roman princes Bartolomeo and Lorenzo Corsini spent three months in London, four in Vienna, and more than eight in Paris. Accompanied by the Imperial Ambassador, Count Georg Adam von Starhemberg, they were introduced to the king by the Introducer of Ambassadors, the marquis de Verneuil, on Tuesday, May 7, 1754, at the cabinet door, and then to members of the royal family. After lunching with the Minister of Foreign Affairs, François Dominique Barberie de Saint-Contest, they returned to Paris in the evening. The brothers were back in Versailles on May 20 to make the acquaintance of several courtiers, including the comtesse de Marsan, sister of the cardinal de Soubise; the maréchal de Noailles; comte Alphonse Marie Louis de Saint-Séverin d'Aragon, one of the negotiators of the Congress of Aix-la-Chapelle; and the marquis de Puisieulx, former Secretary of State for Foreign Affairs and ambassador to Naples

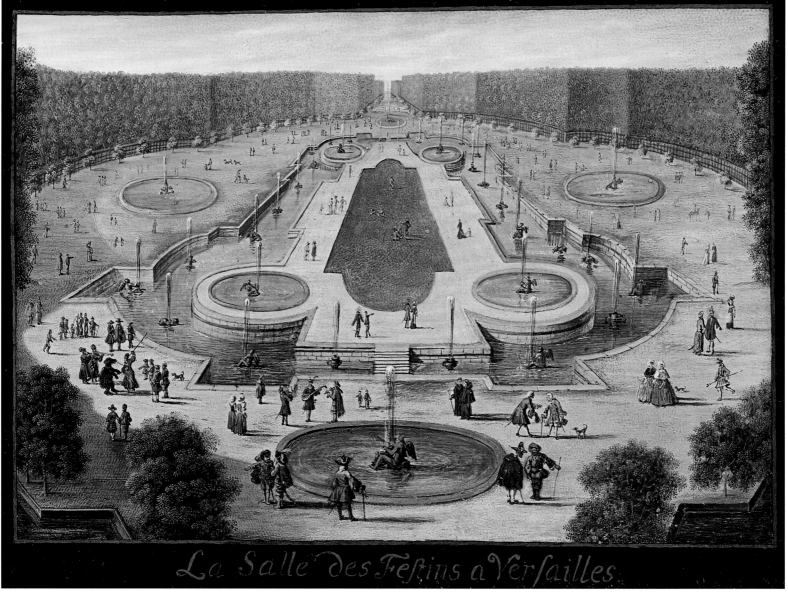

La Salle des Festins à Versailles

Fig. 79. *The Salle des Festins at Versailles*, before 1706. Gouache on vellum with highlights in gold,
4⅞ × 6½ in. (12.5 × 16.5 cm). Musée National des Châteaux de Versailles et de Trianon (INV.DESS 837)

during the pontificate of their uncle Clement XII. This time, they spent the night at an excellent inn. On June 2, Pentecost Sunday, they attended the solemn procession of the Knights of the King's Orders. The Corsinis' visits to the court continued at a rate of one to two per month. On July 2, they went to Marly in the company of the young Prince Friedrich Albrecht von Anhalt-Bernburg, who had benefited from a private audience with Louis XV on April 22,[30] before going to Versailles to visit the gardens, the Menagerie, and the Trianon (fig. 79; cats. 139–141). On August 26, they accompanied the diplomatic corps on the occasion of the birth of the duc de Berry. The princes stopped keeping a regular journal on September 3, but they later mentioned their stay at the court in Fontainebleau in October and left Paris in early January 1755.[31]

The Court of the Princes of Europe

And so thousands of Grand Tourists found their way to Versailles. Most spent a day or two there, visited the palace and its gardens, and occasionally caught sight of the king or a member of the royal family before leaving, either dazzled or disappointed. Some who belonged to the aristocracy were able to come closer to the king and be introduced to him, generally at the door to his cabinet, by their ambassador, the Introducer of Ambassadors (cat. 36), or the First Gentleman of the King's Chamber.[32] This was the case for the two Pamphili princes in 1699; the marquis Parenzi, from Lucca, in 1748; and George William Hervey, Lord Bristol, in 1749.[33] The introduction often took place on Tuesdays, the day on which ambassadors went to pay their respects to the king. When the king went to his cabinet, after the ceremony of the *lever*, the ambassadors introduced the foreigners in a brisk procedure, "His Majesty not being in the habit of talking with foreigners."[34] Only those who, according to the official terminology, "had character," that is, who were sovereign princes or grandees of Spain, like the Roman prince Colonna in January 1747, were entitled to a private audience in the king's cabinet.[35]

Aside from the Introducer of Ambassadors, there were other intermediaries to whom the visitor could turn. During a Grand Tour that took him and his brother to Italy, France, and Great Britain, Prince Johann Georg von Anhalt-Dessau sojourned twice in Paris, from August to November 1766 and from late May 1767 until late January 1768. Although he visited Versailles in the summer of 1766, the prince did not solicit a reception by Louis XV until returning from England. "To this end, I was supposed to address myself to Mr le duc de Choiseul, but it breached etiquette protocol that the duke present someone; and by using the Introducer of Ambassadors, apart from the fact that this means an expenditure of nearly a hundred Louis, it also involved a Grand Ceremony, which the duc de Choiseul

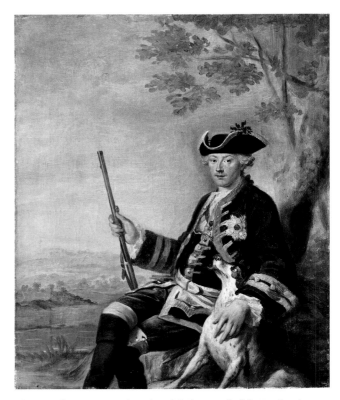

Fig. 80. Johann Georg Ziesenis, *Christian IV of Pfalz-Zweibrücken*, ca. 1757. Oil on canvas, 17¼ × 14⅜ in. (45 × 36.5 cm). Bayerische Staatsgemäldesammlungen, Munich (4435)

advised me to avoid." In the end it was the Imperial Ambassador, comte de Mercy d'Argenteau, who introduced the prince on Tuesday, June 9, 1767. It was a brief meeting: "On being introduced, the King said a few words to the Prince, as did the Queen, a favor that counts for something in this country."[36]

During a private audience, everyone left, including the ministers but not those in the "immediate service of the King's chamber, such as the Grand Chamberlain, the First Gentleman of the Chamber, the Grandmaster of the Wardrobe, etc."[37] The king and the visitor remained standing; after the visitor had spoken a few sentences, usually in French, the king replied just as briefly and accompanied him back to the door, or even to the Queen's Apartment. Only after the farewell audience could the Introducer of Ambas-

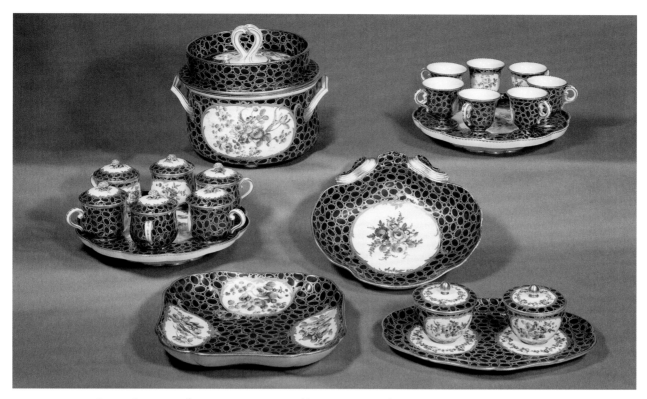

Fig. 81. Sèvres Manufactory, Service presented by Louis XV to Christian VII of Denmark in 1768, 1768–69. Soft-paste porcelain and silver. Christiansborg Palace, Copenhagen

sadors give the visitor presents from the king (see *"Présents du Roy"* by Corinne Thépaut-Cabasset in this volume).[38] The introduction gave foreigners almost the same privileges as the nobles entitled to the honors of the court. In particular, they could accompany the king on the hunt, which took place several times a week, with six horses reserved for them.[39] The prince of Wittenberg thus rode horses from the Small Stable to take part in the chase, and the king gave the Duke of Pfalz-Zweibrücken the uniforms necessary for the stag hunt (fig. 80).[40]

There were very few crowned heads among the visitors of high rank, for they rarely traveled in the eighteenth century. The exceptions included Czar Peter I (1717; fig. 67), Christian VII of Denmark (1768; fig. 81), Emperor Joseph II (1777 and 1781; fig. 68; cats. 94–97)—more of a family visit than an official one, since he visited his sister

Marie Antoinette—and Gustav III of Sweden, who passed through Paris during his second visit on his way back from Italy (1784; cats. 100–111). The list of princes, who all traveled incognito in order to avoid the burden of official protocol (see "Incognito in Versailles" by Volker Barth in this volume), is much longer and ranges from Prince Aleksander Benedykt Sobieski of Poland, who visited Versailles with his younger brother Konstanty Władysław in 1696 (fig. 82), to Clemens Wenceslaus of Saxony, later Elector of Trier (1761) and brother of the Dauphine, the Grand Duke Paul I and Grand Duchess Maria Feodorovna of Russia (1782), and Prince Henry of Prussia (1784; fig. 83; cats. 112, 113).

While the British unquestionably outnumbered the other Grand Tourists, the aristocrats introduced to the king were more often than not German princes on their *Kavalierstour*. The

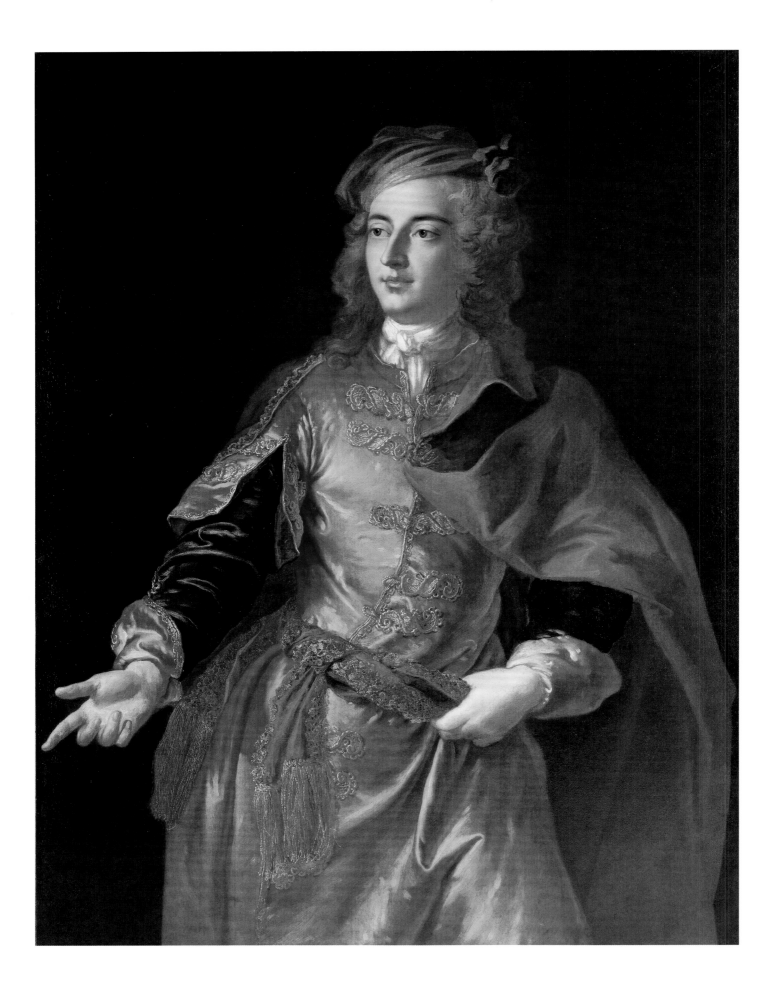

duchesse d'Orléans, Elisabeth Charlotte, had attracted a great many of them during the reign of Louis XIV, and they continued to arrive in the eighteenth century. After an initial visit to a French academy—such as one in Paris attended by the hereditary prince of Saxony-Gotha in 1747, or one at the riding academy in Angers, attended by the two young princes of Württemberg presented to the king in April 1748[41]—these noblemen could become regular guests of the court. The most striking example was Christian IV, Duke of Pfalz-Zweibrücken, who after studying at the University of Leiden was a guest of the king of France for almost a year, from October 1739 until August 1740. Christian later signed a pact of friendship with Louis XV during his stay in Paris in March–June 1751 and bought a town house in the Rue Royale Saint-Roch, then the Rue Saint-Augustin. Under the assumed name comte de Sponheim, he returned in March 1752, January 1753, February 1754, June 1765, and March 1767, always spending most of his time in Versailles.[42] The two sojourns on the way back from Italy (1766 and 1767) of another royal guest—the hereditary Prince of Braunschweig-Wolfenbüttel, later the Duke of Braunschweig-Lüneburg, Karl Wilhelm Ferdinand (fig. 84), husband of Augusta, the daughter of George III of Britain—were prime examples of what was entailed in a true royal hospitality (fig. 85).

Ad Majorem Gloriam Regis Franciae?

In the same way that he had decided to govern alone, without a prime minister, Louis XIV wanted to live in a palace of his own construction. His transformation of a formerly untamed and hostile stretch of land into a unique royal residence fascinated visitors. Even on his first visit, Antonio Farnese recognized this near-divine power: "The

Fig. 82. François de Troy, *Konstanty Władysław Sobieski*, ca. 1696. Oil on canvas, 49⅝ × 37¼ in. (126 × 94.5 cm). Courtesy Galerie Eric Coatalem, Paris

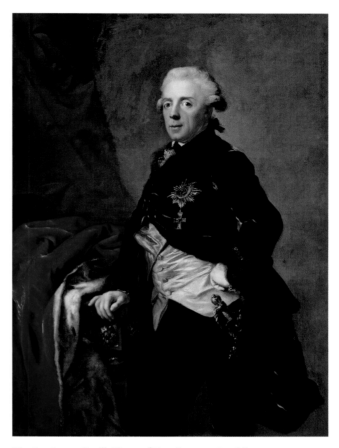

Fig. 83. Anton Graff, *Henry of Prussia*, ca. 1784. Oil on canvas, 53½ × 39 in. (137 × 99 cm). Stiftung Preussische Schlösser und Gärten Berlin-Brandenburg, Berlin-Brandenburg (GK I 30301)

unpromising site accentuates the grandeur of the hand that made it, or better, *created* it." In this, the Italian took up a popular theme that was promulgated by guidebooks and descriptions of the palace starting in the 1670s: "Into a basin crowned by hills, the King has poured treasures. . . . The gold lighting up the entire expanse of ceilings shows off a courtly palace." While Farnese expressed some reservations about the architecture and layout of the buildings, he could not withhold his admiration for their magnificence: "The eye is astounded and the mind grasps the immense expense that was required. Gold, paintings, bronzes, marbles that elsewhere adorn only the most intimate princely rooms here sparkle and embellish even the everyday and ordinary." The Hall of Mirrors

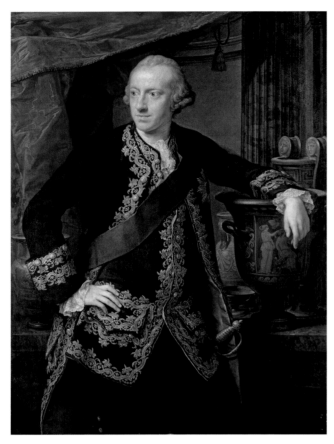

Fig. 84. Pompeo Batoni, *Prince Karl Wilhelm Ferdinand, Later Duke of Braunschweig-Lüneburg*, 1767. Oil on canvas, 53⅞ × 39 in. (137 × 99 cm). Herzog Anton Ulrich Museum, Braunschweig (676)

completely dazzled him: "The hall is majestic in style and graceful, measuring in length 170 or more paces, the width and height proportional. The vault, decorated by Le Brun, famed painter of the French nation, does it justice with scenes of the King's victories. The entire length of one wall is covered by, or rather is made of, crystals that [by] reflecting objects multiply and enlarge them in a trick of the eye."[43]

Throughout the eighteenth century, the trip to Versailles was nearly mandatory for Grand Tourists. Indeed, how could one ignore what a young nobleman of Silesian origin, Georg von Fürst, qualified in 1739 as the "eighth wonder of the world"?[44] Nevertheless, reservations were voiced fairly early on. In 1698 Martin Lister, a

physician from London, opined that "it is without doubt the most magnificent palace in Europe," but he immediately added that the older part "is no longer in today's taste."[45] For a certain Dr. Maihows, who could perceive around 1750 "the spirit of magnificence that characterized Louis XIV," the overabundance of ornament certainly indicated opulence, but to the detriment of taste.[46] Travel accounts and letters gave nearly unanimous approval only to the outer facade, with its vast terrace overlooking the gardens, which was considered "the most imposing thing in the world."[47]

Starting in the 1760s, the gardens also became a target of criticism, especially on the part of British visitors. James St. John, an Irish gentleman who visited France in 1787, found them "squared and angled into the most insipid regularity . . . without being able to produce any thing equal to the romantic charms of rural nature."[48] More generally, the disappointment may have been the inevitable result of unmet expectations arising from the avid consultation of guidebooks and engravings. St. John, for one, confessed, "I had learned such great ideas of Versailles, that I was very much disappointed when I saw it."[49] For others, the palace had lost its splendor over the course of time: even the Grand Couvert of the king and his family was held in a "very dirty, [and] tattered room."[50]

The court itself inspired contrasting reactions. After pointing out that the etiquette of the French court was not friendly to foreign princes, the Baroness d'Oberkirch, a friend of the Grand Duchess of Russia, reported that Grand Duke Paul, who attended the procession of the Knights of the King's Orders on Pentecost Sunday of 1782, "returned enthusiastic about the magnificence of Versailles, the costumes, the elegance of the clothing, and especially the beauty of the queen."[51] At the opposite end of the social scale, visiting German burghers often found such ceremonies quite futile, and the palace itself an expensive waste.[52]

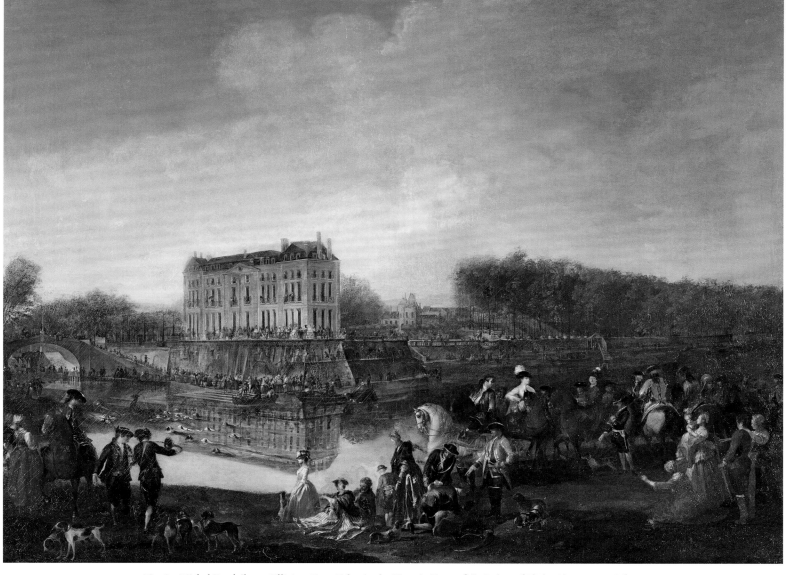

Fig. 85. Michel Barthélemy Ollivier, *Deer Taken in the Water in Front of the Palace of L'Isle-Adam*, 1777. Oil on canvas, 38½ × 51¼ in. (97.7 × 130 cm). Musée National des Châteaux de Versailles et de Trianon (MV 3822)

While the Revolution emptied the palace, it did not put an end to the flow of visitors. However, Versailles now inspired reflections on "the vicissitudes of human affairs, the vanity of grandeur." One visitor in 1798, a German lawyer from Hamburg who had been there earlier in 1784, witnessed the "painful spectacle of total destruction" everywhere. Yet he also discovered, not without surprise, that the palace may well have "gained more beauty and brilliance" and now housed a museum of painting and sculpture that surpassed the Grande Galerie of the Louvre in its arrangement.[53] The transformation had already taken place: within a few years, the palace of Versailles, which was never again to know the "dazzling brilliance of the court,"[54] had become a French monument and, much later, one of the historian Pierre Nora's "sites of memory."

VISITORS' GUIDEBOOKS AND ENGRAVINGS

ELISABETH MAISONNIER

Between 1672 and 1791, nearly thirty known titles were published (in at least 120 editions, both French and foreign) that served as guidebooks to or gave descriptions of Versailles, whether specifically devoted to the château or included in books about France or Paris and its environs.[1] Many other such descriptions appear in historical and geographical dictionaries, guides to Paris, and even in textbooks of English grammar. Taken together, these guidebooks and the engravings that supplement them serve as primary sources for the history of the palace, while the manuals constitute a literary genre in their own right that displays certain general characteristics and adheres to certain rules.

Travel guides discussing the "antiquities" of specific cities or regions have existed since the Middle Ages.[2] Before 1682, when Louis XIV made Versailles the seat of his government, they had mentioned the palace only briefly; afterward, the site became the object of particular descriptions, a rarity in Europe.[3] The first descriptions of Versailles, part of an official project conceived by the entourage of Jean-Baptiste Colbert, took the form of large volumes with commissioned texts and engravings. Colbert created the Petite Académie in February 1663 and tasked its members—which included Charles Perrault, the writer Jean Chapelain, the erudite clergymen Amable de Bourzeis and Jacques Cassagne, and the translator François Charpentier—to compose the emblems, medallions, and captions for the allegorical works presented.

Many of the texts for this project were written by André Félibien (fig. 86), who was granted a patent in 1666 as Historiographer of the King and His Buildings, Arts, and Manufactories in France. Félibien divided his time as a writer between his books on painters and architecture and the publications about Versailles. After an account of the Grotto of Thetis, he published his first *Description sommaire du chasteau de Versailles* in 1674 (fig. 87).[4] The latter was expanded in 1685 and 1687, then integrated into more general publications in 1689 and 1696.[5] Although presented as a tour, the *Description* was meant to be read more than to be followed, to elucidate a decor that was above all allegorical and had to be explained by mythology or history. While it could guide the visitor in situ, it also permitted the reader to

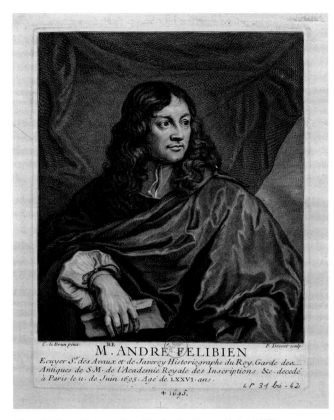

Fig. 86. Pierre Drevet after Charles Le Brun, *André Félibien*, 1695–1700. Engraving, 10¼ × 8 in. (27.3 × 20.4 cm). Musée National des Châteaux de Versailles et de Trianon (LP31 bis.62.1)

Fig. 87. Title page from *Description sommaire du chasteau de Versailles*, by André Félibien. Paris: Guillaume Desprez, 1674. 6⅛ × 3¾ in. (15.6 × 9.5 cm). Musée National des Châteaux de Versailles et de Trianon (GR 61.1)

form an idea of the place that would eventually be completed by a visit.[6]

The 1685 edition of the *Description* mentioned neither the Grotto, the Labyrinth, nor the Grande Galerie (Hall of Mirrors, finished in 1685). However, the Grande Galerie was the subject of six descriptions between 1682 and 1691. Articles in the *Mercure galant* in 1682 and 1684[7] were supplemented by four editions entitled *Explication des tableaux de la galerie de Versailles*, written "by special order of his Majesty." Three of these were issued by members of the Petite Académie—one by Charpentier (1684), which was meant to be read in the hall itself,[8] and two by Pierre Rainssant,

director of the Cabinet des Médailles (1687 and 1691)—while the fourth was published by an anonymous author (1688).[9] The itinerary given in the *Mercure* articles started with the War Salon, then led to the middle of the gallery, with the inaugural scene of Louis XIV's reign. The general meaning of the decor of Charles Le Brun's ceiling could not be clearly discerned, however, since no historical interpretation of the whole, no connections between the paintings of the "grande série" and the "petite série," were offered.[10]

Although Félibien's *Description* is not illustrated, he regarded his text as inseparable from images: "Printing and engraving . . . are two marvelous

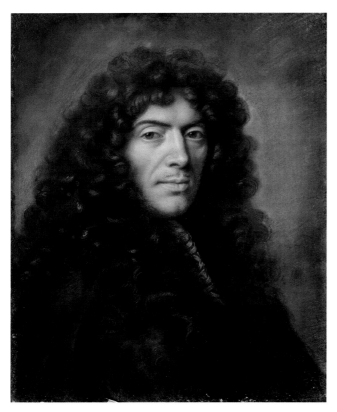

Fig. 88. Charles Le Brun, *Israël Silvestre*, ca. 1670. Pastel, 22 × 16⅞ in. (56 × 43 cm). Musée des Beaux-Arts, Reims (980.5.1/280.5)

Fig. 89. Title page from *Labyrinte de Versailles*, engraved and written by Nicolaes Visscher. Amsterdam, ca. 1720. 8¼ × 6½ in. (21 × 16.5 cm). Musée National des Châteaux de Versailles et de Trianon (GR 184)

means for indefinitely multiplying a discourse and show[ing] the image of the same thing in different places."[11] A vast series of nearly a thousand engravings, designed to publicize the great works of Louis XIV's reign, was assembled in the Cabinet du Roi.[12] The first of these, commissioned from Israël Silvestre (fig. 88) and François Chauveau in 1663 to commemorate the carousel given to Paris on the occasion of the Dauphin's birth, was published in 1670. These were followed by several collections: *Description de la Grotte de Versailles*, with engravings by Jean Le Pautre (1672);[13] *Les plaisirs de l'isle enchantée,* with engravings by Silvestre (1673);[14] *Les divertissemens de Versailles*, engraved by Le Pautre (1676);[15] *Labyrinte de Versailles*, engraved by Sébastien Leclerc the Elder (1677);[16] and *Tableaux du Cabinet du Roy,* engraved by Gilles Rousselet and others, combined

with *Statuës et bustes antiques des maisons royales*, engraved by Gérard Edelinck and Claude Mellan (1677).[17] Various views of the palace, gardens, and fountains of Versailles, entrusted to Silvestre, Jean Marot, Adam Frans van der Meulen, and Gérard Audran, were also available starting in 1676.[18]

For all their excellent quality, these prints were sold at a reasonable price, from six to ten sols per sheet.[19] The print runs of fifteen to eighteen hundred copies for each plate were considerable. As early as 1670, Perrault realized that collections of these engravings with fine morocco leather bindings stamped with the royal coat of arms could serve as royal gifts.[20] Ambassadors were given the task of offering these volumes at the European courts and even as far away as Persia, Siam, and China, so that "all the nations can admire the sumptuous edifices that the king is having built on all sides."[21]

In December 1667, a decree of the Council of State forbade all engravers and printers other than those chosen and named by Colbert to engrave and print the "floor plans and elevations of the Royal Houses, the decorations in painting or sculpture that are inside them, the pictures and figures that are in His Majesty's Cabinet or elsewhere."[22] However, starting in 1678, the process of granting patents at the expense of the State became too costly. It was replaced by a commercial system that gave the Crown the ownership of the plates and the right to reserve several hundred prints; the others were sold by merchants of books and prints in France and abroad.

The engravings of the Cabinet du Roi were widely circulated, and there were almost as many pirated editions and copies as originals. Johann Ulrich Kraus in Augsburg specialized in the engraving and publication of several emblem books (in French and German) devoted to Versailles.[23] In Amsterdam in 1682, Nicolaes Visscher published his engravings of the Labyrinth in a four-language edition (French, English, German, and Dutch) (fig. 89)[24] as well as 141 views of the castles and gardens of Versailles, "engraved from life" by the Dutch Willem Swidde.[25]

Certain engravers in France benefited from royal patents. The father and son Gabriel and Adam Perelle were both official engravers, the former Director of the Plans and Maps of the Cabinet du Roi, and the latter Engraver to the King. Their *Vues des maisons royales de France*, illustrating forty "Views of the nicest places in Versailles," were published individually about 1670 and then assembled into a collection in 1690. The draftsman, engraver, and publisher Pierre Aveline obtained a ten-year patent in 1685 to reproduce views of the royal houses. Around 1715, a patent authorized "Gilles Demortain, painter and print-seller in Paris to have printed, sold, and distributed everywhere" the *Plans, profils, et elevations, des ville, et château de Versailles* (fig. 90).[26] Later, in 1728, the draftsman Jacques Rigaud obtained a

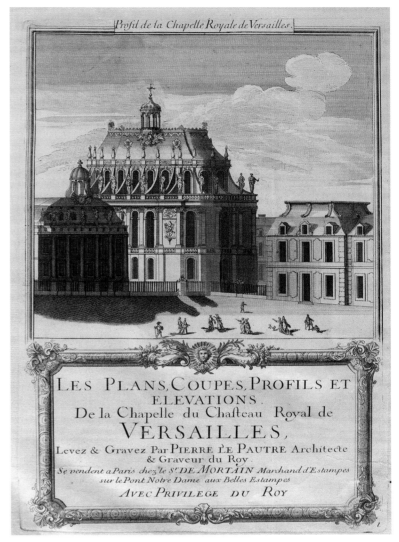

Fig. 90. "Plans, Sections, Profiles, and Elevations of the Royal Chapel at Versailles," included in *Les plans, profils, et elevations, des ville, et château de Versailles*. Paris: Demortain, 1716. 13¼ × 8⅞ in. (33.7 × 22.6 cm). Musée National des Châteaux Versailles et de Trianon (INV.GRAV 318)

royal patent for views of the palace, castles, and royal houses of Versailles; the twenty-three drawings he executed on-site in 1740–50 feature the "most remarkable parts of the gardens" (fig. 91).[27]

Prints and plans of Versailles, either original or simply copied and "arranged," were widely distributed throughout Europe. A volume titled *Perspectives de Versailles*, for instance, appears in a 1724 portrait of Conrad Detlev, Count von Dehn,

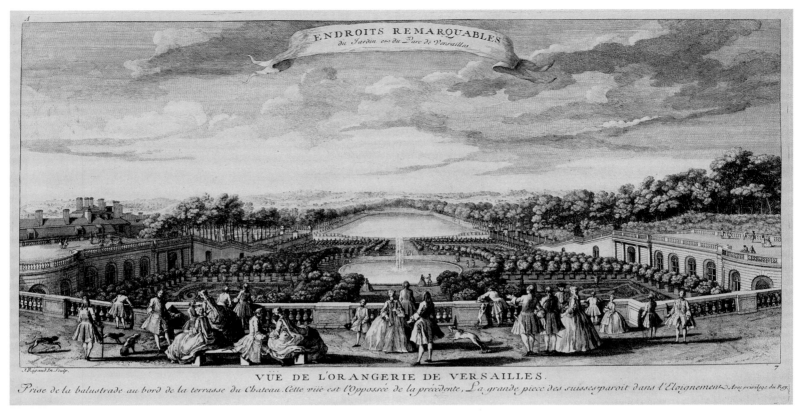

VÜE DE L'ORANGERIE DE VERSAILLES.
Prise de la balustrade au bord de la terrasse du Chateau. Cette vüe est l'Opposée de la précédente. La grande piece des suisses paroit dans l'Eloignement. Avec privilege du Roy.

Fig. 91. Jacques Rigaud, "View of the Orangerie of Versailles," plate 7 of *Endroits remarquables du jardin et du parc de Versailles*, in *Recueil choisi des plus belles vues des palais, châteaux et maisons royales de Paris et des environs*. Paris: Joubert et Basan, 1740–52. Engraving, 9⅞ × 18⅞ in. (25 × 48 cm). Musée National des Châteaux de Versailles et de Trianon (GR 150.30)

envoy of the Duke of Braunschweig-Wolfenbüttel to France (cat. 51). The popularity of these collections is also reflected in a French-English dictionary published in 1776. After the author gives the French definitions of the word "view" (*vue, aspect, perspective*), he states that the word "is also said of a picture or a print that represents a view" and gives as an example, "He has bought a collection of the views of the castle of Versailles."[28]

Hand-tinted prints known as optical views (*vues d'optique*), the widespread and colorful descendants of the Italian *vedute*, allowed for a broad and entertaining distribution thanks to the optical box, which included captions in French as well as in English, German, and Italian for international sale (cat. 161). Among such views were John Bowles's thirty engraved plates "Drawn on the Spot by the Order & with the Approbation of the French King" in *Versailles Illustrated* (fig. 92);[29] those

of Versailles done after Perelle by the German engravers Matthias Diesel and Jeremias Wolff; the volume of thirty-nine engravings devoted to Versailles in the *Galerie agreable du monde* (1729);[30] and George Bickham the Elder's engravings of the Labyrinth "From the Paris Edition," inserted in Daniel Bellamy's *Ethic Amusements* (1768), a collection of moral fables and reflections.[31]

Views of the groves, facades, chapel, and Trianon were the most popular. While the aesthetic quality, depiction of perspective and scale, and precision of line varied considerably from one print to the next, the overall effect was to make the palace of Versailles immediately identifiable. The visitor was therefore able to "recognize" the place he was discovering, as a Dutch traveler did, exclaiming, "It's the Trianon! It looks just like the engraving we have of it!"[32] The guidebooks themselves had to contain illustrations, and marks

Fig. 92. Title page from *Versailles Illustrated, or Divers Views of the Several Parts of the Royal Palace of Versailles*, by John Bowles. London, 1726. 8⅛ × 11⅜ in. (20.6 × 28.9 cm). Musée National des Châteaux de Versailles et de Trianon (GR 111)

intended for the bookbinder, permitting the prints to be inserted in the correct chapters, attest to their crucial role.

The tourist guide genre, developing gradually during the eighteenth century, combined simple architectural descriptions with an actual itinerary, sometimes accompanied by practical instructions.[33] For Versailles these works emphasized the architecture, the painted ceilings, and the paintings in the royal collection. The presentation of the gardens, almost always a must, could be twice as long as that of the palace. Most authors adopted the genre of the topographical description, integrating Versailles into a larger whole that included the other royal residences, Paris and its environs, France, and occasionally even Europe. Few took a didactic approach, such as that of a dictionary.[34]

Except for the official publications, which were issued by the Imprimerie Royale or the patent-holders Antoine Villette (or Vilette) and Sébastien Marbre-Cramoisy, the guidebooks were published by printer-booksellers such as Nicolas Legras, François Muguet, Claude Marin Saugrain, and Pierre Blaizot or by associations specializing in this type of publication. The authors were men of letters, historians, geographers, journalists, and

sometimes the booksellers themselves. As with the engravings, there were also pirated editions, which bore witness to the value of certain titles and contributed to their fame.

One of the best-known guidebooks to Versailles was the work of Jean Aimar Piganiol de La Force, a geographer, journalist, and historiographer entrusted with writing a history of the kingdom. His *Nouvelle description des chasteaux et parcs de Versailles et de Marly* was published in 1701 (fig. 93).[35] He also devoted a long chapter to Versailles in his *Nouvelle description de la France,* which was based on historical sources and observations he had made during his many travels in France.[36] Piganiol's characteristic feature in the 1701 publication was precision, often verging on pedantry. He gave details of everything, including the iconography of the ceilings, the statues, the paintings in Louis XIV's collection, and their creators. He described the project for the chapel (still at the sketching stage in 1701) down to its measurements, which he took himself. Piganiol aimed to correct erroneous interpretations and the mistakes of "certain authors who probably did not know how to read" or were "poorly educated."[37] Thus, regarding the statue of Diana in the Hall of Mirrors, Piganiol wrote indignantly, "I cannot forgive [Félibien des Avaux] for having baldly stated that it was the famous Diana of Ephesus."[38] The numerous and sometimes long digressions were defended by the author: "I do not think that I am going off topic if I report here, as briefly as I can, what the ancients and the moderns thought."[39]

Piganiol's precise, well-documented guide to Versailles went through nine successive editions until 1764.[40] Joachim Christoph Nemeitz, a German lawyer and author, referred to it in 1718 as a work that "our traveler must have read closely before going to that place, in order to see it as it should be seen."[41] The author of the *Gentleman's Guide in His Tour through France,* published in London in 1770, considered it an indispensable acquisition.[42] At the end of Louis XV's reign in 1774, it was still widely used. The painter Louis Jean Jacques Durameau, Keeper of the Pictures of the King at the Surintendance starting in 1784, used Piganiol's descriptions of the apartments, sometimes word for word, as a reference when he drew up the inventory.[43]

The second major guidebook, the *Curiositez de Paris, de Versailles, de Marly,* was first published in 1716 and then frequently reissued.[44] In 1734 the British painter Joseph Highmore mentions having bought it, while Count József Teleki, a Hungarian art collector, also cites it, in 1760.[45] Saugrain, the author of the guide, was also its publisher. Starting in 1771, the cartographer, engraver, and architect Georges Louis Le Rouge, famous for his engravings of the Anglo-Chinese gardens, may have been associated with the new editions of the guide.

The *Curiositez* combined a description of Paris and its environs with an inventory of the "addresses of the city and faubourgs of Paris."[46] The sixty or so pages devoted to Versailles gave a detailed tour to follow as well as basic information for each of the rooms that clearly identified the paintings, named their artists, and offered brief commentaries on the major pieces. Thus, *The Family of Darius at the Feet of Alexander* was mentioned as "one of the best pieces of the famous Lebrun, deserving great attention."[47] In the Apollo Salon, the large full-length portrait of Louis XIV was "painted in all its perfection by Rigaud; it was the last to be done of this prince."[48] Although successive editions of the *Curiositez* were expanded, obvious important omissions and incoherent passages were not addressed. The edition of 1771, for example, still contained a long description of the Small Gallery, painted by Mignard, as well as one of the Ambassadors' Staircase, which had been demolished in 1752. In 1778 an extensive passage was devoted to the Labyrinth, which had been destroyed in 1774, but the Royal Opera, inaugurated in 1770, was left out.

The third major title was the *Voyage pittoresque des environs de Paris* by the naturalist and art critic

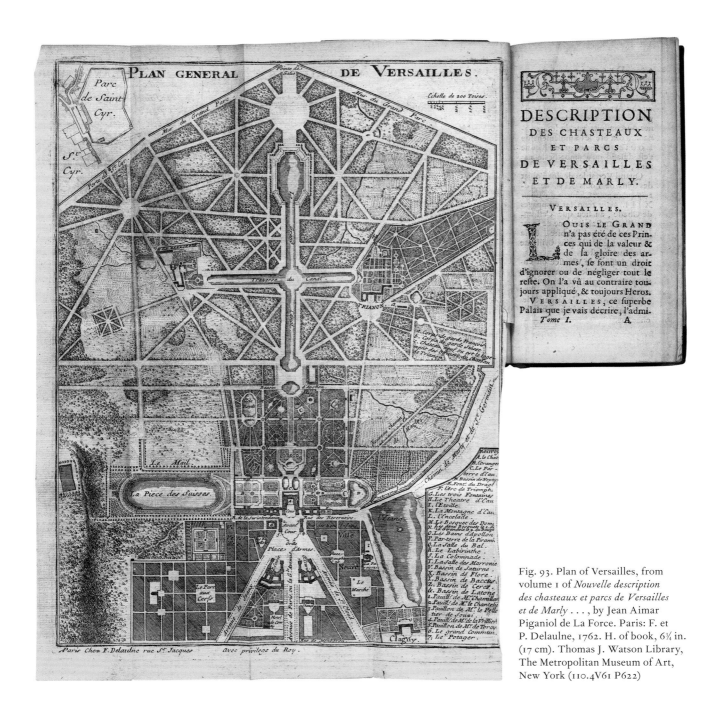

Fig. 93. Plan of Versailles, from volume 1 of *Nouvelle description des chasteaux et parcs de Versailles et de Marly . . .* , by Jean Aimar Piganiol de La Force. Paris: F. et P. Delaulne, 1762. H. of book, 6¾ in. (17 cm). Thomas J. Watson Library, The Metropolitan Museum of Art, New York (110.4V61 P622)

Antoine Nicolas Dezallier d'Argenville, who wrote several books on the gardens as well as other guides (fig. 94). After the publication of his earlier *Voyage pittoresque de Paris*, which went through ten editions between 1749 and 1779, Dezallier wrote this special guide devoted to the outskirts of Paris, which was published in 1755 and expanded in 1762, 1768, and 1779.[49] A hundred pages were given over to the description of Versailles alone in the 1779 edition. The discussion of the gardens, evidence of the author's interest in this subject, covered two-thirds of the text. Generally speaking, Dezallier was more sensitive to the gardens and to the artworks in the palace than to the building itself.

Apart from these three guides, which were regularly reissued, Versailles inspired a vast literature of uneven quality, ranging from dry descriptions

Fig. 94. Frontispiece and title page from *Voyage pittoresque des
environs de Paris, ou Description des maisons royales, châteaux et autres
lieux de plaisance . . .* , by Antoine Nicolas Dezallier d'Argenville.
Paris: De Bure, 1762. H. of book, 6¾ in. (17 cm). Thomas J. Watson
Library, The Metropolitan Museum of Art, New York (121.691P D531)

"You will see the ancient and the new Rome . . . and admit that Versailles eclipses all the enchanted palaces of history and fable."[51] Among the Seven Wonders that Morellet selected, there was neither the Grotto nor the Hall of Mirrors, which were simply mentioned, nor the Labyrinth, which was scarcely more fully described. The absence of Le Brun's Hall of Mirrors has been interpreted as a "press campaign in favor of his great rival Pierre Mignard," painter of the Gallery of Saint-Cloud, which had used Apollonian themes before Versailles.[52] Despite Morellet's stated ambitions, it was difficult to use his *Explication* as a guide when he made such errors as assigning incorrect allegories or attributes to certain sculptures in the park and identifying the Water Theater as a Grove of Love. Although translated very soon after its publication into English and German, the book was reissued only once, in 1695.[53]

In 1715 *Le voyageur fidèle,* presented in the form of a "thirteen-day" stroll, adopted the point of view of a foreign visitor to Paris, a young German named Louis Liger.[54] This was another fictional identity, for the author was actually the bookseller Pierre Ribou. The reader was invited to follow Liger, as descriptions and practical information provided along the way were accompanied by various adventures and anecdotes (the theft of a purse, an amorous intrigue, a mistaken arrest, cheating in a game, and so on). One "day" was devoted to the "trip to Versailles, Meudon, Trianon, the Menagerie, and everything that lies on the road returning to Paris." But *Le voyageur* was merely a

to practical almanacs. Two other books should be mentioned because of the fame they achieved, although they were more on the order of literary hoaxes. In 1681 a "Sir Combes," actually the abbé Laurent Morellet, the chaplain to Monsieur, the king's brother, published the *Explication historique, de qu'il y a de plus remarquable dans la maison royale de Versailles et . . . Saint-Cloud.* This was announced as a guide to Versailles, written "in order to smoothe out . . . the difficulties that arose between some esteemed persons concerning the explanations they gave of the subjects of the paintings that decorate the ceilings, and of those of the sculptures."[50] Adopting a deliberately didactic and grandiloquent tone, the author promised,

compilation of information from various sources, full of errors and inaccuracies, and always very superficial: "These statues are almost all drawn from fables; I would readily have reported all the names and told some of their history if the subject had not taken me so far afield."[55] The visitor equipped with this guide would clearly have had a hard time telling the true from the false.

Generally speaking, the years 1770 to 1800 marked the apogee of travel guidebooks. The *Almanach parisien*, which ran through eight editions and was regularly expanded by volumes appearing in the years 1762 through 1790, was characteristic of this period.[56] Written by the attorney Pons Augustin Alletz in collaboration with a Monsieur Hébert, it was easy to handle, portable, and illustrated, and it combined information about monuments, tourism, and practical affairs. Hébert was also the author of a *Dictionnaire pittoresque et historique*.[57] The "articles" in the *Almanach*, arranged in alphabetical order, discussed various places in Versailles, including the palace itself as well as the Trianon, Marly, and the Menagerie. Also of note is Luc Vincent Thiéry de Sainte-Colombe's *Guide des amateurs et des étrangers voyageurs dans les maisons royales*, published in 1788, which can almost be considered as the last "update" of the *Curiositez de Paris* or of Blaizot's *Almanach de Versailles* (see below).[58]

The abundance and variety of these guides were mentioned by many travelers, who often referred to them in their letters in order to avoid having to write tedious descriptions. Among them were the diplomat Franz de Paula Anton von Hartig, who noted, "I will not tell you about the Royal Houses; they are described in every *Almanach*," and the German writer Johann Jacob Volkmann, who referred to the many existing books by Piganiol and Dezallier.[59]

As one scholar remarked, "the guides [were] basically repetitive, they [did] not show changes,"[60] they cited or copied each other more or less overtly, and they were seldom brought up to date. Despite

the constant alterations made to Versailles, for instance, Piganiol's guide freely admitted that "all these changes, which are quite considerable . . . , will not change anything in this description."[61] Yet the new could be an argument to set oneself off from one's competitors, as the *Almanach parisien* noted: "We have added pieces that we can really call new, for they are not to be found in any description of Paris. Among other things . . . the Theater at the Château de Versailles."[62] Some revised editions mentioned the construction of new areas of the palace, while others omitted them or even, as we have seen, continued to describe elements that had been lost for decades. The *Nouvelle description des environs de Paris*, by the archivist and historian Jacques Antoine Dulaure, published in 1786, was among the most exact guides in this respect. It was one of the only guides, for example, to explain the state of the gardens at the end of Louis XVI's reign: "In 1775, the trees in the small park were cut down because of their old age. Although it was necessary, it was not without much sorrow that we saw the destruction. . . . The new plantings were done by the late M. Le Moine, at the order of M. le comte d'Angivillers. . . . The Labyrinth . . . was destroyed. Today it is a closed grove designed in the English style (see cats. 5, 6)."[63]

The practical information in the guides was always limited, and indeed the time spent at Versailles was often short. According to Félibien, a day was enough, since Versailles's proximity to Paris allowed one to go there easily without having to stay overnight.[64] But Liger said in 1715 that visitors would have to spend four days;[65] according to Claude Jordan, author of *Voyages historiques de l'Europe*, they would need "at least eight days' time, and that still will not be long enough to consider all these marvels."[66] Only a few authors gave the necessary information on how to get to Versailles (see "Going to Versailles" by Mathieu Da Vinha in this volume). Besides Saugrain[67] and especially the two *Almanachs—Parisien* and *de Versailles*—there was Abel Boyer, a French

Protestant exiled to England and the author of the most famous French-English dictionary, who included itineraries, prices, means of transportation, eating habits, and the choice of wines. Boyer advised that, to reach Versailles, "your Coach will carry you hither from *Paris* in less than two Hours, and this should be on a *Tuesday* Morning, which is the public Day that Ambassadors and Foreigners of Distinction go to pay their Compliments to the King; . . . you need not get to *Versailles* 'till about eleven."[68]

Most of the guides mentioned, more or less in passing, the principal monuments of the town, but that was not really their purpose. Detailed information about the place and the conveniences it offered to travelers could be found only in Blaizot's *Almanach de Versailles*, published between 1773 and 1791.[69] After having started out as a seller of prints, paper, and books in one of the stands set up on the ramps of the palace, Blaizot became Bookseller to the King in the Rue de Satory and in 1773 embarked on publishing the annual *Almanach de Versailles*. This directory of the court and town presented itself as the complement to the *Almanach royal*, published by André François Le Breton and devoted to the administration of the kingdom. Blaizot's almanac gave details of the residences of the royal family and of the administrative services when it was based at Versailles. It had the novel feature of including, in addition to a description of the palace and town, street names and a directory of businesspeople: among the many featured were sellers of fabric, candles, jewelry, boots, groceries, and perfume; doctors; language teachers; and of course the booksellers in the town and in the palace itself. Blaizot also provided practical information, in particular concerning transportation: for the carriages of the court, "the price of each seat to Paris is three livres and ten sols, without counting the usual tip for the coach driver." It was Blaizot's intention to show "that there are few sojourns as pleasant . . . for the private person who wants only to stay and live there."[70] The guide was

intended both for travelers passing through and for those inhabitants of Versailles who were not well acquainted with their own town.

Once at Versailles, the visitor had only one route to the palace—along the broad Avenue de Paris to the Place d'Armes. However, the quite unmajestic facade that faced the town posed a problem for the guidebook authors. Both Félibien and Dezallier invoked Louis XIV's respect for the memory of his late father to justify this major flaw.[71] Conversely, *Les curiositez de Paris* actually argued that, if the vantage point were well chosen, a visitor could appreciate the luxury and design of this facade: "From here, the Château has the appearance of a magnificent theater owing to the slope of the glacis and the decrease in the area of the courtyards and in the height and size of the buildings."[72]

Despite the continual construction and demolition at Versailles, the successive guides listed the "must-sees" of the site according to a nearly invariable route: the Ambassadors' Staircase (fig. 95), the Royal Chapel, the Hercules Salon, the Grands Appartements, the Hall of Mirrors, the Queen's Chamber, the King's Apartment, the Princes' Apartments, the Small Gallery, and finally the gardens. Some sites were essential to see, like the chapel: "Artists and art lovers agree that its decoration, both interior and exterior, is beautiful and elegant."[73] Or the Hercules Salon, whose "decoration . . . has, so to speak, something more brilliant than the rest of the apartments in Versailles."[74] In the gardens, although there was actually a greater choice of paths, a description of the palace facade was followed by a presentation of all the groves, one after the other. Most guides identified the statues and also included the Orangerie, the Swiss Lake, the Menagerie, the Trianon, and sometimes the king's kitchen garden. Some remarked on the beauty of the gardens whenever the water system was in operation, but there was no specific information about these occasions. The guides contained very little practical information

about access to various areas of the site itself.

However varied, these guidebooks had two characteristics in common: their formats made them easy to handle and use, and they aimed to help reader-visitors find their way around the palace, gardens, and town. Little is known about the distribution of the guides, but it is believed that most successful eighteenth-century publications generally had a print run of between fifteen hundred and two thousand copies. This was surely the case with the guide-books, whose popularity is attested to by all the new editions. Their presence in many libraries—during the ancien régime no less than today—indicates that they were widely sold. They were carried in France by the printer-booksellers themselves and by other booksellers, and abroad through foreign printings. They could also be found easily in Versailles, in the bookshops of the town near the palace as well as at the stands built along its ramps or against adjacent buildings. The guides could even be bought inside the palace: the bookseller Pierre Dominique Campan had a shop at the Stairway of the Princes; Le Bel, Bookseller and Geographer to the Queen, near the Gallery of Princes; Ravinet, within the gallery itself; and Lefèvre, on the marble staircase. General floor plans of the gardens and, somewhat surprisingly, of the apartments were sold on separate sheets. The plans of the Labyrinth, like the one published in 1716 by Gilles Demortain, showed a path marked by a dotted line that passed, without having to backtrack, all the fountains of Aesop's Fables in the order given by Perrault.[75]

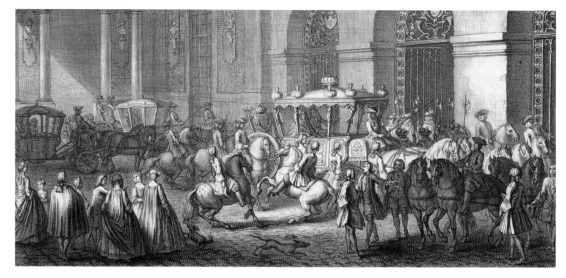

Fig. 95. Louis Surugue after Charles Parrocel, "Entrance of an Ambassador at Versailles," detail from page 1 of *Le Grand Escalier du Château de Versailles*, by L.C. LeFevre. Paris: Louis Surugue, 1725. Sheet: 21 × 16 in. (53.5 × 40.7 cm). The Metropolitan Museum of Art, New York, Rogers Fund, 1918, transferred from the Library (1991.1073.55)

Regardless of their number and the practical information they contained, guidebooks, engravings, and maps did not guarantee that visitors would not get lost in the vast grounds. It was often good to have a guide, such as a watchman or gardener, especially in the Labyrinth. Nemeitz recommended that "foreigners who want to see these pleasure palaces [ask] the ushers who guard them or some concierge in charge, who opens the apartments for the curious and shows them the rarest and most remarkable things."[76] Boyer even specified these companions' tips: "Two Shillings or half a Crown to the Person who shews them; for notwithstanding, what you may have heard at home, that in *France* they dare take nothing of that Kind, I assure you, the Gardener at *Versailles* took half a Crown from me almost under the Window of the King's Apartments."[77] In this respect, as in others, not even the most detailed guidebook or engraving could replace a visit to the palace itself, as Piganiol emphasized: "The most exact description will depict it only imperfectly, even for the most vivid imagination."[78]

125 *View of Versailles*

Pierre Gallays, ca. 1712

Gallays, an engraver, publisher, and printseller in Paris, distributed many engravings depicting the activities of Louis XIV during the last years of his reign, in particular several large almanacs illustrated with engravings. Although the accompanying verses boast the magnificence of the palace ("Of this rich palace the superb structure / Makes both Art and Nature shine . . ."), the primary concern of the print was to show dynastic continuity by means of images. In the middle of a long

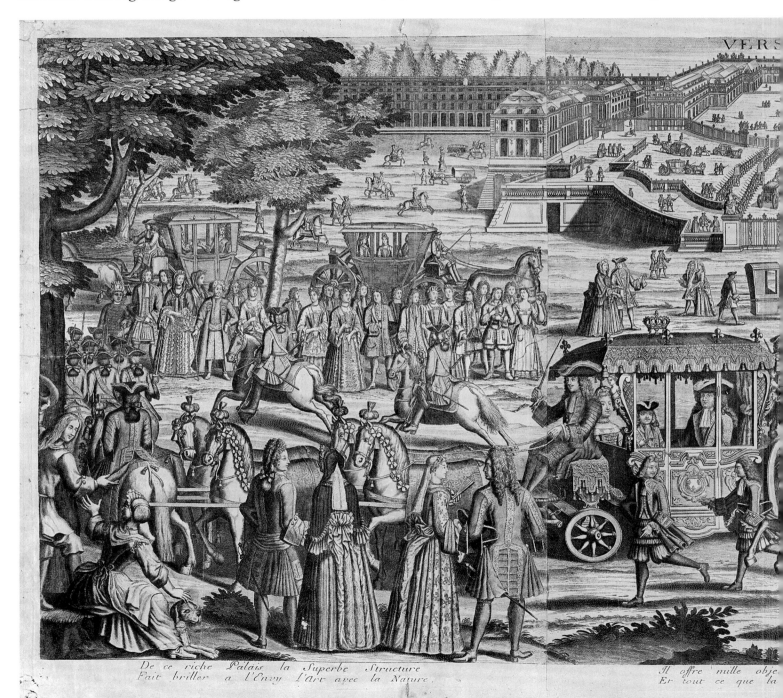

VERS

De ce riche Palais la Superbe Structure
Fait briller a l'Envy L'Art avec la Nature,

Il offre mille obje
Er tout ce que la

procession, the royal carriage crosses the Place d'Armes (Parade Grounds) on its way to the palace; riding in it are the king and his last great-grandson of direct lineage, the future Louis XV, who became Dauphin in 1712. Among the large crowd of spectators are courtiers, abbots and clergymen, ladies of quality and women from town, ministers and men of the sword, pages and water vendors, soldiers and servants—the myriad individuals who formed the microcosm of the court. EM

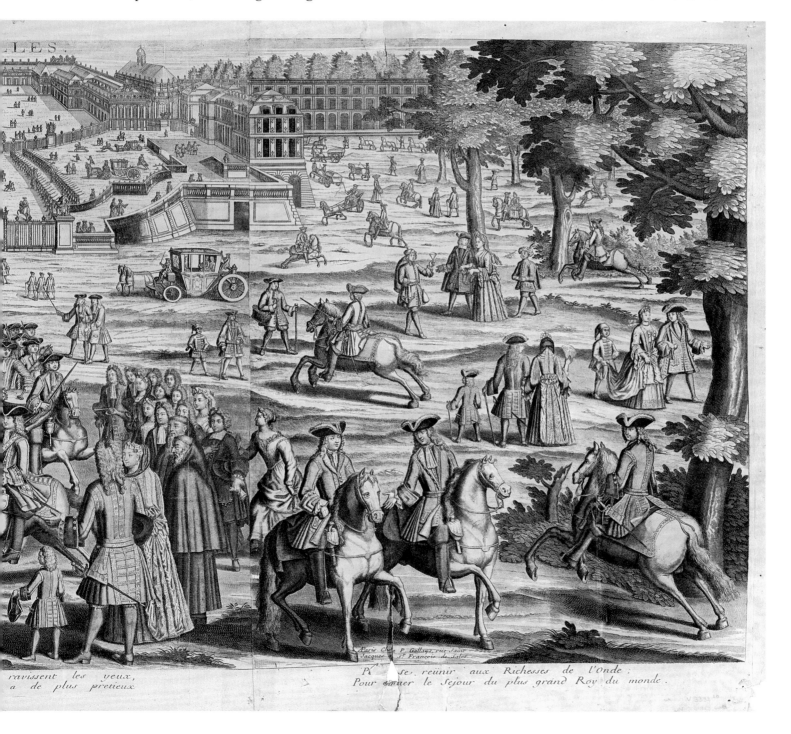

ravissent les yeux,
a de plus pretieux

P... se reünir aux Richesses de l'Onde;
Pour ..uer le Sejour du plus grand Roy du monde.

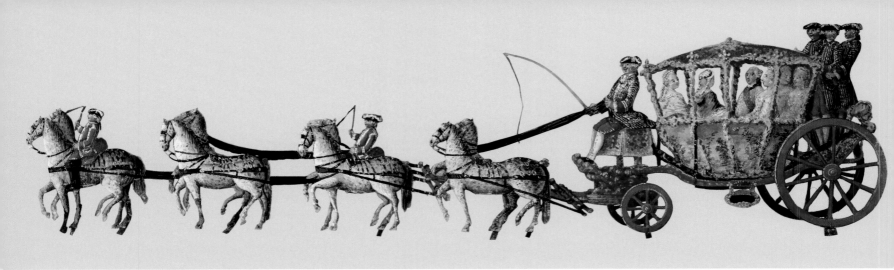

126 A–C Group of Figures Depicting the Royal Carriage and Cavalrymen

Attributed to a member of the Lesueur family, possibly Jean-Baptiste Lesueur, before 1774

A. *The Royal Carriage*
B. *Standard-Bearer*
C. *Cavalryman*

The arrival of the royal carriage offered a wonderful spectacle in itself as well as a chance to see the monarch. A unique group of paper figurines representing such a procession, accompanied by cavalrymen and footmen, has been attributed to the painter Lesueur, known for his gouaches of Revolutionary scenes.[1] With their vivacious poses and accurate coloring, these cutouts show the artist's keen sense of observation and great manual dexterity. Louis XV is accompanied here by his daughters, who were known as "Les Mesdames de France."[2] Rendered with great precision, the cavalrymen are mainly members of the Gardes du Corps, charged with the king's protection. The color of the shoulder belt, matching the saddlecloth of the horse, indicates to which of the four companies of the Gardes du Corps each horseman belonged. Although their function is undocumented, such cutouts may have been used in a miniature theater.[3] DK-G

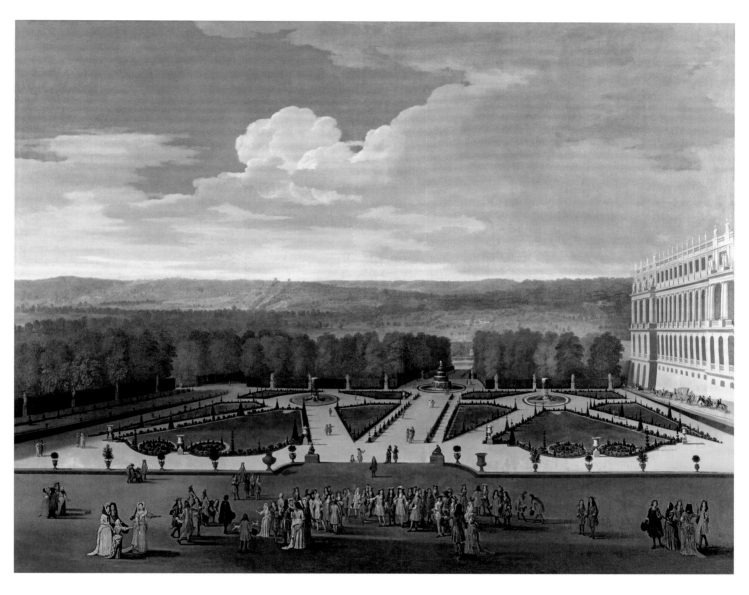

127 *Promenade of Louis XIV in Front of the North Parterre*

Etienne Allegrain, ca. 1688

Intended to decorate the Salon des Portiques (Garden Salon) at the Trianon, this painting was part of Louis XIV's commission of 1688 that included views of the palace and gardens. In the foreground, pausing on the terrace of the North Parterre, the monarch is accompanied by his gardener, André Le Nôtre, on his right, as well as by courtiers and officials from the Bâtiments du Roi. The time of day seems to be late afternoon, judging by the shadows cast on the ground. The king's stroll is coming to an end as a coach waits on the side of the north wing. Louis greatly appreciated these daily walks, which he made regardless of the weather, as the duchesse d'Orléans reported: "The people in this country do not know how to walk any better than geese, except for the king, Mme de Chevreuse, and I. No one is able to take more than twenty steps without breaking into a sweat and becoming short of breath."[1] BS

128 *Louis XV Departing for the Hunt*

Attributed to Pierre Denis Martin the Younger, ca. 1724

Attributed to an artist known for his depictions of royal residences, historical subjects, and battle scenes, this painting shows Louis XV with his retinue and a pack of hounds departing for the hunt. Riding a white stallion in the foreground, the king is set against a perspective view of the palace and gardens at Versailles. The painter rendered the Orangerie, with the double Cent Marches (One Hundred Steps) stairways, as well as the lake constructed by the Swiss Guards and known as Swiss Lake. A passionate hunter, the king could frequently be seen departing on horseback to indulge in his favorite pastime. The pendant to this painting depicts the return of the hunt at Marly.[1] DK-G

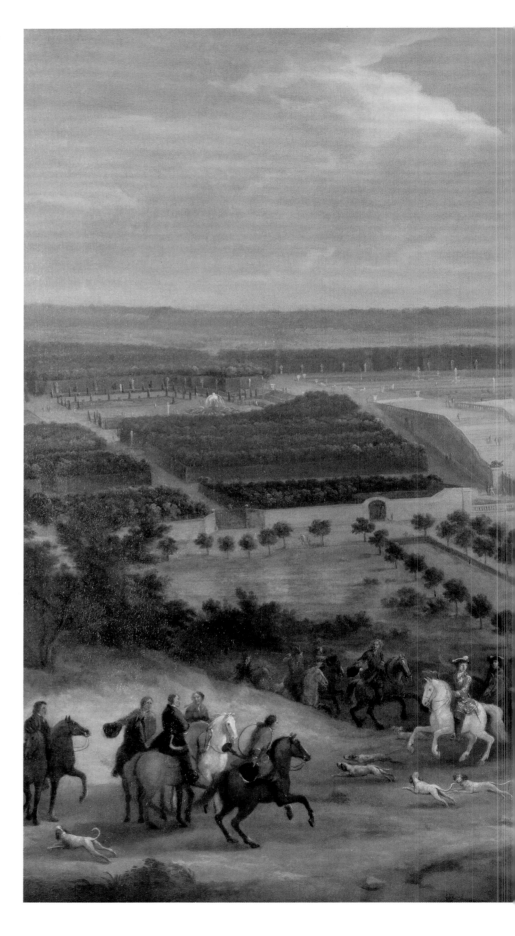

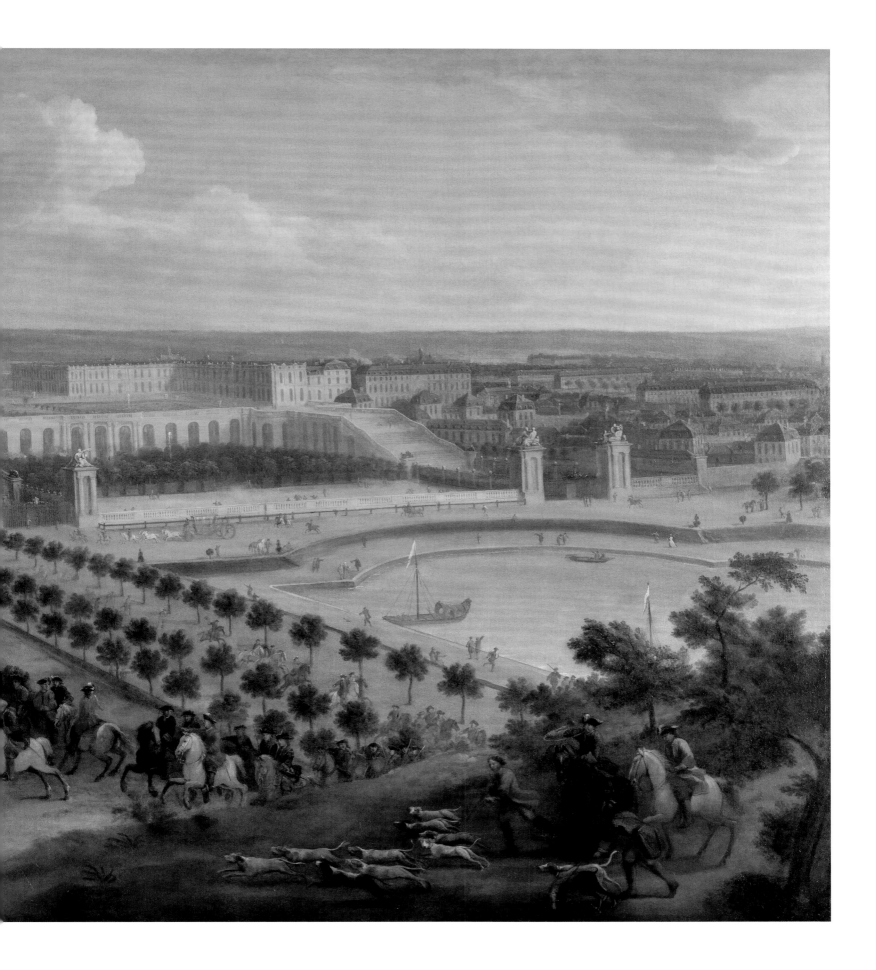

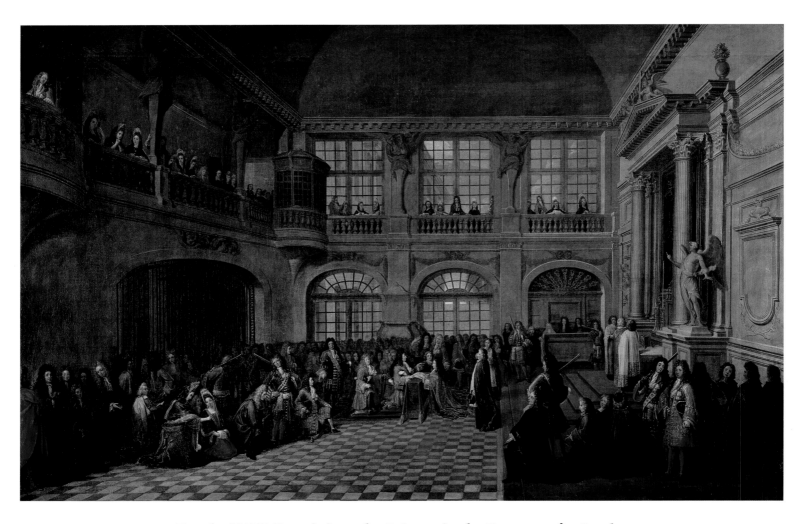

129 *Louis XIV Receiving the Marquis de Dangeau's Oath*

Antoine Pezey, ca. 1695

On December 24, 1693, Louis XIV entrusted one of his favorite courtiers, Philippe de Courcillon, marquis de Dangeau, with the office of Grandmaster of the United Orders of Our Lady of Mount Carmel and Saint Lazarus of Jerusalem. It took two years for this nomination to be confirmed by a papal bull. On December 18, 1695, the day following the feast of Saint Lazarus, the kneeling marquis, draped in the great cloak of the Order, took an oath on the New Testament before Louis, who is shown kneeling at his prie-dieu and holding the insignia in his left hand. The ceremony took place in the fourth chapel of the palace (today's Hercules Salon). A similar engraving by Sébastien Leclerc the Elder bears a legend listing the names of the male participants, who included Louis the Grand Dauphin, kneeling behind the king, and the duc de Bourgogne, Louis XIV's eldest grandson, in the royal box on the gallery.[1] BS

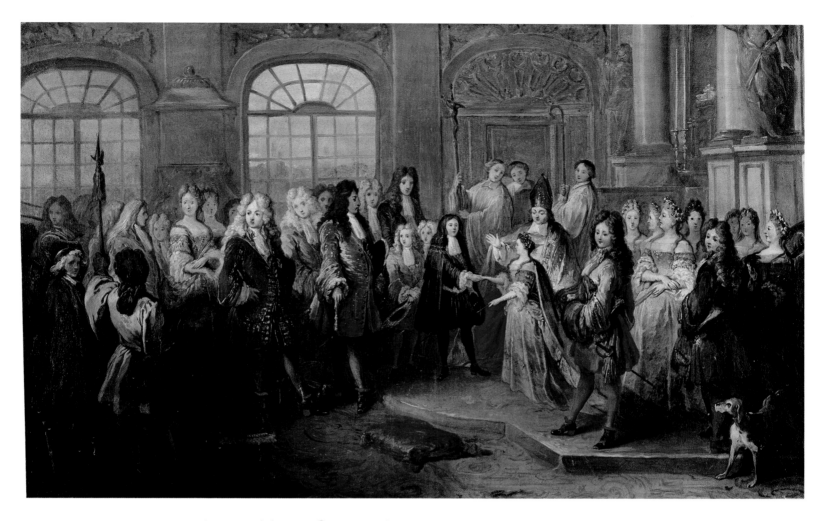

130 *The Wedding of Louis de France, Duc de Bourgogne, and Marie Adélaïde de Savoie*

Antoine Dieu, 1710–11

This preparatory sketch was made prior to the cartoon commissioned in 1710 in order to complete the tapestry series L'Histoire du Roi.[1] Although done after the wedding, which took place on December 7, 1697, the depiction seems faithful to the event, the splendor of which was unanimously praised.[2] The king himself had indicated that he wanted the "court to be magnificent there . . . all rivaled in splendor and inventiveness: the gold and silver were hardly sufficient."[3] Celebrated by the cardinal de Coislin, Grand Chaplain of France, the wedding of the eldest grandson of Louis XIV and the Princess of Savoy was held in the fourth chapel of the palace. The portraits in the sketch are less readily identifiable than those in the cartoon, but clearly recognizable to the left of the young groom are his two younger brothers, the duc d'Anjou and the duc de Berry, Louis XIV, and the Grand Dauphin. On the bride's side are members of the Orléans family, Monsieur (the king's brother), and his son. BS

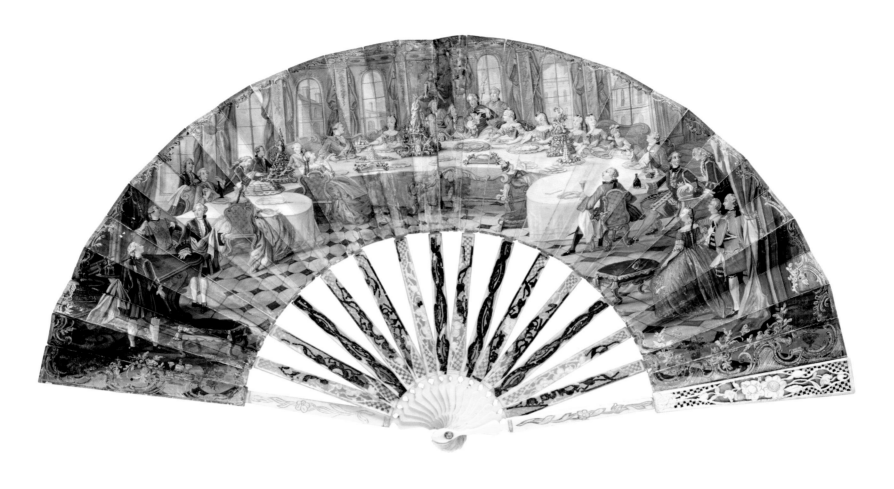

131 *Louis XV with His Family during a Grand Couvert*

French, ca. 1755–60

Set for dessert with pyramids of fruit and sweetmeats, the table in this delightful depiction is horseshoe-shaped, as was customary during the Grand Couvert (see fig. 98). Louis XV, wearing the blue sash of the Order of the Holy Spirit, is seated in the center directly in front of a portrait of his great-grandfather disguised as Apollo. Standing behind him are two bodyguards, known as Gardes de la Manche, easily recognizable from their gold-decorated tunics and their partisans, a type of spearhead mounted on a tall pole (cats. 42–44). To the king's left side is Queen Marie Leszczyńska, while to his right are Louis, Dauphin of France, his wife, the Dauphine, Maria Josepha of Saxony, and the couple's eldest son, Louis, duc de Bourgogne. Although the fan shows only a few spectators, eyewitness accounts report that the meals the royal family ate in public were crowded affairs, not surprisingly so since they offered an excellent opportunity to take a good look at the king and his family.[1] DK-G

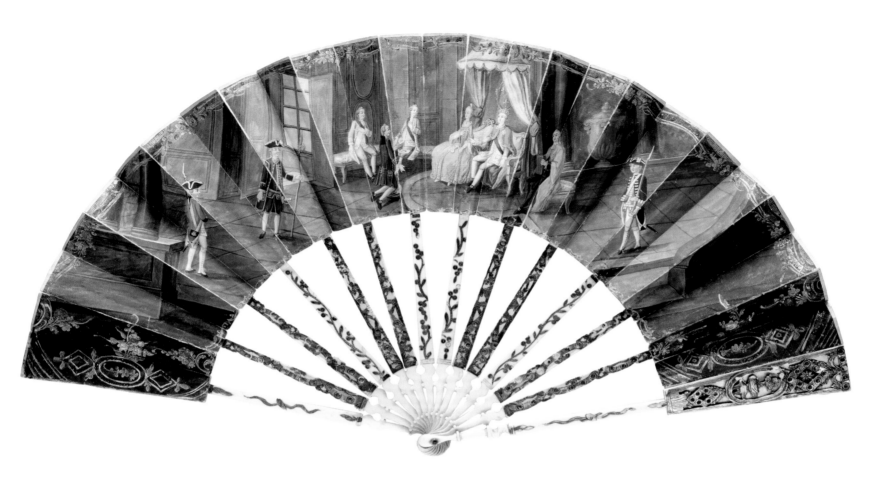

132 *An Audience with Louis XVI and Marie Antoinette*

French, ca. 1775

This fan painting shows a man kneeling before Louis XVI and Marie Antoinette holding a sealed letter, possibly a petition to solicit some right or favor. Petitioning was an important reason for which visitors went to Versailles, but it is rarely depicted in art. Supplicants generally tried to hand their requests to the king or queen in the Hall of Mirrors while the rulers were on their way to daily mass. Set in an unidentified interior, this charming depiction seems entirely fanciful, since the king never wore a crown or carried a scepter. Furthermore, he never granted an audience with the queen, and only by exception did he grant audiences when seated on a throne underneath a canopy. The two onlookers wearing the sash of the Order of the Holy Spirit are possibly the king's younger brothers, the comtes d'Artois and de Provence. DK-G

133 *Exterior View of the Royal Chapel*

Pietro Bellotti, ca. 1750

Bellotti, a nephew of the *vedute* painter Canaletto, accompanied his elder brother, the famous Bernardo Bellotto, to Rome in 1742 and several years later went to France, where he lived during the 1750s in Paris and Versailles. In 1754 and 1755 he exhibited various views that he claimed to have painted on-site. However, this particular work takes up a composition of 1721 engraved by Jacques Rigaud titled *View of the Royal Chapel as Seen from the Courtyard*, which was published in *Diverses vues du château de Versailles*. This painting has an undeniable documentary value. The roof of the chapel, built between 1698 and 1710 after designs by Jules Hardouin-Mansart, is crowned by the lantern that was destroyed in 1765. The grounds of the palace were largely open to visitors, who enliven the composition, bathed in a bright light.[1] GF

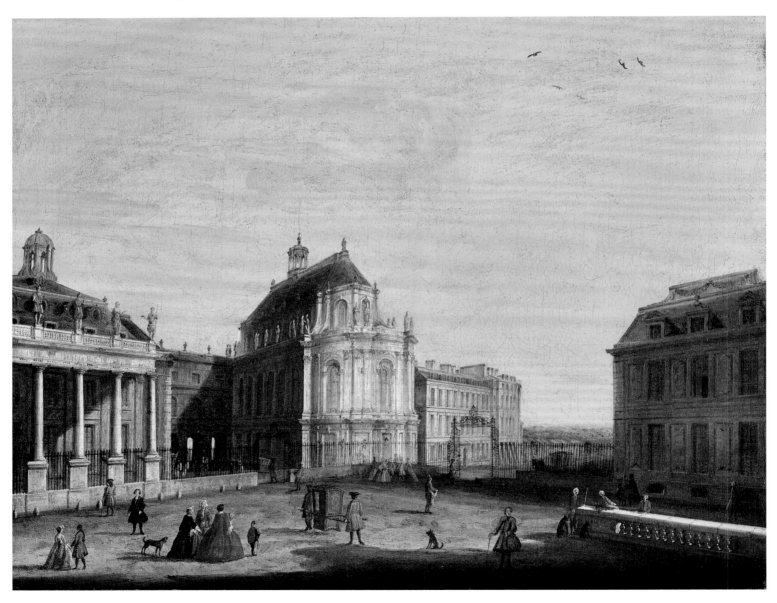

134 *Section and Interior Perspective of the Royal Chapel*

Jean Chaufourier, ca. 1725

Chaufourier, an expert in the art of perspective, executed this interior view of the Royal Chapel about 1725. He concentrated on architectural details: the arcades on the ground floor, the colonnade on the floor above, the vault supported by a system of flying buttresses. The artist added various figures: some are shown at prayer, like the cleric at the right foreground, but most are visitors gesturing in admiration of the building, which was called "an exceeding fine piece of architecture" by Thomas Nugent.[1] Its proportions are quite impressive, considering the overall scale of the palace. The drawing includes some of the furnishings, which would be lost during the Revolution: the pulpit, executed by the sculptor-decorator François Antoine Vassé, the lamps of the shrines flanking the altarpiece on the main altar, and the tabernacle and candlesticks on the altar. AM

135 *Northwest Corner of Louis XIV's Bedroom*

French, after 1701

This drawing is one of the few to show the royal bedroom, located at the very center of the palace. Important ceremonies such as the king's *lever* and *coucher* as well as the public audiences of foreign ambassadors took place in this room. The Sun King drew his last breath there in 1715, and, even many years later, Thomas Greene noted in his diary that he saw "the bed in which Lewis XIV died."[1] Although sketchy in nature, the tapestry on the wall next to the fireplace is recognizable as belonging to the series Portières des Dieux (Portieres of the Gods, Representing the Elements and the Seasons), woven at the Gobelins manufactory after designs by Claude Audran III.[2] Its presence suggests not only that the drawing dates after 1701, when a particularly lavish version of the portieres was commissioned for the King's Apartment, but also that the room was depicted with its winter hangings. The Swedish architect Carl Johan Cronstedt later acquired this rendering, most likely between 1731 and 1737 during his studies in Paris. DK-G

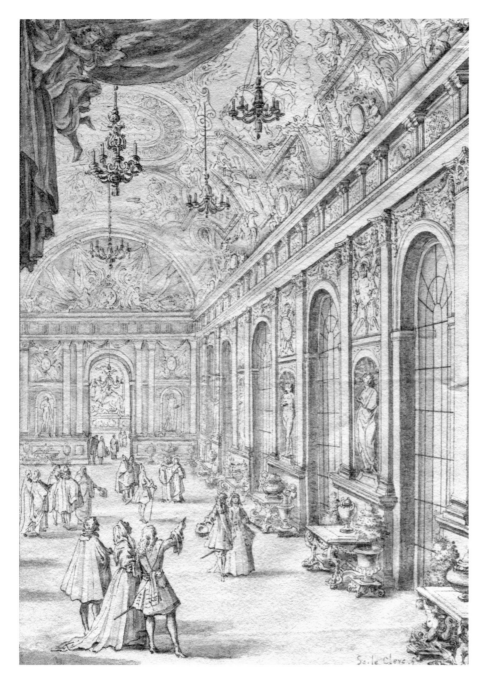

136 *View of the Hall of Mirrors*

Sébastien Leclerc the Elder, ca. 1684

A rare view of the Hall of Mirrors while it was still being decorated, this drawing had a long life and influenced depictions of the gallery into the eighteenth century. It was distributed as an engraving for the frontispiece of Madeleine de Scudéry's *Conversations nouvelles sur divers sujets, dédiées au Roy*, published in 1684, which mentions "the new gallery at Versailles, which has at least been started."[1] However, the work is only an evocative celebration of the pleasures of the royal residence, without any claim to realism or documentary value. The ceiling depicted here is an unrealized design by Charles Le Brun on the theme of Apollo, which was abandoned by 1679. The courtiers and visitors walking through the Grande Galerie are admiring both the vault and the famous silver furniture designed by Le Brun. But most of the depicted objects, which were melted down in 1689 and known only from a few drawings, do not correspond to the descriptions in Scudéry; the exception is the "table of the four parts of the world with cupids riding dolphins," made by Claude Ballin in 1672, which can be seen in the foreground.[2] EM

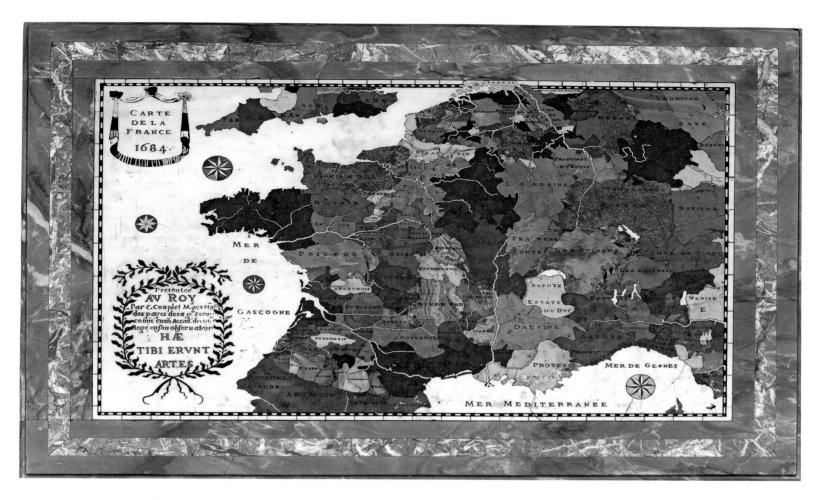

137 Tabletop with Map of France

Probably Gobelins Manufactory, Paris, 1684

According to its inscription, this colorful *pietre dure* tabletop, representing each of the provinces of France in 1684, was offered to Louis XIV by Claude Antoine Couplet, founding member of and professor at the Paris Académie des Sciences. Glorifying the Sun King for his successes on the battlefield—the map includes recently seized territories in the north and east of the country—the inscription also contains a quotation from Virgil. When the table was on public view at the Trianon de Marbre, it impressed numerous visitors, including in 1714 the Reverend James Hume. Calling the Trianon an "enchanted palace," Hume commented on its furnishings as well: "Besides other rich furniture there are several Tables of diverse sorts of marble and agat curiously vein'd, and amongst the rest one on which is a curious map of France in chamfer'd or inlaid work of diverse coloured Marble."[1] DK-G

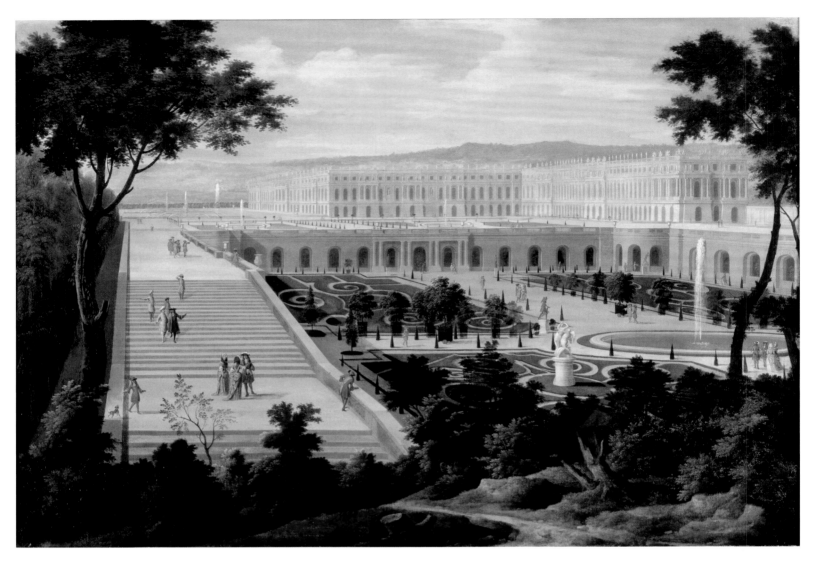

138 *View of the Château de Versailles and the Orangerie*

Etienne Allegrain, ca. 1695

The creation of the north–south axis of the Versailles gardens led to the destruction of Louis Le Vau's Orangerie of 1663 and the construction of a new one underneath the Parterre du Midi by Jules Hardouin-Mansart from 1684 to 1686. Completing the ensemble, and using the sloping site to best advantage, were the two famous staircases known as the Cent Marches (One Hundred Steps). The painter chose to accentuate the monumentality of only one staircase, which he enlivened with strolling figures that included five dressed in Persian costumes. At the end of 1686, an ambassador from Siam visiting the gardens praised the beauty and freshness of the Orangerie.[1] Indeed, the presence of Thomas Regnaudin's statue group *Saturn Abducting Cybele*, which had been put in place on the parterre between 1687 and 1716, makes it possible to situate the painting between these two dates, that is, about 1695. BS

TOURISTS, SOUVENIRS, AND GUIDEBOOKS

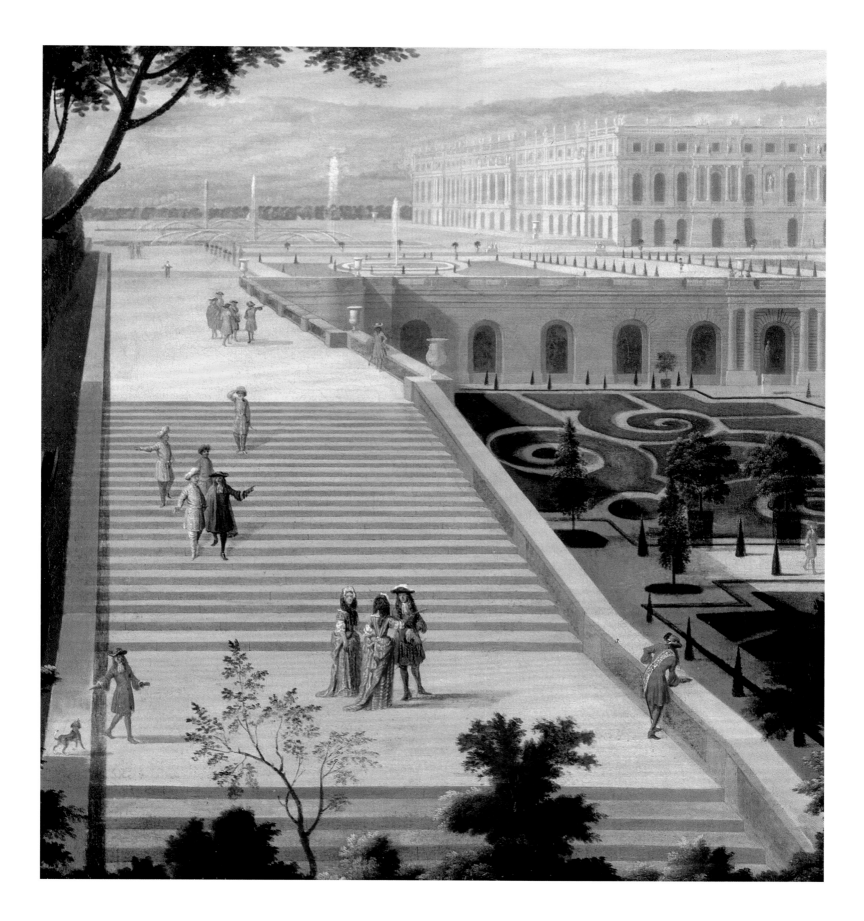

139 *Study of a Chameleon*

Pieter Boel, ca. 1668

140 *Double Study of the Head of a Dromedary*

Pieter Boel, ca. 1669–71

141 *Triple Study of an Ostrich*

Pieter Boel, ca. 1669–71

Working for the Gobelins manufactory, the Flemish animal and still-life painter Boel sketched the various denizens of the newly finished Menagerie. Built by Louis Le Vau between 1663 and 1669, the Menagerie housed exotic birds and animals as well as livestock and domestic fowl for the royal table; its wild, unfamiliar creatures were among the main tourist attractions at Versailles. The creeping chameleon here was probably the reptile that was presented to the king, studied, and later dissected by members of the newly founded Académie des Sciences in 1668.[1] The ostrich long remained an object of curiosity to visitors to the Menagerie: Thomas Greene wrote nearly a century later that he noticed "very few things but what I had seen before, except a pelican and an ostridge."[2] Boel's double study of a dromedary's head reveals the artist's great skill in rendering the animal's hair. Dr. Samuel Johnson had difficulties differentiating between a dromedary and a camel, reporting in 1775 that he saw "the Camel or dromedary with two bunches."[3] Boel's studies, painted from nature, served as models for the Maisons Royales tapestry series, commissioned by Louis XIV from the Gobelins in 1668 (cat. 1) and possibly also for the lead animal figures of the fountains in the Labyrinth (cats. 144–146). DK-G

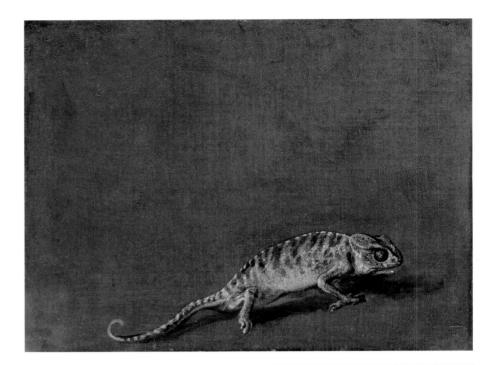

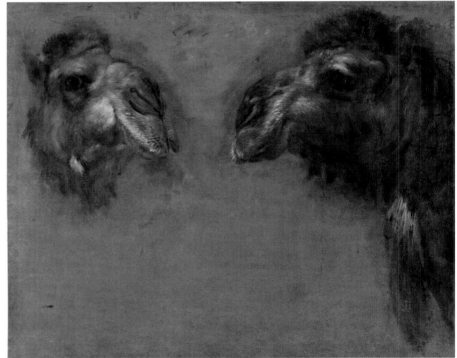

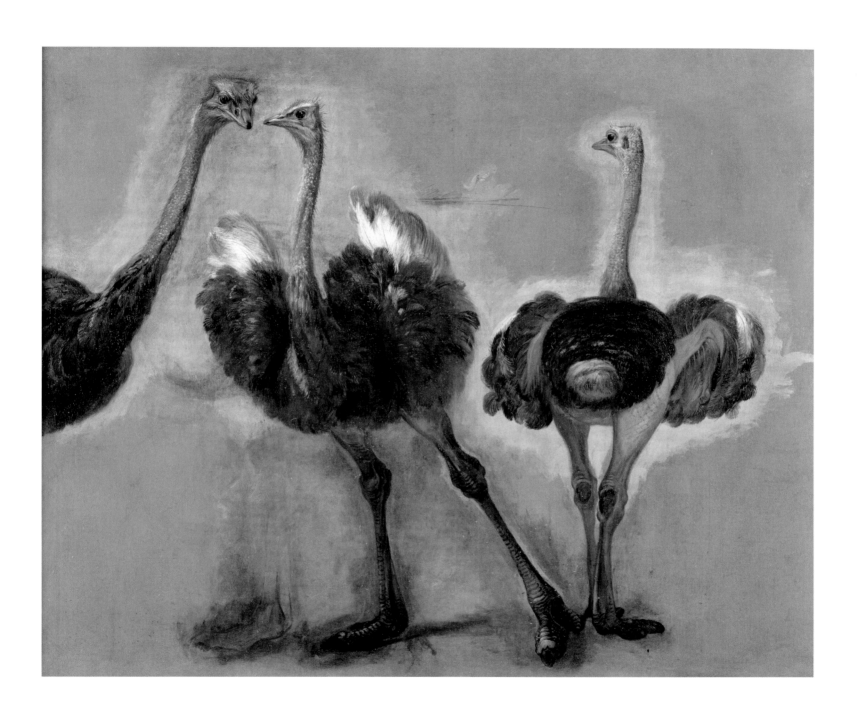

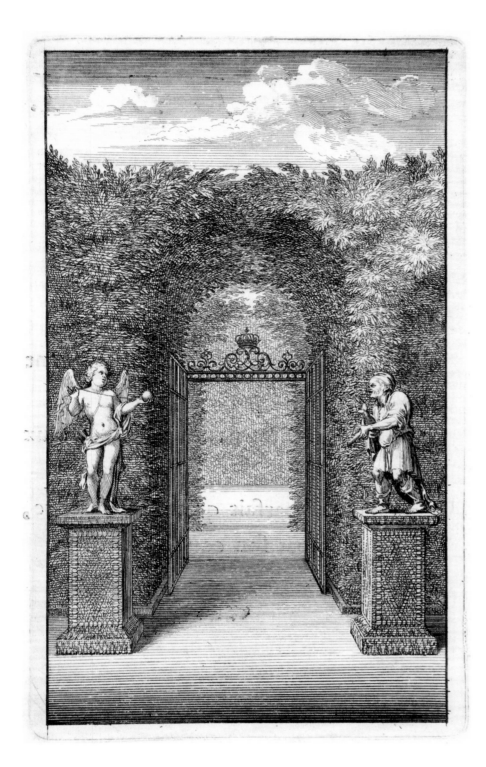

142 *Labyrinte de Versailles*

Sébastien Leclerc the Elder, 1677

143 *Labyrinte de Versailles*

Jacques I Bailly and Sébastien Leclerc the Elder, ca. 1677

André Le Nôtre's 1665 design for the Labyrinth was enriched between 1671 and 1674 by numerous fountains. Featuring more than three hundred painted-lead sculptures of animals from *The Fables of Aesop* (cats. 144–146), the waterworks "surprise the eye here and there in the winding alleys," according to Martin Lister in 1698.[1] Although torn down in 1775, the maze lives on in a series of etchings made by Leclerc in 1674 that were included three years later in the first illustrated guidebook. Following a map with a key and illustrations of the figures of Aesop and Amor, which flanked the entrance gate, there are plates depicting each fountain, always showing the waterworks in action (see fig. 14). Set either in greenery, in trelliswork pavilions, or at the intersection of alleys to create a sense of perspective, Leclerc's representations demonstrate what an enchanting place the Labyrinth must have been. The guidebook contained a description of each fable as well as quatrains for the fountains written by the court poet Isaac de Benserade. This popular publication, immediately translated and then reissued in 1679, also appeared in counterfeit copies produced abroad.

For Louis XIV, a special keepsake volume was prepared of Leclerc's etchings illuminated by Bailly's colorful gouaches. Benserade's verses are rendered in black-and-gold calligraphy (possibly the work of Jean-Pierre Rousselet), and the red morocco leather binding bears the Sun King's cipher on the spine and his arms on both covers. DK-G

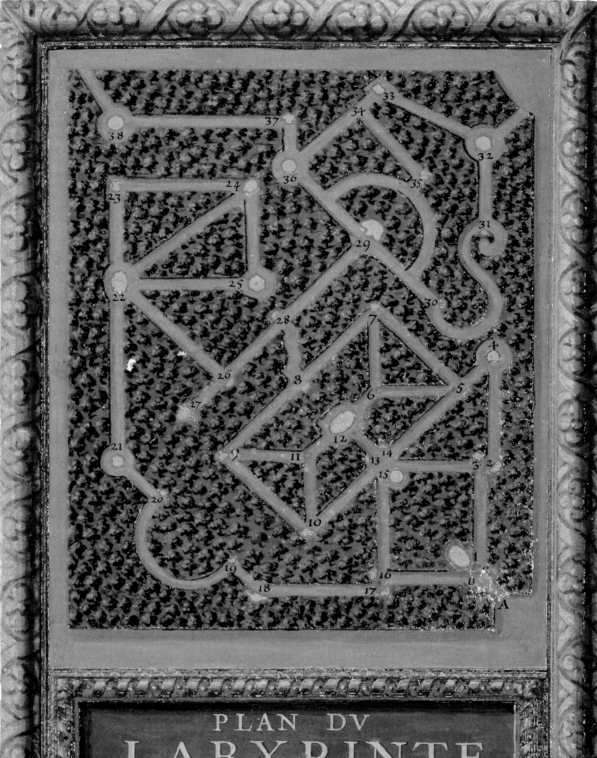

PLAN DV
LABYRINTE
DE VERSAILLES.

144 *Monkey Riding a Goat*

Pierre Legros and Benoît Massou, 1672–74

145 *Wolf*

Benoît Massou, 1672–74

146 *Fox Setting Fire to the Tree with the Eagle's Nest*

French, 1672–74

The bestiary of the Labyrinth was the largest ensemble of animal sculptures before the work of the well-known nineteenth-century artist Antoine-Louis Barye. The decoration of the fountains with scenes from Aesop's *Fables* kept some twenty sculptors busy between 1672 and 1674; the meaning of the sculptures was explained on bronze plaques bearing short poems by Isaac de Benserade. Popular with visitors, the Labyrinth was described in 1742 as a shady grove in which "is Aesop's Fables figur'd, and represented in a most beautiful Manner all furnish'd with Water-Works; and which, when they play, give a most delightful Amusement."[1]

The monkey on a goat is from the twelfth fountain, illustrating "The War between the Birds and the Beasts" and explained as follows: "War on both sides, deadly and bloody / Neither side wanting to step down, / But the bat betrayed his own / And since then no longer dared look at the light."[2] The largest fountain in the grove, this one included many quadrupeds, all aiming their jets of water at the birds perched at the top of a domed trellis pavilion (see fig. 14). The wolf, from the twenty-first fountain, illustrates "The Wolf and the Crane": "The crane took out of the wolf's throat / With his long beak a bone stuck fast: / I could have eaten you if I wanted / Said the ungrateful wolf, let that be your reward."[3] The sixth fountain represented the fable of the eagle and the fox: "Comrades and Neighbors poorly mixed / They both succumbed to temptation / For the eagle snatched the fox's babies / And the fox ate the eaglets as they fell."[4] AM

147 Sheet with Description, Floor Plan, and Elevation of Louis XIV's Medals Cabinet (*cabinet des bijoux* or *cabinet des médailles*)

Nicodemus Tessin the Younger, ca. 1687

Tessin undertook three European trips with the intention of studying art and architecture abroad. While in Paris in 1687, he made drawings and detailed descriptions of Versailles, including this rapid sketch of Louis XIV's medals cabinet. The Swedish architect was duly impressed by the decoration of this room, with its oculus window in the domed ceiling. Arranged three high, twenty-four paintings lined the walls. Brackets and étagères piled with statuettes and objects of silver, bronze, and semiprecious stones,

beautifully reflected in mirror glass, were placed in front of pilasters and in the four corner niches.[1] Tessin visited the room, accessible through the Salon of Abundance, when the king's impressive collections of engraved gems and medals were stored there. Written in German, Tessin's text here is not identical to the account he gave of the cabinet in French in his 1687–88 travel notes, so he may have used this sheet for his preliminary observations, which he later transcribed and augmented in his journal. DK-G

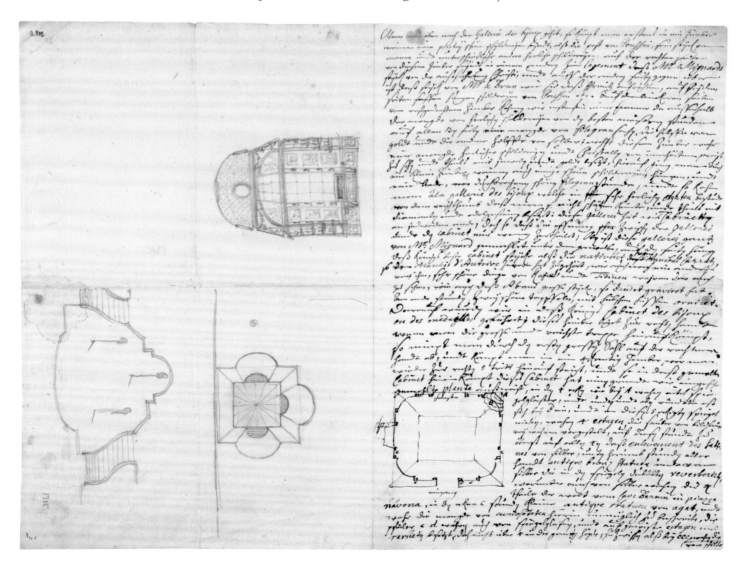

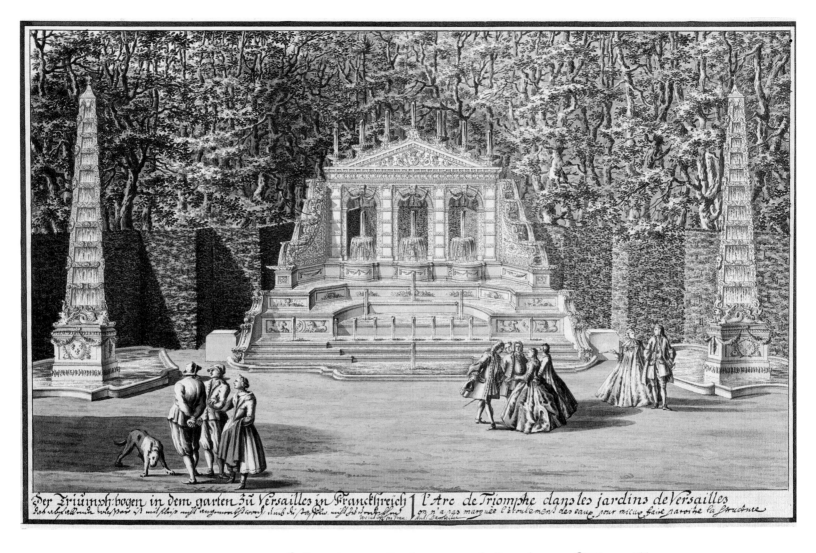

Der Triumph bogen in dem garten zu Versailles in Franckhreich | l'Arc de Triomphe dans les jardins de Versailles

148 *New Maps of the Town, Palace, and Gardens of Versailles*

Franz Anton Danreiter, 1723–24

This valuable album depicting the gardens of Versailles, Marly, Clagny, and the Trianon presents ten overall views of groves and architectural elements alternating with sixteen pages of maps, profiles, and elevations of complete buildings or details. Danreiter, master gardener of the prince-archbishops of Salzburg, was a theoretician and promoter of French-style garden design in the Germanic world.[1] During his stay in Versailles in 1723–24, he made drawings of several groves that captured unique details of such structures as the aviary of the Menagerie and the bas-reliefs of the fountain of the Arch of Triumph. Moreover, his pages are enlivened with many picturesque figures of strollers, courtiers, servants, gardeners, and various animals. The album transmits a selective, but very detailed and exact vision of a dozen important sites, all precisely dated, in the period after the Régence, when the court had returned from Paris to Versailles. It is the testimony of a privileged visitor whose trained eye took in all the technical and aesthetic aspects of the place. EM

149 *Two Winged Putti Holding a Garland* and *A Chair Leg*

Sir William Chambers, ca. 1749–50

Containing sketches Chambers made during voyages on the Continent, primarily in France and Italy, this scrapbook served him as a source of ideas throughout his architectural career. It was most likely in 1749–50, while studying at the Paris Ecole des Arts of Jacques François Blondel, that Chambers visited Versailles and Marly. Some of the album's topographical drawings reveal an interest in the garden design, architectural elements, and decorative details that he observed there. The sketches would have complemented the descriptions and engravings of Versailles in the books Chambers owned.[1] The winged putti holding a garland are copied from the ceiling of the Hercules Salon at Versailles, completed by François Le Moyne in 1736. They share the sheet with a chair leg surmounted by a lion mask at the knee, part of the gilt-wood throne of Louis XV. Designed by the brothers Sébastien Antoine and Paul Ambroise Slodtz, sculptors at the Menus Plaisirs, this Rococo throne was placed in the Apollo Salon in 1743.[2] DK-G

150 *Wolfgang Amadeus Mozart with His Father, Leopold, and His Sister Marie Anna*

Louis Carrogis, known as Carmontelle, 1763–64

Several versions are known of this charming drawing by Carmontelle showing Leopold Mozart making music with his children during their first visit to Paris in 1763–64.[1] Seeking royal patronage, the family traveled to Versailles, where they lodged in the Rue des Bons Enfants from December 24 through January 8. The family incurred substantial expenses since they had ordered four new black suits to wear to court and were forced to take sedan chairs daily because of bad weather. Leopold wrote that "every day I have been with my little man to the mass in the Royal Chapel to hear the choir in the motet, which is always performed there."[2] The young Mozart played the organ on New Year's Day, had an audience with the royal family, and was offered presents, upon which Leopold commented that "if the recognition we receive equals the pleasure which my children have given this court, we ought to do very well."[3] DK-G

151 *John Montagu, Lord Brudenell, Later Marquess of Monthermer*

Pompeo Batoni, 1758

In 1751 Lord Brudenell left England on an extended Grand Tour accompanied by his tutor, Henry Lyte. In a letter to Brudenell's father, George, 4th Earl of Cardigan, Lyte reported on a visit to Versailles, where the great gallery was splendidly illuminated, they saw the king and queen at play, and "Lord Brudenell wore his blue velvet for the first time."[1] Could it be the same costume in which the young milord was later portrayed by Batoni? The artist rendered the softness and sheen of the velvet coat very convincingly and his sitter's features, a slight blush coloring the otherwise pale skin, with remarkable sensitivity. The score in Brudenell's slender hands is depicted so precisely that it can be recognized as the last movement of Arcangelo Corelli's Sixth Violin Sonata, part of the composer's Opus 5. The score and the mandolin placed next to Brudenell suggest not only that the Englishman was cultured but that he had a special interest in music. DK-G

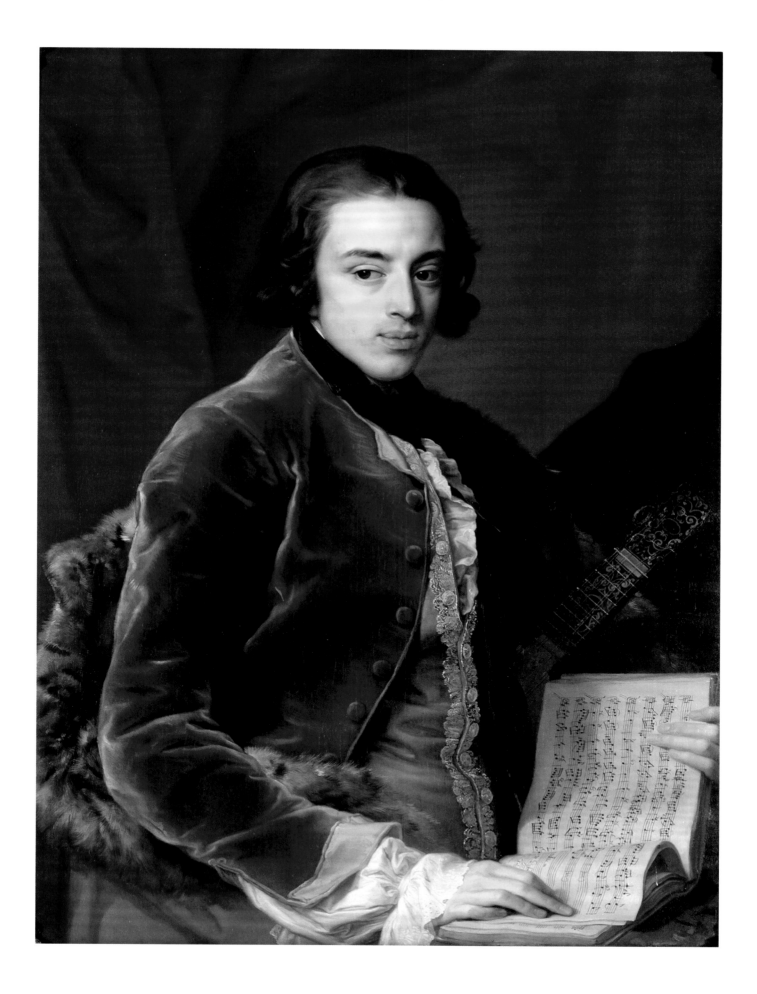

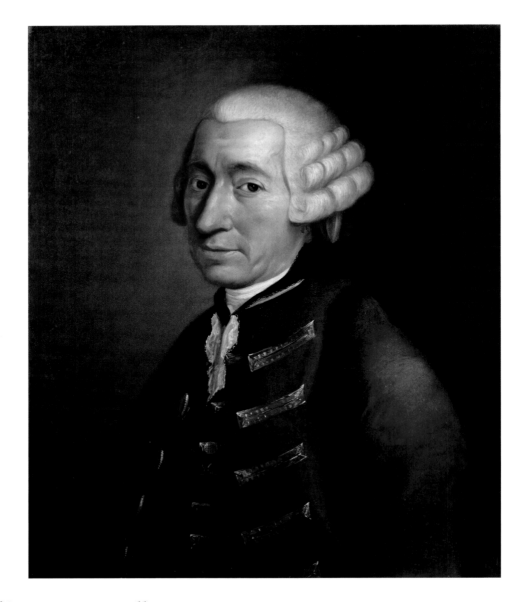

152 *Tobias George Smollett*

Probably Italian, ca. 1770

Trained as a surgeon, Smollett was better known as a novelist. In his 1766 *Travels through France and Italy*, he shows little appreciation for Versailles, which he had visited three years earlier. Smollett notes that "in spite of all the ornaments that have been lavished on Versailles, it is a dismal habitation. The apartments are dark, ill-furnished, dirty, and unprincely. Take the castle, chapel, and garden all together, they make a most fantastic composition of magnificence and littleness, taste, and foppery."[1] Smollett's keen sense of observation and wit in this epistolary work are combined with a cynicism that, according to Sir Walter Scott, may have been caused by ill health and the loss of his only child.[2] A melancholic mood dominates this portrait, which, as stated in an inscription on the reverse, was painted in Pisa toward the end of Smollett's life. Rendered in three-quarter view, the sitter wears a white wig, a plain blue coat, and a matching waistcoat enlivened with gold buttons and gold-trimmed buttonholes. DK-G

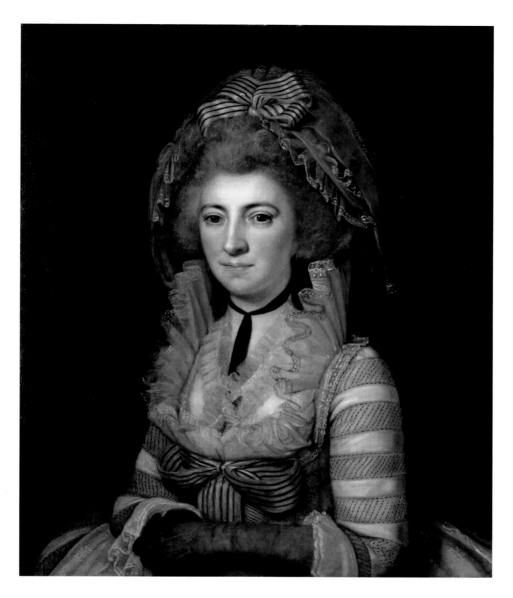

153 *Hester Lynch Piozzi (Née Salusbury, Later Mrs. Thrale)*

Italian, 1785–86

Described by James Boswell as "short, plump and brisk," the diarist Hester Lynch Salusbury married Henry Thrale, an affluent brewer, in 1763.[1] At Streatham Park, their house near London, she hosted a celebrated salon attended by prominent guests such as Boswell and Samuel Johnson. In 1775 the Thrales traveled to France with Johnson and visited Versailles together. While Johnson's journal of their experiences is factual, Thrale's is recounted with an immediacy and a keen sense of perception that make it delightful to read. She described the apartments in the palace as having "effaced every Sight my Eyes have yet seen for Riches, Pomp, & Beauty."[2] Widowed in 1781, the writer caused a scandal by marrying her daughter's music teacher, Gabriele Piozzi. As Mrs. Piozzi, she posed for her portrait in Rome wearing a beribboned cap and a striped gown with a ruffled gauze collar; the black ribbon around her neck accentuates her pale skin. The diarist's face radiates both intelligence and determination. DK-G

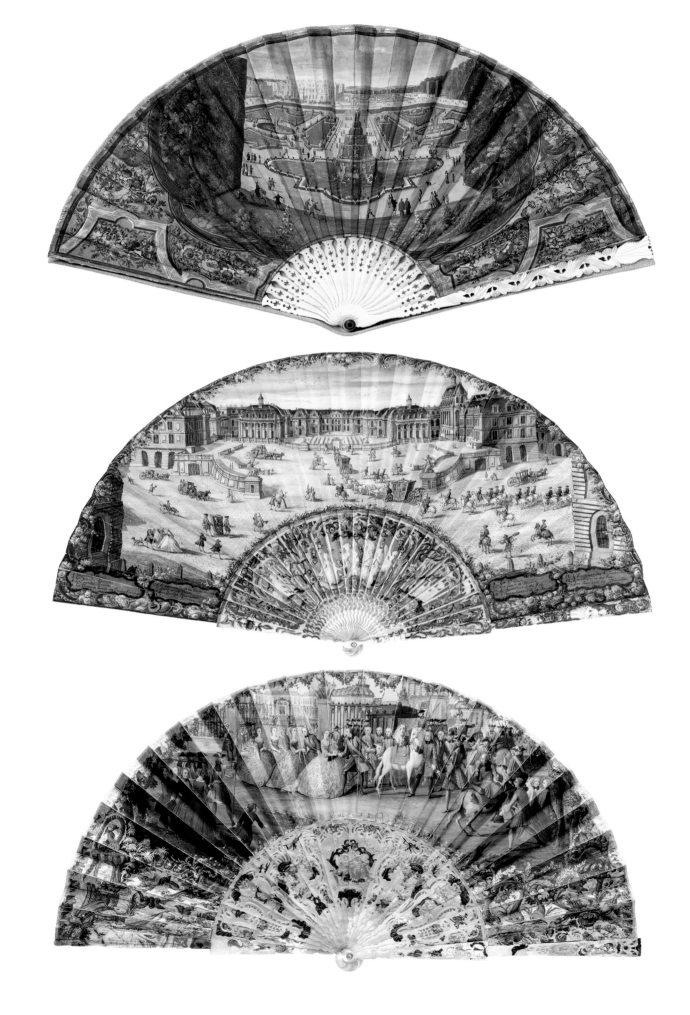

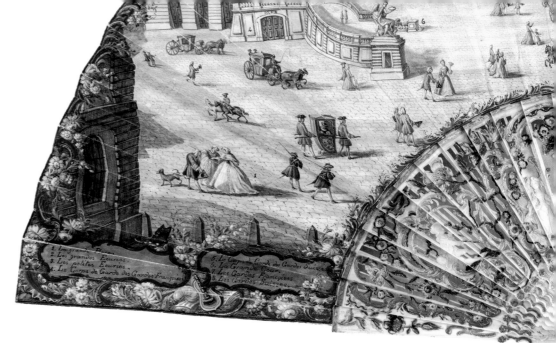

154 *View of the Pyramid Fountain in the Gardens of Versailles*

French, ca. 1680–90

155 *View of the Town and Château de Versailles*

French, ca. 1780–85

156 *The Marriage of the Dauphin Louis Ferdinand to Marie Thérèse, Infanta of Spain*

French, 1745

The creation of fans involved a *tabletier* (maker and vendor of stylish products), who usually produced the *montures* (sticks and guards), and an *évantailliste* (fan painter), responsible for decorating the leaf, which was subsequently pleated and assembled before being sold. Depending on their materials, these fashionable accessories could be precious gifts for special occasions or mementos of a visit to or an event at Versailles.

For the fan with the Pyramid Fountain—created in 1669–71 by François Girardon and turned on whenever Louis XIV or "someone of consequence" would pass by[1]—a print by a member of the Perelle family was meticulously colored, then glued on a fan leaf and framed with a stagelike composition of the painter's design.[2]

The fan depicting the facade of Versailles and its bustling forecourts has a key identifying fifteen parts of the building, including the Ambassadors'

Staircase. Based on an engraving by Antoine Aveline, the landscape scene near Versailles on the reverse is a compilation of two engravings published in 1780.[3] This places the fan's creation well past the 1752 demolition date of the Ambassadors' Staircase.

The painter of the fan showing the Dauphin greeting his Spanish bride at the palace gate in 1745 paid great attention to details such as the blue sash and star of the Order of the Holy Spirit on the coats of the groom and a member of his retinue. He included the French Guard (in blue and red uniforms) to the left of the entrance to the inner courtyard as well as the Swiss Guard (in red and blue uniforms) to the right. The distinctive pavement of the Marble Court is clearly visible behind. The reverse pays tribute to the Battle of Fontenoy, which took place on May 11 that same year and at which both Louis XV and the Dauphin had been present. DK-G

TOURISTS, SOUVENIRS, AND GUIDEBOOKS

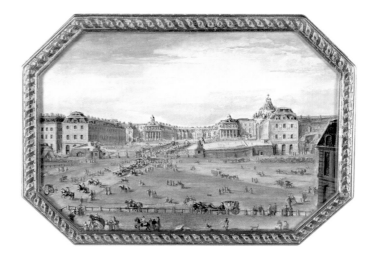

157 Snuffbox with Views of the Royal Residences

Jean Joseph Barrière, 1765–69

Although Horace Walpole reported in 1765 that people were selling all sorts of wares inside the palace, it is highly unlikely that luxury souvenirs such as this snuffbox were offered there.[1] The box is mounted with perspective views of the now-demolished châteaux of Marly, Bellevue, Saint-Hubert, La Muette, and Choisy, as well as with six images of Versailles. Seen from the Place d'Armes, the front of the palace decorates the lid, while the garden facade embellishes the underside.

The smaller miniatures at the corners illustrate four different groves in the gardens: the Colonnade, the Trois Fontaines, the Rocailles, and the Dômes. Most of the gouaches are after engravings from the series Les Maisons Royales de France (1730–ca. 1759) by Jacques Rigaud, completed after his death by his nephew Jean-Baptiste. This is the only box known by Barrière with a gold cagework (*à cage*) frame, here shaped like a balustrade around the hinged lid and like double pilasters at the canted corners. DK-G

158 *View of the Palace of Versailles*

Thomas Compigné, ca. 1760–80

Compigné, *tabletier du Roi*, specialized in the production of novelties such as snuffboxes, cane handles, and various games, which he sold in his Paris shop Du Roi David, located in the Rue Greneta.[1] He was best known, however, for his so-called *compignés*, panels or medallions of tortoiseshell or tin embossed with landscapes or genre or topographical scenes. Metal leaf, gouache, and colored varnishes, applied on top in a technique that has remained a mystery, gave the compositions color and heightened their naturalism. It is not known if this medallion with a view of Versailles was finished in a similar manner. Frequently based on paintings and engravings, Compigné's

works were usually framed for display. In 1772 he traveled to Versailles to present Louis XV with two tortoiseshell panels depicting the hunting castle of Saint-Hubert.[2] Marie Antoinette received two works from Compigné in 1774, one of which commemorated Louis XVI's succession to the throne.[3] DK-G

159 Set of Eighteen Buttons with Views of the Palace and Gardens of Versailles

French, ca. 1780

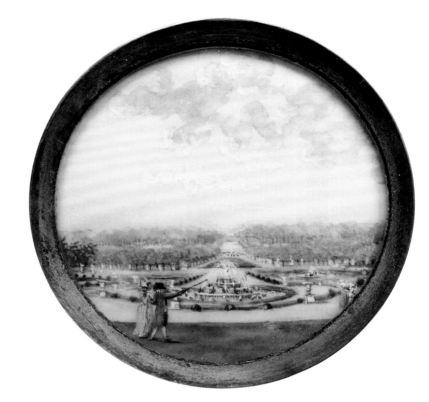

Great variety in materials and techniques characterized the buttons produced in late eighteenth-century France. They were sold in specialized shops such as A la Toilette d'Or of Sieur Darnaudery, supplier to the king, located at the Palais Royal. Some of these buttons may have appealed to tourists since they were decorated with images of Parisian monuments or nearby châteaux.[1] Each of the coin-size buttons of this set, intended for a man's coat, shows a different view of the palace and gardens at Versailles, including the Colonnade and the Latona, Obelisk, and Pyramid fountains. Painted in gouache on an ivory ground, these minute compositions are probably based on engravings. DK-G

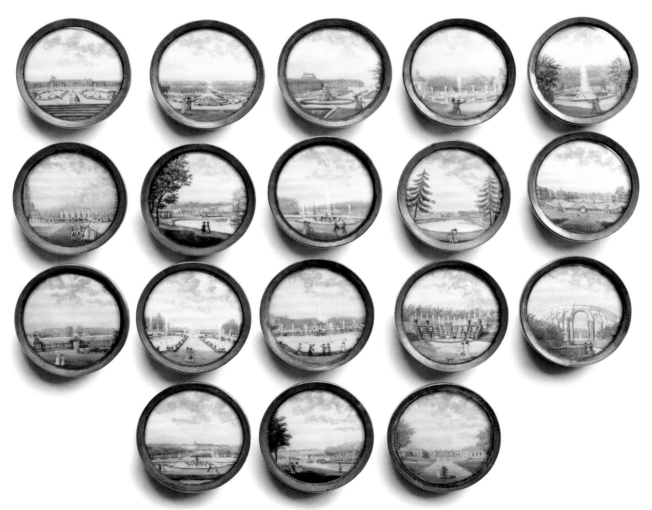

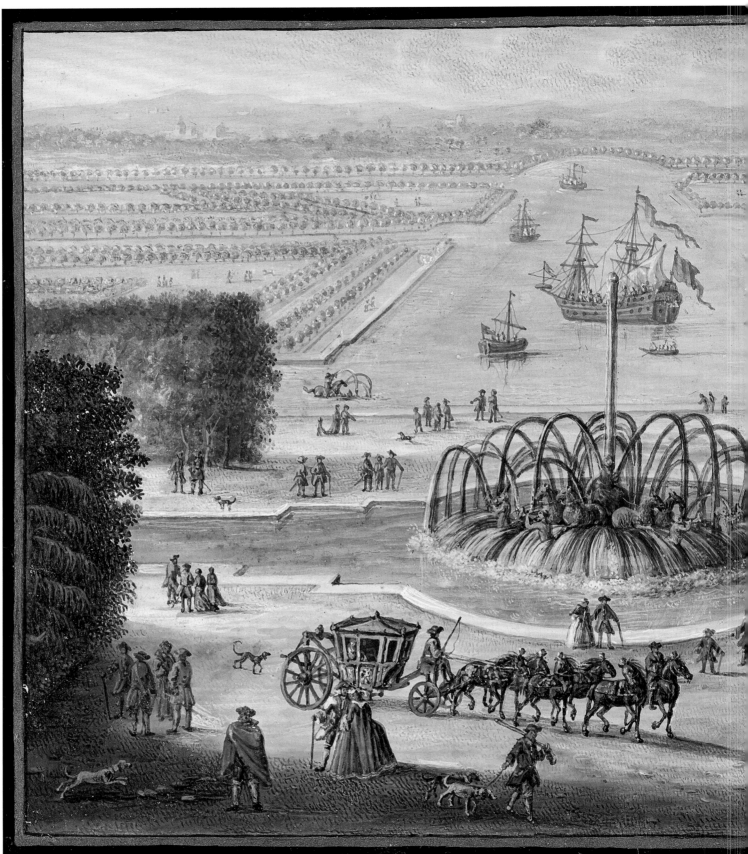

Le Bassin d'Apollon a

160 *The Basin of Apollo and the Grand Canal*

French, 1700–1725

Widespread in Europe during the eighteenth century, the views of European cities and monuments known as *vedute* were intended for a well-to-do public, in particular for aristocrats undertaking the Grand Tour. This small gouache, although not equal in quality to Canaletto's or his nephew Bernardo Bellotto's views of Italian cities, is a fairly exact depiction of the Basin of Apollo and the Grand Canal as designed in 1664. One sees Jean-Baptiste Tuby's large sculpture depicting Apollo on his chariot pulled by four horses and surrounded by tritons and sea monsters (finished in 1670) as well as the two hippocampi placed on either side of the end of the Grand Canal in 1676. With its strolling visitors, hunter and dog, carriages, and boats on the Grand Canal, the view effectively captures the animation of the gardens. EM

161 *Optical View of the Hall of Mirrors*

French, ca. 1760

Optical views, meant to be seen through a special device containing a magnifying lens and mirror to create the illusion of depth, reached their heyday between 1750 and 1770, when they were produced by several families of Parisian printers. This view showing the Hall of Mirrors was probably inspired in part by an engraving by Antoine Hérisset after a drawing by Sébastien Leclerc the Elder. However, its depiction of the gallery's decoration lacks detail and contains errors, as it represents the first design for the ceiling, on the theme of Apollo, which was never actually realized. Although appropriate for topographic scenes, the standard format for optical views (about forty-five centimeters long) resulted in major distortions, here accentuating the width of the gallery. Finally, the application of color was rather crude, as seen here in the green-colored mirrors. The captions in Latin and French indicate the educated public for which optical views were intended, as well as their distribution throughout Europe. EM

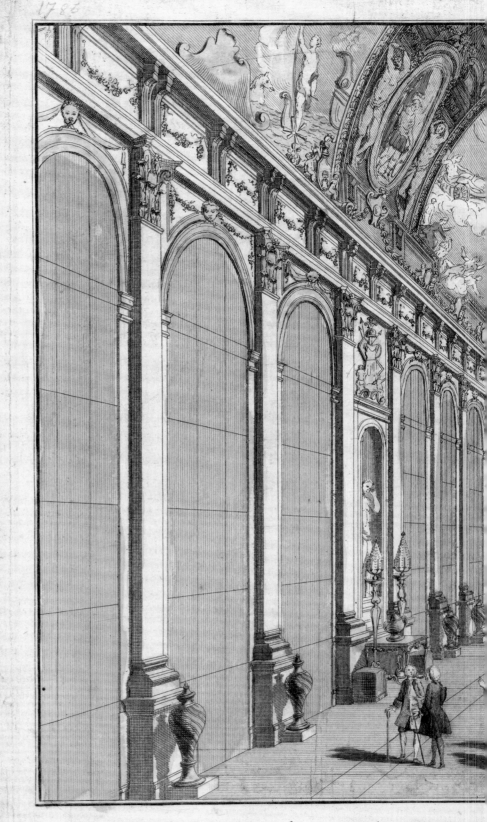

Versalicarum Ædium Major Porticus

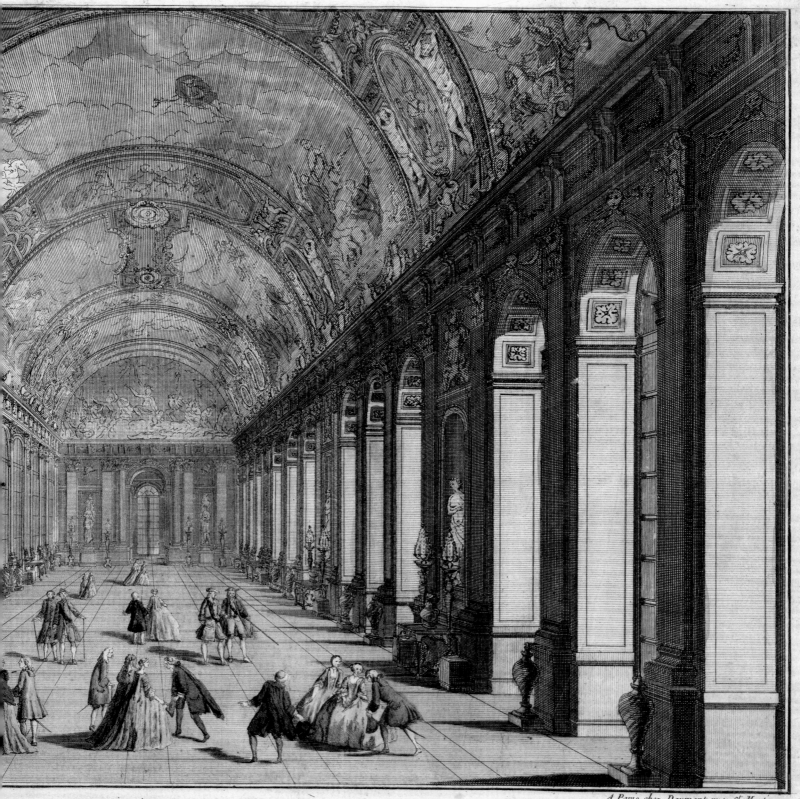

A Paris chez Daumont rue St. Martin.

57.ᵉ VÜE D'OPTIQUE
Repre∫entant

La Grande Gallerie de Versailles.

AMERICANS
AT VERSAILLES

THE AMERICANS

PAUL STAITI

Twenty-two-year-old Isaac Smith Jr., son of a wealthy Boston merchant, spent a day at Versailles in 1771, breathlessly gossiping to future president John Adams afterward that Louis XV was "fond of bestowing his caresses" on the "present *Sultana*," that is to say, Madame Du Barry. Surely, the starchy New Englander intoned, the "amours" of the king ought to be "mortifying" to the French. But Smith nonetheless had to admit he relished "admiring the charms of this celebrated Lady."[1]

Enchantment and its opposite, repulsion, were the strong responses experienced by Americans who came to Versailles either as tourists on the Grand Tour or as diplomats assigned to the Bourbon court. John Jeffries, a Boston surgeon and scientist living in London (fig. 96), flew a montgolfier balloon across the Channel with Jean Pierre Blanchard in 1785, touching down in Guînes. He journeyed to Versailles, toured the grounds—"magnificent beyond my expectations, the statues in the gardens and the spouting deities and sea gods . . . most magnificent"—and on a subsequent visit caught Marie Antoinette casting her "lovely eyes on me."[2] In 1776 Katherine Greene Amory (fig. 97), wife of a prominent Boston merchant and Loyalist, strolled the "beautifull" gardens and encountered the king and queen "in the grand Gallery, which is p[er]haps the finest Room in the world."[3] Thomas Shippen, a twenty-one-year-old lawyer from a prominent Philadelphia family, concurred in 1788: "The situation of this superb building is worthy of its grandeur . . . the unrivalled gardens of this enchanting paradise—What walks! What groves! What water works!"[4]

While Shippen was charmed by the "Oriental splendor and magnificence" of Versailles, he also felt he was in a strange land obsessed with pomp and protocol. He was, moreover, appalled by the thought of "how many thousands of [the king's] subjects were doomed to want and wretchedness" because of the extravagance.[5] Doctor Benjamin Rush, also of Philadelphia, felt moral disgust. Attending a Grand Couvert in 1769, at which the king and queen dined in public, he was shocked to see that "a common prostitute [Madame Du Barry, the king's mistress], picked up a few years ago from the streets of Paris" was dining openly with the king's family. The twenty-three-year-old Rush also noticed that the daughters of Louis XV wore "a prodigious quantity of paint upon their cheeks," but it was not nearly enough to obscure "the want of that Beauty nature had denied them." The prudish and opinionated doctor was further appalled by the Dauphin, the

Fig. 96. After John Russell, *John Jeffries*, ca. 1785–86. Pastel on paper, 23¼ × 17⅞ in. (59 × 44 cm). National Maritime Museum, Greenwich, London, Caird Collection (PAJ2770)

future Louis XVI, pulling food out of his mouth and throwing it on the floor. "He is remarkably coarse," his movements "very awkward," and surely he "was formed on purpose to show the world of how little value Crowns, and Kingdoms are in the sight of Heaven."[6]

Benjamin Franklin first visited in 1767, at a time in his career when he was renowned only for his electrical experiments. In a letter to Polly Stevenson in London, he mapped the seating arrangement at a Grand Couvert (fig. 98) and described the curious dinner protocol: whenever

the king or queen "made a Sign for Drink, the Word was given by one of the Waiters; *A boire pour le Roy*, or, *A boire pour la Reine*." Two persons then approached, "one with Wine the other with Water in *Caraffes*; each drank a little Glass of what he brought, and then put both the *Caraffes* with a Glass on a Salver, and presented it." Although Franklin was one of many spectators that day, the king did him the "Honour of taking some Notice." Franklin, a loyal British subject then, assured Polly that Louis's attentions would not lead to "a Whit less regard" for his own king and queen, George III and Charlotte.[7]

However much Franklin was dazzled by the proceedings, the palace of Versailles was another matter. "The Range of Building is immense; the Garden-Front most magnificent, all of hewn Stone; the Number of Statues, Figures, Urns, &c., in Marble and Bronze of exquisite Workmanship, is beyond Conception. But the Waterworks are out of Repair, and so is [a] great Part of the Front next [to] the Town, . . . with its shabby half-Brick

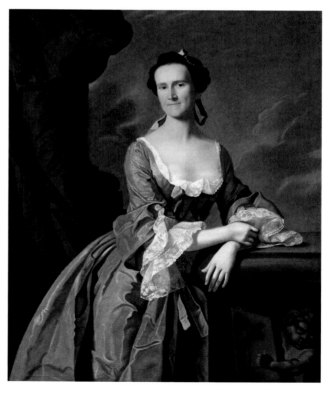

Fig. 97. John Singleton Copley, *Mrs. John Amory (Katherine Greene)*, ca. 1763. Oil on canvas, 49⅞ × 40 in. (126.7 × 101.6 cm). The M. and M. Karolik Collection of Eighteenth-Century American Arts, Museum of Fine Arts, Boston (37.36)

Fig. 98. Letter from Benjamin Franklin to Mary (Polly) Stevenson with seating chart of the royal family, September 14, 1767. Manuscript Division, Library of Congress, Washington, D.C. (Benjamin Franklin Papers, 1726–1907, MSS21451)

Walls, and broken Windows. . . . There is, in short, both at Versailles and Paris, a prodigious Mixture of Magnificence and Negligence, with every kind of Elegance except that of Cleanliness, and what we call *Tidyness*."[8]

John Trumbull visited the palace in 1786. A student of Benjamin West in London, the Connecticut artist had emerged as the great interpreter of the American Revolution. He was boarding at the Hôtel de Langeac in Paris with Thomas Jefferson (then the American minister to France), where in effect he was artist-in-residence,

and from there made excursions to Versailles. As a professional painter, Trumbull experienced Versailles as an unqualified delight. Jefferson reported to Francis Hopkinson in Philadelphia that Trumbull "returned last night from examining the king's collection of paintings at Versailles, and acknoleges it surpassed not only every thing he had seen, but every idea he had ever formed of this art."[9] In Trumbull's detailed notes from that visit, he effused over the artistry of Van Dyck, Correggio, Leonardo, Michelangelo, Raphael, and, especially, Rubens. Architecturally, he found

the Hall of Mirrors "most splendid," the Orangerie "a noble work," and the Fountain of the Giants redolent with the "grandeur of imagination."[10]

War and Peace

For many American travelers, Versailles was an endlessly interesting stop on a trip through Europe. But during and after the American Revolution, diplomats shifted the tone and content of visits to urgent political business. Franklin returned to Versailles in 1776, six months after signing the Declaration of Independence. As minister, his diplomatic goals were immense: solicit recognition of American sovereignty, acquire loans, negotiate commercial treaties, and request military involvement. He succeeded in persuading France to "make all the efforts in its Power" to uphold the liberty, sovereignty, and independence of the fledgling United States in its war for independence.[11] That would open American doors to the formidable French army and navy, laden with troops, commanders, and cannons, not to mention an ancient and active hatred of Britain. Thanks to the French, the Americans won the Revolution, but they inadvertently drained France's treasury in the process, with catastrophic results.

While he was at Versailles, Franklin, christened the *ambassadeur électrique*, did more than convince France to join the war. He personally conquered the court. Franklin shamelessly played to French expectations of Americans as curiously rustic by strategically forgoing court swords and wigs, donning beaver-pelted hats, adopting plain speech and folksy aphorisms, and wearing simple "ditto suits," so called because they use the same fabric and color for coat, waistcoat, and breeches (cat. 163; fig. 99). At fashion-conscious Versailles his plainness was a political stratagem that projected an image in keeping with the new republic's values and ideals.[12] After all, as Franklin knew better than anyone, statecraft was stagecraft.

The tactic worked. A decade earlier Franklin had boasted that "my Taylor and Perruquier had

Fig. 99. Louis Carrogis, known as Carmontelle, *Benjamin Franklin*, ca. 1780–81. Ink, crayon, and watercolor on paper; framed, 19½ × 14⅞ in. (49.5 × 37.8 cm). National Portrait Gallery, Smithsonian Institution, Washington, D.C. Bequest of Mrs. Herbert Clark Hoover (NPG.82.108)

transform'd me into a Frenchman," but as a representative of the new American republic, Franklin displayed an artful artlessness that allowed him to stand out at court.[13] When he arrived at Versailles for the official declaration of the Treaty of Alliance, dressed inappropriately, the crowd outside could have been aghast, but instead they cheered him as "The Apostle of Liberty, Citizen Franklin!"[14] The comte de Ségur marveled at his audacious ordinariness:

Nothing could be more striking than the contrast between the luxury of our capital, the

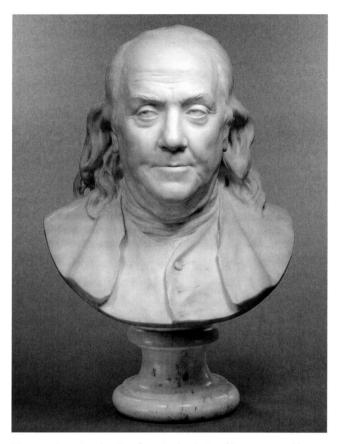

Fig. 100. Jean Antoine Houdon, *Benjamin Franklin*, 1778. Marble, H. with base 23⅛ in. (58.7 cm), W. 14½ in. (36.8 cm), D. 11¼ in. (28.6 cm). The Metropolitan Museum of Art, New York, Gift of John Bard, 1872 (72.6)

because all the European envoys by contrast wore "grand uniforms, covered with gold and cordons."[16]

Franklin so charmed the French that a lively market for Franklinalia arose, encompassing paintings, prints, sculpture, and decorative arts.[17] Busts of Franklin were carved by Jean Jacques Caffiéri, the *sculpteur du Roi*, and by Jean Antoine Houdon (fig. 100), who exhibited one at the 1779 Salon near his stunning heads of Voltaire and Rousseau. Prints allegorized Franklin as the American Zeus or a classical philosopher. A Lemire Père biscuit porcelain group contrasted an ascetic Franklin with a bedecked Louis XVI as the two men celebrate the 1778 Treaty of Alliance joining their respective countries (cat. 167). A grisaille profile of Franklin on the side of a Sèvres cup very nearly required drinkers to kiss the bald head of the "Doctor" (as he wished to be addressed in acknowledgment of his honorary degrees from Oxford and St. Andrews) (cat. 165).

Countless painters captured Franklin's distinctive features in portraits, the most famous of which was by Joseph Siffred Duplessis, a favorite at court (cat. 162). For his 1778 painting of a homespun Franklin he outfitted the painting with a frame full of symbolism. At the top, a laurel wreath circles over a "Don't Tread on Me" rattlesnake, while at the bottom a cartouche is bracketed by a liberty cap and lion skin, the latter a symbol of Hercules. Boldly spelled out is the Latin word for man: *VIR*. No other identification was necessary.

Franklin was everywhere. Medals were struck, tortoiseshell snuffboxes were fabricated, miniatures were nested in women's décolletages, wallpaper was hung, rings were fitted to pinky fingers, Quaker-style hats appeared on men's heads, and "lightning-conductor" dresses were designed with steel points connected to wires dragging on the ground.[18] Souvenir Sèvres medallions of Houdon's bust were sold at Versailles, "directly under the eyes of the King."[19] Franklin, for his part, reveled in the adulation, once crowing to his daughter that hundreds of medallions cast with his profile, along

elegance of our fashions, [and] the magnificence of Versailles, . . . on the one hand; and, on the other hand, the almost rustic apparel, the plain but firm demeanor, the free and direct language [of Franklin and the American envoys], whose antique simplicity of dress and appearance seemed to have introduced within our walls, in the midst of the effeminate and servile refinement of the 18th century, some sages contemporary with Plato, or republicans of the age of Cato and of Fabius.[15]

Court painter Elisabeth Vigée Le Brun said she was so taken aback by Franklin's *"extrême simplicité"* that "I should have taken him for a big farmer." She thought he stood out at Versailles

"with the pictures, busts, and prints, (of which copies upon copies are spread every where) have made your father's face as well known as that of the moon."[20]

John Adams, who had been assigned to the European courts, awkwardly parachuted into the French love affair with Franklin. As the court quickly came to realize, Adams had neither Franklin's social grace nor his intellectual ease. If anything, he rankled the court with unrelenting and abrasive demands for ever greater war assistance. Moreover, he was openly suspicious of the court's underlying motives in helping the United States. Yes, defeat Britain at all costs, but at the same time Adams believed that the comte de Vergennes, the French foreign minister, intended "to keep us down if he can.—to keep his Hand under our Chin, to prevent Us, from drowning, but not to lift our Heads out of Water."[21]

Adams wrote that he was nonetheless duly impressed by what he saw at Versailles: "I was . . . shewn the Galleries, and Royal Apartments, and the K's Bedchamber. The Magnificence of the Scaenes, is immense. The Statues, the Paintings, the every Thing is sublime."[22] The queen, he later noted in his autobiography, "was an Object too sublime and beautiful for my dull pen to describe. I leave this Enterprize to Mr. Burke" (a reference to Edmund Burke, member of Parliament and author of *A Philosophical Enquiry into the Origin of Our Ideas of the Sublime and the Beautiful*).[23] But he did not admire the pomposities of the court. One night he was surprised by an unanticipated invitation to attend a Grand Couvert. Amid the resplendence, Adams knew his modest clothing would expose him as "the raw American" that he was, to be gazed at like the "Sachems who came to make Speeches to Us in Congress." Scanning over the Salon, he registered all the "Gold and Diamonds and Embroidery about me," and imagined himself as some kind of visiting astronomer who "contemplates the Starrs." Later, when reflecting on the political and moral dimensions of

Fig. 101. Jean Démosthène Dugourc, *Project for a Calling Card for Benjamin Franklin*, 1784. Pen and black ink, gray wash. Galerie Talabardon et Gautier, Paris

that evening, he had to wonder whether there will come a day of reckoning when "these Ceremonies and Shows may be condemned by Philosophy and ridiculed by Commedy, with great reason."[24]

Adams was like an American bulldog in a French porcelain shop, so provoking to the court that Vergennes terminated all communication with him in 1780. Adams partially blamed Franklin for the rebuff, and resented the Doctor's celebrity status at Versailles and in France. With bitterness, he said that Franklin had "a Passion for Reputation and Fame, as strong as you can imagine, and his Time and Thoughts are chiefly employed to obtain it, and to set Tongues and Pens male and female, to celebrating him. Painters, Statuaries, Sculptors, China Potters, and all are set to work for this End" (fig. 101).[25] One night when Adams attended

a theatrical production at Versailles, a portrait of Franklin was put on display for the audience. Adams was so revolted that he "got up and left," pretending to be sick, which in a psychological way he was.[26]

To his surprise, all that tension magically lifted when the United States began peace negotiations with Britain. As Adams recalled it, when he approached Versailles in 1782, two years after his humiliation, he anticipated the court's further annoyance with his lack of politesse. He wondered how he would be received, with "an expostulation?

A reproof? An admonition? Or in plain vulgar English, a scolding?"[27] But instead of condescension he was unexpectedly exalted at the French court. The war won, Britain defeated, and peace negotiations at hand, bygones were now bygones. At a dinner at Versailles celebrating the end of war, Adams was showered with previously unheard-of compliments: "When Dinner was served, the Comte [de Vergennes] led Madame de Montmorin, and left me to conduct the Comtesse who gave me her hand with extraordinary Condescention, and I conducted her to Table. She made me sit next her on her right hand and was remarkably attentive to me the whole Time. The Comte who sat opposite was constantly calling out to me, to know what I would eat and to offer me petits Gateaux, Claret

Fig. 102. Benjamin West, *American Commissioners of the Preliminary Peace Negotiations with Great Britain*, begun 1783. Oil on canvas, 28½ × 36½ in. (72.3 × 92.7 cm). Winterthur Museum, Garden & Library, Delaware, Gift of Henry Francis du Pont (1957.0856)

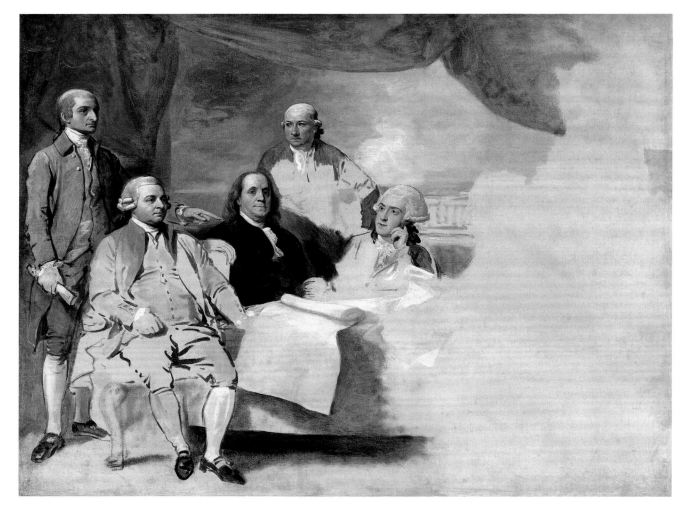

and Madeira &c. &c.—In short I was never treated with half the Respect at Versailles in my Life." He recorded every compliment in his diary: "Je vous felicite sur votre Success, is common to all. One adds, Monsieur, Ma Foi, vous avez reussi bien merveilleusement. Vous avez fait reconnoitre votre Independance. . . . Voila un Succés parfait. . . . Vous avez remué tout le Monde."[28] If that were not enough, it was topped by the most spectacular tribute imaginable to an American: "vous etes le Washington de la Negotiation."[29] Adams confessed to his diary that "a few of these Compliments would kill Franklin if they should come to his Ears."[30]

The peace treaty with Britain was the greatest diplomatic triumph in American history. When it was signed, American victory was sealed, sovereignty promised, and the debut of the United States on the world stage heralded. Benjamin West commemorated the achievement of the American diplomatic team in France with a luscious oil sketch, begun in 1783, showing Adams and Franklin sitting amicably next to each other, left of center, surrounded by John Jay, Henry Laurens, and William Temple Franklin (fig. 102). In West's vision of the peace accord, it is Franklin, in a black ditto suit, presiding as the calm hub of it all. He hovers over the document, sprawled over the table, as if he had hatched it.

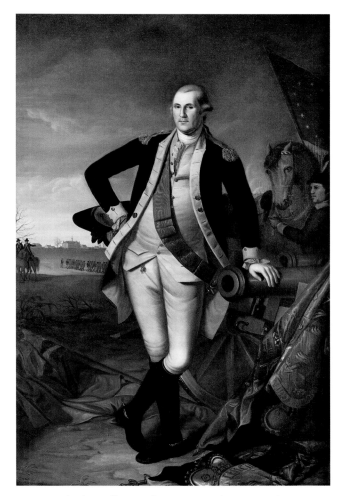

Fig. 103. Charles Willson Peale, *George Washington at Princeton*, 1779. Oil on canvas, 91⅛ × 58⅛ in. (232.7 × 148.3 cm). United States Senate, Washington, D.C. (31.00002.000)

Republican Style

George Washington may never have visited Versailles in person, but Conrad Alexandre Gérard, before departing from his post as France's minister to the United States in 1779, commissioned Charles Willson Peale to paint a full-length portrait of Washington after the successful Battle of Princeton so that he could present it to Louis XVI (fig. 103). Based on the Peale original hanging in the Pennsylvania State House (now Independence Hall), the picture tells the tale of a great American victory, which served to reassure Vergennes that France's investment in America was going very well. Moreover, it allowed Louis and the French court to encounter the famous Washington for the first time. Here was a new kind of military hero, the portrait says, a plain republican who is relaxed, confident, and approachable, as he crosses his legs, flares his elbow, and smiles charismatically. It was a portrait of leadership standing in stark contrast to the images in the War Salon that show Louis XIV in the guise of a conquering Roman general.

Adams, if only he could, would have dressed all the way down to Franklin's inimitable republican plainness. But instead he had to make some grudging concessions to the official mode if he wanted to gain any diplomatic traction. "The first

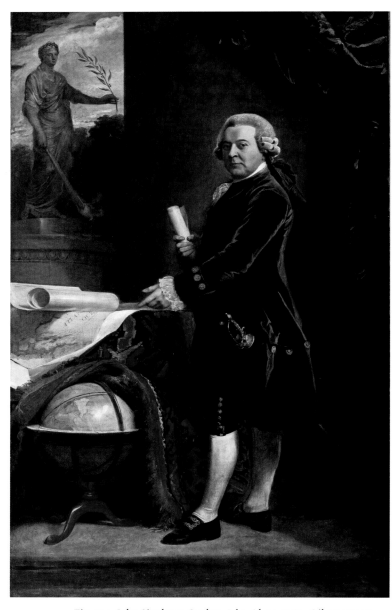

Fig. 104. John Singleton Copley, *John Adams*, 1783. Oil on canvas, 93¾ × 57⅞ in. (238.1 × 147 cm). Harvard University Portrait Collection, Cambridge, Massachusetts, Bequest of Ward Nicholas Boylston to Harvard College, 1828 (H74)

acquired "decent French Dress," which was paid for by Congress.[32] But none of it had to be fancy, and Adams could at least take cold comfort on his trips to Versailles by proudly covering his simple French outfit with "my American Coat."[33]

As a representative of a modern republic, he felt it imperative to look and behave American at the French court, where he hoped to be a walking rebuke to the values on display. John Singleton Copley painted a colossal portrait of Adams within weeks of the signing of the Treaty of Paris, giving some indication of what Adams was talking about (fig. 104). Although the setting is extravagant, Adams dresses modestly in a plain brown suit: an unmistakably political decision. Adams even tutored young Elkanah Watson on republican style when the Rhode Islander arrived in France. "Cultivate the manners of your own country, not those of Europe," Adams advised. Evince "a manly simplicity in your dress, equipage and behavior," and above all strive for "urbanity, without ostentation or extravagance."[34] Watson ignored the advice and hired a French tailor so as not to embarrass himself in front of Vergennes.[35] When Copley painted him in London, he wore a silk waistcoat and red jacket in the French style (cat. 168).

Like it or not, Adams and the other Americans had to conform to court custom at Versailles. The marquis de Lafayette privately admitted to the Americans that "we have a foolish law Call'd *Etiquette* that any one tho a Sensible man, must absolutely follow."[36] That meant adhering to hundreds of diplomatic conventions, whether the occasion was significant or trivial. Codes of behavior demanded that Adams engage in endless polite talk, and that Franklin overlook "the tenderness of my feet and weakness of my knees" and make the trek to Versailles to express condolences when Marie Antoinette's mother died, in 1780.[37] On the occasion of another death in 1784, Thomas Jefferson had to buy a black silk suit and wear it for eleven days.[38] A farcical example of compulsory court etiquette occurred in 1785 when

Thing to be done," Adams lamented in his diary, "is always to send for a Taylor, Peruke maker and Shoemaker, for this nation has established such a domination over the Fashion, that neither Cloaths, Wigs nor Shoes made in any other Place will do."[31] For his first visit to Versailles, in 1778, Adams

Adams and Franklin were officially "presented *for the first time*" to the king's two-month-old child, Louis Charles, "who received them in bed."[39]

When Jefferson succeeded Franklin as minister, in 1785, he encountered dramatic cultural change across France, but he thought that at Versailles the court and diplomatic corps would be "the last refuge from which etiquette, formality and folly will be driven. Take away these and they would be on a level with other people."[40] His job as minister required him to learn court custom, yet he also wished to project his newly won republican identity. Both modes are evident in Mather Brown's portrait of 1786, in which Jefferson's striped waistcoat and flamboyantly ruffled shirt are rococo in style, but over that fancy garb he wears a *frac*, an informal, loose-fitting jacket with working-class origins (fig. 105).[41] Jefferson stood out at Versailles, as noted by Thomas Shippen during his formal presentation before the king in 1788: "I observed that although Mr. Jefferson was the plainest man in the room, and the most destitute of ribbands crosses and other insignia of rank that he was most courted and most attended to (even by the Courtiers themselves) of the whole Diplomatic corps."[42]

Shippen also noted that Americans presented a peculiar problem to the court. "The etiquette of Versailles requires that all persons who are presented at Court shall have some pretensions to that honor from rank." But lacking rank, "in the case of Republics where there are no *hereditary distinctions*, those of *office* shall be substituted."[43] That meant that the Americans coming to Versailles in official capacities were unfamiliar with aristocratic ways and thus prone to gaffes. Congress probably made a mistake in sending John Laurens (cat. 169), an impulsive twenty-six-year-old lieutenant colonel in the Continental Army, to Versailles in 1780, with a mandate to acquire loans, guns, and ordnance. Before Laurens left America, Alexander Hamilton cautioned him to "(be at all) times supple" at court.[44] But Laurens and his assistant, the equally headstrong Tom Paine, stumbled badly. During one

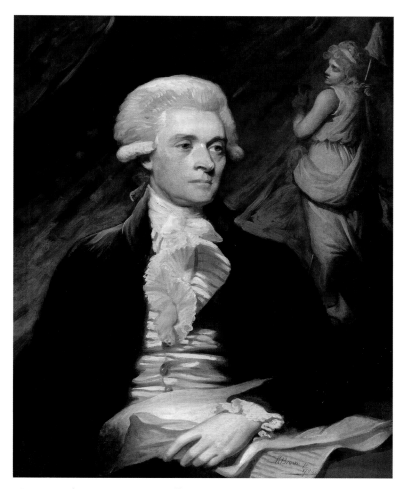

Fig. 105. Mather Brown, *Thomas Jefferson*, 1786. Oil on canvas, 35¼ × 28½ in. (90.8 × 72.4 cm). National Portrait Gallery, Smithsonian Institution, Washington, D.C., Bequest of Charles Francis Adams; Frame conserved with funds from the Smithsonian Women's Committee (NPG.99.66)

social event he committed the supreme faux pas of handing the king a written note requesting money.[45]

Gifts

Although Laurens embarrassed himself at Versailles, he was nonetheless treated like every other envoy when he left and was given a parting gift: a gold and enamel snuffbox ringed with twenty-four diamonds (cat. 170). On the cover, Louis Marie Sicardi's miniature of Louis XVI was set in thirty-two more diamonds. The king presented Franklin a far more extravagant gift: a

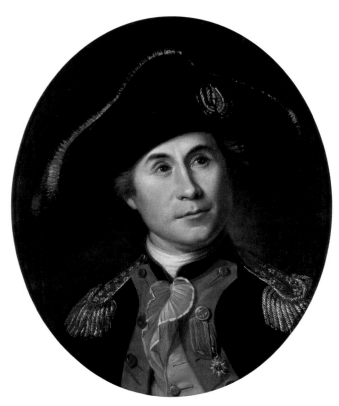

Fig. 106. Charles Willson Peale, *John Paul Jones (From Life)*, ca. 1781–84. Oil on canvas, 22 × 19 in. (55.9 × 48.3 cm). Independence National Historical Park, Philadelphia (INDE 11886)

boîte à portrait that had the miniature set inside two rings encrusted with 408 diamonds (cat. 164). In exchange, Franklin gave gifts to the royal family, including *Libertas Americana*, a medal he commissioned from Augustin Dupré, and *Constitutions des treize Etas-Unis de l'Amérique*, a commemorative book containing the constitutions of the thirteen states, the Declaration of Independence, and the Articles of Confederation, all translated into French and printed on the occasion of the Treaty of Paris (cat. 166).[46]

Before leaving France at the end of his tenure as minister (cat. 174), Jefferson fretted over gifts. There was no problem presenting gold snuffboxes to the French Introducer of Ambassadors and his Secretary, but, Jefferson announced, "I cannot rec[ei]ve the accustomary present from the king" because of a "clause in our new constitution."[47] The recently ratified United States Constitution addressed inappropriate political influence by

declaring it illegal to accept diplomatic gifts and emoluments from "any King, Prince, or foreign State" without "the Consent of the Congress."[48] At the same time, however, Jefferson knew that European protocol demanded he not reject a *marque de souvenir et d'estime*.[49]

Here was another episode of New World meets Old World. William Temple Franklin reminded Jefferson that it was "Part of the Law of Nations" to give and accept gifts and, moreover, that refusal to accept would be diplomatic suicide for the envoy and for the nation.[50] Jefferson's peculiar solution to his dilemma was to instruct his faithful secretary, William Short, to accept the present, secretly dismantle it, and then quietly sell the jewels in "Paris, London, or Amsterdam, depositing the money in my account," with the idea that the sale will cover the expense of buying farewell gifts for the king's staff.[51]

Americans outside the diplomatic corps never had to face such a quandary. John Paul Jones, the brash naval hero of the American Revolution who was made a chevalier in 1780, happily accepted a gold-hilted ceremonial sword (cat. 172) and proudly wore on his lapel the medal of the Institution du Mérite Militaire, as seen in portraits of him by Peale (fig. 106) and Houdon (cat. 171).[52] Jones so captivated the court that the choreographer Maximilien Gardel modeled a character after Jones in the three-act ballet *Mirsa*, which Gardel set on a fictional American island and premiered at Versailles in 1779. Jones was inspiration for the swashbuckling "Officier Corsaire," who tries to steal the affections of an American girl from a French colonel.[53] Marie Antoinette was said to be so taken with Jones during his residency that she "wanted to attach a feather to his hat. . . . This idea was found to be charming, & suddenly hats à la Paul Jones were being ordered from . . . the court's purveyor of fashion."[54]

New Realities

When Jefferson left his post as minister, he was replaced first by his protégé, William Short, and then by Gouverneur Morris, a framer of the

United States Constitution, a man less idealistic and trusting and more sanguine and skeptical than his predecessors (cat. 175). On one of his first trips to Versailles, in March 1789, Morris described the palace as "an immense monument of the vanity and folly of Louis Fourteenth."[55] In May he encountered the strange scene of the Estates-General, twelve hundred strong, gathered together for the first time in 175 years to address France's desperate financial crisis: "The beautiful lawn of the palace was crowded with groups of gayly dressed officers and high dignitaries of the church, each wearing the brilliant tokens of his rank. Ladies decked in the brightest colors and wearing the happiest smiles talked, sauntered about, and sat on the stone benches along the alleys underneath the delicate spring foliage." But nearby: "In striking contrast to these were the groups of the members of the Third Estate—shunned as if they bore the seeds of a pestilence among them. They talked in whispers, hurriedly and earnestly—they never smiled. Their costume of black hose and surtout and short black cloak, to which they had been condemned by the old sumptuary laws and which denoted the plebeian, made the contrast even greater."[56]

For Morris, Versailles was an object lesson in monarchical society. When he walked past the Petit Trianon a few days later, he wondered if the aristocracy understood at all that the luxury on display had occasioned the gathering of the disaffected Third Estate.[57] At the same time, though he realized there was much to revolt against, he surmised that it was folly to think that American-style republican government could be instituted in a nation "not yet fitted by education and habit for the enjoyment of freedom."[58] Left unchecked, the rush toward democracy will push France "headlong to destruction."[59] By July, when the tumult seemed unstoppable, he felt that Versailles had become "the most *triste séjour* on earth."[60]

From the start, in 1789, when he was just an American businessman dealing with the French, to his tenure as minister from 1792 to 1794, Morris adored Marie Antoinette and sympathized with her fate. He watched the crowd heap contempt upon her at the Estates-General, and could not "help feeling the mortification the poor Queen meets with, for I see only the woman."[61] When he traveled with Jefferson to hear Louis address the delegates nearby, he saw that the "Queen weeps or seems to weep, but not one voice is heard to wish her well."[62]

During the Terror, Morris rescued some men from the guillotine and hatched numerous escape plans for the king and queen, including an attempt to raise an army to protect them. But in 1793 he sadly wrote President Washington, "The Queen was executed the day before yesterday. Insulted during her trial and reviled in her last moments, she behaved with dignity throughout."[63] Perhaps as a talisman of his affection for her, he acquired a set of Marie Antoinette's furniture when it was sold at auction during the Terror (cat. 176). Morris would himself eventually run afoul of the Revolutionary government, which successfully demanded that Washington recall him in 1794.

For Morris, Franklin, Adams, and others, Versailles presented a unique opportunity for Americans to feel and express their Americanness. Up to 1789, their tenure at the palace had led them to unexpected encounters with an Old World culture they felt they were accelerating away from, and after 1789 it made them realize how fortunate their own revolution had been. While they were at Versailles, they obsessively compared American government, social customs, class structures, dress codes, and political discourse to those of their French counterparts, and whether that led to feelings of superiority, indifference, or bafflement, it unavoidably caused them to think about their own emerging New World identities. To them, Versailles was Europe condensed into a single entity, and as such it had the power to unlock and amplify the tastes and opinions of Americans who were just beginning to figure out who they were, or wanted to become.

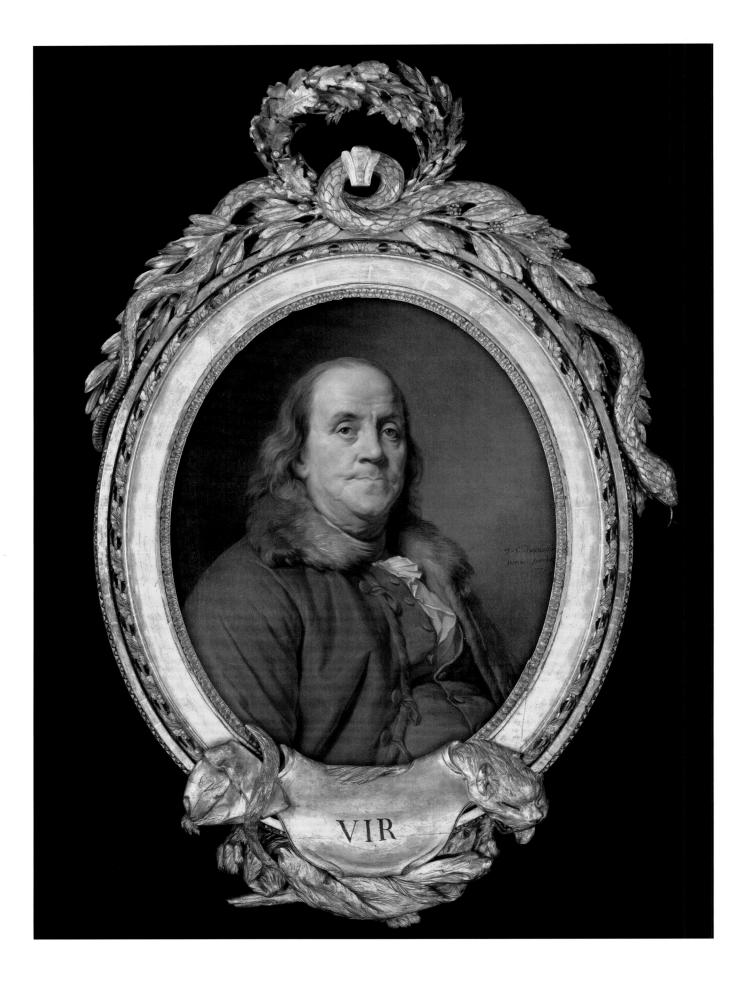

VIR

162 *Benjamin Franklin*

Joseph Siffred Duplessis, 1778

Frame: Attributed to François Charles Buteux, 1778

Duplessis's honest depiction of Franklin found favor with the sitter, who suggested that it could be used as a model for miniature portraits to save him the trouble of posing anew.[1] Dressed in a plain red coat with a fur collar, the famed American diplomat is rendered with a receding hairline and a bulging waistline. The portrait, shown at the Paris Salon of 1779 and copied numerous times, beautifully captures the unpretentiousness of Franklin's appearance. Its original frame incorporates attributes of Liberty, Peace, and Victory as well as the Latin inscription *Vir* (man, implying man of character). Possibly the work of the wood-carver Buteux, the frame has a crest that prominently displays a large, coiling rattlesnake slithering through olive and laurel branches.[2] The motif of this American reptile, which attacks only when tread on, was used in a woodcut by Franklin to argue for unity among the British colonies in America as early as 1754 and became a national symbol in the late eighteenth century.[3] DK-G

163 Three-Piece Suit *(habit à la française)*

French, ca. 1778–79

When Franklin was first presented to Louis XV, in 1767, he was dressed as a Frenchman, complete with bagwig. When he returned a decade later as an American diplomat and became a regular visitor to Versailles, the remarkable simplicity of his dress stood out. That his "rustic" appearance was deceiving is suggested by bills for luxury suits of vicuña wool, silk, and taffeta that he ordered in Paris in 1779, the year he became the American minister plenipotentiary to France; included among these was a plum-colored silk suit similar to this *habit à la française* with coat, vest, and breeches.[1] Franklin's flowing hair and his costumes' lack of adornment distinguished him at the court. DK-G

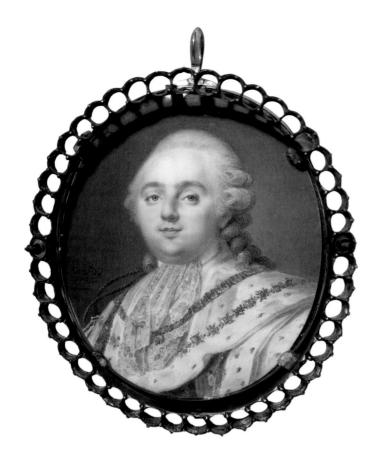

164 *Miniature Portrait of Louis XVI*

Louis Marie Sicardi, 1784

The registers of the *Présents du Roy* record, for June 7, 1785, "une boëte à portrait" (pendant with a miniature portrait of the king), valued at 16,103 livres, that was given to Benjamin Franklin after he took leave of the French court.[1] Only Sicardi's likeness of Louis XVI, wearing the Orders of the Golden Fleece and the Holy Spirit, remains of this precious gift. Originally it was framed by a double row of diamonds and surmounted by a similarly studded crown, counting 408 gemstones overall. The reverse of the miniature is engraved with a crown above a crossed *L* monogram framed by palm branches. In his will, Franklin left the jewel to his daughter, Sarah Bache, stipulating that neither she nor her daughters should ever wear the diamonds, most of which were later sold by her and her descendants.[2] DK-G

165 Cup and Saucer (*tasse litron*)

Sèvres Manufactory, ca. 1779

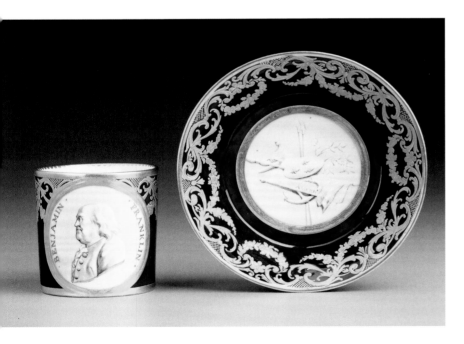

Considered an apostle of liberty, Franklin was celebrated as much for his scientific achievements and perceived wisdom as for his singular demeanor and simplicity of dress. As a result, he enjoyed a kind of cult status in France, and his image was widely disseminated in different media. This Sèvres cup has a medallion with the grisaille portrait of a bare-headed Franklin and is inscribed with his name. The well of the matching saucer shows symbols of the Franco-American Alliance formalized in the Treaty of Alliance, which was cosigned by Franklin on February 6, 1778. According to factory records, fourteen sets of such blue-ground cups and saucers were made between November 1778 and February 1779. The work of several different painters, they each show slight variations in their decoration.[1] DK-G

166 *Constitutions des treize Etats-Unis de l'Amérique*
(*Constitutions of the Thirteen United States of America*)

Printed in Paris, 1783

This volume, compiled under Franklin's direction, contains the separate constitutions of the thirteen original American states, the Declaration of Independence, and the Articles of Confederation as well as texts of various treaties. Louis Alexandre, duc de la Rochefoucauld d'Anville, sympathetic to the American cause, was responsible for the French translation.[1] Franklin ordered more than a hundred copies from the printer because he felt that "the extravagant Misrepresentations of our Political State, in foreign Countries, made it appear necessary to give them better Information, which I thought could not be more effectually and authentically done than by publishing a Translation into French, now the most general Language in Europe."[2] Every foreign ambassador in Paris received two books, one "handsomely bound" for himself and the other "more elegant" for his sovereign.[3] Six of these volumes, with the recipient's coat of arms on the covers, were presented to the royal family.[4] This particular copy belonged to Louis XVI, while the one presented to Marie Antoinette is now in the Bibliothèque Nationale de France, Paris.[5] DK-G

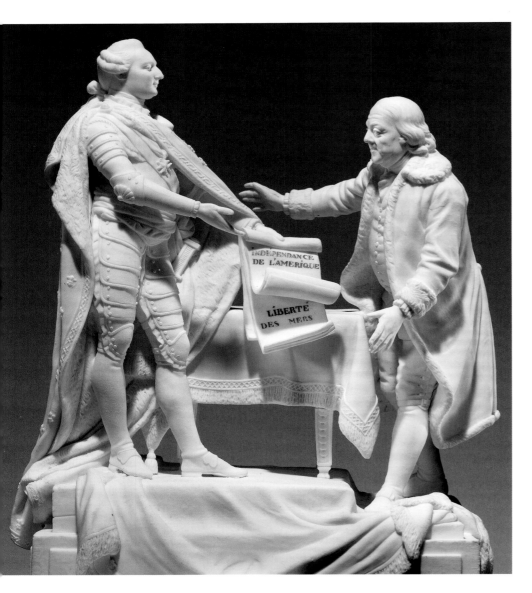

167 *Louis XVI and Benjamin Franklin*

Niderviller Manufactory, Lorraine, ca. 1780–85

Commemorating treaties signed in Paris on February 6, 1778, this biscuit-porcelain group symbolizes the Franco-American Alliance. The Treaty of Amity and Commerce recognized the independence of the United States as a nation and encouraged trade between the two countries, while the Treaty of Alliance provided French military support against Great Britain. Having thus secured the assistance of France for the American cause, Franklin went to Versailles on March 20, 1778. He was presented to Louis XVI that same day during the king's *lever*. The "handsome old man, with his spectacles and his bald head" attracted much attention at court according to the duc de Croÿ, who further stated that "only he who discovered electricity could electrify the two ends of the earth."[1] It is possible that the comte de Custine, owner of the estate where the Niderviller porcelain manufactory was established, may have suggested the subject, since he himself had participated in the American Revolutionary War.[2] DK-G

168 *Elkanah Watson*

John Singleton Copley, 1782

Carrying dispatches from the Continental Congress to Benjamin Franklin, Watson, a successful merchant, arrived in France in September 1779. At Franklin's request—and once he was properly attired in a new French suit[1]—he delivered the packet to the comte de Vergennes, the foreign minister, at Versailles. On that occasion, he also saw the king and queen attending mass in the Royal Chapel. In 1782 Watson left for London, where he had his portrait painted by Copley. Pleased with the appealing realism of the picture, the sitter observed that "the painting was finished in most admirable style."[2] Copley depicted him standing next to a writing table and possibly dressed in his French costume, with sequins decorating the flap of his waistcoat pocket. The sailing vessel in the background flies an American flag, symbolizing George III's formal recognition of the United States.[3] DK-G

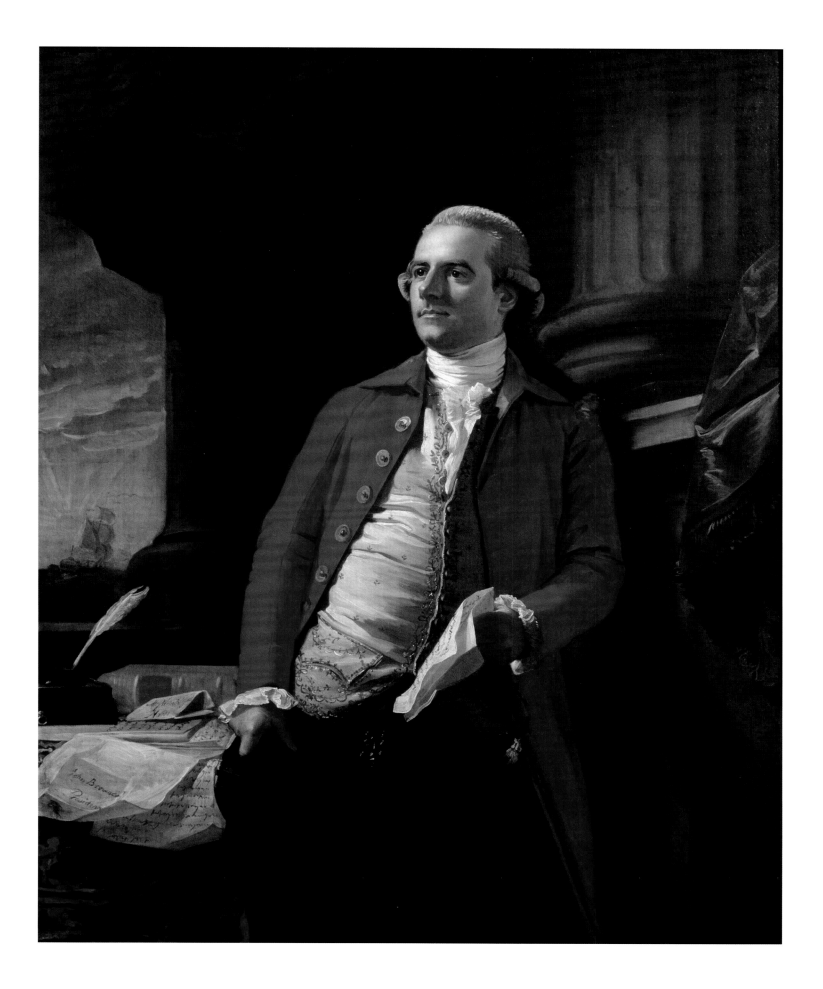

169 *Miniature Portrait of Colonel John Laurens*

Charles Willson Peale, 1780

170 Snuffbox with Miniature Portrait of Louis XVI

Box by Joseph Etienne Blerzy; miniature portrait by Louis Marie Sicardi,
ca. 1779–80

Aide-de-camp to George Washington during the Revolutionary War, Laurens was brave but reckless in battle. Peale rendered him as a handsome man dressed in a military uniform, gazing confidently at the viewer with a slight, somewhat arrogant smile. In December 1780, not long after Laurens received the miniature,[1] the Continental Congress named him a special envoy to France in order to help Franklin secure additional support for the American cause. Laurens spoke excellent French and was indefatigable in his mission, but his bluntness and disdain for protocol ruffled a few feathers at court (although his insistence ultimately paid off). On September 2, 1781, Laurens wrote to Thomas McKean, then president of the Continental Congress: "At taking leave of his most Christian Majesty, he desired me to renew his assurance of affection to the United States—the succeeding day his Majesty honored me with the accustomed present of his portrait."[2] Laurens refers here to this snuffbox, richly embellished with diamonds and valued at 3,830 livres.[3] For fear that valuable gifts from foreign nations might unduly influence American officials, such presents had to be reported to Congress for approval.[4] DK-G

171 *John Paul Jones*

Jean Antoine Houdon, 1781

172 Presentation Sword

Mounted by the workshop of Veuve Guilmin,
Versailles, 1780

During the American Revolution, Jones, a Scottish
seaman, joined the Continental navy and became
captain of a refitted French merchantman, the
Bonhomme Richard (Poor Richard, after Franklin's
pen name). After he heroically defeated the
fifty-gun British frigate *Serapis* in 1779, Jones went
with Franklin to Versailles, where Louis XVI
honored him with the French Order of Military
Merit and this gold-hilted presentation sword. The
pommel of the sword is decorated with the French
coat of arms, a figure of Neptune, and reeds—ref-
erences to both the donor and the recipient. The
figures of Mars and Minerva, military motifs and
emblems of the Franco-American Alliance, are
chased on the grip. Abigail Adams, expecting
Jones to be a "Rough, Stout, warlike Roman," was
surprised that he was small of stature, well pro-
portioned, polite, and soft-spoken as well as bold,
enterprising, and ambitious.[1] Houdon skillfully
expressed these qualities in the bust commissioned
by Jones's Masonic lodge in Paris, the Neuf Soeurs.
Seen here wearing the military cross from the king,
the celebrated naval hero ordered multiple plaster
casts of this bust for friends and associates. DK-G

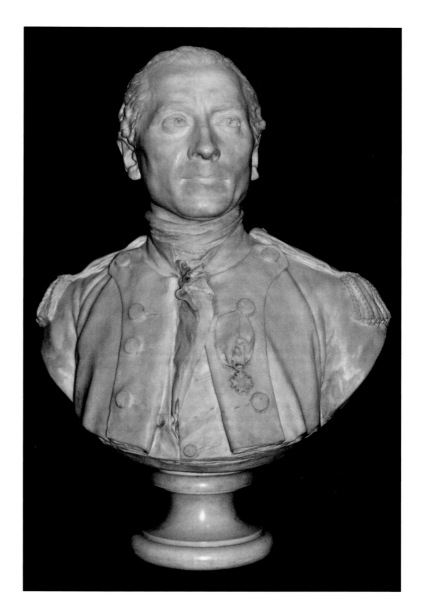

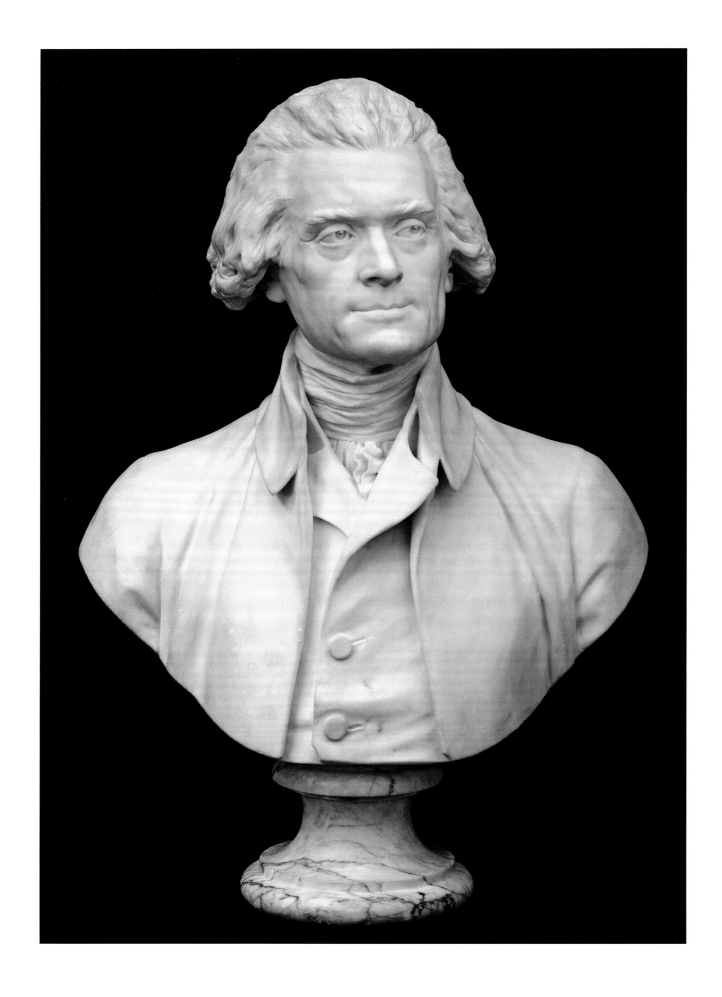

173 *Thomas Jefferson*

Jean Antoine Houdon, 1789

Upon succeeding Benjamin Franklin as minister plenipotentiary to France, Jefferson presented his credentials to Louis XVI in a private audience at Versailles on May 17, 1785.[1] While in Paris, he sat for this beautifully modeled marble bust by Houdon, whom he regarded highly.[2] Jefferson's head is slightly tilted, and his eyes, deeply carved below bushy eyebrows, look away from the viewer. Renowned for such lifelike portraits, the artist rendered the sitter dressed and coiffed according to contemporary fashion. Jefferson acquired a plaster copy of this work, together with ditto busts by the same sculptor of the marquis de Lafayette, John Paul Jones (cat. 171), Franklin, and George Washington, for display at Monticello, his estate in Virginia.[3] The diplomat witnessed the storming of the Bastille on July 14, 1789—the beginning of the French Revolution—but left France several months later. DK-G

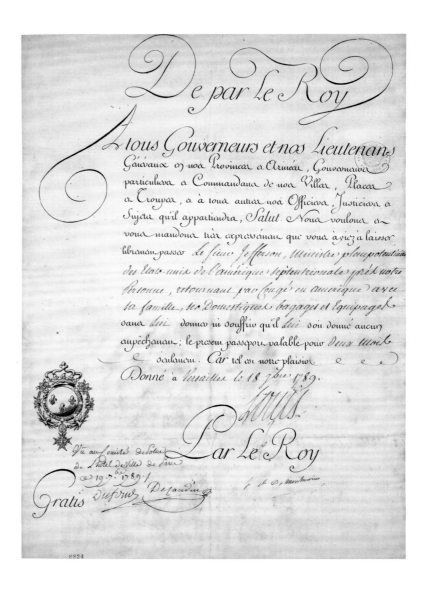

174 Passport Issued to Thomas Jefferson

French, 1789

Louis XVI signed this document at Versailles on September 18, 1789, just over a fortnight before an angry mob would force the French royal family to return to Paris. The passport allowed Jefferson, who had served as American minister plenipotentiary to France since 1785, to travel home with his family, servants, belongings, and even his carriage. DK-G

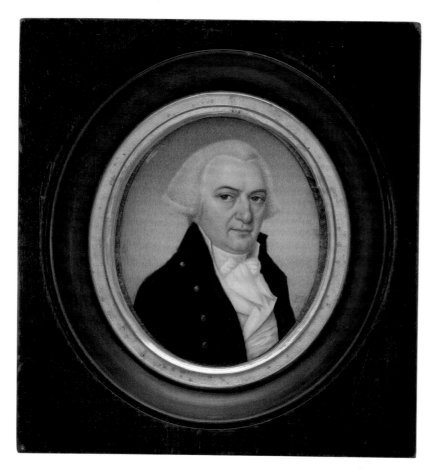

175 *Miniature Portrait of Gouverneur Morris*

Pierre Henri, 1798

176 Armchair (*fauteil à la reine*)

François II Foliot, 1779

The French émigré Henri painted this miniature in 1798 after Morris, American minister plenipotentiary to France from 1792 to 1794, had returned to New York. The sitter looks distinguished but older than his forty-six years, possibly because of the powdered wig. In the diary he kept while in France, Morris wrote that, when visiting Versailles on March 21, 1789, he could not see the Queen's Apartment because Marie Antoinette was there, "but it is ten to one that I should like her better than any other part of the furniture." Several weeks later, he did visit the rooms and judged their furnishings in "very good taste."[1] Morris may not have seen the set of seat furniture Foliot supplied in 1779 for the queen's Grand Cabinet Intérieur. Jacques Gondoin was responsible for its overall design as well as for the design of the exquisite silk-broché covering the walls and seats. When Marie Antoinette had the room redecorated in 1783, the wall hangings and seat furniture were removed to a private room upstairs generally not open to visitors. During the sales of royal property in 1793–94, Morris purchased the armchair and the rest of the suite and shipped them to his family estate, Morrisania, north of New York (now the Bronx). Recently the armchair was reupholstered with a reproduction of the original material.[2] DK-G

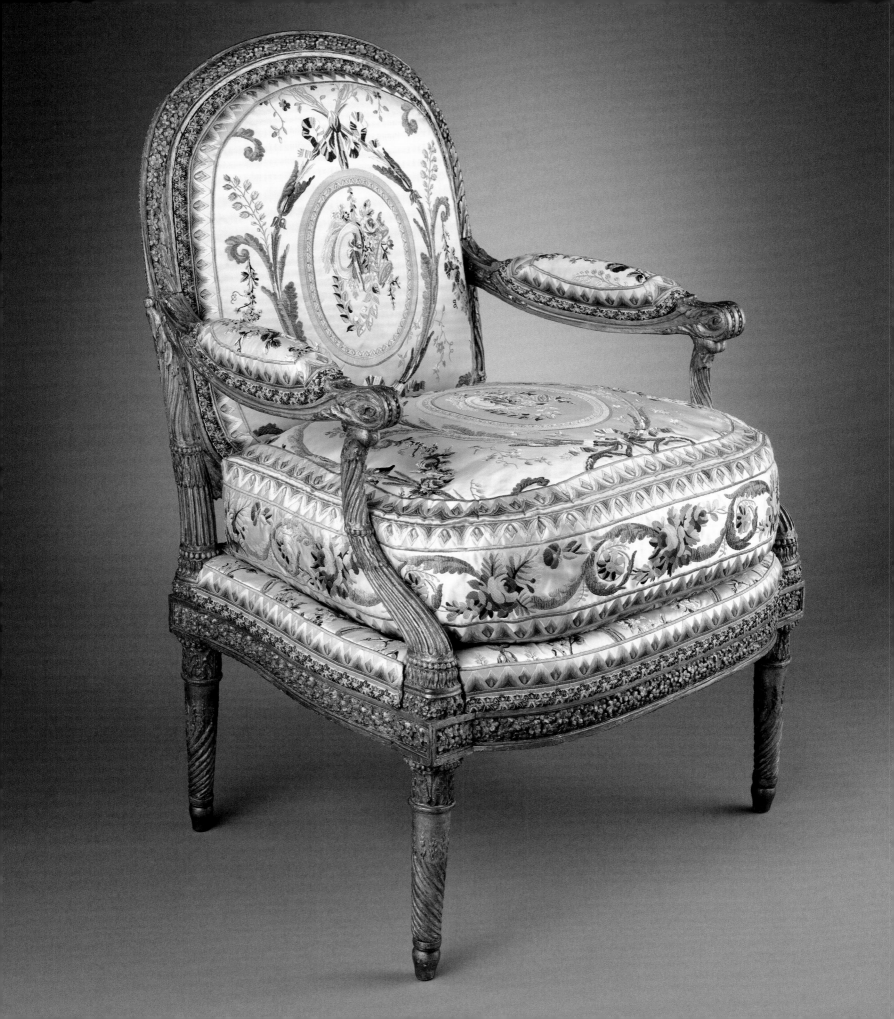

NOTES TO THE ESSAYS, WORKS IN
THE EXHIBITION, BIBLIOGRAPHY,
INDEX, PHOTOGRAPH CREDITS

NOTES TO THE ESSAYS

Notes to the texts accompanying works in the exhibition can be found on pages 322–39.

THE INCOMPARABLE VERSAILLES

1. Ferrier 1894, p. 27.
2. *Traveller's Companion* 1753, pp. 26–27. The dress code does not appear to have been strictly enforced. For comparison with access to the English court, see Bucholz 2000.
3. Mannlich 1910, p. 52.
4. In his report of December 3, 1723, Dutch ambassador Cornelis Hop, for instance, wrote that he would go to Versailles for the latest court news following the death of the duc d'Orléans, regent for Louis XV. Nationaal Archief, The Hague, Staten Generaal, 6802, report of December 3, 1723.
5. Sourches 1882–93, vol. 1 (1882), p. 101 (entry of May 6, 1682).
6. Montpensier 1776, vol. 5, p. 307.
7. Chantelou 2001, pp. 178–79.
8. Christopher Wren, quoted in Tinniswood 2001, pp. 134–35.
9. Sabatier 2016.
10. Nivelon 2004, pp. 471–72. The embassies received by Louis XIV had been evoked allegorically on the ceiling of the Mercury Salon; see Milovanovic 2005, pp. 129–30, nos. 55, 56.
11. Maral 2007a.
12. *Mercure galant*, January 1685, pp. 79–80.
13. In 1693 Guillet de Saint-George, historiographer of the Royal Academy of Painting and Sculpture, described in three meetings the life and oeuvre of Charles Le Brun, who had died three years before, and carefully explained the different scenes on the vault of the Hall of Mirrors; Sabatier 2016, pp. 262–63. See also Goodwin 2009, p. 21.
14. See Sabatier 2016, pp. 144–45.
15. Milovanovic 2007, pp. 190–91.
16. Nivelon 2004, p. 543.
17. France d'Hézecques 1873a, p. 140; French ed., France d'Hézecques 1873b, p. 142.
18. The bed and its dais were finally removed in 1745; Hans 2015, p. 23.
19. Baillie 1967. See also for Germany, and particularly Bavaria, Klingensmith 1993, pp. 10–18, 122–44.
20. France d'Hézecques 1873a, p. 140; French ed., France d'Hézecques 1873b, pp. 142–43.
21. Breteuil 1992, p. 87. The literal meaning of Salle de Descente is "getting out of the carriage." This memory refers to the audience of the Venetian ambassador Lorenzo Tiepolo on February 27, 1703.
22. Ibid., p. 61.
23. Ibid., p. 130.
24. Ibid., p. 151.
25. Sarmant and Stoll 2010. For that reason these meals were sometimes held in different rooms. The 1681 audience of the Muscovite ambassador, for instance, took place in the guardroom of Monsieur (the king's brother). *Mercure galant*, May 1681, p. 303.
26. Breteuil 1992, p. 160.

27. Ibid., p. 166. He suggested such a choice in a note addressed to the king: "the room of M. le comte de Toulouse, who is absent, would appear to be suitable, given the proximity of the small staircase." Ibid., p. 160.
28. Ibid., p. 135.
29. Archives Départementales, Meurthe-et-Moselle, MS B 12432, quoted in Motta 2014, p. 69, n. 38.
30. Bulgakova 2014, p. 245, n. 28.
31. Newton 2015a, p. 17.
32. Veryard 1701, p. 67.
33. Haller 1968, p. 32.
34. Peckham 1788, p. 205.
35. Bourdelot 2013, p. 206.
36. Richard Barrett to Joseph Barrett, June 2, 1719, Beinecke Rare Book and Manuscript Library, Yale University, New Haven, Conn., Osborn MSS 89, box 1, folder 3.
37. France d'Hézecques 1873a, p. 141; French ed., France d'Hézecques 1873b, p. 143.
38. A special issue of the *Mercure galant* (December 1682, pp. 1–72) gives a full account of the silver furnishings. See also Saule 2007b.
39. Radziwiłł 2011, pp. 229–30 (letter of March 2, 1685).
40. Tessin 1926, pp. 281–82.
41. Hardenberg visited Versailles in September 1741. His diary is in the Hardenberg Archiv, Lietzen, 1468, fol. 36; transcribed by Marcus Köhler. He may have learned the name of one of the silversmiths from a guidebook to Versailles, which listed the silver long after it had been melted down.
42. Maral 2007b, p. 53.
43. Pieter de la Court was struck by the fact that the individual mirrors were four times the size of the windowpanes facing them; Driessen 1928, pp. 52–53.
44. Upjohn 2016, p. 45 (entry of June 17, 1768).
45. Poole 1750, vol. 1, p. 158. The floor was polished with wax at dawn by workers who slept in beds set up in the Hall of Mirrors. See Saule 2007a, p. 62; Da Vinha 2009b, pp. 175–76.
46. Driessen 1928, pp. 52–53.
47. John Wickham, Diary, 1784–87, entry of April 16, 1784, Virginia Historical Society, Richmond, Va., Wickham Family Papers, Mss1 W6326 b, fol. 63.
48. Bourdelot 2013, p. 209. See also Maës 2013, paragraphs 41–42.
49. Although Highmore saw the ceiling before it was finished, he recognized its merits and gave the artist high praise: "I think [him] the ablest painter I have seen here in all respects." Johnston 1968–70, p. 86 (entry of June 25, 1734).
50. Amory 1923, p. 29 (entry of April 28, 1776). See also Nugent 1778, vol. 4, p. 117.
51. Alessandro Verri to Pietro Verri, March 8, 1767, in P. Verri and A. Verri 1980, pp. 350–51, letter no. LXIV.
52. Horace Walpole to the Reverend William Cole, September 5, 1765, in Walpole 1937, p. 96.
53. *Traveller's Companion* 1753, p. 27.
54. Castelluccio 2002, pp. 160–64.
55. Lambert Friedrich Corfey, Diary, in Lahrkamp 1977, p. 72; see also Perrin 1963–64, p. 200 (entry of March 23, 1699).

56. France d'Hézecques 1873a, p. 151; French ed., France d'Hézecques 1873b, p. 155.
57. France d'Hézecques 1873a, pp. 151–52 (translation modified by the present authors); French ed., France d'Hézecques 1873b, p. 156.
58. Henry Swinburne to Edward Swinburne, April 30, 1774, in Swinburne 1840, vol. 1, p. 12.
59. See Hardman 2016, p. 66.
60. France d'Hézecques 1873a, pp. 155–56, 152; French ed., France d'Hézecques 1873b, pp. 159–60, 156.
61. A. Young 1794, vol. 1, p. 83 (entry of October 23, 1787).
62. Charpenne 1890, p. 53 (entry of August 17, 1789).
63. Morris 1888, vol. 1, p. 41.
64. Trumbull 1841, p. 113.
65. See the Reverend James Hume's description of 1714 in W. Young 1889, vol. 2, p. 371. See also Peckham 1788, p. 212.
66. Upjohn 2016, p. 46 (entry of June 17, 1768). The clock is also mentioned in Mehmed Efendi 1757, pp. 155–56; Thicknesse 1766, p. 94 (letter of September 30, 1766); Peckham 1788, p. 208; Charpenne 1890, p. 53 (entry of August 17, 1789); Ireland 1790, vol. 2, p. 162.
67. Berger and Hedin 2008.
68. Hoog 1982, p. 11.
69. Ibid., pp. 11–14. See also Cornette 2007, p. 19; Berger and Hedin 2008, pp. 31–42.
70. Breteuil 1992, p. 271. The marquis of Bedmar, Isidro de la Cueva-Benavides, Governor of Arms of the Netherlands, came to Versailles on the occasion of the proclamation of Philip V as king of Spain.
71. See Thiéry de Sainte-Colombe 1784, p. 36.
72. Locke was less enthusiastic about the palace itself: "The rooms at the Chasteau are but little, & the stairs that goe up into the house seeme very litle in proportion either to the greatnesse of the house or the persons [who] are to mount by them." Locke 1953, p. 152 (entry of June 23, 1677).
73. Balthasar Neumann to his patron Johann Phillipp Franz Graf von Schönborn, prince bishop of Würzburg, April 14, 1723: "Yesterday I had the good fortune to see the fountains at Versailles operate for the first time." Lohmeyer 1911, p. 45.
74. Greene 1986, n.p. (entry of September 11, 1764).
75. Smith 1793, vol. 1, p. 70.
76. Dangeau 1854–60, vol. 1 (1854), p. 153 (entry of April 13, 1685); English trans. in Berger 1988, p. 129.
77. Stevens 1756, p. 44.
78. Ibid., p. 42.
79. Lucas 1754, p. 27. Advertised in various newspapers, this book went through four editions published between 1750 and 1765. See *Whitehall Evening Post or London Intelligencer*, June 21–23, 1750; *Gazeteer and London Daily Advertiser*, April 28, 1763; *Lloyd's Evening Post* (London), April 4–7, 1766.
80. Greene 1986, n.p. (entry of September 11, 1764).
81. The guide is later identified as Swiss, but it is not specified whether he was a member of the Cent-Suisses or the Swiss Guards; ibid., n.p. (entry of September 13, 1764). See also Lucas 1754, p. 28. According to Teofila Konstancja z Radziwiłłów Morawska, "After amusing

ourselves for a short time in the palace, we went with our assigned Swiss guard to the garden. He showed some places. Many were closed but he opened them." Morawska 2002, p. 70 (entry of October 7, 1773).

82. Newton 2011, pp. 38–41, 46–47. See also the travel diary of Friedrich Karl von Hardenberg (see note 41 above), fol. 33.

83. For a complete description of the Menagerie and its history, see Mabille and Pieragnoli 2010.

84. Guerrini 2015, pp. 114, 116.

85. Senior 2004, pp. 209–10.

86. Sahlins 2012.

87. Pieragnoli 2010a, pp. 109, 111, 115.

88. Dyâb traveled with Paul Lucas, a French merchant, naturalist, and antiquarian to Louis XIV. Dyâb 2015, pp. 261–62.

89. "Journal de l'ambassade de Suleiman Aga, envoyé extraordinaire du bey de Tunis près Sa Majesté très chrétienne, depuis son arrivée à Toulon, le 18 janvier 1777, jusqu'à son embarquement dans ledit port, le 31 may de la même année, rédigé par le sr Ruffin, secrétaire interprète du Roy pour les langues orientales, et chargé par Sa Majesté de la conduite dudit envoyé," Bibliothèque Nationale de France, Paris, Département des Manuscrits, Français 13982, fols. 14, 91. This journal was written by Pierre Ruffin, who served as translator during this embassy.

90. Rookmaaker 1983. The taxidermic remains of the rhinoceros are in the collections of the Musée National d'Histoire Naturelle and its skeleton is in the Musée d'Anatomie, both in Paris.

91. Ibid., p. 309. See also Morawska 2002, p. 71 (entry of October 7, 1773); Sander 1779.

92. A number of his studies are illustrated in Gallerani 2011.

93. For a complete description of the Labyrinth, see Maisonnier and Maral 2013.

94. In 1721 a "machine" made by the French silversmith Brouard of the fountains at Versailles, including those of the Fables of Aesop, was shown in London: "These waters play with such Art and Proportion, that the Natural are perfectly imitated. Those that have seen Versailles, will be charm'd to see in little, what they have seen at large; and those who have never seen Versailles, may satisfy themselves by this, which represents it in Perfection." The machine, possibly a table fountain, could be seen at the Globe and Duke of Marlborough's Head in Fleet Street from 10 A.M. until 10 P.M. *Daily Post* (London), no. 476 (April 10, 1721).

95. *Travels into France and Italy* 1771, vol. 1, p. 95.

96. Desjardins 1885; Hans 2007, pp. 15–21.

97. Nolhac 1899. The Anglo-Chinese garden was designed by the comte de Caraman, Antoine Richard, and Richard Mique, with some suggestions from Hubert Robert; see Newton 2011, pp. 200–209.

98. Oberkirch 2000, p. 214.

99. A. Young 1794, vol. 1, p. 83 (entry of October 23, 1787).

100. Ebert 1724, p. 145.

101. Moore 1779, vol. 1, p. 40. See also Mercier 1783–89, vol. 4 (1783), pp. 146–52, "La Galerie de Versailles."

102. See Burke 1992, p. 91.

103. Saint-Simon 1985, p. 382.

104. See Wolf 1968, p. 272; Burke 1992, pp. 87–91, 187, 191–94; Hours 2002, p. 395.

105. Solnon 1987, pp. 321–27.

106. James Harris Jr. to his father, 1st Earl of Malmesbury, November 22, 1768, in Malmesbury 1870, vol. 1, p. 167.

107. John Adams, Autobiography, pt. 2, "Travels and Negotiations," entry of May 8, 1778, in *Adams Family Papers* 2003–.

108. The king's mass took place at 10 A.M. during the reign of Louis XIV, at 1 P.M. under Louis XV, and at noon under Louis XVI; see Montagnier 2005, p. 48.

109. France d'Hézecques 1873a, pp. 171–72; French ed., France d'Hézecques 1873b, pp. 177–78.

110. Breteuil 1992, p. 244.

111. *Traveller's Companion* 1753, p. 25.

112. "There is nothing bold, assuming or affected in her manner." Horace Walpole to George Montagu, September 17, 1769, in Walpole 1941, vol. 2, pp. 291–92.

113. Romilly wondered "what an idea must he [the king] not conceive of his own importance, when he thus sees his God less honoured than himself?" Samuel Romilly to the Reverend John Roget, November 10, 1781, in Romilly 1840, vol. 1, pp. 177–78.

114. La Roche 2012, p. 284 (entry of May 31, 1785).

115. Poole 1750, vol. 1, p. 160.

116. Lady Holland to the Marchioness of Kildare, June 25, 1763, in Leinster 1949–57, vol. 1 (1949), pp. 379–80.

117. Bretschneider 1817, pp. 231–32.

118. The Reverend Dr. Jeans to James Harris, 1st Earl of Malmesbury, August 23, 1775, in Malmesbury 1870, vol. 1, pp. 317–19.

119. Public dining occurred less regularly under Louis XIV's successors, and by the end of the eighteenth century it took place only on Sundays and holidays.

120. Ferrier 1894, p. 26.

121. Giustiniana Wynne, in Di Robilant 2003, pp. 166–67 (quotations on p. 167).

122. *Mercure galant*, September 1684, pp. 213–14. Here the Chinese convert is referred to as Mikelh Xin. See also Rochebrune 2014, pp. 44–45, no. 9. A portrait of Shen (also known as Michael Alphonsus Shen Fuzong) by Sir Godfrey Kneller is in the Royal Collections, Windsor Castle (RCIN 405666).

123. Mozart's older sister Nannerl (Marie Anne) kept a diary during their travels. It reveals her keen observations of the fountains in the park: "Versailles. How Latona transforms peasants into frogs, how Neptune halts the horses, Diana at her bath, the rape of Proserpina—very beautiful vases in white marble and alabaster." Cited in Salinger 1991, p. 67, no. 42. The diary is in the collection of the Bibliotheca Mozartiana, Internationale Stiftung Mozarteum, Salzburg (B/D 77).

124. Abert 2007, p. 36.

125. Mannlich 1910, pp. 33–35.

126. Pennant stood in a tub of cinders, left behind by a *femme de chambre*, that offered him a better vantage point; Pennant 1948, pp. 27–28.

127. Benjamin Franklin to Mary (Polly) Stevenson, September 14, 1767, in Franklin 1905–7, vol. 5 (1906), p. 51;
Günderrode 1783, vol. 1, p. 127; "Matthew Baillie's Diary" 1927, p. 524 (entry of 1788).

128. For information about the small shops near the palace, which offered a variety of services, including those of hairdressers and wig-makers, as well as food and drink to courtiers and visitors alike, see Newton 2015b, pp. 313, 461–62.

129. Martin Roland, Diary, 1754–56, entry of August 24, 1755, Hagströmer Medico-Historical Library, Karolinska Institutet, Stockholm, MS, no. 126. Transcribed and translated by Jonas Nordin.

130. Morawska 2002, pp. 71–73 (entry of October 7, 1773).

131. Joseph to his brother Leopold, April, 29, 1777, in Arneth 1867–68, vol. 2 (1867), pp. 130–31.

132. La Roche 2012, p. 283 (entry of May 31, 1785).

133. Burke 1992, p. 9.

134. The Swiss engraver Johann Heinrich Meyer, however, remarked that the young Louis XVI resembled the engraved portrait he had recently bought of him; see Pestalozzi 1926, p. 99.

135. Driessen 1928, p. 53.

136. *Gentleman's Guide* 1770, pp. 71–72: "should you chance to be at Paris on a Whitsunday, *La fête de Pentecoste* in French, that is the time, preferable to any other throughout the year, you ought to be at Versailles; on which day you will see the most numerous and brilliant court in Europe; as the king and queen, with all the royal family, all the princes of the blood, and all the nobility of France, pass and repass in procession several times, and so slowly, that you may make your observations so just, as to know any of them personally ever after." For a description of the foot washing, see John Gemelli Careri to Amato Danio, April 11 and 15, 1686, in A. Churchill and J. Churchill 1732, vol. 6, pp. 98–103, letter nos. XVI, XVII. See also France d'Hézecques 1873a, pp. 178–80; French ed., France d'Hézecques 1873b, pp. 185–88.

137. For a description of the healing of the sick, see John Gemelli Careri to Amato Danio, April 15, 1686, in A. Churchill and J. Churchill 1732, vol. 6, pp. 102–3, letter no. XVII. The belief in the powers of thaumaturgic touch dated back to the Middle Ages. At the coronation, the king's hands were anointed, giving him the sacred power to heal. Louis XIV touched thousands of sick people during his reign, but his successors practiced this rite less frequently. Louis XV performed the royal touch early during his reign but suspended it in 1739; Louis XVI revived the practice only on the day of his coronation, in 1774. See Perez 2006.

138. Teleki 1943, p. 82 (entry of January 1, 1761). See also the description in France d'Hézecques 1873a, pp. 190–94; French ed., France d'Hézecques 1873b, pp. 199–203.

139. John Adams to Abigail Adams, May 15, 1780, in *Adams Family Papers* 2003–.

140. Höweler 1978, pp. 34–35. On this day the Holy Sacrament was carried in a solemn procession from the parish church in the town of Versailles to the Royal Chapel; see Hours 2002, p. 388.

141. Narbonne 1866, pp. 423–25.

142. Fleury 1836–38, vol. 1 (1836), pp. 164–65.

143. Thébaud-Sorger 2010.

144. Sourches 1882–93, vol. 1 (1882), p. 133, n. 2. This occurred in the apartment of Jean-Baptiste Colbert, where the Dauphine had sought refuge to avoid the noise from the apartment that had been allocated to her.

145. As recounted by Charles Lécuyer, Superintendent of the Bâtiments du Roi; Archives Nationales, Paris, O¹ 1071, no. 135.

146. Breteuil 1992, p. 134.

147. *Affaires de l'Inde* 1788.

148. Robson 1787.

149. France d'Hézecques 1873a, p. 218; French ed., France d'Hézecques 1873b, p. 235.

150. Leibetseder 2010, pp. 444–45.

151. Pitzler 2014. See also Tessin 1926; Dölle 2014.

152. Sturm 1719, p. 110. Sturm mentions views by Adam Perelle and prints of sculptures by Simon Thomasin. He refers to the decree issued by the Council of State on December 22, 1667, strictly forbidding all engravers and printers other than those working for the Cabinet du Roi from reproducing in print the plans and elevations of the royal residences and the works of art contained therein, thus protecting the official and commemorative engravings meant to be a visual embodiment of the Sun King's reign and an illustration of his artistic and military achievements. Grivel 1985, p. 38; Adamczak 2014–15, pp. 177–78.

153. Köhler 1997, p. 212.

154. Henry Swinburne to Edward Swinburne, April 30, 1774, in Swinburne 1840, vol. 1, p. 8.

155. *London Gazette*, no. 2315 (January 23–26, 1687). The model was 24 feet long by 18 feet wide. Could this have been the same "representation of the Chateau of Versailles in relief and of the gardens" packed in twelve cases that a "Sieur Defonual" had brought to London and tried to deliver as a present to the king? See "Entry Book: November 1687, 11–20," entry of November 11, 1687, in *Calendar of Treasury Books* 1923, pp. 1592–1609 (http://www.british-history.ac.uk/cal-treasury-books /vol8/pp1592-1609; accessed November 13, 2017).

156. Schramm 1744, col. 2181.

157. Holberg 1970, p. 62.

158. *Mercure de France*, December 1725, p. 2831.

159. Veryard 1701, p. 68. See also Keyssler 1751, p. 695.

160. Garrick 1928, p. 23.

161. Thicknesse 1766, pp. 54–55, letter no. XIII, August 30, 1766.

162. Ireland 1790, vol. 2, p. 161.

163. Thrale and Johnson 1932. The couple visited Versailles on October 22, 1775. For Thrale's account of their visit, see Thrale and Johnson 1932, pp. 130–33; for Johnson's, see pp. 177–78.

164. Ibid., pp. 131, 178.

165. Nationaal Archief, The Hague, Staten Generaal 6802, report of January 18, 1723, and Staten Generaal 6804, report of February 23, 1725.

166. Niedersächsisches Landesarchiv, Staatsarchiv Wolfenbüttel, 2 Alt no. 3642, fol. 40A, recto and verso.

167. Mehmed Efendi 1757, p. 141.

168. Horace Walpole to Richard West, May 15, 1739, in Walpole 1948, vol. 1, pp. 167–68 (quotation on p. 168). See also Stevens 1756, pp. 38–39.

169. A. Young 1794, vol. 1, p. 10 (entry of May 27, 1787).

170. Henry Lyte to George, 4th Earl of Cardigan, January 4, 1752, Buccleuch Papers, Dalkeith Palace, Scotland. For more information about Lord Brudenell's Grand Tour, see Fleming 1958.

171. See Da Vinha 2009b, p. 42.

172. Soullard 2000, p. 65. See also Newton 2008, pp. 94–101.

173. Elisabeth Charlotte, duchesse d'Orléans, to her Aunt Sophie, July 23, 1702, in Orléans 1970, p. 110.

174. W. Cole 1931, pp. 239, 235.

175. Stevens 1756, p. 40.

176. Peckham 1788, p. 205; first published in 1772. See also Levron 2009, chap. 12, "Les 'boutiques' du château de Versailles," pp. 211–21.

177. Bentley also noted shops of various kinds on the grand staircase and in the passages to the principal apartments; Bentley 1977, pp. 44–45 (entry of August 1, 1776).

178. Höweler 1978, p. 36.

179. Bombelles 1977, p. 173 (entry of November 12, 1782).

180. Coke 1970, vol. 4, p. 354.

181. Haller 1968, p. 32 (entry of September 25, 1727); diary of Friedrich Karl von Hardenberg (see note 41 above), fols. 29, 33.

182. Poole 1750, vol. 1, p. 161; Mannlich 1910, p. 50.

183. Radisich 1988.

184. See Robert Wharton to Thomas Lloyd, April 4, 1775, in Rodmell 1968–69, p. 78.

185. See Grosser 1989, pp. 345–59.

186. Grimm 1775, vol. 2, pp. 181–83. See also A. Young 1794, vol. 1, p. 10 (entry of May 27, 1787): "The ceremony of the King's dining in public is more odd than splendid. The Queen sat by him with a cover before her, but ate nothing. . . . To me it would have been a most uncomfortable meal, and were I a sovereign, I would sweep away three-fourths of these stupid forms."

187. Storch 1787, p. 314, cited in Grosser 1989, pp. 354–55.

188. Reverend Garland, "Minutes of a Journey through France," [1766], Beinecke Rare Book and Manuscript Library, Yale University, New Haven, Conn., GEN MSS 310.

189. Morris 1888, vol. 1, p. 41.

190. Carbonnières 2006b.

191. Schulz 1790, p. 182.

192. H. M. Williams 1791, p. 53, letter no. XI.

193. Beurdeley 1981, pp. 94–95. By 1792 there was "hardly any thing in the palace but the bare walls, a very few of the looking-glasses, tapestry, and large pictures remaining." See Twiss 1793, p. 38.

194. Karamzin 2003, p. 344, letter no. 117, June 1790.

195. Ibid., pp. 345–47, letter no. 117 (quotation on p. 347).

GOING TO VERSAILLES

1. See the list of these guides in the corpus "Descriptions imprimées de Versailles de Louis XIV à Louis XVI" on the website of the Centre de Recherche du Château de Versailles (http://chateauversailles-recherche.fr/).

2. See Da Vinha 2012, pp. 294–99.

3. For example, on October 26, 1788, the English traveler Richard Valpy rented a conveyance to go to Versailles for eighteen livres; see Valpy 1814, p. 539.

4. See Fromageot 1900; E. Houth and M. Houth 1980, pp. 281–83 ("Les moyens de transport"). For more details, see La Mare 1738, pp. 437–56 (book 6, pt. 12, "Des voitures en général," chap. 2). See also Louis Sébastien Mercier's description of the disagreeable travel by public transport from Paris to Versailles; Mercier 1783–89, vol. 8 (1783), pp. 67–70, "Carrabas, pots-de-chambre."

5. La Mare 1738, p. 437.

6. Ibid., pp. 438–39.

7. Ibid., p. 452.

8. Ibid., p. 453.

9. See Léry 1927, p. 62.

10. Ibid., p. 63.

11. "Mårten Törnhielms resa," 1687–88, MS, Roggebibliioteket, Strängnäs, quoted in Hedin and Sandgren 2006, app. B, p. 103, and see also p. 112, n. 115.

12. See E. Houth and M. Houth 1980, p. 282.

13. La Mare 1738, p. 454.

14. Ibid., p. 449.

15. See Fromageot 1900, p. 123.

16. See Sourches 1882–93, vol. 11 (1891), p. 236 (entry of December 12, 1708), and n. 1, on the moment when "the marquis de Brissac, former Major of the Gardes du Corps, negotiated his right to have *chaises bleues* with the marquis de Cavoye, to whom the King had extended the right to use it for life, including that of his wife."

17. See the letter from Leopold Mozart to Frau Maria Theresa Hagenauer, February 1–3, 1764, in Anderson 1938, vol. 1, pp. 50–51. A sou was similar in value to a sol.

18. La Mare 1738, p. 451; Léry 1942.

19. Archives Nationales, Paris, O¹ 1809, November 25, 1701.

20. Dangeau 1854–60, vol. 2 (1854), p. 6 (entry of January 12, 1687). A further allusion was made on January 16. This type of chair proved to be very useful to the king when he began suffering from gout.

21. Stevens 1756, pp. 37–38.

22. Nugent 1778, vol. 4, pp. 113–14.

23. See Leferme-Falguières 2015.

24. Trabouillet 1702, vol. 1, pp. 477–80 (quotation on pp. 479–80).

25. For further information, see ibid., pp. 477–82.

26. Ibid., pp. 481–82.

27. See Fromageot 1906.

28. Ibid., pp. 29–33.

29. See Narbonne 1866, p. 69.

30. Goubert 1992, p. 134.

31. Primi Visconti 1988, p. 29 (entry of 1673).

32. Ibid., p. 34 (entry of 1674).

33. A. Young 1794, vol. 1, p. 10.

34. Ibid., p. 83.

35. With the exception of mendicant monks, women of easy virtue, and persons afflicted with fresh smallpox scars.

36. See Nemeitz 1727, vol. 1, pp. 245–48, chap. 23, sect. 4, "Comment il faut faire, pour voir les Solennitez de la Cour, les Fontaines de Versailles jaillir devant du grand monde, les sollenitez & les Processions qui se font en Ville."

37. Ibid., p. 245.

38. Nemeitz confirms this in his more precise description of Versailles on ordinary days; ibid., vol. 2, pp. 495–504.

39. Ibid., vol. 1, p. 246.

40. Valpy 1814, p. 540 (entry of October 26, 1788).

41. Ibid.

42. See Levron 2003, pp. 190–91. See also Narbonne 1866, p. 69, where the number of guards during the reign of Louis XV is given.

43. Dashkova 1840, vol. 1, p. 172.

44. Valpy 1814, p. 542 (entry of October 26, 1788).

EXCHANGING LOOKS

My thanks to Alicia Basso Boccabella and Joséphine Grimm, who, during their internships at the Palais Galliera, Paris,

provided me with valuable assistance in the preparation of this essay.

1. Elias 1985, p. 71.
2. Ibid., pp. 71–72.
3. Dangeau 1854–60, vol. 15 (1858), p. 365 (entry of February 19, 1715); Breteuil 2009, p. 184.
4. Dangeau 1854–60, vol. 15 (1858), p. 365 (entry of February 19, 1715).
5. Fougeret de Monbron 2013, pp. 101–2.
6. Elisabeth Charlotte, duchesse d'Orléans, to the Raugravine Luise, August 9, 1702, in Orléans 1985, p. 218.
7. Oberkirch 1989, p. 336. An aune equals 3.9 feet. Twenty-three aunes is close to ninety feet.
8. Ibid., p. 339.
9. "Cérémonies du règne de Louis XIV," 1666–71 and 1682–91, Bibliothèque Nationale de France, Paris, Département des Manuscrits, Français 16633, fols. 273r–303v (quotation on fol. 293v). The train was nearly twenty-four feet long.
10. Chateaubriand 1849–50, vol. 1 (1849), pp. 337–38.
11. *Voyage des ambassadeurs de Siam* 1686, pp. 198–99.
12. Elisabeth Charlotte, duchesse d'Orléans, to her Aunt Sophie, December 8, 1697, in Orléans 1985, pp. 147–48.
13. Dangeau 1854–60, vol. 15 (1858), p. 364 (entry of February 19, 1715).
14. Luynes 1860–65, vol. 4 (1860), pp. 65–66, 75, 171 (entries of January 5 and 12 and June 12, 1742).
15. Breteuil 2009, p. 221.
16. France d'Hézecques 1873a, p. 133; French ed., France d'Hézecques 1873b, pp. 134–35.
17. Breteuil 2009, p. 313.
18. Luynes 1860–65, vol. 9 (1862), p. 350 (entries of March 5 and 7, 1749).
19. Ibid., p. 476 (entry of September 3, 1749). *Robe de chambre* is a generic term applied to large fashionable gowns pleated in the back, and more particularly to the *robe à la française*.
20. Ibid., p. 513 (entry of September 29, 1749).
21. Ibid., vol. 12 (1863), p. 435 (entry of May 6, 1753).
22. *Mémoires de Madame Campan* 1988, pp. 129–30.
23. La Roche 2012, p. 379 (entry of June 27, 1785).
24. Ibid., p. 380.
25. France d'Hézecques 1873a, p. 19 (translation modified by the present authors); French ed., France d'Hézecques 1873b, p. 9.
26. Bentley 1977, pp. 46–47 (entry of August 1, 1776). My thanks to Philip Sykas, British textile historian, who brought this valuable source to my attention.
27. *Mémoires de Madame Campan* 1988, p. 152.
28. Bill from La Hure, tailor, November 15, 1779; Franklin 1959–, vol. 31 (1995), pp. 102–4.
29. Bills from Angenend, master tailor, October 27, 1780, December 21, 1781, and August 19, 1784; http://franklinpapers.org/franklin//framedNames.jsp. See also Davray-Piékolek 2007.
30. Luynes 1860–65, vol. 9 (1862), p. 15 (entry of April 23, 1748).
31. Nemeitz 1727, vol. 1, pp. 82–83.
32. Ibid.
33. Oberkirch 1989, pp. 338–39.
34. La Roche 2012, p. 282 (entry of May 31, 1785).
35. Ibid., p. 306 (entry of June 7, 1785).
36. Bentley 1977, p. 47 (entry of August 1, 1776).
37. A. Young 1794, vol. 1, pp. 10, 83 (entries of May 27 and October 23, 1787; quotation on p. 83). For more on this subject, see "Going to Versailles" by Mathieu Da Vinha in this volume. My thanks to the author for being kind enough to share his knowledge.
38. W. Cole 1931, p. 239.
39. Sterne 1888, pp. 172–73.

MAGNIFICENT DISPLAY

1. Earl of Manchester to Matthew Prior, October 31, 1698, in C. Cole 1733, p. 65; Kugler 1985.
2. *Life of John Earl of Stair* 1748, pp. 203–8.
3. Matthew Prior to the Earl of Manchester, April 1, 1699, in *Prior Papers* 1908, p. 327.
4. Journal of the embassy of William Bentinck, Duke of Portland, to Paris, 1697–98, National Archives, London, SP 105/26.
5. Named "honors of the Louvre" after the restrictions that had been placed on access to the courtyard of the Louvre since the 1570s; Blin 2015. These honors also accorded other privileges of etiquette.
6. Journal of the embassy of William Bentinck (see note 4 above), fol. 26v (entry of March 11, 1698); "Mémoires de Nicolas de Sainctot (1602–1702)," Bibliothèque Nationale de France, Paris, Département des Manuscrits, Français 14117–14120, vol. 4, fols. 343–45, transcription by Alice Camus, 2015, in "Aux sources d'étiquette à la cour de France, XVIᵉ–XVIIIᵉ siècles: L'étiquette à la cour; textes normatifs et usages," directed by Mathieu Da Vinha and Raphaël Masson, Centre de Recherche du Château de Versailles (https://chateauversailles-recherche.fr/IMG/pdf/memoires_de_sainctot_t._iy.pdf); Dumont and Rousset de Missy 1739, vol. 1, pp. 38–40. See also Sabatier 2009.
7. Maral 2009, p. 130.
8. The *Mercure galant* covered the embassy in great detail; *Mercure galant*, May 1681, pp. 228–342.
9. Maës 2013, paragraphs 12–64.
10. *Mercure galant*, May 1681, p. 279.
11. Ibid., p. 305.
12. *Mercure galant*, May 1685, pp. 298–373 (quotation on p. 338); Dangeau 1825, vol. 1, pp. 32–34 (entries of May 12, 13, and 15, 1685). See also Castelluccio 2007, pp. 110–13.
13. Earl of Manchester to Alexander Stanhope, June 25, 1700, in C. Cole 1733, p. 149.
14. Dangeau 1825, vol. 1, pp. 35–36 (entry of May 17, 1685).
15. Spanheim 1882, pp. 296–97, 169.
16. William Trumbull to the Earl of Sunderland, January 9, 1686, National Archives, London, SP/78/148, fol. 162; Hedin and Sandgren 2006, p. 93.
17. Matthew Prior to Charles Montague, February 18, 1698, in *Prior Papers* 1908, p. 193.
18. British Library, London, Add MS 70362; Journal of the embassy of William Bentinck (see note 4 above).
19. Camus 2013.
20. Spanheim 1882, pp. 146–47.
21. Both the marquis de Dangeau and the duc de Saint-Simon record Portland holding the candlestick, but it is not in the official journal of the embassy. Dangeau 1825, vol. 1, p. 351 (entry of April 29, 1698); Saint-Simon 1954, p. 38.
22. "Mémoires de Nicolas de Sainctot" (see note 6 above), vol. 4, fols. 343–45.
23. Dangeau 1825, vol. 1, pp. 36–37, 38 (entries of May 19 and 22, 1685).
24. Matthew Prior to the Earl of Portland, March 4, 1699, in *Prior Papers* 1908, p. 317.
25. Creutz 2006, p. xxv.
26. Spanheim 1882, pp. 1–9; Matthew Prior to the Earl of Albermarle, March 1, 1698, in *Prior Papers* 1908, p. 195.
27. Earl of Hertford to Horace Walpole, October 28 and November 11, 1763, in Walpole 1974, pp. 218, 220.
28. Creutz to Gustav III, January 14, 1782, in Creutz 2006, p. 501.
29. Woburn Abbey Collection, Bedfordshire, box 19/23/2; J. Evans 1956, p. 149; Creutz 1987, pp. 33, 35, 38, 39, 43.
30. Creutz to Gustav III, August 19, 1766, in Creutz 1987, p. 39.
31. Greppi 1890, p. 367; J. Evans 1956, p. 150.
32. Woburn Abbey Collection, box 19/23/2.
33. Dangeau 1825, vol. 2, pp. 121–22 (entry of October 8, 1706).
34. Dumont and Rousset de Missy 1739, vol. 1, pp. 49–50.
35. Breteuil 1840, p. 159.
36. Earl of Hertford to Horace Walpole, November 11, 1763, in Walpole 1974, p. 220.
37. Earl of Hertford to Horace Walpole, October 28, November 11, and December 16, 1763, in ibid., pp. 217, 220, 261.
38. Horace Walpole to John Chute, October 3, 1765, in Walpole 1842, vol. 3, p. 430.
39. Thicknesse 1770, p. 39, letter no. 4, January 4, 1767.
40. Ibid., p. 248, letter no. 31, undated (between ca. June 24 and August 3, 1767). See also Hoog 1982.
41. Claude Labbé de Villeras (assistant to Nicolas de Sainctot and baron de Breteuil, Introducers of Ambassadors), Journal, entry of April 25, 1703, in Sabatier 2009, p. 207.
42. Berger and Hedin 2008, p. 67.
43. Claude Labbé de Villeras, Journal, entry of April 25, 1703, in Sabatier 2009, p. 207.
44. Matthew Prior to the Earl of Albermarle, April 23, 1698, in *Prior Papers* 1908, p. 212.
45. Guiffrey 1912, pp. 103–8; Archives Diplomatiques, Paris, Ministère des Affaires Etrangères, Correspondance Politique, Angleterre, vol. 178, fol. 38, document dated March 24, 1698.
46. Matthew Prior to the Earl of Jersey, May 17, 1699, Metropolitan Archives, London, ACC 510/104.
47. Hedin and Sandgren 2006, pp. 93–94. Lilierot and Tessin visited the gardens on September 20, 1687.
48. "Private Journal of Matthew Prior," entry of October 28, 1698, British Library, Add MS 70367.
49. Comte de Cheverny, in Newton 2008, pp. 63–64.
50. Woburn Abbey Collection, box 19/23/2.
51. Comte de Cheverny, in Newton 2008, p. 64.
52. Creutz to Gustav III, December 16, 1781, in Creutz 2006, p. 492.
53. Earl of Hertford to Horace Walpole, November 11, 1763, in Walpole 1974, p. 220.
54. Woburn Abbey Collection, HMC 8-47, fol. 86; Creutz 2006, p. xxiv.
55. Creutz to Gustav III, September 14, 1781, in Creutz 2006, p. 467.
56. A. Young 1792, p. 10 (entry of May 27, 1787).

SPECIAL EMBASSIES AND OVERSEAS VISITORS

1. On inaccuracies and recyclings in printed images of exotic ambassadors, see P. Stein 1997, pp. 83–86; M. Martin 2014, pp. 47–49.

2. Several recent books and exhibitions have explored the transformative impact that Asian luxury and consumer goods had on early modern Europe, among them Peck 2013; Rochebrune 2014; van Campen and Corrigan 2015. On "Siamoise" fabrics, see Thépaut-Cabasset 2014. Geneviève Lacambre claims that the Japanese lacquer cabinet depicted in cat. 66 in this volume was one of the gifts presented by the king of Siam in 1686; see Lacambre 2010, p. 47 and fig. 28.

3. Göçek 1987, pp. 14–17. Mehmed Efendi's *Sefâretnâme* was translated into French by Julien Claude Galland, a nephew of the first European translator of *One Thousand and One Nights*, and published in 1757. Galland's translation serves as the basis for Mehmed Efendi 1981.

4. On the role of interpreters and other intermediaries in diplomatic and cross-cultural exchange, see Rothman 2012.

5. On the Ambassadors' Staircase and its decoration, see *Charles Le Brun* 1990; Yerkes 2014–15.

6. Peter Burke discusses the concept of *gloire* in Burke 1992.

7. On ambassadorial receptions in the Hall of Mirrors, see Castelluccio 2006.

8. This propaganda value is suggested in a comment made by a French diplomatic official in connection with an embassy that Tipu Sultan of Mysore sent to Versailles in 1788, in which the official urged his colleagues to exploit the event so as to make the relationship between France and Mysore appear to be "more important than it actually is" (plus important même qu'elle ne l'est). André Piveron de Morlat, "Observations au sujet des ambassadeurs du Nabab Tipou Sultan," Archives Nationales, Paris (hereafter AN), C/2 174, fol. 156.

9. This ceremony is described in detail in Love 1996, pp. 192–96; van der Cruysse 2002, pp. 368–72; Castelluccio 2006, pp. 31–37. Their descriptions form the basis of my own account.

10. For more on this almanac print as well as the Siamese embassy gifts, see M. Martin 2015.

11. Love 1996, pp. 171, 195.

12. For a detailed description of this ceremony, see Castelluccio 2006, pp. 37–44.

13. Berger and Hedin 2008.

14. "Le plus beau moment de ma vie, est celui où j'envisage la gloire de votre [Louis XVI's] throne impérial." "Journal de l'ambassade de Suleiman Aga, envoyé extraordinaire du bey de Tunis près Sa Majesté très chrétienne, depuis son arrivée à Toulon, le 18 janvier 1777, jusqu'à son embarquement dans ledit port, le 31 may de la même année, rédigé par le sr Ruffin, secrétaire interprète du Roy pour les langues orientales, et chargé par Sa Majesté de la conduit dudit envoyé," Bibliothèque Nationale de France, Paris, Département des Manuscrits, Français 13982, fol. 79.

15. Berger and Hedin 2008, p. 28.

16. M. Martin and Weiss 2013, pp. 102–4.

17. Abdallah ben Aisha to Jean Jourdan, November 15, 1699, in Matar 2003, p. 208.

18. Matar 2015, pp. 69–70.

19. Matar 2003, p. xxiv.

20. Engelbert Kaempfer, quoted in Kosa Pan 2002, p. 24.

21. Letter from Cossigny (the French Governor-General of Pondicherry), July 21, 1787, AN, C/2 174, fol. 34. In the end, however, the monarchy decided that such an expenditure would be unwise given France's political

and economic crises of the late 1780s. Rather than the Hall of Mirrors, Louis XVI received Tipu's ambassadors in the more modest Hercules Salon on August 10, 1788. See M. Martin 2014, p. 57.

22. Mokhberi 2012. Mokhberi argues that this violation of protocol was the result not of cultural misunderstandings, as Louis XIV's Introducer of the Ambassadors, the baron de Breteuil, claimed, but stemmed rather from Muhammad Reza Beg's desire not to yield precedence to Louis XIV.

23. Saint-Simon 1968, pp. 404–5, quoted in Mokhberi 2012, p. 79.

24. Halbert 2011, p. 11. See also Omont 1910, pp. 170–71; Diabaté 1975.

25. Halbert 2011, p. 12.

26. Robert Wellington discusses the presentation of the *famille royale* medal to Aniaba and other foreign visitors (including the Abenaki chief Nescambiouit, discussed below) in Wellington 2016.

27. Ibid., p. 297.

28. Ibid., pp. 294–95. On Nescambiouit and his visit to Versailles, see Charland 1969.

29. In so doing, French officials were trying to avoid problems that had occurred in 1684, when two other Siamese emissaries had traveled to France and had been offended by certain aspects of royal protocol, most notably during an opera performance at Versailles. See van der Cruysse 2002, chap. 14; Welch 2017, chap. 7.

30. Kosa Pan 2002, p. 31. Unfortunately, only the Brest portion of Kosa Pan's journal (which stayed behind in France) survived; the rest was taken back to Siam and was destroyed in 1767, when Burmese invaders sacked the Siamese royal palace complex at Ayutthaya.

31. Mehmed Efendi, quoted in Göçek 1987, p. 41. He is referring to the royal ritual of the *lever*.

32. Ibid., pp. 4–5.

33. M. Martin 2014, pp. 51–52.

34. Baghdiantz McCabe 2008, p. 258. See also M. Martin 2015.

35. Mehmed Efendi, quoted in Göçek 1987, p. 57.

36. "Journal de l'ambassade de Suleiman Aga" (see note 14 above), fols. 87, 109, 110, 119.

37. Mehmed Efendi, quoted in Göçek 1987, p. 25.

38. Ibid., pp. 27–28.

39. Hamadeh 2008, pp. 17–47; Avcıoğlu 2011, pp. 76–80.

40. Göçek 1987, p. 69. Unless otherwise indicated, Göçek is the source for details of the 1720–21 and 1742 Ottoman embassies that follow.

41. Whitehead 2009, p. 171. One of these instruments was a microscope in a shagreen case that may have resembled a similar microscope made for Louis XV that is now in the collection of The Metropolitan Museum of Art (1986.1a–d).

42. P. Stein 1997, chap. 5. See also Landweber 2011, pp. 411–15.

43. This document is identified as the trade agreement in *Portrait de Son Excellence Saïd-Pacha* 1742, p. 14. On this agreement, which gave France "an unchallenged position in Levant trade," see R. Olson 1991.

44. P. Stein 1997, p. 153.

45. Mehmed Efendi, quoted in Göçek 1987, p. 45.

46. Ibid., p. 65.

47. My thanks to Nebahat Avcıoğlu for discussing this painting with me.

48. Whitehead 2009, p. 162.

49. Mander 2013, p. 149.

50. Matar 2003, pp. 199, 206.

51. Herbette 1907, pp. 50–51.

52. Pierre Ruffin, letter to the French navy minister Luzerne, August 21, 1788, AN, B/3/803.

53. Ruffin to Luzerne, August 23, 1788, AN, B/3/803.

54. Ruffin to Luzerne, October 20, 1788, AN, B/3/803.

55. Both portraits are visible in a drawing of the Salon of 1789 by Charles de Wailly; see Wilhelm 1963, p. 8.

56. Vigée Le Brun 1869, vol. 1, pp. 41–43.

"PRÉSENTS DU ROY"

1. Archives Diplomatiques, Paris, Ministère des Affaires Étrangères (hereafter MAE), Mémoires et Documents, France, vols. 2037 to 2098. This numbered series includes lists of gifts, sometimes with a copy, as well as registers and account books. See Thépaut-Cabasset 2007–8.

2. Thépaut-Cabasset 2007–8.

3. Richefort 1998.

4. Guery 1984.

5. Wicquefort 1680–81, vol. 1 (1681), p. 947.

6. Ezekiel Spanheim to Frederick III, Paris, June 16, 1698, fol. 71r, Geheimes Staatsarchiv Preussischer Kulturbesitz, Berlin.

7. Wicquefort 1680–81, vol. 1 (1681), p. 953.

8. Furetière 1690, vol. 3, "Present."

9. Wicquefort 1680–81, vol. 1 (1681), p. 959.

10. Spanheim to Frederick III, Paris, January 25–February 5, 1689, fol. 42v, Geheimes Staatsarchiv Preussischer Kulturbesitz.

11. Pecquet 1738, pp. 16–17.

12. Hatton 1987, pp. 103–4.

13. Daniel Cronström to Nicodemus Tessin the Younger, April 19, 1703, in *Relations artistiques* 1964, p. 326.

14. Spanheim to Frederick III, Paris, January 25–February 5, 1689, fol. 42v, Geheimes Staatsarchiv Preussischer Kulturbesitz.

15. Spanheim to Frederick III, February 28, 1689, fols. 64v–65r, Geheimes Staatsarchiv Preussischer Kulturbesitz. See also MAE, Mémoires et Documents, France, vol. 2037, fol. 36r.

16. Wicquefort 1680–81, vol. 1 (1681), p. 962.

17. Ibid., p. 952.

18. Pecquet 1738, p. 16.

19. Hatton 1987, pp. 102, 117.

20. Ibid., p. 103.

21. Furetière 1701, vol. 2, "Libéralité."

22. Bimbenet-Privat 2002; Bimbenet-Privat 2003; Thépaut-Cabasset 2009; Bimbenet-Privat and Farges 2015; Thépaut-Cabasset 2016. See also the letter from Spanheim to Frederick III, Paris, January 25–February 5, 1689, fol. 42v, Geheimes Staatsarchiv Preussischer Kulturbesitz.

23. However, this hypothesis does not tally with Antoine Furetière's definition in his dictionary of the French language: "a small vessel that closes with a lid." Furetière 1690, vol. 1, "Boeste, ou Boiste." See also Bimbenet-Privat 2002, pp. 402–5.

24. This motif appears in a jewelry design engraved by Thomas Lejuge in 1678 (Bibliothèque Nationale de France, Paris, Est. AA3 pl. 4).

25. Found in a notarized bill of sale to Cardinal Mazarin from the goldsmith Gabriel Hardivilliers in 1650; Bimbenet-Privat 2002, pp. 402–5.

26. Ibid., pp. 492–93.

27. Brice 1687, vol. 2, p. 224.

28. Collezioni Comunali d'Arte, Palazzio d'Accursio, Bologna; MAE, Mémoires et Documents, France, vol. 2037, fol. 102v.

29. Gemeente Museum, The Hague (O-Div. 1-1929); MAE, Mémoires et Documents, France, vol. 2037, fol. 78r.

30. Bimbenet-Privat and Farges 2015.

31. Musée National de la Renaissance, Ecouen (ECL 20864).

32. The gift offered by the queen of France to Empress Margaret Theresa of Spain in 1669, in which the portrait inset in the *table de bracelet* with eight diamonds was that of the queen. MAE, Mémoires et Documents, France, vol. 2037, fol. 16v.

33. Brice 1687, vol. 2, p. 224.

34. Furetière 1690, vol. 2, "Espée."

35. MAE, Mémoires et Documents, France, vol. 2037, fols. 211r–v.

36. An embroidered baldric made in France in the seventeenth century can be seen in the Swedish royal armory (Livrustkammaren, Stockholm, Gnr 3440 [21297]).

37. Thépaut-Cabasset 2015.

38. Spanheim to Frederick III, Paris, June 20, 1698, fols. 88v–89r, Geheimes Staatsarchiv Preussischer Kulturbesitz.

39. "Registre et contrôle général de la recette et de la dépense ordinaire et extraordinaire des Menus," 1667–68, Archives Nationales, Paris, O¹ *2815, fol. 9.

40. For example, the silver toilet service executed in Paris between 1658 and 1676 by an unidentified goldsmith for Princess Hedvig Sofia, Duchess of Hollstein-Gottorp (Rosenborg Castle, Copenhagen, Royal Collection, No-8-56-71); see Boesen 1967.

41. Breteuil 1992, pp. 151–52 (quotation on p. 152).

42. MAE, Mémoires et Documents, France, vol. 2042.

43. Oresko 1989.

44. Marin 1981, pp. 147–68, "L'hostie royale: La médaille historique."

45. MAE, Mémoires et Documents, France, vol. 2037, fol. 11r.

46. Ibid., fol. 36v.

47. Cassidy-Geiger 2007.

48. "Registre des livres de figures et estampes qui ont été distribuées suivant les ordres de Monseigneur le marquis de Louvois depuis l'inventaire fait avec Monsieur l'abbé Varès au mois d'août 1684," Bibliothèque Nationale de France, Est. Ye 144 Pet. Fol.

49. Daniel Cronström to Nicodemus Tessin the Younger, August 19, 1695, in *Relations artistiques* 1964, p. 93.

50. Ibid.

51. Marin 1981, p. 165.

52. Félibien des Avaux 1703, p. 244.

53. MAE, Mémoires et Documents, France, vol. 2037, fols. 220r–221v; Breteuil 1992, pp. 151–52.

54. Ferreira, Oliver, and Thépaut-Cabasset 2016.

55. It has been suggested that the fascination of Muslim visitors for these mechanical timepieces relates to a belief that they were "appropriating" the time of the Christians. See Dakhlia 1998, pp. 56–57.

56. Breteuil 1992, p. 47.

INCOGNITO IN VERSAILLES

1. Stollberg-Rilinger 2008, p. 301.

2. Wrigley 2002, p. 211.

3. For more detail, see Barth 2013.

4. Vaugelas 1647, pp. 464–65; quoted in Barbier 1933, p. 96 (italics in the original; omitted in Barbier 1933).

5. Fedorov 2017, pp. 18–20.

6. Breteuil 1992, p. 157.

7. Ibid., pp. 159, 163–64, 183–89. See also Bély 1999, pp. 487–88.

8. Liboy 1890. See also Dangeau 1854–60, vol. 17 (1859), p. 58 (entry of April 4, 1717); Saint-Simon 1829–30, vol. 15 (1829), p. 80; Haussonville 1896, pp. 795–98; Lossky 1932, p. 280.

9. Liboy 1890, p. 164.

10. Haussonville 1896, pp. 799–801; Hughes 2004, p. 116.

11. Haussonville 1896, p. 797, 799.

12. Dangeau 1854–60, vol. 17 (1859), pp. 74, 80 (entries of April 28 and May 7, 1717); Saint-Simon 1829–30, vol. 15 (1829), pp. 80–81; Haussonville 1896, p. 801; Lossky 1932, pp. 282–83.

13. Dangeau 1854–60, vol. 17 (1859), pp. 81–84 (entries of May 8 and 10, 1717); Saint-Simon 1829–30, vol. 15 (1829), pp. 84–85; Lossky 1932, pp. 283–85.

14. Haussonville 1896, pp. 801–2 (the date of the visit is cited erroneously as May 11, 1717).

15. Buvat 1865, vol. 1, p. 270 (entry of May 29, 1717). Also quoted in Haussonville 1896, p. 809.

16. Buvat 1865, vol. 1, pp. 271–72 (entry of May 31, 1717).

17. Ibid., p. 275 (entry of June 13, 1717).

18. Dangeau 1854–60, vol. 17 (1859), pp. 95–96 (entry of May 25, 1717); Hughes 2004, p. 117.

19. Haussonville 1896, pp. 813, 815.

20. Dangeau 1854–60, vol. 17 (1859), pp. 108, 112 (entries of June 17 and 19, 1717); Lossky 1932, pp. 298–99.

21. Barth 2013, pp. 155–70; Barth 2014.

22. Du Coudray 1782, p. 24.

23. Ibid., pp. 124–25.

24. Ibid., pp. 38–42; Oberkirch 1853, vol. 1, p. 216 (entry of May 26, 1782); Bulgakova 2014, pp. 244, 250.

25. See "Journal de ce qui s'est passé à Versailles depuis l'instant de l'arrivée de Monsieur le comte et de Madame la comtesse du Nord, jusqu'à celui de leur départ," Archives Nationales, Paris (hereafter AN), O¹ 824, fols. 80r–90r; and "Nottes sur le voyage de M. le comte et de Mᵐᵉ la comtesse du Nord en France au mois de may 1782," AN, K 161 221, fols. 1r–13v. I thank Daniëlle Kisluk-Grosheide for providing copies of these and other documents.

26. Bulgakova 2014, p. 241.

27. Du Coudray 1782, p. 57.

28. Bulgakova 2014, pp. 242, 250, 252, 255.

29. AN, O¹ 824, fol. 80v; Du Coudray 1782, p. 25.

30. AN, K 161 221, fols. 2r, 6v, 12r.

31. AN, O¹ 824, fol. 81r; Oberkirch 1853, vol. 1, p. 193 (entry of May 19, 1782), vol. 2, p. 168; Bulgakova 2014, p. 249.

32. Oberkirch 1853, vol. 1, p. 32 (entry of early 1770).

33. Dangeau 1854–60, vol. 17 (1859), p. 100 (editor's note); Haussonville 1896, p. 810.

34. AN, K 161 221, fol. 2v.

35. Bulgakova 2014, pp. 247–48.

36. Du Coudray 1782, p. 28, and also pp. 5–14, 55–57, 106, 140; Bombelles 1977, pp. 116–19.

37. Du Coudray 1782, pp. 30–31.

38. Barton 1972, p. 1.

39. Geffroy 1867, vol. 2, p. 23; Stålhane 1953, p. 208; Barton 1972, p. 1; Proschwitz 1994, pp. 292, 298; Bussmann 1998, p. 754.

40. See Rangström 1997.

41. Barton 1972, pp. 6–7; Proschwitz 1994, p. 297; Bély 1999, p. 530; Kent 2008, p. 129.

42. Geffroy 1867, vol. 2, p. 4. See also Grosser 1989.

43. Du Coudray 1784, pp. 13–14.

44. Geffroy 1867, vol. 2, pp. 10, 12–13; Barton 1972, p. 20; Kent 2008, p. 132; Barth 2013, p. 307.

45. Geffroy 1867, vol. 2, p. 4; Beskow 1868, p. 311; Stålhane 1953, p. 209; Proschwitz 1994, p. 300; Bély 1999, p. 530.

46. See AN, O¹ 824, fols. 158–62.

47. Bombelles 1977, pp. 328–29 (entry of June 7, 1784).

48. AN, K 161 27, fol. 31, and O¹ 824, fol. 159r; Geffroy 1867, vol. 2, pp. 25–26, 34; Beskow 1868, pp. 318–19, 323–24; Stålhane 1953, pp. 209–10.

49. Gustav III to Count Gustav Philip von Creutz, June 14, 1784, in Proschwitz 1986, p. 265, letter no. 119.

50. For a list of the works performed, see Geffroy 1867, vol. 2, p. 29; see also Bombelles 1977, p. 331 (entry of June 19, 1784).

51. AN, O¹ 824; Du Coudray 1784, pp. 47–48; Beskow 1868, pp. 320, 322, 326; Stålhane 1953, p. 240.

52. Quoted in Geffroy 1867, vol. 2, p. 36; see also AN, K 161 27; Beskow 1868, p. 322. For a depiction of Gustav during his incognito journey in Italy, see Gerste 1996, p. 154.

53. AN, K 161 27 and O¹ 824, fol. 161v; Geffroy 1867, vol. 2, p. 26.

54. Gustav III to Creutz, June 10, 1784, in Proschwitz 1986, p. 263, letter no. 118; see also Bély 1999, pp. 532–33.

55. The diary entries are reprinted in Geffroy 1867, vol. 2, pp. 352–53.

56. See "Nottes sur le voyage du Roi de Suède à Paris en juin 1784 lequel voyageoit dans l'incognito absolu sous le nom de comte de Haga" (AN, K 161 27, fols. 1r–2r) and "Journal de ce qui s'est passé à Versailles depuis l'instant de l'arrivée de M. le Cte de Haga, jusqu'à celui de son départ" (AN, O¹ 824, fols. 157v–161v).

57. AN, O¹ 824 and K 161 27; Du Coudray 1784, p. 40; Geffroy 1867, vol. 2, p. 25; Beskow 1868, p. 324.

58. Bombelles 1977, pp. 329, 330, 335, 340 (entries of June 8, 10, and 26 and July 19, 1784).

59. Gustav III to Creutz, June 21, 1784, in Proschwitz 1986, p. 268, letter no. 121. For a depiction of the party by Niclas Lafrensen the Younger (called Lavreince), see Magnus Olausson in *Soleil et l'étoile du nord* 1994, p. 306, no. 448, ill. p. 302. See also Geffroy 1867, vol. 2, p. 35; Beskow 1868, p. 323.

60. AN, K 161 27. See the description of Gustav in Proschwitz 1986, p. 270, n. 10. This event was also documented by a special publication: *Première expérience de la montgolfière construite par ordre du Roi, lancée en présence de Leurs Majestés, de la Famille Royale, et de Monsieur le comte d'Haga* (Paris: Imprimerie de Monsieur, 1784). Also see Du Coudray 1784, pp. 59–64; Geffroy 1867, vol. 2, p. 33. A montgolfier in Lyon was also adorned with Gustav's name; see Proschwitz 1994, pp. 299–300.

61. Geffroy 1867, vol. 2, p. 40; Stålhane 1953, p. 246; Proschwitz 1994, p. 301.

62. AN, O¹ 824, fol. 161r; Geffroy 1867, vol. 2, p. 41.

63. Geffroy 1867, vol. 2, p. 46; Beskow 1868, p. 330; Kent 2008, p. 134.

64. Du Coudray 1784, p. 118; Geffroy 1867, vol. 2, p. 30; Proschwitz 1986, p. 265, n. 1; Proschwitz 1994, pp. 300–301.

65. Du Coudray 1784, pp. 44–45.

66. Ibid., pp. 64–66, 74–75. See also Beskow 1868, p. 326.
67. Proschwitz 1986, p. 264, n. 3, p. 272; Proschwitz 1994, pp. 299, 301; Bély 1999, p. 530.
68. Proschwitz 1994, p. 303.
69. Ibid., p. 304; Bussmann 1998, pp. 756–57; Kent 2008, pp. 133, 137.

GRAND TOURISTS

1. Sourches 1882–93, vol. 6 (1886), p. 193 (entry of October 16, 1699), on the Pamphili princes, received at Versailles in 1699.
2. *Curiositez de Paris* 1716, pp. 311–12.
3. Furetière 1690, vol. 1, "Curiosité."
4. Moore 1779, vol. 1, p. 40.
5. La Roche 2012, p. 144 (entry of April 17, 1785).
6. Nemeitz 1727, vol. 2, pp. 491–92.
7. Nugent 1749, vol. 4, pp. 94–98 (quotations on pp. 94, 96).
8. La Roche 2012, p. 341 (entry of August 15, 1785).
9. Nugent 1749, vol. 4, pp. 97–98 (quotation on p. 98).
10. Ibid., pp. 98–103 (quotation on p. 99).
11. Nemeitz 1727, vol. 2, p. 503.
12. Luynes 1860–65, vol. 8 (1862), p. 454 (entry of February 24, 1748).
13. Nemeitz 1727, vol. 1, p. 247, vol. 2, p. 502.
14. La Roche 2012, p. 282 (entry of May 31, 1785).
15. Archives Nationales, Paris (hereafter AN), O¹ 822, fol. 181, August 26, 1739.
16. Nemeitz 1727, vol. 2, pp. 495–97.
17. Ibid., vol. 1, pp. 246–47.
18. Chesterfield 1901, vol. 2, p. 168, letter no. CCLX, June 20, 1751 (old style).
19. Nugent 1749, vol. 1, pp. vii–viii.
20. For the Grand Tour in general, see J. Black 1992; Boutier 2004; Leibetseder 2004.
21. Alessandro Farnese, letter of January 1698, Gabinetto Vieusseux, Florence, Fiametta Olschki Collection, MS 2, fol. 3r.
22. Archivio di Stato, Florence, Carte strozziane, 5th ser., 1171, ins. 29, "Istruzione del viaggio da farsi dall'ill.ᵐᵒ S. Lorenzo Francesco Strozzi. . . ."
23. Luynes 1860–65, vol. 3 (1860), p. 464 (entry of August 29, 1741).
24. Brewer 1963.
25. Chesterfield 1901, vol. 2, p. 137, letter no. CCXLIX, April 7, 1751 (old style).
26. Ibid., p. 151, letter no. CCLIV, May 10, 1751 (old style).
27. Ibid., p. 157, letter no. CCLVI, May 23, 1751 (old style).
28. Ibid., pp. 176–77, letter no. CCLXII, June 30, 1751 (old style).
29. British Library, London, Add. MS 34753, fols. 15–23.
30. Luynes 1860–65, vol. 13 (1863), p. 233 (entry of April 22, 1754).
31. Archivio di Stato, Florence, MS 684, fols. 208r–222r.
32. Kolk et al. 2014.
33. For the Pamphili princes, see Bibliothèque Nationale de France, Paris, Bibliothèque de l'Arsenal, MS 3860, fol. 225. For the marquis Parenzi, see Archives Diplomatiques, Paris, Ministère des Affaires Etrangères, Mémoires et Documents, France, vol. 1852, "Journal de M. le marquis de Verneuil, introducteur des ambassadeurs," 1747–48, fol. 103. For Lord Bristol, see Luynes 1860–65, vol. 9 (1862), p. 432 (entry of June 25, 1749).
34. Archivio di Stato, Florence, MS 684, fol. 209v.
35. "Journal de M. le marquis de Verneuil" (see note 33 above), fols. 91r–v; see also Archives Diplomatiques,

Paris, Ministère des Affaires Etrangères, Mémoires et Documents, France, vol. 1852, fol. 77v, Tuesday, January 31, 1747.
36. Erdmannsdorff and Berenhorst 2014, vol. 2, pp. 707, 754.
37. Description of the visit of Christian IV, Duke of Pfalz-Zweibrücken, received incognito under the assumed name comte de Sponheim; Luynes 1860–65, vol. 3 (1860), pp. 57–58 (entry of October 19, 1739); AN, O¹ 822, fols. 173, 174.
38. Dumont and Rousset de Missy 1739, vol. 1, p. 364.
39. Dufort de Cheverny 1886, vol. 1, p. 70.
40. AN, O¹ 822, fols. 305–6, March 8, 1751, fols. 306–7, March 21, 1751; Luynes 1860–65, vol. 11 (1863), p. 157, June 2, 1751 (entry of June 3, 1751).
41. Luynes 1860–65, vol. 8 (1862), p. 203 (entry of May 2, 1747), vol. 9 (1862), p. 5 (entry of April 9, 1748).
42. AN, O¹ 822, fols. 306, 308; Luynes 1860–65, vol. 11 (1863), p. 450 (entry of March 13, 1752), vol. 12 (1863), pp. 46, 349 (entries of June 16, 1752, and February 9, 1753), vol. 13 (1863), p. 148 (entry of February 3, 1754); Cachau 2012, pp. 135–39.
43. Alessandro Farnese, letter of February 1698, Gabinetto Vieusseux, Florence, Fiametta Olschki Collection, MS 2, fols. 7v–9r.
44. Cited in Struck 2001, p. 20.
45. Lister 1873, p. 183.
46. Maihows 1763, vol. 1, p. 243, letter no. XXIV.
47. Lister 1873, p. 183.
48. St. John 1788, vol. 1, p. 100.
49. Ibid., p. 94.
50. Dashkova 1840, vol. 1, p. 172.
51. Oberkirch 1869, vol. 1, pp. 14, 192 (quotation on p. 192; entry of May 19, 1782).
52. Struck 2001, pp. 22–23.
53. F. J. L. Meyer 1798, vol. 2, pp. 282–98 (quotations on pp. 282, 283, 294).
54. Ibid., p. 294.

VISITORS' GUIDEBOOKS AND ENGRAVINGS

1. A list of most of these guides can be found on the website of the Centre de Recherche du Château de Versailles: http://chateauversailles-recherche.fr/.
2. On travel guides in general, see G. Chabaud et al. 2000.
3. On the other hand, there were numerous series of engravings showing royal, princely, and episcopal residences in Europe.
4. For the accounts of the Grotto of Thetis, see Félibien 1672; Félibien 1674a; Félibien 1676a; Félibien 1679. For the château de Versailles, see Félibien 1674b.
5. Félibien 1685; Félibien 1687; Félibien 1689; Félibien 1696.
6. Félibien's *Description du château de Versailles* was finished in 1703 by his son, Jean François Félibien des Avaux, but unfortunately contained many errors and inaccuracies that undermined its usefulness. See Félibien des Avaux 1703 (with a royal patent from 1698).
7. "Description de la galerie de Versailles" 1682; "Explication de la galerie de Versailles" 1684.
8. According to the *Mercure galant*, January 1685, p. 78.
9. Charpentier 1684; Rainssant 1687; Rainssant 1691; *Explication des tableaux de la galerie de Versailles* 1688.
10. Pagliano 1997, p. 169. See also Burke 1992; Sabatier 1999; Sabatier 2000.
11. *Avertissement*, in Félibien 1670.
12. On the Cabinet du Roi, see Grivel 1985; Grivel 2010.

13. Félibien 1672; see also Félibien 1674a; Félibien 1676a; Félibien 1679.
14. *Plaisirs de l'isle enchantée* 1673.
15. Félibien 1676b.
16. *Labyrinte de Versailles* 1677, with an introduction by Charles Perrault and quatrains by Isaac de Benserade (cat. 142).
17. Félibien 1677. See also Grivel 1985.
18. Grivel 1985, p. 45.
19. *Mercure galant*, August 1679; cited in Grivel 2010.
20. Grivel 2010.
21. Félibien 1677, p. 1.
22. Archives Nationales, Paris, O¹ 1050, Edits, Lettres Patentes, Arrêts, Déclarations, Ordonnances du Roy, 1573–1731, fols. 96–98. See Grivel 1985, p. 38.
23. See *Irrgarten zu Versailles* ca. 1680; *Tapisseries du Roy* 1687, with engravings by Johanna Sybilla Kraus; *Veues de Versailles* ca. 1690a; *Description de la Grotte de Versailles* 1700.
24. *Labyrinte de Versailles* 1682.
25. *Veues de Versailles* ca. 1690b. Pierre Mortier, another printer and bookseller in Amsterdam, also published a *Labyrinte* about 1680; see *Labyrinte de Versailles* ca. 1680.
26. "Extrait du Privilege du Roy," in *Plans, profils, et elevations . . . de Versailles* 1716, n.p.
27. Jacques Rigaud, *Recueil choisi des plus belles vues des palais, châteaux et maisons royales de Paris et des environs*, Paris: Joubert et Basan, [1740–52]. For the royal patent, see Bentz and Ringot 2009.
28. Chambaud and Robinet 1776, p. 580, "View, [prospect]."
29. Bowles 1726 (reprinted in 1745 and 1760).
30. See van der Aa 1729, vol. 2 of *Roïaume de France*.
31. "Aesop at Court; or, the Labyrinth of Versailles Delineated in French and English[.] The Plates Engraved by G. Bickham. From the Paris Edition," in Bellamy 1768, n.p. (following p. 208).
32. Höweler 1978, p. 34. I would like to thank Daniëlle Kisluk-Grosheide for having drawn my attention to this and many other sources.
33. See Berger 1988.
34. See note 57 below.
35. Piganiol de La Force 1701. Subsequent editions appeared in 1707, 1713, and 1717 (Paris: Florentin Delaulne); 1724, 1740, and 1738 (Paris: Veuve Florentin Delaulne); 1751 (Paris: Desprez et Cavelier); 1764 (Paris: Hochereau).
36. Piganiol de La Force 1718, vol. 2, pp. 316–33.
37. Piganiol de La Force 1701, pp. 27, 169.
38. Ibid., p. 97.
39. Ibid., p. 173.
40. See note 35 above.
41. Nemeitz 1718, pp. 379–80; French ed., Nemeitz 1727, vol. 2, p. 489.
42. *Gentleman's Guide* 1770, p. 69: "It is to be hoped that, by this time, you have met with some of your acquaintances, with whom it will be agreeable to make a party to visit the king's palaces at Versailles and Marly; for which purpose you should by all means buy *La nouvelle description des châteaux, & parcs de Versailles & Marly*. That is, the new description of the castles and parks of Versailles and Marly: it is printed in two pocket volumes, and will cost you only five livres."
43. "Coup d'oeil sur les peintures et sculptures qui décorent les châteaux, jardins, bosquets et fontaines de Versailles, Marly, Trianon et la Ménagerie," Versailles,

1787, Musée National des Châteaux de Versailles et de Trianon, MS Vms 138.

44. *Curiositez de Paris* 1716. New editions appeared in 1723, 1733, and 1742 (Paris: Saugrain) and 1771 (Paris: Libraires Associés).

45. Johnston 1968–70, p. 65; Teleki 1943, p. 50 (entry of November 8, 1760).

46. Extract from the *privilège royal* granted to Claude Marin Saugrain in 1715 for "Les Adresses de la Ville & Fauxbourgs de Paris," mentioned in *Curiositez de Paris* 1716, n.p. (following p. viii).

47. *Curiositez de Paris* 1718, vol. 2, p. 528.

48. Ibid., p. 529.

49. A. N. Dezallier d'Argenville 1755; see also A. N. Dezallier d'Argenville 1762; A. N. Dezallier d'Argenville 1768; A. N. Dezallier d'Argenville 1779.

50. Morellet 1681, n.p. ("Epistre à Madame la Dauphine").

51. Ibid., p. 4.

52. Leplatre 2008, p. 275.

53. English ed., Morellet 1684; German ed., Morellet 1683. For the second French edition, see Morellet 1695.

54. *Voyageur fidèle* 1715.

55. Ibid., pp. 417, 440.

56. The first edition was published in two parts for the years 1762 and 1765; see *Almanach parisien* 1762–65; see also *Almanach parisien* 1763–64 (with a royal patent). New editions appeared in 1767, 1771, 1773, 1775, 1781, 1783, and 1786 to 1790.

57. Hébert 1766, vol. 2, "Trianon," pp. 94–99, and "Versailles," pp. 101–52.

58. Thiéry de Sainte-Colombe 1788, vol. 2, pp. 350–432.

59. Hartig 1785, p. 43; Volkmann 1787–88, vol. 1 (1787), pp. 465–66.

60. M. Boyer 2000, p. 340.

61. Piganiol de La Force 1701, pp. 13–14.

62. Foreword to *Almanach parisien* 1776.

63. Dulaure 1786, vol. 2, pp. 282–83, 293.

64. Félibien 1674b, pp. 7–8.

65. *Voyageur fidèle* 1715, which divides the visitor's stay into four days.

66. Jordan 1693–1701, vol. 1 (1693), *France*, p. 187; see also Jordan 1701. Pirated editions with the titles: *Voyages historiques de l'Europe, ou Les delices de la France, d'Espagne, d'Italie . . . augmenté d'une guide à chaque province . . . par M. de B. F.*, 8 vols. (Brussels: Josse De Griecke, 1704); *Voyages historiques de l'Europe . . . augmenté de la guide des voyageurs, par M. de B. F.*, 8 vols. (Amsterdam: P. de Coup, 1718).

67. *Curiositez de Paris* 1718, vol. 2, p. 513.

68. A. Boyer 1753, p. 15 ("A Tour to Paris, Versailles, Marli, &c.").

69. *Almanach de Versailles* 1773. See also the *Almanach de Versailles* for 1774 (Paris: Valade; Versailles: Blaizot); 1775–79 (Versailles: Blaizot; Paris: Valade and Deschamps); 1780–81 (Versailles: Blaizot; Paris: Langlois, Deschamps, Valade, and Lesclapart); 1782–84 (Versailles: Blaizot; Paris: Valade, Langlois, Deschamps, and Froullé); 1785–87 (Versailles: Blaizot; Paris: Langlois, Deschamps, Froullé, and La Veuve Valade); 1788–89 (Versailles: Blaizot; Paris: Langlois, Deschamps, Froullé, La Veuve Valade, and Lesclapart); 1790–91 (Versailles and Paris: Blaizot).

70. *Almanach de Versailles* 1774, pp. 258, 55.

71. Félibien 1674b, p. 2; A. N. Dezallier d'Argenville 1755, p. 48.

72. *Curiositez de Paris* 1716, p. 315.

73. A. N. Dezallier d'Argenville 1779, p. 62.

74. A. N. Dezallier d'Argenville 1755, p. 53.

75. *Plans, profils et elevations . . . de Versailles* 1716.

76. Nemeitz 1727, vol. 2, pp. 507–8.

77. A. Boyer 1753, pp. 16–17 ("A Tour to Paris, Versailles, Marli, &c.").

78. Piganiol de La Force 1701, p. 183.

THE AMERICANS

1. Isaac Smith Jr. to John Adams, September 3, 1771, in *Adams Family Correspondence* 1963–, vol. 1 (1963), pp. 78–79.

2. Jeffries 1786, pp. 73, 76.

3. Amory 1923, pp. 29–30 (entry of April 28, 1776).

4. Thomas Shippen to William Shippen, February 14–March 26, 1788, in Jefferson 1950–, vol. 12 (1955), note on p. 503.

5. Ibid., note on pp. 502–3.

6. Rush 1947, pp. 390–91.

7. Benjamin Franklin to Mary (Polly) Stevenson, September 14, 1767, in Franklin 1905–7, vol. 5 (1906), pp. 51–52.

8. Ibid., p. 52.

9. Thomas Jefferson to Francis Hopkinson, August 14, 1786, in Jefferson 1950–, vol. 10 (1954), p. 250.

10. Trumbull 1841, pp. 113–15.

11. Treaty of Alliance between the United States and France, signed in Paris, February 6, 1778, art. 3.

12. See Shi 1985; Brekke 2006; Haulman 2011.

13. Franklin to Stevenson, September 14, 1767, in Franklin 1905–7, vol. 5 (1906), p. 54.

14. Schoenbrun 1976, p. 183. Franklin may have dressed down at Versailles, but he procured fancier clothing while living in Passy, including velvet suits, frock suits "à la marinière," and an expensive vicuña suit; see Franklin 1959–, vol. 31 (1995), p. 102, n. 3 (order placed February 19, 1779), pp. 104–5, n. 2 (invoice of October 27, 1780, for orders placed between December 18, 1779, and August 21, 1880).

15. Ségur 1825, pp. 81–82.

16. Vigée Le Brun 1869, vol. 2, p. 273.

17. See Sellers 1962; Miles 1993. On the topic of American style, see Chrisman-Campbell 2015, pp. 156–70.

18. Boucher and Huard 1921, p. 104.

19. "Old Note-Book" 1863, p. 657.

20. Benjamin Franklin to Sally Franklin Bache, June 3, 1779, in Franklin 1840, vol. 1, p. 43.

21. John Adams to Jonathan Jackson, November 8, 1782, in J. Adams 1977–, vol. 14 (2008), p. 44.

22. John Adams, Diary, entry of April 11, 1778, in *Adams Family Papers* 2003–.

23. John Adams, Autobiography, pt. 2, "Travels, and Negotiations," entry of June 7, 1778, in *Adams Family Papers* 2003–.

24. Ibid.

25. John Adams, Diary, entry of May 10, 1779, in *Adams Family Papers* 2003–. See also W. B. Evans 1968.

26. Reported in *American Aurora*, November 12, 1798, n.p.

27. John Adams, in *Boston Patriot*, September 4, 1811, p. 1; quoted in J. Adams 1961, vol. 3, p. 48, n. 2.

28. John Adams, Diary, entry of November 10, 1782, in *Adams Family Papers* 2003–.

29. Ibid.

30. John Adams, Diary, entry of November 12, 1782, in ibid.

31. John Adams, Diary, entry of October 26, 1782, in ibid.

32. John Adams, Autobiography, pt. 2, "Travels and Negotiations," entry of June 7, 1778, in ibid. Not only Adams, but Silas Deane, Ralph Izard, William Lee, and other American diplomats were allotted thirty pounds sterling by Congress to have their clothes tailored according to the protocols set by the Royal Chamberlain.

33. John Adams, Autobiography, pt. 2, "Travels and Negotiations," entry of April 10, 1778, in ibid.

34. John Adams to Elkanah Watson, April 30, 1780, in Watson 1856, p. 103.

35. Bangs 2015, p. 47.

36. Marquis de Lafayette to Benjamin Franklin, February 21, 1779, in Franklin 1959–, vol. 28 (1990), p. 585.

37. Benjamin Franklin, Diary, entry of December 26, 1780, in Franklin 1905–7, vol. 10 (1907), p. 340.

38. Abigail Adams to Mary Smith Cranch, September 5, 1784, in *Adams Family Correspondence* 1963–, vol. 5 (1993), p. 439.

39. John Quincy Adams, Diary, entry of March 29, 1785, in J. Q. Adams 1981, vol. 1, p. 242.

40. Thomas Jefferson to David Humphreys, August 14, 1787, in Jefferson 1950–, vol. 12 (1955), p. 32.

41. See Wilson and Chew 2002.

42. Thomas Shippen to William Shippen, February 14–March 26, 1788, in Jefferson 1950–, vol. 12 (1955), note on p. 504.

43. Ibid., note on p. 502.

44. Alexander Hamilton to John Laurens, February 4, 1781, in Hamilton 1961–87, vol. 26 (1979), p. 407.

45. Keane 1995, p. 211.

46. See L. C. Olson 2004, pp. 141–95.

47. Thomas Jefferson to William Short, April 6, 1790, in Jefferson 1950–, vol. 16 (1961), p. 318. A similar clause appears in the Articles of Confederation. Franklin received approval from Congress in 1786 to keep his gift. See Teachout 2014, pp. 1–31.

48. U.S. Constitution, art. 1, sec. 9.

49. Arthur Lee to the Committee of Foreign Affairs, January 19, 1780, in Davis 1970, p. 380.

50. William Temple Franklin to Thomas Jefferson, April 27, 1790, in Jefferson 1950–, vol. 16 (1961), p. 364.

51. Thomas Jefferson to William Short, January 24, 1791, in Davis 1970, p. 387.

52. Antoine de Sartine to John Paul Jones, June 28, 1780, in Sherburne 1851, p. 196.

53. Guest 1996, p. 143; see also La Laurencie 1921, p. 297.

54. Métra 1787–90, vol. 8 (1787), p. 288 (note of September 5, 1779); English trans. in Poulet 2003, p. 251. Marie Antoinette's milliner made her a hat like Jones's; see Boucher and Huard 1921, p. 104.

55. Morris 1888, vol. 1, p. 41.

56. Ibid., p. 70.

57. Ibid., p. 82.

58. Gouverneur Morris to John Jay, July 1, 1789, in ibid., p. 109.

59. Morris 1888, vol. 1, pp. 104–5.

60. Gouverneur Morris to William Carmichael, July 1789, in ibid., p. 113.

61. Morris 1888, vol. 1, p. 74.

62. Ibid., p. 75.

63. Gouverneur Morris to George Washington, October 18, 1793, in ibid., vol. 2, p. 53. See also M. R. Miller 2005, p. 187.

WORKS IN THE EXHIBITION

For two-dimensional works, dimensions are given height by width; for three-dimensional works, height by width by depth. References comprise only selected publications. An asterisk before an entry indicates that the work was not shown in New York.

1. *The Palace of Versailles and the Month of April*
Gobelins Manufactory, Paris (atelier of Jans *fils*)
From the series The Royal Residences and the Months of the Year
After designs by Charles Le Brun (French, Paris 1619–1690 Paris)
French, ca. 1673–77
Wool, silk, metal thread
13 ft. 1½ in. × 21 ft. 4 in. (400 × 650 cm)
Mobilier National, Paris (GMTT 108/4)

REFERENCES: Fenaille 1903–23, vol. 2 (1903), pp. 141–44; Vittet and Brejon de Lavergnée 2010, pp. 170–71, no. 83, fig. 141

NOTES
1. Bremer-David 2015, pp. 115–17.
2. These were melted down in 1689; Buckland 1983, p. 278, fig. 24.
3. Foucart-Walter 2001, pp. 132–33, no. 67.

2. *Louis XIV*
Antoine Coysevox (French, Lyon 1640–1720 Paris)
1678–81
Marble
H. 36¼ in. (92 cm), with base 46½ in. (118 cm); W. 38⅛ in. (97 cm); D. 16⅛ in. (41 cm)
Signed and dated (on back): *LVD. XIIII. 1681 / A. COYSEVOX.f.* (Louis XIIII. 1681 Made by A. Coysevox)
Musée National des Châteaux de Versailles et de Trianon (MV 789)

REFERENCES: Piganiol de La Force 1701, p. 22; Keller-Dorian 1920, vol. 1, p. 26, no. 23, pl. 34; Souchal 1977, p. 182, no. 12; Berger 1985, pp. 39, 87; *Charles Le Brun* 1990, ill. p. 39; Hoog 1990, p. 41; Hoog 1993, p. 239; Sabatier 1999, p. 150; Sabatier 2006, p. 217; Milovanovic and Maral 2009, pp. 172, 393, no. 35

NOTES
1. The description "breastplate decorated with lambrequins and covered in drapery with an embroidered edge" appears in the "Inventaire de 1707," Archives Nationales, Paris, O¹ 1976ᴬ, fol. 585.
2. See Keller-Dorian 1920, vol. 1, pls. 34, 35.

3. *Louis XV*
Jean-Baptiste Lemoyne (French, Paris 1704–1778 Paris)
1757
Marble
H. with integral base 30½ in. (77.5 cm), W. 25¼ in. (64.1 cm), D. 16⅜ in. (41.6 cm)

Signed and dated (on back): *Par / J.-B. Lemoyne / 1757*
The Metropolitan Museum of Art, New York, Gift of George Blumenthal, 1941 (41.100.244)

REFERENCES: Raggio 1967, pp. 218–22, figs. 1, 3, 4; Scherf 2002, pp. 62–63, fig. 3; Wardropper 2011, pp. 178–79, no. 61

NOTES
1. Furcy-Raynaud 1927, p. 199.
2. Thicknesse 1768, pp. 215–16 (quotation on p. 216).
3. Furcy-Raynaud 1927, p. 203.

4. *Louis XVI*
Louis Simon Boizot (French, Paris 1743–1809 Paris)
1777
Marble
H. 25 in. (63.5 cm), with base 30¾ in. (78 cm); W. 20½ in. (52 cm); D. 14⅛ in. (36 cm)
Signed and dated (on back): *par Boizot 1777* (by Boizot 1777)
Musée National des Châteaux de Versailles et de Trianon (MV 5789)

REFERENCES: *Marie-Antoinette* 1955, p. 58, no. 122; Hoog 1993, p. 246; Picquenard 1999, pp. 484–85; Alexandre Maral in Chapman et al. 2007, p. 96, no. 29

NOTE
1. "Exécutés sous les ordres directs de la Reine." Archives Nationales, Paris, O¹ 2767.

5. *The Entrance to the Lawn*
6. *The Grove of the Baths of Apollo*
Hubert Robert (French, Paris 1733–1808 Paris)
1777
Oil on canvas
Cat. 5: 48⅞ × 75¼ in. (124 x 191 cm); cat. 6: 50⅜ × 75⅛ in. (128 × 192 cm)
Musée National des Châteaux de Versailles et de Trianon (MV 774, 775)

REFERENCES (cats. 5, 6): "Exposition des peintures" 1777, p. 120; "Lettre XIV: Exposition des peintures" 1777, pp. 335–36; Bachaumont 1784, pp. 31–32; Radisich 1988, pp. 454–71, figs. 1, 3; Fort 1999, p. 177; Gwenola Firmin in Faroult 2016, pp. 354–57, nos. 111, 112

NOTES (cats. 5, 6)
1. Robert Wharton to Thomas Lloyd, April 4, 1775, in Rodmell 1968–69, p. 78.
2. Croÿ 1906–7, vol. 3 (1907), p. 219.

7–10. Jean Louis Prieur the Younger (French, Paris 1759–1795 Paris)
1789
Graphite, gray wash, ink applied with brush, on paper
Musée Carnavalet–Histoire de Paris, Dépôt du Musée du Louvre D.A.G.

7. *The Banquet of the Guards in the Versailles Opera (October 1, 1789)*
7⅛ × 10 in. (19.5 × 25.4 cm)
(RF 6193/ D7760)

8. *The Market Women Leaving Paris to Search for the King at Versailles (October 5, 1789)*
7¾ × 9⅞ in. (19.6 × 25.1 cm)
(RF 6194/ D7730)

9. *The King Promising to Come to Paris with His Family (October 6, 1789)*
7⅛ × 10 in. (19.5 × 25.3 cm)
(RF 6195/ D7705)

10. *The King and Royal Family Arriving in Paris Escorted by Thirty Thousand Souls (October 6, 1789)*
7¾ × 10 in. (19.6 × 25.3 cm)
(RF 6196/ D7702)

REFERENCES (cats. 7–10): Roberts 2000, pp. 121–27, figs. 37–40; Carbonnières 2006b, pp. 112–19, nos. 27–30

11. Drop-Front Secretary
Jean Henri Riesener (Gladbeck, Germany 1734–1806 Paris)
French, 1783
Oak veneered with ebony and 17th-century Japanese lacquer; interiors veneered with tulipwood, amaranth, holly, and ebonized holly; gilt-bronze mounts; marble; velvet
H. 57 in. (144.8 cm), W. 43 in. (109.2 cm), D. 16 in. (40.6 cm)
The Metropolitan Museum of Art, New York, Bequest of William K. Vanderbilt, 1920 (20.155.11)

12. Commode
Jean Henri Riesener (Gladbeck, Germany 1734–1806 Paris)
French, 1783
Oak veneered with ebony and 17th-century Japanese lacquer; gilt-bronze mounts; marble
H. 36¾ in. (93.4 cm), W. 56½ in. (143.5 cm), D. 23½ in. (59.7 cm)
The Metropolitan Museum of Art, New York, Bequest of William K. Vanderbilt, 1920 (20.155.12)

REFERENCES (cats. 11, 12): Verlet 1963, pp. 158–60, no. 28, pls. 28a–e; Kisluk-Grosheide 2006, pp. 24, 26–27, figs. 34–37; William Rieder in Kisluk-Grosheide, Koeppe, and Rieder 2006, pp. 198–201, nos. 82, 83; Daniëlle Kisluk-Grosheide in Kisluk-Grosheide and Munger 2010, pp. 100–102, nos. 39, 40

NOTES (cats. 11, 12)
1. Baulez 1985, p. 151.
2. Christie's 1882, nos. 1297, 1298, and ill.

13. Suit
British, 1755–65
Wool broadcloth
L. of coat, at center back (a) 42 in. (106.7 cm), of breeches (b) 29½ in. (74.9 cm)
The Metropolitan Museum of Art, New York, Brooklyn Museum Costume Collection at The Metropolitan Museum of Art, Gift of the Brooklyn Museum, 2009; H. Randolph Lever Fund, 1968 (2009.300.916a, b)

NOTE
1. *Gentleman's Guide* 1770, pp. 10, 210 (quotation on p. 10), cited in Ribeiro 1995, p. 39.

14. Embroidered Panels for a Man's Suit
French, 1780s
Silk embroidery on woven silk; satin stitch; stem stitch, knots, silk net
(b) 45 × 22¼ in. (114.3 × 56.5 cm); (d) 49 × 22¼ in. (124.5 × 56.5 cm); (e) 20½ × 22¼ in. (52.1 × 56.5 cm)
The Metropolitan Museum of Art, New York, Purchase, Irene Lewisohn and Alice L. Crowley Bequests, 1982 (1982.290b, d, e)

REFERENCE: Druesedow 1987, pp. 22–23 and back cover

NOTE
1. John Adams, Diary, entry of October 26, 1782, in *Adams Family Papers* 2003–.

15. *Jean Jacques Caffiéri*
Adolf Ulrik Wertmüller (Swedish, Stockholm 1751–1811 Naamans Creek, Delaware)
1784
Oil on canvas
50¾ × 37¼ in. (128.9 × 95.9 cm)
Signed and dated (at lower left, on table): *A Wertmuller / Paris 1784*
Museum of Fine Arts, Boston, Purchase, Ernest Wadsworth Longfellow Fund (63.1082)

REFERENCES: Zafran 1998, pp. 158–60, no. 71; *Peintres du roi* 2000, p. 280, no. R. 377; Katherine Brinson in *Citizens and Kings* 2007, pp. 392–93, no. 77, ill. p. 172

NOTE
1. H. Williams 2015, pp. 37, 42, pl. 3.

16. Suit (*habit à la française*)
French, 1780s
Coat and breeches (a, b) Voided silk velvet with faille ground, embroidered in silk; waistcoat (c) Ivory silk satin with silk embroidery
L. of coat and breeches (a) 43 in. (109.2 cm), (b) 29 in. (73.7 cm), of waistcoat (c) 30 in. (76.2 cm)
The Metropolitan Museum of Art, New York, Rogers Fund, 1932 (32.40a–c)

REFERENCES: *Of Men Only* 1975, p. 8, no. 7, ill. p. 9; Koda and Bolton 2006, p. 117 and frontispiece

17. Suit (*habit à la française*)
French, 1780s
Embroidered silk (modern breeches)
Coat: L. at center back 44¼ in. (113.5 cm); waistcoat: L. at center front 28¼ in. (73 cm)
Nordiska Museet, Stockholm (NM.0154745A–C)

REFERENCE: Ilmakunnas 2017, pp. 247, 259, n. 20

NOTES
1. Farr 1995, pp. 34, 39–41.
2. Fersen 1902, p. 12 (entry of August 26, 1778).
3. Farr 1995, pp. 102–4.

18. Tricorne
Italian, mid-18th century
Wool felt, metal thread
4½ × 15½ in. (11.4 × 39.4 cm)
The Metropolitan Museum of Art, New York, Rogers Fund, 1926 (26.56.88)

REFERENCE: *Of Men Only* 1975, p. 7, no. 13, ill.

NOTE
1. La Tour du Pin 1913, vol. 1, p. 110.

19. Smallsword
French, ca. 1750
Steel, silver, gold, wood, textile
L. overall 37¾ in. (95.8 cm), of blade 30⅞ in. (78.4 cm); max. W. of blade ⅞ in. (2.2 cm); max. thickness of blade ⅛ in. (0.8 cm); Wt. 13 oz. (368.5 g)
The Metropolitan Museum of Art, New York, Gift of Jean Jacques Reubell, in memory of his mother, Julia C. Coster, and of his wife, Adeline E. Post, both of New York City, 1926 (26.145.283)

REFERENCE: Dean 1929, p. 31, no. 55, pl. XLIII

20. Smallsword
French, ca. 1780
Steel, gold, wood, textile
L. overall 35¼ in. (89.5 cm), of blade 29½ in. (74.8 cm); max. W. of blade ⅝ in. (1.6 cm); max. thickness of blade ⅜ in. (1 cm); Wt. 10 oz. (283.5 g)
The Metropolitan Museum of Art, New York, Gift of Jean Jacques Reubell, in memory of his mother, Julia C. Coster, and of his wife, Adeline E. Post, both of New York City, 1926 (34.57.11)

21. Smallsword with Scabbard
Mounted by C. Liger (French, active 1770–93)
French, ca. 1780
Steel, silver, gold, wood, textile, fish skin
L. overall with scabbard 38⅛ in. (98.1 cm), without scabbard 38⅛ in. (96.8 cm), of blade 31½ in. (80 cm); max. W. of blade ¼ in. (2 cm); max. thickness of blade ⅜ in. (0.8 cm); Wt. 13 oz. (368.5 g)

Inscribed (on reverse of blade, at base): *LIGER / fourbisseur / de S: A / Msgr / Le Duc / de Chartre / & Comte / de Clermont / Ruë / Coquilliere / à Paris* (LIGER sword-cutler of His Highness Msgr the Duc de Chartres & Comte de Clermont Rue Coquilliere in Paris)
The Metropolitan Museum of Art, New York, Gift of Jean Jacques Reubell, in memory of his mother, Julia C. Coster, and of his wife, Adeline E. Post, both of New York City, 1926 (26.145.291a, b)

REFERENCE: Dean 1929, p. 44, no. 88, pl. LXVI

22. Riding Habit
British, early 1770s
Wool broadcloth, linen, embroidered with silver-gilt thread and spangles
H. 59 in. (150 cm)
Victoria and Albert Museum, London (269&A&B-1890)

REFERENCE: Ginsburg, Hart, and Mendes 1984, p. 125, no. 15

NOTE
1. Tobias Smollett, *The Adventures of Peregrine Pickle: in Which Are Included, Memoirs of a Lady of Quality*, in Smollett 1870, p. 353. *The Adventures of Peregrine Pickle* was first published in 1751.

23. Dress (*robe à l'anglaise*)
French, 1785–87
Silk taffeta
Dress (a) L. at center back 59 in. (150 cm); petticoat (b) 37 in. (94 cm)
The Metropolitan Museum of Art, New York, Purchase, Irene Lewisohn Bequest, 1966 (C.I.66.39a, b)

REFERENCES: Bourhis 1989, pp. 28, 257, ill. no. 8; R. Martin and Koda 1996, pp. 10–11; R. Martin 1998, p. 19; Koda and Bolton 2006, p. 117, ill. p. 31

24. Pair of Shoes
British, 1780s
Silk satin
L. heel to toe 7¼ in. (19.7 cm)
The Metropolitan Museum of Art, New York, Gift of Mrs. Frederick Street Hoppin, 1963 (C.I.63.7.6a, b)

NOTE (cats. 23, 24)
1. *Magasin des modes nouvelles* 2, no. 22 (June 20, 1787), p. 169.

25. **Dress** (*robe à la française*)
French, ca. 1770–75
Silk faille with cannelé stripes, brocaded in polychrome floral motif; trimmed with self fabric and silk fly fringe
Dress (a) L. at center back 69 in. (175.3 cm); petticoat (b) 38¼ in. (98.4 cm)
The Metropolitan Museum of Art, New York, Purchase, Irene Lewisohn Bequest, 1961 (C.I.61.13.1a, b)

REFERENCE: Koda and Bolton 2006, p. 119, ill. pp. 62–65

26. **Dress** (*grande robe à la française*)
French, 1775–85
Silk brocade (woven 1760s)
H. from neck to train 59⅞ in. (152 cm)
The Kyoto Costume Institute (AC11075 2004-2AB)

REFERENCE: *Oberkampf* 2015, pp. 28–29

Stomacher
Not original to dress
Swiss, 1760–69
White "bouillonné" silk satin with polychrome silk, chenille threads, flowers of fly fringe
15 × 13¾ in. (38 × 35 cm)
The Kyoto Costume Institute (AC4854 84-18-13)

NOTE
1. Pierre Philippon, "Notice historique sur Mʳ Oberkampf," n.d., MS, Musée de la Toile de Jouy, Jouy-en-Josas.

27. **Doll's Court Gown** (*grand habit de poupée*)
French, ca. 1769–75
Silk brocade, metal thread, metal lace, spangles, silk ribbon flowers
H. of doll 23⅛ (59.5 cm); W. of petticoat base 27½ in. (70 cm); D. of petticoat and train 28½ in. (72.5 cm)
Fashion Museum Bath, Acquired with generous assistance from The Art Fund, and The V&A / Purchase Grant Fund (BATMC 93.436 to B)

REFERENCES: Arizzoli-Clémentel and Gorguet Ballesteros 2009, p. 256, no. 65, figs. 204, 205; Chrisman-Campbell 2015, p. 96, fig. 60

28. **Formal Ball Gown** (*robe parée*)
Attributed to Marie Jeanne "Rose" Bertin (French, Abbeville 1747–1813 Epinay-sur-Seine)
French, 1780s (with later alterations)
Silk satin, with silk embroidery, appliqués of satin; metallic threads, chenille, sequins, applied glass paste
H. 84⅛ in. (215 cm), L. of train 41¼ in. (106 cm)
Royal Ontario Museum, Toronto (925.18.3.A–B)

REFERENCES: Chrisman-Campbell 2002–3, pp. 17–19; Arizzoli-Clémentel and Gorguet Ballesteros 2009, p. 259, no. 112; L. E. Miller 2009, pp. 82, 86, 87, fig. 58

NOTE
1. Genlis 1818, vol. 1, p. 66.

29. *The Tuileries Palace Seen from the Seine*
Nicolas Jean-Baptiste Raguenet (French, Gentilly 1715–1793 Gentilly)
1757
Oil on canvas
17⅞ × 33⅛ in. (45.5 × 84 cm)
Signed and dated (at lower right): *Raguenet / .1757.*
Musée Carnavalet–Histoire de Paris (P.279)

REFERENCES: Montgolfier 1992, p. 57; Bruson and Leribault 1999, p. 353, no. P.279

NOTES
1. Stevens 1756, pp. 37–38 (quotation on p. 38).
2. For 1716, see *Curiositez de Paris* 1716, p. 312; for 1756, see Stevens 1756, p. 37.

*30. *Panoramic View of Versailles*
French, early 18th century
Oil on parchment
23⅛ × 31⅞ in. (60 × 81 cm)
Musée Lambinet, Versailles (1276)

REFERENCES: Gendre 1997, pp. 13, 14, ill. no. 8; Roche 1998, p. 26; Musée Lambinet 2005, p. 140, no. 498

NOTES
1. Stevens 1756, p. 37.
2. Veryard 1701, p. 68.

31. *View of the Château de Versailles from the Place d'Armes*
Pierre Denis Martin the Younger (French, Paris 1663–1742 Paris)
1722
Oil on canvas
54¼ × 59 in. (139 x 150 cm)
Signed and dated (at lower right): *P.D. Martin. Peintre Ordinaire Et / Pensionnaire du Roy. 1722*
Musée National des Châteaux de Versailles et de Trianon (MV 726)

REFERENCES: Constans 1980, p. 92, no. 3191; Brouzet 1998, ill. no. 2; A. Gady 2009, p. 316; Milovanovic and Maral 2009, p. 406, no. 199

32. **Folding Screen**
Charles Cozette (French, Paris or Vitry 1713–1797)
Ca. 1768–70
Wood, oil on canvas, painted leather
79½ in. × 12 ft. 9⅛ in. (202 × 389 cm)
Signed (on fourth panel, at lower center): *C: Cozette*
Collection of Monsieur and Madame Dominique Mégret, Paris

REFERENCE: Vincent Droguet in Droguet 2016, pp. 46–47, no. 17

NOTES
1. Smaller images of Bellevue and Choisy were ordered at the same time; Maillet-Chassagne 2001, p. 184.
2. See van Eikema Hommes 2012, pp. 22–23.

33. *The Arrival of the Papal Nuncio*
French School, after 1692
Oil on canvas
48⅞ × 61 in. (124 × 155 cm)
Collection of Aline Josserand-Conan, Paris

NOTES
1. Dangeau 1854–60, vol. 4 (1855), p. 200 (entry of November 18, 1692).
2. Madame de Maintenon had met the nuncio on September 4, 1692, before his public audience with the king. See Blet 2002, pp. 178–79.
3. During the period that Louis XIV kept court at Versailles, Henri de Lorraine, comte de Brionne, and Grand Equerry of France, always accompanied the nuncios for their ceremonial audience.
4. The eaglet of Lorraine, the comte de Brionne being a prince of that house, is visible on the cartouches decorating the top corners of the glazed carriage. This procession took place after 1683, the year that Queen Maria Theresa of Austria died.
5. As specified for the farewell audience of Monseigneur Galtiero with the Dauphin, August 7, 1706; see *Gazette de France*, August 14, 1706, pp. 392–93.

34. **Tavern Sign**
French, second half 18th century
Carved and painted wood
29½ × 51⅛ in. (75 × 130 cm)
Musée Lambinet, Versailles, Gift of Mr. Robert Crebasse, 1987 (88.12.1)

REFERENCE: Gendre 1997, p. 20, ill. no. 22

NOTE
1. Martin Roland, Diary, 1754–56, entry of September 24, 1754, Hagströmer Medico-Historical Library, Karolinska Institutet, Stockholm, MS, no. 126. Transcribed and translated by Jonas Nordin.

35. **Sedan Chair**
French, ca. 1785
Carved and gilded wood; gilt bronze; leather; velvet, gold galloon; silk taffeta; carved, painted, and gilded wooden poles
H. 58¼ in. (148 cm), W. 33½ in. (85 cm), D. 40½ in. (103 cm)
Musée National des Châteaux de Versailles et de Trianon (T 765C)

REFERENCES: Marie Maggiani in Saule 2012, p. 73; Delalex 2016, p. 70

NOTES
1. The coat of arms dates to the nineteenth century and probably replaced one from the eighteenth century removed during the Revolution.
2. Thicknesse 1766, p. 57, letter no. XIII, August 30, 1766.

36. *Nicolas II de Sainctot*
French, 17th century
Oil on canvas
56¼ × 44⅛ in. (143 × 112 cm)
Musée National des Châteaux de Versailles et de Trianon (MV 3569)

REFERENCE: Andia and Courtin 1997, ill. p. 199

NOTES

1. Chéruel 1899, vol. 2, p. 605.
2. Boppe, L.-C.-M. Delavaud, and L. Delavaud 1901, pp. 2, 5–6.
3. "Mémoires de Nicolas de Sainctot (1602–1702)," Bibliothèque Nationale de France, Paris, Département des Manuscrits, Français 14117–14120, transcription by Alice Camus, 2015, in "Aux sources d'étiquette à la cour de France, XVIᵉ–XVIIIᵉ siècles: L'étiquette à la cour; textes normatifs et usages," directed by Mathieu Da Vinha and Raphaël Masson, Centre de Recherche du Château de Versailles (https://chateauversailles-recherche.fr).

37. Smallsword

French, 1769
Hilt by an unidentified *fourbisseur* (Paris, active 1769)
Mounted by Guilmin (French, active 1767–75)
Steel, silver, wood, textile
L. overall 39¼ in. (99.8 cm), of blade 32⅛ in. (81.6 cm); max. W. of blade ⅞ in. (2.2 cm); max. thickness of blade ⅛ in. (0.9 cm); Wt. 14 oz. (396.9 g)
Inscribed: (on obverse of blade) *GARDES • DU • CORP • DU • ROY*; (on reverse of blade) *Guilmin fourbisseur à Versailles* (Guilmin sword-cutler in Versailles)
Marks: (on front arm of hilt) [three silver marks: date stamp for the year 1769, verification mark (star of lilies) of Inspector Julien Alaterre, 1768–74, [unidentified *fourbisseur*'s mark]; (on quillon block, knuckle guard, and outside of shell) [additional verification marks (head of man wearing a helmet) of Alaterre]
The Metropolitan Museum of Art, New York; Gift of Jean Jacques Reubell, in memory of his mother, Julia C. Coster, and of his wife, Adeline E. Post, both of New York City, 1926 (26.145.317)

REFERENCE: Dean 1929, pp. 38–39, no. 75, pl. LVII

38. Musket

Royal Manufactory of Saint-Etienne
French, ca. 1730–40
Steel, wood, brass
L. 52¾ in. (134 cm)
Inscribed (on barrel): *Svisse Dv Chateav De Versaille Nᵒ 18* (Swiss from the Château de Versailles Nᵒ 18)
Musée de l'Armée, Paris (12741)

NOTES

1. Alder 1997, pp. 186–90.
2. Da Vinha 2009b, pp. 242, 368, n. 23; Loire and Mendella 2017, pp. 42–45.

39. Ceremonial Uniform of the Cent-Suisses

French, 18th century
Silk and velvet (uniform), gold-plated iron (halberd), linen and flax (collar)
Trousers: L. 39⅛ in. (100 cm), W. of waist 33½ in. (85 cm); jacket: L. of sleeve 27½ in. (70 cm), of back 23⅛ in. (60 cm), W. of waist 35⅛ in. (90 cm); halberd: H. 93¾ in. (237 cm), W. 11⅝ in. (29.5 cm), D. 4¾ in. (12 cm)
Swiss National Museum, Zurich (LM-16618.1-.2 [uniform], LM 70591 [halberd], LM 450-c [collar], AG–2419 [gloves], AD–2248 [wig])

REFERENCE: Furger 1998, p. 81

NOTE

1. Grimm 1775, vol. 1, p. 366.

40. Model of the Ambassadors' Staircase

Charles Arquinet (French, 1900–1992)
1958
Wood, cardboard, plaster, plastic
H. 41⅜ in. (105 cm), W. 86⅛ in. (220 cm), D. 37¾ in. (96 cm)
Musée National des Châteaux de Versailles et de Trianon (V 6251-2)

REFERENCE: Burchard 2016, pp. 197, 198, figs. 161, 162

41A. *The Nations of Europe*
41B. *The Nations of Asia*

After Charles Le Brun (French, Paris 1619–1690 Paris)
After 1678
Oil on canvas
28 × 22⅞ in. (71 × 58 cm) each
Musée National des Châteaux de Versailles et de Trianon (MV 5778, 5779)

REFERENCES (cats. 41A, 41B): Lydia Beauvais in *Charles Le Brun* 1990, pp. 84–86, nos. 42, 44; *Fastes de Versailles* 2002, pp. 74–75, 214, nos. 018, 019; Burchard 2016, p. 222, figs. 185, 186

NOTE (cats. 40, 41A, 41B)

1. B. Gady 2015, pp. 62, 70.

42. Partisan

French, ca. 1658–1715
Steel, wood, gold, textile, brass
L. overall 94⅛ in. (239.7 cm), of head 20¾ in. (52.7 cm); W. of head 5⅞ in. (15 cm)
Inscribed (on blade): *NEC PLVRIBVS IMPAR* (Not Unequal to Many)
The Metropolitan Museum of Art, New York, Rogers Fund, 1904 (04.3.64)

REFERENCE: Cosson 1901, p. 86, no. H.20, pl. 18

43. Partisan

Attributed to Bonaventure Ravoisié (French, active 1678–1709)
French, ca. 1678–1709
Steel, wood, gold, textile, brass
L. overall 94⅛ in. (239 cm), of head 22½ in. (57.3 cm); W. of head 6½ in. (16.5 cm)
Inscribed (on blade): *NEC PLVRIBVS IMPAR* (Not Unequal to Many) and *RAVOISIE FOVRBISSEVR DV ROY A PARIS* (Ravoisié sword-cutler of the king in Paris)
The Metropolitan Museum of Art, New York, Rogers Fund, 1904 (04.3.65)

REFERENCE: Cosson 1901, p. 86, no. H.21, pl. 18

44. Partisan

Jean Bérain the Elder (French, Saint-Michel 1640–1711 Paris), designer
French, ca. 1679
Steel, wood, gold, textile
L. overall 86¼ in. (220.2 cm), of head 20½ in. (52.2 cm)
Inscribed (on blade): *NEC PLVRIBVS IMPAR* (Not Unequal to Many)
The Metropolitan Museum of Art, New York, Gift of William H. Riggs, 1913 (14.25.454)

REFERENCES: Ariès 1968; Norman 1997, pp. 141–44, fig. 4

NOTES (cats. 42–44)

1. For a discussion of this design and type, of which several other examples survive, see Ariès 1974.
2. "Mariage de Mademoiselle avec le Roy d'Espagne" 1679, pp. 215–16.
3. The partisans are in the collections of the Musée de l'Armée, Paris; the Musée Lambinet, Versailles; the Musée Promenade, Marly-le-Roi, Louveciennes; and the Muzeum Narodowe, Kraków.

45. *Justaucorps* from the Grand Livery of the Royal Household

French, 1770–80
Wool with silk and linen trim
H. 40¾ in. (103.5 cm), W. 19¾ in. (50 cm), D. 5⅞ in. (15 cm)
Musée National des Châteaux de Versailles et de Trianon; Gift of the Forum Connaissances de Versailles through the Société des Amis de Versailles, 2011 (V 2011.4)

REFERENCES: Lafabrié 2011, paragraph 27, fig. 5; Bertrand Rondot in "Libéralités" 2012, p. 15, no. 32; Saule 2013, pp. 29–30, fig. 41

NOTES

1. Lafabrié 2011.
2. See Da Vinha 2009a.

46. Armchair

French, ca. 1700
Gilded walnut with carved and applied ornament, caning, silk velvet
H. 57 in. (144.8 cm), W. 27⅛ in. (70.2 cm), D. 28 in. (71.1 cm)
The Metropolitan Museum of Art, New York, Gift of J. Pierpont Morgan, 1917 (17.190.1738)

REFERENCES: James Parker in "French Decorative Arts" 1989, pp. 25, 64, ill.; Ronfort 1989, pp. 30–31, fig. 26; Ronfort 2005a, p. 84, fig. 84

NOTE

1. Archives Nationales, Paris, Maison du Roi, O¹ 3341, fol. 300v, no. 400.

47. *Matthew Prior*
Alexis Simon Belle (French, Paris 1674–1734 Paris)
1713–14
Oil on canvas
57 × 44⅛ in. (144.8 × 112.1 cm)
Inscribed (on document): *Mr. Prior Com.*
By permission of the Master and Fellows of St John's
College, Cambridge (10)

REFERENCES: *Art français* 1958, p. 22, no. 5; Goodison
1958, pp. 231, 234, no. 10; Ingamells 2009, p. 229

NOTES
1. Eves 1973, p. 262, n. 46. A letter of credence for Matthew
 Prior, written by Queen Anne to Louis XIV, was dated
 September 13, 1712. See fig. 39 in this volume.
2. Saint-Simon 1879–1928, vol. 38 (1926), p. 263.

48. Double Doors
French, ca. 1710
Carved, painted, and gilded oak (modern hardware)
Single leaf: H. 10 ft. (304.8 cm), W. 28 in. (71.1 cm)
The Metropolitan Museum of Art, New York, Gift
of Hubert de Givenchy, in honor of Mrs. Charles
Wrightsman, 1988 (1988.142a, b)

NOTE
1. Niedersächsisches Landesarchiv, Staatsarchiv
 Wolfenbüttel, 2 Alt no. 3642, fols. 47r–v.

49. *Boîte à portrait* of Louis XIV
Miniature portrait by Jean Petitot the Elder (Swiss,
Geneva 1607–1691 Vevey)
Setting by Laurent Le Tessier de Montarsy (French,
d. 1684) or his son Pierre (French, 1647–1710)
Ca. 1668
Painted enamel on gold, silver, set with ninety-two
diamonds
H. 2⅞ in. (7.2 cm), W. 1⅝ in. (4.2 cm), D. ⅜ in.
(0.8 cm)
Musée du Louvre, Paris, Département des Objets
d'Art (OA 12280)

REFERENCES: Jeannerat 1929; Milovanovic and
Maral 2009, p. 410, no. 250; Thépaut-Cabasset 2009;
Bimbenet-Privat and Farges 2015, pp. 5–9, 28–34,
figs. 1a–i

50. *Médailles sur les principaux événements du règne
de Louis le Grand*
Académie Royale des Médailles & des Inscriptions
Frontispiece engraved by Charles Simonneau (French,
Orléans 1645–1728 Paris), after Antoine Coypel
(French, Paris 1661–1722 Paris); binding attributed to
Luc Antoine Boyet (ca. 1658–1733)
Imprimerie Royale, Paris, 1702
Red morocco leather, gilt, marbled paper endleaves
H. 17⅜ in. (44 cm), W. 12¼ in. (31 cm)
The Morgan Library & Museum, New York.
Purchased as the gift of Julia P. Wightman, 1970
(PML 61327)

51. *Conrad Detlev, Count von Dehn*
Nicolas de Largillière (French, Paris 1656–1746 Paris)
1724
Oil on canvas
36¼ × 29 in. (92 × 73.5 cm)
Inscribed (on reverse): *Conrad Detleff de Dehn seigneur
de Wendhausen pp. Peint par Largilliere 1724* (Conrad
Detleff of Dehn lord of Wendhausen pp. Painted by
Largillière 1724)
Herzog Anton Ulrich Museum, Braunschweig (GG 521)

REFERENCES: Rosenfeld 1982, pp. 270–72, no. 55;
Luckhardt 2005, pp. 78–81, fig. 5; David Mandrella
in Rosenberg 2005, pp. 370–71, no. 76; Silke
Gatenbröcker in Luckhardt and Marth 2006,
pp. 104–5, 107, no. 1.4

NOTES (cats. 49–51)
1. The diplomat's detailed account of the ceremony
 appears in Niedersächsisches Landesarchiv, Staatsarchiv
 Wolfenbüttel, 2 Alt no. 3642, fols. 44v–55v.
2. Niedersächsisches Landesarchiv, Staatsarchiv
 Wolfenbüttel, 2 Alt no. 3643, fols. 50–53, contains
 Dehn's report of his farewell visit.
3. This was valued at 5,192 livres and 10 sols. Archives
 Diplomatiques, Paris, Ministère des Affaires Etrangères,
 Mémoires et Documents, France, vol. 2097, "Les
 présents du Roy," 61, fol. 127.
4. See "Visitors' Guidebooks and Engravings" by Elisabeth
 Maisonnier in this volume.

52. *The Formal Entry of Cornelis Hop into Paris*
Adolf van der Laan (Dutch, Utrecht? 1684–1755)
Ca. 1719–20
Ink on paper
5⅜ × 7⅜ in. (13.7 × 18.6 cm)
Rijksmuseum, Amsterdam (RP-T-00-1741)

REFERENCE: van Luttervelt 1947–49, pp. 91–92, fig. 1

53. *The Formal Audience of Cornelis Hop at the Court
of Louis XV*
Louis Michel Dumesnil (French, Paris 1663–1739 Paris)
Ca. 1720–29
Oil on canvas
41⅛ × 64⅛ in. (104.5 × 163 cm)
Signed and dated (on pedestal, at lower right):
L.M. Dumes[nil Pr.] Regius [Pinxit Anno 172.]
(L. M. Dumes[nil Painter] of the king [Painted in the
year 172(?).]
Rijksmuseum, Amsterdam, On loan from the
Koninklijk Oudheidkundig Genootschap (SK-C-512)

REFERENCES: van Luttervelt 1947–49, pp. 94–100,
fig. 2; Aulanier 1955, pp. 46–47, fig. 18; van Thiel et al.
1976, p. 205, no. C 512

54. Box for the Storage of Medals
French, ca. 1700
Oak; gold-embossed red morocco leather; silk; with
sixty-five silver medals of the French kings
Open: H. 5⅞ in. (15 cm), W. 5⅞ in. (15 cm), D. 9¼ in.
(23.5 cm)
Rijksmuseum, Amsterdam, F. G. S. Baron van Brakell
tot den Brakell Bequest, Arnhem (BK-VBR-106)

*55. Snuffbox with Miniature Portraits of Louis XV
and Marie Leszczyńska
Box: Daniel Govaers, goldsmith (French, master in
Paris, 1717)
Miniature portraits: Attributed to Jean-Baptiste Massé
(French, Paris 1687–1767 Paris)
Paris, 1725–26
Gold, diamonds, enamel, tortoiseshell
H. 1⅛ in. (3 cm), W. 3⅜ in. (8.5 cm), D. 2½ in. (6.5 cm)
Signed (at front, on bezel): *Gouers A Paris* (Gouers in
Paris)
Marks: (on inside wall) *I* [maison commune, Paris,
1725–26], [maker's mark Daniel Govaers]; (on bezel, at
left) [discharge mark, Saint Esprit, 1722–27]; (on bezel,
at right) *V* [early 19th-century Dutch import mark]
Musée du Louvre, Paris, Département des Objets
d'Art (OA 10670)

REFERENCES: Grandjean 1979, pp. 294–97, figs. 1–3;
Grandjean 1981, pp. 110–11, no. 121; Truman 2013,
p. 21, fig. 5

NOTES (cats. 52–55)
1. Molhuysen and Blok 1911–37, vol. 2 (1912), cols. 601–2;
 André and Bourgeois 1924, pp. 456–57. This arrange-
 ment had long been stipulated by the Dutch Republic
 but had been acceded to by France only in 1717 at the
 time of the Triple Alliance, a treaty between France,
 Great Britain, and the Netherlands intended to check the
 ambitions of the Spanish king Philip V.
2. Hop arrived in Paris on October 21, 1718; Dangeau
 1854–60, vol. 17 (1859), p. 406, vol. 18 (1860), p. 91. A
 detailed account of Hop's entry and public audience is
 given by Dumont and Rousset de Missy 1739, vol. 1,
 pp. 63–68.
3. Nationaal Archief, The Hague, Staten Generaal, 6798,
 reports of July 14 and 28, 1719. See also *Europische
 Mercurius* 30, pt. 2 (July–December 1719), pp. 9–11;
 Dumont and Rousset de Missy 1739, vol. 1, p. 66.
4. Because the Tuileries Palace was being cleaned, Hop was
 received at the Louvre in the former Grand Cabinet of
 Anne of Austria, Louis XV's great-great-grandmother.
 Aulanier 1955, pp. 45–47.
5. The full text of Hop's speech and of Louis XIV's answer
 are recorded in *Europische Mercurius* 30, pt. 2 (July–
 December 1719), pp. 65–67.
6. On the canvas, the artist identified the most important
 people as the Abbot Dubois, Minister of Foreign Affairs;
 the duc de Bourbon; the maréchal-duc de Villeroy, the
 king's governor; and Nicolas de Sainctot, the Introducer
 of Ambassadors. Although these names are now barely
 legible, an engraving after Dumesnil's painting by
 Simon Fokke recorded them as well (Musée National des
 Châteaux de Versailles et de Trianon, INV.GRAV 1122).
7. The Regent had the fountains turned on in Hop's honor,
 although unfortunately they made but a poor showing
 because of the lack of water. Nationaal Archief, The
 Hague, Staten Generaal, 6798, report of September 15,
 1719.
8. The queen, in a separate meeting, very graciously
 answered Hop's compliments. Nationaal Archief, The
 Hague, Staten Generaal, 6804, report of November 8,
 1725.
9. Offered in 1725, the *médaillers* contained medals valued
 at twelve thousand livres. Archives Diplomatiques,

Paris, Ministère des Affaires Etrangères, Mémoires et Documents, France, vol. 2097, "Les présents du Roy," 61, fol. 100.

10. The snuffbox, offered in 1726, was valued at 7,207 livres. Ibid.

56. *Louis XV*
Augustin Oudart Justina (French, d. 1743)
Ca. 1717
Oil on canvas
33½ × 29¼ in. (85 × 75.5 cm)
Musée National des Châteaux de Versailles et de Trianon (MV 8562)

REFERENCE: Frédéric Lacaille in Bacquart, Leimbacher, and Taxil 2014, pp. 64–65

NOTE
1. *Le nouveau Mercure*, March 21, 1721, pp. 137–38; *Le nouveau Mercure*, May 1721, p. 145.

57. *Isabella, Countess of Hertford*
Alexander Roslin (Swedish, Malmö 1718–1793 Paris)
1765
Oil on canvas
33¼ × 28¼ in. (85.7 × 73 cm)
Signed and dated (at left, above skirt): *Roslin Suedois / à Paris 1765* (Roslin Swedish in Paris 1765)
The Hunterian, University of Glasgow (GLAHA 43803)

REFERENCES: Ribeiro 1995, pp. 59, 62, pl. 61; Cumming 1998, pp. 11, 61, no. 48, ill. p. 60; L. E. Miller 2002, pp. 117–18, fig. 13; Peter Black in P. Black 2007, pp. 147–48, no. 77; Campbell 2007, p. 14, ill.

NOTES
1. Earl of Hertford to Horace Walpole, November 11, 1763, in Walpole 1974, p. 220. See also Hertford's letters of October 28 and December 16, 1763; Walpole 1974, pp. 216–17, 261.
2. Earl of Hertford to Horace Walpole, November 19, 1763, in ibid., p. 237.

58. Bracelet Element with Miniature Portrait of Louis XIV
Jean Petitot the Elder (Geneva 1607–1691 Vevey)
French, ca. 1670
Silver, gold, enamel, diamonds; miniature portrait: gouache on paper, crystal glass
H. 1⅖ in. (3.7 cm), W. 1¼ in. (3.3 cm)
Signed (on reverse of miniature): *P*
Patek Philippe Museum, Geneva (E-66)

REFERENCE: Bimbenet-Privat and Farges 2015, pp. 9, 43, fig. 8

NOTES
1. Dangeau 1825, vol. 2, pp. 121–22.
2. See Francois Boucher's *Madame de Pompadour at Her Toilette* (Fogg Museum, Harvard Art Museums, Cambridge, Mass., 1966.47) and Anton Raphael Mengs's portrait of the Infanta Maria Luisa (Kunsthistorisches Museum, Gemäldegalerie, Vienna, 1644).
3. A. J. Dezallier d'Argenville 1762, vol. 3, p. 28.

59. *The Moroccan Ambassador, Muhammad Temin, and His Retinue at the Comédie-Italienne*
Antoine Coypel (French, Paris 1661–1722 Paris)
Ca. 1682
Oil on wood
11 × 8¼ in. (28 × 21 cm)
Inscribed (on reverse): *Les ambassadeurss de . . . faits de ressouvenir par M. Coypel* (The ambassadors of . . . made from memory by M. Coypel)
Musée National des Châteaux de Versailles et de Trianon (MV 5487)

REFERENCES: Garnier 1989, pp. 94–95, no. 10, pl. 1; T. Bajou 1998, pp. 204–5

NOTE
1. *Mercure galant*, February 1682, pp. 322–24. An engraving by Antoine Trouvain, based on Coypel's painting and illustrated in this article, is in the collection of the Musée National des Châteaux de Versailles et de Trianon (INV.GRAV 218).

60. *Louis XIV Receiving the Siamese Ambassadors*
Jean Mauger (French, Dieppe 1648–1722 Paris)
Ca. 1687–89
Silver
Diam. 2⅞ in. (7.2 cm)
Inscribed and signed (on obverse): *FAMA VIRTVTIS • / ORATORES REGIS SIAM* (Virtuous Fame, Ambassadors of the King of Siam) / *M • DC • LXXXVI • / MAVGER • F •* (1686 Made by MAUGER)
Bibliothèque Nationale de France, Département des Monnaies, Médailles et Antiques (Série Royale 939)

REFERENCES: M. Martin 2015, p. 656, pl. 2; Wellington 2016, pp. 292–93, fig. 186

NOTES
1. M. Martin 2015, pp. 656–57.
2. Wellington 2016, pp. 292–93.

61. *The Royal Reception of Ambassadors from the King of Siam by His Majesty*
Attributed to Pierre Paul Sevin (French, Tournon 1650–1710 Tournon), published by François Jollain (French, Paris 1641–1704 Paris)
Ca. 1687
Etching and engraving on paper
32¼ × 20½ in. (82 × 52 cm)
Musée du Louvre, Paris, Département des Arts Graphiques, Collection Edmond de Rothschild (26985LR)

REFERENCE: M. Martin 2015, pp. 652–67, pls. 1, 4, 7

NOTE
1. M. Martin 2015, p. 665.

62. *The Siamese Ambassadors and Their Interpreter, the Abbé de Lionne*
Jacques Vigoureux-Duplessis (French, before 1680–1732 Paris)
Ca. 1715
Oil on canvas

63 × 55⅛ in. (160 × 140 cm)
Signed (at lower left): *J. V. Da . . . invenit et pinxit.* (J. V. Da . . . invented and painted)
Institut de France, Abbaye Royale de Chaalis, Fontaine-Chaalis (MCAJ-P 344)

REFERENCES: Eidelberg 1977, pp. 65–66, fig. 3; La Gorce 1981, p. 74; Michel Jacq-Hergoualc'h in *Phra Narai* 1986, no. 123, ill.; Roland Michel 2003, pp. 115, 119, n. 43; Xavier Salmon in Salmon 2011, p, 69, no. 11

NOTES
1. La Gorce 1981, p. 74; Eidelberg 1977.
2. M. Martin 2015, pp. 664–65.
3. Love 2006, p. 24.

63. Processional Miniature Throne (*Busabok*)
Thailand, Early Rattanakosin (Bangkok) period, late 18th–early 19th century
Wood with lacquer, inlaid mirrored glass, gold leaf
H. 34 in. (86.5 cm), W. 11⅛ in. (29.5 cm), D. 13¾ in. (34.8 cm)
National Museum of Thailand, Bangkok (RS 147 [9939])

NOTES
1. For further information, see Smithies 1986.
2. According to the French adjunct ambassador, Abbé de Choisy, who accompanied the Siamese mission, some three hundred bales of goods were packed in Ayutthaya under his supervision (Choisy 1727). Lists of the gifts were published in 1687 as an appendix to Ambassador Kosa Pan's *Harangues*, including those presented to Louis XIV and the Dauphin by Phra Narai (see Smithies 1986). That they were not all appreciated is clear from the journal of the marquis de Dangeau, who noted that on September 2, 1686, after a "grand supper in his apartments," the Dauphin "auctioned off a part of the presents he had received from Siam." Dangeau 1854–60, vol. 1 (1854), p. 378 (entry of September 2, 1686); Smithies 1986, p. 15.

64. Siamese Hat of Rank and Case (*Lompok*)
Thailand, Early Rattanakosin (Bangkok) period, late 18th–early 19th century
Hat: cotton (muslin) on rattan or bamboo armature, gilt metal band; case: leather with lacquer and gold
H. of hat 18⅞ in. (48 cm), of case 22 in. (56 cm); Diam. of hat 6½ in. (16.5 cm), of case 8½ in. (21.6 cm)
Somdet Phra Narai National Museum, Lopburi (1748/24/1, 2)

REFERENCE: Guy 1998, p. 142, ill. no. 192

NOTES
1. While this diplomatic mission is the most celebrated undertaken by the Siamese to Europe in the seventeenth century, it was not their first. As early as 1608, King Ekathotsarot sent two ambassadors to the Netherlands in response to the overtures of the Dutch East India Company (VOC) and its establishing a station at Ayutthaya. They sailed on VOC ships and were received by Prince Maurice of Orange-Nassau in The Hague in September of that year. See van der Cruysse 2002, pp. 1–2.
2. *Harangues faites a Sa Majesté, et aux princes et princessses de la maison royale, par les ambassadeurs du Roy de Siam*

a leur première audience et a leur audience de congé (Paris: Sébastien Mabre-Cramoisy, 1687), facsimile reprint in Smithies 1986, pp. 20–69.

3. For an examination of the instigation of sumptuary laws at the Siamese court, see Guy 1998, p. 127.

4. Persian merchants frequently rose to high positions in the Siamese administration and on occasion were elevated to ministerial rank (*caophraya*) to oversee the king's foreign trading interests. Siamese relations with Persia were already strong in the early seventeenth century, and Phra Narai actively fostered these in the 1660s; he also cultivated relations with other Asian and European countries, including Portugal, to which a mission was sent in 1684, two years before that sent to France (see Smithies and Dhiravat na Pomberja 2002). The adoption of a Persianesque mode of nobleman's dress, as seen in this *lompok*, was part of the legacy of the extended presence of Persians at the Siamese court over the seventeenth century and a reflection of their social integration.

65. Cannon
Siamese, before 1686
Cast iron, silver-plated brass inlay
L. 73⅛ in. (187 cm); caliber: 50 mm, or ½-pound ("livre") ball
The Royal Artillery Museum, Larkhill, United Kingdom (GUN1/020)

REFERENCES: Jacq-Hergoualc'h 1985; van der Cruysse 2002, pp. 373–74

NOTES

1. See, for example, the two nineteenth-century guns captured at Annam in 1863 (Musée de l'Armée, Paris, 751 and 751 *bis*). Guy 1998, p. 131, ill. no. 172.

2. "Mémoire des présens du Roy de Siam au Roy de France," excerpt from the "Relation de l'ambassade de Mr. le Chevalier de Chaumont à la cour du Roy de Siam" (1686), reprinted in Belevitch-Stankevitch 1910, p. 256.

3. A detailed study of these two cannons is forthcoming.

66. Lacquer Cabinet
Japanese, 17th century
Lacquer
H. 45⅛ in. (116 cm), W. 42½ in. (107.9 cm), D. 24⅛ in. (62 cm)
Musée du Louvre, Paris, Département des Objets d'Art (OA 5474)

REFERENCES: Lacambre 2010, p. 47, fig. 28; Castelluccio 2014, p. 20, fig. 3

NOTES

1. Impey and Jörg 2005, p. 353. For the list of these presents, see also Archives Nationales, Paris, MS, Col/1/23, fols. 260–64.

2. Lacambre 2010, p. 47.

3. The 1688 Siamese revolution forced the French to trade through the Dutch East India Company; M. Martin 2015, p. 664.

67. *Music*
Savonnerie Manufactory, Paris
French, ca. 1685–97
Wool
15 ft. 10 in. × 29 ft. 8 in. (482.6 × 904.2 cm)
The Metropolitan Museum of Art, New York, Rogers Fund, 1952 (52.118)

REFERENCES: Standen 1955, pp. 257–65, ill. pp. 258–59, 261–63; Burchard 2012, pp. 5, 33–34, no. 11, fig. 2

NOTES

1. M. Martin 2015, p. 655, n. 6.

2. Standen 1955, p. 260.

3. Ibid.

68. *Brittany Offers Louis XIV the Model of His Equestrian Statue*
Antoine Coysevox (French, Lyon 1640–1720 Paris)
1692–93
Bronze
H. 54⅛ in. (138 cm), W. 85⅛ in. (217 cm), D. 4¼ in. (12 cm)
Musée des Beaux-Arts, Rennes (794.2.2)

REFERENCES: Keller-Dorian 1920, vol. 1, pp. 76–89, no. 55, pl. 90; Pocquet du Haut-Jussé 1922, pp. 51–62; Michel Jacq-Hergoualc'h in *Phra Narai* 1986, no. 58, ill.; Coulon et al. 1996, p. 65; Françoise de La Moureyre in Bresc-Bautier and Scherf 2009, pp. 322–25, no. 89

69A, B. Pair of Vases
Italian, early 18th century
Porphyry
H. 31½ in. (80 cm), W. 26 in. (66 cm) each
The Al Thani Collection (BELM0348)

REFERENCES: Connolly and Zerbe 1962, ill. p. 202; Del Bufalo 2012, p. 149, no. V81

NOTES

1. Bertrand Rondot in Bacquart, Leimbacher, and Taxil 2014, p. 40.

2. Driessen 1928, p. 53.

3. I am grateful to Alexis Kugel for this information. Sold at Christie's, Paris, October 4, 2012, no. 300. Current location unknown.

70. *Famille Royale*
Roettiers family, possibly Jacques (French, Saint-Germain-en-Laye 1707–1784 Paris)
1693 or later
Gold
Diam. 2⅜ in. (5.9 cm)
Inscribed and dated: (on obverse) *LUDOVICUS • MAGNUS • REX • CHRISTIANISSIMUS •* (Louis Most Christian King); (on reverse) *FELICITAS DOMUS AUGUSTAE* (The Joy of the Royal House), (under profile of the Dauphin, at top) *SEREN • DELPH •* (His Highness the Great Dauphin), (under profiles of his three sons, left to right) *LUD • D • BURG •* (Louis, duc de Bourgogne) / *CAR • D • BITUR •* (Charles, duc de Berry) / *PHIL • D • AND •* (Philippe, duc d'Anjou), (at bottom center) *M • DC • XCIII •* (1693)

Marks (on obverse, beneath profile of Louis XIV): *R* [possibly mark for Jacques Roettiers, active 1732–72] Bibliothèque Nationale de France, Paris, Département des Monnaies, Médailles et Antiques (1034)

NOTES

1. In 1706 the Abenaki chief Nescambiouit was brought to Versailles by Jacques Testard de Montigny, an officer from Montreal, to receive his medal in person; Wellington 2016, p. 302.

2. Letter of Marie André Regnard Duplessis de Sainte Hélène, October 17, 1723, in Verreau 1875, pp. 105–11, cited in Wellington 2016, p. 303.

3. Archives Diplomatiques, Paris, Ministère des Affaires Etrangères, Mémoires et Documents, France, vol. 2037, "Les présents du Roy," 1, fol. 462.

4. Wellington 2016, p. 304.

71. *Louis XIV Receiving the Persian Ambassador Muhammad Reza Beg*
Attributed to Nicolas Largillière (French, Paris 1656–1746 Paris)
After 1715
Oil on canvas
27½ × 60¼ in. (70 × 153 cm)
Musée National des Châteaux de Versailles et de Trianon (MV 5461)

REFERENCES: Bouret 1982, p. 123, no. 15; T. Bajou 1998, pp. 322–23; *Fastes de Versailles* 2002, p. 213, no. 015; Nicolas Milovanovic in *Louis XIV, le Roi-Soleil* 2005, pp. 110–13, no. 17; Salmon 2007, pp. 54–55, 206, no. 10; Christine Dixon in Saule and Ward 2016, pp. 62–63, no. 13

NOTES

1. The king "had to the right of him, in a semicircle, Monsieur le Dauphin [the king's grandson and future Louis XV], Monsieur le duc de Dombes, Monsieur le comte d'Eu, and Monsieur le duc du Maine; to his left, Monseigneur le duc d'Orléans [the future Regent], Monsieur le Duc [de Bourbon], Monsieur le comte de Charollais, Monsieur le prince de Conty, and Monsieur le comte de Toulouse. On both sides of the throne and behind the princes were the princesses of the blood." *Mercure galant*, March 1715, pp. 256–58, reprinted in Castelluccio 2007, pp. 126–32.

2. Saint-Simon 1856–58, vol. 12 (1857), p. 17.

72. *A Persian Ambassador*
Jacques Vigoureux-Duplessis (French, before 1680–1732)
1721
Oil on canvas
63 × 55⅛ in. (160 × 140 cm)
Signed (at bottom center): *J. V. D.*
Institut de France, Abbaye Royale de Chaalis, Fontaine-Chaalis (MJAC-P 345)

REFERENCES: Eidelberg 1977, pp. 65–66, fig. 2; Bouret 1982, p. 110; La Gorce 1981, p. 74

NOTES

1. Saule 2007a, pp. 68–69.

2. Reza Beg came from the province of Erivan, modern-day Armenia.

3. Letter to the Raugravine Luise, February 7, 1715, Versailles, in Orléans 1924–25, vol. 2, p. 84; see also Herbette 1907, pp. 110–11, 142. Unexpected rain nearly ruined his rescheduled entry into Paris on February 7; Herbette 1907, p. 122.

4. Herbette 1907, p. 154. The perceived mediocrity of Reza Beg's proffered gifts ultimately led many courtiers to question his credentials; see Saint-Simon 1829–30, vol. 12 (1829), p. 98; Herbette 1907, pp. 182–84. The king's gifts to the shah included gold and silver brocades, colored silks, luxury arms, a Savonnerie carpet, clocks, medals, and gems; see the inventory of gifts from Louis XIV to the Persians in Archives Diplomatiques, Paris, Ministère des Affaires Etrangères, Mémoires et Documents, France, vol. 2096, "Les présents du Roy," 60, 1669–1724, fols. 76–77.

5. Hostelfort 1716.

73. *Yirmisekiz Çelebi Mehmed Efendi*
Attributed to Pierre Gobert (French, Fontainebleau 1662–1744 Paris)
1724
Oil on canvas, stretched on board
42⅛ × 30½ in. (107.5 × 77.5 cm); trimmed from 44¼ × 44¼ in. (113.6 × 113.6 cm)
Loaned from Philip Mould & Company, London

REFERENCES: Engerand 1897, p. 163; Engerand 1900, pp. 211, 243

NOTES
1. Engerand 1900, p. 211.
2. Mehmed Efendi 1757, p. 141.
3. Ibid., p. 157.

74. *The Departure of the Ottoman Embassy from the Tuileries*
Gobelins Manufactory, Paris, workshop of Le Febvre and Monmerqué
After a design by Charles Parrocel (French, Paris 1688–1752 Paris)
1734–1736/37
Wool and silk
13 ft. 9⅛ in. × 19 ft. 2⅛ in. (420 × 585 cm)
Signed: (at lower left) *Charles Parrocel Px* (Painted by Charles Parrocel); (at lower right) *Gobs* ⚜ *—Monmerqué*
Mobilier National, Paris (GMTT/184/2)

REFERENCE: Fenaille 1903–23, vol. 3 (1904), pp. 318–22, ill.

NOTE
1. Mehmed Efendi 1757, pp. 165–67.

75. *Mehmed Said Efendi, Ambassador of the Sublime Porte*
Jacques André Joseph Aved (French, Douai 1702–1766 Paris)
1742
Oil on canvas
90½ × 63⅜ in. (230 × 161 cm)
Signed and dated (at lower right): *Aved 1742*
Musée National des Châteaux de Versailles et de Trianon (MV 3716)

REFERENCES: Wildenstein 1922, vol. 1, pp. 60–63, 102–3, vol. 2, p. 120, no. 92, ill.; Béatrix Saule and Corinne Thépaut-Cabasset in *Topkapi à Versailles* 1999, pp. 328–29, no. 284; Lespes 2009, ill. p. 76

NOTE
1. Maskill 2017.

76. Powder Flask
Ottoman, before 1742
Precious stones, diamonds, emeralds, rubies, brass, enamel, silver gilt
H. 11⅞ in. (30 cm), W. 5½ in. (14 cm)
Musée de l'Armée, Paris (M 2349)

REFERENCE: Reverseau 2005–6, pp. 23, 25, ill. pp. 23, 24

77. Quiver
Ottoman, before 1742
Velvet, silver gilt embroidery, precious stones, pearls, emeralds, gold
H. 25⅛ in. (65 cm)
Musée de l'Armée, Paris (L 226)

REFERENCE: Reverseau 2005–6, pp. 24–25, ill.

NOTES (cats. 76, 77)
1. For a related example, see Thérèse Bittar in *Topkapi à Versailles* 1999, p. 276, no. 233.
2. Göçek 1987, pp. 143–44; Whitehead 2009, p. 166.

78. Horned Headdress
Eastern Plains or Western Great Lakes
Ca. 1700–1750
Buffalo rawhide, native tanned leather, porcupine quills, bison or cow horn, glass beads, dyed deer hair and horsehair
H. 6⅛ in. (15.5 cm), W. 25⅛ in. (65 cm), D. 5⅞ in. (15 cm)
Musée du Quai Branly, Paris (71.1878.32.156)

REFERENCE: André Delpuech in Torrence 2014, p. 71, no. 11

NOTE
1. André Delpuech in Torrence 2014, p. 71.

79. *Süleyman Aga*
Jean Bernard Restout (French, Paris 1732–1797 Paris)
1777
Oil on canvas
31⅞ × 26¾ in. (81 × 68 cm)
Inscribed (on reverse): *Suleiman Aga, général de cavalrie, envoyé de Tunis en 1777* (Suleiman Aga, general of cavalry, envoy from Tunis in 1777)
Musée des Beaux-Arts de Quimper, Bequest of Jean-Marie de Silguy, 1864 (873-1-597)

REFERENCES: Sophie Barthélémy in *Siglo de pintura francesa* 1992, pp. 161–62, no. 12; Barthélémy in *Van Boucher tot Boudin* 1992, pp. 50–51, no. 18

NOTES
1. "Journal de l'ambassade de Suleiman Aga, envoyé extraordinaire du bey de Tunis près Sa Majesté très chrétienne, depuis son arrivée à Toulon, le 18 janvier 1777, jusqu'à son embarquement dans ledit port, le 31 may de la même année, rédigé par le sr Ruffin, secrétaire interprète du Roy pour les langues orientales, et chargé par Sa Majesté de la conduit dudit envoyé," Bibliothèque Nationale de France, Paris, Département des Manuscrits, Français 13982, fols. 1–2. My thanks to Daniëlle Kisluk-Grosheide for bringing this manuscript to my attention.
2. To reach Paris, for instance, he preferred a quick ride on horseback to a lengthy trip by carriage. Ibid., fol. 15.
3. Restout and an unnamed artist received payment of 2,988 livres for this and another portrait. Ibid., fol. 173.
4. On being expected to wear traditional dress, see, for example, Dyâb 2015, pp. 258, 267.
5. "Journal de l'ambassade de Suleiman Aga" (see note 1 above), fol. 65.
6. Ibid., fol. 75. While in Paris, he enjoyed the Comédie for its pantomime, but the Garde Meuble made little impression except for the presents he saw from the 1721 Ottoman embassy; ibid., fols. 72, 109.
7. Ibid., fols. 6, 89.
8. Ibid., fol. 107.

80. *Nguyễn Phúc Cảnh*
Maupérin (French, active 1774–1800)
1787
Oil on canvas
62⅛ × 39⅜ in. (158.5 × 100 cm)
Signed and dated (at right, on base of column): *Mauperin 1787*
Société des Missions Etrangères de Paris

REFERENCES: Mantienne 1999, p. 114; Noël 2006, p. 150 and colorpl.; Bruckbauer 2013, pp. 7–29, 61, fig. 1

NOTES
1. Jefferson was particularly interested in Cochinchinese rice. See France d'Hézecques 1873a, pp. 219–21 (French ed., France d'Hézecques 1878b, pp. 235–37); Bruckbauer 2013, p. 11, n. 22.
2. Noël 2006, p. 150; Bruckbauer 2013, p. 11, n. 21; Chrisman-Campbell 2015, p. 252.
3. In a 1787 Sèvres plaster model of the prince (Manufacture Nationale de Sèvres, casier modèle 377), he wears the same turban and a floor-length robe, and is paired with the same mandarin's hats. See Anne Billon in *Louis Simon Boizot* 2001, pp. 227–28, no. 76.
4. Archives Diplomatiques, Paris, Ministère des Affaires Etrangères, Mémoires et Documents, France, vol. 2092, "Les présents du Roy," 56, 1787, fol. 16.

81. *Muhammad Osman Khan*
Claude André Deseine (French, Paris 1740–1823 Petit-Gentilly)
1788
Terracotta
H. 21¼ in. (54 cm), with wood base 25⅛ in. (65 cm); W. 15¾ in. (40 cm); D. 9⅞ in. (25 cm)
Signed (on right shoulder): *ft par / Deseine / Sourd et / Muet 1788* (Made by Deseine Deaf and Mute 1788)
Musée du Louvre, Paris, Département des Sculptures, Gift of Pierre-Evariste Villemant, 1934 (RF 2334)

REFERENCES: Guilhem Scherf in *Skulptur aus dem Louvre* 1989, pp. 228–29, 309, no. 81; Bresc-Bautier, Lemaistre, and Scherf 1998, p. 335; Buddle 1999, pp. 29, 83, no. 82, pl. 34

82. *Nephew of Muhammad Osman Khan*
Claude André Deseine (French, Paris 1740–1823 Petit-Gentilly)
1788
Terracotta
H. 18½ in. (47 cm), with wood base 26⅛ in. (67 cm); W. 13¼ in. (33.5 cm); D. 7⅞ in. (19.5 cm)
Musée du Louvre, Paris, Département des Sculptures (RF 4664)

NOTE (cats. 81, 82)
 1. Vigée Le Brun 1904, p. 24.

83. *Promenade of the Ambassadors of Tipu Sultan in the Park of Saint-Cloud*
Charles Eloi Asselin (French, active 1765–1803)
1788
Gouache on paper, mounted on canvas
26 × 38¼ in. (66 × 98.5 cm)
Cité de la Céramique–Sèvres et Limoges (Mp51893N01)

REFERENCES: Brunet 1961, pp. 278–80, figs. 3, 4; M. Martin 2014, pp. 37–68, figs. 1–3

NOTES
 1. M. Martin 2014, p. 63, n. 2.
 2. Ibid., pp. 41–42.

84. *Louis XVI*
Sèvres Manufactory
Louis Simon Boizot (French, Paris 1743–1809 Paris)
1788
Soft-paste biscuit porcelain
H. 15 in. (38 cm), W. 10⅜ in. (26.5 cm), D. 9½ in. (24 cm)
Victoria and Albert Museum, London (A-1983)

85. *Marie Antoinette*
Sèvres Manufactory
Louis Simon Boizot (French, Paris 1743–1809 Paris)
1788
Soft-paste biscuit porcelain
H. 16 in. (40.7 cm), W. 10¼ in. (26 cm), D. 5⅞ in. (15 cm)
Victoria and Albert Museum, London (C.367)

NOTES (cats. 84, 85)
 1. Brunet 1961, p. 275.
 2. M. Martin 2014, p. 51.
 3. Related examples of these busts in the Cité de la Céramique, Sèvres (M.N.C. 22328 and 22329), have been published by Anne Billon in *Louis Simon Boizot* 2001, p. 226, nos. 74, 75, and another pair from the Royal Collection Trust (RCIN 39496 and 39497) has been published in Bellaigue 2009, vol. 3, p. 1085, nos. 307, 308.

86. Set of Twelve Cups and Saucers (*tasses litrons*)
Sèvres Manufactory
French, 1776–88
Hard- and soft-paste porcelain
Diam. (cups) 2¾ in. (7 cm); (saucers) 5⅜ in. (13.5 cm)
Powis Castle, The Clive Collection (The National Trust), County of Powys, Wales (1181042.1–.24)
Only nos. 1181042.1, .2, .5, .6, .21, and .22 are in the exhibition.

REFERENCES: Archer, Rowell, and Skelton 1987, pp. 141–42, no. 244; Rowell 1987, p. 28

NOTES
 1. Archives, Cité de la Céramique, Sèvres, Vg 10, fols. 276v–277v, cited in Archer, Rowell, and Skelton 1987, p. 141.
 2. Rowell 1987, p. 28.

87. Cup and Saucer (*tasse litron*)
Sèvres Manufactory
Decorated by Nicolas Pierre Pithou the Younger (active 1763–67, 1769–95, 1814–18) and Jean-Baptiste Etienne Nicolas Noualhier *fils* (active 1779–82, 1786–91, 1806, 1824–35)
French, 1788
Soft-paste porcelain
H. of cup 2⅞ in. (7.2 cm); Diam. of saucer 5½ in. (14 cm)
Musée Carnavalet–Histoire de Paris, Gift of Edouard Dutey-Harispe (C1465)

REFERENCES: Brunet 1961, p. 280, fig. 6; M. Martin 2014, p. 52, fig. 10

NOTES
 1. M. Martin 2014, pp. 39, 63, n. 1.
 2. Brunet 1961, p. 280.
 3. Ibid., pp. 280, 283, nn. 24, 25.

88. *Louis XIV Receiving the Prince Elector of Saxony at Fontainebleau*
Louis de Silvestre (French, Sceaux 1675–1760 Paris)
1715
Oil on canvas
47¼ × 61 in. (120 × 155 cm)
Musée National des Châteaux de Versailles et de Trianon (MV 4344)

REFERENCES: Salmon 1997, pp. 24–27, no. 6; Catherine Tran in Marx and Starcky 2001, p. 141; Xavier Salmon in Gaehtgens, Syndram, and Saule 2006, pp. 152–53, no. 11; Masson 2015, p. 55, fig. 18; Raphaël Masson in Sabatier and Saule 2015, p. 220, no. 144

89. *Gustav III*
Alexander Roslin (Swedish, Malmö 1718–1793 Paris)
1775
Oil on canvas
28¾ × 23¼ in. (73 × 59 cm)
Signed and dated (at lower left): *Roslin 1775*
Nationalmuseum, Stockholm (NM 1012)

REFERENCES: Bjurström 1993, pp. 111, 113ff., 117, 221, 226; Grate 1998, p. 202; Olausson 2007a, pp. 76–77; Olausson 2007b, pp. 145, 256, no. 92

90. *Frederick Adolf*
Alexander Roslin (Swedish, Malmö 1718–1793 Paris)
1771
Oil on canvas
32¼ × 25⅝ in. (82 × 65 cm)
Signed and dated (at lower left): *Roslin à Paris 1770* [*sic*] (Roslin in Paris 1770 [*sic*])
The Swedish National Portrait Gallery, Stockholm, Gift 1879 from Baronness Anna Adelswärd, b. Macnamara (NMGrh 1991)

REFERENCES: Bjurström 1993, pp. 42–43, 191, 194ff., 237; Olausson 2007b, pp. 142, 237, no. 61; Olausson 2007c, p. 100; Olausson 2008; Olausson and Salmon 2008, p. 173, no. 50

91. Hunting Costume
Le Duc
French, recorded 1771
Body: broadcloth with velvet details, gold and silver galloons; lining: wool (coat), silk (waistcoat), chamois (breeches); swordbelt: chamois with gold galloons; boots: leather
L. of coat, at back 42½ in. (108 cm), of waistcoat, at back 29½ in. (75 cm), of breeches 23⅝ in. (60 cm); swordbelt 3 × 45¼ in. (7.5 × 115 cm); boots H. 21⅞ in. (55.5 cm)
The Royal Armoury, Stockholm (11596–99, 27511–12)

REFERENCES: Proschwitz 1986, p. 107, letter no. 41, February 17, 1771; Rangström 1997, pp. 84–91; Philippe Dulac in Caude, La Gorce, and Saule 2016, p. 46, no. 7

NOTES
 1. Madame du Deffand to Horace Walpole, March 7, 1771, in Walpole 1939, p. 36.
 2. Proschwitz 1986, p. 107, letter no. 41, February 17, 1771. Christian VII's hunting costume (1768) is in the Danish Royal Collections, Rosenborg Castle, Copenhagen (KA.1 31B.2).

92. Tureen and Stand (*terrine et plateau*)
Sèvres Manufactory
Painted by Antoine Joseph Chappuis (active 1756–87)
French, 1771
Soft-paste porcelain, decorated in polychrome enamels and gold
Tureen: H. 9⅝ in. (24.5 cm), W. 12¼ in. (31 cm), D. 7⅝ in. (19.5 cm); stand: H. 18⅛ in. (46 cm), W. 14⅜ in. (36.5 cm)
The Royal Collections Sweden, Stockholm (HGK 7, HGK 12)

REFERENCES: Lars Ljungström in *Soleil et l'étoile du nord* 1994, pp. 323–24, no. 491a; Peters 2005, vol. 2, pp. 455–58, no. 71-5

NOTE
 1. Tydén-Jordan 1994, p. 309.

93. *Marie Antoinette, Louis XVI, and the Archduke Maximilian*
Josef Hauzinger (Austrian, Vienna 1778–1786 Vienna)
1778
Oil on canvas
98 × 59 in. (249 × 150 cm)
Kunsthistorisches Museum, Vienna, Gemäldegalerie, now on display in the Widow's Apartment at Schloss Hof (8854)

REFERENCES: Barta-Fliedl 2001, p. 113, pl. 15, fig. 102; Karl Schütz in *Marie-Antoinette* 2008, pp. 326–28, no. 238

NOTES
1. This early sketch and a study for a painting in the series are in the Bildarchiv, Österreichische Nationalbibliothek, Vienna; see Barta-Fliedl 2001, p. 113, figs. 103, 104.
2. Smythe 1902, vol. 2, pp. 407–8.

94. *The Rock and Belvedere at the Petit Trianon*
Claude Louis Châtelet (French, Paris 1753–1794 Paris)
1781
Oil on canvas
22⅞ × 31½ in. (58 × 80 cm)
Signed and dated (at lower right): *CHATELET / 1781*
Musée National des Châteaux de Versailles et de Trianon (MV 7796)

REFERENCES: Nolhac 1927, pp. 175–76; Xavier Salmon in Boysson and Salmon 2005, pp. 176–77, no. 67; Salmon in Chapman et al. 2007, p. 155, no. 64; Béatrice Sarrazin in Le Bon 2017, pp. 233, 336, no. 146, ill. p. 217

95. *Souvenir Album of the Petit Trianon*
Richard Mique (French, Nancy 1728–1794 Paris)
Claude Louis Châtelet (French, Paris 1753–1794 Paris)
1781
Watercolor, pen and ink; stamped morocco leather binding; blue silk linings
H. 19½ in. (49.5 cm), W. 15⅜ in. (39 cm), D. 1 in. (2.5 cm)
Vartanian & Sons, New York

REFERENCES: Arizzoli-Clémentel 1998, pp. 16–17; Chapman et al. 2007, pp. 82–85, 150–54, no. 63, ill. p. 2

NOTES
1. Joseph II: 1781 (present copy); Archduke Ferdinand: 1786 (Biblioteca Estense Universitaria, Modena, Est. 119); Gustav III: one copy sent in 1779 (Royal Library, Stockholm, KoB H, vol. 35), another received in 1784 that no longer exists; comte and comtesse du Nord: 1782 (Pavlovsk Palace, Saint Petersburg, CCh-873-XII, frontispiece in the Metropolitan [cat. 99]); queen's personal copy (Versailles, V.2016.12). A sixth was commissioned in 1786 for the Spanish Princess of the Asturias, Maria Luisa of Parma.
2. Oberkirch 1852, vol. 1, p. 325.

96. Fire Screen Panel
Savonnerie Manufactory, Paris
After a design attributed to Claude Audran III (Lyon 1658–1734 Paris)
French, before 1777; design, late 1720s; woven until second half of 18th century
Wool, possibly linen
H. 37 in. (94 cm), W. 30⅞ in. (78.5 cm)
MAK—Austrian Museum of Applied Arts / Contemporary Art, Vienna (T 8409)

REFERENCE: Verlet 1982, app. B, p. 508, no. 39

NOTES
1. Verlet 1982, pp. 306–7.
2. Ibid., p. 310.

97A–D. Four Folding Screen Panels
Savonnerie Manufactory, Paris
After designs by Jean-Baptiste Oudry (Paris 1686–1755 Beauvais) and Pierre Josse Perrot (1678–1750)
French, before 1777; designs, 1739
Wool, linen
MAK—Austrian Museum of Applied Arts / Contemporary Art, Vienna

A. *The Rooster and the Pearl*
H. 8 ft. 5⅛ in. (257 cm), W. 29⅞ in. (76 cm)
(T 8320)

B. *The Fox and the Crow*
H. 8 ft. 3⅛ in. (253 cm), W. 29⅜ in. (74.5 cm)
(T 8322)

C. *The Fox and the Grapes*
H. 8 ft. 3⅛ in. (253 cm), W. 29⅞ in. (76 cm)
(T 8324)

D. *The Stag at the Pool*
H. 8 ft. 1¼ in. (247 cm), W. 30¼ in. (78 cm)
(T 8325)

REFERENCES: Baldass 1920, room XVII, pp. 35–36, nos. 53–58; Waltraud Neuwirth in Koschatzky 1980, p. 301, no. 58,02; Verlet 1982, app. B, p. 508, no. 39

NOTES
1. Verlet 1982, p. 459, n. 99.
2. Ibid., pp. 100, 304.
3. "Mémoires de Jean Raussin" 2010, p. 159.

98. *Nighttime Festivities with Fireworks in the Gardens of the Petit Trianon*
Hubert Robert (French, Paris 1733–1808 Paris)
1782–83
Oil on canvas
23⅛ × 29⅛ in. (60 × 74 cm)
Musée des Beaux-Arts de Quimper, Bequest of Comte de Silguy (873-1-411)

REFERENCES: Hubertus Gassner in *Krieg und Frieden* 2001, p. 119, no. 86; Jérôme de La Gorce in Caude, La Gorce, and Saule 2016, p. 375, no. 366, ill. p. 361

NOTE
1. Xavier Salmon in Chapman et al. 2007, p. 155; Proschwitz 1986, p. 268, letter no. 121, June 21, 1784.

99. *Design for a Frontispiece*
Claude Louis Châtelet (French, Paris 1753–1794 Paris)
1782
Pen and brown and gray ink, brush and brown and gray wash, watercolor on paper. Framing lines in pen and black ink, with pink wash outside line
17½ × 13 in. (44.6 × 32.9 cm)
Inscribed and dated (at lower left, on plinth, in pen and brown ink): *RECUEIL / Contenant le Plan general & / diverses Vues du Jardin de la / Reine au petit Trianon. / Par le S͏ͬ. Mique Chevalier de / L'ordre de S͏ͬ. Michel, Premier / Architecte honoraire Intend͏ͬ. / General des Batimens du / Roy & de ceux de la Reine. / 1782* (Album Containing the General Plan & diverse Views of the Garden of the Queen at the Petit Trianon By Le. Sͬ. Mique Chevalier of the Order of Sͭ. Michael, First Architect honorary intendant General of the Buildings of the King & those of the Queen 1782)
The Metropolitan Museum of Art, New York, Edward Pearce Casey Fund, 1984 (1984.1150)

REFERENCES: Myers 1991, pp. 42–45, no. 25; Olga Lameko in *Krieg und Frieden* 2001, p. 118; Xavier Salmon in *Marie-Antoinette* 2008, p. 279

NOTES
1. Oberkirch 1852, vol. 1, p. 39.
2. Croÿ 1906–7, vol. 4 (1907), p. 254; Bulgakova 2014, p. 243.
3. Oberkirch 1852, vol. 1, p. 325; Bulgakova 2014, p. 245.
4. Pavlovsk Palace, Saint Petersburg (CCh-873-XII); Myers 1991, pp. 44–45.

100. Mechanical Table
Jean Henri Riesener (Gladbeck, Germany 1734–1806 Paris)
French, 1781
Oak veneered with *bois satiné*, amaranth, holly, barberry, and various stained marquetry woods; gilt-bronze mounts; iron and brass fittings; mirror glass; velvet (not original)
H. 28½ in. (72.4 cm), W. 30¼ in. (78.1 cm), D. 19 in. (48.3 cm)
The Metropolitan Museum of Art, New York, The Jules Bache Collection, 1949 (49.7.117)

REFERENCES: Verlet 1945–94, vol. 3 (1994), pp. 166–69, no. 19; William Rieder in Kisluk-Grosheide, Koeppe, and Rieder 2006, pp. 187–89, no. 77; Daniëlle Kisluk-Grosheide in Kisluk-Grosheide and Munger 2010, pp. 96–97, no. 37

NOTES
1. Archives Nationales, Paris, O¹ 3630.
2. The other table is also in the Metropolitan's collection (33.10). Riesener was asked to supply several new pieces for this apartment as well. Archives Nationales, Paris, O¹ 3321, fol. 10r.; see Freyberger 1996.
3. On June 14, 1784, however, Gustav III wrote to the comte de Creutz, "I have dined and passed the night at Versailles," and on June 21, "I'm here at Versailles since yesterday evening when I had supper with Mde de Lamballe, and because the party at the Trianon is given tonight, I stayed the night to save myself the expense." See Proschwitz 1986, p. 265, letter no. 119, p. 268, letter no. 121.

101. Mantel Clock
Movement by Joseph Juhel (1728–Year XI [1803])
Case by François Caranda (Paris 1704–after 1789
Paris), master in 1741
French, 1784 (case)
Patinated bronze, gilt bronze, white marble, enamel,
glass
H. 23⅝ in. (60 cm), W. 16⅞ in. (43 cm), D. 11⅛ in.
(28.3 cm)
Signed (on dial): *Juhel à Versailles*
Musée National des Châteaux de Versailles et de
Trianon (V 5057)

REFERENCE: Kuraszewski 1976, pp. 214–15, fig. 2

NOTES
1. Archives Nationales, Paris, O¹ 3630.
2. "figures de vert antique dont l'Etimologie représente
 L'union des arts, . . . désignés par deux Enfants qui les
 couronnent, autour desquels sont les attributs des dits
 arts." Ibid.

102. Armchair (*fauteuil à la reine*)
Jean-Baptiste II Tilliard (French, 1723–1798)
1777–78
Carved and gilded walnut; covered in lampas brocade
(modern)
H. 41⅛ in. (104.5 cm), W. 28⅛ in. (71.3 cm), D. 28½ in.
(72.5 cm)
Musée National des Châteaux de Versailles et de
Trianon (OA 9496)

103. Fire Screen
Jean-Baptiste II Tilliard (French, 1723–1798)
1777–78
Carved and gilded walnut; covered in lampas brocade
(modern)
H. 49⅛ in. (126 cm), W. 33⅛ in. (84 cm), D. 22¼ in.
(56.6 cm)
Musée National des Châteaux de Versailles et de
Trianon (OA 9370 / VMB 14942)

REFERENCES (cats. 102, 103): Verlet 1945–94, vol. 1
(1945), pp. 73–77, no. 29, pls. XL, XLII; D. Meyer
2002, pp. 158–63, no. 41; Pierre-Xavier Hans in
Starcky, Caude, and Delieuvin 2006, pp. 130–33,
no. 21b, c

NOTES (cats. 102,103)
1. Order of Thierry de Ville d'Avray, no. 126, April 26,
 1784, Archives Nationales, Paris, O¹ 3573/12.
2. Order of Thierry de Ville d'Avray, no. 100, April 22,
 1784, Archives Nationales, Paris, O¹ 3573/12. "Il
 serait nécessaire de demander à M. Dangiviller que
 la manufacture de Sève ornat la cheminée et comode
 de porcelaine en vases et figures pour faire plus de
 richesse." See also "Journal de cequi s'est passé à
 Versailles depuis l'instant de l'arrivée de M. le Cᵗᵉ de
 Haga, jusqu'a celui de son depart," Archives Nationales,
 Paris, O¹ 824, fols. 157v–161v, June–August 1784.

104. Tureen and Stand (*terrine et plateau*)
Sèvres Manufactory
Painted by François Antoine Pfeiffer (active
1771–1800) and Nicolas Sinsson (active 1773–95)
Gilded by Henri François Vincent (active 1753–1806)
French, ca. 1777
Hard-paste porcelain, decorated in polychrome
enamels and gold
Tureen: H. 13⅛ in. (33.2 cm), W. 16⅜ in. (41.6 cm),
D. 11⅝ in. (29.5 cm); stand: H. 3 in. (7.6 cm),
W. 24¼ in. (61.6 cm), D. 18½ in. (47 cm)
Marks: Tureen: (painted on underside, in gold)
[crowned foliate interlaced *LL*'s, *F* (painter's mark
for Pfeiffer), and *2000* (gilder's mark for Vincent)
below]; (painted on underside, in red enamel) *339*.
Stand: (painted on underside, in gold) [crowned foliate
interlaced *LL*'s with laurel wreath (painter's mark for
Nicolas Sinsson) and *2000* (gilder's mark for Henri-
François Vincent) below]; (painted on underside, in
red enamel) *N333*
The Metropolitan Museum of Art, New York, The
F. O. Matthiessen Collection, Gift of Mrs. Emma
Matthiessen, in memory of her husband, 1904 (04.6.3a,
b, .4)

REFERENCES: Peters 2005, vol. 3, pp. 707–12, no. 84-5;
Munger 2018, no. 66

NOTES
1. Peters 2005, vol. 3, p. 707.
2. Another example is in the collection of the Hillwood
 Estate, Museum & Gardens, Washington, D.C.
 (24.134.3–.5), while those given to Joseph II are now in
 the Hofburg Imperial Palace, Vienna (Paredes 2009,
 pp. 40, 144, no. 20).
3. Elkan 1913, vol. 2, p. 642; Peters 2005, vol. 3, p. 708.

105. Tureen and Stand (*pot à oille et plateau*)
Sèvres Manufactory
Tureen: Painted by Jacques François Micaud, gilded
by Etienne Henri Le Guay
Stand: Painted by Jacques François de Laroche, gilded
by Henri François Vincent
French, 1784
Soft-paste porcelain, decorated in polychrome enamels
and gold
Tureen: H. 9⅞ in. (25 cm), W. 11¼ in. (28.5 cm),
D. 9 in. (23 cm); stand: H. 21⅝ in. (55 cm), W. 18¼ in.
(46.2 cm), D. 14¾ in. (37.5 cm)
Musée du Louvre, Paris, Département des Objets
d'Art (OA 11979–11980)

REFERENCES: A. F. Cradock 1896, p. 53 (entry of
June 24, 1784); Peters 2005, vol. 3, pp. 707–12,
no. 84-5, pp. 717–18, no. 84-8; Guillaume Séret
in Durand, Bimbenet-Privat, and Dassas 2014,
pp. 490–91, no. 213

NOTES
1. Bombelles 1977, p. 327 (entry of June 7, 1784).
2. Stålhane 1953, p. 227.
3. A replacement service was delivered to the queen later
 that summer; Freyberger 1996.

4. A. F. Cradock 1896, p. 53 (entry of June 24, 1784).
 The gift and its value were recorded on June 23, 1784,
 in the registers of the "Présents du Roy" (Archives
 Diplomatiques, Paris, Ministère des Affaires Etrangères,
 Mémoires et Documents, France, vol. 2095, fol. 35).
 For the record of its receipt by the Ministry of Foreign
 Affairs, see the "Etat des présents" in the same archives
 (Mémoires et Documents, France, vol. 2089, fol. 39,
 no. 94); see also Peters 2005, vol. 3, p. 707.
5. A. F. Cradock 1896, p. 53 (entry of June 24, 1784).

106. *Beauty Crowned by the Graces*
Sèvres Manufactory, after a 1775 model by Louis
Simon Boizot (French, Paris 1743–1809 Paris)
After 1775
Biscuit porcelain
H. 14⅜ in. (36.5 cm)
Nationalmuseum, Stockholm, Bequest 1873 from
King Karl XV (NMK CXV 459)

107. *The Birth of Bacchus*
Sèvres Manufactory, after a 1783 model
French, after 1783
Biscuit porcelain
H. 13¾ in. (35 cm)
Nationalmuseum, Stockholm, Bequest 1873 from
King Karl XV (NMK CXV 460)

REFERENCES (cats. 106, 107): J. Cradock 1826, p. 80
(entry of June 24, 1784); A. F. Cradock 1896, p. 53
(entry of June 24, 1784)

NOTES (cats. 106, 107)
1. Bastien 2017, p. 280.
2. A. F. Cradock 1896, p. 53 (entry of June 24, 1784).
 Although both Mr. and Mrs. Cradock indicate that
 Gustav received biscuit figures representing learned men
 and historical subjects, it seems likely that they meant
 the latter category to signify mythology.
3. Ibid.

**108. Cup and Saucer (*tasse litron*) with Portrait of
Marie Antoinette**
Sèvres Manufactory
Painted by Nicolas Pierre Pithou the Younger
(French, 1750–1818), enameled by Philippe Parpette
(French, 1736–ca. 1808), gilded by Etienne Henri
Le Guay (French, Saint-Cloud 1719/20–1799
Saint-Cloud)
1782
Soft-paste porcelain, decorated with enamel "pearls"
Cup: H. 3 in. (7.5 cm); saucer: Diam. 5½ in. (14 cm)
Marks: Cup (signed in gold, on underside) [interlaced
L's and *LG* (for Le Guay)]. Saucer (signed in gold, on
underside [interlaced *L*'s, *L.*, and *P.J.* (for Pithou the
Younger)]
Nationalmuseum, Stockholm, Bequest 1940 from Eva
Charlotta Mörner (NMK 379)

109. Cup and Saucer (*tasse litron*) with Portrait of Louis XVI
Sèvres Manufactory
Painted by Nicolas Pierre Pithou the Younger (French, 1750–1818), enameled by Philippe Parpette (French, 1736–ca. 1808)
1782
Soft-paste porcelain, decorated with enamel "pearls"
Cup: H. 3 in. (7.6 cm); saucer: Diam. 5⅞ in. (14.8 cm)
Marks: Cup (signed in gold, on underside) [interlaced *L*'s, *L.*, and *P.J.* (for the painter Pithou the Younger)]. Saucer (signed in gold, on underside) [interlaced *L*'s, *EE* (for 1782), and *L.*, *P.J.*]
Nationalmuseum, Stockholm, Bequest 1940 from consul Hjalmar Wicander (NMK 106/1940)

REFERENCE (cats. 108, 109): *Porslin från Sèvres* 1982, p. 20, no. 87

NOTES (cats. 108, 109)
1. Archives, Cité de la Céramique, Sèvres, Vj' 2, fols. 202r, 202v, and F 24, June, July, 48 livres. The brothers were Nicolas Pierre Pithou the Younger and Pierre Nicolas Pithou the Elder.
2. Archives, Cité de la Céramique, Sèvres, Vj' 2, fols. 203, 220v, and F 24, August, September, December. Archives, Cité de la Céramique, Sèvres, Vl' 2, fol. 44r.
3. Archives, Cité de la Céramique, Sèvres, Vy 9, fol. 114r.

110. Carpet
Savonnerie Manufactory, Paris
1780–81
Wool and linen
13 ft. 8⅛ in. × 8 ft. 7⅛ in. (417 × 262 cm)
The Royal Collections Sweden (HGK, TxI 475)

REFERENCE: Verlet 1982, app. B, p. 509, and p. 265, fig. 164

NOTES
1. No more than thirty carpets were sold between 1750 and the Revolution; Verlet 1982, p. 100.
2. Ibid., pp. 262–66, no. 7, and p. 445, nn. 5, 6. For Choisy, see Archives Nationales, Paris, O¹ 3315, fol. 37; Guiffrey 1892, p. 42, no. 337. For Fontainebleau, see Archives Nationales, Paris, O¹ 3315, fol. 255; Guiffrey 1892, p. 42, no. 339.
3. During the period from 1782 to 1786, visiting foreign royalty could tour the Savonnerie factory and indicate their preference for their gifts; Verlet 1982, p. 510.

111. Tableau
Sèvres Manufactory, painted by Jacques François Micaud (French, Villeneuve ca. 1735–1811 Sèvres)
Early 1780s(?)
Porcelain
17⅛ × 13 in. (44 × 33 cm)
Signed (at lower right): *Micault*
Nationalmuseum, Stockholm (NMDrh 99)

REFERENCES: *Porslin från Sèvres* 1982, p. 20, no. 86, ill. p. 19; Sassoon 1991, p. 186; *Soleil et l'étoile du nord* 1994, p. 308, no. 450

NOTE
1. Eriksen 1968b, p. 332.

112. *Cupid in a Medallion*
Gobelins Manufactory, Paris
Workshop of Jacques Neilson (London 1714–1788 Paris); after designs by François Boucher (French, Paris 1703–1770 Paris) (Cupid) and Maurice Jacques (French, 1712–1784) and Louis Tessier (French, 1719/20–1781) (surround)
Ca. 1776–83
Wool and silk
12 ft. 1¼ in. × 7 ft. 7⅛ in. (370 × 232 cm)
Signed (at lower right, near upper edge of platform): *Neilson.éx.*
Rijksmuseum, Amsterdam, Purchased with the support of the Stichting tot Bevordering van de Belangen van het Rijksmuseum (BK-1975-68)

REFERENCES: Nicolai 1786, vol. 2, pp. 915–16; Hartkamp-Jonxis and Smit 2004, pp. 371–72, 373, 376, ill. p. 375; Baarsen 2013, pp. 402–3, no. 97

NOTE
1. Nicolai 1786, vol. 2, p. 916.

113. Plate
Sèvres Manufactory, painted by Jean-Baptiste Tandart (French, active 1754–1800), gilded by Michel Barnabé Chauvaux (French, ca. 1729–ca. 1788)
1784
Soft-paste porcelain
Diam. 9½ in. (24.1 cm)
The Metropolitan Museum of Art, New York, Bequest of Emma Townsend Gary, 1934 (37.20.228)

REFERENCE: "Bequest of Emma Townsend Gary" 1937

NOTES
1. Samuel Wittwer in *Prinz Heinrich von Preussen* 2002, pp. 477–78, no. VII.57; Wittwer 2002, p. 467.
2. Brulon 1993a; Brulon 1993b, p. 186, ill. p. 187; Dorothée Guillemé Brulon in *Versailles et les tables royales en Europe* 1993, p. 341, no. 301.
3. Peters 2005, vol. 3, pp. 731–33.

114A–C. Tokens
French, 1785
Bronze
Diam. 1⅜ in. (3.6 cm) each
(A) Inscribed and dated (on reverse): *jardins de Versailles / entrée pour quatre / maison de la reine / 1785* (gardens of Versailles entrance for four, maison de la reine 1785)
Musée National des Châteaux de Versailles et de Trianon (V 5150.3 [illustrated], V 5913, V 957)

REFERENCES: Christian Baulez in "Acquisitions" 2001, p. 91, no. 28 (V 5913); Yves Carlier in Caude, La Gorce, and Saule 2016, p. 187, no. 160

115. Master Key (*passe-partout*)
French, ca. 1760–74
Wrought iron
L. 6⅛ in. (16.7 cm), W. 2 in. (5.1 cm)
Inscribed: (on shank) ⚜ *SERVICE DE MADAME LA DAUPHINE* ⚜ */N°. 1* (Service of Madame la Dauphine No. 1); (on handle) *W* (double *V* for "Versailles")
Musée National des Châteaux de Versailles et de Trianon (V 5717)

REFERENCE: Christian Baulez in "Acquisitions" 1993, p. 83, no. 26

NOTE (cats. 114A–C, 115)
1. Greene 1986, n.p. (entry of September 11, 1764).

116. *Orders for the Sentinel at the Queen's Apartment*
French, after 1774
Stencil and manuscript, pen and brown ink, gold gouache, brush and wash with brown ink traced over graphite on cream paper
14 × 11⅛ in. (35.5 × 29.5 cm)
Musée National des Châteaux de Versailles et de Trianon (INV.DESS 1106)

REFERENCE: Xavier Salmon in Boysson and Salmon 2005, p. 117, no. 34

117. *The Marais Grove*
French, early 18th century
Oil on canvas
24 × 46⅞ in. (61 × 119 cm)
Musée National des Châteaux de Versailles et de Trianon (MV 7378)

REFERENCE: Lucina Ward in Saule and Ward 2016, pp. 173–75, no. 78

NOTE
1. Pincas 1995, pp. 246–55.

118A, B. Pair of Pedestals
André Charles Boulle (French, Paris 1642–1732 Paris)
Ca. 1684
Pine with ebony veneer and marquetry of brass and pewter inlaid in a tortoiseshell ground; blue stained horn; gilt-bronze mounts
H. 51⅛ in. (130 cm), W. 16¾ in. (42.5 cm), D. 15 in. (38.1 cm) each
The Al Thani Collection (BELG021)

REFERENCES: Ronfort 2005b, pp. 57–58, fig. 54; Jean Nérée Ronfort in Ronfort 2011, p. 196

NOTES
1. A similar pair is in the Victoria and Albert Museum, London (1025-1882); illustrated in Ronfort 2011, pp. 196–97, no. 5a, b.
2. Carlier 1987, pp. 50–51.
3. Piganiol de La Force 1715, vol. 1, p. 168; Tessin 1926, p. 288. See also Perrin 1963–64, p. 200 (entry of March 23, 1699); Lahrkamp 1977, p. 72.

119. Fall-Front Secretary on Stand
Attributed to Adam Weisweiler (Rhineland 1744–1820 Paris)
French, 1784
Oak, exterior veneered with ebony and Japanese lacquer, mother-of-pearl; gilt bronze; interior: sycamore and other marquetry woods, leather
H. 54⅛ in. (138 cm), W. 52⅜ in. (133 cm), D. 18⅛ in. (46 cm)
The Al Thani Collection (BELG022)

REFERENCES: Bourne 1981, pp. 93–95, figs. 1–4 and cover ill.; Lemonnier 1983, pp. 63, 179, no. 72; Pradère 1989, pp. 388–89; Impey and Whitehead 1990, pp. 161–64, pl. 11; Wolvesperges 2000, pp. 207, 209, 433, ill. no. 183; Impey and Jörg 2005, pp. 94, 295, ill. no. 591

NOTE
1. Archives Nationales, Paris, O¹ 3469, fol. 44. See Bourne 1981, pp. 94–95.

120. *Henry Swinburne*
Pompeo Batoni (Italian, Lucca 1708–1787 Rome)
1779
Oil on canvas
27⅞ × 22⅛ in. (70.8 × 57.5 cm)
Signed and dated (on edge of coat): *Pompeo. de Batoni. pinx. Rome 1779* (Pompeo de Batoni painted Rome 1779)
Laing Art Gallery, Newcastle upon Tyne (TWCMS C3940)

REFERENCES: *Pompeo Batoni* 1982, pp. 67–68, no. 35; Bowron 2016, vol. 2, pp. 548–50, no. 429

NOTE
1. Henry Swinburne to Edward Swinburne, April 30, 1774, in Swinburne 1840, vol. 1, pp. 9, 12 (quotation on p. 12).

121. *Jeanne Bécu, Comtesse Du Barry, Being Offered a Cup of Coffee by Zamor*
Jean-Baptiste André Gautier Dagoty (French, Paris 1738?–1786, Paris)
Ca. 1770
Color mezzotint on paper printed from four plates
14⅜ × 11⅞ in. (36.5 × 30.3 cm)
Musée National des Châteaux de Versailles et de Trianon (INV.GRAV 6677)

REFERENCES: *Mercure de France*, April 1771, pp. 185–86; Noël et al. 2010, p. 11, ill.; Berly 2015, p. 25, ill.; Herda-Mousseaux 2015, p. 24, fig. 11; *Thé, café ou chocolat?* 2015, p. 126, no. 21

NOTE
1. Henry Swinburne to Edward Swinburne, April 30, 1774, in Swinburne 1840, vol. 1, p. 12.

122. Side Chair (*chaise à châssis*)
Louis Delanois (French, Savignies 1731–1792 Paris); carved by Joseph Nicolas Guichard; gilded by Jean-Baptiste Cagny
1769
Carved and gilded walnut (modern upholstery)
H. 35¼ in. (89.4 cm), W. 21¼ in. (55.1 cm), D. 20 in. (50.8 cm)
Musée National des Châteaux de Versailles et de Trianon (MV 5924.3)

REFERENCES: Baulez 1992a, p. 26, ill. p. 36 (another side chair of the set); Christian Baulez in "Acquisitions" 1995, p. 83, no. 22 (another side chair of the set); Arizzoli-Clémentel 2002, pp. 222–23, no. 77

123. Barometer and Thermometer
Works by Claude Siméon Passement (1702–1769)
French, 1769
Oak; gilt bronze; glass; enamel; three Sèvres soft-paste porcelain plaques
H. 40¼ in. (103.5 cm), W. 11 in. (27.9 cm), D. 3⅜ in. (8.6 cm)
The Metropolitan Museum of Art, New York, Gift of Samuel H. Kress Foundation, 1958 (58.75.59)

REFERENCES: James Parker and Carl Christian Dauterman in Metropolitan Museum 1964, pp. 261–65, no. 63, figs. 221, 222; Baulez 1992b, pp. 45–46, ill.; Daniëlle Kisluk-Grosheide in Kisluk-Grosheide and Munger 2010, pp. 78–79, no. 27

124. Writing Desk (*bonheur-du-jour*)
Attributed to Martin Carlin (Freiburg ca. 1730–1785 Paris)
Twelve of the Sèvres plaques bear on the back the date letter for 1768 and the painter's mark of Denis Levé (active 1754–1805)
French, 1768
Oak veneered with tulipwood, amaranth, and stained sycamore, mahogany, seventeen soft-paste porcelain plaques; gilt-bronze mounts; velvet (not original)
H. 32½ in. (82.6 cm), W. 25⅞ in. (65.7 cm), D. 16 in. (40.6 cm)
The Metropolitan Museum of Art, New York, Gift of Samuel H. Kress Foundation, 1958 (58.75.48)

REFERENCES: James Parker and Carl Christian Dauterman in Metropolitan Museum 1964, pp. 134–37, no. 22, figs. 104, 105; Baulez 1992b, p. 45, ill.; Daniëlle Kisluk-Grosheide in Kisluk-Grosheide, Koeppe, and Rieder 2006, pp. 156–58, no. 63; Kisluk-Grosheide in Kisluk-Grosheide and Munger 2010, pp. 76–77, no. 26

NOTES (cats. 122–24)
1. Northumberland 1926, pp. 116–17 (entry of May 16, 1770; quotation on p. 117).
2. Eriksen 1968a, pp. 55–56.
3. See Daniëlle Kisluk-Grosheide in Kisluk-Grosheide, Koeppe, and Rieder 2006, pp. 156–58, no. 63.

125. *View of Versailles*
Pierre Gallays (French, 1677?–1749), publisher
French, ca. 1712
Engraving on paper
36⅛ × 69¼ in. (92.5 × 176 cm), framed
Musée National des Châteaux de Versailles et de Trianon (INV.GRAV 6088)

*126A–C. Group of Figures Depicting the Royal Carriage and Cavalrymen
Attributed to a member of the Lesueur family, possibly Jean-Baptiste Lesueur (French, Paris 1749–1826 Clély, Oise)
Before 1774
Gouache on cutout cardboard, mounted on metal rods (possibly pewter or tin)
Musée Carnavalet–Histoire de Paris, Gift of Monsieur and Madame Jean-Charles Bidault de l'Isle, 2015

A. *The Royal Carriage*
4¾ × 18⅞ in. (12.1 × 48 cm)
Inscribed (on back): *Le Roi Louis XV avec ses filles entrant dans Paris par la porte St Martin venant de compiengne [sic]* (Louis XV with his daughters entering Paris through the Porte St Martin coming from compiengne [sic])
(D.17417–01)

B. *Standard-Bearer*
4½ × 2⅛ in. (11.5 × 6.6 cm)
(D.17417–03)

C. *Cavalryman*
3⅛ × 2½ in. (7.8 × 6.5 cm)
(D.17417–20)

NOTES
1. Possibly part of a larger set mentioned by Carbonnières 2006a, p. 97.
2. The identification of the set as Louis XV and Mesdames comes from the inscription, of unknown date, on the back of *The Royal Carriage*. It is also possible that the Mesdames might actually be accompanying their nephew, the young Louis XVI.
3. Carbonnières 2005, pp. 24–32.

127. *Promenade of Louis XIV in Front of the North Parterre*
Etienne Allegrain (French, Paris 1644–1736 Paris)
Ca. 1688
Oil on canvas
7 ft. 8⅛ in. × 9 ft. 8¾ in. (234 × 296.5 cm)
Musée National des Châteaux de Versailles et de Trianon (MV 752)

REFERENCES: T. Bajou 1998, pp. 244–45; Bouchenot-Déchin and Farhat 2013, pp. 233–35; Patricia Bouchenot-Déchin in Caude, La Gorce, and Saule 2016, p. 180, no. 145

NOTE
1. Elisabeth Charlotte, duchesse d'Orléans, to her Aunt Sophie, February 5, 1672, in Orléans 1985, p. 31.

128. *Louis XV Departing for the Hunt*
Attributed to Pierre Denis Martin the Younger
(French, Paris ca. 1663–1742 Paris)
Ca. 1724
Oil on canvas
46⅞ × 69⅛ in. (119 × 177 cm)
Musée Lambinet, Versailles (91.3.1)

REFERENCES: Gendre 1997, p. 13, ill. no. 7; Musée
Lambinet 2005, p. 100, no. 369

NOTE
1. Musée Promenade, Marly-le-Roi, Louveciennes
(90.25.1). Both paintings were in the sale at Christie's,
Monaco, December 7, 1990, no. 333A.

129. *Louis XIV Receiving the Marquis de Dangeau's Oath*
Antoine Pezey (French, active 1695–1710)
Ca. 1695
Oil on canvas
44⅞ × 69⅛ in. (114 × 177 cm)
Musée National des Châteaux de Versailles et de
Trianon (MV 164)

REFERENCES: T. Bajou 1998, pp. 268–69; Maral and
Sarmant 2014, pp. 162–63, 222; Rebecca Scott in Saule
and Ward 2016, pp. 60–61, no. 12

NOTE
1. Musée National des Châteaux de Versailles et de Trianon
(INV.GRAV 89).

130. *The Wedding of Louis de France, Duc de
Bourgogne, and Marie Adélaïde de Savoie*
Antoine Dieu (French, Paris 1662–1727 Paris)
1710–11
Oil on canvas
20⅛ × 31⅞ in. (51 × 81 cm)
Musée National des Châteaux de Versailles et de
Trianon (MV 9177)

REFERENCE: Salmon 2009, pp. 141–42

NOTES
1. Musée National des Châteaux de Versailles et de Trianon
(MV 2095).
2. *Mercure galant*, December 1697, pp. 206–19; Elisabeth
Charlotte, duchesse Orléans, to her Aunt Sophie, Decem-
ber 8, 1697, in Orléans 1985, pp. 147–49.
3. Saint-Simon 1983, pp. 432–33.

131. *Louis XV with His Family during a Grand
Couvert*
French, ca. 1755–60
Fan leaf: gouache on vellum doubled with paper;
sticks and guards: engraved, gilded, and silvered ivory
and mother-of-pearl
L. closed 11⅛ in. (28.2 cm), W. open 21¼ in. (54 cm)
The Fan Museum, London (LDFAN2006.15)

REFERENCE: Georgina Letourmy-Bordier in
Letourmy-Bordier and Los Llanos 2013, pp. 88–89,
no. 22

NOTE
1. An identical, but unmounted, fan leaf is in the collection of
Waddesdon Manor, Aylesbury, Buckinghamshire (2095).

132. *An Audience with Louis XVI and Marie
Antoinette*
French, ca. 1775
Leaf: gouache on doubled paper; sticks and guards:
gilded and silvered ivory
L. closed 9⅞ in. (25 cm), W. open 18⅞ in. (48 cm)
The Fan Museum, London, Hélène Alexander
Collection (1080)

133. *Exterior View of the Royal Chapel*
Pietro Bellotti (Italian, Venice 1725–before 1818)
Ca. 1750
Oil on canvas
14⅞ × 19 in. (37.8 × 48.3 cm)
Musée National des Châteaux de Versailles et de
Trianon (V.2015.24)

REFERENCE: Beddington 2007, p. 684, fig. 32

NOTE
1. Other versions of this composition are known. See
A. van de Sandt and U. van de Sandt 2001, pp. 110–11,
fig. 20; Charles Beddington in Beddington and Crivellari
2013, p. 67, no. 21, ill. p. 101; Lucina Ward in Saule and
Ward 2016, pp. 106–7, no. 40.

134. *Section and Interior Perspective of the Royal
Chapel*
Jean Chaufourier (French, Paris 1679–1757
Saint-Germain-en-Laye)
Ca. 1725
Pen and India ink, polychrome highlights over a
graphite sketch on cream-colored paper
18¼ × 15¼ in. (47.5 × 38.7 cm)
Signed (at lower left): *De Chaufourier*
Musée National des Châteaux de Versailles et de
Trianon (INV.DESS 1202)

REFERENCES: Christian Baulez in "Acquisitions" 1997,
p. 96, no. 22; Salmon 1999, pp. 34–35, no. 26; Maral
2010, p. 352, fig. 17; Maral 2011, pp. 158, 169–70, fig. 262

NOTE
1. Nugent 1778, vol. 4, p. 117. First published in 1749.

135. *Northwest Corner of Louis XIV's Bedroom*
French, after 1701
Pen and ink, wash with graphite underdrawing on
cream-colored laid paper
9⅛ × 7⅛ in. (23.3 × 18.2 cm)
Inscribed (on mount, at lower left): *Raphaelle*
Nationalmuseum, Stockholm, Donated 1941 by Eric
Langenskiöld (NMH CC 513)

REFERENCES: Guy Walton in *Versailles à Stockholm*
1985, p. 80, no. c 25; Walton in Dee and Walton 1988,
p. 33, no. 15

NOTES
1. Greene 1986, n.p. (entry of September 13, 1764).
2. Vittet 2015, p. 31.

136. *View of the Hall of Mirrors*
Sébastien Leclerc the Elder (French, Metz 1637–1714
Paris)
Ca. 1684
Pen and brown ink, brown wash on paper
5⅛ × 3⅛ in. (13.6 × 9.1 cm)
Signed in pen and ink (at bottom right): *Se.Le Clerc f.*
(Made by Se. Le Clerc)
Musée National des Châteaux du Versailles et de
Trianon (INV.DESS 1247)

REFERENCES: Mabille 1998, pp. 62–63, fig. 4; Nicolas
Milovanovic in "Principales acquisitions" 2009, p. 68

NOTES
1. Scudéry 1684, vol. 1, p. 6.
2. Mabille 1998, pp. 61–62, fig. 1.

137. Tabletop with Map of France
Probably Gobelins Manufactory, Paris
Design by Claude Antoine Couplet (French, Paris
1642–1722 Paris); lapidary work probably by Horace
and Ferdinand Megliorini, Philippe Branchi, and Jean
Ambrosio Gachetti
1684
Hard stones, marble, alabaster
H. 43¼ in. (110 cm), W. 30¼ in. (78 cm), D. 1⅛ in. (4 cm)
Inscribed: (on top cartouche) *CARTE / DE LA
/ France 1684* (Map of France 1684); (on bottom
cartouche) *Présentée / AU ROY / Par C. COUPLET
M.^{gis} que Math. / des pages de sa g.^{de} Escurie / comis
enso Accad. des Scien. / Logé en son observatoire / HAE
/ TIBI ERUNT / ARTES* (Presented to the king by
C. Couplet Teacher of Mathematics of the pages of
the Large Stables Founder of the Academy of Sciences
Living in his laboratory. These Are Your Arts)
Musée National des Châteaux de Versailles et de
Trianon (V 3537), on long-term loan from the Musée
du Louvre, Paris (OA 6632)

REFERENCES: Dreyfus 1922, p. 21, no. 27; Dimier
1925; D. Meyer 2002, pp. 194–95, no. 49; Florian
Knothe in Koeppe 2008, pp. 276–77, no. 99

NOTE
1. See W. Young 1889, vol. 2, p. 371.

138. *View of the Château de Versailles and the
Orangerie*
Etienne Allegrain (French, Paris 1644–1736 Paris)
Ca. 1695
Oil on canvas
45¼ × 65 in. (115 × 165 cm)
Musée National des Châteaux de Versailles et de
Trianon (MV 6812)

REFERENCES: T. Bajou 1998, pp. 252–53; *Fastes
de Versailles* 2002, pp. 72–73, 213–14, no. 017;
Nicolas Milovanovic in *Louis XIV, le Roi-Soleil* 2005,
pp. 190–91, no. 53; Lucina Ward in Saule and Ward
2016, pp. 102–3, no. 38

NOTE
1. *Mercure galant*, November 1686, vol. 16, pp. 130–31.

139. *Study of a Chameleon*
Pieter Boel (Flemish, Antwerp 1622–1674 Paris)
Ca. 1668
Oil on canvas
13¾ × 17¼ in. (35 cm × 45 cm)
Musée du Louvre, Paris, Département des Peintures, Collection de Louis XIV (3976)

REFERENCES: Foucart-Walter 2001, p. 91, no. 14; Gallerani 2011, pp. 42–43, and back cover; Guerrini 2015, pp. 137–41, fig. 4.4

140. *Double Study of the Head of a Dromedary*
Pieter Boel (Flemish, Antwerp 1622–1674 Paris)
Ca. 1669–71
Oil on canvas
21¼ × 25⅝ in. (54 × 65 cm)
Musée du Louvre, Paris, Département des Peintures, Collection de Louis XIV (3987)

REFERENCES: Foucart-Walter 2001, pp. 99–100, no. 23; Gallerani 2011, pp. 82–83

141. *Triple Study of an Ostrich*
Pieter Boel (Flemish, Antwerp 1622–1674 Paris)
Ca. 1669–71
Oil on canvas
37⅜ × 45¼ in. (95 × 115 cm)
Musée du Louvre, Paris, Département des Peintures (3970)

REFERENCES: Foucart-Walter 2001, pp. 84–85, no. 8; Pieragnoli 2010b, p. 77; Gallerani 2011, pp. 40–41

NOTES (cats. 139–41)
1. Sahlins 2015, pp. 15, 19, fig. 1.
2. Greene 1986, n.p. (entry of September 13, 1764).
3. Thrale and Johnson 1932, p. 177 (entry of October 22, 1775).

142. *Labyrinte de Versailles*
Charles Perrault and Isaac de Benserade, authors
Sébastien Leclerc the Elder (French, Metz 1637–1714 Paris), etcher
Published by L'Imprimerie Royale (Paris, 1677)
Etching on paper; binding: dark brown calfskin with gold-tooled floral motifs on spine
H. 8½ in. (21.5 cm), W. 5¾ in. (14.7 cm), D. ¾ in. (1.9 cm)
The Metropolitan Museum of Art, New York, Harris Brisbane Dick Fund, 1931 (31.77.30)

REFERENCES: Maisonnier 2013, pp. 80–81; Adamczak 2014–15, pp. 196–200, figs. 10–12

143. *Labyrinte de Versailles*
Charles Perrault and Isaac de Benserade, authors
Jacques I Bailly (French, Graçay 1629–1679 Paris), painter
Sébastien Leclerc the Elder (French, Metz 1637–1714 Paris), etcher
Ca. 1677
Vellum, gouache, ink, gold; binding: red morocco leather

H. 7⅛ in. (18.2 cm), W. 5⅜ in. (13.8 cm), D. 1 in. (2.4 cm)
Petit Palais, Musée des Beaux-Arts de la Ville de Paris, Collection Dutuit (LDUT00724)

REFERENCES: Chevalier 2013; Maisonnier 2013, pp. 81–83; Sahlins 2014, p. 79, fig. 3.3; Guerrini 2015, pp. 174–76, fig. 5.2

NOTE (cats. 142, 143)
1. Lister 1823, pp. 175–76 (quotation on p. 176).

144. *Monkey Riding a Goat*
Pierre Legros (French, Chartres 1629–1714 Paris) and Benoît Massou (French, Richelieu 1633–1684 Paris)
1672–74
Painted lead
H. 39⅜ cm (100 cm), W. 47¼ in. (120 cm), D. 17⅛ in. (44 cm)
Musée National des Châteaux de Versailles et de Trianon (MV 7926)

145. *Wolf*
Benoît Massou (French, Richelieu 1633–1684 Paris)
1672–74
Painted lead
H. 33⅞ in. (86 cm), W. 18⅛ in. (46 cm), D. 16⅛ in. (41 cm)
Musée National des Châteaux de Versailles et de Trianon (MV 7181)

146. *Fox Setting Fire to the Tree with the Eagle's Nest*
French, 1672–74
Painted lead
H. 48⅛ in. (123 cm), Diam. 40½ in. (103 cm)
Musée National des Châteaux de Versailles et de Trianon (MV 7946.1)

REFERENCES (cats. 144–46): Maisonnier and Maral 2013, p. 65, no. 5, p. 69, no. 14, p. 71, no. 19; Maral 2013

NOTES (cats. 144–46)
1. Poole 1750, vol. 1, p. 161. First published in 1742.
2. Chevalier 2013, p. 130.
3. Ibid., p. 148.
4. Ibid., p. 118.

147. Sheet with Description, Floor Plan, and Elevation of Louis XIV's Medals Cabinet (*cabinet des bijoux* or *cabinet des médailles*)
Nicodemus Tessin the Younger (Swedish, Nyköping 1654–1728 Stockholm)
Ca. 1687
Pen and ink (right half) and graphite (left half) on cream-colored laid paper
13⅛ × 17½ in. (34.5 × 44.6 cm)
Nationalmuseum, Stockholm (NMH THC 1315)

REFERENCES: Guy Walton in *Versailles à Stockholm* 1985, pp. 142–45, no. K 1; Tessin 2002, pp. 202–4, pl. 24; Wellington 2015a, pp. 85–98, fig. 3.4; Wellington 2015b, p. 12, figs. 1, 2

NOTE
1. For a full description of this room and its collections, see Castelluccio 2002, pp. 112–17.

148. *New Maps of the Town, Palace, and Gardens of Versailles*
Franz Anton Danreiter (Austrian, Salzburg 1695–1760 Salzburg)
1723–24
Graphite, pen and black ink, gray wash, watercolor on ribbed paper with watermark; decorated cardboard and paper at bottom board; remains of gilding on edges
H. 10¼ in. (26 cm), W. 15 in. (38 cm), D. ½ in. (1.2 cm)
Musée National des Châteaux de Versailles et de Trianon (V 2016.16)

REFERENCES: Elisabeth Maisonnier in "Acquisitions" 2017; Maisonnier forthcoming

NOTE
1. For further information about this artist, see Lauterbach 2010; Prange 2010; Schnitzler-Sekyra 2010. See also Peter Prange in Kaltenbrunner and Salmon 2016, pp. 106–11, 112–13, no. 17, and see also pp. 96–105, no. 16a–r.

149. *Two Winged Putti Holding a Garland* and *A Chair Leg*
From the Franco-Italian Album
Sir William Chambers (Swedish, Gothenborg 1723–1796 London)
Ca. 1749–50
Pen and ink, graphite and gray wash on paper
6⅞ × 6¼ in. (17.5 × 15.9 cm)
Inscribed and numbered (at upper right, in ink): *51 Versailles*
Victoria and Albert Museum, London (5712:67)

REFERENCES: Harris 1970, p. 191; Barrier 1996a, pp. 19–20; Barrier 1996b; Snodin 1996, pp. 54–55, no. 110, pl. 24

NOTES
1. Harris 1970, pp. 182–83.
2. Maës 2013, paragraphs 109–13, fig. 18.

***150.** *Wolfgang Amadeus Mozart with His Father, Leopold, and His Sister Marie Anna*
Louis Carrogis, known as Carmontelle (French, Paris 1717–1806 Paris)
1763–64
Red chalk, graphite, and watercolor on paper
12⅞ × 8 in. (32.6 × 20.2 cm)
Musée Carnavalet–Histoire de Paris (D4496)

REFERENCES: Charageat 1946, p. 21, no. 36; Salinger 1991, p. 64, no. 26

NOTES
1. At Musée Condé, Chantilly (346); Castle Howard, York; British Museum, London (1994,0514.48); and in a French private collection. See Gétreau 2010, pp. 77–78.
2. Leopold Mozart to Frau Maria Theresa Hagenauer, February 1–3, 1764, in Anderson 1938, vol. 1, pp. 50–51 (quotation on p. 50).
3. Leopold Mozart to Frau Maria Theresa Hagenauer, February 1–3, 1764, in ibid., p. 48.

151. *John Montagu, Lord Brudenell, Later Marquess of Monthermer*
Pompeo Batoni (Italian, Lucca 1708–1787 Rome)
1758
Oil on canvas
38 × 28 in. (96.5 × 71 cm)
Inscribed (on verso, in a later hand): *John Marquis of Monthermer, son to George Duke of Montagu / ob. 1770, aet. 35: / by Mengs*
The Duke of Buccleuch & Queensberry, Boughton House, United Kingdom (BLHT/BH/122)

REFERENCES: *Pompeo Batoni* 1982, pp. 39–40, no. 13; Clark 1985, pp. 270–71, no. 202, pl. 188, colorpl. VI; Francis Russell in Jackson-Stops 1985, pp. 254–55, no. 173; Bowron and Kerber 2007, pp. 40, 48, 59, 178, no. 37, fig. 53; Bowron 2016, vol. 1, pp. 244–46, no. 201

NOTE
1. Henry Lyte to George, 4th Earl of Cardigan, January 4, 1752, Buccleuch Papers, Dalkeith Palace, Scotland. The visit to Versailles took place on December 30, 1751. See Fleming 1958, pp. 129–30 (the date of the visit to Versailles is given erroneously as December 31, 1753), and also pp. 136–37, pl. 1, for the Batoni portrait of Lord Brudenell.

152. *Tobias George Smollett*
Probably Italian, ca. 1770
Oil on canvas
27 × 20¾ in. (68.6 × 52.7 cm)
Inscribed (in black paint on reverse): *Doctor / Tobias Smollet / taken at Pisa*
The National Portrait Gallery, London (NPG 1110)

REFERENCE: Kerslake 1977, vol. 1, pp. 253–55, no. 1110, vol. 2, pl. 746

NOTES
1. Smollett 1766, vol. 1, letter no. VI, October 12, 1763.
2. Scott 1829, p. 111.

153. *Hester Lynch Piozzi (Née Salusbury, Later Mrs. Thrale)*
Italian, 1785–86
Oil on canvas
29¾ × 24¾ in. (75.6 × 62.9 cm)
The National Portrait Gallery, London (NPG 4942)

REFERENCES: Ribeiro 2000, pp. 143–44, no. 54; Ingamells 2004, pp. 382–83; D'Ezio 2010, p. 85 and cover ill.

NOTES
1. Boswell 1826, vol. 1, p. 390.
2. Thrale and Johnson 1932, p. 132 (entry of October 22, 1775).

154. *View of the Pyramid Fountain in the Gardens of Versailles*
French, ca. 1680–90
Paper leaf, engraved and painted in gouache, gilded; sticks and guards: carved and pierced ivory
L. closed 12¾ in. (32.3 cm), W. open 24 in. (61 cm)

The Philadelphia Museum of Art, The Bloomfield Moore Collection, 1899 (1899-770)

REFERENCE: Blum 1988, pp. 6–7

155. *View of the Town and Château de Versailles*
French, ca. 1780–85
Single paper leaf, painted in gouache, with gilt paper trim; sticks and guards: carved and pierced ivory, decorated with gilding, gouache, and mother-of-pearl
L. closed 6¼ in. (16 cm), W. open 12¼ in. (31 cm)
Musée Lambinet, Versailles (95.15.1)

REFERENCES: "Principales acquisitions" 1996, p. 16, no. 52; Gendre 1997, p. 154, ill. no. 256

156. *The Marriage of the Dauphin Louis Ferdinand to Marie Thérèse, Infanta of Spain*
French, 1745
Double "chicken skin" leaf, painted in gouache; sticks and guards: carved and engraved mother-of-pearl mounted with gold, silver, rubies, and emeralds
L. closed 11⅛ in. (29 cm), W. open 21½ in. (54.5 cm)
The Fan Museum, London, Hélène Alexander Collection (1995A)

REFERENCE: Georgina Letourmy-Bordier in Letourmy-Bordier and Los Llanos 2013, pp. 84–85, no. 20

NOTES (cats. 154–56)
1. Berger 2010.
2. Recueil de Gravures Grosseuvre 137, pl. 53, *Vue perspective de la Fontaine de la Pyramide, du Parterre Nord et du Grotte de Thétis et du Chàteau de Versailles*, ca. 1675, Musée National des Châteaux de Versailles et de Trianon.
3. I am grateful to Elisabeth Maisonnier for identifying this engraving, titled *Vue et perspective du château royal de Versailles du coté de l'entrée*, as well as the two used for the reverse: a view of the château de Montmorency, engraved by Niquet from a drawing by Gabriel Moreau the Elder, and *IIIᵐᵉ vue de la ville et du château de Versailles, prisé de la maison du Bel Air qui est au nord et à 1500 toises du château, près le grand chemin de la Selle*, engraved by Pierre Laurent Auvray, both published in *Voyage pittoresque de la France* (Paris: Laborde, 1781–96).

157. Snuffbox with Views of the Royal Residences
Jean Joseph Barrière (French, master goldsmith in 1763)
1765–69
Engraved and chased gold; crystal; mounted with eleven miniatures in gouache
H. 1⅛ in. (4 cm), W. 3⅛ in. (7.8 cm), D. 2¼ in. (5.8 cm)
Musée du Louvre, Paris, Baronne Salomon de Rothschild Bequest, 1922 (OA 7709)

REFERENCES: Grandjean 1974, pp. 32–35, figs. 1, 3, 4, 7, 8; Grandjean 1981, pp. 41–42, no. 12; Catherine Gougeon in Durand, Bimbenet-Privat, and Dassas 2014, p. 518, no. 230

NOTE
1. Horace Walpole to John Chute, October 3, 1765, in Walpole 1973, p. 112.

158. *View of the Palace of Versailles*
Thomas Compigné
French, ca. 1760–80
Gilded and painted copper or tin, ebonized wood frame
Diam. 2¾ in. (7 cm), with frame 4½ × 4½ in. (11.5 × 11.5 cm)
Inscribed (on front): *Vue du Château de Versailles, prise de l'Avenue de Paris, Exécutée sur le Tour, par Compigné Tablettier du Roi* (View of the Palace of Versailles, Seen from the Avenue de Paris, made with the lathe, by Compigné the king's dealer in luxury goods)
Musée Lambinet, Versailles (95.2.1)

NOTES
1. Semail 1975. For a similar medallion, see *Compigné* 1991, pp. 67–68, no. 20.
2. *Gazette de France*, December 21, 1772, p. 468. Possibly the pair in the sale at Christie's, London, July 6, 2017, no. 24.
3. *Gazette de France*, October 17, 1774, p. 365.

159. Set of Eighteen Buttons with Views of the Palace and Gardens of Versailles
French, ca. 1780
Gouache on ivory; glass
Diam. 1⅛ in. (4.2 cm) each
Musée Lambinet, Versailles (94-111)

REFERENCES: Gendre 1997, pp. 150–51, ill. nos. 245–50; Le Bon 2017, pp. 259, 334, no. 176, ill. p. 256

NOTE
1. Maze-Sencier 1885, p. 742.

160. *The Basin of Apollo and the Grand Canal*
French, 1700–1725
Gouache and gold on vellum
5 × 6½ in. (12.5 × 16.5 cm)
Musée National des Châteaux de Versailles et de Trianon (INV.DESS 838)

REFERENCE: Saule and Arminjon 2010, ill. p. 94

161. *Optical View of the Hall of Mirrors*
Jean François Daumont (French, active 1740–75), publisher
French, ca. 1760
Etching with watercolor on paper
12 × 17½ in. (30.5 × 44.4 cm)
Musée National des Châteaux de Versailles et de Trianon (INV.GRAV 219)

162. *Benjamin Franklin*
Joseph Siffred Duplessis (French, Carpentras 1725–1802 Versailles)
1778
Oil on canvas
28½ × 23 in. (72.4 × 58.4 cm)
Signed and dated (at right center): *J.S. Duplessis / pinx.parisis / 1778* (J.S. Duplessis Painter from Paris 1778)

Frame
Attributed to François Charles Buteux (French, 1732–1788)
1778
Carved and gilded oak
49 × 32 in. (124.5 × 81.3 cm)
Inscribed (at bottom): *Vir* (Man)
The Metropolitan Museum of Art, New York, The Friedsam Collection, Bequest of Michael Friedsam, 1931 (32.100.132)

REFERENCES: Sellers 1962, pp. 123–24, 125–37, 247–49, no. 1, pl. 12; J.-P. Chabaud 2003, pp. 41, 112, 123–24, pl. XVI

NOTES
1. Benjamin Franklin to Simon Pierre Fournier Le Jeune, May 4, 1780, in Franklin 1959–, vol. 32 (1996), pp. 349–50.
2. See Cynthia Moyer's 2015 catalogue entry on the frame of 32.100.132 on the Metropolitan Museum's website (www.metmuseum.org).
3. See Clayton 2016, pp. 50–51.

163. Three-Piece Suit *(habit à la française)*
French, ca. 1778–79
Ribbed silk and linen (reproduction shirt, shoes, and stockings)
H. 60 in. (152.4 cm), W. 30 in. (76.2 cm), D. 24 in. (61 cm)
Smithsonian's National Museum of American History, Washington, D.C. (2012.0187.001)

REFERENCE: R. T. H. Halsey, Joseph Downs, and Marshall Davidson in *Benjamin Franklin and His Circle* 1936, p. 142, no. 319, ill. p. 144

NOTE
1. Franklin 1959–, vol. 31 (1995), pp. 102–4.

164. *Miniature Portrait of Louis XVI*
Louis Marie Sicardi (French, Avignon 1743–1825 Paris)
1784
Watercolor on ivory, gold, glass; silver frame
H. 2⅜ in. (6 cm), W. 1¼ in. (4.3 cm), D. ⅜ in. (1 cm)
Signed and dated (at left center): *Sicardy 1784*
American Philosophical Society, Philadelphia. Gift of the Richard Bache Duane Family of New York, 2014 (2014.9)

REFERENCES: R. T. H. Halsey, Joseph Downs, and Marshall Davidson in *Benjamin Franklin and His Circle* 1936, p. 66, no. 105, ill. p. 31; Middlekauff 2005, pp. 220, 221, 357, fig. 6.19

NOTES
1. Archives Diplomatiques, Paris, Ministère des Affaires Etrangères, Mémoires et Documents, France, vol. 2095, fol. 36. This *boîte à portrait* was supplied by the jeweler "Solle" (Jean Michel Sollé, d. 1806), according to Maze-Sencier 1885, p. 184.
2. Gillespie 1901, pp. 27, 36.

165. Cup and Saucer *(tasse litron)*
Sèvres Manufactory
Etienne Henri Le Guay *père*, painter and gilder (French, active 1776–1817)
Ca. 1779
Soft-paste porcelain
Cup: H. 3 in. (7.6 cm), W. 4 in. (10.2 cm), D. 3 in. (7.6 cm); saucer: 1¼ × 5⅞ in. (3.3 × 14.9 cm)
Marks (on underside of both pieces): [crossed letters *L* and letters *LG*]
Bequest of Marjorie Merriweather Post, 1973 (24.151.1–2); Hillwood Estate, Museum & Gardens, Washington, D.C.

REFERENCES: Sellers 1962, p. 368, no. 3, pl. 12; Liana Paredes in Odom and Paredes 1998, pp. 161–62, no. 69; Paredes 1998, pp. 56–57, fig. 34; Paredes 2009, pp. 43, 143, no. 16, ill. pp. 42, 43, fig. 19

NOTE
1. Additional soft-paste examples are in the Wallace Collection, London (see Savill 1988, vol. 2, pp. 508–10, no. C350), the Victoria and Albert Museum, London (cup only; C.1442-1919), and the Art Institute of Chicago (1959.478a–b). A hard-paste cup and saucer are in the collection of the Philadelphia Museum of Art (1998-67-1a, b).

166. *Constitutions des treize Etats-Unis de l'Amérique (Constitutions of the Thirteen United States of America)*
Printed in Paris by Philippe Denis Pierres; available at Pierres and Pissot père & fils, 1783
Red and green gold-tooled morocco leather, gilt, blue paper endleaves
H. 9⅞ in. (25 cm), W. 7⅛ in. (18 cm), D. 2⅜ in. (6 cm)
Bibliothèque Municipale de Versailles (Res 4° U114c)

NOTES
1. Chinard 1943, pp. 96–98.
2. Benjamin Franklin to Thomas Mifflin, December 25, 1783, in Franklin 1988–.
3. Ibid.
4. Benjamin Franklin to Philippe Denis Pierres, June 10, 1783, in Franklin 1988–.
5. Res 4-PB-746; see Susan Taylor-Leduc in Feigenbaum 2003, p. 30, no. 8.

167. *Louis XVI and Benjamin Franklin*
Niderviller Manufactory (active 1754–1827), Lorraine
Charles Gabriel Sauvage, called Lemire (French, Lunéville 1741–1827 Paris), modeler
Ca. 1780–85
Hard-paste porcelain
H. 12¼ in. (32.4 cm), W. 9½ in. (24.1 cm), D. 6 in. (15.2 cm)
Inscribed (on treaty): *INDÉPENDANCE DE L'AMERIQUE / LIBERTÉ DES MERS* (American Independence / Freedom of the Seas)
The Metropolitan Museum of Art, New York, Gift of William H. Huntington, 1883 (83.2.260)

REFERENCES: Ralston 1925, pp. 271–73, ill.; R. T. H. Halsey, Joseph Downs, and Marshall Davidson in *Benjamin Franklin and His Circle* 1936, pp. 46–48, no. 69, ill.

NOTES
1. Croÿ 1906–7, vol. 4 (1907), pp. 78–80.
2. See Marie-Laure de Rochebrune in V. Bajou 2016, p. 92, no. 62.

168. *Elkanah Watson*
John Singleton Copley (American, Boston? 1738–1815 London)
1782
Oil on canvas
58⅛ × 47⅛ in. (149 × 121 cm)
Inscribed (at lower left, on papers): *John Brown Esq / President and Mess[ieurs] Watson & Cossoul, Nant[e]s*
Princeton University Art Museum, Gift of the Estate of Josephine Thomas Swann (y1964-181)

REFERENCES: R. T. H. Halsey, Joseph Downs, and Marshall Davidson in *Benjamin Franklin and His Circle* 1936, p. 60, no. 97, ill. p. 61; Neff 1995, pp. 120–23, no. 11

NOTES
1. Bangs 2015, pp. 46–47.
2. Watson 1856, p. 176.
3. Ibid.

169. *Miniature Portrait of Colonel John Laurens*
Charles Willson Peale (American, Chester, Maryland 1741–1827 Philadelphia)
1780
Watercolor on ivory
H. 1½ in. (3.8 cm), W. 1⅛ in. (2.9 cm)
National Portrait Gallery, Smithsonian Institution, Washington, D.C.; acquired with the generous support of an anonymous donor. Conserved with funds from the Smithsonian Women's Committee (NPG.2009.111)

REFERENCE: Sellers 1952, pp. 123, 367, no. 464, fig. 420

170. Snuffbox with Miniature Portrait of Louis XVI
Joseph Etienne Blerzy (French, active 1750–1806)
Miniature portrait by Louis Marie Sicardi (French, Avignon 1743–1825 Paris)
Ca. 1779–80
Gold, enamel, set with fifty-six diamonds; ivory, glass
Box: H. 1⅜ in. (3.5 cm), W. 3¼ in. (8.3 cm), D. 2½ in. (6.4 cm); miniature: oval, H. 1¼ in. (3.2 cm), W. 1 in. (2.5 cm)
Signed and dated (on miniature): *Sicardy / 1780*
Engraved (on inside of lid): *PRESENTED / TO / COL. John Laurens. / by / LOUIS THE 16ᵗʰ A.D. 1780* [sic]
Marks: (on inside bottom) [crowned fleur-de-lis, two *grains de remède*, *JEB*, device a level (maker's mark)]; (on front wall) *PARIS* [in cipher (Paris charge mark for gold and small silver, 1774–80)]; (on cover) [crowned italic *Q* (Paris warden's mark for gold, 1779–80)]; (on insetting rim of box) [monkey's head (Paris discharge mark for gold and small silver, 1774–80)], *878* (probably a retailer's number)

The Metropolitan Museum of Art, New York, Bequest of Edward C. Post, 1930 (30.58.3)

REFERENCES: "Bequest of Edward C. Post" 1930, p. 163, fig. 2; Reynolds 1996, p. 98, no. 60, colorpl., p. 32

NOTES (cats. 169, 170)
1. Charles Willson Peale, Diary, entry of October 2, 1780, in L. B. Miller 1983–2000, vol. 1 (1983), p. 352.
2. John Laurens to Thomas McKean, September 2, 1781, National Archives, Washington, D.C. (microfilm, M247, reel 182, item 165, p. 160).
3. Archives Diplomatiques, Paris, Ministère des Affaires Etrangères, Mémoires et Documents, France, vol. 2095, "Les présents du Roy," 59, fol. 32v.
4. Laurens refers to this practice in his letter to Thomas McKean (see note 2 above).

171. *John Paul Jones*
Jean Antoine Houdon (French, Versailles 1741–1828 Paris)
1781
Marble
H. 22½ in. (57.2 cm), with base, 27½ in. (70 cm); W. 21 in. (53.3 cm); D. 12 in. (30.5 cm)
Signed and dated (on back edge of truncation): *J.A.H. 1781*
United States Naval Academy Museum, Annapolis (1958.6)

REFERENCES: Réau 1964, vol. 1, pp. 84–85, 97, 150–51, 403–5, vol. 2, p. 34, no. 140; Poulet 2003, pp. 251–55, no. 44; Valérie Bajou in V. Bajou 2016, p. 109, no. 83

172. Presentation Sword
Hilt by an unidentified goldsmith, mounted by the workshop of Veuve Guilmin, Versailles
French, 1780
Sword: partly blued steel, gold hilt; scabbard: black-painted leather and gold; case: wood covered with morocco leather with gold tooling and lined with chamois; brass
Sword: L. 39¼ in. (101 cm); scabbard: L. 33 in. (83.8 cm); case: L. 41 in. (104.1 cm), H. 3½ in. (8.9 cm), W. 4½ in. (11.4 cm)
Signed (on reverse, on ricasso): *COU / VEUVE / GUILMINÒ / VERSAILLE*

Inscribed (on blade): *Vindicati Mans Ludovicus XVI remunerator Strenuo Vindici* (A Reward from Louis XVI to the Valiant Avenger of the Rights of the Sea) and *Vive le Roi* (Long Live the King)
Marks: [multiple discharge marks: clock (used 1768–74); monkey's head (used 1774–80); *graine de mouron* (chickweed seed) (used 1774–80)]
United States Naval Academy Museum, Annapolis (2011.17.1)

REFERENCES: Russell 1979; Tuite 2004, pp. 120–22, ill. nos. 4.1–4.3

NOTE (cats. 171, 172)
1. Abigail Adams to Elizabeth Cranch, December 3, 1784, in *Adams Family Correspondence* 1963–, vol. 6 (1993), p. 5.

173. *Thomas Jefferson*
Jean Antoine Houdon (French, Versailles 1741–1828 Paris)
1789
Marble
H. 22¼ in. (56.5 cm), with base 27⅝ in. (70.2 cm); W. 18⅞ in. (48 cm); D. 10¼ in. (26 cm)
Signed and dated (on truncation of right shoulder): *houdon f 1789* (Made by Houdon 1789)
Museum of Fine Arts, Boston, George Nixon Black Fund (34.129)

REFERENCES: Réau 1964, vol. 1, pp. 406–7, vol. 2, p. 34, no. 139, pl. LXVIII; Bush 1987, pp. 11–14, no. 4; Poulet 2003, pp. 269–73, no. 48

NOTES
1. Thomas Jefferson to John Jay, June 17, 1785, in Jefferson 1950–, vol. 8 (1953), pp. 226–27.
2. Hart and Biddle 1911, pp. 186–87. There are also multiple plaster versions of the bust.
3. S. R. Stein 1993, p. 230.

174. Passport Issued to Thomas Jefferson
French, 1789
Brown and black ink on paper
13⅛ × 9⅛ in. (33.3 × 23.8 cm)
The Thomas Jefferson Papers, Manuscript Division, Library of Congress, Washington, D.C. (Thomas Jefferson Papers, Box 37, Folder 1, Doc. 8824)

REFERENCE: Jefferson 1950–, vol. 15 (1958), pp. xxxiv–xxxv, ill. facing p. 424

175. *Miniature Portrait of Gouverneur Morris*
Pierre Henri (French, Paris ca. 1760–1822 New York)
1798
Watercolor on ivory, glass
2¼ × 2⅛ in. (7 × 5.4 cm)
Signed and dated (at lower right): *P.H. / 98*
The Metropolitan Museum of Art, New York, Dale T. Johnson Fund, 2006 (2006.235.84)

REFERENCES: Johnson 1990, pp. 135–36, no. 102, pl. 5c; Barratt and Zabar 2010, p. 61, no. 103

176. Armchair (*fauteuil à la reine*)
Designed by Jacques Gondouin (French, Saint-Ouen 1737–1818 Paris); made by François II Foliot (French, 1748–?1839); carved in the workshop of Madame Pierre Edme Babel; gilded in the workshop of Marie Catherine Renon
1779
Carved and gilded beech; modern silk broché
H. 39 in. (99.1 cm), W. 25½ in. (64.8 cm), D. 19¾ in. (50.2 cm)
The Metropolitan Museum of Art, New York, Gift of Susan Dwight Bliss, 1944 (44.157.2)

REFERENCES: Kisluk-Grosheide 2006, pp. 22–24, figs. 29, 30; Daniëlle Kisluk-Grosheide in Kisluk-Grosheide, Koeppe, and Rieder 2006, pp. 178–180, no. 74; Kisluk-Grosheide in Kisluk-Grosheide and Munger 2010, pp. 92–93, no. 34

NOTES (cats. 175, 176)
1. Morris 1888, vol. 1, pp. 41, 81.
2. The creation of this silk broché, hand-woven by Prelle in Lyon, was made possible through the generous support of Mrs. Jayne Wrightsman. Nancy Britton was responsible for the reupholstery.

BIBLIOGRAPHY

van der Aa, Pieter
1729 *La galerie agreable du monde, où l'on voit en un grand nombre de cartes tres-exactes et de belles tailles-douces, les principaux empires, roïaumes, republiques, provinces, villes, bourgs et forteresses . . . divisee en LXVI. tomes.* Leiden: Pierre van der Aa.

Abert, Hermann
2007 *W. A. Mozart.* Translated by Stewart Spencer. Edited by Cliff Eisen. New Haven, Conn.: Yale University Press.

"Acquisitions"
1993 *Revue du Louvre: La revue des musées de France* 43, no. 4 (Oct.), pp. 76–96.
1995 *Revue du Louvre: La revue des musées de France* 45, no. 3 (June), pp. 76–106.
1997 *Revue du Louvre: La revue des musées de France* 47, no. 2 (Apr.), pp. 90–111.
2001 *Revue du Louvre: La revue des musées de France* 51, no. 3 (June), pp. 82–110.
2017 *Revue du Louvre: La revue des musées de France.* Forthcoming.

Adamczak, Audrey
2014–15 "Engraving Sculpture: Depictions of Versailles Statuary in the *Cabinet du Roi.*" *Princeton University Library Chronicle* 76, nos. 1–2 (Autumn 2014–Winter 2015), pp. 176–210.

Adams, John
1961 *Diary and Autobiography of John Adams.* Edited by L. H. Butterfield. 4 vols. Cambridge, Mass.: Belknap Press of Harvard University Press.
1977– *The Papers of John Adams.* Edited by Robert J. Taylor et al. 18 vols. to date. Cambridge, Mass.: Belknap Press of Harvard University Press.

Adams, John Quincy
1981 *Diary of John Quincy Adams.* Edited by David Grayson Allen et al. 2 vols. Cambridge, Mass.: Belknap Press of Harvard University Press.

Adams Family Correspondence
1963– *Adams Family Correspondence.* Edited by L. H. Butterfield et al. 13 vols. to date. Cambridge, Mass.: Belknap Press of Harvard University Press.

Adams Family Papers
2003– *Adams Family Papers: An Electronic Archive.* Boston: Massachusetts Historical Society. https://www.masshist.org/digitaladams/.

Affaires de l'Inde
1788 *Affaires de l'Inde: Depuis le commencement de la guerre avec la France en 1756, jusqu'à la conclusion de la paix en 1783.* 2 vols. Paris: Buisson.

Alder, Ken
1997 *Engineering the Revolution: Arms and Enlightenment in France, 1763–1815.* Princeton, N.J.: Princeton University Press.

Allen, Zachariah
1832 *The Practical Tourist, or Sketches of the State of the Useful Arts, and of Society, Scenery, &c. &c. in Great-Britain, France and Holland. . . .* 2 vols. Providence, R.I.: A. S. Beckwith; Boston: Richardson, Lord and Holbrook, and Carter and Hendee.

Almanach de Versailles
1773 *Almanach de Versailles. . . .* [Versailles]: [Blaizot].
1774 *Almanach de Versailles. . . .* Paris: Valade; Versailles: Blaizot.

Almanach parisien
1762–65 [M. Hébert] and [Pons Augustin Alletz]. *Almanach parisien en faveur des étrangers et des personnes curieuses, indiquant par ordre alphabétique tous les monuments des beaux-arts, répandus dans la ville de Paris & aux environs. . . .* 2 pts. Paris: Veuve Duchesne.
1763–64 [M. Hébert] and [Pons Augustin Alletz]. *Almanach parisien en faveur des étrangers et des personnes curieuses, indiquant par ordre alphabétique tous les monumens des beaux-arts, répandus dans la ville de Paris & aux environs. . . .* 2 pts. Paris: Veuve Duchesne, [1763–64].

American Wanderer
1783 *The American Wanderer, through Various Parts of Europe, in a Series of Letters to a Lady . . . by a Virginian.* London: J. Robson.

Amory, Katherine Greene
1923 *The Journal of Mrs. John Amory (Katharine Greene), 1775–1777, with Letters from Her Father, Rufus Greene, 1759–1777.* Edited by Martha C. Codman. Boston: Privately printed.

Anderson, Emily
1938 *The Letters of Mozart & His Family.* Translated and edited by Emily Anderson. 3 vols. London: Macmillan.

Andia, Béatrice de, and Nicolas Courtin
1997 Eds. *L'Ile Saint-Louis.* Exh. cat. Hôtel Lauzun, Paris. Paris: Action Artistique de la Ville de Paris.

André, Louis, and Emile Bourgeois
1924 Eds. *Recueil des instructions données aux ambassadeurs et ministres de France depuis les traités de Westphalie jusqu'à la Révolution française.* Vol. 23, *Hollande*, pt. 3, *1730–1788.* Paris: E. de Boccard.

Archer, Mildred, Christopher Rowell, and Robert Skelton
1987 *Treasures from India: The Clive Collection at Powis Castle.* New York: Meredith Press.

Ariès, Christian
1968 *Armes blanches militaires françaises.* Vol. 10, no. 4, *Les armes d'hast: Pertuisanes des Gardes de la Manche sous la monarchie.* Nantes: Christian Ariès.
1974 *Armes blanches militaires françaises.* Vol. 22, *Les armes d'Hast: Pertuisanes de la Maison du Roi, règne du Roi Soleil.* Nantes: Christian Ariès.

Arizzoli-Clémentel, Pierre
1998 *Views and Plans of the Petit Trianon at Versailles.* Paris: Alain de Gourcuff.
2002 *Versailles: Furniture of the Royal Palace, 17th and 18th Centuries.* Vol. 2. Dijon: Faton.

Arizzoli-Clémentel, Pierre, and Pascale Gorguet Ballesteros
2009 Eds. *Fastes de cour et cérémonies royales: Le costume de cour en Europe, 1650–1800.* Exh. cat. Château de Versailles. Paris: Réunion des Musées Nationaux.

Arneth, Alfred, Ritter von
1867–68 Ed. *Maria Theresia und Joseph II.: Ihre Correspondenz sammt Briefen Joseph's an seinen Bruder Leopold.* 3 vols. Vienna: Carl Gerold's Sohn.

Art français
1958 *L'art français et l'Europe aux XVIIᵐᵉ et XVIIIᵐᵉ siècles.* Exh. cat. Orangerie des Tuileries. Paris: Musées Nationaux.

Aulanier, Christiane
1955 *Histoire du Palais et du Musée du Louvre.* [Vol. 5], *La petite galerie: Appartement d'Anne d'Autriche; salles romaines.* Paris: Musées Nationaux.

Avcıoğlu, Nebahat
2011 *"Turquerie" and the Politics of Representation, 1728–1876.* Farnham, Surrey: Ashgate.

Baarsen, Reinier
2013 *Paris, 1650–1900: Decorative Arts in the Rijksmuseum.* New Haven, Conn.: Yale University Press.

Bachaumont, Louis Petit de
1784 *Mémoires secrets pour servir à l'histoire de la république des lettres en France, depuis MDCCLXII jusqu'à nos jours, ou Journal d'un observateur.* Vol. 11. London: John Adamson.

Bacquart, Jean-Vincent, Marie Leimbacher, and Gaëlle Taxil
2014 Eds. *Le château de Versailles en 100 chefs-d'oeuvre / The Palace of Versailles through 100 Masterpieces.* Exh. cat. Musée des Beaux Arts, Arras; 2014–16. Cinisello Balsamo: Silvana.

Baghdiantz McCabe, Ina
2008 *Orientalism in Early Modern France: Eurasian Trade, Exoticism, and the Ancien Régime.* New York: Berg.

Baillie, Hugh Murray
1967 "Etiquette and the Planning of the State Apartments in Baroque Palaces." *Archaeologia* 101, pp. 169–99.

Bajou, Thierry
1998 *La peinture à Versailles, XVIIe siècle.* Paris: Musées Nationaux and Buchet-Chastel.

Bajou, Valérie
2016 Ed. *Versailles and the American Revolution.* Exh. cat. Château de Versailles. Montreuil: Editions Gourcuff Gradenigo.

Baldass, Ludwig
1920 *Katalog der Gobelinausstellung.* Exh. cat. Belvedereschloss, Vienna. Vienna: Österreichische Verlagsgesellschaft Ed. Hölzel & Co.

Balfour, Andrew
1700 *Letters Write to a Friend . . . Containing Excellent Directions and Advices for Travelling thro' France and Italy.* Edinburgh.

Bangs, Jeremy Dupertuis
2015 *The Travels of Elkanah Watson: An American Businessman in the Revolutionary War, in 1780s Europe and in the Formative Decades of the United States.* Jefferson, N.C.: McFarland.

Barbier, Paul
1933 "Miscellanea Lexicographica." Pt. X. *Proceedings of the Leeds Philosophical and Literary Society, Literary and Historical Section* 3, no. 2 (May), pp. 73–136.

Barratt, Carrie Rebora, and Lori Zabar
2010 *American Portrait Miniatures in The Metropolitan Museum of Art.* New York: The Metropolitan Museum of Art.

Barrier, Janine
1996a "Chambers in France and Italy." In *Sir William Chambers: Architect to George III*, edited by John Harris and Michael Snodin, pp. 19–33. Exh. cat. Courtauld Gallery, London, and Nationalmuseum, Stockholm; 1996–97. New Haven, Conn.: Yale University Press.
1996b "The Franco-Italian Album and Its Significance." In Snodin 1996, pp. 20–26.

Barta-Fliedl, Ilsebill
2001 *Familienporträts der Habsburger: Dynastische Repräsentation im Zeitalter der Aufklärung.* Vienna: Böhlau.

Barth, Volker
2013 *Inkognito: Geschichte eines Zeremoniells.* Munich: Oldenbourg.
2014 "Les visites incognito à la cour des Bourbons au XVIIIe siècle." In Kolk et al. 2014, pp. 323–35.

Barton, H. Arnold
1972 "Gustav III of Sweden and the Enlightenment." *Eighteenth-Century Studies* 6, no. 1 (Autumn), pp. 1–34.

Bastien, Vincent
2017 "Un allié francophile: Gustave III de Suède. Deux long voyages, 1771 et 1784." In Kisluk-Grosheide and Rondot 2017, pp. 278–83.

Baulez, Christian
1985 "Le choix du citoyen Alcan." In *Drouot, 1984–1985: L'art et les enchères*, pp. 149–51. Paris: Compagnie des Commissaires, Priseurs de Paris.
1992a "Le mobilier et les objets d'art de Madame Du Barry." In *Madame Du Barry: De Versailles à Louveciennes*, pp. 25–85. Exh. cat. Musée de Promenade, Marly-le-Roi, Louveciennes. Paris: Flammarion.
1992b "Sèvres: Commandes et achats de Madame Du Barry." *L'estampille/L'objet d'art*, no. 257 (Apr.), pp. 34–53.

Beddington, Charles
2007 "Pietro Bellotti in England and Elsewhere." *Burlington Magazine* 149, no. 1255 (Oct.), pp. 678–84.

Beddington, Charles, and Domenico Crivellari
2013 Eds. *Pietro Bellotti: Un altro Canaletto.* Exh. cat. Ca' Rezzonico, Museo del Settecento Veneziano, Venice; 2013–14. Verona: Scripta Edizioni.

Belevitch-Stankevitch, Hélène
1910 *Le goût chinois en France au temps de Louis XIV.* Paris: Jouve.

Bellaigue, Geoffrey de
2009 *French Porcelain in the Collection of Her Majesty the Queen.* 3 vols. London: Royal Collection Enterprises.

Bellamy, Mr.
1768 *Ethic Amusements.* Revised by Daniel Bellamy. London: Printed by W. Faden for the author.

Bély, Lucien
1999 *La société des princes, XVIe–XVIIIe siècles.* Paris: Fayard.

Benjamin Franklin and His Circle
1936 *Benjamin Franklin and His Circle.* With contributions by R. T. H. Halsey et al. Exh. cat. New York: The Metropolitan Museum of Art.

Bentley, Thomas
1977 *Journal of a Visit to Paris, 1776.* Edited by Peter France. Brighton: University of Sussex Library.

Bentz, Bruno, and Benjamin Ringot
2009 "Jacques Rigaud et les recueils des maisons royales de France." *Les nouvelles de l'estampe*, no. 224 (May–June), pp. 22–34.

"Bequest of Edward C. Post"
1930 "The Bequest of Edward C. Post." *Bulletin of The Metropolitan Museum of Art* 25, no. 7 (July), pp. 162–64.

"Bequest of Emma Townsend Gary"
1937 "The Bequest of Emma Townsend Gary." *Bulletin of The Metropolitan Museum of Art* 32, no. 7 (July), pp. 166–67.

Berger, Robert W.
1985 *Versailles: The Château of Louis XIV.* Monographs on the Fine Arts 40. University Park: Published for the College Art Association of America by Pennsylvania State University Press.
1988 "Tourists during the Reign of the Sun King: Access to the Louvre and Versailles and the Anatomy of Guidebooks and Other Printed Aids." In *Paris: Center of Artistic Enlightenment*, edited by George Mauner et al., pp. 126–58. University Park: Pennsylvania State University.

2010 "The Pyramid Fountain at Versailles." *Studies in the History of Gardens & Designed Landscapes* 30, no. 3, pp. 263–82.

Berger, Robert W., and Thomas F. Hedin
2008 *Diplomatic Tours in the Gardens of Versailles under Louis XIV*. Penn Studies in Landscape Architecture. Philadelphia: University of Pennsylvania Press.

Bergmann, Alfred
1938 Carl August, Grand Duke of Saxe-Weimar-Eisenach. *Briefe des Herzogs Carl August von Sachsen-Weimar an seine Mutter die Herzogin Anna Amalia, Oktober 1774 bis Januar 1807*. Edited by Alfred Bergmann. Jenaer Germanistische Forschungen 30. Jena: Frommann.

Berly, Cécile
2015 "Madame Du Barry: La dernière favorite de Versailles." *Château de Versailles: De l'Ancien Régime à nos jours*, no. 18 (July–Sept.), pp. 17–25.

Bernoulli, Johann
1784 *Johann Bernoulli's Sammlung kurzer Reisebeschreibungen*. Vol. 15. Berlin.

Berry, Mary
1905 *Voyages de Miss Berry à Paris, 1782–1836*. Translated by Albertine Ida Gustavine, duchesse de Broglie. Paris: A. Roblot.

Beskow, Bernhard von
1868 *Gustave III jugé comme roi et comme homme*. Vol. 1. Stockholm: P. A. Norstedt et Fils.

Bessborough, Henrietta Frances Spencer Ponsonby, countess of
1940 *Lady Bessborough and Her Family Circle*. Edited by Vere Brabazon Ponsonby, 9th Earl of Bessborough. London: J. Murray.

Beurdeley, Michel
1981 *La France à l'encan, 1789–1799: Exode des objets d'art sous la Révolution*. Fribourg: Office du Livre.

Bimbenet-Privat, Michèle
2002 *Les orfèvres et l'orfèvrerie de Paris au XVIIe siècle*. Paris: Commission des Travaux Historiques de la Ville de Paris.
2003 "Les pierreries de Louis XIV: Objets de collection et instruments politiques." In *Etudes sur l'ancienne France offertes en hommage à Michel Antoine*, edited by Bernard Barbiche and Yves-Marie Bercé, pp. 81–96. Mémoires et documents de l'Ecole des Chartes 69. Paris: Ecole des Chartes.

Bimbenet-Privat, Michèle, and François Farges
2015 *La boîte à portrait de Louis XIV*. Paris: Louvre Editions and Somogy Editions d'Art.

Bjurström, Per
1993 *Roslin*. Höganäs: Wiken.

Black, Jeremy
1992 *The British Abroad: The Grand Tour in the Eighteenth Century*. New York: St. Martin's Press. [Reprint, Stroud: History Press, 2009.]

Black, Peter
2007 Ed. *"My Highest Pleasures": William Hunter's Art Collection*. Glasgow: Hunterian, University of Glasgow, in association with Paul Holberton Publishing.

Blet, Pierre
2002 *Les nonces du pape à la cour de Louis XIV*. Paris: Perrin.

Blin, Maxime
2015 "Carrosses et privilèges: Entrer en voiture dans la cour royale." *Château de Versailles: De l'Ancien Régime à nos jours*, no. 18 (July–Sept.), pp. 54–59.

Blum, Dilys
1988 "Fans from the Collection." *Philadelphia Museum of Art Bulletin* 84, nos. 358–59 (Spring), pp. 1–36.

Boesen, Gudmund
1967 "Le service de toilette français de Hedvig Sofia." In *Opuscula in Honorem C. Hernmarck, 27-12-1966*, pp. 22–38. Nationalmusei skriftserie, n.s., 15. Stockholm: Nationalmuseum.

Bombelles, Marc Marie, marquis de
1977 *Journal*. Edited by Jean Grassion and Frans Durif. Vol. 1. Histoire des idées et critique littéraire 170. Geneva: Librairie Droz.

Boppe, Auguste, Louis-Charles-Marie Delavaud, and Louis Delavaud
1901 *Les introducteurs des ambassadeurs, 1585–1900*. Paris: Félix Alcan.

Boswell, James
1826 *The Life of Samuel Johnson, LL.D*. 4 vols. Oxford English Classics. London: William Pickering; Oxford: Talboys and Wheeler.

Bouchenot-Déchin, Patricia, and Georges Farhat
2013 Eds. *André Le Nôtre en perspectives*. Exh. cat.; 2013–14. Paris: Hazan; Versailles: Château de Versailles.

Boucher, François, and Frances Wilson Huard
1921 *François Boucher. American Footprints in Paris: A Guide Book of Historical Data Pertaining to Americans in the French Capital from the Earliest Days to the Present Times*. Translated, revised, and edited by Frances Wilson Huard. New York: George H. Doran.

Bourdelot, Pierre-Michon
2013 "Relation des assemblées faites à Versailles dans le Grand Appartement du roi pendant ce carnival de l'an 1683 et des divertissements que Sa Majesté y avais ordonnés." In *Manières de montrer Versailles: Guides, promenades et relations sous le règne de Louis XIV*, edited by Timothée Chevalier, pp. 205–12. Paris: Hermann Editeurs.

Bouret, Blandine
1982 "L'ambassade persane à Paris en 1715 et son image." *Gazette des beaux-arts*, 6th ser., 100 (Oct.), pp. 109–30.

Bourhis, Katell le
1989 Ed. *The Age of Napoleon: Costume from Revolution to Empire, 1789–1815*. Exh. cat.; 1989–90. New York: The Metropolitan Museum of Art.

Bourne, Jonathan
1981 "A Newly-Discovered French Royal Cabinet." *Apollo* 114, n.s., no. 234 (Aug.), pp. 93–95.

Boutier, Jean
2004 "Le grand tour: Une pratique d'éducation des noblesses européennes (XVIe–XVIIIe siècles)." In *Le voyage à l'époque moderne*, pp. 7–21. Paris: Presses de l'Université de Paris-Sorbonne.

Bowles, John
1726 *Versailles Illustrated, or Divers Views of the Several Parts of the Royal Palace of Versailles*. London: Printed and sold by John Bowles.

Bowron, Edgar Peters
2016 *Pompeo Batoni: A Complete Catalogue of His Paintings*. 2 vols. New Haven, Conn.: Yale University Press.

Bowron, Edgar Peters, and Peter Björn Kerber
2007 *Pompeo Batoni: Prince of Painters in Eighteenth-Century Rome*. Exh. cat. Museum of Fine Arts, Houston, and National Gallery, London; 2007–8. New Haven, Conn.: Yale University Press; Houston: Museum of Fine Arts.

Boyer, Abel
1753 *The Compleat French Master. . . . To Which Is Added, A Tour to Paris, Versailles, Marli, &c*. Dublin: J. Exshaw.

Boyer, Marc
2000 "Les séries de guides imprimés portatifs, de Charles Estienne aux XIXe et XXe siècles." In G. Chabaud et al. 2000, pp. 339–52.

Boysson, Bernadette de, and Xavier Salmon
2005 Eds. *Marie-Antoinette à Versailles: Le goût d'une reine*. Exh. cat.; 2005–6. Paris: Somogy Editions d'Art; Bordeaux: Musée des Arts Décoratifs.

Brekke, Linzy
2006 "'To Make a Figure': Clothing and the Politics of Male Identity in Eighteenth-Century America." In *Gender, Taste, and Material Culture in Britain and North America, 1700–1830*, edited by John Styles and Amanda Vickery, pp. 225–46. New Haven, Conn.: Yale Center for British Art.

Bremer-David, Charissa
2015 *Woven Gold: Tapestries of Louis XIV*. With essays by Pascal-François Bertrand, Arnauld Brejon de Lavergnée, and Jean Vittet. Los Angeles: J. Paul Getty Museum.

Bresc-Bautier, Geneviève, Isabelle Leroy-Jay Lemaistre, and Guilhem Scherf
1998 *Sculpture française. Renaissance et temps modernes*. Edited by Jean-René Gaborit. Vol. 2, pt. 1, *Adam–Gois*. Paris: Réunion des Musées Nationaux.

Bresc-Bautier, Geneviève, and Guilhem Scherf
2009 Eds., with James David Draper. *Cast in Bronze: French Sculpture from Renaissance to Revolution*. Exh. cat. Musée du Louvre, Paris; The Metropolitan Museum of Art, New York; and J. Paul Getty Museum, Los Angeles; 2008–9. Paris: Musée du Louvre Editions and Somogy Art Publishers.

Breteuil, Louis Nicolas Le Tonnelier, baron de
1840 "Des baisers d'étiquette donnés par le Roi, les Reines, et les Filles de France, à propos de la réception de l'ambassadrice de Hollande." In Félix Danjou, *Archives curieuses de l'histoire de France depuis Louis XI jusqu'à Louis XVIII*, ser. 2, vol. 12, pp. 157–62. Paris: Blanchet.
1992 *Mémoires*. Edited by Evelyne Lever. Paris: François Bourin.
2009 "Mémoires." In *Lettres d'amour, mémoires de cour, 1680–1715*, edited by Evelyne Lever, pp. 137–373. Paris: Tallandier.

Bretschneider, Heinrich Gottfried von
1817 *Reise des Herrn von Bretschneider nach London und Paris: Nebst Auszügen aus seinen Briefen an Herrn Friedrich Nicolai*. Edited by Leopold Friedrich Günther von Göckingk. Berlin: Nicolai.

Brewer, Stella Margaret
1963 *Design for a Gentleman: The Education of Philip Stanhope*. London: Chapman & Hall.

Brice, Germain
1687 *Description nouvelle de ce qu'il y a de plus remarquable dans la ville de Paris*. 2nd edition. 2 vols. Paris: Jean Pohier.

Broderick, Thomas
1754 *Letters from Several Parts of Europe, and the East. . . .* 2 vols. Dublin: Printed for George Faulkner.

Brouzet, David
1998 "Jean-Baptiste et Pierre-Denis Martin: Peintres des maisons royales." *L'estampille/L'objet d'art*, no. 328 (Oct.), pp. 64–82.

Bruckbauer, Ashley
2013 "Crossing Cultural, National, and Racial Boundaries: Portraits of Diplomats and the Pre-Colonial French-Cochinchinese Exchange, 1787–1863." M.A. thesis, University of North Carolina at Chapel Hill.

Brulon, Dorothée Guillemé
1993a "Service offert par Louis XVI au Prince Henri de Prusse en 1784." In *Versailles et les tables royales en Europe* 1993, p. 341.
1993b "Les services de porcelaine de Sèvres: Présents des rois Louis XV et Louis XVI aux souverains étrangers." In *Versailles et les tables royales en Europe* 1993, pp. 184–87.

Brunet, Marcelle
1961 "Incidences de l'ambassade de Tipoo-Saïb (1788) sur la porcelaine de Sèvres." *Cahiers de la céramique du verre et des arts du feu*, no. 24, pp. 275–84.

Bruson, Jean-Marie, and Christophe Leribault
1999 *Peintures du Musée Carnavalet: Catalogue sommaire*. Paris: Paris-Musées.

Bucholz, R. O.
2000 "Going to Court in 1700: A Visitor's Guide." *Court Historian* 5, no. 3 (Dec.), pp. 181–215.

Buckland, Frances
1983 "Gobelins Tapestries and Paintings as a Source of Information about the Silver Furniture of Louis XIV." *Burlington Magazine* 125, no. 962 (May), pp. 271–83.

Buddle, Anne
1999 With Pauline Rohatgi and Iain Gordon Brown. *The Tiger and the Thistle: Tipu Sultan and the Scots in India, 1760–1800*. Exh. cat. Edinburgh: National Gallery of Scotland.

Bulgakova, Ekaterina
2014 "'Voyager en sage, avant de régner en héros': L'accueil du comte et de la comtesse du Nord à la cour de France en 1782." In Kolk et al. 2014, pp. 239–58.

Burchard, Wolf
2012 "Savonnerie Reviewed: Charles Le Brun and the 'Grand Tapis de Pied d'Ouvrage à la Turque' Woven for the *Grande Galerie* at the Louvre." *Furniture History* 48, pp. 1–43.
2016 *The Sovereign Artist: Charles Le Brun and the Image of Louis XIV*. London: Paul Holberton Publishing.

Burke, Peter
1992 *The Fabrication of Louis XIV*. New Haven, Conn.: Yale University Press. [French ed., *Louis XIV: Les stratégies de la gloire*. Paris: Seuil, 1995.]

Burton, John Hill
1967 *Life and Correspondence of David Hume*. 2 vols. Burt Franklin Research and Source Works Series 186; Philosophy Monograph Series 13. New York: Burt Franklin.

Bush, Alfred L.
1987 *The Life Portraits of Thomas Jefferson*. Charlottesville, Va.: Thomas Jefferson Memorial Foundation.

Bussmann, Walter
1998 Ed. *Europa von der Französischen Revolution zu den nationalstaatlichen Bewegungen des 19. Jahrhunderts*. 2nd edition. Vol. 5 of *Handbuch der europäischen Geschichte*, edited by Theodor Schieder. Stuttgart: Klett-Cotta.

Butler, Alban
1803 *Travels through France & Italy, and Part of Austrian, French, & Dutch Netherlands, during the Years 1745 and 1746*. Edinburgh: Keating, Brown, and Keating.

Buvat, Jean
1865 *Journal de la Régence (1715–1723)*. Edited by Emile Campardon. 2 vols. Paris: Henri Plon.

Cachau, Philippe
2012 "Le château de Christian IV, duc des Deux-Ponts, à Jägesburg: Un château français en Allemagne (1752–1756)." *Francia* 39, pp. 135–65.

Calendar of Treasury Books
1923 *Calendar of Treasury Books . . . Preserved in the Public Record Office*. Vol. 8, *1685–1689*. Edited by William A. Shaw. London: His Majesty's Stationery Office.

Câmara, Luís Manuel da
1716 *Noticia da entrada publica que fez na corte de Paris em 18. de agosto de 1715. O excellentissimo senhor D. Luis Manoel da Camara . . . embayxador extraordinario à . . . Luis XIV. o Grande*. Lisbon: Joseph Lopes Ferreyra.

Campbell, Mungo
2007 "London's Loss?" In P. Black 2007, pp. 11–18.

Campe, Joachim Heinrich
1790 *Briefe aus Paris zur Zeit der Revolution geschrieben*. Braunschweig: In der Schulbuchhandlung.

van Campen, Jan, and Karina Corrigan
2015 Eds. *Asia in Amsterdam: The Culture of Luxury in the Golden Age*. Exh. cat. Salem, Mass.: Peabody Essex Museum.

Camus, Alice
2013 "Etre reçu en audience chez le roi." *Bulletin du Centre de Recherche du Château de Versailles.* Published online July 10, 2013. https://crcv.revues.org/12207.

Carbonnières, Philippe de
2005 *Lesueur: Gouaches révolutionnaires. Collections du Musée Carnavalet.* Paris: Paris-Musées and Nicolas Chaudun.
2006a "Les gouaches révolutionnaires de Lesueur au Musée Carnavalet." *Annales historiques de la Révolution française,* no. 343 (Jan.–Mar.), pp. 93–122.
2006b *Prieur, les tableaux historiques de la Révolution: Catalogue raisonné des dessins originaux. Collections du Musée Carnavalet.* Exh. cat. Musée Carnavalet. Paris: Paris-Musées and Nicolas Chaudun.

Carlier, Yves
1987 "Les cabinets du Grand Dauphin au château de Versailles, 1684–1711." *Bulletin de la Société de l'Histoire de l'Art Français,* 1987 (pub. 1989), pp. 45–54.

Cassidy-Geiger, Maureen
2007 *Fragile Diplomacy: Meissen Porcelain for European Courts, 1710–1763.* New York: Bard Center for Graduate Studies in the Decorative Arts, Design, and Culture; New Haven, Conn.: Yale University Press.

Castelluccio, Stéphane
2002 *Les collections royales d'objets d'art de François I^{er} à la Révolution.* Paris: Les Editions de l'Amateur.
2006 "La Galerie des Glaces: Les réceptions d'ambassadeurs." *Versalia,* no. 9, pp. 24–52.
2007 Ed. *Les fastes de la Galerie des Glaces: Recueil d'articles du* Mercure galant *(1681–1773).* Paris: Payot.
2014 "La commerce des laques à la fin du XVII^e siècle." In *Les secrets de la laque française: Le vernis Martin,* edited by Anne Forray-Carlier and Monika Kopplin, pp. 19–22. Exh. cat. Paris: Musée des Arts Décoratifs.

Caude, Elisabeth, Jérôme de La Gorce, and Béatrix Saule
2016 Eds. *Fêtes & divertissements à la cour.* Exh. cat.; 2016–17. Versailles: Château de Versailles; Paris: Gallimard.

Chabaud, Gilles, Evelyne Cohen, Natacha Coquery, and Jérome Penez
2000 Eds. *Les guides imprimés du XVI^e au XX^e siècle: Villes, paysages, voyages.* Paris: Belin.

Chabaud, Jean-Paul
2003 *Joseph-Siffred Duplessis, 1725–1802: Biographie.* Mazan: Etudes Comtadines.

Chambaud, Louis, and Jean-Baptiste Robinet
1776 *A New Dictionary, English and French and French and English, Containing the Signification of Words with Their Different Uses....* Vol. 2 of Louis Chambaud and Jean-Baptiste Robinet, *Nouveau dictionnaire françois-anglois, et anglois-françois, contenant la signification et les differens usages des mots....* Paris: C. Panckoucke; Amsterdam: Arkstée and Merkus; Rotterdam: H. Beman.

Chantelou, Paul Fréart de
2001 *Journal de voyage du cavalier Bernin en France.* Paris: Macula-Insulaire.

Chapman, Martin, et al.
2007 *Marie Antoinette and the Petit Trianon at Versailles.* Exh. cat.; 2007–8. San Francisco: Fine Arts Museums of San Francisco, Legion of Honor.

Charageat, Madeleine
1946 Ed. *Trois siècles de dessin parisien.* Exh. cat. Paris: Musée Carnavalet.

Charland, Thomas
1969 "Nescambiouit." In *Dictionary of Canadian Biography,* vol. 2, pp. 494–96. Toronto: University of Toronto Press.

Charles Le Brun
1990 *Charles Le Brun, 1619–1690: Célébration du tricentenaire de la mort de l'artist. Le décor de l'Escalier des Ambassadeurs à Versailles.* Preface by Jacques Thuillier. Exh. cat. Musée National du Château de Versailles; 1990–91. Paris: Réunion des Musées Nationaux.

Charpenne, Pierre
1890 Ed. *Voyage à Paris en 1789 de Martin, faiseur de bas d'Avignon.* Avignon: J. Roumanille.

Charpentier, François
1684 *Explication des tableaux de la galerie de Versailles.* Paris: François Muguet.

Chateaubriand, François René, vicomte de
1849–50 *Mémoires d'outre-tombe.* 12 vols. Paris: Eugène et Victor Penaud Frères.

Chéruel, Adolphe
1899 *Dictionnaire historique des institutions, moeurs et coutumes de la France.* 7th edition. 2 vols. Paris: Librairie Hachette.

Chesterfield, Philip Dormer Stanhope, Earl of
1901 *The Letters of the Earl of Chesterfield to His Son.* Edited by Charles Strachey; with notes by Annette Calthrop. 2 vols. London: Methuen.

Chevalier, Timothée
2013 "Les enluminures de Jacques Bailly." In Maisonnier and Maral 2013, pp. 103–85.

Chinard, Gilbert
1943 "Notes on the French Translations of the 'Forms of Government or Constitutions of the Several United States,' 1778 and 1783." *Year Book* (American Philosophical Society), 1943 (pub. 1944), pp. 88–106.

Choisy, Abbé de
1727 *Mémoires pour servir à l'histoire de Louis XIV.* Utrecht: Wan-de-Vater.

Chrisman-Campbell, Kimberly
2002–3 "Designing Woman." *Rotunda* 35, no. 2 (Winter), pp. 12–19.
2015 *Fashion Victims: Dress at the Court of Louis XVI and Marie-Antoinette.* New Haven, Conn.: Yale University Press.

Christie's
1882 *Catalogue of the Collection of Pictures, Works of Art, and Decorative Objects, the Property of His Grace the Duke of Hamilton, K.T....* Sale cat. Collection of William Alexander Louis Stephen Douglas-Hamilton, 12th Duke of Hamilton. Pt. 4. Christie, Manson & Woods, London, July 8–11, 1882.

Churchill, Awnsham, and John Churchill
1732 *A Collection of Voyages and Travels....* 6 vols. London.

Citizens and Kings
2007 *Citizens and Kings: Portraits in the Age of Revolution, 1760–1830.* Exh. cat. Galeries Nationales du Grand Palais, Paris, and Royal Academy of Arts, London; 2006–7. London: Royal Academy of Arts.

Clark, Anthony M.
1985 *Pompeo Batoni: A Complete Catalogue of His Works, with an Introductory Text.* New York: New York University Press.

Clayton, Tim
2016 "War of Words." In V. Bajou 2016, pp. 50–55.

Clenche, John
1745 "A Tour in France and Italy Made by an English Gentleman, 1675." In *A Collection of Voyages and Travels ... Compiled from the Curious and Valuable Library of the Late Earl of Oxford,* vol. 1, pp. 409–74. London: Printed for Thomas Osborne.

Coke, Mary
1970 *The Letters and Journals of Lady Mary Coke.* 4 vols. Bath: Kingsmead Reprints. [Reprint of the 1st edition, Edinburgh: David Douglas, 1889–96.]

Cole, Christian
1733 Ed. *Memoirs of Affairs of State: Containing Letters Written by Ministers Employed in Foreign Negotiations, from the Year 1697, to the Latter End of 1708*. London: Christian Cole.

Cole, William
1931 *A Journal of My Journey to Paris in the Year 1765*. Edited by Francis Griffin Stokes. London: Constable.

Compigné
1991 *Compigné: Peintre et tabletier du Roy*. Exh. cat. Grasse: Villa, Musée Fragonard.

Connolly, Cyril, and Jerome Zerbe
1962 *Les Pavillons: French Pavilions of the Eighteenth Century*. New York: Macmillan.

Constans, Claire
1980 *Musée National du Château de Versailles: Catalogue des peintures*. Paris: Réunion des Musées Nationaux.

Copley, John Singleton, and Henry Pelham
1914 *Letters & Papers of John Singleton Copley and Henry Pelham, 1739–1776*. Collections of the Massachusetts Historical Society 71. Boston: Massachusetts Historical Society.

Cornette, Joël
2007 Louis XIV, King of France. *Mémoires: Suivis de Manière de visiter les jardins de Versailles*. Edited by Joël Cornette. Paris: Tallandier.

Cosson, Charles Alexander, baron de
1901 *Le cabinet d'armes de Maurice de Talleyrand-Périgord, duc de Dino: Etude descriptive*. Paris: Edouard Rouveyre.

Coulon, François, et al.
1996 *Musée des Beaux-Arts de Rennes: Guide des collections*. Paris: Réunion des Musées Nationaux.

Cradock, Anna Francesca
1896 *Journal de Madame Cradock: Voyage en France (1783–1786)*. Translated by O. Delphin-Balleyguier. Paris: Perrin.

Cradock, Joseph
1826 *Literary and Miscellaneous Memoirs*. Vol. 2. London: Printed for the author by J. Nichols and Son.

Creutz, Gustav Philip von
1987 *Le comte de Creutz: Lettres inédites de Paris, 1766–1770*. Edited by Marianne Molander [Beyer]. Romanica Gothoburgensia 33. Göteborg: Acta Universitas Gothoburgensis.

2006 *La Suède & les Lumières: Lettres de France d'un ambassadeur à son roi (1771–1783)*. Edited by Marianne Molander Beyer. Paris: Michel de Maule.

Croÿ, Emmanuel, duc de
1906–7 *Journal inédit du duc de Croÿ, 1718–1784*. Edited by Emmanuel Henri, vicomte de Grouchy, and Paul Cottin. 4 vols. Paris: Ernest Flammarion.

van der Cruysse, Dirk
2002 *Siam & the West, 1500–1700*. Translated by Michael Smithies. Chiang Mai, Thailand: Silkworm Books.

Cumming, Valerie
1998 *The Visual History of Costume Accessories*. London: BT Batsford.

Curiositez de Paris
1716 *Les curiositez de Paris, de Versailles, de Marly, de Vincennes, de S. Cloud, et des environs. . . . Ouvrage enrichi d'un grand nombre de figures*. Paris: Saugrain.
1718 *Les curiositez de Paris, de Versailles, de Marly, de Vincennes, de S. Cloud, et des environs. . . . Ouvrage enrichi d'un grand nombre de figures*. 2nd edition. 2 vols. Paris: Saugrain.

Da Vinha, Mathieu
2009a "Les gens de livrée dans la maison civile du roi de France." In Arizzoli-Clémentel and Gorguet Ballesteros 2009, pp. 160–65.
2009b *Le Versailles de Louis XIV*. Paris: Perrin.
2012 *Le Versailles de Louis XIV: Le fonctionnement d'une résidence royale au XVIIᵉ siècle*. [2nd edition.] Paris: Perrin.
2015 *Au service du roi: Dans les coulisses de Versailles*. Paris: Tallandier.

Dakhlia, Jocelyne
1998 *Le divan des rois: Le politique et le religieux dans l'Islam*. Paris: Aubier.

Dangeau, Philippe de Courcillon, marquis de
1825 *Memoirs of the Court of France, from the Year 1684 to the Year 1720*. Translated by John Davenport. 2 vols. London: Printed for Henry Colburn.
1854–60 *Journal du marquis de Dangeau*. Edited by Eudore Soulié et al. 19 vols. Paris: Firmin Didot Frères.

Dashkova, Ekaterina Romanovna
1840 *Memoirs of the Princess Daschkaw, Lady of Honour to Catherine II, Empress of All the Russias*. Edited by Mrs. W. Bradford. 2 vols. London: Henry Colburn.

Davis, Robert Ralph, Jr.
1970 "Diplomatic Gifts and Emoluments: The Early National Experience." *Historian* 32, no. 3 (May), pp. 376–91.

Davray-Piékolek, Renée
2007 "Franklin et les modes parisiennes." In *Franklin: Un américain à Paris (1776–1785)*, pp. 124–26. Exh. cat. Musée Carnavelet, Paris; 2007–8. Paris: Paris-Musées.

Dean, Bashford
1929 *Catalogue of European Court Swords and Hunting Swords, including the Ellis, De Dino, Riggs, and Reubell Collections*. New York: The Metropolitan Museum of Art.

Dee, Elaine Evans, and Guy Walton
1988 *Versailles: The View from Sweden*. Exh. cat. New York: Cooper-Hewitt Museum, Smithsonian Institution's National Museum of Design.

Del Bufalo, Dario
2012 *Porphyry: Red Imperial Porphyry; Power and Religion / Porfido: Rosso imperial; potere e religione*. Turin: Umberto Allemandi & C.

Delalex, Hélène
2016 *La galerie des carrosses: Château de Versailles*. Paris: Artlys.

"Description de la galerie de Versailles"
1682 *Mercure galant*, Dec., pp. 6–13.

Description de la Grotte de Versailles
1700 *Description de la Grotte de Versailles, oder Beschreibung der Grotten zu Versailles*. Augsburg: Johann Ulrich Krauss.

Desjardins, Gustave
1885 *Le Petit-Trianon: Histoire et description*. Versailles: L. Bernard.

Dezallier d'Argenville, Antoine Joseph
1762 *Abrégé de la vie des plus fameux peintres. . . .* New edition. 4 vols. Paris: De Bure.

Dezallier d'Argenville, Antoine Nicolas
1755 *Voyage pittoresque des environs de Paris, ou Description des maisons royales, châteaux et autres lieux de plaisance, situés à quinze lieues aux environs de cette ville*. Paris: De Bure l'Aîné.
1762 *Voyage pittoresque des environs de Paris, ou Description des maisons royales, châteaux et autres lieux de plaisance, situés à quinze lieues aux environs de cette ville*. New edition. Paris: De Bure Père and De Bure Fils l'Aîné.
1768 *Voyage pittoresque des environs de Paris, ou Description des maisons royales, châteaux et autres lieux de plaisance, situés à quinze lieues aux environs de cette ville*. 3rd edition. Paris: De Bure Père.
1779 *Voyage pittoresque des environs de Paris, ou Description des maisons royales, châteaux et autres lieux de plaisance, situés à quinze lieues aux environs de cette ville*. 4th edition. Paris: De Bure l'Aîné.

D'Ezio, Marianna
2010 *Hester Lynch Thrale Piozzi: A Taste for Eccentricity.* Newcastle upon Tyne: Cambridge Scholars Publishing.

Di Robilant, Andrea
2003 *A Venetian Affair.* New York: Alfred A. Knopf.

Diabaté, Henriette
1975 *Aniaba: Un Assinien à la cour de Louis XIV.* Paris: A.B.C.; Dakar: N.E.A.; Yaoundé: C.L.E.

Dimier, Louis
1925 "Une table du cabinet des curiosités à Versailles." *Bulletin de la Société de l'Histoire de l'Art Français,* p. 200.

Dölle, Florian
2014 "Le regard d'un architecte étranger: Versailles dans le journal de Christoph Pitzler (1657–1707)." In Kolk et al. 2014, pp. 121–42.

Dreyfus, Carle
1922 *Catalogue sommaire du mobilier et des objets d'art du XVIIᵉ et du XVIIIᵉ siècle: Meubles, sièges, tapisseries, bronzes d'ameublement, porcelaines, marbres et laques montés en bronzes, objets d'orfèvrerie.* Musée National du Louvre. 2nd edition. Paris: Musées Nationaux.

Driessen, Felix
1928 *De reizen der de la Courts: 1641, 1700, 1710.* Leiden: Ydo.

Droguet, Vincent
2016 Ed. *Louis XV à Fontainebleau: La "demeure des rois" au temps des Lumières.* Exh. cat. Paris: Réunion des Musées Nationaux; Fontainebleau: Château de Fontainebleau.

Druesedow, Jean L.
1987 "In Style: Celebrating Fifty Years of the Costume Institute." *The Metropolitan Museum of Art Bulletin,* n.s., 45, no. 2 (Fall).

Du Coudray, Alexandre
1782 *Le comte et la comtesse du Nord: Anecdote russe.* Paris: Belin.
1784 *Voyage du comte de Haga, en France.* Paris: Belin.

Dufort de Cheverny, Jean Nicolas, comte de
1886 *Mémoires sur les règnes de Louis XV et Louis XVI et sur la Révolution.* Edited by Robert St.-John de Crèvecoeur. 2 vols. Paris: Librairie Plon.
1909 *Mémoires du comte Dufort de Cheverny: Introducteur des ambassadeurs, lieutenant général du Blaisois.* Edited by Robert St.-John de Crèvecoeur. 3rd edition. Paris: Plon-Nourrit.

Dulaure, Jacques Antoine
1786 *Nouvelle description des environs de Paris, contenant les détails historiques & descriptifs des maisons royales, des villes, bourgs, villages, châteaux, &c. . . .* 2 vols. Paris: Lejay.

Dumont, Jean, and Jean Rousset de Missy
1739 *Le cérémonial diplomatique des cours de l'Europe.* 2 vols. Vols. 4 and 5 of *Supplement au Corps universel diplomatique du droit des gens. . . .* Amsterdam: Janssons à Waesberge, Wetstein & Smith, & Z. Chatelain; The Hague: P. de Hondt, la Veuve de Ch. Le Vier, & J. Neaulme.

Durand, Jannic, Michèle Bimbenet-Privat, and Frédéric Dassas
2014 Eds. *Decorative Furnishings and Objets d'Art in the Louvre from Louis XIV to Marie-Antoinette.* Paris: Somogy Art Publishers and Louvre Editions.

Duval, Valentin Jameray
1784 *Oeuvres de Valentin Jamerai Duval, précédées des mémoires sur sa vie.* 3 vols. in 2. Saint Petersburg.

Dyâb, Hanna
2015 *D'Alep à Paris: Les pérégrinations d'un jeune Syrien au temps de Louis XIV.* Translated and edited by Paule Fahmé-Thiéry, Bernard Heyberger, and Jérôme Lentin. Arles: Actes Sud; Paris: Sindbad.

Ebert, Adam
1724 *Auli Apronii vermehrte Reise-Beschreibung von Franco Porto der Chur-Brandenburg durch Teutschland, Holland und Braband, England, Franckreich.* Frankfurt an der Oder.

Eidelberg, Martin
1977 "A Chinoiserie by Jacques Vigouroux Duplessis." *Journal of the Walters Art Gallery* 35, pp. 62–76.

van Eikema Hommes, Margriet
2012 With Mariska Vonk. *A Mysterious Series by Ferdinand Bol: The Painted Wall Hangings in the Peace Palace Examined.* The Hague: Carnegie Foundation.

Elias, Norbert
1985 *La société de cour.* Paris: Flammarion.

Elkan, Sophie
1913 *An Exiled King: Gustaf Adolf IV of Sweden.* Edited and translated by Eugénie Koch. 2 vols. London: Hutchinson.

Engerand, Fernand
1897 "Pierre Gobert: Peintre de portraits (1666–1744)." *L'artiste,* n.s., 13 (Mar.), pp. 161–74.
1900 Ed. *Inventaire des tableaux commandés et achetés par la direction des Bâtiments du Roi (1709–1792).* Paris: E. Leroux.

Erdmannsdorff, Friedrich Wilhelm von, and Georg Heinrich von Berenhorst
2014 *Un Grand Tour: Deux journaux d'un même voyage en Italie, France et Angleterre (1765–1768).* Edited by François Colson. 2 vols. Paris: Honoré Champion.

Eriksen, Svend
1968a *Louis Delanois: Menuisier en sièges (1731–1792).* Translated by Else Dahl. Paris: F. de Nobele.
1968b *Sèvres Porcelain.* The James A. de Rothschild Collection at Waddesdon Manor. Fribourg: Office du Livre.

Evans, Joan
1956 "The Embassy of the 4th Duke of Bedford to Paris, 1762–1763." *Archaeological Journal* 113, pp. 137–56.

Evans, William B.
1968 "John Adams' Opinion of Benjamin Franklin." *Pennsylvania Magazine of History and Biography* 92, no. 2 (Apr.), pp. 220–38.

Eves, Charles Kenneth
1973 *Matthew Prior: Poet and Diplomatist.* New York: Octagon Books. [Originally published in 1939.]

"Explication de la galerie de Versailles"
1684 [Monsieur Lorne.] *Mercure galant,* Dec., pp. 1–84.

Explication des tableaux de la galerie de Versailles
1688 *Explication des tableaux de la galerie de Versailles et de ses deux sallons.* Versailles: François Muguet.

"Exposition des peintures"
1777 "Exposition des peintures, sculptures & gravures de l'Académie Royale de Peinture & Sculpture, faite, suivant l'intention de S. M., à Paris, dans un des sallons du Louvre en 1777." In *Journal encyclopédique* 8, no. 1 (Nov. 15), pp. 116–25.

Faroult, Guillaume
2016 With the assistance of Catherine Voiriort. *Hubert Robert, 1733–1808: Un peintre visionnaire.* Exh. cat. Paris: Somogy Editions d'Art and Louvre Editions.

Farr, Evelyn
1995 *Marie-Antoinette and Count Axel Fersen: The Untold Love Story.* London: Peter Owen.

Fastes de Versailles
2002 *Fastes de Versailles.* Edited by Xavier Salmon and Pierre-Xavier Hans. Exh. cat. [In Japanese and French.] Municipal Museum, Kobe, and Metropolitan Art Museum, Tokyo; 2002–3. Tokyo.

Fedorov, Viatcheslav
2017 "Pierre le Grand: Premier empereur de toutes les Russies." In *Pierre le Grand: Un tsar en France, 1717*, edited by Gwenola Firmin, Francine-Dominique Liechtenhan, and Thierry Sarmant, pp. 15–22. Exh. cat. Paris: Lienart Editions; Versailles: Château de Versailles.

Feigenbaum, Gail
2003 *Jefferson's America & Napoleon's France: An Exhibition for the Louisiana Purchase Bicentennial.* With contributions by Victoria Cooke et al. Exh. cat. New Orleans: New Orleans Museum of Art.

Félibien, André
1670 *Devises pour les tapisseries du Roy.* Paris: Imprimerie Royale.
1672 *Description de la Grotte de Versailles.* Paris: Sébastien Mabre-Cramoisy.
1674a *Description de la Grotte de Versailles.* N.p.
1674b *Description sommaire du chasteau de Versailles.* Paris: Guillaume Desprez.
1676a *Description de la Grotte de Versailles.* Paris: Imprimerie Royale.
1676b *Les divertissemens de Versailles, donnez par le Roy à toute sa cour au retour de la conqueste de la Franche-Comté, en l'année M.DC.LXXIV.* Paris: Imprimerie Royale.
1677 *Tableaux du Cabinet du Roy: Statuës et bustes antiques des maisons royales.* Vol. 1. Paris: Imprimerie Royale.
1679 *Description de la Grotte de Versailles.* Paris: Imprimerie Royale.
1685 *Description sommaire du chasteau de Versailles.* Versailles: Antoine Vilette.
1687 *Description sommaire du château de Versailles.* Versailles: Antoine Vilette.
1689 *Recueil de descriptions de peintures et d'autres ouvrages faits pour le Roy.* Paris: Veuve Sébastien Mabre-Cramoisy.
1696 *Description du château de Versailles, de ses peintures, et d'autres ouvrages faits pour le Roy.* Paris: Florentin and Pierre Delaulne.

Félibien des Avaux, Jean François
1703 *Description sommaire de Versailles ancienne et nouvelle.* Paris: Antoine Chrétien.

Fenaille, Maurice
1903–23 *Etat général des tapisseries de la Manufacture des Gobelins depuis son origine jusqu'à nos jours, 1600–1900.* 5 vols. Paris: Imprimerie Nationale, Librairie Hachette.

Ferreira, Maria João, Liza Oliver, and Corinne Thépaut-Cabasset
2016 "Les textiles à la période moderne: Circulation, échanges et mondialisation." *Perspective*, no. 1, pp. 21–32. [Issue titled *Textiles*.]

Ferrier, Richard
1894 *The Journal of Major Richard Ferrier, M.P., while Traveling in France in the Year 1687.* Compiled by Richard F. E. Ferrier and John A. H. Ferrier. The Camden Miscellany 9, no. 7. Works of the Camden Society, n.s., 53. Westminster: Camden Society.

Fersen, Hans Axel von
1902 *Diary and Correspondence of Count Axel Fersen, Grand-Marshall of Sweden, Relating to the Court of France.* Translated by Katharine Prescott Wormeley. London: William Heinemann.

Fleming, John
1958 "Lord Brudenell and His Bear-Leader." *English Miscellany: A Symposium of History, Literature and the Arts* 9, pp. 127–41.

Fleury, Abraham Joseph Bénard
1836–38 *Mémoires de Fleury de la Comédie Française (1757 à 1820).* 2nd edition. 6 vols. Paris: Ambroise Dupont.

Fort, Bernadette
1999 Ed. *Les Salons des "Mémoires secrets," 1767–1787.* Paris: Ecole Supérieure Nationale des Beaux-Arts.

Foucart-Walter, Elisabeth
2001 *Pieter Boel, 1622–1674: Peintre des animaux de Louis XIV. Le fonds des études peintes des Gobelins.* Exh. cat. Musée du Louvre, Paris. Dossiers du Musée du Louvre 60. Paris: Réunion des Musées Nationaux.

Fougeret de Monbron, Louis-Charles
2013 *Le cosmopolite, ou Le citoyen du monde.* Paris: Payot & Rivages.

France d'Hézecques, Félix, comte de
1873a *Recollections of a Page at the Court of Louis XVI.* Edited by Charlotte M. Yonge. London: Hurst and Blackett.
1873b *Souvenirs d'un page de la cour de Louis XVI.* Paris: Didier.

Franklin, Benjamin
1905–7 *The Writings of Benjamin Franklin.* Edited by Albert Henry Smyth. 10 vols. New York: Macmillan.
1817 *The Private Correspondence of Benjamin Franklin.* Edited by William Temple Franklin. 2nd edition. 2 vols. London: Printed for Henry Colburn.
1959– *The Papers of Benjamin Franklin.* Edited by Leonard W. Labaree et al. 42 vols. to date. New Haven, Conn.: Yale University Press.
1988– *The Papers of Benjamin Franklin.* Edited by Barbara B. Oberg et al. Digital edition. Packard Humanities Institute. www.franklinpapers.org.

"French Decorative Arts"
1989 "French Decorative Arts during the Reign of Louis XIV, 1654–1715." *The Metropolitan Museum of Art Bulletin*, n.s., 46, no. 4 (Spring).

Freyberger, Ronald
1996 "Royal Porcelain, Royal Gift: The Prologue." In *Service de la reine*, sale cat., Sotheby's, New York, May 18, 1996, n.p.

Fromageot, Paul
1900 "Les voitures publiques à Versailles sous l'Ancien Régime." *Versailles illustré*, no. 47, pp. 121–25; no. 48, pp. 136–40; no. 49, pp. 7–11; no. 50, pp. 21–24; no. 51, pp. 27–31.
1906 "Les hôtelleries et cabarets de l'ancien Versailles." *Revue de l'histoire de Versailles et de Seine-et-Oise* 8, no. 1 (Feb.), pp. 24–46.

Furcy-Raynaud, Marc
1927 *Inventaire des sculptures exécutées au XVIIIᵉ siècle pour la direction des Bâtiments du Roi.* Paris: A. Colin.

Furetière, Antoine
1690 *Dictionnaire universel, contenant generalement tous les mots françois tant vieux que modernes, et les termes de toutes les sciences & des arts. . . .* 3 vols. The Hague and Rotterdam: A. et R. Leers.
1701 *Dictionnaire universel, contenant generalement tous les mots françois tant vieux que modernes, & les termes des sciences et des arts. . . .* 2nd edition; revised and enlarged by Henri Basnage de Beauval. 3 vols. The Hague: Arnoud et Reinier Leers.

Furger, Andres
1998 *Swiss National Museum, Zürich & Prangins.* Geneva: Banque Paribas, in cooperation with the Swiss Institute for Art Research.

Fürst, Georg von
1739 *Herrn Georgen von Fürst, eines berühmten Cavaliers aus Schlesien, Curieuse Reisen durch Europa, in welcher allerhand Merckwürdigkeiten zu finden.* Sorau: Gottlob Hebold.

Gady, Alexandre
2009 "Le sceptre et le compas." In Milovanovic and Maral 2009, pp. 314–18.

Gady, Bénédicte
2015 "La escalera es un sueño." In *Dibujar Versalles: Bocetos y cartones de Charles Le Brun, 1619–1690, para la Escalera de los Embajadores y la Galería de los Espejos*, pp. 61–71. Exh. cat. Caixa Forum, Barcelona; Caixa Forum, Madrid; 2015–16. [Barcelona]: Lunwerg and Obra Social "la Caixa."

Gaehtgens, Thomas W., Dirk Syndram, and Béatrix
Saule
2006 Eds. *Splendeurs de la cour de Saxe: Dresde à
Versailles.* Exh. cat. Musée National des Châteaux
de Versailles et de Trianon. Paris: Réunion des
Musées Nationaux.

Gallerani, Paola
2011 *The Menagerie of Pieter Boel: Animal Painter in
the Age of Louis XIV.* Milan: Officina Libraria.

Garnier, Nicole
1989 *Antoine Coypel (1661–1722).* Paris: Arthena.

Garrick, David
1928 *The Diary of David Garrick: Being a Record
of His Memorable Trip to Paris in 1751.* Edited
by Ryllis Clair Alexander. New York: Oxford
University Press.

Geffroy, Auguste
1867 *Gustave III et la cour de France.* 2 vols. Paris:
Didier.

Gendre, Catherine
1997 *Musée Lambinet, Versailles.* Versailles: Musée
Lambinet.

Genlis, Stéphanie Félicité, comtesse de
1818 *Dictionnaire critique et raisonné des étiquettes de la
cour. . . .* 2 vols. Paris: P. Mongie.

Gentleman's Guide
1770 [John Millard or Philip Playstowe]. *The Gentle-
man's Guide in His Tour through France. Wrote by an
Officer.* 4th edition. London: G. Kearsl[e]y.

Gerste, Ronald D.
1996 *Der Zauberkönig: Gustav III. und Schwedens
Goldene Zeit.* Göttingen: Steidl.

Gétreau, Florence
2010 "Retour sur les portraits de Mozart au clavier:
Un état de la question." In *Cordes et claviers au
temps de Mozart: Actes des Rencontres Internationales
Harmoniques Lausanne, 2006 / Bowed and Keyboard
Instruments in the Age of Mozart: Proceedings of the
Harmoniques International Congress, Lausanne,
2006,* edited by Thomas Steiner, pp. 73–112.
Bern: Peter Lang.

Gillespie, Elizabeth Duane
1901 *A Book of Remembrance.* Philadelphia:
J. B. Lippincott.

Ginsburg, Madeleine, Avril Hart, and Valerie D.
Mendes
1984 *400 Years of Fashion.* London: Victoria and
Albert Museum.

Göçek, Fatma Müge
1987 *East Encounters West: France and the Ottoman
Empire in the Eighteenth Century.* Studies in Middle
Eastern History. New York: Oxford University
Press.

Goodison, J. W.
1958 "Cambridge Portraits, II: Later Seventeenth
and Early Eighteenth Centuries." *Connoisseur* 140,
no. 566 (Jan.), pp. 231–40.

Goodwin, Stefan
2009 *Africa in Europe.* Vol. 2, *Interdependencies,
Relocations, and Globalization.* Plymouth, Devon:
Lexington Books.

Goubert, Pierre
1992 Louis XIV, King of France. *Mémoires pour
l'instruction du Dauphin.* Edited by Pierre
Goubert. Acteurs de l'histoire. Paris: Imprimerie
Nationale.

Grandjean, Serge
1974 "Sur une tabatière d'or et d'émail appartenant
au Musée du Louvre: Les maisons royales de
France." *Plaisir de France* 40, no. 419 (May),
pp. 32–35.
1979 "Une tabatière royale de Gouers." *La revue
du Louvre et des musées de France* 29, no. 4,
pp. 294–97.
1981 *Catalogue des tabatières, boîtes et étuis des XVIIIᵉ
et XIXᵉ siècles du Musée du Louvre.* Paris: Réunion
des Musées Nationaux.

Grate, Pontus
1998 "Bildkonsten." In *Den gustavianska konsten,*
pp. 195–295. Signums svenska konsthistoria 8.
Lund: Bokförlaget Signum.

Greene, Thomas
1986 "Diary of Thomas Greene of Slyne during His
Tour with George Romney, 1764." In *Thomas
Greene: Romney's Friend & Patron,* n.p. Kendal:
Abbot Hall.

Greppi, Giuseppe, conte
1890 "Notes de voyage du comte Giandemaria:
Envoyé du duc de Parme à la cour de Louis XIV
(1680)." *Revue d'histoire diplomatique* 4 (1890),
pp. 352–67.

Grimm, Johann Friedrich Karl
1775 *Bemerkungen eines Reisenden durch Deutschland,
Frankreich, England und Holland in Briefen an
seine Freunde.* 4 vols. Altenburg: Richterische
Buchhandlung.

Grivel, Marianne
1985 "Le Cabinet du Roi." *Revue de la Bibliothèque
Nationale,* no. 18 (Winter), pp. 36–57.

2010 "Ouvrages, volumes ou recueils? La
constitution du recueil du Cabinet du Roi." In
*A l'origine du livre d'art: Les recueils d'estampes
comme entreprise éditoriale en Europe (XVIᵉ–XVIIIᵉ
siècles),* edited by Cordélia Hattori, Estelle
Leutrat, and Véronique Meyer, with the assistance
of Laura de Fuccia, pp. 65–79. Papers from a
colloquium organized by the Association des
Historiens de l'Art Italien and held at the Institut
National d'Histoire de l'Art and the Institut
Néerlandais, Paris, Oct. 20–21, 2006. Cinisello
Balsamo: Silvana.

Grosser, Thomas
1989 *Reiseziel Frankreich: Deutsche Reiseliteratur vom
Barock bis zur Französischen Revolution.* Opladen:
Westdeutscher Verlag.

Guerrini, Anita
2015 *The Courtiers' Anatomists: Animals and Humans in
Louis XIV's Paris.* Chicago: University of Chicago
Press.

Guery, Alain
1984 "Le roi dépensier: Le don, la contrainte, et l'ori-
gine du système financier de la monarchie française
d'Ancien Régime." *Annales: Economies, sociétés,
civilisations* 39, no. 6, pp. 1241–69.

Guest, Ivor Forbes
1996 *The Ballet of the Enlightenment: The Establish-
ment of the Ballet d'Action in France, 1770–1793.*
London: Dance Books.

Guiffrey, Jules
1892 "Les tapisseries de la Couronne autrefois et
aujourd'hui: Complément de l'inventaire du mobi-
lier de la Couronne sous le règne de Louis XIV."
Nouvelles archives de l'art français, 3rd ser., 8,
pp. 1–55.
1912 *André Le Nostre.* Les grands artistes: Leur vie,
leur oeuvre. Paris: Henri Laurens.

Günderrode, Friedrich Justinian von
1783 *Beschreibung einer Reise aus Teutschland durch
einen Theil von Frankreich, England und Holland.*
2 vols. Breslau: Johann Ernst Meyer.

Guy, John
1998 *Woven Cargoes: Indian Textiles in the East.*
London: Thames & Hudson.

Hahn-Hahn, Ida, Gräfin
1842 *Erinnerungen aus und an Frankreich.* 2 vols.
Berlin: Alexander Duncker.

Halbert, Philippe
2011 "An African Prince at the Court of the Sun
King." *Monitor: Journal of International Stories* 16,
no. 2 (Summer), pp. 7–17.

Haller, Albrecht von
1968 *Albrecht Hallers Tagebuch seiner Studienreise nach London, Paris, Strassburg und Basel, 1727–1728*. Edited by Erich Hintzsche. 2nd edition. Berner Beiträge zur Geschichte der Medizin und der Naturwissenschaften, n.s., 2. Bern: Hans Huber.

Hamadeh, Shirine
2008 *The City's Pleasures: Istanbul in the Eighteenth Century*. Seattle: University of Washington Press.

Hamilton, Alexander
1961–87 *The Papers of Alexander Hamilton*. Edited by Harold C. Syrett. 27 vols. New York: Columbia University Press.

Hans, Pierre-Xavier
2007 "The History of the Petit Trianon." In Chapman et al. 2007, pp. 15–23.
2015 "Destination et usage du salon" / "The Salon: Function and Use." In *Le Salon de Mercure: Chambre de parade du roi / The Mercury Salon: The King's Ceremonial Bedchamber*, edited by Pierre-Xavier Hans, pp. 18–23. Versailles: Château de Versailles; Paris: Artlys.

Hardman, John
2016 *The Life of Louis XVI*. New Haven, Conn.: Yale University Press.

Harris, John
1970 *Sir William Chambers: Knight of the Polar Star*. With contributions by J. Mordaunt Crook and Eileen Harris. London: A. Zwemmer.

Hart, Charles Henry, and Edward Biddle
1911 *Memoirs of the Life and Works of Jean Antoine Houdon: The Sculptor of Voltaire and of Washington*. Philadelphia: Printed for the authors.

Hartig, Franz de Paula Anton von
1785 *Lettres sur la France, l'Angleterre et l'Italie*. Geneva.

Hartkamp-Jonxis, Ebeltje, and Hillie Smit
2004 *European Tapestries in the Rijksmuseum*. Zwolle: Waanders; Amsterdam: Rijksmuseum.

Hatton, Ragnhild
1987 "Presents and Pensions: A Methodological Search and the Case Study of Count Nils Bielke's Prosecution for Treason in Connection with Gratifications from France." In *Politics and Culture in Early Modern Europe: Essays in Honor of H. G. Koenigsberger*, edited by Phyllis Mack and Margaret C. Jacob, pp. 101–17. Cambridge: Cambridge University Press.

Haulman, Kate
2011 *The Politics of Fashion in Eighteenth-Century America*. Chapel Hill: University of North Carolina Press.

Haussonville, comte d'
1896 "La visite du tsar Pierre le Grand en 1717." *Revue des deux mondes* 137 (Oct. 15), pp. 795–815.

Hébert, M.
1766 *Dictionnaire pittoresque et historique, ou Description d'architecture, peinture, sculpture, gravure, histoire naturelle, antiquités, & dates des établissemens et monumens de Paris, Versailles, Marly, Trianon, S. Cloud, Fontainebleau, Compiégne. . . .* 2 vols. Paris: Claude Hérissant.

Hedin, Thomas, and Folke Sandgren
2006 "Deux voyageurs suédois visitent Versailles sous le règne du Roi-Soleil." *Versalia*, no. 9, pp. 86–113.

Herbette, Maurice
1907 *Une ambassade persane sous Louis XIV d'après des documents inédits*. Paris: Perrin.

Herda-Mousseaux, Rose-Marie
2015 "Thé, café ou chocolat?" In *Thé, café ou chocolat?* 2015, pp. 7–43.

Hobhouse, Benjamin
1796 *Remarks on Several Parts of France, Italy, &c in the Years 1783, 1784, and 1785*. Bath: Printed by R. Cruttwell.

Holberg, Ludvig
1970 *Ludvig Holberg's Memoirs: An Eighteenth Century Danish Contribution to International Understanding*. Edited by Stewart E. Fraser. Leiden: E. J. Brill.

Hoog, Simone
1982 *Louis XIV: Manière de montrer les jardins de Versailles*. Paris: Réunion des Musées Nationaux.
1990 "Le décor sculpté de l'Escalier des Ambassadeurs." In *Charles Le Brun* 1990, pp. 41–42.
1993 *Les sculptures*. Vol. 1, *Le Musée*. Musée National du Château de Versailles. Paris: Réunion des Musées Nationaux.

Hostelfort, M. de l'
1716 *Amanzolide: Nouvelle historique et galante, qui contient les avantures secretes de Mehemed-Riza-Beg, ambassadeur du Sophi de Perse, à la cour de Louis-le-Grand, en 1715*. Paris: Pierre Huet.

Hours, Bernard
2002 *Louis XV et sa cour: Le roi, l'étiquette et le courtisan. Essai historique*. Paris: Presses Universitaires de France.

Houth, Emile, and Madeleine Houth
1980 *Versailles aux 3 visages: Le Val de Galie, le Château des Rois, la cité vivante*. Versailles: Lefebvre.

Höweler, H. A.
1978 *Een Amsterdammer naar Parijs in 1778: Reisverslag van de koopman Jacob Muhl*. Nederlandse verlichting in teksten en studies 1. Zutphen: De Walburg Pers.

Hughes, Lindsey
2004 *Peter the Great: A Biography*. New Haven, Conn.: Yale University Press.

Ilmakunnas, Johanna
2017 "French Fashions: Aspects of Elite Lifestyle in Eighteenth-Century Sweden." In *A Taste for Luxury in Early Modern Europe: Display, Acquisition, Boundaries*, edited by Johanna Ilmakunnas and Jon Stobart, pp. 243–63. London: Bloomsbury Academic.

Impey, Oliver, and Christiaan Jörg
2005 *Japanese Export Lacquer, 1580–1850*. Amsterdam: Hotei.

Impey, Oliver, and John Whitehead
1990 "From Japanese Box to French Royal Furniture." *Apollo* 132, n.s., no. 343 (Sept.), pp. 159–65.

Ingamells, John
2004 *National Portrait Gallery: Mid-Georgian Portraits, 1760–1790*. London: National Portrait Gallery.
2009 *National Portrait Gallery: Later Stuart Portraits, 1685–1714*. London: National Portrait Gallery.

Ireland, Samuel
1790 *A Picturesque Tour through Holland, Brabant, and Part of France; Made in the Autumn of 1789*. 2 vols. London: Printed for T. and I. Egerton.

Irrgarten zu Versailles
ca. 1680 *Der Irrgarten zu Versailles*. [Augsburg]: Johann Ulrich Krauss.

Iselin, Isaak
1919 *Isaak Iselins Pariser Tagebuch, 1752*. Edited by Ferdinand Schwarz. Basel: Benno Schwabe.

Jackson-Stops, Gervase
1985 Ed. *The Treasure Houses of Britain: Five Hundred Years of Private Patronage and Art Collecting*. Exh. cat.; 1985–86. Washington, D.C.: National Gallery of Art; New Haven, Conn.: Yale University Press.

Jacq-Hergoualc'h, Michel
1985 "A propos des canons siamois, offerts à Louis XIV, qui participèrent à la prise de la Bastille." *Annales historiques de la Révolution française*, no. 261 (July–Sept.), pp. 317–34.

Jeannerat, Carlo
1929 "Un émail inédit de Jean Petitot." *Bulletin de la Société de l'Histoire de l'Art Français*, pp. 74–80.

Jefferson, Thomas
1950– *The Papers of Thomas Jefferson.* Edited by Julian P. Boyd et al. 43 vols. to date. Princeton, N.J.: Princeton University Press.

Jeffries, John
1786 *A Narrative of the Two Aerial Voyages of Doctor Jeffries with Mons. Blanchard; with Meteorological Observations and Remarks. . . . Presented to the Royal Society, London, April 14, 1785; and Read before Them, January, 1786.* London: Printed for the author and sold by J. Robson.

Johnson, Dale T.
1990 *American Portrait Miniatures in the Manney Collection.* New York: The Metropolitan Museum of Art.

Johnston, Elizabeth
1968–70 "Joseph Highmore's Paris Journal, 1734." *Volume of the Walpole Society* 42 (1968–70), pp. 61–104.

Jones, John Paul
1979 *John Paul Jones' Memoir of the American Revolution, Presented to King Louis XVI of France.* Translated and edited by Gerard W. Gawalt. Washington, D.C.: American Revolution Bicentennial Office, Library of Congress.

Jordan, Claude
1693–1701 *Voyages historiques de l'Europe.* 8 vols. Paris: Pierre Aubouyn, Pierre Emery, Charles Clouzier, and Nicolas Le Gras.
1701 *Voyages historiques de l'Europe.* Vol. 1, *France.* Rev. edition. Paris: Nicolas Le Gras.

Kaltenbrunner, Regina, and Xavier Salmon
2016 Eds. *Geste baroque: Collections de Salzbourg.* Exh. cat. Musee du Louvre, Paris; 2016–17. Paris: Louvre Editions and Somogy Editions d'Art; Salzburg: Salzburg Museum, Neue Residenz.

Karamzin, Nikolai
2003 *Nikolai Karamzin: Letters of a Russian Traveller.* With an essay by Andrew Kahn. Oxford: Voltaire Foundation.

Keane, John
1995 *Tom Paine: A Political Life.* New York: Grove.

Keller-Dorian, Georges
1920 *Antoine Coysevox (1640–1720): Catalogue raisonné de son oeuvre.* 2 vols. Paris: L'auteur.

Kent, Neil
2008 *A Concise History of Sweden.* Cambridge: Cambridge University Press.

Kerslake, John F.
1977 *Early Georgian Portraits.* 2 vols. National Portrait Gallery. London: Her Majesty's Stationery Office.

Keyssler, Johann Georg
1751 *Neueste Reisen durch Deutschland, Böhmen, Ungarn, die Schweiz, Italien und Lothringen. . . .* Hannover: Im Verlage sel. Nicolai Försters und Sohns Erben Hof-Buchhandlung.

Kisluk-Grosheide, Daniëlle
2006 "French Royal Furniture in the Metropolitan Museum." *The Metropolitan Museum of Art Bulletin,* n.s., 63, no. 3 (Winter).

Kisluk-Grosheide, Daniëlle, Wolfram Koeppe, and William Rieder
2006 *European Furniture in The Metropolitan Museum of Art: Highlights of the Collection.* New York: The Metropolitan Museum of Art.

Kisluk-Grosheide, Daniëlle, and Jeffrey H. Munger
2010 *The Wrightsman Galleries for French Decorative Arts, The Metropolitan Museum of Art.* New York: The Metropolitan Museum of Art.

Kisluk-Grosheide, Daniëlle, and Bertrand Rondot
2017 Eds. *Visiteurs de Versailles: Voyageurs, princes, ambassadeurs, 1682–1789.* Exh. cat. Château de Versailles and The Metropolitan Museum of Art, New York; 2017–18. Paris: Gallimard; Versailles: Château de Versailles.

Klingensmith, Samuel John
1993 *The Utility of Splendor: Ceremony, Social Life, and Architecture at the Court of Bavaria, 1600–1800.* Edited by Christian F. Otto and Mark Ashton. Chicago: University of Chicago Press.

Knight, Ellis Cornelia
1861 *Autobiography of Miss Cornelia Knight, Lady Companion to the Princess Charlotte of Wales.* 3rd edition. 2 vols. London: W. H. Allen.

Koda, Harold, and Andrew Bolton
2006 *Dangerous Liaisons: Fashion and Furniture in the Eighteenth Century.* New York: The Metropolitan Museum of Art.

Koeppe, Wolfram
2008 Ed. *Art of the Royal Court: Treasures in Pietre Dure from the Palaces of Europe.* Exh. cat. by Wolfram Koeppe and Annamaria Giusti, with contributions by Cristina Acidini et al. New York: The Metropolitan Museum of Art.

Köhler, Marcus
1997 "Friedrich Karl von Hardenberg's (1696–1763) Journeys to England and His Contribution to the Introduction of the English Landscape Garden to Germany." *Garden History* 25, no. 2 (Winter), pp. 212–18.

Kolk, Caroline zum, Jean Boutier, Bernd Klesmann, and François Moureau
2014 Eds. *Voyageurs étrangers à la cour de France, 1589–1789: Regards croisés.* Rennes: Presses Universitaires de Rennes.

Kosa Pan
2002 *The Diary of Kosa Pan (Ok-phra Wisut Sunthon): Thai Ambassador to France, June–July 1686.* Introduction by Dirk van der Cruysse. Translated by Visudh Busyakul. Edited by Michael Smithies. Chiang Mai, Thailand: Silkworm Books.

Koschatzky, Walter
1980 Ed. *Maria Theresia und ihre Zeit: Zur 200. Wiederkehr des Todestages.* Exh. cat. Schloss Schönbrunn, Vienna. Salzburg: Residenz Verlag.

Krieg und Frieden
2001 *Krieg und Frieden: Eine deutsche Zarin in Schloss Pawlowsk.* Exh. cat. Munich: Haus der Kunst; Hamburg: Dölling und Galitz.

Kugler, Georg
1985 *The Golden Carriage of Prince Joseph Wenzel von Liechtenstein.* New York: The Metropolitan Museum of Art.

Kuraszewski, Guy
1976 "Objets retrouvés: Pendules et baromètres royaux." *La revue du Louvre et des musées de France* 26, no. 3 (1976), pp. 213–19.

La Gorce, Jérôme de
1981 "Un peintre du XVIIIᵉ siècle au service de l'Opéra de Paris: Jacques Vigoureux Duplessis." *Bulletin de la Société de l'Histoire de l'Art Français,* 1981 (pub. 1983), pp. 71–80.

La Laurencie, Lionel de
1921 "America in the French Music of the Seventeenth and Eighteenth Centuries." *Musical Quarterly* 7, no. 2 (Apr.), pp. 284–302.

La Mare, Nicolas de
1738 *Continuation du Traité de la police.* Vol. 4, *De la voirie.* Paris: Jean-François Herissant.

La Roche, Sophie von
1787 *Journal einer Reise durch Frankreich.* Altenburg: In der Richterschen Buchhandlung.
2012 *Journal d'un voyage à travers la France, 1785.* Saint-Quentin de Baron: Les Editions de l'Entre-deux-Mers.

La Tour du Pin, Henriette Lucie Dillon, marquise de
1913 *Journal d'une femme de cinquante ans, 1778–1815.*
2 vols. Paris: Marc Imhaus & René Chapelot.

Labyrinte de Versailles
1677 *Labyrinte de Versailles.* Introduction by Charles
Perrault. Quatrains by Isaac de Benserade. Paris:
Imprimerie Royale.
ca. 1680 *Labyrinte de Versailles.* Amsterdam: Pierre
Mortier, n.d.
1682 *Labyrinte de Versailles / The Labyrinth of
Versailles / Der Irr-garte zu Versailles / 't Dool-hof
tot Versailles.* Introduction by Charles Perrault.
Quatrains by Isaac de Benserade. Amsterdam:
Nicolaus Visscher.

Lacambre, Geneviève
2010 "Les laques du Japon et la France." In *L'or du
Japon: Laques anciens des collections publiques fran-
çaises*, edited by Geneviève Lacambre, pp. 47–57.
Exh. cat. Monastère Royale de Brou, Bourg-en-
Bresse, and Musée des Beaux-Arts, Arras. Paris:
I.A.C. Editions d'Art.

Lafabrié, François
2011 "L'habit de livrée dans la Maison Civile du roi:
Entre prestige et servitude." *Bulletin du Centre
de Recherche du Château de Versailles.* Published
online Aug. 9, 2011. https://crcv.revues.org/11373.

Lahrkamp, Helmut
1977 Ed. "Lambert Friedrich Corfey: Reisetagebuch,
1698–1700." *Quellen und Forschungen zur Geschichte
der Stadt Münster*, n.s., 9, pp. 1–79.

Landsberg, Franz Anton, Freiherr von
1984 *Die Kavaliersreise des Franz Anton Freiherr von
Landsberg, 1675–1678: Tagebuch und Briefwechsel.*
Edited by Gerd Dethlefs. Münster: Vereinigte
Westfälische Adelsarchive.

Landweber, Julia A.
2011 "How Can One Be Turkish? French Responses
to Two Ottoman Embassies." In *Europa und
die Türkei im 18. Jahrhundert / Europe and
Turkey in the 18th Century*, edited by Barbara
Schmidt-Haberkamp, pp. 403–15. Göttingen:
V&R Unipress; Bonn: Bonn University Press.

Lauterbach, Iris
2010 "Franz Anton Danreiter: Hochfürstlicher
Garteninspektor in Salzburg." *Barockberichte:
Informationsblätter des Salzburger Barockmuseums
zur bildenden Kunst des 17. und 18. Jahrhunderts*,
nos. 53–54, pp. 501–20.

Le Bon, Laurent
2017 Ed. *Jardins.* Exh. cat. Galeries Nationales
du Grand Palais. Paris: Réunion des Musées
Nationaux.

Leferme-Falguières, Frédérique
2015 "Honneurs du Louvre." In *Versailles: Histoire,
dictionnaire et anthologie*, edited by Mathieu
Da Vinha and Raphaël Masson, pp. 363–64.
Paris: Robert Laffont.

Leibetseder, Mathis
2004 *Die Kavalierstour: Adlige Erziehungsreisen im
17. und 18. Jahrhundert.* Cologne: Böhlau.
2010 "Across Europe: Educational Travelling of
German Noblemen in a Comparative Perspec-
tive." *Journal of Early Modern History* 14, no. 5,
pp. 417–49.

Leinster, Emilia Mary Lennox Fitzgerald, Duchess of
1949–57 *Correspondence of Emily, Duchess of Leinster
(1731–1814).* Edited by Brian Fitzgerald. 3 vols.
Dublin: Stationery Office.

Lemonnier, Patricia
1983 *Weisweiler.* Paris: Editions d'Art Monelle Hayot.

Leplatre, Olivier
2008 "*Ekphrasis* et politique: Le *Traité de morale
pour l'éducation des princes, tiré des Peintures de la
gallerie de Saint-Cloud* de l'abbé Laurent Morelet."
In *Discours politique et genres littéraires (XVI^e–
XVII^e siècles)*, edited by Sabine Gruffat and Olivier
Leplatre, pp. 273–99. Cahiers du Gadges 6.
Geneva: Librairie Droz.

Léry, Edmond
1927 "Les premières messageries entre Paris et
Versailles." *Revue de l'histoire de Versailles et de
Seine-et-Oise* 29, no. 1 (Jan.–Mar.), pp. 61–64.
1942 "A propos des roulettes de la cour de Versailles:
Pascal est-il l'inventeur des chaises roulantes?"
Revue de l'histoire de Versailles et de Seine-et-Oise
42–44 (July 1940–Dec. 1942), pp. 109–18.

Lespes, Michelle
2009 "Jacques-André-Joseph Aved: Portraitiste
des Lumières." *L'estampille/L'objet d'art*, no. 443
(Feb.), pp. 70–77.

Letourmy-Bordier, Georgina, and José de Los Llanos
2013 *Le siècle d'or de l'éventail: Du Roi-Soleil à
Marie-Antoinette.* Exh. cat. Musée Cognacq-Jay,
Paris; 2013–14. Dijon: Faton.

"Lettre XIV: Exposition des peintures"
1777 "Lettre XIV: Exposition des peintures, sculptures
& gravures au Salon du Louvre. Année 1777."
L'année littéraire 6, pp. 311–44.

Levron, Jacques
2003 *Les inconnus de Versailles: Les coulisses de la cour.*
Paris: Perrin.
2009 *Les inconnus de Versailles: Les coulisses de la cour.*
New edition. Paris: Perrin.

"Libéralités"
2012 *Revue du Louvre: La revue des musées de France* 62,
no. 2 (Apr.), pp. 5–44.

Liboy, M. de
1890 "M. de Liboy. Chargé de la réception de Pierre
le Grand, 1717." In *Recueil des instructions données
aux ambassadeurs et ministres de France depuis les
traités de Westphalie jusqu'à la Révolution française*,
vol. 8, *Russie*, pt. 1, *Des origines jusqu'à 1748*,
edited by Alfred Rambaud, pp. 157–67. Paris:
Félix Alcan.

Life of John Earl of Stair
1748 *The Life of John Earl of Stair, Containing His
Birth and Education; . . . His Magnificent Entry into
Paris. . . . By an Impartial Hand.* London: Printed
for the author and sold by A. Henderson and
M. Mechell.

Limberg, Johannes
1690 *Denckwürdige Reisebeschreibung durch
Teutschland, Italien, Spanien, Portugall, Engeland,
Franckreich und Schweitz &c.* Leipzig: Johann
Christian Wohlfart.

Lindemann, Christoph Friedrich Heinrich
1784 *Reisebemerkungen über einen Theil von Italien,
Frankreich und Engelland.* Celle: Runge und Richter.

Lister, Martin
1823 *An Account of Paris, at the Close of the Seventeenth
Century.* Edited by George Henning. Shaftesbury:
J. Rutter; London: Longman and Co., Young and
Co., and Underwood.
1873 *Voyage de Lister à Paris en MDCXCVIII.* Paris:
Société des Bibliophiles.

Locke, John
1953 *Locke's Travels in France, 1675–1679, as Related
in His Journals, Correspondence and Other Papers.*
Edited by John Lough. Cambridge: Cambridge
University Press.

Loen, Johann Michael von
1750 *Des Herrn von Loen gesammlete kleine Schrifften.*
Edited by Johann Caspar Schneider. 2 vols.
Frankfurt: Philipp Heinrich Huttern.

Lohmeyer, Karl
1911 *Die Briefe Baltasar Neumanns von seiner Pariser
Studienreise 1723.* Düsseldorf: L. Schwann.

Loire, Alexandre, and Gabriele Mendella
2017 *La maison militaire du roi: Prestige et valeur à la
cour de Versailles.* Paris: Editions Sotéca.

Lossky, Boris
1932 "Le séjour de Pierre le Grand en France."
Le monde slave 9, no. 8 (Aug.), pp. 278–303.

Lough, John
1984 *France Observed in the Seventeenth Century by British Travellers*. Stocksfield, Northumberland: Oriel Press.
1987 *France on the Eve of Revolution: British Travellers' Observations, 1763–1788*. London: Croom Helm.

Louis XIV, le Roi-Soleil
2005 *Louis XIV, le Roi-Soleil: Trésors du Château de Versailles*. Exh. cat. [In Chinese and French.] Shanghai Museum. Beijing: Zijincheng Chubanshe.

Louis Simon Boizot
2001 *Louis-Simon Boizot, 1743–1809: Sculpteur du roi et directeur de l'atelier de sculpture à la Manufacture de Sèvres*. Exh. cat.; 2001–2. Paris: Somogy Editions d'Art; Versailles: Musée Lambinet.

Love, Ronald S.
1996 "Rituals of Majesty: France, Siam, and Court Spectacle in Royal Image-Building at Versailles in 1685 and 1686." *Canadian Journal of History* 31, no. 2 (Aug.), pp. 171–98.
2006 "Royal Protocol and Cultural Synthesis in the Preparations for the Chevalier de Chaumont's Embassy to Siam in 1685." *Proceedings of the Western Society for French History* 34 (2006), pp. 1–26.

Lucas, William
1754 *A Five Weeks Tour to Paris, Versailles, Marli, &c. . . .* 3rd edition. London: Printed for T. Waller.

Luckhardt, Jochen
2005 "Voyages, diplomatie et ceremonial: Les portraits exécutés en France pour la cour de Brunswick." In Rosenberg 2005, pp. 75–81.

Luckhardt, Jochen, and Regine Marth
2006 Eds. *Lockenpracht und Herrschermacht: Perücken als Statussymbol und modisches Accessoire*. Exh. cat. Herzog Anton Ulrich-Museum Braunschweig. Leipzig: Koehler & Amelang.

van Luttervelt, Remmet
1947–49 "De ontvangst van Cornelis Hop als Nederlandsch ambassadeur te Parijs." *Jaarverslag van het Koninklijk Oudheidkundig Genootschap* 90–91 (1947–49; pub. 1950), pp. 80–104.

Luynes, Charles Philippe d'Albert, duc de
1860–65 *Mémoires du duc de Luynes sur la cour de Louis XV (1735–1758)*. Edited by Louis Dussieux and Eudore Soulié. 17 vols. Paris: Firmin Didot Frères.

Mabille, Gérard
1998 "Les tables d'argent de Louis XIV." *Versalia*, no. 1, pp. 60–64.

Mabille, Gérard, and Joan Pieragnoli
2010 *La Ménagerie de Versailles*. [Arles]: Honoré Clair; [Versailles]: Château de Versailles.

Maës, Antoine
2013 "L'ameublement du salon d'Apollon, XVIIᵉ–XVIIIᵉ siècle." *Bulletin du Centre de Recherche du Château de Versailles*. Published online Mar. 26, 2013. http://crcv.revues.org/12144.

Maihows, Dr.
1763 *Voyage en France, en Italie et aux Isles de l'Archipel, ou Lettres écrites de plusieurs endroits de l'Europe et du Levant en 1750, &c. . . .* 4 vols. Paris: Charpentier.

Maillet-Chassagne, Monique
2001 *Une dynastie de peintres lillois: Les Van Blarenberghe*. Paris: Bernard Giovanangeli Editeur.

Maisonnier, Elisabeth
2013 "Représenter le Labyrinthe: Construction d'une image." In Maisonnier and Maral 2013, pp. 79–99.
forthcoming "Franz Anton Danreiter: Un architecte jardinier de Salzbourg à Versailles en 1723. Un album inédit de dessins des jardins de Versailles." *Barockberichte: Informationsblätter des Salzburger Barockmuseums zur bildenden Kunst des 17. und 18. Jahrhunderts*.

Maisonnier, Elisabeth, and Alexandre Maral
2013 Eds. *Le Labyrinthe de Versailles: Du mythe au jeu*. Exh. cat. Bibliothèque Municipale de Versailles. Paris: Magellan & Cie.

Malmesbury, James Harris, Earl of
1870 *A Series of Letters of the First Earl of Malmesbury, His Family and Friends, from 1745 to 1820*. 2 vols. Edited by James Howard Harris, 3rd Earl of Malmesbury. London: Richard Bentley.

Mander, Jenny
2013 "Turkish Delight? Confecting Entertainment for Ottoman Guests in Eighteenth-Century France." *L'esprit créateur* 53, no. 4 (Winter), pp. 139–51.

Mandrisio, Nicolo
1899 "Un habitant d'Udine à Paris et à Versailles en 1698." In Bernardo Bizoni, *Aventures d'un grand seigneur italien à travers l'Europe, 1606*, pp. 291–302. Translated and edited by Emmanuel Rodocanachi. Paris: Ernest Flammarion.

Mannlich, Johann Christian von
1910 *Ein deutscher Maler und Hofmann: Lebens-erinnerungen des Joh. Christian v. Mannlich, 1741–1822*. Edited by Eugen Stollreither. Berlin: Ernst Siegfried Mittler und Sohn.

Mantienne, Frédéric
1999 *Mgr. Pierre Pigneaux: Evêque d'Adran, dignitaire de Cochinchine*. Paris: Eglises d'Asie.

Maral, Alexandre
2007a "Architectural Work on the 'Grande Galerie.'" In *The Hall of Mirrors: History & Restoration*, pp. 40–51, 388. Dijon: Faton.
2007b "The Marbles. The Mirrors." In *The Hall of Mirrors: History & Restoration*, pp. 52–53, 388. Dijon: Faton.
2009 "Grande Galerie et appartement du roi à Versailles: Sens et usages sous Louis XIV." *Versalia*, no. 12, pp. 121–33.
2010 *La Chapelle Royale de Versailles sous Louis XIV: Cérémonial, liturgie et musique*. 2nd edition. Etudes du Centre de Musique Baroque de Versailles. Wavre: Mardaga.
2011 *La Chapelle Royale de Versailles: Le dernier grand chantier de Louis XIV*. Paris: Arthena.
2013 "Le bestiaire de Versailles: Les plombs du bosquet du Labyrinthe." In Maisonnier and Maral 2013, pp. 43–61.

Maral, Alexandre, and Thierry Sarmant
2014 *Louis XIV: L'univers du Roi-Soleil*. Paris: Tallandier; Versailles: Château de Versailles.

"Mariage de Mademoiselle avec le Roy d'Espagne"
1679 "Contenant la relation du mariage de Mademoiselle avec le Roy d'Espagne." *Mercure galant*, Oct., pt. 2, pp. 1–255.

Marie-Antoinette
1955 *Marie-Antoinette: Archiduchesse, dauphine et reine*. Exh. cat. Château de Versailles. [Paris]: Musées Nationaux.
2008 *Marie-Antoinette*. With contributions by Pierre Arizzoli-Clémentel et al. Exh. cat. Galeries Nationales du Grand Palais. Paris: Réunion des Musées Nationaux.

Marin, Louis
1981 *Le portrait du roi*. Paris: Les Editions de Minuit.

Martin, Meredith
2014 "Tipu Sultan's Ambassadors at Saint-Cloud: Indomania and Anglophobia in Pre-Revolutionary Paris." *West 86th: A Journal of Decorative Arts, Design History, and Material Culture* 21, no. 1 (Spring–Summer 2014), pp. 37–68.
2015 "Mirror Reflections: Louis XIV, Phra Narai, and the Material Culture of Kingship." *Art History* 38, no. 4 (Sept.), pp. 652–67.

Martin, Meredith, and Gillian Weiss
2013 "'Turks' on Display during the Reign of Louis XIV." *L'esprit créateur* 53, no. 4 (Winter), pp. 98–112.

Martin, Richard
1998 *Ceaseless Century: 300 Years of Eighteenth-Century Costume*. Exh. cat. New York: The Metropolitan Museum of Art.

Martin, Richard, and Harold Koda
1996 *Bare Witness*. Exh. cat. New York: The Metropolitan Museum of Art.

Marx, Harald, and Emmanuel Starcky
2001 Eds. *Dresde, ou Le rêve des princes: La galerie de peintures au XVIIIᵉ siècle*. Exh. cat. Musée des Beaux-Arts, Dijon. Paris: Réunion des Musées Nationaux.

Maskill, David
2017 "A Turk in the Hall of Mirrors." Paper delivered at the conference "Enchanted Isles, Fatal Shores: Living Versailles," National Gallery of Australia, Canberra, Mar. 17, 2017. https://youtu.be /89QQ7kU-p-k.

Masson, Raphaël
2015 "Esthétique et étiquette du deuil à la cour." In Sabatier and Saule 2015, pp. 50–59.

Matar, Nabil
2003 Ed. and trans. *In the Lands of the Christians: Arabic Travel Writing in the Seventeenth Century*. New York: Routledge.
2015 "'Abdallah Ibn 'Aisha and the French Court, 1699–1701: An Ambassador without Diplomacy." *French History* 29, no. 1, pp. 62–75.

"Matthew Baillie's Diary"
1927 V.G.P. "Matthew Baillie's Diary of Travel in 1788." *British Medical Journal* 1, no. 3454 (Mar. 19), pp. 523–24.

Maze-Sencier, Alphonse
1885 *Le livre des collectionneurs*. Paris: Librairie Renouard.

Mehmed Efendi, Yirmisekiz Çelebi
1757 *Relation de l'ambassade de Mehemet-Effendi à la cour de France en M.DCC.XXI*. Translated by Julien-Claude Galland. Constantinople: Ganeau.
1981 *Le paradis des infidèles: Relation de Yirmisekiz Çelebi Mehmed Efendi, ambassadeur ottoman en France sous la Régence*. Edited by Gilles Veinstein. La découverte 40. Paris: François Maspero.

"Mémoires de Jean Raussin"
2010 "Mémoires de Jean Raussin, dit Narcisse." In Sabine Cotté, "Le comte d'Angiviller à Versailles à la veille de la Révolution." *Bulletin de la Société de l'Histoire de l'Art Français*, 2010 (pub. 2011), pp. 153–67.

Mémoires de Madame Campan
1988 *Mémoires de Madame Campan: Première femme de chambre de Marie-Antoinette*. Edited by Jean Chalon. Le temps retrouvé 53. Paris: Mercure de France.

Mercier, Louis Sébastien
1783–89 *Tableau de Paris*. New edition. 12 vols. Amsterdam.

Métra, François
1787–90 *Correspondance secrete, politique & littéraire, ou Mémoires pour servir à l'histoire des cours, des sociétés & de la littérature en France, depuis la mort de Louis XV*. 18 vols. London: John Adamson. [Facsimile reprint, 18 vols. in 3. Geneva: Slatkine, 1967.]

Metropolitan Museum
1964 The Metropolitan Museum of Art. *Decorative Art from the Samuel H. Kress Collection at The Metropolitan Museum of Art: The Tapestry Room from Croome Court, Furniture, Textiles, Sèvres Porcelains, and Other Objects*. With contributions by James Parker, Carl Christian Dauterman, and Edith Appleton Standen. London: Phaidon Press.

Meyer, Daniel
2002 *Versailles: Furniture of the Royal Palace, 17th and 18th Centuries*. Vol. 1, *Prestigious Royal Furniture*. Dijon: Faton.

Meyer, Friedrich Johann Lorenz
1798 *Fragments sur Paris*. 2 vols. Hamburg.

Middlekauff, Robert
2005 "Benjamin Franklin, Pragmatic Visionary: Politician, Diplomat, Statesman." In *Benjamin Franklin: In Search of a Better World*, edited by Page Talbott, pp. 199–233, 329–32, 356–58. New Haven, Conn.: Yale University Press.

Miles, Ellen G.
1993 "The French Portraits of Benjamin Franklin." In *Reappraising Benjamin Franklin: A Bicentennial Perspective*, edited by J. A. Leo Lemay, pp. 272–89. Newark: University of Delaware Press.

Miller, Lesley Ellis
2002 "Mysterious Manufacturers: Situating L. Galy, Gallien et Compe. in the Eighteenth-Century Lyons Silk Industry." *Studies in the Decorative Arts* 9, no. 2 (Spring–Summer), pp. 87–131.
2009 "Les matériaux du costume de cour." In Arizzoli-Clémentel and Gorguet Ballesteros 2009, pp. 78–89.

Miller, Lillian B.
1983–2000 Ed. *The Selected Papers of Charles Willson Peale and His Family*. 5 vols. New Haven, Conn.: Yale University Press for the National Portrait Gallery, Smithsonian Institution.

Miller, Melanie Randolph
2005 *Envoy to the Terror: Gouverneur Morris and the French Revolution*. Dulles, Va.: Potomac Books.

Milovanovic, Nicolas
2005 *Les grands appartements de Versailles sous Louis XIV: Catalogue des décors peints*. Musée National des Châteaux de Versailles et de Trianon. Paris: Réunion des Musées Nationaux.
2007 "The Studio of Le Brun: The Paintings." In *The Hall of Mirrors: History & Restoration*, pp. 182–93, 394–95. Dijon: Faton.

Milovanovic, Nicolas, and Alexandre Maral
2009 Eds. *Louis XIV: L'homme & le roi*. Exh. cat. Musée National des Châteaux de Versailles et de Trianon; 2009–10. Paris: Skira Flammarion; Versailles: Château de Versailles.

Mokhberi, Susan
2012 "Finding Common Ground between Europe and Asia: Understanding and Conflict during the Persian Embassy to France in 1715." *Journal of Early Modern History* 16, no. 1, pp. 53–80.

Molhuysen, Philipp Christiaan, and Petrus Johannes Blok
1911–37 Eds. *Nieuw Nederlandsch biografisch woordenboek*. 10 vols. Leiden: A. W. Sijthof.

Monicart, Jean-Baptiste de
1720 *Versailles immortalisé par les merveilles parlantes . . . dans les châteaux de Versailles, de Trianon, de la Ménagerie et de Marly*. Vol. 1. Paris: Etienne Ganeau and Jacques Quillau.

Montagnier, Jean-Paul C.
2005 "French *Grand Motets* and Their Use at the Chapelle Royale from Louis XIV to Louis XVI." *Musical Times* 146, no. 1891 (Summer), pp. 47–57.

Montgolfier, Bernard de
1992 *The Carnavalet Museum*. Paris: Musées et Monuments de France; Les Amis du Musée Carnavalet; and Albin Michel.

Montpensier, Anne Marie Louise d'Orléans, duchesse de
1776 *Mémoires de Mademoiselle de Montpensier, fille de Gaston d'Orléans, frere de Louis XIII, roi de France*. New edition. 8 vols. Maastricht: J. Edme Dufour & Ph. Roux.

Moore, John
1779 *A View of Society and Manners in France, Switzerland, and Germany: With Anecdotes Relating to Some Eminent Characters*. 2nd edition. 2 vols. London: Printed for W. Strahan and T. Cadell.

Morawska, Teofila Konstancja
2002 *Diariusz podróży europejskiej w latach 1773–1774*. Acta Universitatis Wratislaviensis 2426. Wrocław: Wydawnictwo Uniwersytetu Wrocławskiego.

Morellet, Laurent
1681 Le sieur Combes [Laurent Morellet]. *Explication historique, de qu'il y a de plus remarquable dans la maison royale de Versailles. Et en celle de Monsieur à Saint-Cloud*. Paris: C. Nego.
1683 Le sieur Combes [Laurent Morellet]. *Historische Erklärung aller merckwürdigsten Sachen in dem königlichen frantzosischen Lust-Hause zu Versailles. . . .* Göttingen: J. H. Schmidt.
1684 Le sieur Combes [Laurent Morellet]. *An Historical Explication of What There Is Most Remarkable in That Wonder of the World, the French King's Royal House at Versailles, and in That of Monsieur, at St. Cloud*. London: Printed for Matthew Turner.
1695 Le sieur Combes [Laurent Morellet]. *Explication historique, de qu'il y a de plus remarquable dans la maison royale de Versailles. Et en celle de Monsieur à Saint-Cloud*. 2nd edition. Paris: François Pralard Fils.

Morris, Gouverneur
1888 *The Diary and Letters of Gouverneur Morris: Minister of the United States to France; Member of the Constitutional Convention, etc*. Edited by Anne Cary Morris. 2 vols. New York: Charles Scribner's Sons.

Motta, Anne
2014 "Un hôte à la cour de Louis XIV: Charles-Henri de Vaudémont (1649–1723), prince 'en dehors-en dedans.'" In Kolk et al. 2014, pp. 63–73.

Munger, Jeffrey H.
2018 *European Porcelain in The Metropolitan Museum of Art*. New York: The Metropolitan Museum of Art.

Musée Lambinet
2005 *Peintures du Musée Lambinet à Versailles: Catalogue sommaire*. Foreword by Catherine Gendre. Paris: Somogy Editions d'Art; Versailles: Musée Lambinet.

Myers, Mary L.
1991 *French Architectural and Ornament Drawings of the Eighteenth Century*. Exh. cat.; 1991–92. New York: The Metropolitan Museum of Art.

Narbonne, Pierre
1866 *Journal des règnes de Louis XIV et Louis XV de l'année 1701 à l'année 1744*. Edited by J.-A. Le Roi. Paris: A. Durand et Pedone Lauriel.

Neff, Emily Ballew
1995 *John Singleton Copley in England*. Houston: Museum of Fine Arts.

Nemeitz, Joachim Christoph
1718 *Séjour de Paris, oder Getreue Anleitung, welchergestalt Reisende von Condition sich zu verhalten haben, wenn sie ihre Zeit und Geld nützlich und wohl zu Paris anwenden wollen. . . .* Frankfurt am Main: F.-W. Förster.
1727 *Séjour de Paris: C'est à dire, instructions fidéles, pour les voiageurs de condition, comment ils se doivent conduire, s'ils veulent faire un bon usage de leur tems & argent, durant leur séjour à Paris*. 2 vols. Leiden: Jean van Abcoude.

New Journey to France
1715 *A New Journey to France; with an Exact Description of the Sea-Coast from London to Calais, and of the Roads from Thence to Orleans, and Back Again to Dieppe: Giving an Account of the Present Condition of That Country. . . .* London: J. Baker.

Newton, William Ritchey
2008 *Derrière la façade: Vivre au château de Versailles au XVIIIe siècle*. Paris: Perrin.
2011 *Versailles, côté jardins: Splendeurs et misères, de Louis XIV à la Révolution*. Paris: Tallandier.
2015a *Les chevaux et les chiens du roi à Versailles au XVIIIe siècle: La Grande et la Petite Ecurie, les Ecuries de la reine, le Grand Chenil et la Louveterie*. Paris: Honoré Champion.
2015b *Dans l'ombre de la cour: Les baraques autour du château de Versailles. Le Nouveau Marché. L'hôtel de Limoges*. Paris: Honoré Champion.

Nicolai, Friedrich
1786 *Beschreibung der königlichen Residenzstädte Berlin und Potsdam, aller daselbst befindlicher Merkwürdigkeiten, und der umliegenden Gegend*. 4 vols. Berlin: Friedrich Nicolai.

Nivelon, Claude
2004 *Vie de Charles Le Brun et description détaillée de ses ouvrages*. Edited by Lorenzo Pericolo. Hautes études médiévales et modernes 86. Paris: Librairie Droz.

Noël, Erick
2006 *Etre noir en France au XVIIIe siècle*. Paris: Tallandier.

Noël, Erick, et al.
2010 *Etre noir en France au XVIIIe siècle (1685–1805)*. Catalogue for an exhibition organized by the Musées d'Art et d'Histoire de La Rochelle and held at the Musée du Nouveau Monde. La Rochelle: Musée du Nouveau Monde.

Nolhac, Pierre de
1899 "Les consignes de Marie-Antoinette au Petit-Trianon." *Revue de l'histoire de Versailles et de Seine-et-Oise* 1, pp. 73–80.
1927 *Versailles et la cour de France: Trianon*. Paris: Louis Conard.

Norman, A. V. B.
1997 "A State Partizan by Jean Bérain for a Royal Wedding." *Metropolitan Museum Journal* 32 (1997), pp. 141–44.

Northumberland, Elizabeth Seymour Percy, Duchess of
1926 *The Diaries of a Duchess: Extracts from the Diaries of the First Duchess of Northumberland (1716–1776)*. Edited by James Greig. London: Hodder and Stoughton.

Nugent, Thomas
1749 *The Grand Tour: Containing an Exact Description of Most of the Cities, Towns, and Remarkable Places of Europe. . . .* 4 vols. London: S. Birt, D. Browne, A. Millar, and G. Hawkins.
1778 *The Grand Tour, or A Journey through the Netherlands, Germany, Italy and France*. 3rd edition. 4 vols. London: Printed for J. Rivington and Sons, B. Law, T. Caslon, G. Robinson, T. Cadell, W. Goldsmith, J. Bew, S. Hayes, W. Fox, and T. Evans.

Oberkampf
2015 *Oberkampf, 1738–1815: Les toiles de Jouy; une aventure humaine, industrielle et artistique*. Exh. cat. Jouy-en-Josas: Musée de la Toile de Jouy.

Oberkirch, Henriette Louise von Waldner, baronne d'
1852 *Memoirs of the Baroness d'Oberkirch, Countess de Montbrison*. Edited by Léonce, comte de Montbrison. 3 vols. London: Colburn.
1853 *Mémoires de la baronne d'Oberkirch*. Edited by Léonce, comte de Montbrison. 2 vols. Paris: Charpentier.
1869 *Mémoires de la baronne d'Oberkirch*. Edited by Léonce, comte de Montbrison. 2 vols. Paris: Charpentier.
1989 *Mémoires de la baronne d'Oberkirch sur la cour de Louis XVI et la société française avant 1789*. Edited by Suzanne Burkard. New edition. Le temps retrouvé 21. Paris: Mercure de France.
2000 *Mémoires de la baronne d'Oberkirch sur la cour de Louis XVI et la société française avant 1789*. Edited by Suzanne Burkard. New edition. Le temps retrouvé 21. Paris: Mercure de France.

Odom, Anne, and Liana Paredes
1998 *A Taste for Splendor: Russian Imperial and European Treasures from the Hillwood Museum.* With contributions by Frederick J. Fisher, Wendy R. Salmond, and Albert Marshall. Exh. cat. Alexandria, Va.: Art Services International.

Of Men Only
1975 *Of Men Only: A Review of Men's and Boys' Fashions, 1750–1975.* With an essay by Elizabeth A. Coleman. Exh. cat.; 1975–76. Brooklyn, N.Y.: Brooklyn Museum, 1975.

Olausson, Magnus
2007a *Alexander Roslin.* Stockholm: Nationalmuseum and Natur & Kultur.
2007b Ed. *Alexander Roslin.* Exh. cat.; 2007–8. Stockholm: Nationalmuseum.
2007c "Swedish Princes in Paris." In Olausson 2007b, pp. 100–101.
2008 "Princes suédois à Paris." In Olausson and Salmon 2008, p. 172.

Olausson, Magnus, and Xavier Salmon
2008 Eds. *Alexandre Roslin, 1718–1793: Un portraitiste pour l'Europe.* Exh. cat. Château de Versailles. Paris: Réunion des Musées Nationaux.

"Old Note-Book"
1863 "Monograph from an Old Note-Book." *Atlantic Monthly* 12, no. 73 (Nov.), pp. 648–62.

Olson, Lester C.
2004 *Benjamin Franklin's Vision of American Community: A Study in Rhetorical Iconology.* Columbia: University of South Carolina Press.

Olson, Robert
1991 "The Ottoman-French Treaty of 1740: A Year to Be Remembered?" *Turkish Studies Association Bulletin* 15, no. 2 (Sept.), pp. 347–55.

Omont, Henri
1910 "Un roi nègre à Paris en 1701." *Bulletin de la Société de l'Histoire de Paris et de l'Ile-de-France* 37, pp. 170–72.

Oresko, Robert
1989 "The Histoire Métallique of Louis XIV and the Diplomatic Gift." *Médailles et antiques,* pp. 49–55.

Orléans, Elisabeth Charlotte, duchesse d'
1924–25 *The Letters of Madame: The Correspondence of Elizabeth-Charlotte of Bavaria, Princess Palatine, Duchess of Orleans, called "Madame" at the Court of King Louis XIV.* Translated and edited by Gertrude Scott Stevenson. 2 vols. London: Arrowsmith.
1970 *Letters from Liselotte, Elisabeth Charlotte, Princess Palatine and Duchess of Orléans, "Madame", 1652–1722.* Translated and edited by Maria Kroll. London: Gollancz.

1985 *Lettres de Madame, duchesse d'Orléans, née princesse Palatine.* Edited by Olivier Amiel. New edition. Le temps retrouvé 32. Paris: Mercure de France.

Pagliano, Eric
1997 "Le discours sur l'art par prétérition: Décrire les représentations du roi. La Galerie de Versailles et le *Portrait du roi* par Félibien." *Revue d'esthétique,* nos. 31–32, pp. 161–72. [Issue titled *La naissance de la théorie de l'art en France, 1640–1720,* edited by Christian Michel and Maryvonne Saison.]

Paredes, Liana
1998 *Sèvres Porcelain at Hillwood.* Washington, D.C.: Hillwood Museum and Gardens.
2009 *Sèvres Then and Now: Tradition and Innovation in Porcelain, 1750–2000.* Exh. cat. Hillwood Museum and Gardens, Washington, D.C.; 2009–10. Washington, D.C.: Hillwood Museum and Gardens Foundation, in association with D. Giles, London.

Paul, John Dean
1802 *Journal of a Party of Pleasure to Paris, in the Month of August, 1802.* London: Printed by A. Strahan for T. Cadell, Jun., and W. Davies.

Peck, Amelia
2013 Ed. *Interwoven Globe: The Worldwide Textile Trade, 1500–1800.* With contributions by Amy Bogansky et al. Exh. cat.; 2013–14. New York: The Metropolitan Museum of Art.

Peckham, Harry
1788 *A Tour through Holland, Dutch Brabant, the Austrian Netherlands, and Part of France: in Which Is Included a Description of Paris and Its Environs.* 4th edition. London: Printed for G. Kearsley.

Pecquet, Antoine
1738 *De l'art de négocier avec les souverains.* The Hague: Jean van Duren.

Peintres du roi
2000 *Les peintres du roi, 1648–1793.* Exh. cat. Musée des Beaux-Arts, Tours, and Musée des Augustins, Toulouse. Paris: Réunion des Musées Nationaux.

Pennant, Thomas
1948 *Tour on the Continent, 1765.* Edited by G. R. De Beer. London: Ray Society.

Perez, Stanis
2006 "Le toucher des écrouelles: Médecine, thaumaturgie et corps du roi au Grand Siècle." *Revue d'histoire moderne et contemporaine* 53, no. 2 (Apr.–June), pp. 92–111.

Perrin, Bernard
1963–64 "Un professeur de droit solliciteur à la cour du grand Roi (1699–1704)." *Revue de l'histoire de Versailles et de Seine-et-Oise* 55, pp. 151–206.

Pestalozzi, F. O.
1926 Ed. "Eine Reise nach Paris im Jahre 1776: In briefen Beschrieben von J. H. Meyer, Kupferstecher." *Zürcher Taschenbuch auf das Jahr 1927,* n.s., 47 (pub. 1926), pp. 67–116.

Peters, David
2005 *Sèvres Plates and Services of the 18th Century.* 7 vols. Little Berkhamsted, Hertfordshire: David Peters.

Phra Narai
1986 *Phra Narai, roi de Siam, et Louis XIV.* With a catalogue by Michel Jacq-Hergoualc'h. Exh. cat. Paris: Musée de l'Orangerie.

Picquenard, Thérèse
1999 "Les bustes de Louis-Simon Boizot sous l'Ancien Régime: Portraits d'apparat et portraits intimes." In *Augustin Pajou et ses contemporains: Actes du colloque organisé au Musée du Louvre par le Service Culturel les 7 et 8 novembre 1997,* edited by Guilhem Scherf, pp. 481–506. Paris: La Documentation Française.

Pieragnoli, Joan
2010a "Les animaux exotiques de la Ménagerie." In Saule and Arminjon 2010, pp. 109–15.
2010b "La Ménagerie: Les bêtes et les hommes." In Mabille and Pieragnoli 2010, pp. 57–93, 94.

Piganiol de La Force, Jean Aimar
1701 *Nouvelle description des chasteaux et parcs de Versailles et de Marly: Contenant une explication historique de toutes les peintures, tableaux, statuës, vases, & ornemens qui s'y voyent. . . .* Paris: Florentin & Pierre Delaulne.
1715 *Description des chateaux et parcs de Versailles, de Trianon, et de Marly. Contenant une explication historique de toutes les peintures, tableaux, statuës, vases, & ornemens qui s'y voyent. . . .* 2 vols. Amsterdam: David Mortier Libraire.
1718 *Nouvelle description de la France: Dans laquelle on voit le gouvernement general de ce royaume, celui de chaque province en particulier; et la description des villes, maisons royales, châteaux, & monumens les plus remarquables. . . .* 6 vols. Paris: Florentin Delaulne.

Pincas, Stéphane
1995 *Versailles: Un jardin à la française.* Paris: Editions de la Martinière.

Pitzler, Christoph
2014 "Etude du voyage en France et du séjour
 à Versailles de Christoph Pitzler: Extrait de
 son carnet d'esquisses (1685–1688) conservé à
 la Stiftung Preussische Schlösser und Gärten
 Berlin-Brandenburg." *Bulletin du Centre de
 Recherche du Château de Versailles.* Published
 online Sept. 25, 2014. https://crcv.revues
 .org/12347.

Plaisirs de l'isle enchantée
1673 *Les plaisirs de l'isle enchantée. Course de bague;
 collation ornée de machines; comedie, meslée de danse
 et de musique; ballet du palais d'Alcine; feu d'artifice: Et
 autres festes galantes et magnifiques, faites par le Roy
 à Versailles, le VII. may M.DC.LXIV. et continuées
 plusieurs autres jours.* Paris: Imprimerie Royale.

Plans, profils, et elevations . . . de Versailles
1716 *Les plans, profils, et elevations, des ville, et
 château de Versailles, avec les bosquets, et fontaines,
 tels quils sont a present; levez sur les lieux, dessinez et
 gravez en 1714 et 1715.* Paris: Demortain.

Pocquet du Haut-Jussé, Barthélemy
1922 *Les aventures d'une statue: Le Louis XIV
 de Coysevox à Rennes.* Société d'Histoire et
 d'Archéologie de Bretagne. Rennes: Imprimeries
 Oberthur.

Pöllnitz, Karl Ludwig von
1738 *The Memoirs of Charles-Lewis, Baron de Pollnitz:
 Being the Observations He Made in His Late Travels
 from Prussia thro' Poland, Germany, Italy, France,
 Spain, Flanders, Holland, England, &c.* Vol. 3.
 London: Printed for Daniel Browne and John
 Brindley.

Pompeo Batoni
1982 *Pompeo Batoni and His British Patrons.* With an
 essay by Edgar Peters Bowron. Exh. cat. Iveagh
 Bequest, Kenwood. London: Greater London
 Council.

Pontier, Gédéon
1684 *A New Survey of the Present State of Europe:
 Containing Remarks upon Several Soveraign and
 Republican States. With Memoires Historical,
 Chronological, Topographical, Hydrographical,
 Political, &c.* Translated by J. B., Doctor of
 Physick. London: Printed for W. Crooke.

Ponz, Antonio
1947 *Viaje de España: Seguido de los dos tomos del
 Viaje fuera de España.* Edited by Casto María del
 Rivero. Madrid: M. Aguilar.

Poole, Robert
1750 *A Journey from London to France and Holland, or
 The Traveller's Useful* Vade Mecum. 2 vols. London:
 Printed for E. Duncomb. [Reprint of the 2nd
 edition, London: Printed for E. Duncomb, 1746.]

Porslin från Sèvres
1982 *Porslin från Sèvres.* Exh. cat. Nationalmuseum,
 Stockholm; Kunstindustrimuseet, Oslo; and
 Kunstindustrimuseum, Bergen, Norway.
 Stockholm: Nationalmuseum.

Portrait de Son Excellence Saïd-Pacha
1742 *Lettre au sujet du portrait de Son Excellence
 Saïd-Pacha, ambassadeur extraordinaire du
 grand-seigneur à la cour de France, en 1742.* Paris:
 Prault Père.

Poulet, Anne L.
2003 With Guilhem Scherf et al. *Jean-Antoine Houdon:
 Sculptor of the Enlightenment.* Exh. cat. National
 Gallery of Art, Washington, D.C.; J. Paul Getty
 Museum, Los Angeles; Musée et Domaine National
 du Château de Versailles; 2003–4. Washington,
 D.C.: National Gallery of Art.

Pradère, Alexandre
1989 *Les ébénistes français de Louis XIV à la
 Révolution.* Paris: Chêne.

Prange, Peter
2010 "Salzburg im Bild: Franz Anton Danreiters
 Salzburger Ansichtenwerk." *Barockberichte:
 Informationsblätter des Salzburger Barockmuseums
 zur bildenden Kunst des 17. und 18. Jahrhunderts,*
 nos. 53–54, pp. 485–500.

Primi Visconti, Giovanni Battista
1988 *Mémoires sur la cour de Louis XIV, 1673–1681.*
 Edited by Jean-François Solnon. Collection
 l'histoire en mémoires. Paris: Perrin.

"Principales acquisitions"
1996 "Principales acquisitions des musées en 1995."
 Gazette des beaux-arts, 6th ser., 127 (Mar.),
 pp. 3–105.
2009 "Principales acquisitions des musées de
 France." *Revue du Louvre: La revue des musées de
 France* 59, no. 2 (Apr.), pp. 59–111.

Prinz Heinrich von Preussen
2002 *Prinz Heinrich von Preussen: Ein Europäer in
 Rheinsberg.* Catalogue for an exhibition organized
 by the Stiftung Preussische Schlösser und Gärten
 Berlin-Brandenburg and held at the Schloss
 Rheinsberg. Munich: Deutscher Kunstverlag.

Prior Papers
1908 *Prior Papers.* Vol. 3 of *Calendar of the Manuscripts
 of the Marquis of Bath Preserved at Longleat,
 Wiltshire.* Historical Manuscripts Commission.
 London: His Majesty's Stationery Office.

Proschwitz, Gunnar von
1986 Gustave III, King of Sweden. *Gustave III par
 ses lettres.* Edited by Gunnar von Proschwitz.
 Stockholm: Norstedts; Paris: J. Touzot.

1994 "Gustave III et la France." In *Soleil et l'étoile du
 nord* 1994, pp. 292–94, 297–304.

Radisich, Paula Rea
1988 "The King Prunes His Garden: Hubert Robert's
 Picture of the Versailles Gardens in 1775."
 Eighteenth-Century Studies 21, no. 4 (Summer),
 pp. 454–71.

Radziwiłł, Karol Stanisław
2011 *Diariusz peregrynacji europejskiej (1684–1687).*
 Edited by Adam Kucharski. Toruń: Wydawnictwo
 Naukowe Uniwersytetu Mikołaja Kopernika.

Raggio, Olga
1967 "Two Great Portraits by Lemoyne and Pigalle."
 The Metropolitan Museum of Art Bulletin, n.s., 25,
 no. 6 (Feb.), pp. 219–29.

Rainssant, Pierre
1687 *Explication des tableaux de la galerie de
 Versailles, et de ses deux sallons.* Versailles:
 François Muguet.
1691 *Explication des tableaux de la galerie de Versailles,
 et de ses deux sallons.* Paris: Robert Pepie.

Ralston, Ruth
1925 "Franklin and Louis XVI: A Niderviller
 Group." *Bulletin of The Metropolitan Museum of
 Art* 20, no. 11 (Nov.), pp. 271–73.

Rangström, Lena
1997 *Kläder för tid och evighet: Gustaf III sedd genom
 sina dräkter.* Stockholm: Livrustkammaren.

Réau, Louis
1964 *Houdon: Sa vie et son oeuvre.* 2 vols. Paris:
 F. de Nobele.

"Reception of Lord Stair"
1805 "Ceremonial of Reception of Lord Stair When
 Going as Ambassador to Paris in 1715." *Scots
 Magazine, and Edinburgh Literary Miscellany* 67
 (June), pp. 421–26.

Reise des Herrn Grafen von Falkenstein nach Frankreich
1777 *Anthologische Beschreibung der Reise des Herrn
 Grafen von Falkenstein nach Frankreich 1777.*
 Schwabach: Enderes.

Relations artistiques
1964 *Les relations artistiques entre la France et la
 Suède, 1693–1718: Nicodème Tessin le jeune et
 Daniel Cronström. Correspondance (extraits).*
 Edited by Roger-Armand Weigert and Carl
 Hernmarck. Nationalmuseum, Skriftserie 10.
 Stockholm: Egnellska Boktryckeriet.

Reverseau, Jean-Pierre
2005–6 "Identification de présents diplomatiques turcs dans les collections royales." *Cahiers d'études et de recherches du Musée de l'Armée*, no. 6 (2005–6; pub. 2008), pp. 17–26. [Issue titled *Armes et cultures de guerre en Europe centrale, XV* siècle–XIX* siècle*. Proceedings of a conference held at the Musée de l'Armée, Paris, Feb. 2–4, 2006.]

Reynolds, Graham
1996 With the assistance of Katharine Baetjer. *European Miniatures in The Metropolitan Museum of Art*. Exh. cat.; 1996–97. New York: The Metropolitan Museum of Art.

Ribeiro, Aileen
1995 *The Art of Dress: Fashion in England and France, 1750 to 1820*. New Haven, Conn.: Yale University Press.
2000 *The Gallery of Fashion*. London: National Portrait Gallery.

Richefort, Isabelle
1998 "Présents diplomatiques et diffusion de l'image de Louis XIV." In *L'invention de la diplomatie: Moyen âge–temps modernes*, edited by Lucien Bély, with the assistance of Isabelle Richefort, pp. 263–79. Papers from a conference held in Paris, February 9–10, 1996. Paris: Presses Universitaires de France.

Roberts, Warren
2000 *Jacques-Louis David and Jean-Louis Prieur, Revolutionary Artists: The Public, the Populace, and Images of the French Revolution*. Albany: State University of New York Press.

Robson, Francis
1787 *Vie d'Haïder-Aly-Khan: Précédée de l'histoire de l'usurpation du pays de Maïssour. . . .* Paris: Regnault. [Translation of *The Life of Hyder Ally: With an Account of His Usurpation of the Kingdom of Mysore. . . .* London: Printed for S. Hooper, 1786.]

Roche, Daniel
1998 Ed. *Les écuries royales du XVI* au XVIII* siècle*. Preface by Jean-Pierre Babelon. Paris: Association pour l'Académie d'Art Equestre de Versailles.
2001 Ed. *Almanach parisien, en faveur des étrangers et des personnes curieuses*. Lire le dix-huitième siècle. Saint-Etienne: Publications de l'Université de Saint-Etienne.

Rochebrune, Marie-Laure de
2014 Ed. *La Chine à Versailles: Art et diplomatie au XVIII* siècle*. Exh. cat. Paris: Somogy Editions d'Art; Versailles: Château de Versailles.

Rodmell, Graham E.
1968–69 "An Englishman's Impressions of France in 1775." *Durham University Journal* 61 (n.s., 30), pp. 75–93.

Roland Michel, Marianne
2003 "Exoticism and Genre Painting in Eighteenth-Century France." In *The Age of Watteau, Chardin, and Fragonard: Masterpieces of French Genre Painting*, edited by Colin B. Bailey, Philip Conisbee, and Thomas W. Gaehtgens, pp. 106–19. Exh. cat. National Gallery of Canada, Ottawa; National Gallery of Art, Washington, D.C; and Gemäldegalerie, Staatliche Museen zu Berlin; 2003–4. New Haven, Conn.: Yale University Press, in association with the National Gallery of Canada, Ottawa.

Romilly, Samuel
1840 *Memoirs of the Life of Sir Samuel Romilly, Written by Himself; with a Selection from His Correspondence*. 2nd edition. 3 vols. London: John Murray.

Ronfort, Jean-Nérée
1989 "Le mobilier royal à l'époque de Louis XIV et le Garde-Meuble de la Couronne." In *De Versailles à Paris: Le destin des collections royales*, edited by Jacques Charles, pp. 15–39. Exh. cat. Mairie du V* arrondissement de Paris. Paris: Centre Culturel du Panthéon.
2005a "André-Charles Boulle: Commandes pour la duchesse de Bourgogne à Versailles et au château de la Ménagerie." *Dossier de l'art*, no. 124 (Nov.), pp. 66–89.
2005b "André-Charles Boulle: Commandes pour le Grand Dauphin à Versailles." *Dossier de l'art*, no. 124 (Nov.), pp. 38–65.
2011 Ed. *André Charles Boulle, 1642–1732: A New Style for Europe*. Exh. cat.; 2009–10. Paris: Somogy Editions d'Art; Frankfurt am Main: Museum für Angewandte Kunst Frankfurt.

Rookmaaker, L. C.
1983 "Histoire du rhinocéros de Versailles (1770–1793)." *Revue d'histoire des sciences* 36, nos. 3–4 (July–Dec.), pp. 307–18.

Rosenberg, Pierre
2005 Ed. *Poussin, Watteau, Chardin, David . . . : Peintures françaises dans les collections allemandes, XVII*–XVIII* siècles*. Exh. cat. Galeries Nationales du Grand Palais, Paris; Haus der Kunst, Munich; and Kunst- und Ausstellungshalle der Bundesrepublik Deutschland, Bonn; 2005–6. Paris: Réunion des Musées Nationaux; Munich: Bayerische Staatsgemäldesammlungen; Bonn: Kunst- und Ausstellungshalle der Bundesrepublik Deutschland.

Rosenfeld, Myra Nan
1982 *Largillierre and the Eighteenth-Century Portrait*. Exh. cat. Montreal: Montreal Museum of Fine Arts.

Rothman, E. Natalie
2012 *Brokering Empire: Trans-Imperial Subjects between Venice and Istanbul*. Ithaca, N.Y.: Cornell University Press.

Rowell, Christopher
1987 "Clive of India and His Family: The Formation of the Collection." In Archer, Rowell, and Skelton 1987, pp. 17–30.

Rush, Benjamin
1947 *The Selected Writings of Benjamin Rush*. Edited by Dagobert D. Runes. New York: Philosophical Library.

Russell, John
1979 "John Paul Jones' Sword." *American Blade* (Nov.–Dec.), pp. 30–33.

Sabatier, Gérard
1999 *Versailles, ou La figure du roi*. Paris: Albin Michel.
2000 "La gloire du roi: Iconographie de Louis XIV de 1661 à 1672." *Histoire, économie et société* 19, no. 4, pp. 527–60.
2006 "'Le portrait de César, c'est César': Lieux et mise en scène du portrait du roi dans la France de Louis XIV." In *L'image du roi de François I* à Louis XIV*, edited by Thomas W. Gaehtgens and Nicole Hochner, pp. 209–44. Passages/Passagen 10. Papers from a conference held at the Centre Allemand d'Histoire de l'Art, June 2002. Paris: Maison des Sciences de l'Homme.
2009 "Les itinéraires des ambassadeurs pour les audiences à Versailles au temps de Louis XIV." In *Diplomatisches Zeremoniell in Europa und im Mittleren Osten in der frühen Neuzeit*, edited by Ralph Kauz, Giorgio Rota, and Jan Paul Niederkorn, pp. 187–212. Archiv für österreichische Geschichte 141. Veröffentlichungen zur Iranistik 52. Sitzungsberichte (Österreichische Akademie der Wissenschaften, Philosophisch-Historische Klasse) 796. Vienna: Verlag der Österreichischen Akademie der Wissenschaften.
2016 *Versailles, ou La disgrâce d'Apollon*. Rennes: Presses Universitaires de Rennes; Versailles: Centre de Recherche du Château de Versailles.

Sabatier, Gérard, and Béatrix Saule
2015 Eds. *Le roi est mort: Louis XIV—1715*. Exh. cat.; 2015–16. Paris: Tallandier; Versailles: Château de Versailles.

Sahlins, Peter
2012 "The Royal Menageries of Louis XIV and the
 Civilizing Process Revisited." *French Historical
 Studies* 35, no. 2 (Spring), pp. 237–67.
2014 "Where the Sun Don't Shine: Animals and
 Animality in Louis XIV's Royal Labyrinth
 of Versailles (1668–74)." In *Animals and
 Early Modern Identity*, edited by Pia F. Cuneo,
 pp. 67–88. Farnham, Surrey: Ashgate.
2015 "A Tale of Three Chameleons: The Animal
 between Science and Literature in the Age of
 Louis XIV." In *French Thinking about Animals*,
 edited by Louisa Mackenzie and Stephanie
 Posthumus, pp. 15–30. East Lansing: Michigan
 State University Press.

St. John, James
1788 *Letters from France to a Gentleman in the South
 of Ireland: Containing Various Subjects Interesting
 to Both Nations; Written in 1787.* 2 vols. Dublin:
 Printed by P. Byrne.

Saint-Simon, Louis de Rouvroy, duc de
1829–30 *Mémoires complets et authentiques du duc de
 Saint-Simon sur le siècle de Louis XIV et la Régence.*
 21 vols. Paris: A. Sautelet.
1856–58 *Mémoires complets et authentiques du duc de
 Saint-Simon sur le siècle de Louis XIV et la Régence.*
 13 vols. Paris: Librairie de L. Hachette.
1879–1928 *Mémoires de Saint Simon.* Edited by
 A. de Boislisle. New edition. 41 vols. Paris:
 Librairie Hachette.
1954 *Louis XIV at Versailles: A Selection from the
 Memoirs of the Duc de Saint-Simon.* Translated and
 edited by Desmond Flower. London: Cassell.
1968 *Historical Memoirs of the Duc de Saint-Simon:
 A Shortened Version.* Vol. 2. Edited and translated
 by Lucy Norton. New York: McGraw-Hill.
1983 *Mémoires: Additions au Journal de Dangeau.*
 Edited by Yves Coirault. Vol. 1, *1691–1701.*
 Bibliothèque de la Pléiade. Paris: Gallimard.
1985 *Mémoires: Additions au Journal de Dangeau.*
 Edited by Yves Coirault. Vol. 5, *1714–1716.*
 Bibliothèque de la Pléiade. Paris: Gallimard.

Salinger, Nicole
1991 Ed. *Mozart à Paris.* Exh. cat. Musée Carnavalet,
 Paris; 1991–92. Organized by the city of Paris with
 the Bibliothèque Nationale. Paris: Paris-Musées
 and Francis van de Velde.

Salmon, Xavier
1997 *Louis de Silvestre (1675–1760): Un peintre français
 à la cour de Dresde.* Exh. cat. Musée National des
 Châteaux de Versailles et de Trianon. Versailles:
 Château de Versailles.
1999 *Château de Versailles: Nouvelles acquisitions du
 Cabinet des Dessins, 1988–1998.* Exh. cat. Musée
 National des Châteaux de Versailles et de Trianon.
 Versailles: Société des Amis de Versailles.

2005 *Versailles.* Preface by Pierre Arizzoli-Clémentel.
 With an essay by Gianni Guadalupi. Grand Tour 38.
 Bologna: FMR.
2007 *Imagens do soberano: Acervo do Palácio de
 Versalhes.* Exh. cat. São Paulo: Pinacoteca do
 Estado de São Paulo.
2009 "Un *modello* inédit pour la tenture de l'*Histoire
 du Roi.*" In "*Man könnt vom Paradies nicht
 angenehmer träumen*": Festschrift für Prof. Dr.
 Harald Marx zum 15. Februar 2009, edited by
 Andreas Henning, Uta Neidhardt, and Martin
 Roth, pp. 139–45. Berlin: Deutscher Kunstverlag;
 Emsdetten: Edition Imorde.
2011 Ed. *Le Siam à Fontainebleau: L'ambassade du
 27 juin 1861.* Exh. cat. Château de Fontainebleau;
 2011–12. Paris: Réunion des Musées Nationaux.

Sander, Heinrich
1779 "Nachricht vom Rhinoceros in Versailles."
 Narturforscher 13, pp. 1–10.
1783–84 *Beschreibung seiner Reisen durch Frankreich,
 die Niederlande, Holland, Deutschland und
 Italien. . . .* 2 vols. Leipzig: Friedrich Gotthold
 Jacobäer und Sohn.

van de Sandt, Anne, and Udolpho van de Sandt
2001 "Alla ricerca di 'Pietro Bellotti, un Veneziano
 di Tolosa.'" *Saggi e memorie di storia dell'arte*,
 no. 25, pp. 89–120.

Sarmant, Thierry, and Mathieu Stoll
2010 *Régner et gouverner: Louis XIV et ses ministres.*
 Pour l'histoire. Paris: Perrin.

Sassoon, Adrian
1991 *Vincennes and Sèvres Porcelain: Catalogue of the
 Collections.* Malibu, Calif.: J. Paul Getty Museum.

Saule, Béatrix
2007a "The Hall of Mirrors during Louis XIV's
 Reign: From the Ordinary to the Extraordinary."
 In *The Hall of Mirrors: History & Restoration*,
 pp. 54–73, 388–89. Dijon: Faton.
2007b "Quand Versailles était meublé d'argent." In
 Quand Versailles était meublé d'argent, edited by
 Catherine Arminjon, pp. 27–59. Exh. cat. Château
 de Versailles; 2007–8. Paris: Réunion des Musées
 Nationaux.
2012 Ed. *Roulez carrosses! Le château de Versailles à
 Arras.* Exh. cat. Musée des Beaux-Arts, Arras.
 Paris: Skira Flammarion.
2013 "L'enrichissement des collections du Château
 de Versailles et des Trianons de l'année 2011."
 Versalia, no. 16, pp. 11–30.

Saule, Béatrix, and Catherine Arminjon
2010 Eds. *Sciences & curiosités à la cour de Versailles.*
 Exh. cat.; 2010–11. Paris: Réunion des Musées
 Nationaux; Versailles: Château du Versailles.

Saule, Béatrix, and Lucina Ward
2016 Eds. *Versailles: Treasures from the Palace.*
 Exh. cat.; 2016–17. Canberra: National Gallery
 of Australia.

Savill, Rosalind
1988 *The Wallace Collection Catalogue of Sèvres
 Porcelain.* 3 vols. London: Trustees of the Wallace
 Collection.

Scherf, Guilhem
2002 "Madame de Pompadour et la sculpture."
 Dossier de l'art, no. 83 (Feb.), pp. 60–73. [Issue
 titled *Madame de Pompadour et les arts.*]

Schnitzler-Sekyra, Andrea Alexa
2010 "Franz Anton Danreiter (1695–1760)."
 *Barockberichte: Informationsblätter des Salzburger
 Barockmuseums zur bildenden Kunst des 17. und
 18. Jahrhunderts*, nos. 53–54, pp. 451–84.

Schoenbrun, David
1976 *Triumph in Paris: The Exploits of Benjamin
 Franklin.* New York: Harper & Row.

Schramm, Carl Christian
1744 *Neues europäisches historisches Reise-Lexicon.*
 Leipzig: Gleditsch.

Schulz, Friedrich
1790 "Einige Data zur Uebersicht des Aufwandes des
 königlichen Hauses von Frankreich." *Journal des
 Luxus und der Moden* 5, no. 4 (Apr.), pp. 181–205.

Scott, Sir Walter
1829 "Tobias Smollett." In *The Miscellaneous Prose
 Works of Sir Walter Scott, Bart.*, vol. 3, *Biographical
 Memoirs*, pp. 83–126. Boston: Wells and Lilly.

Scudéry, Madeleine de
1684 *Conversations nouvelles sur divers sujets, dédiées au
 Roy.* 2 vols. Paris: Claude Barbin.

Ségur, Louis Philippe, comte de
1825 *Memoirs and Recollections of Count Segur:
 Ambassador from France to the Courts of Russia
 and Prussia.* Boston: Wells and Lilly; New York,
 E. Bliss and E. White.

Sellers, Charles Coleman
1952 *Portraits and Miniatures by Charles Willson
 Peale.* Transactions of the American Philosophical
 Society, n.s., 42, pt. 1. Philadelphia: American
 Philosophical Society.
1962 *Benjamin Franklin in Portraiture.* New Haven,
 Conn.: Yale University Press.

Semail, Anita
1975 "Les compignés: Ces délicats chefs-d'oeuvre de
 la tabletterie au XVIIIᵉ siècle ont pris le nom de
 leur créateur." *Plaisir de France* 41, no. 427 (Mar.),
 pp. 25–31.

Senior, Matthew
2004 "The Ménagerie and the Labyrinthe: Animals at Versailles, 1662–1792." In *Renaissance Beasts: Of Animals, Humans, and Other Wonderful Creatures*, edited by Erica Fudge, pp. 209–32. Urbana: University of Illinois Press.

Sévigné, Marie de Rabutin-Chantel, marquise de
1878 *The Letters of Madame de Sévigné to Her Daughter and Friends*. Edited by Sarah Josepha Buell Hale. Rev. edition. Boston: Roberts Brothers.

Shaw, Joseph
1709 *Letters to a Nobleman from a Gentleman Travelling thro' Holland, Flanders and France. With a Description of Ghent, Lisle, &c. and of the Courts of Versailles and St. Germains*. London: Daniel Midwinter. [Letters addressed to Anthony Ashley Cooper, 3rd Earl of Shaftesbury.]

Sherburne, John Henry
1851 *The Life and Character of John Paul Jones, a Captain in the United States Navy, during the Revolutionary War*. 2nd edition. New York: Adriance, Sherman.

Shi, David E.
1985 *The Simple Life: Plain Living and High Thinking in American Culture*. New York: Oxford University Press.

Siglo de pintura francesa
1992 *Un siglo de pintura francesa, 1750–1850 (colección Museo de Quimper)*. Exh. cat. Kiosco Alfonso, Ayuntamiento de La Coruña; Museo de Zaragoza; and Museu Sant Pius V., Valencia. [Valencia]: [Generalitat Valenciana], 1992.

Skulptur aus dem Louvre
1989 *Skulptur aus dem Louvre: 89 Werke des französischen Klassizismus, 1770–1830*. Exh. cat. Wilhelm-Lehmbruck-Museum, Duisburg. Duisburg: Stadt Duisburg.

Smith, James Edward
1793 *A Sketch of a Tour on the Continent, in the Years 1786 and 1787*. 3 vols. London: Printed for the author by J. Davis.

Smithies, Michael
1986 Ed. and trans. *The Discourses at Versailles of the First Siamese Ambassadors to France, 1686–7; Together with the List of Their Presents to the Court*. [In French and English.] Bangkok: Siam Society.

Smithies, Michael, and Dhiravat na Pomberja
2002 "Instructions Given to the Siamese Envoys Sent to Portugal, 1684." *Journal of the Siam Society* 90, nos. 1–2, pp. 125–35.

Smollett, Tobias George
1766 *Travels through France and Italy*. 2 vols. London: Printed for R. Baldwin.

1870 *The Adventures of Peregrine Pickle; in Which Are Included Memoirs of a Lady of Quality*. In *The Works of Tobias Smollett*, edited by David Herbert, pp. 197–466. Edinburgh: William P. Nimmo.

Smythe, Lillian C.
1902 *The Guardian of Marie Antoinette: Letters from the Comte de Mercy-Argenteau, Austrian Ambassador to the Court of Versailles, to Marie Thérèse, Empress of Austria, 1770–1780*. 2 vols. New York: Dodd, Mead.

Snodin, Michael
1996 Ed. *Sir William Chambers*. Catalogues of Architectural Drawings in the Victoria and Albert Museum. London: V&A Publications.

Snow, Vernon F.
1958 Ed. "The Grand Tour Diary of Robert C. Johnson, 1792–1793." *Proceedings of the American Philosophical Society* 102, no. 1 (Feb. 17), pp. 60–105.

Soleil et l'étoile du nord
1994 *Le soleil et l'étoile du nord: La France et la Suède au XVIIIᵉ siècle*. Exh. cat. Nationalmuseum, Stockholm, and Galeries Nationales du Grand Palais, Paris; 1993–94. Paris: Association Française d'Action Artistique and Réunion des Musées Nationaux.

Solnon, Jean-François
1987 *La cour de France*. Paris: Fayard.

Souchal, François
1977 *French Sculptors of the 17th and 18th Centuries: The Reign of Louis XIV*. Vol. 1. Oxford: Bruno Cassirer Publishers.

Soullard, Eric
2000 "Eaux, fontaines et salles de bains: Le propre et le sale à Versailles." *L'histoire*, no. 240 (Feb.), pp. 62–67.

Sourches, Louis François du Bouchet, marquis de
1882–93 *Mémoires du marquis de Sourches sur le règne de Louis XIV*. Edited by Gabriel-Jules, comte de Cosnac, Arthur, comte Bertrand de Broussillon, and Edouard Pontal. 13 vols. Paris: Hachette.

Spanheim, Ezekiel
1882 *Relation de la cour de France en 1690*. Edited by Charles Schefer. Société de l'Histoire de France. Paris: Librairie Renouard.

Stålhane, Henning
1953 *Gustaf III:s resa till Italien och Frankrike*. Stockholm: Nordisk Rotogravyr.

Standen, Edith Appleton
1955 "A King's Carpet." *The Metropolitan Museum of Art Bulletin*, n.s., 13, no. 9 (May), pp. 257–65.

Starcky, Emmanuel, Elisabeth Caude, and Vincent Delieuvin
2006 Eds. *Louis XVI et Marie-Antoinette à Compiègne*. Exh. cat. Musée National du Château de Compiègne; 2006–7. Paris: Réunion des Musées Nationaux.

Stein, Perrin
1997 "Exoticism as Metaphor: *Turquerie* in Eighteenth-Century French Art." PhD diss., Institute of Fine Arts, New York University.

Stein, Susan R.
1993 *The Worlds of Thomas Jefferson at Monticello*. New York: Harry N. Abrams.

Sterne, Laurence
1888 *A Sentimental Journey through France and Italy*. London: G. Routledge and Sons.

Stevens, Sacheverell
1756 *Miscellaneous Remarks Made on the Spot, in a Late Seven Years Tour through France, Italy, Germany and Holland*. London: Printed for S. Hooper and J. Swan.

Stollberg-Rilinger, Barbara
2008 *Des Kaisers alte Kleider: Verfassungsgeschichte und Symbolsprache des Alten Reiches*. Munich: C. H. Beck.

Storch, Heinrich Friedrich
1787 *Skizzen, Szenen und Bemerkungen auf einer Reise durch Frankreich*. Heidelberg: Friedrich Ludwig Pfähler.

Struck, Bernhard
2001 "De l'affinité sociale à la différence culturelle: La France vue par les voyageurs allemands du XVIIIᵉ siècle." *Francia* 28, no. 2, pp. 17–34.

Sturm, Leonhard Christoph
1719 *Leonhard Christoph Sturms durch einen grossen Theil von Teutschland und den Niederlanden biss nach Pariss gemachete architectonische Reise-Anmerckungen*. Augsburg: Jeremias Wolff.

Swinburne, Henry
1840 *Secret Memoirs of the Courts of Europe: Letters Written at the End of the Eighteenth Century*. 2 vols. Philadelphia: George Barrie & Sons, [1840].

Tapisseries du Roy
1687 *Tapisseries du Roy, ou sont representez les quatre elemens et les quatre saisons: Avec les devises qui les accompagnent et leur explication / Königliche französische Tapezereijen, oder ueberaus schoene Sinn-Bilder, in welchen die vier Element, samt den vier Jahr-Zeiten, neben den Denckspruechen und ihren Auslegungen, vorgestellet werden*. Augsburg: Johann Ulrich Krauss; printed by J. Koppmayer, 1687.

Teachout, Zephyr
2014 *Corruption in America: From Benjamin Franklin's Snuff Box to Citizens United.* Cambridge, Mass.: Harvard University Press.

Teleki, József
1943 *La cour de Louis XV: Journal de voyage du comte Joseph Teleki.* Edited by Gabriel Tolnai. Bibliothèque de la revue d'histoire comparée 1. Paris: Les Presses Universitaires de France.

Tessin, Nicodemus, the Younger
1926 "Relation de la visite de Nicodème Tessin à Marly, Versailles, Clagny, Rueil et Saint-Cloud en 1687." Edited by Pierre Francastel. *Revue de l'histoire de Versailles et de Seine-et-Oise* 28 (July–Sept.), pp. 150–67; (Oct.–Dec.), pp. 274–300.
2002 *Travel Notes, 1673–77 and 1687–88.* Edited by Merit Laine and Börje Magnusson. Nicodemus Tessin the Younger: Sources, Works, Collections. Stockholm: Nationalmuseum.

Thé, café ou chocolat?
2015 *Thé, café ou chocolat? Les boissons exotiques à Paris au XVIIIe siècle.* Exh. cat. Musée Cognacq-Jay. Paris: Paris-Musées.

Thébaud-Sorger, Marie
2010 "Versailles, le roi et la montgolfière." In Saule and Arminjon 2010, pp. 247–48.

Thépaut-Cabasset, Corinne
2007–8 "*Présents du Roi*: An Archive at the Ministry of Foreign Affairs in Paris." *Studies in the Decorative Arts* 15, no. 1 (Fall–Winter 2007–8), pp. 4–18.
2009 "La boîte à portrait de diamants ou le médaillon du roi: Le cadeau d'une image royale." In Milovanovic and Maral 2009, pp. 360–62.
2014 "Fashion Encounters: The 'Siamoise', or the Impact of the Great Embassy on Textile Design in Paris in 1687." In *Global Textile Encounters*, edited by Marie-Louise Nosch, Zhao Feng, and Lotika Varadarajan, pp. 165–70. Ancient Textiles Series 20. Oxford: Oxbow Books.
2015 "Une épée de diamants pour le prince électeur de Saxe en 1673." *Château de Versailles: De l'Ancien Régime à nos jours*, no. 18 (July–Sept.), pp. 32–34.
2016 "Les boîtes à portraits en diamants." *Château de Versailles: De l'Ancien Régime à nos jours*, no. 21 (Apr.–June), pp. 60–61.

Thicknesse, Philip
1766 *Observations on the Customs and Manners of the French Nation, in a Series of Letters, in Which That Nation Is Vindicated from the Misrepresentations of Some Late Writers.* London: Printed for Robert Davis, G. Kearsley, and N. Young.
1768 *Useful Hints to Those Who Make the Tour of France, in a Series of Letters Written from That Kingdom.* London: Printed for R. Davis, G. Kearsl[e]y, and H. Parker.

1770 *Useful Hints to Those Who Make the Tour of France, in a Series of Letters, Written from That Kingdom.* 2nd edition. London: G. Kearsl[e]y.
1777 *A Year's Journey through France, and Part of Spain.* 2 vols. Bath: Printed by R. Cruttwell for the author.

van Thiel, Pieter J. J., et al.
1976 *All the Paintings of the Rijksmuseum in Amsterdam: A Completely Illustrated Catalogue.* Amsterdam: Rijksmuseum; Maarssen: Gary Schwartz.

Thiéry de Sainte-Colombe, Luc Vincent
1784 *Almanach du voyageur à Paris, contenant une description exacte & intéressante de tous les monumens, chefs-d'oeuvres des arts, etablissemens utiles.* Paris: Hardouin.
1788 *Guide des amateurs et des étrangers voyageurs dans les maisons royales, châteaux, lieux de plaisance, établissemens publics, villages & séjours les plus renommés. Aux environs de Paris. . . .* 2 vols. Paris: Hardouin & Gattey.

Thrale, Hester Lynch, and Samuel Johnson
1932 *The French Journals of Mrs. Thrale and Doctor Johnson.* Edited by Moses Tyson and Henry Guppy. Manchester: Manchester University Press.

Tinniswood, Adrian
2001 *His Invention So Fertile: A Life of Christopher Wren.* London: Jonathan Cape.

Topkapi à Versailles
1999 *Topkapi à Versailles: Trésors de la cour ottoman.* Exh. cat. Musée National des Châteaux de Versailles et de Trianon. Paris: Association Française d'Action Artistique and Réunion des Musées Nationaux.

Torrence, Gaylord
2014 *The Plains Indians: Artists of Earth and Sky.* With contributions by Arthur Amiotte et al. Exh. cat. Musée du Quai Branly, Paris; Nelson-Atkins Museum of Art, Kansas City; and The Metropolitan Museum of Art, New York; 2014–15. Paris: Musée du Quai Branly and Editions Skira; New York: Skira Rizzoli.

Trabouillet, Louis
1702 *Etat de la France.* 3 vols. Paris: Charles Osmont.

Traveller's Companion
1753 *The Traveller's Companion and Guide through France, Flanders, Brabant, and Holland. . . .* London: Printed for R. Richards.

Travels into France and Italy
1771 *Travels into France and Italy. In a Series of Letters to a Lady.* 2 vols. London: Printed for T. Becket and P. A. de Hondt.

Truman, Charles
2013 *The Wallace Collection: Catalogue of Gold Boxes.* London: Wallace Collection.

Trumbull, John
1841 *Autobiography, Reminiscences and Letters of John Trumbull, from 1756 to 1841.* New York: Wiley and Putnam; New Haven, Conn.: B. L. Hamlen.

Tuite, Peter T.
2004 *U.S. Naval Officers: Their Swords and Dirks.* Lincoln, R.I.: Andrew Mowbray.

Twiss, Richard
1793 *A Trip to Paris, in July and August, 1792.* London: Minerva Press.

Tydén-Jordan, Astrid
1994 "Le repas public." In *Soleil et l'étoile du nord* 1994, pp. 309, 314.

Upjohn, James
2016 *The Life and Travels of James Upjohn.* Edited by John Leopold and Roger Smith. London: Antiquarian Horological Society.

Valpy, Richard
1814 "A Short Sketch of a Short Trip to Paris, in 1788." *Pamphleteer: Respectfully Dedicated to Both Houses of Parliament* 3, no. 6 (May), pp. 489–551.

Van Boucher tot Boudin
1992 *Van Boucher tot Boudin: Honderd jaar Franse schilderkunst, 1750–1850, uit de collectie van het Musée des Beaux-Arts te Quimper.* Exh. cat. Noordbrabants Museum, 's-Hertogenbosch. Ghent: Snoeck-Ducaju.

Vaugelas, Claude Favre de
1647 *Remarques sur la langue françoise, utiles à ceux qui veulent bien parler et bien escrire.* Paris: Veuve Jean Camusat et Pierre Le Petit.

Verlet, Pierre
1945–94 *Le mobilier royal français.* 4 vols. Paris: Editions d'Art et d'Histoire.
1963 *French Royal Furniture.* London: Barrie and Rockliff.
1982 *The Savonnerie: Its History. The Waddesdon Collection.* The James A. de Rothschild Collection at Waddesdon Manor. London: Published for the National Trust by Office du Livre, Fribourg.

Verreau, Hospice-Anthelme-Jean-Baptiste
1875 "Lettres de la Révérende Mère Marie André Regnard Duplessis de Ste. Hélène." *Revue canadienne* 12 (Feb.), pp. 105–20.

Verri, Pietro, and Alessandro Verri
1980 *Viaggio a Parigi e Londra (1766–1767): Carteggio di Pietro e Alessandro Verri.* Edited by Gianmarco Gaspari. Milan: Adelphi.

Versailles à Stockholm
1985 *Versailles à Stockholm: Dessins du National-museum. Peintures, meubles et arts décoratifs des collections suédoises et danoises.* Exh. cat. Institut Culturel Suédois, Hôtel de Marle, Paris. Stockholm: Nationalmuseum.

Versailles et les tables royales en Europe
1993 *Versailles et les tables royales en Europe, XVIIème–XIXème siècles.* Exh. cat. Musée National des Châteaux de Versailles et de Trianon; 1993–94. Paris: Réunion des Musées Nationaux.

Veryard, Ellis
1701 *An Account of Divers Choice Remarks, as Well Geographical, as Historical, Political, Mathematical, Physical, and Moral; Taken in a Journey through the Low-Countries, France, Italy, and Part of Spain. . . .* London: Printed and sold by S. Smith and B. Walford.

Veues de Versailles
ca. 1690a *Veues de Versailles / Die Prospect von Versailles.* [Augsburg]: Johann Ulrich Krauss.
ca. 1690b *Veues de Versailles gravées sur les dessins au naturel par Guillaume Swidde.* [Amsterdam]: Nicolaus Visscher.

Viera y Clavijo, José de
1849 *Apuntes del diario e itinerario de mi viage a Francia y Flandes . . . en los años de 1777 y 1778.* Santa Cruz de Tenerife: Litografía y Librería Isleña.

View of Paris
1701 *A View of Paris, and Places Adjoining. With an Account of the Court of France; and of the Late King James.* London: Printed for John Nutt.

Vigée Le Brun, Elisabeth
1869 *Souvenirs de Madame Vigée Le Brun.* 2 vols. Paris: Charpentier.
1904 *The Memoirs of Madame Vigée Lebrun.* Translated by Lionel Strachey. London: Grant Richards.

Villiers, John Charles, 3rd Earl of Clarendon
1789 *A Tour through Part of France, Containing a Description of Paris, Cherbourg, and Ermenonville. . . .* London: Printed for T. Cadell.

Vittet, Jean
2015 "The French Royal Collection of Tapestries at Its Zenith: Louis XIV as Heir, Collector, and Patron." In Bremer-David 2015, pp. 5–37.

Vittet, Jean, and Arnauld Brejon de Lavergnée
2010 With the collaboration of Monique de Savignac. *La collection de tapisseries de Louis XIV.* Dijon: Faton.

Volkmann, Johann Jacob
1787–88 *Neueste Reisen durch Frankreich: Vorzüglich in Absicht auf die Naturgeschichte, Oekonomie, Manufakturen und Werke der Kunst aus den besten Nachrichten und neuern Schriften zusammengetragen.* 3 vols. Leipzig: Caspar Fritsch.

Voyage des ambassadeurs de Siam
1686 *Voyage des ambassadeurs de Siam en France.* Suppl. to *Mercure galant*, Nov. 1686. Vol. 2. Lyon: Mercure Galant, 1686. [Reprint, Bangkok: Chalermnit Books, 1985.]

Voyageur fidèle
1715 [Pierre Ribou]. *Le voyageur fidèle, ou Le guide des étrangers dans la ville de Paris.* Paris: Pierre Ribou.

Walpole, Horace
1842 *Letters of Hon. Horace Walpole, Earl of Orford: Including Numerous Letters Now First Published from the Original Manuscripts.* Edited by John Wright. 4 vols. Philadelphia: Lea and Blanchard.
1937 *Horace Walpole's Correspondence with the Rev. William Cole.* Edited by W. S. Lewis and A. Dayle Wallace. Yale Edition of Horace Walpole's Correspondence 1. New Haven, Conn.: Yale University Press.
1939 *Horace Walpole's Correspondence with Madame du Deffand and Mademoiselle Sanadon.* Edited by W. S. Lewis and Warren Hunting Smith. Vol. 3. Yale Edition of Horace Walpole's Correspondence 5. New Haven, Conn.: Yale University Press.
1941 *Horace Walpole's Correspondence with George Montagu.* Edited by W. S. Lewis and Ralph S. Brown Jr. 2 vols. Yale Edition of Horace Walpole's Correspondence 9, 10. New Haven, Conn.: Yale University Press.
1948 *Horace Walpole's Correspondence with Thomas Gray, Richard West and Thomas Ashton.* Edited by W. S. Lewis, George L. Lam, and Charles H. Bennett. 2 vols. in 1. Yale Edition of Horace Walpole's Correspondence 13, 14. New Haven, Conn.: Yale University Press.
1973 *Horace Walpole's Correspondence with John Chute, Richard Bentley, the Earl of Strafford, Sir William Hamilton, the Earl and Countess Harcourt, George Hardinge.* Edited by W. S. Lewis et al. Yale Edition of Horace Walpole's Correspondence 35. New Haven, Conn.: Yale University Press.
1974 *Horace Walpole's Correspondence with Henry Seymour Conway, Lady Ailesbury, Lord and Lady Hertford, Lord Beauchamp, Henrietta Seymour Conway.* Edited by W. S. Lewis et al. Vol. 2. Yale Edition of Horace Walpole's Correspondence 38. New Haven, Conn.: Yale University Press.

Wardropper, Ian
2011 *European Sculpture, 1400–1900, in The Metropolitan Museum of Art.* New York: The Metropolitan Museum of Art.

Watson, Elkanah
1856 *Men and Times of the Revolution, or Memoirs of Elkanah Watson, including His Journals of Travels in Europe and America, from the Year 1777 to 1842. . . .* Edited by Winslow C. Watson. New York: Dana.

Welch, Ellen R.
2017 *A Theater of Diplomacy: International Relations and the Performing Arts in Early Modern France.* Philadelphia: University of Pennsylvania Press.

Wellington, Robert
2015a *Antiquarianism and the Visual Histories of Louis XIV: Artifacts for a Future Past.* Farnham, Surrey: Ashgate.
2015b "Louis XIV's Medal Cabinet at Versailles." *Medal*, no. 67 (Autumn), pp. 12–25.
2016 "Médailles en mouvement: La réception des médailles de Louis XIV à la croisée des cultures." In *Les médailles de Louis XIV et leur livre*, edited by Yvan Loskoutoff, pp. 289–307. Mont-Saint-Aignan: Presses Universitaires de Rouen et du Havre.

Whitehead, John
2009 "Royal Riches and Parisian Trinkets: The Embassy of Saïd Mehmet Pasha to France in 1741–42 and Its Exchange of Gifts." *Court Historian* 14, no. 2 (Dec.), pp. 161–75.

Wicquefort, Abraham de
1680–81 *L'ambassadeur et ses fonctions.* 2 vols. The Hague: Jean & Daniel Steucker.

Wildenstein, Georges
1922 *Le peintre Aved: Sa vie et son oeuvre, 1702–1766.* 2 vols. Paris: Les Beaux-Arts, Editions d'Etudes et de Documents.

Wilhelm, Jacques
1963 "Un projet de Charles de Wailly pour l'aménagement du Salon du Louvre." *Bulletin du Musée Carnavalet* 16, no. 1 (June), pp. 5–10.

Willebrandt, Johann Peter
1758 *Historische Berichte und practische Anmerkungen auf Reisen in Deutschland, in die Niederlande, in Frankreich, England, Dännemark, Böhmen und Ungarn.* Hamburg: Bonischen Buchhandlung.

Williams, Hannah
2015 *Académie Royale: A History in Portraits.* Farnham, Surrey: Ashgate.

Williams, Helen Maria
1791 *Letters on the French Revolution, Written in France, in the Summer of 1790, to a Friend in England; Containing, Various Anecdotes Relative to That Interesting Event, and Memoirs of Mons. and Madame Du F—.* Boston: Printed by J. Belknap and A. Young.

Wilson, Gaye, and Elizabeth V. Chew
2002 "Fashioning an American Diplomat: The
Mather Brown Portrait of Thomas Jefferson."
Dress, no. 29, pp. 19–26.

Wittwer, Samuel
2002 "Prinz Heinrich und das Porzellan." In *Prinz
Heinrich von Preussen* 2002, pp. 467–72.

Wolf, John B.
1968 *Louis XIV*. New York: W. W. Norton.

Wolvesperges, Thibaut
2000 *Le meuble français en laque au XVIIIe siècle*.
Paris: Amateur; Brussels: Racine.

Woodhouse, Anne
1981 "A Visit to Paris, 1726." *Bodleian Library
Record* 10, no. 5 (Aug.) pp. 290–96.

Wright, Edward
1730 *Some Observations Made in Travelling through
France, Italy, &c. in the Years 1720, 1721, and
1722*. 2 vols. London: Printed for Tho. Ward and
E. Wicksteed.

Wrigley, Richard
2002 "Protokollierte Identität: Anmerkungen
über das Inkognito in der Reisepraxis und der
Reiseliteratur des 18. Jahrhunderts." In *Europa-
reisen politisch-sozialer Eliten im 18. Jahrhundert:
Theoretische Neuorientierung, kommunikative Praxis,
Kultur- und Wissenstransfer*, edited by Joachim
Rees, Winfried Siebers, and Hilmar Tilgner,
pp. 209–18. Aufklärung und Europa 6. Berlin:
Berliner Wissenschafts-Verlag.

Yerkes, Carolyn
2014–15 "The Grand Escalier at the Château de
Versailles: The Monumental Staircase and Its
Edges." *Princeton University Library Chronicle* 76,
nos. 1–2 (Autumn 2014–Winter 2015), pp. 51–83.

Young, Arthur
1792 *Travels during the Years 1787, 1788, and 1789.
Undertaken More Particularly with a View of
Ascertaining the Cultivation, Wealth, Resources,
and National Prosperity, of the Kingdom of France*.
Bury St. Edmund's: Printed by J. Rackham for
W. Richardson, London.

1794 *Travels during the Years 1787, 1788, & 1789;
Undertaken More Particularly with a View of
Ascertaining the Cultivation, Wealth, Resources,
and National Prosperity of the Kingdom of
France*. 2nd edition. 2 vols. London: Printed for
W. Richardson.

1909 *Arthur Young's Travels in France during the years
1787, 1788, 1789*. Edited by Matilda Betham-
Edwards. London: George Bell and Sons, 1909.

Young, William
1889 *The History of Dulwich College*. . . . 2 vols.
Edinburgh: Printed for the author by Morrison &
Gibb.

Zafran, Eric M.
1998 With the assistance of Katherine Rothkopf and
Sydney Resendez. *French Paintings in the Museum
of Fine Arts, Boston*. Vol. 1, *Artists Born before 1790*.
Boston: Museum of Fine Arts.

INDEX

PHOTOGRAPH CREDITS

This catalogue is published in conjunction with "Visitors to Versailles: From Louis XIV to the French Revolution," on view at The Metropolitan Museum of Art, New York, from April 16 through July 29, 2018.

The exhibition is made possible by the Internationál Council.

Additional support is provided by the William Randolph Hearst Foundation, Beatrice Stern, the Diane W. and James E. Burke Fund, the Gail and Parker Gilbert Fund, The Florence Gould Foundation, The Danny Kaye and Sylvia Fine Kaye Foundation/French Heritage Society, and The Al-Thani Collection.

It is organized by The Metropolitan Museum of Art and the Palace of Versailles.

The catalogue is made possible by the Diane W. and James E. Burke Fund and The Andrew W. Mellon Foundation.

PUBLISHED BY THE METROPOLITAN MUSEUM OF ART, NEW YORK
Mark Polizzotti, Publisher and Editor in Chief
Gwen Roginsky, Associate Publisher and General Manager
 of Publications
Peter Antony, Chief Production Manager
Michael Sittenfeld, Senior Managing Editor

Edited by Margaret Donovan and Dale Tucker
Designed by Laura Lindgren
Production by Lauren Knighton
Bibliography edited by Jayne Kuchna
Image acquisitions and permissions by Jessica Palinski
Translations from French by Jean-Marie Clarke and Jane Marie Todd
 and from German by Russell Stockman
Index by Cheryl Lemmens

Photographs of works in The Metropolitan Museum of Art's collection are by the Imaging Department, The Metropolitan Museum of Art, unless otherwise noted.

Additional photography credits appear on page 369.

Typeset in Monotype Fournier and Theano Didot by Laura Lindgren
Printed on 135 gsm Perigord
Separations by Professional Graphics, Inc., Rockford, Illinois
Printed and bound by Verona Libri, Verona, Italy

Jacket illustration and pages 224–25: Etienne Allegrain, *Promenade of Louis XIV in Front of the North Parterre*, ca. 1688 (detail, cat. 127). Endpapers: Jean Michel Chevotet (1698–1772), "View of the Ambassadors' Staircase," plate 6 from *Le Grand Escalier du Château de Versailles* (Paris: Louis Surugue, 1725), The Metropolitan Museum of Art, New York, Rogers Fund, 1918, transferred from the Library (1991.1073.55). Pages ii–iii: Richard Mique and Claude Louis Châtelet, "Temple of Love," from *Souvenir Album of the Petit Trianon*, 1781 (detail, cat. 95). Page iv: Augustin Oudart Justina, *Louis XV*, ca. 1717 (detail, cat. 56). Pages vi–vii: Attributed to Pierre Denis Martin the Younger, *Louis XV Departing for the Hunt*, ca. 1724 (detail, cat. 128). Page viii: Jacques André Joseph Aved, *Mehmed Said Efendi, Ambassador of the Sublime Porte*, 1742 (detail, cat. 75). Pages x–xi: Attributed to Nicolas Largillière, *Louis XIV Receiving the Persian Ambassador Muhammad Reza Beg*, after 1715 (detail,

cat. 71). Pages xviii–xix: Etienne Allegrain, *View of the Château de Versailles and the Orangerie*, ca. 1695 (detail, cat. 138). Pages xxii–1: Pierre Denis Martin the Younger, *View of the Château de Versailles from the Place d'Armes*, 1722 (detail, cat. 31). Pages 42–43: Louis Surugue after Charles Parrocel, "Entrance of an Ambassador at Versailles," from *Le Grand Escalier du Château de Versailles* (Paris: Louis Surugue, 1725) (detail, fig. 95). Pages 92–93: Claude Guy Hallé, cartoon for *Reparation Made to Louis XIV by the Doge of Genoa, May 15, 1685*, 1715 (detail, fig. 46). Pages 178–79: Louis de Silvestre, *Louis XIV Receiving the Prince Elector of Saxony at Fontainebleau*, 1715 (detail, cat. 88). Pages 286–87: Louis Carrogis, known as Carmontelle, *Benjamin Franklin*, ca. 1780–81 (detail, fig. 99). Pages 312–13: Louis Michel Dumesnil, *The Formal Audience of Cornelis Hop at the Court of Louis XV*, ca. 1720–29 (detail, cat. 53).

The Metropolitan Museum of Art
1000 Fifth Avenue
New York, New York 10028
metmuseum.org

Distributed by
Yale University Press, New Haven and London
yalebooks.com/art
yalebooks.co.uk

Cataloguing-in-Publication Data is available from the Library of Congress.
ISBN 978-1-58839-622-8

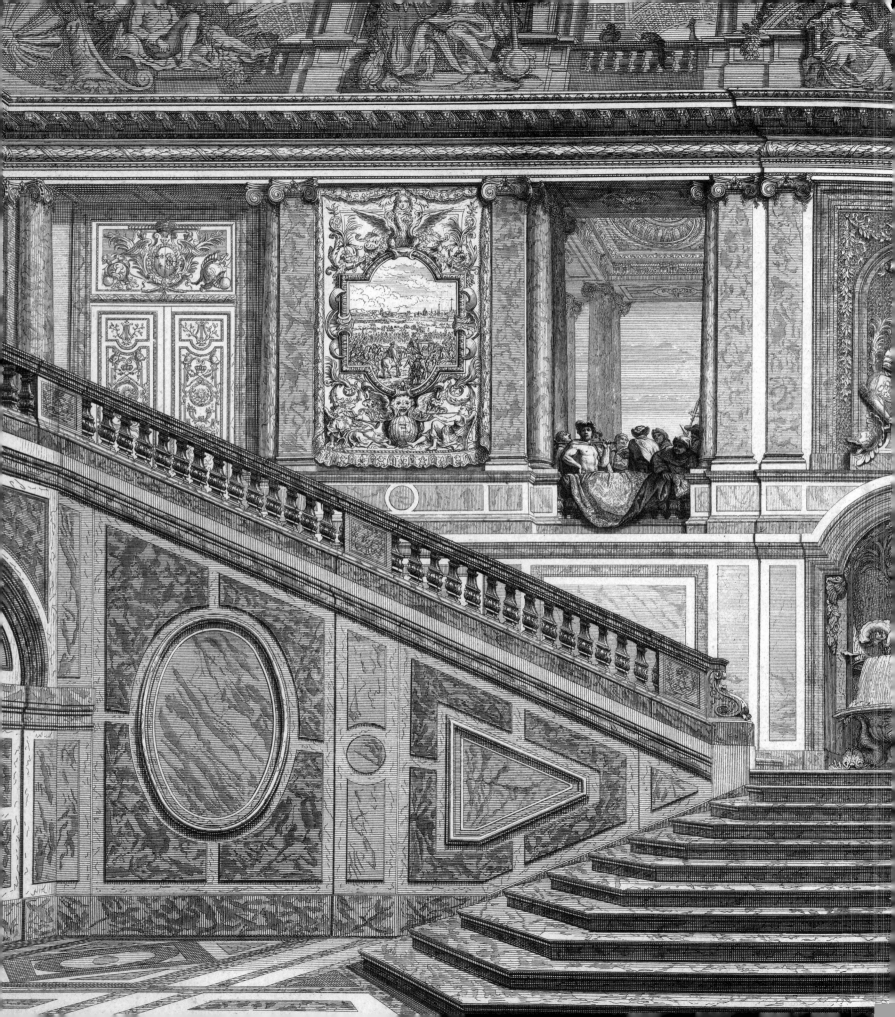